D0205162

GARDNER'S

ART THROUGHTHE AGES

BOOK A: ANTIQUITY

FIFTEENTH EDITION

FRED S. KLEINER

Gardner's Art through the Ages, Fifteenth Edition, Book A: Antiquity Fred S. Kleiner

Product Director: Monica Eckman
Product Manager: Sharon Adams Poore
Content Developer: Rachel Harbour
Associate Content Developer: Erika Hayden

Product Assistant: Rachael Bailey Media Developer: Chad Kirchner Marketing Manager: Jillian Borden

Senior Content Project Manager: Lianne Ames

Senior Art Director: Cate Rickard Barr Manufacturing Planner: Sandee Milewski

IP Analyst: Jessica Elias

IP Project Manager: Farah Fard

Production Service and Layout: Dovetail

Publishing Services

Compositor: Cenveo® Publisher Services

Text Designer: Frances Baca

Cover Designer: Mark Fox, Design is Play Cover Image: Hirmer Fotoarchiv, Munich © 2016, 2013, 2009 Cengage Learning

WCN: 01-100-101

ALL RIGHTS RESERVED. No part of this work covered by the copyright herein may be reproduced, transmitted, stored, or used in any form or by any means graphic, electronic, or mechanical, including but not limited to photocopying, recording, scanning, digitizing, taping, web distribution, information networks, or information storage and retrieval systems, except as permitted under Section 107 or 108 of the 1976 United States Copyright Act, without the prior written permission of the publisher.

For product information and technology assistance, contact us at Cengage Learning Customer & Sales Support, 1-800-354-9706

For permission to use material from this text or product, submit all requests online at www.cengage.com/permissions.

Further permissions questions can be emailed to permissionrequest@cengage.com.

Library of Congress Control Number: 2014943688

Book A:

ISBN: 978-1-285-83798-7

Cengage Learning

20 Channel Center Street Boston, MA 02210 USA

Cengage Learning is a leading provider of customized learning solutions with office locations around the globe, including Singapore, the United Kingdom, Australia, Mexico, Brazil, and Japan. Locate your local office at www.cengage.com/global.

Cengage Learning products are represented in Canada by Nelson Education, Ltd.

To learn more about Cengage Learning Solutions, visit www.cengage.com.

Purchase any of our products at your local college store or at our preferred online store **www.cengagebrain.com.**

Printed in the United States of America Print Number: 02 Print Year: 2015

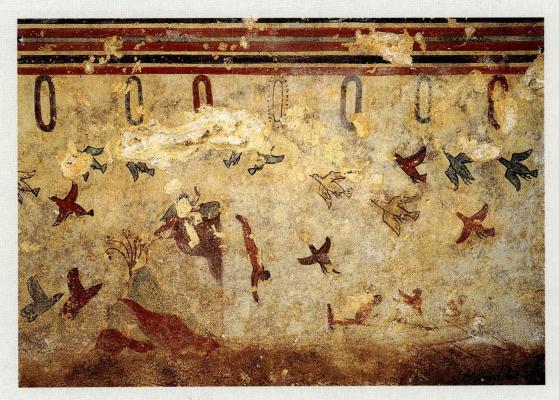

Youths diving and fishing, detail of the fresco on the left wall of the Tomb of Hunting and Fishing, Monterozzi necropolis, Tarquinia, Italy, ca. 530–520 BCE.

The first painters, who covered the walls and ceilings of the caves of France and Spain beginning around 30,000 years ago, chose animals and occasionally humans as their exclusive subjects. The first landscapes appeared many thousands of years later, but soon became staples of most, but by no means all, artistic cultures worldwide.

At the Etruscan site of Tarquinia between Florence and Rome in central Italy, archaeologists have located thousands of underground tombs laboriously carved out of the bedrock, but only about 200 were decorated with frescoes, and in only one—the aptly named Tomb of Hunting and Fishing—are all four walls of the main chamber decorated with scenes of Etruscans enjoying the pleasures of nature. On the wall shown here, youths fish from a boat while another dives off a rocky promontory. Elsewhere, hunters aim their slingshots at birds. Although certain stylistic details of the representation derive from Greek art, large-scale fresco paintings as well as landscapes are unknown in Greece at this time, underscoring the independence of Etruscan artists.

The identity of the painter(s) of the Tomb of Hunting and Fishing is unknown, but that is the norm in the history of art before the Renaissance, when the modern notion of individual artistic genius took root. Artthrough the Ages surveys the art of all periods from prehistory to the present, and worldwide, and examines how artworks of all kinds have always reflected the historical contexts in which they were created.

Brief Contents

Preface xi **CHAPTER 5** Ancient Greece 102 INTRODUCTION What Is Art History? 1 **CHAPTER 6** The Etruscans 162 **CHAPTER 1** Art in the Stone Age 14 **CHAPTER 7** The Roman Empire 176 **CHAPTER 2** Ancient Mesopotamia and Persia 30 Notes 230 **CHAPTER 3** Glossary 231 Egypt from Narmer to Cleopatra 54 Bibliography 239 Credits 245 **CHAPTER 4** The Prehistoric Aegean 82 Index 247

Contents

Preface xi

INTRODUCTION

What Is Art History?

Art History in the 21st Century 2

Different Ways of Seeing 13

1 Art in the Stone Age 14

FRAMING THE ERA The Dawn of Art 15

TIMELINE 16

Paleolithic Art 16

Neolithic Art 23

- PROBLEMS AND SOLUTIONS: How to Represent an Animal 17
- PROBLEMS AND SOLUTIONS: Painting in the Dark 20
- ART AND SOCIETY: Why Is There Art in Paleolithic Caves? 21

MAP 1-1 Stone Age sites in Europe 16

MAP 1-2 Neolithic sites in Anatolia and Mesopotamia 24

THE BIG PICTURE 29

2 Ancient Mesopotamia and Persia

FRAMING THE ERA Pictorial Narration in Ancient Sumer 31

TIMELINE 32

Mesopotamia 32

Persia 48

- RELIGION AND MYTHOLOGY: The Gods and Goddesses of Mesopotamia 34
- PROBLEMS AND SOLUTIONS: Sumerian Votive Statuary 35

- MATERIALS AND TECHNIQUES: Mesopotamian Seals 39
- ART AND SOCIETY: Enheduanna, Priestess and Poet 41
- THE PATRON'S VOICE: Gudea of Lagash 43
- ART AND SOCIETY: Hammurabi's Laws 44
- PROBLEMS AND SOLUTIONS: How Many Legs Does a Lamassu Have? 46
- WRITTEN SOURCES: Babylon, City of Wonders 49

MAP 2-1 Ancient Mesopotamia and Persia 32

THE BIG PICTURE 53

3 Egypt from Narmer to Cleopatra 54

FRAMING THE ERA Life after Death in Ancient Egypt 55

TIMELINE 56

Egypt and Egyptology 56

Predynastic and Early Dynastic Periods 56

Old Kingdom 60

Middle Kingdom 67

New Kingdom 68

First Millennium BCE 79

- RELIGION AND MYTHOLOGY: The Gods and Goddesses of Egypt 58
- ART AND SOCIETY: Mummification and Immortality 60
- PROBLEMS AND SOLUTIONS: Building the Pyramids of Gizeh 62
- PROBLEMS AND SOLUTIONS: How to Portray a God-King 64
- ART AND SOCIETY: Hatshepsut, the Woman Who Would Be King 69
- PROBLEMS AND SOLUTIONS: Illuminating Buildings before Lightbulbs 73

MAP 3-1 Ancient Egypt 56

THE BIG PICTURE 81

4 The Prehistoric Aegean 82

FRAMING THE ERA Greece in the Age of Heroes 83

TIMELINE 84

Greece before Homer 84

Cycladic Art 85

Minoan Art 86

Mycenaean Art 93

- ART AND SOCIETY: Archaeology, Art History, and the Art Market 85
- ART AND SOCIETY: The Theran Eruption and the Chronology of Aegean Art 91
- PROBLEMS AND SOLUTIONS: Fortified Palaces for a Hostile World 94
- ARCHITECTURAL BASICS: Corbeled Arches, Vaults, and Domes 95

MAP 4-1 The prehistoric Aegean 84

THE BIG PICTURE 101

5

Ancient Greece 102

FRAMING THE ERA The Perfect Temple 103

TIMELINE 104

The Greeks and Their Gods 104

Geometric and Orientalizing Periods 106

Archaic Period 109

Early and High Classical Periods 123

Late Classical Period 142

Hellenistic Period 150

- RELIGION AND MYTHOLOGY: The Gods and Goddesses of Mount Olympus 105
- MATERIALS AND TECHNIQUES: Greek Vase Painting 108
- ARCHITECTURAL BASICS: Greek Temple Plans 113
- ARCHITECTURAL BASICS: Doric and Ionic Orders 114
- PROBLEMS AND SOLUTIONS: The Invention of Red-Figure Painting 119
- RELIGION AND MYTHOLOGY: Herakles, the Greatest Greek Hero 124
- MATERIALS AND TECHNIQUES: Hollow-Casting Life-Size Bronze Statues 127
- PROBLEMS AND SOLUTIONS: Polykleitos's Prescription for the Perfect Statue 129

- ART AND SOCIETY: The Hegeso Stele 139
- MATERIALS AND TECHNIQUES: White-Ground Painting 140
- ARCHITECTURAL BASICS: The Corinthian Capital 149
- PROBLEMS AND SOLUTIONS: Hippodamos's Plan for the Ideal City 151

MAP 5-1 The Greek world 104

THE BIG PICTURE 161

6 The Etruscans 162

FRAMING THE ERA The Painted Tombs of Tarquinia 163

TIMELINE 164

Etruria and the Etruscans 164

Early Etruscan Art 164

Later Etruscan Art 171

- RELIGION AND MYTHOLOGY: Etruscan Counterparts of Greco-Roman Gods and Heroes 165
- WRITTEN SOURCES: Etruscan Artists in Rome 166
- ART AND SOCIETY: The "Audacity" of Etruscan Women 167
- PROBLEMS AND SOLUTIONS: Houses of the Dead in a City of the Dead 168

MAP 6-1 Italy in Etruscan times 164

THE BIG PICTURE 175

7 The Roman Empire 176

FRAMING THE ERA Roman Art as Historical

Fiction 177

TIMELINE 178

Rome, Caput Mundi 178

Republic 179

Pompeii and the Cities of Vesuvius 186

Early Empire 195

High Empire 206

Late Empire 218

- ART AND SOCIETY: Who's Who in the Roman World 179
- ARCHITECTURAL BASICS: Roman Concrete Construction 182
- ART AND SOCIETY: Roman Ancestor Portraits 183
- **ART AND SOCIETY:** Art for Former Slaves 185

- WRITTEN SOURCES: An Eyewitness Account of the Eruption of Mount Vesuvius 186
- ART AND SOCIETY: The Roman House 188
- ART AND SOCIETY: Role Playing in Roman Portraiture 196
- THE PATRON'S VOICE: The Res Gestae of Augustus 197
- WRITTEN SOURCES: Vitruvius's *Ten Books* on Architecture 199
- WRITTEN SOURCES: The Golden House of Nero 201
- ART AND SOCIETY: Spectacles in the Colosseum 202
- PROBLEMS AND SOLUTIONS: The Spiral Frieze of the Column of Trajan 208
- PROBLEMS AND SOLUTIONS: The Ancient World's Largest Dome 211
- WRITTEN SOURCES: Hadrian and Apollodorus of Damascus 212

- MATERIALS AND TECHNIQUES: Iaia of Cyzicus and the Art of Encaustic Painting 217
- PROBLEMS AND SOLUTIONS: Tetrarchic Portraiture 224

MAP 7-1 The Roman Empire at the death of Trajan in 117 CE 178

THE BIG PICTURE 229

Notes 230

Glossary 231

Bibliography 239

Credits 245

Index 247

Preface

I take great pleasure in introducing the extensively revised and expanded 15th edition of *Gardner's Art through the Ages: A Global History*, which, like the 14th edition, is a hybrid art history textbook—the first, and still the only, introductory survey of the history of art of its kind. This innovative new kind of "Gardner" retains all of the best features of traditional books on paper while harnessing 21st-century technology to significantly increase the number of works examined—without substantially increasing the size of the text or abbreviating the discussion of each work.

When Helen Gardner published the first edition of *Art through the Ages* in 1926, she could not have imagined that nearly a century later, instructors all over the world would still be using her textbook (available even in Mandarin Chinese) in their classrooms. Indeed, if she were alive today, she would not recognize the book that, even in its traditional form, long ago became—and remains—the world's most widely read introduction to the history of art and architecture. I hope that instructors and students alike will agree that this new edition lives up to the venerable Gardner tradition and even exceeds their high expectations.

The 15th edition follows the 14th in incorporating an innovative new online component that includes, in addition to a host of other features (enumerated below), *bonus essays* and *bonus images* (with zoom capability) of more than 300 additional important works of all eras, from prehistory to the present and worldwide. The printed and online components of the hybrid 15th edition are very closely integrated. For example, every one of the more than 300 bonus essays is cited in the text of the traditional book, and a thumbnail image of each work, with abbreviated caption, is inset into the text column where the work is mentioned. The integration extends also to the maps, index, glossary, and chapter summaries, which seamlessly merge the printed and online information.

KEY FEATURES OF THE 15TH EDITION

In this new edition, in addition to revising the text of every chapter to incorporate the latest research and methodological developments, I have added several important features while retaining the basic format and scope of the previous edition. Once again, the hybrid Gardner boasts roughly 1,700 photographs, plans, and drawings, nearly all in color and reproduced according to the highest standards of clarity and color fidelity. Included in this count are updated and revised maps along with hundreds of new images, among them a new series of superb photos taken by Jonathan Poore exclusively for *Art through the Ages* during photographic campaigns in 2012 and 2013 in Germany and Rome (following similar forays into France and Tuscany in 2009–2011). The online component also includes custom videos made at architectural sites. This extraordinary new archive of visual material ranges from ancient temples in Rome; to medieval, Renaissance, and Baroque churches in France, Germany, and

Italy; to such modernist masterpieces as the Notre-Dame-du-Haut in Ronchamp, France, and the Guggenheim Museum in New York. The 15th edition also features an expanded number of the highly acclaimed architectural drawings of John Burge. Together, these exclusive photographs, videos, and drawings provide readers with a visual feast unavailable anywhere else.

Once again, a scale accompanies the photograph of every painting, statue, or other artwork discussed—another unique feature of the Gardner text. The scales provide students with a quick and effective way to visualize how big or small a given artwork is and its relative size compared with other objects in the same chapter and throughout the book—especially important given that the illustrated works vary in size from tiny to colossal.

Also retained in this edition are the Quick-Review Captions (brief synopses of the most significant aspects of each artwork or building illustrated) that students have found invaluable when preparing for examinations. These extended captions accompany not only every image in the printed book but also all the digital images in the online supplement. Each chapter also again ends with the highly popular full-page feature called *The Big Picture*, which sets forth in bullet-point format the most important characteristics of each period or artistic movement discussed in the chapter. Also retained from the 14th edition are the timeline summarizing the major artistic and architectural developments during the era treated (again in bullet-point format for easy review) and a chapter-opening essay called *Framing the Era*, which discusses a characteristic painting, sculpture, or building and is illustrated by four photographs.

Another pedagogical tool not found in any other introductory art history textbook is the Before 1300 section that appears at the beginning of the second volume of the paperbound version of the book and at the beginning of Book D of the backpack edition. Because many students taking the second half of a survey course will not have access to Volume I or to Books A, B, and C, I have provided a special (expanded) set of concise primers on architectural terminology and construction methods in the ancient and medieval worlds, and on mythology and religion-information that is essential for understanding the history of art after 1300, both in the West and the East. The subjects of these special boxes are Greco-Roman Temple Design and the Classical Orders; Arches and Vaults; Basilican Churches; Central-Plan Churches; the Gods and Goddesses of Mount Olympus; the Life of Jesus in Art; Early Christian Saints and Their Attributes; Buddhism and Buddhist Iconography; and Hinduism and Hindu Iconography.

Boxed essays once again appear throughout the book as well. These essays fall under eight broad categories, two of which are new to the 15th edition:

Architectural Basics boxes provide students with a sound foundation for the understanding of architecture. These discussions are concise explanations, with drawings and diagrams, of the major aspects of design and construction. The information included is essential to an understanding of architectural technology and terminology.

Materials and Techniques essays explain the various media that artists employed from prehistoric to modern times. Because materials and techniques often influence the character of artworks, these discussions contain essential information on why many monuments appear as they do.

Religion and Mythology boxes introduce students to the principal elements of the world's great religions, past and present, and to the representation of religious and mythological themes in painting and sculpture of all periods and places. These discussions of belief systems and iconography give readers a richer understanding of some of the greatest artworks ever created.

Art and Society essays treat the historical, social, political, cultural, and religious context of art and architecture. In some instances, specific monuments are the basis for a discussion of broader themes.

Written Sources present and discuss key historical documents illuminating important monuments of art and architecture throughout the world. The passages quoted permit voices from the past to speak directly to the reader, providing vivid and unique insights into the creation of artworks in all media.

In the *Artists on Art* boxes, artists and architects throughout history discuss both their theories and individual works.

New to the 15th edition are *The Patron's Voice* boxes. These essays underscore the important roles played by the individuals and groups who paid for the artworks and buildings in determining the character of those monuments. Also new are boxes designed to make students think critically about the decisions that went into the making of every painting, sculpture, and building from the Old Stone Age to the present. Called *Problems and Solutions* boxes, these essays address questions of how and why various forms developed, the problems painters, sculptors, and architects confronted, and the solutions they devised to resolve them.

Other noteworthy features retained from the 14th edition are the extensive (updated) bibliography of books in English; a glossary containing definitions of and page references for italicized terms introduced in both the printed and online texts; and a complete museum index, now housed online only, listing all illustrated artworks by their present location. The host of state-of-the-art online resources accompanying the 15th edition are enumerated on page xv).

ACKNOWLEDGMENTS

A work as extensive as a global history of art could not be undertaken or completed without the counsel of experts in all areas of world art. As with previous editions, Cengage Learning has enlisted more than a hundred art historians to review every chapter of Art through the Ages in order to ensure that the text lives up to the Gardner reputation for accuracy as well as readability. I take great pleasure in acknowledging here the important contributions to the 15th edition made by the following: Patricia Albers, San Jose State University; Kirk Ambrose, University of Colorado Boulder; Jenny Kirsten Ataoguz, Indiana University-Purdue University Fort Wayne; Paul Bahn, Hull; Denise Amy Baxter, University of North Texas; Nicole Bensoussan, University of Michigan-Dearborn; Amy R. Bloch, University at Albany, State University of New York; Susan H. Caldwell, The University of Oklahoma; David C. Cateforis, The University of Kansas; Thomas B. F. Cummins, Harvard University; Joyce De Vries, Auburn University; Verena Drake, Hotchkiss School; Jerome Feldman, Hawai'i Pacific University; Maria Gindhart, Georgia State University; Annabeth Headrick, University of Denver;

Shannen Hill, University of Maryland; Angela K. Ho, George Mason University; Julie Hochstrasser, The University of Iowa; Hiroko Johnson, San Diego State University; Julie Johnson, The University of Texas at San Antonio; Paul H.D. Kaplan, Purchase College, State University of New York; Rob Leith, Buckingham Browne & Nichols School; Brenda Longfellow, The University of Iowa; Susan McCombs, Michigan State University; Jennifer Ann McLerran, Northern Arizona University; Patrick R. McNaughton, Indiana University Bloomington; Mary Miller, Yale University; Erin Morris, Estrella Mountain Community College; Nicolas Morrissey, The University of Georgia; Basil Moutsatsos, St. Petersburg College-Seminole; Johanna D. Movassat, San Jose State University; Micheline Nilsen, Indiana University South Bend; Catherine Pagani, The University of Alabama; Allison Lee Palmer, The University of Oklahoma; William H. Peck, University of Michigan-Dearborn; Lauren Peterson, University of Delaware; Holly Pittman, University of Pennsylvania; Romita Ray, Syracuse University; Wendy Wassyng Roworth, The University of Rhode Island; Andrea Rusnock, Indiana University South Bend; Bridget Sandhoff, University of Nebraska Omaha; James M. Saslow, Queens College, City University of New York; Anne Rudolph Stanton, University of Missouri; Achim Timmermann, University of Michigan; David Turley, Weber State University; Lee Ann Turner, Boise State University; Marjorie S. Venit, University of Maryland; Shirley Tokash Verrico, Genesee Community College; Louis A. Waldman, The University of Texas at Austin; Ying Wang, University of Wisconsin-Milwaukee; Gregory H. Williams, Boston University; and Benjamin C. Withers, University of Kentucky.

I am especially indebted to the following for creating the instructor and student materials for the 15th edition: Ivy Cooper, Southern Illinois University Edwardsville; Patricia D. Cosper (retired), The University of Alabama at Birmingham; Anne McClanan, Portland State University; Amy M. Morris, The University of Nebraska Omaha; Erika Schneider, Framingham State University; and Camille Serchuk, Southern Connecticut State University. I also thank the more than 150 instructors and students who participated in surveys, focus groups, design sprints, and advisory boards to help us better understand readers' needs in our print and digital products.

I am also happy to have this opportunity to express my gratitude to the extraordinary group of people at Cengage Learning involved with the editing, production, and distribution of Art through the Ages. Some of them I have now worked with on various projects for nearly two decades and feel privileged to count among my friends. The success of the Gardner series in all of its various permutations depends in no small part on the expertise and unflagging commitment of these dedicated professionals, especially Sharon Adams Poore, product manager (as well as videographer extraordinaire); Rachel Harbour, content developer; Lianne Ames, senior content project manager; Chad Kirchner, media developer; Erika Hayden, associate content developer; Elizabeth Newell, associate media developer; Rachael Bailey, senior product assistant; Cate Barr, senior art director; Jillian Borden, marketing manager; and the incomparable group of local sales representatives who have passed on to me the welcome advice offered by the hundreds of instructors they speak to daily during their visits to college campuses throughout North America.

I am also deeply grateful to the following out-of-house contributors to the 15th edition: the incomparable quarterback of the entire production process, Joan Keyes, Dovetail Publishing Services; Helen Triller-Yambert, developmental editor; Michele Jones, copy editor; Susan Gall, proofreader; Mark Fox, Design is Play, cover designer; Frances Baca, text designer; PreMediaGlobal, photo researchers; Cenveo Publisher Services; Jay and John Crowley, Jay's Publishing Services;

Mary Ann Lidrbauch, art log preparer; and, of course, Jonathan Poore and John Burge, for their superb photos and architectural drawings.

I also owe thanks to two individuals not currently associated with this book but who loomed large in my life for many years: Clark Baxter, who retired in 2013 at the end of a long and distinguished career, from whom I learned much about textbook publishing and whose continuing friendship I value highly; and former coauthor and longtime friend and colleague, Christin J. Mamiya of the University of Nebraska-Lincoln, with whom I have had innumerable conversations not only about Art through the Ages but the history of art in general. Her thinking continues to influence my own, especially with regard to the later chapters on the history of Western art. I conclude this long (but no doubt incomplete) list of acknowledgments with an expression of gratitude to my colleagues at Boston University and to the thousands of students and the scores of teaching fellows in my art history courses since I began teaching in 1975, especially my research assistant, Angelica Bradley. From them I have learned much that has helped determine the form and content of Art through the Ages and made it a much better book than it otherwise might have been.

Fred S. Kleiner

CHAPTER-BY-CHAPTER CHANGES IN THE 15TH EDITION

The 15th edition is extensively revised and expanded, as detailed below. Each chapter contains a revised Big Picture feature, and all maps in the text are new to this edition. Instructors will find a very helpful figure number transition guide in the online instructor companion site.

Introduction: What Is Art History? Added 18th-century Benin Altar to the Hand and details of Claude Lorrain's *Embarkation of the Queen of Sheba*.

- 1: Art in the Stone Age. New Problems and Solutions boxes "How to Represent an Animal" and "Painting in the Dark." New bonus essay on Göbekli Tepe. New photographs of the Paleolithic Hohlenstein-Stadel statuette and of Neolithic Jericho, Göbekli Tepe, and Stonehenge, as well as a new drawing of post-and-lintel construction.
- 2: Ancient Mesopotamia and Persia. New Framing the Era essay "Pictorial Narration in Ancient Sumer." New Problems and Solutions boxes "Sumerian Votive Statuary" and "How Many Legs Does a Lamassu Have?" New Patron's Voice box "Gudea of Lagash." New photographs of the *Warka Vase* (including three new details), Akkadian ruler portrait, Lion Gate at Hattusa, Khorsabad lamassu, Ashurbanipal hunting lions, and the triumph of Shapur I over Valerian.
- **3: Egypt from Narmer to Cleopatra.** New Framing the Era essay "Life after Death in Ancient Egypt" and new Problems and Solutions

boxes "Building the Pyramids of Gizeh," "How to Portray a God-King," and "Illuminating Buildings before Lightbulbs." New photographs of the palette of King Narmer, stepped pyramid of King Djoser, Great Sphinx, tomb of Khnumhotep II, temple complex and hypostyle hall at Karnak, portrait of Tiye with sun disk crown, and temple of Horus at Edfu.

- **4:** The Prehistoric Aegean. New Problems and Solutions box "Fortified Palaces for a Hostile World." New Architectural Basics box "Corbeled Arches, Vaults, and Domes." New photographs of the Lion Gate, the exterior and interior of the Treasury of Atreus, and Grave Circle A at Mycenae. New restored view of the palace at Knossos.
- 5: Ancient Greece. New Problems and Solutions boxes "The Invention of Red-Figure Painting," "Polykleitos's Prescription for the Perfect Statue," and "Hippodamos's Plan for the Ideal City." New Materials and Techniques box "White-Ground Painting." New photographs of the Achilles and Ajax vases by Exekias and the Lysippides and Andokides Painters; the Temple of Aphaia at Aegina; the Parthenon and two sections of its Ionic frieze; Mnesikles's Propylaia; the Erechtheion and a detail of its caryatid porch; the restored Athena Nike temple; the Phiale Painter's krater with Hermes and Dionysos; Gnosis's stag hunt mosaic; the theater at Epidauros; the tholos at Delphi; the choragic monument of Lyskikrates; and the *Barberini Faun*.
- **6: The Etruscans.** New Framing the Era essay "The Painted Tombs of Tarquinia." New Problems and Solutions box "Houses of the Dead for a City of the Dead." New section on Etruscan city planning. New photographs of the Tarquinian Tomb of the Triclinium and the Tomb of the Leopards, including four new details, as well as of the Tomb of the Reliefs at Cerveteri. New plan of Marzabotto and new drawing of arch construction.
- 7: The Roman Empire. New Framing the Era essay "Roman Art as Historical Fiction." New Patron's Voice box "The Res Gestae of Augustus." New Written Sources box "Vitruvius's Ten Books on Architecture." New Problems and Solutions boxes "The Spiral Frieze of the Column of Trajan," "The Ancient World's Largest Dome," and "Tetrarchic Portraiture." New photographs of details of the apotheosis of Antoninus and Faustina; the Temple of Vesta at Tivoli; cubiculum 15 of the Villa of Agrippa Postumus at Boscotrecase; the Ara Pacis and its Tellus panel; the Maison Carrée at Nîmes; the Arch of Titus (general view and three reliefs); the Column of Trajan (general view and four details of the frieze); the exterior and interior of the Markets of Trajan; the Pantheon; the Baths of Neptune at Ostia; the Arch of Constantine (general view and detail of the Hadrianic tondi and Constantinian frieze); the colossal portrait head of Constantine; the Basilica Nova in Rome; and the interior and exterior of the Aula Palatina at Trier.

ABOUT THE AUTHOR Fred S. Kleiner

FRED S. KLEINER (Ph.D., Columbia University) has been the author or coauthor of *Gardner's Art through the Ages* beginning with the 10th edition in 1995. He has also published more than a hundred books, articles, and reviews on Greek and Roman art and architecture, including *A History of Roman Art*, also published by Cengage Learning. Both *Art through the Ages* and the book on Roman art have been awarded Texty prizes as the outstanding college textbook of the year in the humanities and social sciences, in 2001 and 2007, respectively. Professor Kleiner has taught the art history survey course since 1975, first at the University of Virginia and, since 1978, at Boston University, where he is currently professor of the history of art and architecture and classical archaeology and has served as department chair for five terms, most recently from 2005 to 2014. From 1985 to 1998, he was editor-in-chief of the *American Journal of Archaeology*.

Long acclaimed for his inspiring lectures and devotion to students, Professor Kleiner won Boston University's Metcalf Award for Excellence in Teaching as well as the College Prize for Undergraduate Advising in the Humanities in 2002, and he is a two-time winner of the Distinguished Teaching Prize in the College of Arts & Sciences Honors Program. In 2007, he was elected a Fellow of the Society of Antiquaries of London, and, in 2009, in recognition of lifetime achievement in publication and teaching, a Fellow of the Text and Academic Authors Association.

Also by Fred Kleiner: A History of Roman Art, Enhanced Edition (Wadsworth/Cengage Learning 2010; ISBN 9780495909873), winner of the 2007 Texty Prize for a new college textbook in the humanities and social sciences. In this authoritative and lavishly illustrated volume, Professor Kleiner traces the development of Roman art and architecture from Romulus's foundation of Rome in the eighth century BCE to the death of Constantine in the fourth century CE, with special chapters devoted to Pompeii and Herculaneum, Ostia, funerary and provincial art and architecture, and the earliest Christian art. The enhanced edition also includes a new introductory chapter on the art and architecture of the Etruscans and of the Greeks of South Italy and Sicily.

Resources

FOR FACULTY

Instructor Companion Site

Access the Instructor Companion Site to find resources to help you teach your course and engage your students. Here you will find the Instructor's Manual; Cognero computerized testing; and Microsoft PowerPoint slides with lecture outlines and images that can be used as offered or customized by importing personal lecture slides or other material.

Digital Image Library

Display digital images in the classroom with this powerful tool. This one-stop lecture and class presentation resource makes it easy to assemble, edit, and present customized lectures for your course. Available on Flashdrive, the Digital Image Library provides high-resolutions images (maps, diagrams, and the fine art images from the text) for lecture presentations and allows you to easily add your own images to supplement those provided. A zoom feature allows you to magnify selected portions of an image for more detailed display in class, or you can display images side-by-side for comparison.

Google EarthTM

Take your students on a virtual tour of art through the ages! Resources for the 15th edition include Google Earth™ coordinates for all works, monuments, and sites discussed in the text, encouraging students to make geographical connections between places and sites. Use these coordinates to start your lectures with a virtual journey to locations all over the globe, or take aerial screenshots of important sites to incorporate in your lecture materials.

FOR STUDENTS

MindTap for Art through the Ages

MindTap for Gardner's Art through the Ages: A Global History, 15th edition, helps you engage with your course content and achieve greater comprehension. Highly personalized and fully online, the MindTap learning platform presents authoritative Cengage Learning content, assignments, and services offering you a tailored presentation of course curriculum created by your instructor.

MindTap guides you through the course curriculum via an innovative Learning Path Navigator where you will complete reading assignments, annotate your readings, complete homework, and engage with quizzes and assessments. Concepts are brought to life with: zoomable versions of close to 1,500 images; videos to reinforce concepts and expand knowledge of particular works or art trends; numerous study tools, including image flashcards; a glossary complete with an audio pronunciation guide; Google EarthTM coordinate links for all works, monuments, and sites discussed in the text; and much more! Additional features, such as the ability to synchronize your eBook notes with your personal EverNote account, provide added convenience to help you take your learning further, faster.

Slide Guides

The Slide Guide is a lecture companion that allows you to take notes alongside representations of the art images shown in class. This handy resource includes reproductions of the images from the book, with full captions and space for note-taking.

▲ I-1a Among the questions art historians ask is why artists chose the subjects they represented. Why would a 17th-century French painter set a biblical story in a contemporary harbor with a Roman ruin?

▲ I-1b Why is the small boat in the foreground much larger than the sailing ship in the distance? What devices did Western artists develop to produce the illusion of deep space in a two-dimensional painting?

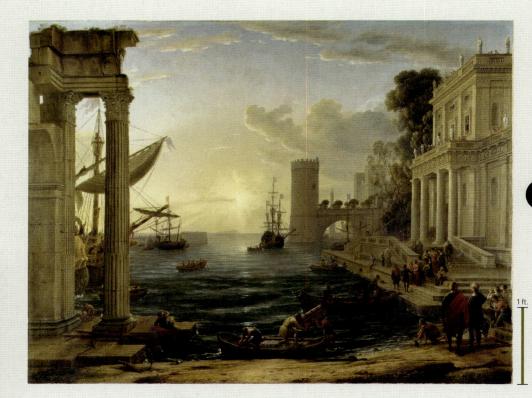

-1 CLAUDE LORRAIN, Embarkation of the Queen of Sheba, 1648. Oil on canvas, 4' 10" × 6' 4". National Gallery, London.

◄ I-1c Why does the large port building at the right edge of this painting seem normal to the eye when the top and bottom of the structure are not parallel horizontal lines, as they are in a real building?

What Is Art History?

What is art history? Except when referring to the modern academic discipline, people do not often juxtapose the words *art* and *history*. They tend to think of history as the record and interpretation of past human events, particularly social and political events. In contrast, most think of art, quite correctly, as part of the present—as something people can see and touch. Of course, people cannot see or touch history's vanished human events, but a visible, tangible artwork is a kind of persisting event. One or more artists made it at a certain time and in a specific place, even if no one now knows who, when, where, or why. Although created in the past, an artwork continues to exist in the present, long surviving its times. The first painters and sculptors died 30,000 years ago, but their works remain, some of them exhibited in glass cases in museums built only a few years ago.

Modern museum visitors can admire these objects from the remote past and countless others produced over the millennia—whether a large painting on canvas by a 17th-century French artist (FIG. I-1), a wood portrait from an ancient Egyptian tomb (FIG. I-14), an illustrated book by a medieval German monk (FIG. I-8), or an 18th-century bronze altar glorifying an African king (FIG. I-15)—without any knowledge of the circumstances leading to the creation of those works. The beauty or sheer size of an object can impress people, the artist's virtuosity in the handling of ordinary or costly materials can dazzle them, or the subject depicted can move them emotionally. Viewers can react to what they see, interpret the work in the light of their own experience, and judge it a success or a failure. These are all valid responses to a work of art. But the enjoyment and appreciation of artworks in museum settings are relatively recent phenomena, as is the creation of artworks solely for museum-going audiences to view.

Today, it is common for artists to work in private studios and to create paintings, sculptures, and other objects to be offered for sale by commercial art galleries. This is what American artist CLYFFORD STILL (1904–1980) did when he created his series of paintings (FIG. I-2) of pure color titled simply with the year of their creation. Usually, someone the artist has never met will purchase the artwork and display it in a setting that the artist has never seen. This practice is not a new phenomenon in the history of art—an ancient potter decorating a vase for sale at a village market stall probably did not know who would buy the pot or where it would be housed—but it is not at all typical. In fact, it is exceptional. Throughout history, most artists created paintings, sculptures, and other objects for specific patrons and settings and to fulfill a specific purpose, even if today no one knows the original contexts of those artworks. Museum visitors can appreciate the visual and tactile qualities of these objects, but they cannot understand why they were made or why they appear as they do without knowing the circumstances of their creation. Art *appreciation* does not require knowledge of the historical context of an artwork (or a building). Art *history* does.

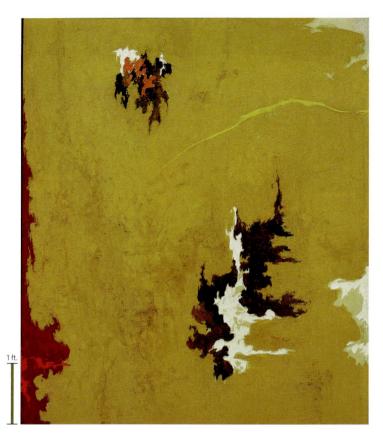

I-2 CLYFFORD STILL, 1948-C, 1948. Oil on canvas, $6' \, 8 \, \frac{7}{8}'' \times 5' \, 8 \, \frac{3}{4}''$. Hirshhorn Museum and Sculpture Garden, Smithsonian Institution, Washington, D.C. (purchased with funds of Joseph H. Hirshhorn, 1992).

Clyfford Still painted this abstract composition without knowing who would purchase it or where it would be displayed, but throughout history, most artists created works for specific patrons and settings.

Thus a central aim of art history is to determine the original context of artworks. Art historians seek to achieve a full understanding not only of why these "persisting events" of human history look the way they do but also of why the artistic events happened at all. What unique set of circumstances gave rise to the construction of a particular building or led an individual patron to commission a certain artist to fashion a singular artwork for a specific place? The study of history is therefore vital to art history. And art history is often indispensable for a thorough understanding of history. In ways that other historical documents may not, art objects and buildings can shed light on the peoples who made them and on the times of their creation. Furthermore, artists and architects can affect history by reinforcing or challenging cultural values and practices through the objects they create and the structures they build. Although the two disciplines are not the same, the history of art and architecture is inseparable from the study of history.

The following pages introduce some of the distinctive subjects that art historians address and the kinds of questions they ask, and explain some of the basic terminology they use when answering these questions. Readers armed with this arsenal of questions and terms will be ready to explore the multifaceted world of art through the ages.

ART HISTORY IN THE 21ST CENTURY

Art historians study the visual and tangible objects that humans make and the structures that they build. Scholars traditionally have classified these works as architecture, sculpture, the pictorial arts (painting, drawing, printmaking, and photography), and the craft arts, or arts of design. The craft arts comprise utilitarian objects, such as ceramics, metalwork, textiles, jewelry, and similar accessories of ordinary living—but the fact that these objects were used does not mean that they are not works of art. In fact, in some times and places, these so-called minor arts were the most prestigious artworks of all. Artists of every age have blurred the boundaries among these categories, but this is especially true today, when multimedia works abound.

Beginning with the earliest Greco-Roman art critics, scholars have studied objects that their makers consciously manufactured as "art" and to which the artists assigned formal titles. But today's art historians also study a multitude of objects that their creators and owners almost certainly did not consider to be "works of art." Few ancient Romans, for example, would have regarded a coin bearing their emperor's portrait as anything but money. Today, an art museum may exhibit that coin in a locked case in a climate-controlled room, and scholars may subject it to the same kind of art historical analysis as a portrait by an acclaimed Renaissance or modern sculptor or painter.

The range of objects that art historians study is constantly expanding and now includes, for example, computer-generated images, whereas in the past almost anything produced using a machine would not have been regarded as art. Most people still consider the performing arts—music, drama, and dance—as outside art history's realm because these arts are fleeting, impermanent media. But during the past few decades, even this distinction between "fine art" and "performance art" has become blurred. Art historians, however, generally ask the same kinds of questions about what they study, whether they employ a restrictive or expansive definition of art.

The Questions Art Historians Ask

HOW OLD IS IT? Before art historians can write a history of art, they must be sure they know the date of each work they study. Thus an indispensable subject of art historical inquiry is *chronology*, the dating of art objects and buildings. If researchers cannot determine a monument's age, they cannot place the work in its historical context. Art historians have developed many ways to establish, or at least approximate, the date of an artwork.

Physical evidence often reliably indicates an object's age. The material used for a statue or painting—bronze, plastic, or oil-based pigment, to name only a few—may not have been invented before a certain time, indicating the earliest possible date (the terminus post quem: Latin, "point after which") someone could have fashioned the work. Or artists may have ceased using certain materials—such as specific kinds of inks and papers for drawings—at a known time, providing the latest possible date (the terminus ante quem: Latin, "point before which") for objects made of those materials. Sometimes the material (or the manufacturing technique) of an object or a building can establish a very precise date of production or construction. The study of tree rings, for instance, usually can determine within a narrow range the date of a wood statue or a timber roof beam.

Documentary evidence can help pinpoint the date of an object or building when a dated written document mentions the work. For

example, official records may note when church officials commissioned a new altarpiece—and how much they paid to which artist.

Internal evidence can play a significant role in dating an artwork. A painter might have depicted an identifiable person or a kind of hairstyle, clothing, or furniture fashionable only at a certain time. If so, the art historian can assign a more accurate date to that painting.

Stylistic evidence is also very important. The analysis of style—an artist's distinctive manner of producing an object—is the art historian's special sphere. Unfortunately, because it is a subjective assessment, an artwork's style is by far the most unreliable chronological criterion. Still, art historians find stylistic evidence a very useful tool for establishing chronology.

WHAT IS ITS STYLE? Defining artistic style is one of the key elements of art historical inquiry, although the analysis of artworks solely in terms of style no longer dominates the field the way it once did. Art historians speak of several different kinds of artistic styles.

Period style refers to the characteristic artistic manner of a specific era or span of years, usually within a distinct culture, such as "Archaic Greek" or "High Renaissance." But many periods do not

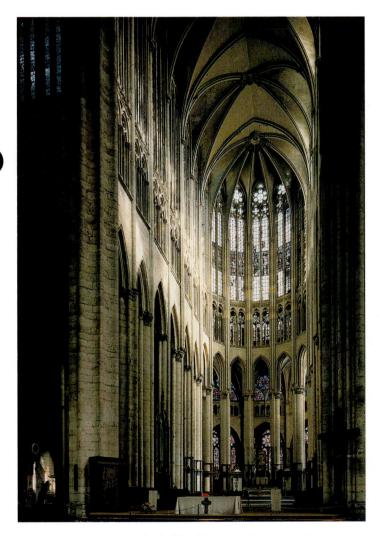

I-3 Choir of Beauvais Cathedral (looking east), Beauvais, France, rebuilt after 1284.

The style of an object or building often varies from region to region. This cathedral has towering stone vaults and large stained-glass windows typical of 13th-century French architecture.

display any stylistic unity at all. How would someone define the artistic style of the second decade of the new millennium in North America? Far too many crosscurrents exist in contemporary art for anyone to describe a period style of the early 21st century—even in a single city such as New York.

Regional style is the term that art historians use to describe variations in style tied to geography. Like an object's date, its provenance, or place of origin, can significantly determine its character. Very often two artworks from the same place made centuries apart are more similar than contemporaneous works from two different regions. To cite one example, usually only an expert can distinguish between an Egyptian statue carved in 2500 BCE and one made in 500 BCE. But no one would mistake an Egyptian statue of 500 BCE for one of the same date made in Greece or Mexico.

Considerable variations in a given area's style are possible, however, even during a single historical period. In late medieval Europe, French architecture differed significantly from Italian architecture. The interiors of Beauvais Cathedral (FIG. I-3) and the church of Santa Croce (Holy Cross, FIG. I-4) in Florence typify the architectural styles of France and Italy, respectively, at the end of the 13th century. The rebuilding of the east end of Beauvais Cathedral began in 1284. Construction commenced on Santa Croce only 10 years later. Both structures employ the *pointed arch* characteristic of this era, yet the two churches differ strikingly. The French church has towering stone ceilings and large expanses of colored-glass windows, whereas the Italian building has a low timber roof and small,

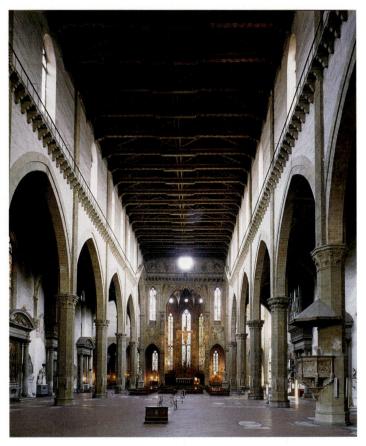

I-4 Interior of Santa Croce (looking east), Florence, Italy, begun 1294.

In contrast to Beauvais Cathedral (FIG. I-3), this contemporaneous Florentine church conforms to the quite different regional style of Italy. The building has a low timber roof and small windows.

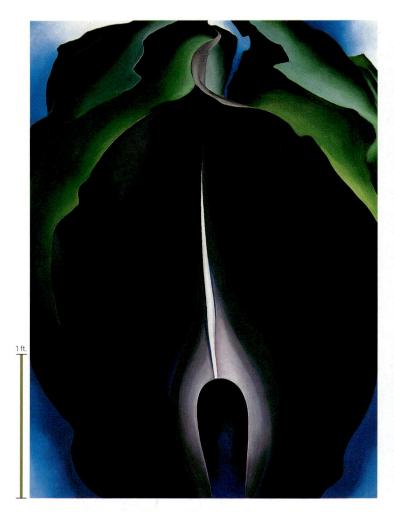

I-5 GEORGIA O'KEEFFE, *Jack-in-the-Pulpit No. 4*, 1930. Oil on canvas, $3' 4'' \times 2' 6''$. National Gallery of Art, Washington, D.C. (Alfred Stieglitz Collection, bequest of Georgia O'Keeffe).

O'Keeffe's paintings feature close-up views of petals and leaves in which the organic forms become powerful abstract compositions. This approach to painting typifies the artist's distinctive personal style.

widely separated clear windows. Because the two contemporaneous churches served similar purposes, regional style mainly explains their differing appearance.

Personal style, the distinctive manner of individual artists or architects, often decisively explains stylistic discrepancies among paintings, sculptures, and buildings of the same time and place. For example, in 1930, the American painter Georgia O'Keeffe (1887-1986) produced a series of paintings of flowering plants. One of them—Jack-in-the-Pulpit No. 4 (FIG. 1-5)—is a sharply focused closeup view of petals and leaves. O'Keeffe captured the growing plant's slow, controlled motion while converting the plant into a powerful abstract composition of lines, forms, and colors (see the discussion of art historical vocabulary in the next section). Only a year later, another American artist, Ben Shahn (1898-1969), painted The Passion of Sacco and Vanzetti (FIG. 1-6), a stinging commentary on social injustice inspired by the trial and execution of two Italian anarchists, Nicola Sacco and Bartolomeo Vanzetti. Many people believed that Sacco and Vanzetti had been unjustly convicted of killing two men in a robbery in 1920. Shahn's painting compresses time in a symbolic representation of the trial and its aftermath. The two executed men lie in their coffins. Presiding over them are the three members of the commission (headed by a college president wearing

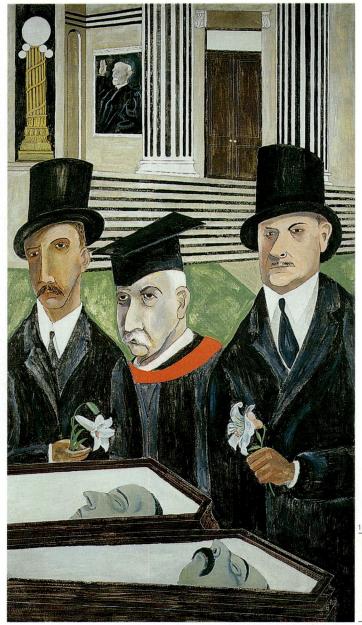

I-6 Ben Shahn, *The Passion of Sacco and Vanzetti*, 1931–1932. Tempera on canvas, $7'\frac{1}{2}''\times 4'$. Whitney Museum of American Art, New York (gift of Edith and Milton Lowenthal in memory of Juliana Force).

O'Keeffe's contemporary, Shahn developed a style markedly different from hers. His paintings are often social commentaries on recent events and incorporate readily identifiable people.

academic cap and gown) who declared that the original trial was fair and cleared the way for the executions. Behind, on the wall of a stately government building, hangs the framed portrait of the judge who pronounced the initial sentence. Personal style, not period or regional style, sets Shahn's canvas apart from O'Keeffe's. The contrast is extreme here because of the very different subjects that the artists chose. But even when two artists depict the same subject, the results can vary widely. The way O'Keeffe painted flowers and the way Shahn painted faces are distinctive and unlike the styles of their contemporaries. (See the "Who Made It?" discussion on page 6.)

The different kinds of artistic styles are not mutually exclusive. For example, an artist's personal style may change dramatically during a long career. Art historians then must distinguish among

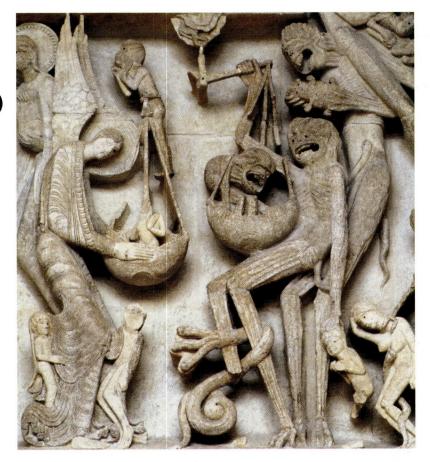

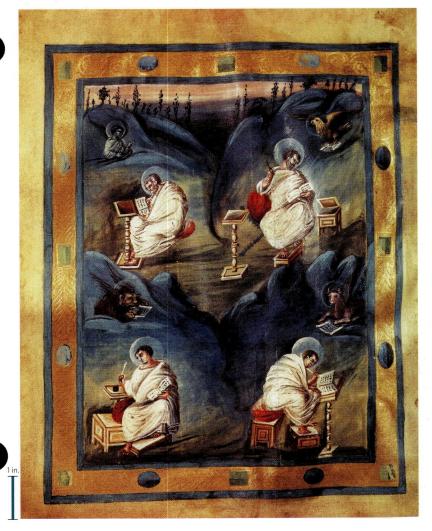

I-7 GISLEBERTUS, weighing of souls, detail of *Last Judgment* (FIG. 12-15), west tympanum of Saint-Lazare, Autun, France, ca. 1120–1135.

In this high relief portraying the weighing of souls on judgment day, Gislebertus used disproportion and distortion to dehumanize the devilish figure yanking on the scales of justice.

the different period styles of a particular artist, such as the "Rose Period" and the "Cubist Period" of the prolific 20th-century artist Pablo Picasso.

what is its subject? Another major concern of art historians is, of course, subject matter, encompassing the story, or narrative; the scene presented; the action's time and place; the persons involved; and the environment and its details. Some artworks, such as modern abstract paintings (Fig. I-2), have no subject, not even a setting. The "subject" is the artwork itself—its colors, textures, composition, and size. But when artists represent people, places, or actions, viewers must identify these features to achieve complete understanding of the work. Art historians traditionally separate pictorial subjects into various categories, such as religious, historical, mythological, genre (daily life), portraiture, landscape (a depiction of a place), still life (an arrangement of inanimate objects), and their numerous subdivisions and combinations.

Iconography—literally, the "writing of images"—refers both to the content, or subject, of an artwork, and to the study of content in art. By extension, it also includes the study of *symbols*, images that stand for other images or encapsulate ideas. In Christian art, two intersecting lines of unequal length or a simple geometric cross can serve as an emblem of the religion as a whole, symbolizing the cross of Jesus Christ's crucifixion. A symbol also can be a familiar object that an artist has imbued with greater meaning. A balance or scale, for example, may symbolize justice or the weighing of souls on judgment day (FIG. 1-7).

Artists may depict figures with unique *attributes* identifying them. In Christian art, for example, each of the authors of the biblical gospel books, the four evangelists (FIG. **I-8**), has a distinctive attribute. People can recognize Saint Matthew by the winged man associated with him, John by his eagle, Mark by his lion, and Luke by his ox.

Throughout the history of art, artists have used *personifications*—abstract ideas codified in human form. Because of the fame of the colossal statue set up in New York City's harbor in 1886, people everywhere visualize Liberty as a robed woman wearing a rayed crown and holding a torch. Four different personifications appear in *The Four Horsemen*

I-8 The four evangelists, folio 14 verso of the *Aachen Gospels*, ca. 810. Ink and tempera on vellum, $1' \times 9\frac{1}{2}"$. Domschatzkammer, Aachen.

Artists depict figures with attributes in order to identify them for viewers. The authors of the four gospels have distinctive attributes—winged man (Matthew), eagle (John), lion (Mark), and ox (Luke).

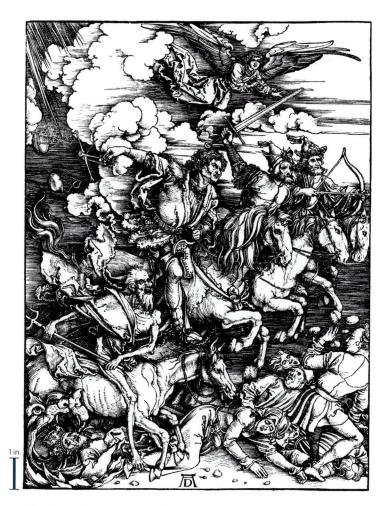

I-9 Albrecht Dürer, *The Four Horsemen of the Apocalypse*, ca. 1498. Woodcut, 1' $3\frac{1}{4}$ " × 11". Metropolitan Museum of Art, New York (gift of Junius S. Morgan, 1919).

Personifications are abstract ideas codified in human form. Here, Albrecht Dürer represented Death, Famine, War, and Pestilence as four men on charging horses, each one carrying an identifying attribute.

of the Apocalypse (FIG. I-9) by German artist Albrecht Dürer (1471–1528). The late-15th-century print is a terrifying depiction of the fateful day at the end of time when, according to the Bible's last book, Death, Famine, War, and Pestilence will annihilate the human race. Dürer personified Death as an emaciated old man with a pitchfork. Famine swings the scales for weighing human souls (compare FIG. I-7). War wields a sword, and Pestilence draws a bow.

Even without considering style and without knowing a work's maker, informed viewers can determine much about the work's period and provenance by iconographical and subject analysis alone. In *The Passion of Sacco and Vanzetti* (FIG. I-6), for example, the two coffins, the trio headed by an academic, and the robed judge in the background are all pictorial clues revealing the painting's subject. The work's date must be after the trial and execution, probably while the event was still newsworthy. And because the two men's deaths caused the greatest outrage in the United States, the painter-social critic was probably an American.

WHO MADE IT? If Ben Shahn had not signed his painting of Sacco and Vanzetti, an art historian could still assign, or *attribute* (make an *attribution* of), the work to him based on knowledge of the

artist's personal style. Although signing (and dating) works is quite common (but by no means universal) today, in the history of art, countless works exist whose artists remain unknown. Because personal style can play a major role in determining the character of an artwork, art historians often try to attribute anonymous works to known artists. Sometimes they assemble a group of works all thought to be by the same person, even though none of the objects in the group is the known work of an artist with a recorded name. Art historians thus reconstruct the careers of artists such as "the Achilles Painter," the anonymous ancient Greek artist whose masterwork is a depiction of the hero Achilles. Scholars base their attributions on internal evidence, such as the distinctive way an artist draws or carves drapery folds, earlobes, or flowers. It requires a keen, highly trained eye and long experience to become a connoisseur, an expert in assigning artworks to "the hand" of one artist rather than another. Attribution is subjective, of course, and ever open to doubt. For example, scholars continue to debate attributions to the famous 17th-century Dutch painter Rembrandt van Rijn.

Sometimes a group of artists works in the same style at the same time and place. Art historians designate such a group as a *school*. "School" does not mean an educational institution or art academy. The term connotes only shared chronology, style, and geography. Art historians speak, for example, of the Dutch school of the 17th century and, within it, of subschools such as those of the cities of Haarlem, Utrecht, and Leyden.

WHO PAID FOR IT? The interest that many art historians show in attribution reflects their conviction that the identity of an artwork's maker is the major reason the object looks the way it does. For them, personal style is of paramount importance. But in many times and places, artists had little to say about what form their work would take. They toiled in obscurity, doing the bidding of their *patrons*, those who paid them to make individual works or employed them on a continuing basis. The role of patrons in dictating the content and shaping the form of artworks is also an important subject of art historical inquiry, more so today than at any time in the past.

In the art of portraiture, to name only one category of painting and sculpture, the patron has often played a dominant role in deciding how the artist represented the subject, whether that person was the patron or another individual, such as a spouse, son, or mother. Many Egyptian pharaohs and some Roman emperors, for example, insisted that artists depict them with unlined faces and perfect youthful bodies no matter how old they were when portrayed. In these cases, the state employed the sculptors and painters, and the artists had no choice but to portray their patrons in the officially approved manner. This is why Augustus, who lived to age 76, looks so young in his portraits (FIG. I-10). Although Roman emperor for more than 40 years, Augustus demanded that artists always represent him as a young, godlike head of state.

All modes of artistic production reveal the impact of patronage. Learned monks provided the themes for the sculptural decoration of medieval church portals (FIG. I-7). Renaissance princes and popes dictated the subject, size, and materials of artworks destined for display in buildings also constructed according to their specifications. An art historian could make a very long list of commissioned works, and it would indicate that patrons have had diverse tastes and needs throughout history and consequently have demanded different kinds of art. Whenever a patron contracts with an artist or architect to paint, sculpt, or build in a prescribed manner, personal style often becomes a very minor factor in the ultimate

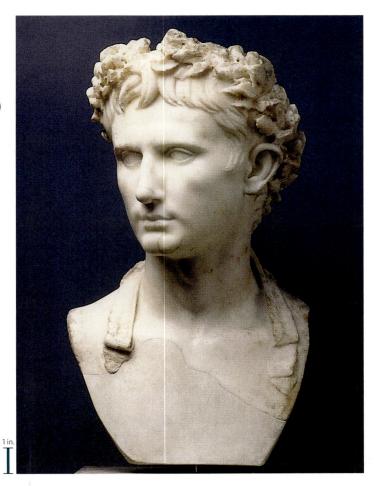

I-10 Bust of Augustus wearing the corona civica, early first century CE. Marble, 1' 5" high. Glyptothek, Munich.

Patrons frequently dictate the form that their portraits will take. Emperor Augustus demanded that he always be portrayed as a young, godlike head of state even though he lived to age 76.

appearance of the painting, statue, or building. In these cases, the identity of the patron reveals more to art historians than does the identity of the artist or school. The portrait of Augustus illustrated here (FIG. I-10)—showing the emperor wearing a *corona civica*, or civic crown—was the work of a virtuoso sculptor, a master wielder of hammer and chisel. But scores of similar portraits of this Roman emperor also exist today. They differ in quality but not in kind from this one. The patron, not the artist, determined the character of these artworks. Augustus's public image never varied.

The Words Art Historians Use

As in all fields of study, art history has its own specialized vocabulary consisting of hundreds of words, but certain basic terms are indispensable for describing artworks and buildings of any time and place. They make up the essential vocabulary of *formal analysis*, the visual analysis of artistic form. Definitions and discussions of the most important art historical terms follow.

FORM AND COMPOSITION *Form* refers to an object's shape and structure, either in two dimensions (for example, a figure painted on a wood panel) or in three dimensions (such as a statue carved from a marble block). Two forms may take the same shape but differ in

their color, texture, and other qualities. *Composition* refers to how an artist *composes* (organizes) forms in an artwork, either by placing shapes on a flat surface or by arranging forms in space.

MATERIAL AND TECHNIQUE To create art forms, artists shape materials (pigment, clay, marble, gold, and many more) with tools (pens, brushes, chisels, and so forth). Each of the materials and tools available has its own potentialities and limitations. Part of all artists' creative activity is to select the *medium* and instrument most suitable to the purpose—or to develop new media and tools, such as bronze and concrete in antiquity and cameras and computers in modern times. The processes that artists employ, such as applying paint to canvas with a brush, and the distinctive, personal ways that they handle materials constitute their *technique*. Form, material, and technique interrelate and are central to analyzing any work of art.

LINE Among the most important elements defining an artwork's shape or form is *line*. A line can be understood as the path of a point moving in space, an invisible line of sight. More commonly, however, artists and architects make a line visible by drawing (or chiseling) it on a *plane*, a flat surface. A line may be very thin, wirelike, and delicate. It may be thick and heavy. Or it may alternate quickly from broad to narrow, the strokes jagged or the outline broken. When a continuous line defines an object's outer shape, art historians call it a *contour line*. All of these line qualities are present in Dürer's *Four Horsemen of the Apocalypse* (FIG. I-9). Contour lines define the basic shapes of clouds, human and animal limbs, and weapons. Within the forms, series of short broken lines create shadows and textures. An overall pattern of long parallel strokes suggests the dark sky on the frightening day when the world is about to end.

COLOR Light reveals all colors. Light in the world of the painter and other artists differs from natural light. Natural light, or sunlight, is whole or *additive light*. As the sum of all the wavelengths composing the visible *spectrum*, it may be disassembled or fragmented into the individual colors of the spectral band. The painter's light in art—the light reflected from pigments and objects—is *subtractive light*. Paint pigments produce their individual colors by reflecting a segment of the spectrum while absorbing all the rest. Green pigment, for example, subtracts or absorbs all the light in the spectrum except that seen as green.

Hue is the property giving a color its name. Although the spectrum colors merge into each other, artists usually conceive of their hues as distinct from one another. Color has two basic variables—the apparent amount of light reflected and the apparent purity. A change in one must produce a change in the other. Some terms for these variables are *value* or *tonality* (the degree of lightness or darkness) and *intensity* or *saturation* (the purity of a color, its brightness or dullness).

Artists call the three basic colors—red, yellow, and blue—the *primary colors*. The *secondary colors* result from mixing pairs of primaries: orange (red and yellow), purple (red and blue), and green (yellow and blue). *Complementary colors* represent the pairing of a primary color and the secondary color created from mixing the two other primary colors—red and green, yellow and purple, and blue and orange. They "complement," or complete, each other, one absorbing the colors that the other reflects.

Artists can manipulate the appearance of colors, however. One artist who made a systematic investigation of the formal aspects of art, especially color, was JOSEPH ALBERS (1888–1976), a German-born

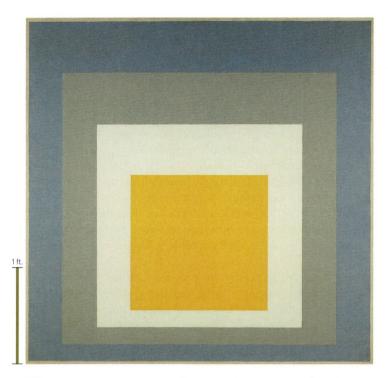

I-11 Josef Albers, *Homage to the Square: "Ascending,*" 1953. Oil on composition board, 3' $7\frac{1}{2}$ " \times 3' $7\frac{1}{2}$ ". Whitney Museum of American Art, New York.

Albers created hundreds of paintings using the same composition but employing variations in hue, saturation, and value in order to reveal the relativity and instability of color perception.

artist who emigrated to the United States in 1933. In connection with his studies, Albers created the series *Homage to the Square*—hundreds of paintings, most of which are color variations on the same composition of concentric squares, as in the illustrated example (FIG. I-11). The series reflected Albers's belief that art originates in "the discrepancy between physical fact and psychic effect." Because the composition in most of these paintings remains constant, the works succeed in revealing the relativity and instability of color perception. Albers varied the hue, saturation, and value of each square in the paintings in this series. As a result, the sizes of the squares from painting to painting appear to vary (although they remain the same), and the sensations emanating from the paintings range from clashing dissonance to delicate serenity. Albers explained his motivation for focusing on color juxtapositions:

They [the colors] are juxtaposed for various and changing visual effects. . . . Such action, reaction, interaction . . . is sought in order to make obvious how colors influence and change each other; that the same color, for instance—with different grounds or neighbors—looks different. . . . Such color deceptions prove that we see colors almost never unrelated to each other.²

TEXTURE The term *texture* refers to the quality of a surface, such as rough or shiny. Art historians distinguish between true texture—that is, the tactile quality of the surface—and represented texture, as when painters depict an object as having a certain texture even though the pigment is the true texture. Sometimes artists combine different materials of different textures on a single surface, juxtaposing paint with pieces of wood, newspaper, fabric, and so forth. Art historians refer to this mixed-media technique as *collage*. Texture

is, of course, a key determinant of any sculpture's character. People's first impulse is usually to handle a work of sculpture—even though museum signs often warn "Do not touch!" Sculptors plan for this natural human response, using surfaces varying in texture from rugged coarseness to polished smoothness. Textures are often intrinsic to a material, influencing the type of stone, wood, plastic, clay, or metal that a sculptor selects.

SPACE, MASS, AND VOLUME *Space* is the bounded or boundless "container" of objects. For art historians, space can be the real three-dimensional space occupied by a statue or a vase or contained within a room or courtyard. Or space can be *illusionistic*, as when painters depict an image (or illusion) of the three-dimensional spatial world on a two-dimensional surface.

Mass and volume describe three-dimensional objects and space. In both architecture and sculpture, mass is the bulk, density, and weight of matter in space. Yet the mass need not be solid. It can be the exterior form of enclosed space. Mass can apply to a solid Egyptian pyramid or stone statue; to a church, synagogue, or mosque (architectural shells enclosing sometimes vast spaces); and to a hollow metal statue or baked clay pot. Volume is the space that mass organizes, divides, or encloses. It may be a building's interior spaces, the intervals between a structure's masses, or the amount of space occupied by a three-dimensional object such as a statue, pot, or chair. Volume and mass describe both the exterior and interior forms of a work of art—the forms of the matter of which it is composed and the spaces immediately around the work and interacting with it.

PERSPECTIVE AND FORESHORTENING *Perspective* is one of the most important pictorial devices for organizing forms in space. Throughout history, artists have used various types of perspective to create an illusion of depth or space on a two-dimensional surface. The French painter CLAUDE LORRAIN (1600-1682) employed several perspective devices in Embarkation of the Queen of Sheba (FIG. I-1), a painting of a biblical episode set in a 17th-century European harbor with an ancient Roman ruin in the left foreground—an irrationally anachronistic combination that the art historian can explain only in the context of the cultural values of the artist's time and place. In Claude's painting, the figures and boats on the shoreline are much larger than those in the distance, because decreasing the size of an object makes it appear farther away. The top and bottom of the port building at the painting's right side are not parallel horizontal lines, as they are in a real building. Instead, the lines converge beyond the structure, leading the viewer's eye toward the hazy, indistinct sun on the horizon. These three perspective devices—the reduction of figure size, the convergence of diagonal lines, and the blurring of distant forms—have been familiar features of Western art since they were first employed by the ancient Greeks. It is important to state, however, that all kinds of perspective are only pictorial conventions, even when one or more types of perspective may be so common in a given culture that people accept them as "natural" or as "true" means of representing the natural world.

These perspective conventions are by no means universal. In Waves at Matsushima (FIG. I-12), a Japanese seascape painting on a six-part folding screen, Ogata Korin (1658–1716) ignored these Western "tricks" for representing deep space on a flat surface. A Western viewer might interpret the left half of Korin's composition as depicting the distant horizon, as in the French painting, but the sky is an unnatural gold, and the clouds that fill that unnaturally colored sky are almost indistinguishable from the waves below.

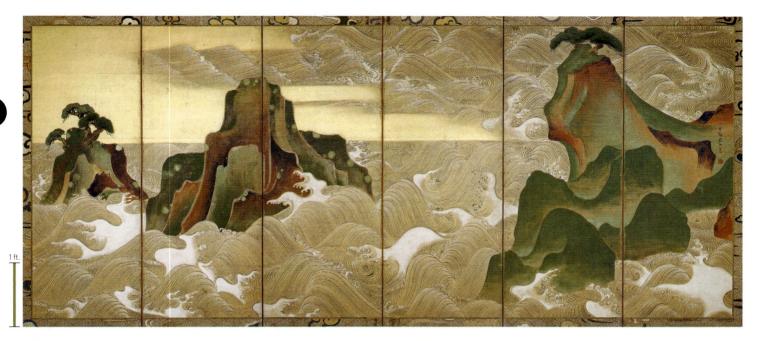

I-12 OGATA KORIN, *Waves at Matsushima*, Edo period, ca. 1700–1716. Six-panel folding screen, ink, color, and gold leaf on paper, 4' $11\frac{1}{8}$ " × $12'\frac{7}{8}$ ". Museum of Fine Arts, Boston (Fenollosa-Weld Collection).

Asian artists rarely employed Western perspective (Fig. I-1). Korin was more concerned with creating an intriguing composition of shapes on a surface than with locating boulders, waves, and clouds in space.

The rocky outcroppings decrease in size with distance, but all are in sharp focus, and there are no shadows. The Japanese artist was less concerned with locating the boulders and waves and clouds in space than with composing shapes on a surface, playing the swelling curves of waves and clouds against the jagged contours of the rocks. Neither the French nor the Japanese painting can be said to project "correctly" what viewers "in fact" see. One painting is not a "better" picture of the world than the other. The European and Asian artists simply approached the problem of picture making differently.

Artists also represent single figures in space in varying ways. When Flemish artist Peter Paul Rubens (1577–1640) painted *Lion*

Hunt (FIG. 1-13), he used foreshortening for all the hunters and animals—that is, he represented their bodies at angles to the picture plane. When in life one views a figure at an angle, the body appears to contract as it extends back in space. Foreshortening is a kind of perspective. It produces the illusion that one part of the body is farther away than another, even though all the painted forms are on the same plane. Especially noteworthy in *Lion Hunt* are the gray horse at the left, seen from behind with the bottom of its left rear hoof facing viewers and most of its head hidden by its rider's shield, and the fallen hunter at the painting's lower right corner, whose barely visible legs and feet recede into the distance.

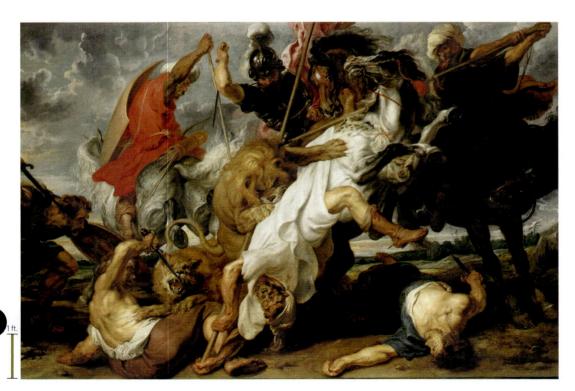

I-13 PETER PAUL RUBENS, *Lion Hunt*, 1617–1618. Oil on canvas, 8' 2" × 12' 5". Alte Pinakothek, Munich.

Foreshortening—the representation of a figure or object at an angle to the picture plane—is a common device in Western art for creating the illusion of depth. Foreshortening is a type of perspective.

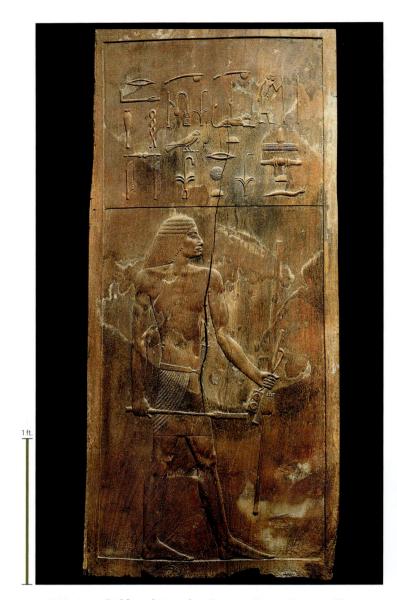

I-14 Hesire, relief from his tomb at Saqqara, Egypt, Dynasty III, ca. 2650 BCE. Wood, 3' 9" high. Egyptian Museum, Cairo.

Egyptian artists combined frontal and profile views to give a precise picture of the parts of the human body, as opposed to depicting how an individual body appears from a specific viewpoint.

The artist who carved the portrait of the ancient Egyptian official Hesire (FIG. I-14) for display in Hesire's tomb did not employ foreshortening. That artist's purpose was to present the various human body parts as clearly as possible, without overlapping. The lower part of Hesire's body is in profile to give the most complete view of the legs, with both the heel and toes of each foot visible. The frontal torso, however, allows viewers to see its full shape, including both shoulders, equal in size, as in nature. (Compare the shoulders of the hunter on the gray horse or those of the fallen hunter in *Lion Hunt*'s left foreground.) The result—an "unnatural" 90-degree twist at the waist—provides a precise picture of human body parts, if not an accurate picture of how a standing human figure really looks. Rubens and the Egyptian sculptor used very different means of depicting forms in space. Once again, neither is the "correct" manner.

PROPORTION AND SCALE *Proportion* concerns the relationships (in terms of size) of the parts of persons, buildings, or objects. People can judge "correct proportions" intuitively ("that statue's head

seems the right size for the body"). Or proportion can be a mathematical relationship between the size of one part of an artwork or building and the other parts within the work. Proportion in art implies using a *module*, or basic unit of measure. When an artist or architect uses a formal system of proportions, all parts of a building, body, or other entity will be fractions or multiples of the module. A module might be the diameter of a *column*, the height of a human head, or any other component whose dimensions can be multiplied or divided to determine the size of the work's other parts.

In certain times and places, artists have devised *canons*, or systems, of "correct" or "ideal" proportions for representing human figures, constituent parts of buildings, and so forth. In ancient Greece, many sculptors formulated canons of proportions so strict and allencompassing that they calculated the size of every body part in advance, even the fingers and toes, according to mathematical ratios.

Proportional systems can differ sharply from period to period, culture to culture, and artist to artist. Part of the task that art history students face is to perceive and adjust to these differences. In fact, many artists have used disproportion and distortion deliberately for expressive effect. In the medieval French depiction of the weighing of souls on judgment day (FIG. I-7), the devilish figure yanking down on the scale has distorted facial features and stretched, lined limbs with animal-like paws for feet. Disproportion and distortion make him appear "inhuman," precisely as the sculptor intended.

In other cases, artists have used disproportion to focus attention on one body part (often the head) or to single out a group

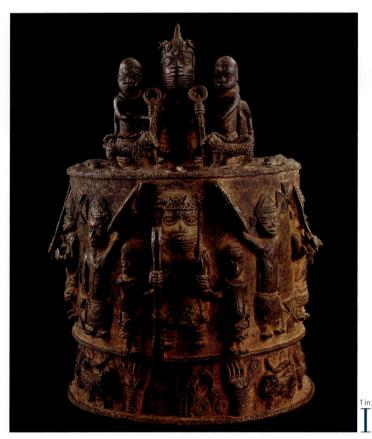

I-15 Altar to the Hand (ikegobo), from Benin, Nigeria, ca. 1735–1750. Bronze, 1' $5\frac{1}{2}$ " high. British Museum, London (gift of Sir William Ingram).

One of the Benin king's praise names is Great Head, and on this cast-bronze royal altar, the artist represented him larger than all other figures and with a disproportionately large head.

member (usually the leader). These intentional "unnatural" discrepancies in proportion constitute what art historians call *hierarchy of scale*, the enlarging of elements considered the most important. On the bronze altar from Benin, Nigeria, illustrated here (FIG. I-15), the sculptor varied the size of each figure according to the person's social status. Largest, and therefore most important, is the Benin king, depicted twice, each time flanked by two smaller attendant figures and shown wearing a multistrand coral necklace emblematic of his high office. The king's head is also disproportionately large compared to his body, consistent with one of the Benin ruler's praise names: Great Head.

One problem that students of art history—and professional art historians too—confront when studying illustrations in art history books is that although the relative sizes of figures and objects in a painting or sculpture are easy to discern, it is impossible to determine the absolute size of the work reproduced because they all are printed at approximately the same size on the page. Readers of *Art through the Ages* can learn the exact size of all artworks from the dimensions given in the captions and, more intuitively, from the scales positioned at the lower left or right corner of each illustration.

CARVING AND CASTING Sculptural technique falls into two basic categories, *subtractive* and *additive*. *Carving* is a subtractive technique. The final form is a reduction of the original mass of a block of stone, a piece of wood, or another material. Wood statues were once

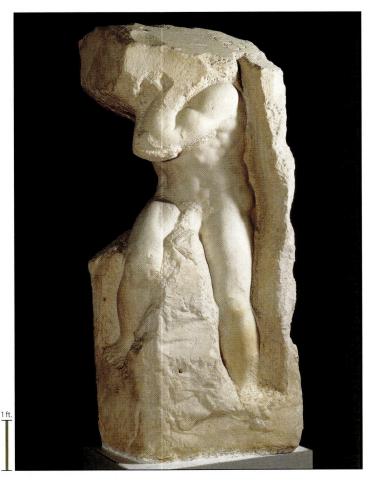

I-16 MICHELANGELO BUONARROTI, unfinished statue, 1527–1528. Marble, 8' $7\frac{1}{2}$ " high. Galleria dell'Accademia, Florence.

Carving a freestanding figure from stone or wood is a subtractive process. Michelangelo thought of sculpture as a process of "liberating" the statue contained within the block of marble.

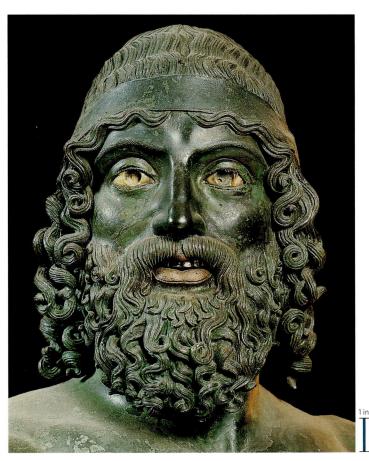

I-17 Head of a warrior, detail of a statue (FIG. 5-36) from the sea off Riace, Italy, ca. 460–450 BCE. Bronze, full statue 6' 6" high. Museo Archeologico Nazionale, Reggio Calabria.

The sculptor of this life-size statue of a bearded Greek warrior cast the head, limbs, torso, hands, and feet in separate molds, then welded the pieces together and added the eyes in a different material.

tree trunks, and stone statues began as blocks pried from mountains. The unfinished marble statue illustrated here (FIG. I-16) by renowned Italian artist MICHELANGELO BUONARROTI (1475–1564) clearly reveals the original shape of the stone block. Michelangelo thought of sculpture as a process of "liberating" the statue within the block. All sculptors of stone or wood cut away (subtract) "excess material." When they finish, they "leave behind" the statue—in this example, a twisting nude male form whose head Michelangelo never freed from the stone block.

In additive sculpture, the artist builds up the forms, usually in clay around a framework, or *armature*. Or a sculptor may fashion a *mold*, a hollow form for shaping, or *casting*, a fluid substance such as bronze or plaster. The ancient Greek sculptor who made the bronze statue of a warrior found in the sea near Riace, Italy, cast the head (Fig. I-17) as well as the limbs, torso, hands, and feet (Fig. 5-36) in separate molds and then *welded* them together (joined them by heating). Finally, the artist added features, such as the pupils of the eyes (now missing), in other materials. The warrior's teeth are silver, and his lower lip is copper.

RELIEF SCULPTURE *Statues* and *busts* (head, shoulders, and chest) that exist independent of any architectural frame or setting and that viewers can walk around are *freestanding sculptures*, or *sculptures in the round*, whether the artist produced the piece by carving (Fig. I-10) or casting (Fig. I-17). In *relief sculpture*, the subjects

project from the background but remain part of it. In *high-relief* sculpture, the images project boldly. In some cases, such as the medieval weighing-of-souls scene (FIG. I-7), the *relief* is so high that not only do the forms cast shadows on the background, but some parts are even in the round, which explains why some pieces—for example, the arms of the scales—broke off centuries ago. In *low-relief*, or *bas-relief*, sculpture, such as the portrait of Hesire (FIG. I-14), the projection is slight. Artists can produce relief sculptures, as they do sculptures in the round, either by carving or casting. The altar from Benin (FIG. I-15) is an example of bronze-casting in high relief (for the figures on the cylindrical altar) as well as in the round (for the king and his two attendants on the top).

ARCHITECTURAL DRAWINGS Buildings are groupings of enclosed spaces and enclosing masses. People experience architecture both visually and by moving through and around it, so they perceive architectural space and mass together. These spaces and masses can be represented graphically in several ways, including as plans, sections, elevations, and cutaway drawings.

A plan, essentially a map of a floor, shows the placement of a structure's masses and, therefore, the spaces they circumscribe and enclose. A section, a kind of vertical plan, depicts the placement of the masses as if someone cut through the building along a plane. Drawings showing a theoretical slice across a structure's width are lateral sections. Those cutting through a building's length are longitudinal sections. Illustrated here are the plan and lateral section of Beauvais Cathedral (Fig. 1-18), which readers can compare with the photograph of the church's choir (Fig. 1-3). The plan shows the choir's shape and the location of the piers dividing the aisles and supporting the vaults above, as well as the pattern of the crisscrossing vault ribs. The lateral section shows not only the interior of the choir with its vaults and tall stained-glass windows but also the structure of the roof and the form of the exterior flying buttresses holding the vaults in place.

Other types of architectural drawings appear throughout this book. An *elevation* drawing is a head-on view of an external or internal wall. A *cutaway* combines in a single drawing an exterior view with an interior view of part of a building.

This overview of the art historian's vocabulary is not exhaustive, nor have artists used only painting, drawing, sculpture, and architecture as media over the millennia. Ceramics, jewelry, textiles, photography, and computer graphics are just some of the numerous other arts. All of them involve highly specialized techniques described in distinct vocabularies. As in this introductory chapter, new terms are in *italics* when they first appear. The comprehensive Glossary at the end of the book contains definitions of all italicized terms.

Art History and Other Disciplines

By its very nature, the work of art historians intersects with the work of others in many fields of knowledge, not only in the humanities but also in the social and natural sciences. Today, art historians must go beyond the boundaries of what the public and even professional art historians of previous generations traditionally considered the specialized discipline of art history. In short, art historical research in the 21st century is typically interdisciplinary in nature. To cite one example, in an effort to unlock the secrets of a particular statue, an art historian might conduct archival research hoping to uncover new documents shedding light on who paid for the work and why, who made it and when, where it originally stood, how people of the time viewed it, and a host of other questions. Realizing, however, that the authors of the written documents often were not objective recorders of fact but observers with their own biases and agendas, the art historian may also use methodologies developed in such fields as literary criticism, philosophy, sociology, and gender studies to weigh the evidence that the documents provide.

At other times, rather than attempting to master many disciplines at once, art historians band together with other specialists in multidisciplinary inquiries. Art historians might call in chemists to date an artwork based on the composition of the materials used, or might

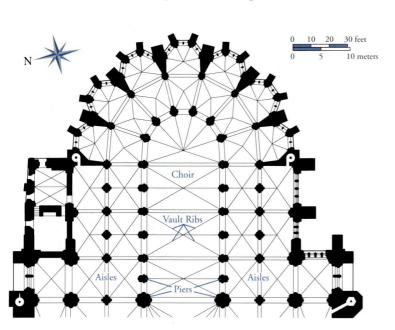

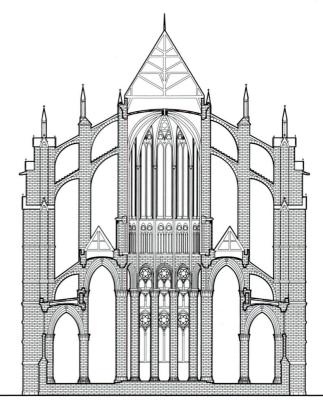

1-18 Plan (left) and lateral section (right) of Beauvais Cathedral, Beauvais, France, rebuilt after 1284.

Architectural drawings are indispensable aids for the analysis of buildings. Plans are maps of floors, recording the structure's masses. Sections are vertical "slices" across a building's width or length.

ask geologists to determine which quarry furnished the stone for a particular statue. X-ray technicians might be enlisted in an attempt to establish whether a painting is a forgery. Of course, art historians often reciprocate by contributing their expertise to the solution of problems in other disciplines. A historian, for example, might ask an art historian to determine—based on style, material, iconography, and other criteria—if any of the portraits of a certain king date after his death. Such information would help establish the ruler's continuing prestige during the reigns of his successors. Some portraits of Augustus (FIG. I-10), the founder of the Roman Empire, postdate his death by decades, even centuries, as do the portraits of several deceased U.S. presidents on coins and paper currency produced today.

DIFFERENT WAYS OF SEEING

The history of art can be a history of artists and their works, of styles and stylistic change, of materials and techniques, of images and themes and their meanings, and of contexts and cultures and patrons. The best art historians analyze artworks from many viewpoints. But no art historian (or scholar in any other field), no matter how broad-minded in approach and no matter how experienced, can be truly objective. Like the artists who made the works illustrated and discussed in this book, art historians are members of a society, participants in its culture. How can scholars (and museum visitors and travelers to foreign locales) comprehend cultures unlike their own? They can try to reconstruct the original cultural contexts of artworks, but they are limited by their distance from the thought patterns of the cultures they study and by the obstructions to understanding—the assumptions, presuppositions, and prejudices peculiar to their own culture—that their own thought patterns raise. Art historians may reconstruct a distorted picture of the past because of culture-bound blindness.

A single instance underscores how differently people of diverse cultures view the world and how various ways of seeing can result in sharp differences in how artists depict the world. Illustrated here are two contemporaneous portraits of a 19th-century Maori chieftain (Fig. 1-19)—one by an Englishman, John Sylvester (active early 19th century), and the other by the New Zealand chieftain himself, Te Pehi Kupe (d. 1829). Both reproduce the chieftain's facial *tattoo*. The European artist (Fig. I-19, *left*) included the head and shoulders and downplayed the tattooing. The tattoo pattern is one aspect of the likeness among many, no more or less important than the chieftain's European attire. Sylvester also recorded his subject's momentary glance toward the right and the play of light on his hair, fleeting aspects having nothing to do with the figure's identity.

In contrast, Te Pehi Kupe's self-portrait (FIG. I-19, right)— made during a trip to Liverpool, England, to obtain European arms to take back to New Zealand—is not a picture of a man situated in space and bathed in light. Rather, it is the chieftain's statement of the supreme importance of the tattoo design announcing his rank among his people. Remarkably, Te Pehi Kupe created the tattoo patterns from memory, without the aid of a mirror. The splendidly composed insignia, presented as a flat design separated from the body and even from the head, is Te Pehi Kupe's image of himself. Only by understanding the cultural context of each portrait can art historians hope to understand why either representation appears as it does.

As noted at the outset, the study of the context of artworks and buildings is one of the central concerns of art historians. *Art through the Ages* seeks to present a history of art and architecture that will help readers understand not only the subjects, styles, and techniques of paintings, sculptures, buildings, and other art forms created in all parts of the world during 30 millennia but also their cultural and historical contexts. That story now begins.

I-19 Left: John Henry Sylvester, Portrait of Te Pehi Kupe, 1826. Watercolor, $8\frac{1}{4}" \times 6\frac{1}{4}"$. National Library of Australia, Canberra (Rex Nan Kivell Collection). Right: Te Pehi Kupe, Self-Portrait, 1826. From Leo Frobenius, The Childhood of Man: A Popular Account of the Lives, Customs and Thoughts of the Primitive Races (Philadelphia: J. B. Lippincott, 1909), 35, fig. 28.

These strikingly different portraits of the same Maori chief reveal the different ways of seeing by a European artist and an Oceanic one. Understanding the cultural context of artworks is vital to art history.

▼ 1-1a The species of animals depicted in the cave paintings of France and Spain are not among those that Paleolithic humans typically consumed as food. The meaning of these paintings remains a mystery.

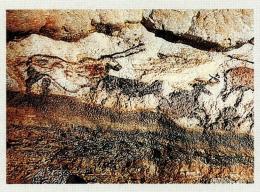

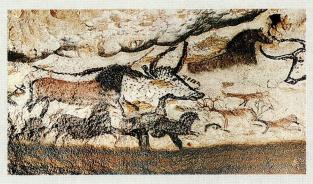

▲ 1-1b The Lascaux animals are inconsistent in size and move in different directions. Some are colored silhouettes, others are outline drawings. They were probably painted at different times by different painters.

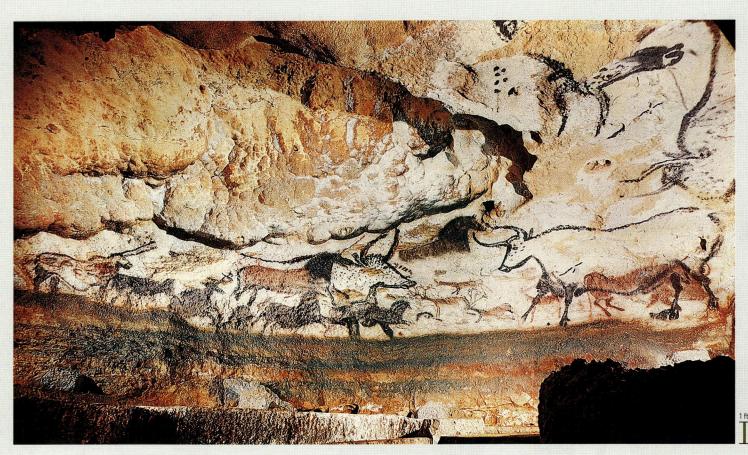

Left wall of the Hall of the Bulls in the cave at Lascaux, France, ca. 16,000-14,000 BCE. Largest bull 11' 6" long.

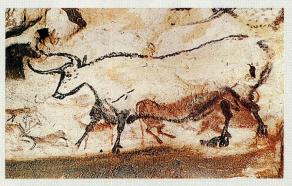

▲ 1-1c Prehistoric painters consistently represented animals in strict profile, the only view showing the head, body, tail, and all four legs. But at Lascaux, both horns are included to give a complete picture of the bull.

Art in the Stone Age

THE DAWN OF ART

The Old Stone Age, or *Paleolithic* period (from the Greek *paleo*, "old," and *lithos*, "stone"), which began around 40,000 BCE, was arguably the most important era in the entire history of art. It was then that humans invented the concept of recording the world around them in pictures, often painted on or carved into the walls of caves.

The oldest and best-known painted caves are in southern France and northern Spain (MAP 1-1). The most famous is the cave at Lascaux. More than 17,000 years ago, prehistoric painters covered many of the walls of the cave with images of animals. The main chamber (FIG. 1-1), nicknamed the Hall of the Bulls, is an unusually large space and easily accessible, but many of the paintings at Lascaux and in other caves are almost impossible to reach. Even in the Hall of the Bulls, the people who congregated there could only have viewed the paintings in the flickering light of a primitive lamp. The representations of animals cannot have been merely decorative, but what meaning they carried for those who made and viewed them remains a mystery. Bulls and horses, the most commonly depicted species, were not diet staples in the Old Stone Age. Why, then, did the painters choose to represent these particular animals? In the absence of written records, no one will ever know.

Art historians can, however, learn a great deal about the working methods and conceptual principles of the world's first artists by closely studying the Lascaux paintings and others like them. The immediate impression that a modern viewer gets of a rapidly moving herd is almost certainly false. The "herd" consists of several different kinds of animals of various sizes moving in different directions. Also, two fundamentally different approaches to picture making are on display. Many of the animals are colored silhouettes, whereas others are outline drawings. These differences in style and technique suggest that different painters created the images at different times, perhaps over the course of generations.

Nonetheless, all prehistoric representations of animals for thousands of years depict the beasts in the same way: in strict profile, the only view of an animal wherein the head, body, tail, and all four legs are visible. The Lascaux painters, however, showed the bulls' horns from the front, not in profile, because two horns are part of the concept "bull." Only much later in the history of art did painters become concerned with how to depict animals and people from a fixed viewpoint or develop an interest in recording the environment around the figures. The paintings created at the dawn of art are in many ways markedly different in kind from all that followed.

PALEOLITHIC ART

Humankind originated in Africa in the very remote past. From that great continent also has come the earliest evidence of human recognition of pictorial images in the natural environment—a three-million-year-old pebble (FIG. 1-1A) found at Makapansgat in South Africa. The first examples of what people generally call "art" are much more recent, however. They date to around 40,000 to 30,000 BCE during the Paleolithic period. This era was of unparalleled importance in human history and

1-1A Pebble resembling a face, Makapansgat, ca. 3,000,000 BCE.

in the history of art. It was during the Old Stone Age that humans first consciously manufactured pictorial images. The works the earliest artists produced are remarkable not simply for their existence but also for their astonishing variety. They range from simple shell necklaces to human and animal forms in ivory, clay, and stone to life-size mural (wall) paintings and sculptures in caves. During the Paleolithic period, humankind went beyond the recognition of human and animal forms in the natural environment to the representation (literally, the presenting again—in different and substitute form—of something observed) of humans and animals. The immensity of this achievement cannot be overstated.

Africa

Some of the earliest paintings yet discovered come from Africa, but unlike the paintings in European caves most people think of as synonymous with Paleolithic art, the oldest African paintings were portable objects.

APOLLO 11 CAVE Between 1969 and 1972, scientists working in the Apollo 11 Cave in Namibia (MAP 19-1) found seven fragments of painted stone plaques, including four or five recognizable images of animals. In most cases, including the example illustrated here (FIG. 1-2), the species is uncertain, but the painters always rendered the forms with care—and in the identical way (see "How to Represent an Animal," page 17). One plaque depicts a striped beast, possibly a zebra. The approximate date of the charcoal from the archaeological layer containing the Namibian plaques is 23,000 BCE.

Europe

Even older than the Namibian painted plaques are some of the first sculptures and paintings of western Europe (MAP 1-1), although examples of still greater antiquity may yet be found in Africa.

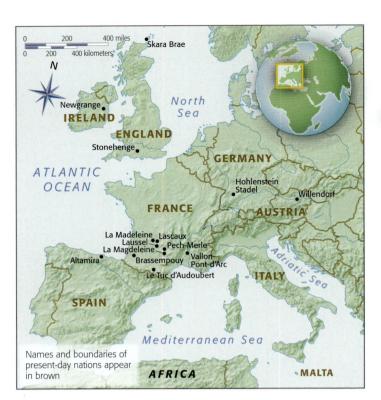

MAP 1-1 Stone Age sites in Europe.

HOHLENSTEIN-STADEL One of the oldest sculptures ever discovered is an extraordinary ivory statuette (FIG. 1-3), which may date back as far as 40,000 BCE. Found in 1939 in fragments inside a cave at Hohlenstein-Stadel in Germany, the statuette, carved from the tusk of a woolly mammoth, is nearly a foot tall—a truly huge image for its era. Long thought to have been created about 30,000 years ago, the recent discovery of hundreds of additional tiny fragments has pushed the date back about 10,000 years based on radiocarbon dating of the bones found in the same excavation level. (Radiocarbon dating is a measure of the rate of degeneration of carbon 14 in organic materials.) The statuette thus testifies to a very early date for the development of the human brain, because the subject of the work is not something the Paleolithic sculptor could see and copy but something that existed only in the artist's vivid imagination. The ivory figurine represents a human (whether male or female cannot be determined) with a feline (lion?) head. Composite creatures with animal heads and human bodies (and vice versa) are familiar in the art of ancient Mesopotamia and Egypt (compare, for example, FIGS. 2-10 and 3-1). In those civilizations, surviving texts usually enable historians to name the figures and describe their role

40.000-20.000 BCE

Early Paleolithic

- Hunter-gatherers create the first sculptures and paintings, long before the invention of writing
- The works range in scale from tiny figurines, such as the Venus of Willendorf, to life-size paintings and relief sculptures, such as the painted horses in the cave at Pech-Merle

20,000-9000 BCE

Later Paleolithic

- · Painters cover the walls and ceilings of caves at Altamira and Lascaux with profile representations of animals
- Sculptors carve images of nude women on the walls of the cave at La Magdeleine

9000-8000 BCE Mesolithic

8000-5000 BCE

Early Neolithic

- In Anatolia and Mesopotamia. the earliest settled communities take shape and agriculture begins
- Neolithic builders erect stone towers and fortification walls at
- Sculptors fashion large-scale painted plaster human figures
- Painters depict coherent narratives and employ composite views for human figures at Çatal Höyük

5000-2300 BCE

Later Neolithic

- Neolithic builders in Ireland and Britain erect megalithic passage graves and henges
- The stone temples of Malta incorporate sophisticated curved and rectilinear forms

PROBLEMS AND SOLUTIONS

How to Represent an Animal

Like every artist in every age in every medium, the Paleolithic painter of the animal plaque (FIG. 1-2) found in the Apollo 11 Cave in Namibia had to answer two questions before beginning work: What shall be my subject? How shall I represent it? In Paleolithic art, the almost universal answer to the first question was an animal. Bison, horse, woolly

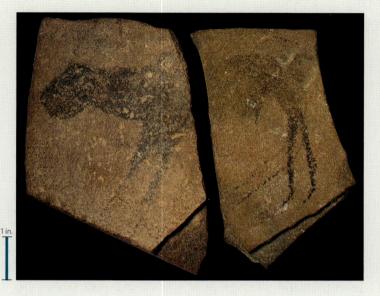

mammoth, and ibex are the most common. In fact, Paleolithic painters and sculptors depicted humans infrequently, and men almost never. In equally stark contrast to today's world, there was also agreement on the best answer to the second question. During at least the first 20,000 years of the history of art, artists represented virtually every animal in every painting in the same manner: in strict profile. Why?

The profile is the only view of an animal in which the head, body, tail, and all four legs are visible. The frontal view conceals most of the body, and a three-quarter view shows neither the front nor side fully. Only the profile view is completely informative about the animal's shape, and that is why Stone Age painters universally chose it.

A very long time passed before artists placed any premium on "variety" or "originality" either in subject choice or in representational manner. These are quite modern notions in the history of art. The aim of the earliest painters was to create a convincing image of their subject, a kind of pictorial definition of the animal capturing its very essence, and only the profile view met their needs.

1-2 Animal facing left, from the Apollo 11 Cave, Namibia, ca. 23,000 BCE. Charcoal on stone, $5'' \times 4\frac{1}{4}''$. State Museum of Namibia, Windhoek.

As in almost all paintings for thousands of years, in this very early example from Africa, the painter represented the animal in strict profile so that the head, body, tail, and all four legs are clearly visible.

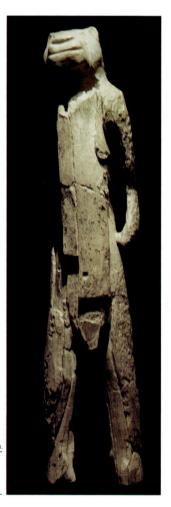

1-3 Human with feline (lion?) head, from Hohlenstein-Stadel, Germany, ca. 40,000-35,000 BCE. Woolly mammoth ivory, $11\frac{5}{8}$ " high. Ulmer Museum, Ulm.

One of the world's oldest preserved sculptures is this large ivory figure of a human with a feline head. It is uncertain whether the work depicts a composite creature or a human wearing an animal mask.

in religion and mythology. But for Stone Age representations, no one knows what their makers had in mind. Some scholars identify the animal-headed humans as sorcerers, whereas others describe them as magicians wearing masks. Similarly, some researchers have interpreted Paleolithic representations of human-headed animals as humans wearing animal skins. In the absence of any contemporaneous written explanations-this was a time before writing, before history-experts and amateurs alike can only

speculate on the purpose and function of statuettes such as the one from Hohlenstein-Stadel.

Art historians are certain, however, that these sculptures were important to those who created them, because manufacturing an ivory figure, especially one a foot tall, was a complicated process. First, the hunter or the sculptor had to remove the tusk from the dead animal by cutting into the tusk where it joined the head. Then the sculptor cut the ivory to the desired size and rubbed it into its approximate final shape with sandstone. Finally, the carver used a sharp stone blade to shape the body, limbs, and head, and a stone burin (a pointed engraving tool) to incise (scratch or engrave) lines into the surfaces, as on the Hohlenstein-Stadel creature's arms. Experts estimate that this large figurine required about 400 hours (about two months of uninterrupted working days) of skilled work.

WILLENDORF The composite feline-human from Germany is exceptional both for its early date and its subject. The vast majority of Stone Age sculptures depict either animals or humans. In the earliest art, humankind consists almost exclusively of women as opposed to men. Paleolithic painters and sculptors almost invariably showed them nude, although historians generally assume that during the Ice Age both women and men wore garments covering parts of their bodies. When archaeologists first encountered these statuettes of women, they dubbed them "Venuses" after the Greco-Roman goddess of beauty and love, whom later artists usually depicted nude. The nickname is inappropriate and misleading. Indeed, it is doubtful that the Paleolithic figurines represent deities of any kind.

One of the oldest and most famous Paleolithic female images is the tiny limestone figurine of a woman that long ago became known

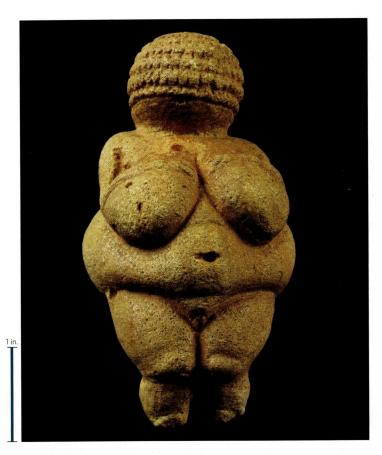

1-4 Nude woman (*Venus of Willendorf*), from Willendorf, Austria, ca. 28,000–25,000 BCE. Limestone, $4\frac{1}{4}$ " high. Naturhistorisches Museum, Vienna.

The anatomical exaggerations in this tiny figurine from Willendorf are typical of Paleolithic representations of women, whose child-bearing capabilities ensured the survival of the species.

as the *Venus of Willendorf* (FIG. 1-4) after its *findspot* (place of discovery) in Austria. Its cluster of almost ball-like shapes is unusual, the result in part of the sculptor's response to the natural shape of the stone selected for carving. The anatomical exaggeration has suggested to many observers that this and similar statuettes served as fertility images. But other Paleolithic figurines depicting women with far more slender proportions exist, and the meaning of these images is as elusive as everything else about the world's earliest art. Yet the preponderance of female over male figures seems to indicate a preoccupation with women, whose child-bearing capabilities ensured the survival of the species.

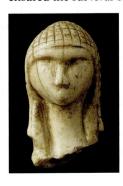

One thing at least is clear: the *Venus* of *Willendorf* sculptor did not aim for naturalism (fidelity to nature) in shape and proportion. As is true of most Paleolithic figures, the sculptor of this woman did not carve any facial features. A similar but even smaller ivory figurine found in 2008 in a cave at Hohle Fels, near Ulm, Germany, contemporaneous with or perhaps even several thousand years older than the Hohlenstein-Stadel statuette, lacks any head at all. The ivory head (FIG. 1-4A) of a woman from Brassempouy, France, is a notable exception. The carver

of the Willendorf figurine suggested only a mass of curly hair or, as some researchers have argued, a hat woven from plant fibers—evidence for the art of textile manufacture at a very early date. In either case, the emphasis is on female anatomy. The breasts of the Willendorf woman are enormous, far larger in proportion than the tiny forearms and hands resting on them. The carver also took pains to scratch into the stone the outline of the pubic triangle. Sculptors often omitted this detail in other early figurines, leading some scholars to question the function of these figures as fertility images. Whatever the purpose of these statuettes, the makers' intent seems to have been to represent not a specific woman but the female form.

LAUSSEL Probably later in date than the *Venus of Willendorf* is a female figure (FIG. 1-5) from Laussel in France. The Willendorf and Hohlenstein-Stadel figures are *sculptures in the round* (*freestanding sculptures*). The Laussel woman is one of the earliest *relief sculptures* known. The sculptor employed a stone *chisel* to cut into the relatively flat surface of a large rock in order to create an image projecting from the background. Today, the Laussel relief is on display in a museum, divorced from its original context, a detached piece of what once was a much more imposing work. When discovered,

1-5 Woman holding a bison horn, from Laussel, France, ca. 25,000–20,000 BCE. Painted limestone, 1' 6" high. Musée d'Aquitaine, Bordeaux.

One of the oldest known relief sculptures depicts a woman who holds a bison horn and whose left arm draws attention to her belly. Scholars continue to debate the meaning of the gesture and the horn.

1-6 Two bison, reliefs in the cave at Le Tuc d'Audoubert, France, ca. 15,000–10,000 BCE. Clay, right bison $2'\frac{7}{8}"$ long.

Representations of animals are far more common than those of humans in Paleolithic art. The sculptor built up these clay bison using a stone spatula-like smoothing tool and fingers to shape the details.

bison (FIG. 1-6) in clay against a large, irregular freestanding rock. The two bison, like the much older painted animal (FIG. 1-2) from the Apollo 11 Cave, are in strict profile. Each is about 2 feet long. They are among the largest Paleolithic sculptures known. The sculptor brought the clay from elsewhere in the cave complex and used both hands to form the overall shape of the animals. The next step was to smooth the surfaces with a spatula-like tool. Finally, the sculptor used fingers to shape the eyes, nostrils, mouths, and manes. The cracks in the two reliefs resulted from the drying process and probably appeared within days of the clay sculptures' completion.

the Laussel woman (who is about $1\frac{1}{2}$ feet tall, more than four times larger than the Willendorf statuette) was part of a great stone block measuring about 140 cubic feet. The carved block stood in the open air in front of a Paleolithic rock shelter. Rock shelters were a common type of dwelling for early humans, along with huts and the mouths of caves. The Laussel relief is one of many examples of open-air art

✓ 1-5A Reclining woman,

La Magdeleine, ca. 12,000 BCE.

in the Old Stone Age. The popular notions that early humans dwelled exclusively in caves and that all Paleolithic art comes from mysterious dark caverns are false. Reliefs depicting nude women do, however, occur inside Old Stone Age caves. Perhaps the most interesting is the pair of reclining nude women (FIG. 1-5A) on the wall of a corridor in a cave at La Magdeleine, France.

After chiseling out the female body and incising the details with a sharp burin, the Laussel sculptor applied red ocher, a naturally colored mineral, to the body. (Traces of red ocher coloration also remain on parts of the *Venus of Willendorf*.) Contrary to modern misconceptions, ancient artists usually painted stone sculptures (compare FIG. 5-63A). The Laussel woman has the same bulbous body as the earlier Willendorf figurine, with a similar exaggeration of the breasts, abdomen, and hips. The head is once again featureless, but the arms have taken on greater importance. The left arm draws attention to the midsection and pubic area, and the raised right hand holds what most scholars identify as a bison horn with 13 incised lines. Scholars continue to debate the meaning of the horn and its incisions as well as the gesture of the left hand.

LE TUC D'AUDOUBERT Paleolithic sculptors sometimes created reliefs by building up forms out of clay instead of cutting into stone blocks or cave walls. Sometime 12,000 to 17,000 years ago in the low-ceilinged circular space at the end of a succession of cave chambers at Le Tuc d'Audoubert, a master sculptor modeled a pair of

LA MADELEINE As already noted, sculptors fashioned the ivory tusks of woolly mammoths into human (FIG. 1-4A), animal, and composite human-animal (FIG. 1-3) forms from very early times. Stone Age carvers also used antlers as a sculptural medium. The bison (FIG. 1-7) found at La Madeleine in France is what remains of a spear-thrower carved from a reindeer antler. Although only 4 inches long, the engraved antler is more detailed than the two much larger bison at Le Tuc d'Audoubert. The sculptor used a sharp burin to incise lines for the Madeleine bison's mane, horns, eye, ear, nostrils, mouth, tongue, and facial hair. Especially interesting is the engraver's decision to represent the bison with its head turned and licking its flank. The small size and irregular shape of the reindeer horn, rather than a desire to record a characteristic anecdotal activity,

1-7 Bison licking its flank, fragmentary spear-thrower, from La Madeleine, France, ca. 12,000 BCE. Reindeer horn, $4\frac{1}{8}$ " long. Musée d'Archéologie nationale, Saint-Germain-en-Laye.

This fragment of a spear-thrower was carved from a reindeer antler. The sculptor turned the bison's head a full 180 degrees to maintain the profile view and incised the details with a stone burin.

PROBLEMS AND SOLUTIONS

Painting in the Dark

The caves of Altamira (Fig. 1-8), Lascaux (Figs. 1-1, 1-9A, and 1-10), and other sites in prehistoric Europe are a few hundred to several thousand feet long. They are often choked, sometimes almost impassably, by mineral deposits, such as stalactites and stalagmites. Far inside these caverns, well removed from the cave mouths early humans often chose for habitation, painters sometimes made pictures on the walls and ceilings. How did the world's first *muralists* paint bison and other animals on surfaces far from any source of natural light? What tools and materials did the Paleolithic painters of France and Spain use, and how did they make them?

To illuminate the cave walls and ceilings while working, Paleolithic painters lit fires on cave floors and used stone lamps filled with marrow or fat, with a wick, perhaps of moss, as well as simple torches. For drawing, they used chunks of charcoal and red and yellow ocher. For painting, they ground these same natural materials into powders that they mixed with water before applying. Recent analyses of the pigments used show that Paleolithic painters employed many different minerals, attesting to a technical sophistication surprising at so early a date. Large flat stones served as palettes. The painters made brushes from reeds, bristles, or twigs and may have used a blowpipe of reed or hollow bone to spray pigments on out-of-reach surfaces. Some caves have natural ledges on the rock walls upon which the painters could have stood in order to reach the upper surfaces of the naturally formed chambers and corridors. One gallery wall in the Lascaux cave complex has holes that once probably anchored a scaffold made of saplings lashed together.

Despite the difficulty of making the tools and pigments, modern attempts at replicating the techniques of Paleolithic painting have demonstrated that skilled workers could cover large surfaces with images in less than a day.

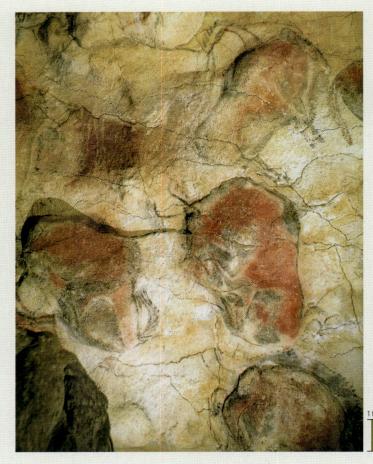

1-8 Bison, detail of a painted ceiling in the cave at Altamira, Spain, ca. 13,000–11,000 BCE. Standing bison 5' $2\frac{1}{2}$ " long.

Paleolithic painters used stone lamps to provide light in the dark caves. They made brushes from reeds and twigs or used reed or bone blowpipes to spray ground ocher pigments onto out-of-reach surfaces.

may have been the primary motivation for this space-saving device. Whatever the reason, it is noteworthy that the sculptor turned the neck a full 180 degrees to maintain the strict profile Stone Age sculptors and painters insisted on for the sake of clarity and completeness (see "How to Represent an Animal," page 17).

ALTAMIRA The works examined here thus far, whether portable or fixed to rocky outcroppings or cave walls, are all small, with the exception of the paintings in the Lascaux Hall of the Bulls (FIG. 1-1). The Lascaux animals dwarf all the other illustrated examples, as do the other "herds" of painted animals roaming the walls and ceilings of other caves in southern France and northern Spain, where some of the most spectacular examples of Paleolithic art have been discovered. An amateur archaeologist accidentally found the first known examples of cave paintings at Altamira, Spain, in 1879. Don Marcelino Sanz de Sautuola (1831-1888) was exploring a cavern on his estate where he had previously collected specimens of flint and carved bone. His little daughter Maria was with him when they reached a chamber some 85 feet from the cave's entrance. Because it was dark (see "Painting in the Dark," above) and the ceiling of the debris-filled chamber was only a few inches above the father's head, the child was the first to notice, from her lower vantage point, the shadowy forms of bison (fig. 1-8, a detail of a much larger painting approximately 60 feet long).

Sanz de Sautuola was certain the paintings in his cave dated to prehistoric times. Professional archaeologists, however, doubted the authenticity of these works, and at the 1880 Congress on Prehistoric Archaeology in Lisbon, they officially dismissed the Altamira paintings as forgeries. But by the close of the century, explorers had discovered other caves with painted walls partially covered by mineral deposits that would have taken thousands of years to accumulate. This additional evidence finally persuaded skeptics that the world's oldest paintings were of an age far more remote than anyone had ever imagined. Examples of Paleolithic painting now have been found at more than 200 sites. Nonetheless, art historians still regard painted caves as rare occurrences because the images in them, even if they number in the hundreds, span a period of some 10,000 to 20,000 years.

The bison at Altamira are 13,000 to 14,000 years old, but the painters of Paleolithic Spain approached the problem of representing an animal in essentially the same way as the painter of the Namibian stone plaque (FIG. 1-2), who worked in Africa more than 10,000 years earlier. Every one of the Altamira bison is in profile, whether alive and standing or curled up on the ground—probably dead, although some scholars dispute this. (One suggestion is that

ART AND SOCIETY

Why Is There Art in Paleolithic Caves?

Ever since the discovery in 1879 of the first cave paintings, scholars have wondered why the hunters of the Old Stone Age decided to cover the surfaces of dark caverns with animal images such as those found at Lascaux (FIG. 1-1), Altamira (FIG. 1-8), and Pech-Merle (FIG. 1-9). Researchers have proposed various theories, including that the painted and engraved animals were mere decoration, but this explanation cannot account for the inaccessibility of many of the representations. In fact, the remote locations of many images, and indications the caves were used for centuries, are precisely why many experts have suggested that prehistoric peoples attributed magical properties to the images they painted and sculpted. According to this argument, by confining animals to the surfaces of their cave walls, Paleolithic communities believed they were bringing the beasts under their control. Some scholars have even hypothesized that rituals or dances were performed in front of the images and that these rites served to improve the luck of the community's hunters. Others have suggested that the animal representations may have served as teaching tools to instruct new hunters about the character of the various species they would encounter, or even were targets for spears.

In contrast, other experts have argued that the magical purpose of the paintings and reliefs was not to facilitate the *destruction* of bison and other species. Instead, they believe that the world's first painters and sculptors created animal images to assure the *survival* of the herds on which Paleolithic peoples depended for their food supply and for their clothing. A central problem for both the hunting-magic and food-creation theories is that the staple foods of Old Stone Age diets did not include the animals most frequently portrayed. For example, faunal remains show that the Altamirans ate red deer, not bison.

Other scholars have sought to reconstruct an elaborate belief system based on the cave paintings and sculptures, suggesting, for example, that the animals are deities or ancestors that Paleolithic humans revered. Some researchers have equated certain species with men and others with women and postulated various meanings for the dots, squares, and other signs accompanying some images.

Almost all of these theories have been discredited over time, and most experts admit that the intent of these representations is unknown. In fact, a single explanation for all Paleolithic animal images, even ones similar in subject, style, and *composition* (how the motifs are arranged on the surface), is unlikely to apply universally. The meaning of these works remains an unsolved mystery—and always will, because before the invention of writing, no contemporaneous explanations could be recorded.

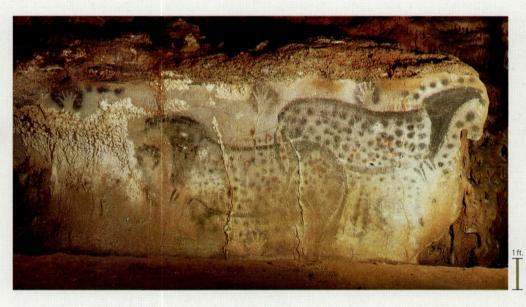

1-9 Spotted horses and negative hand imprints, wall painting in the cave at Pech-Merle, France, ca. 23,000–22,000 BCE. 11' 2" long.

The purpose and meaning of Paleolithic art are unknown. Some researchers think the painted hands near the Pech-Merle horses are "signatures" of community members or of individual painters.

these bison are giving birth.) To maintain the profile in the latter case, the painter had to adopt a viewpoint above the animal, looking down, rather than the view of a person standing on the ground.

Modern critics often refer to the Altamira animals as a "group" of bison, but that is very likely a misnomer. The several bison in Fig. 1-8 do not stand on a common *ground line* (a painted or carved baseline on which figures appear to stand in paintings and reliefs), unlike many of the animals at Lascaux (Fig. 1-1), nor do they share a common orientation. They seem almost to float above viewers' heads, like clouds in the sky. And the painter provided an "aerial view" of the dead(?) bison, whereas the observer views the others from a position on the ground. The painting has no setting, no background, no indication of place. *Where* the animals are or how they relate to one another, if at all, was of no concern to the Paleolithic

painters of Altamira. Instead, several *separate* images of bison adorn the ceiling, perhaps painted at different times spanning generations, and each is as complete and informative as possible.

PECH-MERLE No one knows why animals play a central, indeed a nearly exclusive, role in the caves at Altamira, Lascaux (FIG. 1-1), and elsewhere in Paleolithic Europe (see "Why Is There Art in Paleolithic Caves?" above). That these paintings of different animal species did have meaning to Stone Age peoples cannot, however, be doubted. In fact, signs consisting of checks, dots, squares, or other arrangements of lines often accompany the pictures of animals. Painted human hands also are common. At Pech-Merle (FIG. 1-9), the hands accompany representations of spotted horses. (The "spots" also surround the horses and may not be spots at all but

stones or signs.) Most of the painted hands in Paleolithic caves are "negative." That is, the painter placed one hand against the wall and then brushed or blew or spat pigment around it. Occasionally, the painter dipped a hand in the pigment and then pressed it against the wall, leaving a "positive" imprint. These handprints must have served a purpose. Some researchers consider them "signatures" of cult or community members or, less likely, of individual painters. But like so much in Paleolithic art, their meaning is unknown.

The mural paintings at Pech-Merle also furnish some insight into the reasons Paleolithic peoples chose subjects for specific places in a cave. One of the horses (at the right in FIG. 1-9) may have been inspired by the rock formation in the wall surface resembling a horse's head and neck. Old Stone Age painters and sculptors frequently and skillfully used the naturally irregular surfaces of caves to help give the illusion of real presence to their forms, as they did at La Magdeleine (FIG. 1-5A) and at Altamira (FIG. 1-8), where many of the bison paintings cover bulging rock surfaces. In fact, art historians have observed that bison and cattle appear almost exclusively on convex surfaces, whereas nearly all horses and hands are painted on concave surfaces. What this signifies has yet to be determined.

LASCAUX Perhaps the most impressive collection of Paleolithic animal paintings is in the Hall of the Bulls (FIG. 1-1) at Lascaux. The large chamber, away from the cave entrance and mysteriously dark, has good acoustics, and would have provided an excellent setting for the kinds of rituals many archaeologists assume took place in front of the paintings. One noteworthy aspect of the Lascaux murals is that they exhibit, side by side, the two basic approaches to drawing and painting found repeatedly in the history of art—silhouettes and outlines—indicating that different painters created these pictures, probably at different times. The Lascaux bulls also show a convention of representing horns in what art historians call *twisted perspective*, or a *composite view*, because viewers see the heads in profile but the horns from the front. Thus, the painter's approach is not strictly or consistently optical (seen from a fixed viewpoint).

Rather, the approach is descriptive of the fact that cattle have two horns. Two horns are part of the concept "bull." In strict optical-perspective profile, only one horn would be visible, but to paint the animal in that way would amount to an incomplete definition of it.

Paintings of animals appear throughout the cave complex at Lascaux, including in the so-called Axial Gallery, which features a representation of a running, possibly pregnant horse (FIG. 1-9A) surrounded by what may be arrows or traps. But the most perplexing painting at Lascaux and perhaps in all Paleolithic art is deep in a well shaft. In this mural (FIG. 1-10), man

1-9A "Chinese horse," Lascaux, ca. 16,000-14,000 BCE.

(as opposed to woman) makes one of his earliest appearances in the history of art. At the left, and moving to the left, is a rhinoceros. Beneath its tail are two rows of three dots of uncertain significance. At the right is a bison, also facing left but with less realistic proportions, probably the work of someone else. The second painter nonetheless successfully suggested the bristling rage of the animal, whose bowels are hanging from it in a heavy coil. Between the two beasts is a bird-faced (masked?) man (compare FIG. 1-3) with outstretched arms and hands having only four fingers. The painter depicted the man with far less care and detail than either animal, but made the hunter's gender explicit by the prominent penis. The position of the man is ambiguous. Is he wounded or dead or merely tilted back and unharmed? Do the staff(?) with the bird on top and the spear belong to him? Is it he or the rhinoceros that gravely wounded the bison or neither? Which animal, if either, has knocked the man down, if indeed he is on the ground? Are these three images related at all? Modern viewers can be sure of nothing, but if the painters placed the figures beside each other to tell a story, this is evidence for the creation of complex narrative compositions involving humans and animals at a much earlier date than anyone had imagined only a few

1-10 Rhinoceros, wounded man, and disemboweled bison, painting in the well of the cave at Lascaux, France, ca. 16,000-14,000 BCE. Bison $3' 4\frac{1}{2}"$ long.

If these paintings of two animals and a bird-faced (masked?) man deep in a Lascaux well shaft depict a hunting scene, they constitute the earliest example of narrative art ever discovered.

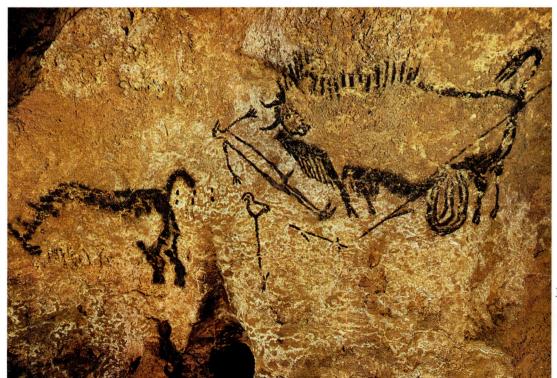

III.

generations ago. Yet it is important to remember that even if the painter(s) intended to tell a story, very few people would have been able to "read" it. The mural, in a deep shaft, is very difficult to reach and could have been viewed only in flickering lamplight. Like all Paleolithic art, the scene in the Lascaux well shaft is a puzzle.

CHAUVET CAVE One of the most spectacular archaeological finds of the past century poses a problem of a different kind. In December 1994, a French team led by Jean-Marie Chauvet discovered Paleolithic mural paintings (FIG. 1-11) in a cave at Vallon-Pont-d'Arc. To determine the date of the Chauvet Cave paintings, French scientists used radiocarbon dating of the charcoal in the black pigments. The tests revealed that the mural paintings dated between 30,000 and 28,000 BCE and were thousands of years older than any previously discovered.

This unexpectedly early date immediately forced scholars to reevaluate the scheme of "stylistic development" from simple to more complex forms that historians of Stone Age art had accepted for decades. In the Chauvet Cave, in contrast to Lascaux (FIG. 1-1), the painters depicted the horns of the aurochs (extinct long-horned wild oxen) naturalistically, one behind the other, not in the twisted perspective normally used in Paleolithic art. Moreover, the two rhinoceroses at the lower right of FIG. 1-11 appear to attack each other, suggesting that the painter intended a narrative, another "first" in either painting or sculpture. If the paintings are twice as old as those of Lascaux and Altamira (FIG. 1-8) and almost 10,000 years earlier than the Pech-Merle murals (FIG. 1-9), the assumption that Paleolithic art "evolved" from simple to more sophisticated representations is wrong.

Because the Chauvet paintings require a rethinking of conventional assumptions about Paleolithic art, the French team's findings immediately became the subject of intense controversy. Some archaeologists have contested the early dating of the Chauvet paintings on the grounds that the tested samples were contaminated. If the Chauvet animals are later than those at Lascaux, their advanced stylistic fea-

tures can be more easily explained. In fact, recent investigations in the cave and at neighboring sites seem conclusively to support the later date. The dispute exemplifies the frustration—and the excitement—of studying the art of an age so remote that almost nothing remains and almost every new find causes art historians to reevaluate what they had previously taken for granted.

NEOLITHIC ART

Around 9000 BCE, the ice that covered much of northern Europe during the Paleolithic period melted as the climate warmed. The sea level rose more than 300 feet, separating England from continental Europe, and Spain from Africa. The reindeer migrated north, and the woolly mammoth disappeared. The Paleolithic gave way to a transitional period, usually called the *Mesolithic* (Middle Stone Age), and then, for several thousand years at different times in different parts of the globe, a great new age, the *Neolithic* (New Stone Age), dawned.* Human beings began to domesticate plants and animals and to settle in fixed abodes. Their food supply assured, many groups changed from hunters to herders to farmers and finally to townspeople. Wandering hunters settled down to organized community living in villages surrounded by cultivated fields.

The basis for the conventional division of the Stone Age into three periods is the development of stone implements. However, a different kind of distinction can be made between an age of food gathering and an age of food production. In this scheme, the Paleolithic period corresponds roughly to the age of food gathering. Intensified food gathering and the taming of the dog are the hallmarks of the Mesolithic period. In the Neolithic period, agriculture and livestock became humankind's major food sources. The transition to the Neolithic was nothing less than a revolution. It occurred first in Anatolia and Mesopotamia.

*This chapter treats the Neolithic art of Europe, Anatolia, and Mesopotamia only. For the Neolithic art of Africa, see Chapter 19; for Asia, see Chapters 15, 16, and 17.

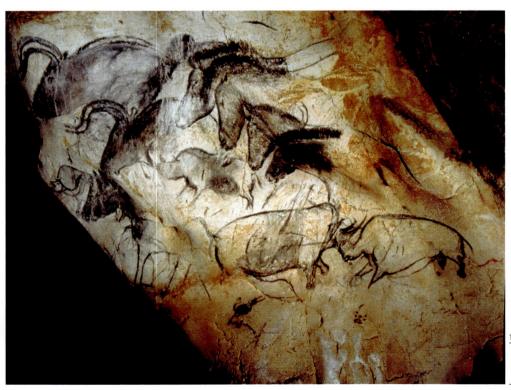

1-11 Aurochs, horses, and rhinoceroses, wall painting in the Chauvet Cave, Vallon-Pont-d'Arc, France, ca. 30,000–28,000 or ca. 15,000–13,000 BCE. Right rhinoceros 3' 4" long.

The date of the Chauvet Cave paintings is the subject of much controversy. If the murals are the oldest paintings known, they exhibit surprisingly advanced features, such as overlapping animal horns.

Anatolia and Mesopotamia

The remains of the oldest known settled communities lie in the grassy foothills of the Antilebanon, Taurus, and Zagros mountains in present-day Turkey, Syria, Iraq, and Iran (MAP 1-2). These regions provided the necessary preconditions for the development of agriculture. Species of native plants, such as wild wheat and barley, were plentiful, as were herds of animals (goats, sheep, and pigs) that could be domesticated. Sufficient rain occurred for the raising of crops. When village farming life was well developed, some settlers, attracted by the greater fertility of the soil and perhaps also by the need to find more land for their rapidly growing populations, moved into the valleys and deltas of the Tigris and Euphrates Rivers.

In addition to systematic agriculture, the new village societies of the Neolithic Age originated weaving, metalworking, pottery, and counting and recording with clay tokens. These innovations spread with remarkable speed throughout Anatolia (roughly equivalent to present-day Turkey) and Mesopotamia (primarily present-day Syria and Iraq). Settled farming communities such as Jarmo in Iraq and Çatal Höyük in southern Anatolia date to the mid-seventh millennium BCE. The remarkable fortified town of Jericho, before whose walls the biblical Joshua appeared thousands of years later, is even older. Archaeologists are constantly uncovering surprises, and the exploration of new sites each year is compelling them to revise their

✓ 1-11A Göbekli Tepe,
ca. 9000 BCE.

views about the emergence of Neolithic society. Especially noteworthy are the ongoing excavations at Göbekli Tepe in southeastern Turkey, where German archaeologists have uncovered the remains of what appear to be the world's oldest stone temples, dating around 9000 BCE, with animal reliefs on T-shaped pillars (FIG. 1-11A). Of those sites known for some time, Jericho, Ain Ghazal, and Çatal Höyük together probably offer the most representative picture of the rapid and exciting transformation of human society and of art during the Neolithic period.

JERICHO By 7000 BCE, agriculture was well established from Anatolia to ancient Palestine and Iran. Its advanced state by this date presupposes a long development. Indeed, the very existence of a major settlement such as Jericho gives strong support to this assumption. Jericho, situated on a plateau in the Jordan River Val-

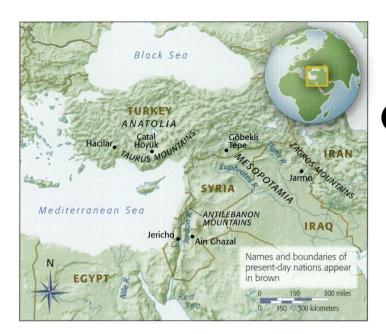

MAP 1-2 Neolithic sites in Anatolia and Mesopotamia.

ley with an unfailing spring, was the site of a small village as early as the ninth millennium BCE. This village underwent spectacular development around 8000 BCE, when the inhabitants established a new Neolithic settlement (FIG. 1-12) covering about 10 acres. Its mud-brick houses sat on round or oval stone foundations and had roofs of branches covered with earth.

As Jericho's wealth grew, the need for protection against marauding nomads resulted in the first known permanent stone fortifications. By 7500 BCE, a wide rock-cut ditch and a 5-foot-thick wall surrounded the town, which probably had a population exceeding 2,000. Set into the circuit wall, which has been preserved to a height of almost 13 feet, was a 30-foot-tall circular tower (FIG. 1-12, bottom center) constructed of roughly shaped stones laid without mortar (dry masonry). Almost 33 feet in diameter at the base, the tower has an inner stairway leading to its summit. Not enough of the site has been excavated to determine whether this tower was solitary or one of several similar towers forming a complete defense system. In either case, a stone structure as large as the Jericho tower was a tremendous technological achievement and a testimony to the Neolithic builders' ability to organize a significant workforce.

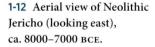

Protecting Neolithic Jericho were 5-foot-thick walls and at least one tower 30 feet high and 33 feet in diameter constructed of stone laid without mortar—an outstanding technological achievement.

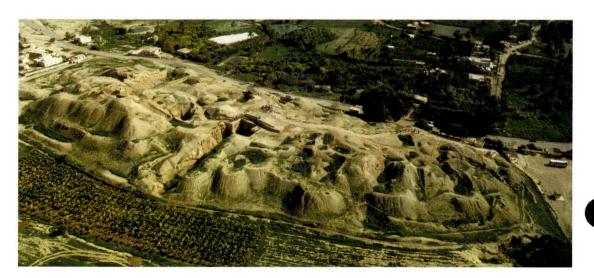

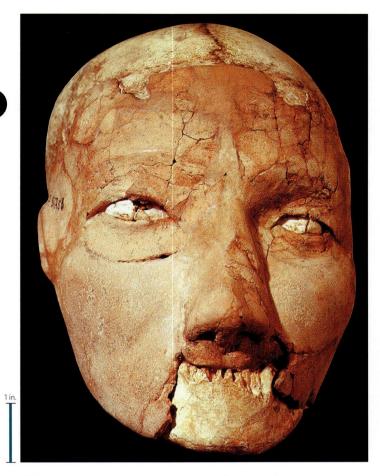

1-13 Human skull with restored features, from Jericho, ca. 7200–6700 BCE. Features modeled in plaster, painted, and inlaid with seashells. Life-size. Archaeological Museum, Amman.

The Neolithic farmers of Jericho removed the skulls of their dead before burial, modeled them with plaster, and inlaid the eyes to create lifelike "portraits" of their ancestors, whom they may have worshiped.

Sometime around 7000 BCE, Jericho's inhabitants abandoned their fortified site, but new settlers arrived in the early seventh millennium and established a farming community of rectangular mud-brick houses on stone foundations with plastered and painted floors and walls. Several of the excavated buildings contained statuettes of animals and women and seem to have served as shrines. The new villagers buried their dead beneath the floors of their houses with the craniums detached from their skeletons and their features reconstructed in plaster. Subtly modeled with inlaid seashells for eyes and painted hair, the appearance of these reconstructed heads is strikingly lifelike. One head (FIG. 1-13) features a painted mustache, distinguishing it from the others. The Jericho skulls constitute the world's earliest known "portrait gallery," but the artists' intention was certainly not portraiture in the modern sense. The plastered skulls must have served a ritualistic purpose. The community of several hundred Neolithic farmers who occupied Jericho at this time honored and perhaps worshiped their ancestors as intercessors between the living and the world beyond. They may have believed that the dead could exert power over the living and that they had to offer sacrifices to their ancestors to receive favorable treatment. These skulls were probably the focus of rites in honor of those ancestors.

AIN GHAZAL A second important Neolithic settlement in ancient Palestine was Ain Ghazal, near the modern Jordanian capital of

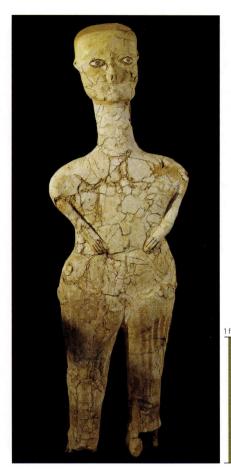

1-14 Human figure, from Ain Ghazal, Jordan, ca. 6750–6250 BCE. Plaster, painted and inlaid with bitumen, $3' 5 \frac{3}{8}"$ high. Musée du Louvre, Paris.

The dozens of large painted plaster statuettes (some with two heads and with details added in paint or inlaid with bitumen) found at Ain Ghazal are the earliest large-scale sculptures known.

Amman. Occupied from around 7200 to 5000 BCE, the site featured houses of irregularly shaped stones with plastered floors and walls painted red. The most striking finds, however, are two caches containing three dozen plaster statuettes (FIG. 1-14) and busts, some with two heads, datable to ca. 6500 BCE. The sculptures, which appear to have been ritually buried, are white plaster built up over a core of reeds and twine, with black bitumen, a tarlike substance, for the pupils of the eyes. Some of the figures have painted clothing. Only rarely did the sculptors indicate the gender of the figures. Whatever their purpose, by their size (as much as 3 feet tall) and sophisticated technique, the Ain Ghazal statuettes and busts tower over Paleolithic figurines such as the tiny *Venus of Willendorf* (FIG. 1-4) and even the foot-tall Hohlenstein-Stadel ivory statuette (FIG. 1-3). They mark the beginning of the long history of large-scale sculpture in Mesopotamia.

ÇATAL HÖYÜK During the past half century, archaeologists also have made remarkable discoveries in Turkey, not only at Göbekli Tepe

(FIG. 1-11A) but also at Hacilar and especially Çatal Höyük (FIG. 1-14A), the site of a flourishing Neolithic culture on the central Anatolian plain between 6500 and 5700 BCE. Although animal husbandry was well established, hunting continued to play an important part in the early Neolithic economy of Çatal Höyük. The importance of hunting

1-14A Restored view of Çatal Höyük, ca. 6000-5900 BCE.

as a food source is reflected in the wall paintings of the site's older decorated rooms, where hunting scenes predominate. In style and

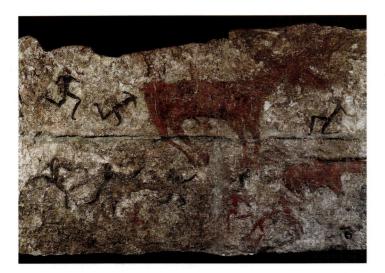

1-15 Deer hunt, detail of a wall painting from level III, Çatal Höyük, Turkey, ca. 5750 BCE. Museum of Anatolian Civilization, Ankara.

This Neolithic painter depicted human figures as a composite of frontal and profile views, the most descriptive picture of the shape of the human body. This format would become the rule for millennia.

concept, however, the deer hunt mural (FIG. 1-15) at Çatal Höyük is worlds apart from the wall paintings the hunters of the Paleolithic period produced. Perhaps what is most strikingly new about the Çatal Höyük painting and similar Neolithic examples is the regular appearance of the human figure—not only singly but also in large, coherent groups with a wide variety of poses, subjects, and settings. As noted earlier, humans rarely figured in Paleolithic cave paintings, and pictorial narratives are almost unknown. Even the "hunting

scene" (FIG. 1-10) in the well at Lascaux is doubtful as a narrative. In contrast, human themes and concerns and action scenes with humans dominating animals are central subjects of Neolithic paintings.

In the Çatal Höyük hunt, the group of hunters—and it is, indeed, an organized hunting party, not a series of individual figures—is a rhythmic repetition of basic shapes, but the painter took care to distinguish important descriptive details (bows, arrows, and garments), and the heads have clearly defined noses, mouths, chins, and hair. The Neolithic painter placed all the heads in profile for the same reason Paleolithic painters uni-

1-16 Landscape with volcanic eruption(?), wall painting in situ (*top*) and watercolor copy (*bottom*), from level VII, Çatal Höyük, Turkey, ca. 6150 BCE.

One of the oldest mural paintings from Çatal Höyük may represent the settlement during a volcanic eruption. It is the first known landscape—a painting of nature without either humans or animals.

versally chose the profile view for representations of animals (see "How to Represent an Animal," page 17). Only the side view of the human head shows all its shapes clearly. However, at Çatal Höyük the painter presented the torsos from the front—again, the most informative viewpoint—whereas the profile view was the choice for the legs and arms. This composite view of the human body is highly artificial—the human body cannot make an abrupt 90-degree shift at the hips—but it well describes what a human body is, as opposed to how it appears from a particular viewpoint. The technique of painting also changed dramatically from the Paleolithic to the Neolithic Age. The Çatal Höyük painters used brushes to apply their pigments to a background of dry white plaster. The careful preparation of the wall surface is in striking contrast to the direct application of pigment to the irregularly shaped walls and ceilings of Old Stone Age caves.

More remarkable still is a painting (FIG. 1-16) in one of the older rooms at Çatal Höyük. Art historians generally have acclaimed this mural as the world's first landscape (a picture of a natural setting in its own right, without any narrative content). As such, it remained unique for thousands of years. According to radiocarbon analysis, the painting dates to around 6150 BCE. Scholars interpret the foreground as a town with rectangular houses neatly laid out in rows, probably representing Çatal Höyük itself. Behind the town appears a mountain with two peaks. Many archaeologists think the dots and lines issuing from the higher of the two cones represent a volcanic eruption, and have suggested that the mountain is the 10,600-foot-high Hasan Dağ, the only twin-peaked volcano in central Anatolia, which is within view of Çatal Höyük. The conjectured volcanic eruption shown in the mural does not necessarily depict a specific historical event. Rather, the landscape may represent a recurring phenomenon. In either case, it is the earliest preserved representation of nature without either humans or animals.

Europe

In Europe, where Paleolithic paintings and sculptures abound, no evidence exists for comparably developed early Neolithic towns. However, in succeeding millennia, perhaps as early as 4000 BCE, the local populations of several European regions constructed imposing monuments employing massive rough-cut stones. The very dimensions of the stones, some as high as 17 feet and weighing as much as 50 tons, have prompted historians to call them *megaliths* (great stones) and to designate Neolithic architecture employing them as *megalithic*.

NEWGRANGE One of the most impressive megalithic monuments in Europe is also one of the oldest. The megalithic tomb at Newgrange in Ireland, north of Dublin, may date to as early as 3200 BCE and is one of the oldest funerary monuments in Europe. It takes the form of a *passage grave*—that is, a tomb with a long stone corridor leading to a burial chamber (FIG. 1-17) beneath a great *tumulus* (earthen burial mound). Some mounds contain more than one passage grave. Similar graves have been found also in England, France, Spain, and Scandinavia. All attest to the importance of honoring the dead in Neolithic society. The Newgrange tumulus is 280 feet in diameter and 44 feet tall. Its passageway is 62 feet long, and it and the primitive *dome* over the main chamber are early examples of *corbeled vaulting* (see "Corbeled Arches, Vaults, and Domes,"

1-17 Corbeled dome of the main chamber in the passage grave, Newgrange, Ireland, ca. 3200–2500 BCE.

The Newgrange passage grave is an early example of corbeled vaulting. The huge stones (megaliths) of the dome of the main burial chamber beneath the tumulus are held in place by their own weight.

page 95, and FIG. 4-18). At Newgrange, the huge megaliths forming the vaulted passage and the dome are held in place by their own weight without mortar, each stone countering the thrust of neighboring stones. Decorating some of the megaliths are incised spirals and other motifs (not visible in FIG. 1-17). A special feature of the Newgrange tomb is that at the winter solstice, the sun illuminates the passageway and the burial chamber.

HAGAR QIM By the end of the fourth millennium BCE, Neolithic civilization had spread to the most remote parts of Europe, includ-

ing, in the far north, Skara Brae (FIG. 1-17A) in the Orkney Islands, and, in the far south, Malta. The megalithic temple (FIG. 1-18) of Hagar Qim is one of many constructed on Malta between 3200 and 2500 BCE. The Maltese builders erected their temples by piling carefully cut stone blocks

1-17A House 1, Skara Brae, ca. 3100-2500 BCE.

in *courses* (stacked horizontal rows). To construct the doorways at Hagar Qim, the builders employed the *post-and-lintel system*

1-18 Aerial view of the ruins of Hagar Qim (looking east), Malta, ca. 3200–2500 BCE.

The 5,000-year-old stone temple at Hagar Qim on the remote island of Malta is remarkably sophisticated for its date, especially in the way the Neolithic builders incorporated both rectilinear and curved forms.

1-19 Post-and-lintel construction (John Burge).

The simplest and oldest method of spanning a passageway is to set up two upright blocks (posts), which support a horizontal beam (lintel), a technique used in both prehistoric Europe and Egypt.

(FIG. 1-19) in which two upright stones (posts) support a horizontal block (*lintel* or *beam*). The layout of this and other Neolithic Maltese temples is especially noteworthy for the combination of rectilinear and curved forms, including multiple *apses* (semicircular recesses). Inside the Hagar Qim temple, archaeologists found altars (hence the identification of the structure as a religious shrine) and several stone statues of headless nude women—one standing, the others seated. The level of architectural and sculptural sophistication seen on this isolated island at so early a date is extraordinary.

STONEHENGE The most famous megalithic monument in Europe is Stonehenge (FIG. 1-20) on the Salisbury Plain in southern England. A *henge* is an arrangement of megalithic stones in a circle, often surrounded by a ditch. The type is almost exclusively limited to Britain. Stonehenge is a complex of rough-cut sarsen (a form of sandstone) stones and smaller "bluestones" (various volcanic rocks) built in several stages over hundreds of years. The final henge consists of concentric post-and-lintel circles. Huge sarsen megaliths form the outer ring, which is almost 100 feet in diameter. (Note how they dwarf the visitors to the site in FIG. 1-20.) Inside is a ring of bluestones, and this ring, in turn, encircles a horseshoe (open end facing east) of trilithons (three-stone constructions)—five lintel-topped pairs of the largest sarsens, each weighing 45 to 50 tons. Standing apart and to the east (outside the aerial view in Fig. 1-20) is the "heel stone," which, for a person looking outward from the center of the complex, would have marked the point where the sun rose at the summer solstice. Stonehenge, perhaps originally a funerary site where Neolithic peoples cremated their dead, seems in its latest phase to have been a kind of astronomical observatory and a remarkably accurate solar calendar. According to a recent theory, it also served as a center of healing that attracted the sick and dying from throughout the region.

Whatever role they played in society, the megalithic tombs, temples, houses, and henges of Europe are enduring testaments to the rapidly developing intellectual powers of Neolithic humans as well as to their capacity for heroic physical effort.

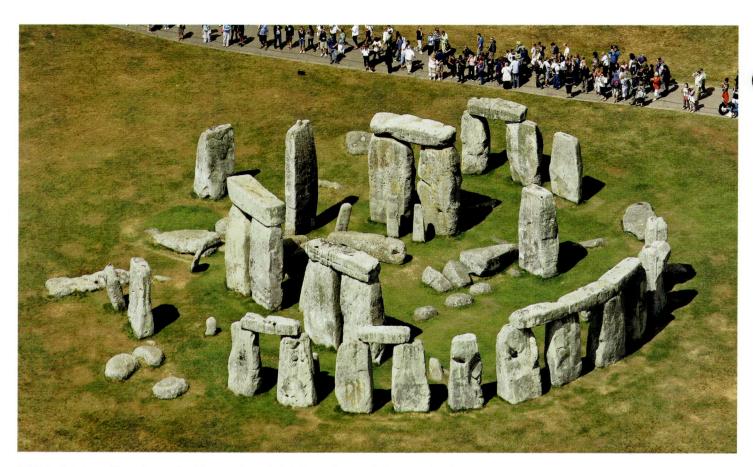

1-20 Aerial view of Stonehenge (looking northwest), Salisbury Plain, Wiltshire, England, ca. 2550–1600 BCE. Circle 97' in diameter; trilithons 24' high.

Stonehenge's circles of trilithons probably functioned as an astronomical observatory and solar calendar. The sun rises over its "heel stone" at the summer solstice. Some of the megaliths weigh 50 tons.

ART IN THE STONE AGE

Paleolithic (Old Stone Age) Art ca. 40,000-9000 BCE

- The first sculptures and paintings antedate the invention of writing by tens of thousands of years. Paleolithic humans' decision to represent the world around them initiated an intellectual revolution of enormous consequences.
- No one knows why humans began to paint and carve images or what role those images played in the lives of Paleolithic peoples. Women were far more common subjects than men, but animals, not humans, dominate Paleolithic art. Some scholars believe that Stone Age hunters performed rituals in front of the animal images, which aided them in killing their prey. In contrast, other researchers think the purpose of the images was to ensure the fertility of the species on which humans depended for food and clothing.
- The works created range in size from tiny portable figurines, such as the so-called Venus of Willendorf, to large, sometimes over-life-size, carved and painted representations of animals, as in the caves of Lascaux, Pech-Merle, Altamira, and elsewhere in southern France and northern Spain.
- The earliest known sculptures date to 40,000 to 30,000 BCE. The oldest paintings may be in the Chauvet Cave at Vallon-Pont-d'Arc, but the early dating of ca. 30,000–28,000 BCE is controversial.
- Paleolithic artists regularly depicted animals in profile in order to present a complete picture of each beast, including its head, body, tail, and all four legs. This format persisted for millennia.

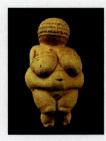

Nude woman (Venus of Willendorf), ca. 28,000-25,000 BCE

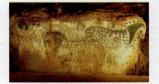

Horses and hands, Pech-Merle,

Neolithic (New Stone Age) Art ca. 8000-2300 BCE

- Around 9000 BCE, the ice that had covered much of northern Europe for millennia receded. After a transitional period, the Neolithic Age began in Anatolia and Mesopotamia.
- The Neolithic Age revolutionized human life with the beginning of agriculture and the formation of the first settled communities, such as that at Çatal Höyük in Anatolia, where archaeologists have uncovered an extensive town with numerous shrines.
- Some Neolithic towns—for example, Jericho in the Jordan River Valley—also had fortified stone circuit walls.
- In art, the Neolithic period brought the birth of large-scale sculpture, notably the painted plaster figurines from Ain Ghazal and the restored life-size skulls from Jericho.
- In painting, coherent narratives became common, and artists began to represent human figures as composites of frontal and profile views—another formula that would remain universal for a very long time.
- Neolithic technology spread gradually from Anatolia and Mesopotamia to Europe, where it continued longer in remote places—for example, Stonehenge in England.

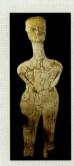

Human figure, Ain Ghazal, ca. 6750-6250 BCE

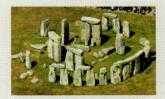

Stonehenge, Salisbury Plain, ca. 2550-1600 BCE

▼ 2-1a The Warka Vase is the first great work of narrative relief sculpture known. It represents a religious ceremony in honor of Inanna in which a priest-king brings votive offerings to deposit in the goddess's shrine.

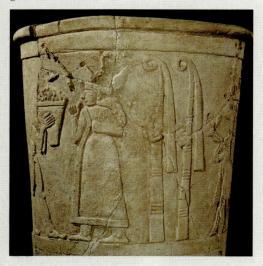

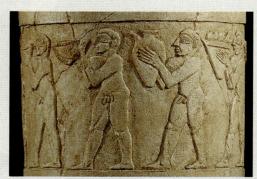

▲ 2-1b The Sumerians were probably the first to use pictures to tell coherent stories. This sculptor placed the figures in three registers. Humans are shown in composite views standing on a common ground line.

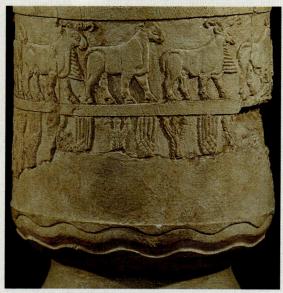

▲ 2-1c As in prehistoric art, representations of animals in Mesopotamian art are always strict profile views, save for the animals' eyes, which are seen from the front, as are also sometimes an animal's two horns.

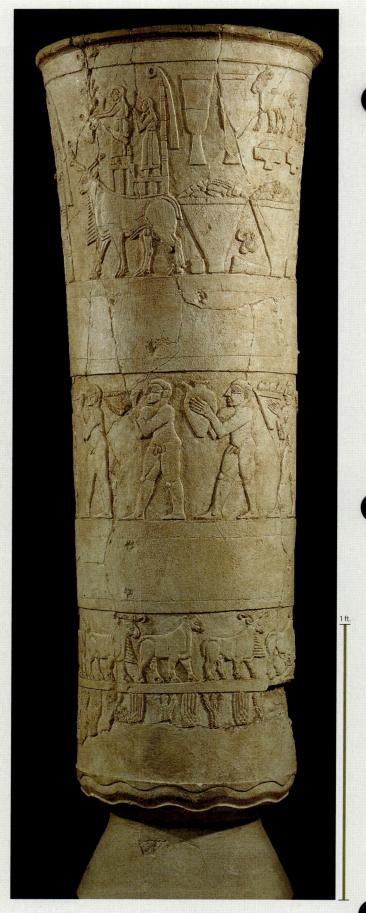

Presentation of offerings to Inanna (*Warka Vase*), from the Inanna temple complex, Uruk (modern Warka), Iraq, ca. 3200-3000 BCE. Alabaster, 3' ¹/₄" high. National Museum of Iraq, Baghdad.

Ancient Mesopotamia and Persia

PICTORIAL NARRATION IN ANCIENT SUMER

In ancient Sumer, "the cradle of civilization" in Mesopotamia, humans first learned how to use the wheel and plow and how to control floods and construct irrigation canals. In the fourth millennium BCE, the Sumerians also invented writing and were the first to establish complex urban societies, called *city-states*, and to use pictures to tell coherent stories, far surpassing Stone Age artists' tentative efforts at pictorial narration.

The Warka Vase (FIG. 2-1), found within the Inanna temple complex at Uruk (modern Warka), is the first great work of narrative relief sculpture known. Its depiction of a religious ceremony honoring Inanna already incorporates all of the pictorial conventions that would dominate narrative art for the next 2,000 years. The artist divided the pictorial field into three bands (called *registers*, or *friezes*) and placed all the figures on a common *ground line*, a compositional format that marks a significant break with the haphazard figure placement of Stone Age art. The lowest band shows crops above a wavy line representing water. Then comes a register with alternating ewes and rams. Agriculture and animal husbandry were the staples of the Sumerian economy, but the produce and the female and male animals are also fertility symbols. They underscore that Inanna had blessed Uruk's inhabitants with good crops and increased herds.

A procession of naked men moving in the opposite direction of the animals fills the band at the center of the vase. The men carry baskets and jars overflowing with the earth's abundance. They will present their bounty to the goddess as a *votive offering* (gift of gratitude to a deity usually made in fulfillment of a vow). In the uppermost (and tallest) band of the *Warka Vase* is a female figure with a tall horned headdress next to two reed posts with streamers, the sign of the goddess Inanna. (Some scholars think that the woman is a priestess and not the goddess herself.) Facing her is a nude male figure bringing a large vessel brimming with offerings to be deposited in the goddess's shrine, and behind her (not visible in Fig. 2-1), a man wearing a tasseled skirt and an attendant carrying his long train. Near the man is the *pictograph* for the Sumerian official that scholars ambiguously refer to as a "priest-king"—that is, both a religious and secular leader. Some art historians interpret the scene as a symbolic marriage between the priest-king and the goddess, ensuring her continued goodwill—and reaffirming the leader's exalted position in society. The greater height of the priest-king and Inanna (or her priestess) compared with the offering bearers indicates their greater importance, a convention called *hierarchy of scale*, which the Sumerians also pioneered.

MESOPOTAMIA

When humans first gave up the dangerous and uncertain life of the hunter and gatherer for the more predictable and stable life of the farmer and herder, the change in human society was so significant that historians justly have dubbed it the Neolithic Revolution (see page 23). This fundamental change in the nature of daily life first occurred in Mesopotamia—the Greek name for "the land between the [Tigris and Euphrates] rivers." The foothills surrounding the Mesopotamian valley form a huge arc from the mountainous border between Turkey and Syria through Iraq to Iran's Zagros Mountains (MAP 2-1). Often called the Fertile Crescent, Mesopotamia is the presumed locale of the biblical Garden of Eden (Gen. 2.10-15) and the region that gave birth to three of the world's great modern faiths— Judaism, Christianity, and Islam. This land "between the rivers" has, consequently, long been of interest to historians. Not until the 19th century, however, did systematic excavation open the public's eyes to the extraordinary art and architecture of ancient Mesopotamia.

After the first discoveries in Syria and Iraq, the great museums of Europe and North America began to avidly collect Mesopotamian art. The most popular 19th-century acquisitions were the stone reliefs depicting warfare and hunting (FIGS. 2-22 and 2-23) and the colossal statues of monstrous man-headed winged bulls (FIG. 2-20) from the palaces of the Assyrians, rulers of a northern Mesopotamian empire during the ninth to the seventh centuries BCE. But nothing extracted from the earth during the 19th century garnered as much attention as the treasure of gold objects, jewelry, artworks, and musical instruments (FIGS. 2-7 to 2-11) that British archaeologist Sir Leonard Woolley (1880-1960) discovered in the 1920s at the Royal Cemetery at Ur in southern Iraq. The interest in the lavish third-millennium Sumerian cemetery he excavated rivaled the fascination with the 1922 discovery of the tomb of the Egyptian boy-king Tutankhamen (FIGS. 3-34 to 3-36).

Sumer

The discovery of the treasures of ancient Ur put the Sumerians once again in a prominent position on the world stage, from which they had been absent for more than 4,000 years. Ancient Sumer, which roughly corresponds to southern Iraq today, comprised a dozen or so independent city-states under the protection of different Mesopotamian deities (see "The Gods and Goddesses of Mesopotamia," page 34). The Sumerian rulers were the gods' representatives on earth and the stewards of their earthly treasure.

The rulers and priests directed all communal activities, including canal construction, crop collection, and food distribution.

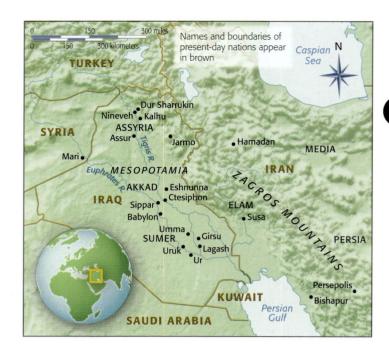

MAP 2-1 Ancient Mesopotamia and Persia.

Because the Sumerians developed agriculture to such an extent that only a portion of the population had to produce food, some members of the community were free to specialize in other activities, including manufacturing, trade, and administration. Specialization of labor is the hallmark of the first complex urban societies. In the city-states of ancient Sumer, activities that once had been individually initiated became institutionalized for the first time. The city-state, whether ruled by a single person or a council chosen from among the leading families, assumed functions such as defense against enemies and the whims of nature, roles previously the responsibility of individuals and their extended families. The city-state was one of the great Sumerian inventions.

Another was writing. The oldest written documents known are Sumerian records of administrative acts and commercial transactions. At first, around 3400 to 3200 BCE, the Sumerians made inventories of cattle, food, and other items by drawing pictographs (simplified pictures standing for words), often in boxes, in soft clay with a sharp tool, or stylus. The clay hardened into breakable, yet nearly indestructible, tablets. Thousands of these tablets, dating back nearly five millennia, exist today. By 3000 to 2900 BCE, the Sumerians had further simplified the pictographic signs by reducing

ANCIENT MESOPOTAMIA AND PERSIA

3500-2332 BCE

Sumerian

- Sumerians found the world's first city-states and invent writing
- Sumerian builders construct the oldest Mesopotamian temples on lofty
- Sumerian artists present narratives in register format

2332-2150 BCE

Akkadian

- The Akkadians become the first Mesopotamian rulers to call themselves kings and have themselves depicted in art with divine attributes
- Akkadian sculptors create the earliest preserved hollow-cast statues

2150-1600 BCE

Neo-Sumerian and Babylonian

- Neo-Sumerian builders erect the largest extant ziggurat at Ur
- Gudea of Lagash rebuilds temples and commissions portraits
- Babylonian King Hammurabi sets up a stele recording his laws

1600-612 BCE

Hittite and Assyrian

- Hittites sack Babylon and fortify their capital at Hattusa
- Assyrians rule a vast empire from citadels guarded by lamassu
- Extensive relief cycles celebrate Assyrian military campaigns

604-559 BCE

Neo-Babylonian and Achaeminid

- Nebuchadnezzar II rebuilds Babylon, home of the gigantic ziggurat called the Tower of Babel in the Bible
- Persians build an immense palace complex at Persepolis

330 все-636 се

Greco-Roman and Sasanian

- After conquest by Alexander the Great, Mesopotamia and Persia are absorbed into the Greco-Roman world
- New Persian Empire challenges Rome from Ctesiphon

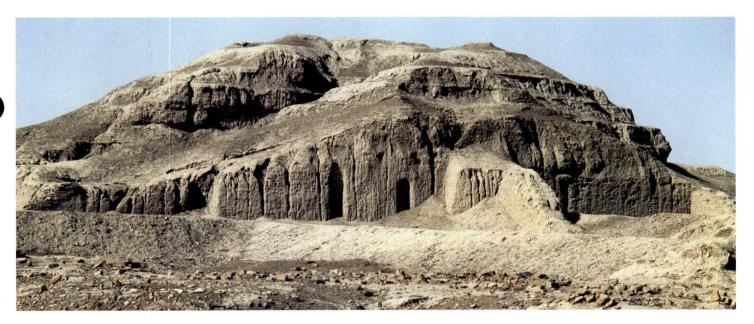

2-2 White Temple, Uruk (modern Warka), Iraq, ca. 3200-3000 BCE.

Using only mud bricks, the Sumerians erected towering temple platforms several centuries before the Egyptians built stone pyramids. This temple was probably dedicated to Anu, the sky god.

them to a group of wedge-shaped (*cuneiform*) signs read from top to bottom and right to left (FIGS. 2-6 and 2-11 are early examples; see also FIGS. 2-13, 2-16, 2-17, and 2-18). The development of cuneiform marked the beginning of writing, as historians strictly define it. The surviving cuneiform tablets testify to the far-flung network of Sumerian contacts reaching from southern Mesopotamia eastward to the Iranian plateau, northward to Assyria, and westward to Syria. Trade was essential to the Sumerians, because despite Sumer's fertile soil, the land was poor in such vital natural resources as metal, stone, and wood.

The Sumerians also produced great literature. Their most famous work, known from fragmentary cuneiform texts, is the late-third-millennium BCE *Epic of Gilgamesh*, which antedates the Greek poet Homer's *Iliad* and *Odyssey* by some 1,500 years. It recounts the heroic story of Gilgamesh, legendary king of Uruk (FIGS. 2-1 to 2-4) and slayer of the monster Huwawa. Translations of the Sumerian epic into several other ancient languages attest to the fame of the original version.

WHITE TEMPLE, URUK The layout of Sumerian cities reflected the central role of the gods in daily life. The main temple to each state's chief god formed the city's monumental nucleus. In fact, the temple complex was a kind of city within a city, where a staff of priests and scribes carried on official administrative and commercial business as well as oversaw all religious functions.

The outstanding preserved example of early Sumerian temple architecture is the 5,000-year-old White Temple (FIGS. 2-2 and 2-3) at Uruk, a city that in the late fourth millennium BCE had a population of about 40,000. Usually only the foundations of early Mesopotamian temples remain. The White Temple is a rare exception. Sumerian builders did not have access to stone quarries and instead formed mud bricks for the superstructures of their temples and other buildings. Mud brick is a durable building material, but unlike stone, it deteriorates with exposure to water. Almost all the Sumerian mud-brick structures have eroded over the course

2-3 Restored view of the White Temple, Uruk (modern Warka), Iraq, ca. 3200–3000 BCE.

The 5,000-year-old White Temple at Uruk is the outstanding example of early Sumerian religious architecture. In its central hall (cella), the Sumerian priests would await the apparition of the deity.

of time. The Sumerians nonetheless erected towering works, such as the Uruk temple, several centuries before the Egyptians built their famous stone pyramids. The construction of monumental shrines when stone was unavailable says a great deal about the Sumerians' desire to provide grandiose settings for the worship of their deities.

Enough of the White Temple at Uruk remains to permit a fairly reliable reconstruction (FIG. 2-3). The temple (whose whitewashed walls suggested its modern nickname) stands atop a high platform 40 feet above street level in the city center. A stairway on one side leads to the top but does not end in front of any of the temple doorways, necessitating two or three angular changes in direction. This bent-axis plan is the standard arrangement for Sumerian temples, a striking contrast to the linear approach the Egyptians preferred for their temples and tombs (compare FIGS. 3-10 and 3-20).

As in other Sumerian temples, the corners of the White Temple are oriented to the cardinal points of the compass. The building, probably dedicated to Anu, the sky god, is of modest proportions (61 by 16 feet). By design, Sumerian temples did not accommodate large throngs of worshipers but only a select few, the priests and perhaps the leading community members. The White Temple had several chambers. The central hall, or *cella*, was the divinity's room and housed a stepped altar. The Sumerians referred to their temples as "waiting rooms," a reflection of their belief that the deity would descend from the heavens to appear before the priests in the

RELIGION AND MYTHOLOGY

The Gods and Goddesses of Mesopotamia

The Sumerians and their successors in Mesopotamia worshiped numerous deities, mostly nature gods. Listed here are the Mesopotamian gods and goddesses discussed in this chapter.

- **Anu,** the god of the sky and of the city of Uruk, was the chief deity of the Sumerians. One of the earliest Mesopotamian shrines, the White Temple at Uruk (FIGS. 2-2 and 2-3), may have been dedicated to his worship.
- **Enlil** was Anu's son and lord of the winds and the earth. He eventually replaced his father as king of the gods.
- Inanna was the Sumerian goddess of love and war. Later known as Ishtar, she was the most important female deity in all periods of Mesopotamian history. As early as the fourth millennium BCE, the Sumerians constructed a sanctuary to Inanna at Uruk. Amid the ruins, excavators uncovered sculptures (FIGS. 2-1 and 2-4) connected with her worship.
- Nanna, also known as Sin, was the moon god and chief deity of Ur, where the Sumerians erected his most important shrine (Fig. 2-14).
- Utu, the sun god, later known as Shamash, was especially revered at Sippar. On a Babylonian stele (Fig. 2-18) of ca. 1780 BCE, King Hammurabi presents his laws to Shamash, whom the sculptor depicted as a bearded god wearing a horned headdress. Flames radiate from the sun god's shoulders.
- Ningirsu was the local god of Lagash and Girsu. He helped Eannatum, one of the early rulers of Lagash, defeat an enemy army. The Stele of the Vultures (FIG. 2-6) of ca. 2600-2500 BCE records Ningirsu's role in the victory. Gudea (FIGS. 2-16 and 2-17), one of Eannatum's Neo-Sumerian successors, built a great temple around 2100 BCE in honor of Ningirsu after the god instructed him to do so in a dream.
- Marduk was the chief god of the Babylonians.
- Nabu, Marduk's son, was the Babylonian god of writing and wisdom.
- Adad was the Babylonian god of storms. Adad's sacred bull and Marduk and Nabu's dragon adorn the sixth-century BCE Ishtar Gate (FIG. 2-24) at Babylon.

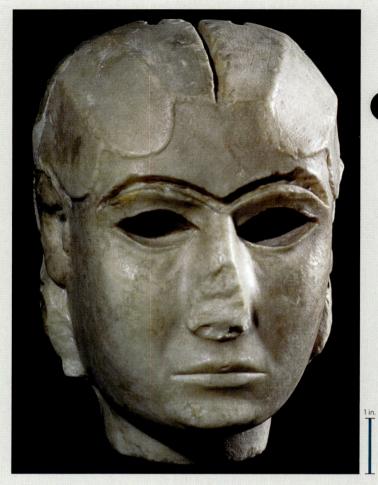

2-4 Female head (Inanna?), from the Inanna temple complex, Uruk (modern Warka), Iraq, ca. 3200–3000 BCE. Marble, 8" high. National Museum of Iraq, Baghdad.

The Sumerians imported the marble for this head at great cost. It may represent the goddess Inanna and originally had inlaid colored shell or stone eyes and brows, and a wig, probably of gold leaf.

Ashur was the local deity of Assur, the city that took his name. Sometimes identified with Enlil, he became the king of the Assyrian gods.

cella. It is unclear whether the Uruk temple had a roof, and if it did, what kind.

The Sumerian notion of the gods' residing above the world of humans is central to most of the world's religions. Moses ascended Mount Sinai to receive the Ten Commandments from the Hebrew God, and the Greeks placed the home of their gods and goddesses on Mount Olympus. The elevated placement of Mesopotamian temples on giant platforms reaching to the sky is consistent with this widespread religious concept. The loftiness of the Sumerian temple platforms made a profound impression on the peoples of ancient Mesopotamia. The tallest, at Babylon, was about 270 feet high. Known to the Hebrews as the Tower of Babel, it became the centerpiece of a biblical story about the arrogant and disrespectful pride of humans (see "Babylon, City of Wonders," page 49).

INANNA A fragmentary white marble female head (FIG. 2-4) from Uruk is also an extraordinary achievement at so early a date. The head, one of the treasures of the National Museum of Iraq in Baghdad, disappeared during the Iraq War of 2003, but was later recovered, along with other priceless items (FIGs. 2-1 and 2-12). The Sumerians lacked a ready source of fine stones suitable for carving sculptures, and consequently used stone sparingly. The glossy hard stone selected for this head had to be brought to Uruk at great cost. In fact, the "head" is really only a face with a flat back. It has drilled holes for attachment to the rest of the head and the body, which may have been of much less costly wood. Although found in the sacred precinct of the goddess Inanna, the subject is unknown. Many have suggested that the face is an image of Inanna, although others think it portrays a mortal woman, perhaps a priestess.

PROBLEMS AND SOLUTIONS

Sumerian Votive Statuary

The Sumerians, innovators in so many areas, were also the first to adopt the practice of placing in their shrines votive offerings representing the donors of the gods' gifts. Because there was no established tradition for depicting donors, the Sumerians had to invent a new pictorial formula. The votive statuettes from Eshnunna (FIG. 2-5) are among the earliest examples. Carved of soft gypsum and inlaid with shell and black limestone, the statuettes range in size from well under a foot to about 30 inches tall. The two largest figures from the group are shown here. All of the statuettes represent mortals, rather than deities. They hold the small beakers that the Sumerians used for libations (ritual pouring of liquid) in honor of the gods. (Archaeologists found hundreds of these goblets in the temple complex at Eshnunna.) The men wear belts and fringed skirts. Most have beards and shoulder-length hair. The women wear long robes, with the right shoulder bare.

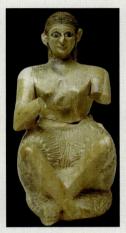

2-5A Urnanshe, from Mari, ca. 2600-2500 BCE.

Similar figurines have been unearthed at other sites. Some stand, as do the Eshnunna statuettes. Others are seated-for example, the figurine portraying Urnanshe (FIG. 2-5A) from the Ishtar temple at Mari in Syria. Many bear inscriptions giving valuable information, such as the name of the donor or the god. The texts inscribed on some statuettes are specific prayers to the deity on the owner's behalf. With their heads tilted upward, the figures represented in these statuettes wait in the Sumerian "waiting room" for the divinity to appear.

The Sumerian sculptors employed simple forms, primarily cones and cylinders, for the figures. The statuettes, even those bearing the names of individuals (for example, Urnanshe), are not portraits in the strict

sense of the word, but the sculptors did distinguish physical types. At Eshnunna, the sculptors portrayed at least one child, because next to the woman in FIG. 2-5 are the remains of two small legs. Most striking is the disproportionate relationship between the inlaid oversized eyes and the tiny hands, which represents a conscious decision on the part of the sculptors to vary the size of the parts of the body—a kind of hierarchy of scale within a single figure complementing the hierarchy of scale among figures in a group. Scholars have explained the exaggeration of the eye size in various ways. Because the purpose of these

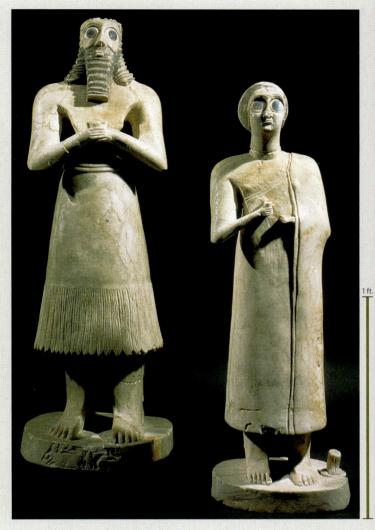

2-5 Statuettes of two worshipers, from the Square Temple at Eshnunna (modern Tell Asmar), Iraq, ca. 2700 BCE. Gypsum, shell, and black limestone, man 2' 4\frac{1}{4}" high, woman 1' 11\frac{1}{4}" high. National Museum of Iraq, Baghdad.

The oversized eyes probably symbolize the perpetual wakefulness of these substitute worshipers offering prayers to the deity. The beakers that the figures hold were used to pour libations for the gods.

votive figures was to offer constant prayers to the gods on their donors' behalf, the open-eyed stares most likely symbolize the eternal wakefulness necessary to fulfill their duty.

Often the present condition of an artwork can be very misleading, and this female head from Uruk is a dramatic example. Its original appearance would have been much more vibrant than the pure white fragment preserved today. Colored shell or stone filled the deep recesses for the eyebrows and the large eyes. The deep groove at the top of the head anchored a wig, probably made of gold leaf. The hair strands engraved in the metal fell in waves over the forehead and sides of the face. The bright coloration of the eyes, brows, and hair likely overshadowed the soft modeling of the cheeks and mouth. The missing body was probably clothed in expensive fabrics and bedecked with jewels.

ESHNUNNA STATUETTES The Warka Vase (FIG. 2-1), also from the Inanna sanctuary of Uruk, provides some insight into the rituals in honor of the goddess. Further clues about Sumerian religious beliefs and votive practices come from a group of sculptures (FIG. 2-5) reverently buried beneath the floor of a temple at Eshnunna (modern Tell Asmar) during remodeling of the structure (see "Sumerian Votive Statuary," above).

STELE OF THE VULTURES The city-states of ancient Sumer were often at war with one another, and warfare is the theme of the so-called Stele 2-6 Battle scenes, fragment of the victory stele of Eannatum (*Stele of the Vultures*), from Girsu (modern Telloh), Iraq, ca. 2600–2500 BCE. Limestone, fragment 2' 6" high; full stele 5' 11" high. Musée du Louvre, Paris.

Cuneiform inscriptions on this stele describe Eannatum's victory over Umma with the aid of the god Ningirsu. This fragment shows Eannatum leading his troops into battle on foot and in a chariot.

of the Vultures (FIG. 2-6) from Girsu. A stele is a carved stone slab erected to commemorate a historical event or, in some cultures, to mark a grave. The Girsu stele presents a labeled historical narrative, with cuneiform inscriptions filling almost every blank space. (It is not, however, the first historical representation in the history of art. That honor belongs—at the moment—to an Egyptian relief [FIGS. 3-2 and 3-3] carved more than three centuries earlier.) The inscriptions inform the viewer that the Stele of the Vultures celebrates the victory of Eannatum, the ensi (ruler; king?) of Lagash, over the neighboring city-state of Umma. The stele has reliefs on both sides and takes its modern name from a fragment depicting a gruesome scene of vultures carrying off the severed heads and arms of the defeated enemy soldiers. Another fragment shows the giant figure of the local god Ningirsu holding tiny enemies in a net and beating one of them on the head with a mace.

The fragment in Fig. 2-6 depicts Eannatum leading an infantry battalion into battle (*above*) and attacking from a war chariot (*below*). The foot soldiers protect themselves by forming a wall of shields—there are far more hands and spears than heads and feet—and trample naked enemies as they advance. (The fragment representing vultures devouring corpses belongs just to the right in the same register.) Both on foot and in a chariot, Eannatum is larger than everyone else, save for Ningirsu on the other side of the stele. The artist presented the ensi as the fearless general who paves the way for his army. Many Girsu attackers nonetheless lost their lives, and the inscription reports that Eannatum himself sustained wounds in the campaign, although the sculptor always portrayed the ensi as unharmed. In art, the outcome was never in doubt, because Ningirsu fought with the men of Lagash.

Eannatum and his men, like the Neolithic deer hunters (FIG. 1-15) at Çatal Höyük and the figures on the Warka Vase (FIG. 2-1), are a composite of frontal and profile views, with large staring frontal eyes in profile heads. The artist depicted those body parts necessary to communicate the human form and avoided positions, attitudes, or views that would conceal the characterizing parts. For example, if the figures were in strict profile, an arm and perhaps a leg would be hidden. The body would appear to have only half its breadth. And the eye would not "read" as an eye at all, because it would not have its distinctive oval shape. Art historians call this characteristic early approach to representation conceptual representation (as opposed to optical representation—the portrayal of people and objects seen from a fixed point) because the artists who painted and carved figures in this manner did not seek to record the immediate, fleeting aspects of the human body. Instead, they rendered the human form's distinguishing and fixed properties. The fundamental shapes of the head, arms, torso, and legs, not their accidental appearance, dictated the artists' selection of the composite view as the best way to represent the human body.

Despite its fragmentary state, the *Stele of the Vultures* is an extraordinary find, not only as a very early effort to record historical

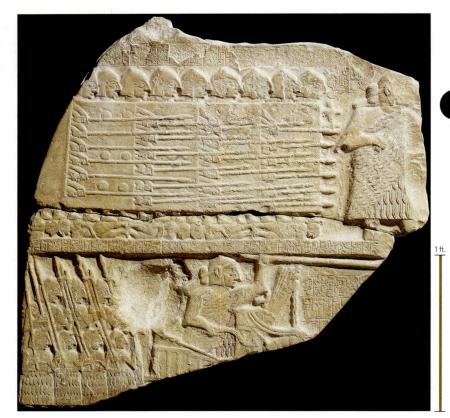

events in relief but also for the insight it yields about Sumerian society. Through both words and pictures, it provides information about warfare and the special nature of the Sumerian ruler. Eannatum was greater in stature than other men, and Ningirsu watched over him. According to the text, the ensi was born from the god Enlil's semen, which Ningirsu implanted in his mother's womb. When Eannatum incurred injuries in battle, the god shed tears for him. The inscription also says that it was Ningirsu who chose Eannatum to rule Lagash and preside over all aspects of the city-state, both in war and in peace. This also seems to have been the role of the ensi in the other Sumerian city-states.

STANDARD OF UR Agriculture and trade brought considerable wealth to some of the city-states of ancient Sumer. Nowhere is this more evident than in the burial ground the excavators dubbed the Royal Cemetery at Ur, the city that was home to the biblical Abraham. In the third millennium BCE, the leading families of Ur placed their dead in vaulted chambers beneath the earth. Scholars still debate whether the deceased individuals were true kings and queens or merely aristocrats and priests, but they were laid to rest in regal fashion. The archaeologists who explored the Ur cemetery uncovered gold helmets and daggers with handles of lapis lazuli (a rich azureblue stone imported from Afghanistan), golden beakers and bowls, jewelry of gold and lapis, musical instruments, chariots, and other luxurious items. The excavators also found dozens of bodies in the richest tombs—a retinue of musicians, servants, charioteers, and soldiers ritually sacrificed in order to accompany the "kings and queens" into the afterlife. (Comparable rituals are documented in other societies—for example, in ancient America; see page 514).

Not the costliest object found in the "royal" graves, but probably the most significant from the viewpoint of the history of art, is the *Standard of Ur* (FIGS. 2-7 and 2-8). This wooden box inlaid with shell, lapis lazuli, and red limestone has broad rectangular faces and narrow trapezoidal ends. Woolley (see page 32) thought the object was

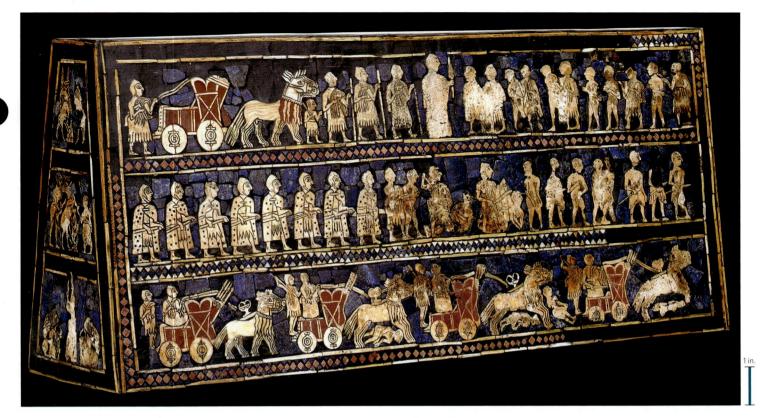

originally mounted on a pole, and he considered it a kind of military standard—hence its nickname. The "standard" may have been the sound box of a musical instrument.

Art historians usually refer to the two long sides of the box as the "war side" and "peace side," but the two sides may represent the first and second parts of a single narrative. The artist divided each side into three horizontal bands. The narrative reads from bottom to top. On the war side (FIG. 2-7), four ass-drawn four-wheeled war chariots crush enemies, whose bodies appear on the ground in front of and beneath the animals. The gait of the asses accelerates along the band from left to right. The artist depicted all the asses in strict profile, consistent with an approach to representing animals that was then some 20,000 years old (see "How to Represent an

2-7 War side of the *Standard of Ur*, from tomb 779, Royal Cemetery, Ur (modern Tell Muqayyar), Iraq, ca. 2600–2400 BCE. Wood, lapis lazuli, shell, and red limestone, 8" × 1' 7". British Museum, London.

Using a mosaic-like technique, this Sumerian artist depicted a battlefield victory in three registers. The narrative reads from bottom to top, and the size of the figures varies with their importance in society.

2-8 Peace side of the *Standard of Ur*, from tomb 779, Royal Cemetery, Ur (modern Tell Muqayyar), Iraq, ca. 2600–2400 BCE. Wood, lapis lazuli, shell, and red limestone, $8" \times 1"$ 7". British Museum, London.

The entertainers at this banquet of Sumerian nobility include a musician playing a bull-headed harp of a type found in royal graves at Ur (FIG. 2-9). The long-haired, bare-chested singer is a court eunuch.

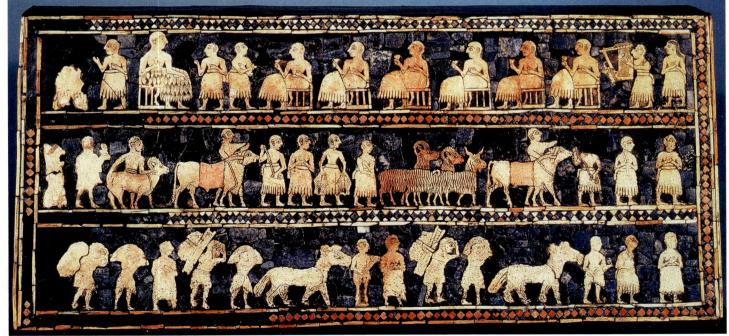

1 i

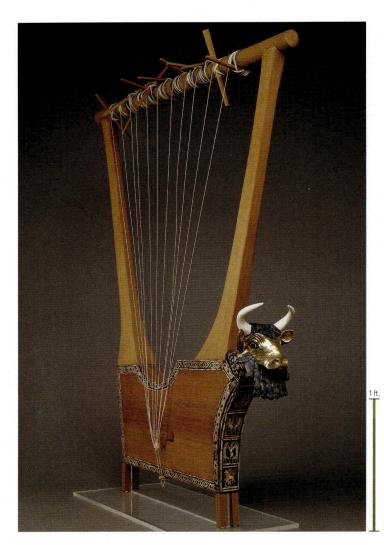

2-9 Bull-headed harp with inlaid sound box, from the tomb of Pu-abi (tomb 800), Royal Cemetery, Ur (modern Tell Muqayyar), Iraq, ca. 2600–2400 BCE. Wood, gold, lapis lazuli, red limestone, and shell, 3' $8\frac{1}{8}$ " high. British Museum, London.

A bearded bull's head fashioned of gold leaf and lapis lazuli over a wood core adorns this harp from the tomb of Pu-abi, perhaps the queen of Ur. The inlaid sound box features four narrative scenes.

Animal," page 17). Above, foot soldiers (shown in composite view with frontal eyes in their profile heads) gather up and lead away captured foes. In the uppermost register, soldiers bring bound captives (whom the victors have stripped naked to degrade them) to a kinglike figure, who has stepped out of his chariot. His central place in the composition and his greater stature (his head breaks through the border at the top) set him apart from all the other figures.

In the lowest band on the peace side (FIG. 2-8), men carry provisions, possibly war booty, on their backs. Above, attendants transport animals, perhaps also spoils of war, and fish for the great banquet depicted in the uppermost register. There, seated dignitaries and a larger-than-life personage (third from the left; probably a king, whose head interrupts the upper border) attend a feast. A harp player and singer entertain the group. Some art historians have interpreted the scene as a celebration after the victory in warfare represented on the other side of the box. But the two sides may be independent narratives illustrating the two principal roles of a Sumerian ruler—the mighty warrior who defeats enemies of his city-state (compare FIG. 2-6), and the chief administrator who, with the blessing of the gods, assures

the bountifulness of the land in peacetime (compare FIG. 2-1). The absence of an inscription prevents connecting the scenes with a specific event or person, but the *Standard of Ur* undoubtedly is another early example of historical narrative, even if only of a generic kind.

BULL-HEADED HARPS As noted, the peace side of the Standard of Ur portrays a banquet at which a musician plays a harp and a longhaired eunuch (castrated male) sings (FIG. 2-8, top right; compare FIG. 2-5A). From the tomb of "Queen" Pu-abi comes a fragmentary harp that, as reconstructed (FIG. 2-9), resembles the instrument depicted on the Standard of Ur. (Many historians prefer to designate her more conservatively and ambiguously as Lady Pu-abi, perhaps a high priestess of the moon god Nanna.) A magnificent bull's head fashioned of gold leaf over a wood core caps the sound box of Puabi's harp. The hair and beard of the bull are of lapis lazuli, as is the inlaid background of the sound box, which features figures of shell and red limestone. The excavators unearthed a similar harp in the adjacent burial, which they dubbed the King's Grave. That harp also has a costly inlaid sound box (FIG. 2-10). In the uppermost of the four panels is a heroic figure embracing two man-bulls in a heraldic composition (symmetrical on either side of a central figure). The hero's body and that of the scorpion-man in the lowest panel are in composite view. The animals are, equally characteristically, solely in profile: the dog wearing a dagger and carrying a laden table, the lion bringing in the beverage service, the ass playing the harp, the jackal playing the zither, the bear steadying the harp (or perhaps dancing), and the gazelle bearing goblets. The meaning of the sound box scenes is unclear. Some scholars have suggested, for example, that the

2-10 Sound box of the bull-headed harp from tomb 789 (King's Grave), Royal Cemetery, Ur (modern Tell Muqayyar), Iraq, ca. 2600–2400 BCE. Wood, lapis lazuli, and shell, 1' 7" high. University of Pennsylvania Museum of Archaeology and Anthropology, Philadelphia.

The four inlaid panels on the sound box of the harp found in the King's Grave at Ur represent a Gilgamesh-like hero between man-bulls, and animals acting out scenes of uncertain significance.

MATERIALS AND TECHNIQUES

Mesopotamian Seals

Archaeologists (and farmers and treasure hunters) have unearthed seals in great numbers at sites throughout Mesopotamia. Generally made of stone, Mesopotamian seals of ivory, glass, and other materials also survive. The seals take two forms: flat *stamp seals* and *cylinder seals*. The latter have a hole drilled lengthwise through the center of the cylinder so that they could be strung and worn around the neck or suspended from the wrist. Cylinder seals (FIG. 2-11) were prized possessions, signifying high positions in society. When elite individuals died, their families frequently buried them with their seals to carry into the afterlife.

The primary function of cylinder seals, however, like the earlier stamp seals, was not to serve as items of adornment or signifiers of wealth and prestige. The Sumerians (and other ancient Mesopotamian peoples) used both stamp and cylinder seals to authenticate their documents and protect storage jars and doors against tampering. The oldest seals predate the invention of writing and conveyed their messages with pictographs that certified ownership. Later seals often bore long cuneiform inscriptions and recorded the names and titles of rulers, bureaucrats, and deities. Although sealing is increasingly rare today, the tradition lives on whenever someone seals an envelope with a lump of wax and then stamps it with a monogram or other identifying

mark. Customs officials often still seal packages and sacks with official stamps when goods cross national borders.

In Mesopotamia, artists incised designs in both stamp and cylinder seals, producing a raised pattern when the owner pressed the seal into soft clay. (Cylinder seals largely displaced stamp seals because they could be rolled over the clay and could thus cover a greater area more quickly.) Illustrated here are a cylinder seal from the Royal Cemetery at Ur with the name of Pu-abi (the owner of the harp in Fig. 2-9) and a modern impression made from it. Note how cracks in the stone cylinder become raised lines in the impression and how the engraved figures, chairs, and cuneiform characters appear in relief. Continuous rolling of the seal over a clay strip results in a repeating design, as the illustration demonstrates at the edges.

The miniature reliefs the seals produce are a priceless source of information about Mesopotamian religion and society. Without them, archaeologists would know much less about how Mesopotamians dressed and dined; what their shrines looked like; how they depicted their gods, rulers, and mythological figures; how they fought wars; and what role women played in society. Clay seal impressions excavated in architectural contexts shed a welcome light on the administration and organization of Mesopotamian city-states. Finally, Mesopotamian seals are an invaluable resource for art historians, providing them with thousands of miniature examples of relief sculpture spanning three millennia.

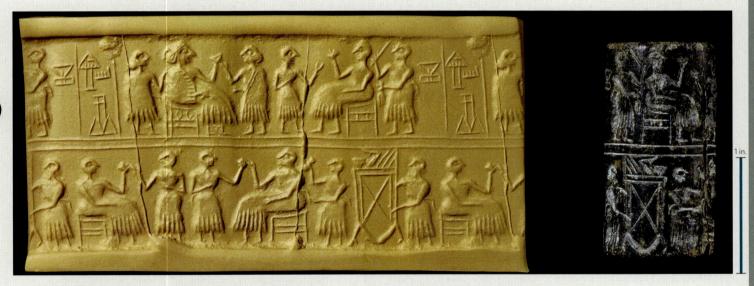

2-11 Banquet scene, modern impression (*left*) and cylinder seal (*right*), from the tomb of Pu-abi (tomb 800), Royal Cemetery, Ur (modern Tell Muqayyar), Iraq, ca. 2600–2400 BCE. Lapis lazuli, $1\frac{7}{8}$ " high, 1" diameter. British Museum, London.

The Mesopotamians used seals to identify and secure goods. Artists incised designs into stone cylinders that could be rolled over clay to produce miniature artworks such as this banquet scene.

depicted creatures inhabit the land of the dead and that the narrative has a funerary significance. In any event, the sound box is a very early instance of the recurring theme in both literature and art of animals acting as people. Later examples include Aesop's fables in ancient Greece, medieval bestiaries, and, in modern times, Walt Disney's cartoon animal actors.

CYLINDER SEALS The excavators of the Ur cemetery found Pu-abi's remains on a bier in her tomb, wearing an elaborate head-

dress and jewelry of gold, silver, lapis lazuli, carnelian, and agate. Near her body were pins to fasten her garment and three *cylinder seals*, one of which (FIG. **2-11**) gives her name in cuneiform script. The seal is typical of the period, consisting of a cylindrical piece of stone engraved to produce a raised impression when rolled over clay (see "Mesopotamian Seals," above). In the upper zone, a woman, probably Pu-abi, and a man sit and drink from beakers, attended by servants. Below, male attendants serve two more seated men. Even when working in miniature and in a medium very different from

that of the *Standard of Ur* (FIG. 2-8), the Sumerian artist employed the same figure types and followed the same compositional rules to depict a banquet. All the figures are in composite views with large frontal eyes in profile heads, and the seated dignitaries are larger in scale to underscore their elevated position in the social hierarchy.

Akkad

In 2332 BCE, the loosely linked group of cities known as Sumer came under the domination of a great ruler, Sargon of Akkad (r. 2332–2279 BCE). Archaeologists have yet to locate the site of Akkad, but the city was in the vicinity of Babylon. The Akkadians were Semitic in origin—that is, they were a Mesopotamian people who spoke a language related to Hebrew and Arabic. Their language, Akkadian, was very different from the language of Sumer, but they used the Sumerians' cuneiform characters for their written documents. Under Sargon (whose name means "true king") and his followers, the Akkadians introduced a new concept of royal power based on unswerving loyalty to the king rather than to the city-state. Naram-Sin (r. 2254–2218 BCE; FIG. 2-13), Sargon's grandson, regarded the governors of his cities as mere royal servants, and called himself King of the Four Quarters—in effect, ruler of the earth, akin to a god.

AKKADIAN PORTRAITURE A magnificent copper head (Fig. 2-12) of an Akkadian king embodies this new concept of absolute monarchy. Found at Nineveh, the head is all that survives of a statue

2-12 Head of an Akkadian ruler, from Nineveh (modern Kuyunjik), Iraq, ca. 2250–2200 BCE. Copper, 1' $2\frac{3}{8}$ " high. National Museum of Iraq, Baghdad.

The sculptor of this oldest extant life-size hollow-cast head captured the distinctive features of the ruler while also displaying a keen sense of abstract pattern. Vandals damaged the head in antiquity.

knocked over in antiquity, perhaps when the Medes, a people that occupied the land south of the Caspian Sea (MAP 2-1), sacked the city in 612 BCE. But the damage to the portrait was not the result solely of the statue's toppling. There are also signs of deliberate mutilation. To make a political statement, the attackers gouged out the eyes (once inlaid with precious or semiprecious stones), broke off the lower part of the beard, and slashed the ears of the royal portrait. Later parallels for this kind of political vandalism abound—for example (in the same region), the destruction of images of Saddam Hussein after the Iraqi ruler's downfall in 2003. Even in its mutilated state, however, the Akkadian portrait conveys the king's majestic serenity, dignity, and authority. The portrait is also remarkable for the masterful way the sculptor balanced naturalism and abstract patterning. The artist carefully observed and recorded the Akkadian's distinctive features—the profile of the nose and the long, curly beard—and brilliantly communicated the differing textures of flesh and hair, even the contrasting textures of the mustache, beard, and

2-13 Victory stele of Naram-Sin, set up at Sippar, Iraq, found at Susa, Iran, 2254–2218 BCE. Pink sandstone, 6' 7" high. Musée du Louvre, Paris.

To commemorate his conquest of the Lullubi, Naram-Sin set up this stelle showing him leading his army up a mountain. The sculptor staggered the figures, abandoning the traditional register format.

ART AND SOCIETY

Enheduanna, Priestess and Poet

In the man's world of ancient Akkad, one woman stands out prominently-Enheduanna, daughter of King Sargon and priestess of the moon god Nanna at Ur. Her name appears in several inscriptions, and she was the author of a series of hymns in honor of the goddess Inanna. Enheduanna's is the oldest recorded name of a poet, male or female—indeed, the earliest known name of the author of any literary work in world history.

The most important surviving object associated with Enheduanna is the alabaster disk (FIG. 2-14) found in several fragments in the residence of the priestess of Nanna at Ur. The reverse bears a cuneiform inscription identifying Enheduanna as the "wife of Nanna" and "daughter of Sargon, king of the world." It also credits Enheduanna with erecting an altar to Nanna in his temple. The dedication of the relief to the moon god explains its unusual round format, which corresponds to the shape of the full moon. The front of the disk shows four figures approaching a four-story temple platform. The first figure is a nude man who is either a priest or Enheduanna's assistant. He pours a libation into a plant stand. The second figure, taller than the rest and wearing the headgear of a priestess, is Enheduanna herself. She raises her right hand in a gesture of greeting and respect for the god (compare FIG. 2-18). Two figures, probably female attendants, follow her.

Artworks created to honor women are rare in Mesopotamia and in the ancient world in general, but they are by no means unknown. The Sumerians, for example, buried Pu-abi of Ur in her own tomb filled with a treasure of jewelry, metal vessels, musical instruments (FIG. 2-9), and cylinder seals (FIG. 2-11), accompanied by 10 female retainers to attend her in the afterlife. The works created in honor of Pu-abi and Enheduanna are among the oldest known, but they pale in comparison with

2-14 Votive disk of Enheduanna, from Ur (modern Tell Muqayyar), Iraq, ca. 2300-2275 BCE. Alabaster, diameter 10". University of Pennsylvania Museum of Archaeology and Anthropology, Philadelphia.

Enheduanna, daughter of Sargon of Akkad and priestess of Nanna at Ur, is the first author whose name is known. She is the tallest figure on this votive disk, which she dedicated to the moon god.

the monuments erected in the mid-second millennium BCE in honor of Queen Hatshepsut of Egypt (see "Hatshepsut, the Woman Who Would Be King," page 69).

braided hair on the top of the head. The coiffure's triangles, lozenges, and overlapping disks of hair and the great arching eyebrows that give such character to the portrait reveal that the sculptor was also sensitive to formal pattern.

No less remarkable is the fact that this is a life-size, hollow-cast sculpture (see "Hollow-Casting Life-Size Bronze Statues," page 127), one of the earliest known. The head demonstrates the foundry worker's sophisticated skill in casting and polishing copper and in engraving the details. The portrait is the oldest known large-scale work of hollow-cast sculpture.

NARAM-SIN STELE The godlike sovereignty the kings of Akkad claimed is also evident in the victory stele (FIG. 2-13) Naram-Sin set up at Sippar. The stele commemorates the Akkadian ruler's defeat of the Lullubi, a people of the Iranian mountains to the east. It carries two inscriptions, one in honor of Naram-Sin and one naming the Elamite king who captured Sippar in 1157 BCE and took the stele as booty back to Susa in southwestern Iran (MAP 2-1), the stele's findspot. The sculptor depicted Naram-Sin leading his army up the slopes of a wooded mountain. His routed enemies fall, flee, die, or beg for mercy. The king stands alone, far taller than his men, treading on the bodies of two of the fallen Lullubi. He wears the horned helmet signifying divinity—the first time a king appears as a god in Mesopotamian art. At least three favorable stars (the stele is damaged at the top) shine on his triumph.

By storming the mountain, Naram-Sin seems also to be scaling the ladder to the heavens, the same idea that lies behind the Mesopotamian temples on their elevated platforms. His troops march up the mountain behind him in orderly files, suggesting the discipline and organization of the king's forces. In contrast, his enemies are in disarray, depicted in a great variety of postures. One falls headlong down the mountainside. The Akkadian artist adhered to older conventions in many details, especially by enlarging the size of the king, portraying him and his soldiers in composite views, and placing a frontal two-horned helmet on Naram-Sin's profile head. But the sculptor showed daring innovation in creating a landscape setting for the story and placing the figures on successive levels within that landscape. Among extant Mesopotamian works, this is the first time an artist rejected the standard format of telling a story in a series of horizontal registers, the compositional formula that had been the rule for a millennium. The traditional frieze format was the choice, however, for an alabaster disk (FIG. 2-14) that is in other respects an equally unique find (see "Enheduanna, Priestess and Poet," above).

THIRD DYNASTY OF UR Around 2150 BCE, a mountain people, the Gutians, brought an end to Akkadian power. The cities of Sumer, however, soon united in response to the alien presence, drove the Gutians out of Mesopotamia, and established a Neo-Sumerian state ruled by the kings of Ur. Historians call this period the Neo-Sumerian age or the Third Dynasty of Ur.

41

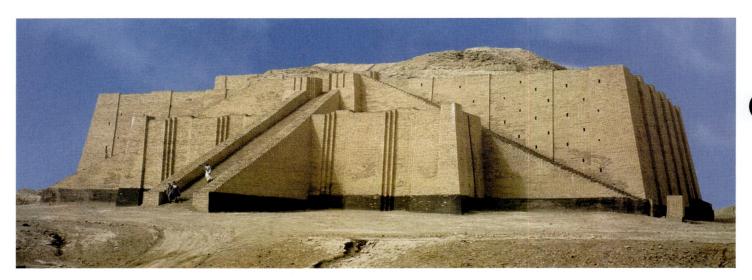

2-15 Ziggurat (looking southwest), Ur (modern Tell Muqayyar), Iraq, ca. 2100 BCE.

The Ur ziggurat is one of the largest in Mesopotamia. It has three (restored) ramplike stairways of a hundred steps each that originally ended at a gateway to a brick temple, which does not survive.

ZIGGURAT, UR The most imposing extant Neo-Sumerian monument is the 50-foot-high mud-brick *ziggurat* (FIG. **2-15**) at Ur. A millennium later than Uruk's more modest White Temple (FIGS. 2-2 and 2-3), the Ur ziggurat is the oldest preserved tiered temple platform (compare FIG. 2-14). (The platform of the White Temple is commonly, if incorrectly, called a ziggurat. It is a singlestory platform.) The Neo-Sumerian builders used baked bricks laid in bitumen, an asphaltlike substance, for the facing of the entire monument. (Today, most of the bricks are part of a modern reconstruction.) Three ramplike stairways of a hundred steps each converge on a tower-flanked gateway. From there another flight of steps (which has not been rebuilt) probably led to the temple that once crowned the ziggurat.

GUDEA OF LAGASH Of all the preserved sculptures of the Third Dynasty of Ur, the most conspicuous are those portraying Gudea, the ensi of Lagash around 2100 BCE. His statues show him seated (FIG. 2-16) or standing (FIG. 2-17), hands usually tightly clasped, head shaven, sometimes wearing a brimmed sheepskin hat, and always dressed in a long garment that leaves one shoulder and arm exposed. He has a youthful face with large, arching, herringbone-patterned eyebrows framing wide-open eyes. Almost all of his portraits are of polished diorite, a rare and costly dark stone that had to be imported from present-day Oman. Diorite is also extremely hard and difficult to carve. Underscoring the prestige of the material—which in turn lent prestige to Gudea's portraits—is an inscription on one of his statues: "This statue has not been made from silver nor from lapis lazuli, nor from copper nor from lead, nor yet from bronze; it is made of diorite." Indeed, the inscriptions on Gudea's portraits furnish a rare explicit record in the ancient world of a patron's motivations for commissioning artworks (see "Gudea of Lagash," page 43).

Babylon

The resurgence of Sumer was short-lived. The last of the kings of the Third Dynasty of Ur fell at the hands of the Elamites, who ruled the territory east of the Tigris River. In the following two centuries, the traditional Mesopotamian political pattern of several independent city-states existing side by side reemerged.

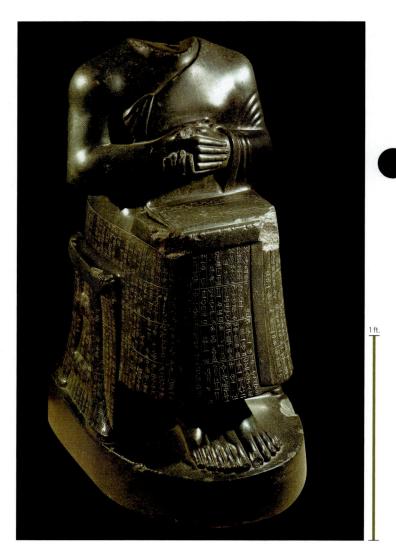

2-16 Gudea seated, holding the plan of a temple, from Girsu (modern Telloh), Iraq, ca. 2100 BCE. Diorite, 2' 5" high. Musée du Louvre, Paris.

Gudea built or rebuilt many temples and placed statues of himself in them. The inscription on this seated portrait states that Gudea has on his lap a plan of the new temple he erected to Ningirsu.

THE PATRON'S VOICE

Gudea of Lagash

A central figure of the Neo-Sumerian age was Gudea of Lagash. Nearly two dozen portraits of him survive, many with inscriptions revealing Gudea's reasons for commissioning the portraits and setting them up where he did. All of Gudea's statues stood in temples where they could render perpetual service to the gods and intercede with the divine powers on his behalf. Although a powerful ruler, Gudea rejected the regal trappings of Sargon of Akkad and his successors, as well as their pretensions of divinity, in favor of a return to the Sumerian model of the ruler as the agent of the gods in the service of his people. Gudea's portraits follow the votive tradition of the Eshnunna (FIG. 2-5) and Mari (FIG. 2-5A) statuettes. Like the earlier examples, many of his statues bear inscriptions with messages to the gods of Sumer. They constitute one of the most extensive examples of "the patron's voice" in the ancient world.

In these inscriptions, Gudea often addresses the viewer directly. One inscribed portrait statue from Girsu says, "I am the shepherd loved by my king [Ningirsu, the god of Girsu]. May my life be prolonged." Another, also from Girsu, as if in answer to the first, says, "Gudea, the builder of the temple, has been given life." Some of the inscriptions clarify why Gudea was portrayed as he was. For example, his large chest is a sign that the gods have given him fullness of life, and his muscular arms reveal his god-given strength. Other inscriptions explain that his large eyes signify that his gaze is perpetually fixed on the gods (compare FIG. 2-5).

Gudea built or rebuilt, at great cost, all the temples in which he placed his statues. One characteristic portrait (FIG. 2-16) depicts Gudea as a pious ruler seated with his hands clasped in front of him in a gesture of prayer. But the statue is unique because Gudea has a temple plan drawn on a tablet on his lap. It is the plan for a new temple dedicated to Ningirsu. Gudea buried accounts of his building enterprises in the temple foundations. The surviving texts describe how the Neo-Sumerians prepared and purified the sites, obtained the materials, and dedicated the completed temples. They also record Gudea's dreams of the gods asking him to erect temples in their honor, promising him prosperity if he fulfilled his duty. In one of these dreams, Ningirsu addresses Gudea:

When, O faithful shepherd Gudea, thou shalt have started work for me on Erinnu, my royal abode [Ningirsu's new temple], I will call up in heaven a humid wind. It shall bring the abundance from on high. . . . All the great fields will bear for thee; dykes and canals will swell for thee; . . . good weight of wool will be given in thy time.*

One of Gudea's portraits (FIG. 2-17) differs from the rest in depicting the ensi holding a jar from which water flows freely in two streams,

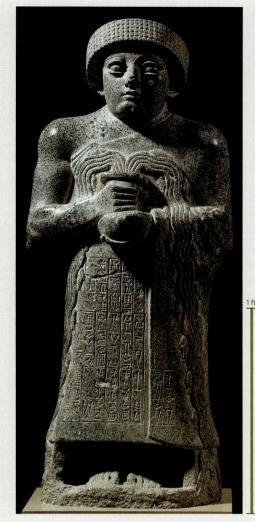

2-17 Gudea standing, holding an overflowing water jar, from the Temple of Geshtinanna, Girsu (modern Telloh), Iraq, ca. 2100 BCE. Calcite, 2' 3/8" high. Musée du Louvre, Paris.

The overflowing water jar Gudea holds symbolizes the prosperity he brings to the people of Lagash. In Mesopotamian art, normally only gods and goddesses are the sources of life-giving water.

one running down each side of his cloak. Fish swim in the coursing water. In Mesopotamian art, gods and goddesses often hold similar overflowing vessels (FIG. 2-17A), which symbolize the prosperity they bring to their people. This small statue (less than half life-size) is the only known instance in which a Mesopotamian ruler is so depicted. For that reason and because the statue is made of calcite instead of the costly imported diorite used for Gudea's other portraits (FIG. 2-16), some scholars have questioned the authenticity of this piece. But the cuneiform inscription, which states that Gudea dedicated the statue in the temple he built in honor of the goddess Geshtinanna, the divine interpreter of dreams, is genuine, and so too must be the statue.

*Translated by Thorkild Jacobsen, in Henri Frankfort, *The Art and Architecture of the Ancient Orient*, 5th ed. (New Haven, Conn.: Yale University Press, 1996), 98.

HAMMURABI One of those city-states was Mari, home of Urnanshe (FIG. 2-5A) in the third millennium, and ruled by Zimri-Lin (r. 1779–1757 BCE; FIG. 2-17A) in the 18th century BCE. Another was Babylon, until its most powerful king, Hammurabi (r. 1792–1750 BCE), reestablished a centralized gov-

2-17A Investiture of Zimri-Lim, Mari, ca. 1775–1760 BCE.

ernment in southern Mesopotamia in the area known as Babylonia, after its chief city.

Perhaps the most renowned king in Mesopotamian history, Hammurabi was famous for his conquests. But he is best known today for his laws (FIG. 2-18), which he enacted more than a thousand years before Draco provided Athens with its first comprehensive law code and when parts of Europe were still in the Stone Age. Hammurabi's laws prescribed penalties for everything from adultery and murder to the cutting down of a neighbor's trees (see "Hammurabi's Laws," page 44).

ART AND SOCIETY

Hammurabi's Laws

In the early 18th century BCE, the Babylonian king Hammurabi formulated a set of nearly 300 laws for his people. Two earlier sets of Sumerian laws survive in part, but Hammurabi's are the only laws known in great detail, thanks to the chance survival of a tall black basalt stele (FIG. 2-18) that an Elamite king carried off with the Naram-Sin stele (FIG. 2-13) as war booty to Susa in 1157 BCE. At the top is a representation in high relief of Hammurabi in the presence of Shamash, the flame-shouldered sun god. The king raises his hand in respect. The god extends to Hammurabi the rod and ring that symbolize authority. The symbols are builders' tools—measuring rods and coiled rope. They connote the ruler's capacity to build the social order and to measure people's lives—that is, to render judgments and enforce the laws spelled out on the stele. The collection of Hammurabi's judicial pronouncements is inscribed on the Susa stele in Akkadian in 3,500 lines of cuneiform characters. Hammurabi's laws governed all aspects of Babylonian life, from commerce and property to murder and theft to marital fidelity, inheritances, and the treatment of slaves.

Here is a small sample of the infractions described and the penalties imposed, which vary with the person's standing in society and notably deal with the rights and crimes of women as well as men:

- If a man puts out the eye of another man, his eye shall be put out.
- If he kills a man's slave, he shall pay one-third of a mina.
- If someone steals property from a temple, he will be put to death, as will the person who receives the stolen goods.
- If a married woman dies before bearing any sons, her dowry shall be repaid to her father, but if she gave birth to sons, the dowry shall belong to them.
- If a man strikes a freeborn woman so that she loses her unborn child, he shall pay ten shekels for her loss. If the woman dies, his daughter shall be put to death.
- If a man is guilty of incest with his daughter, he shall be exiled.

2-18 Stele with the laws of Hammurabi, set up at Babylon, Iraq, found at Susa, Iran, ca. 1780 BCE. Basalt, 7' 4" high. Musée du Louvre, Paris.

Crowning the stele recording Hammurabi's laws is a representation of the flame-shouldered sun god Shamash extending to the Babylonian king the symbols of his authority to govern and judge.

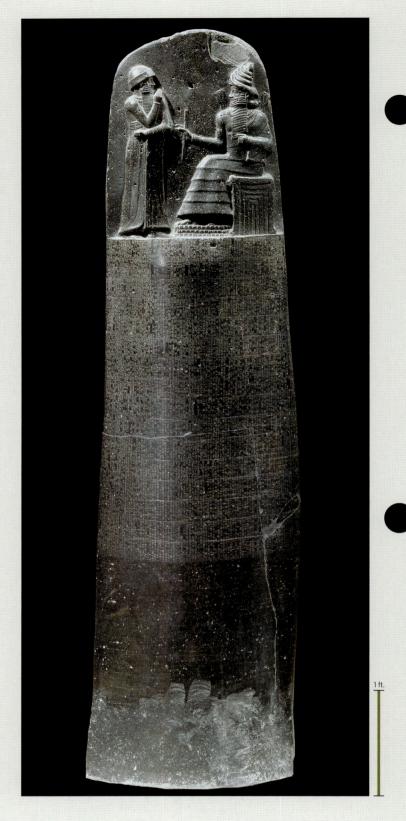

Hammurabi's stele (FIG. 2-18) is noteworthy artistically as well. At the top, the sculptor depicted the sun god Shamash in the familiar convention of combined front and side views, but with two important exceptions. Shamash's great headdress with its four pairs of horns is in true profile so that only four, not all eight, of the horns are visible. Also, the artist seems to have tentatively explored the

notion of *foreshortening*—a means of suggesting depth by representing a figure or object at an angle, instead of frontally or in profile. Shamash's beard is a series of diagonal rather than horizontal lines, suggesting its recession from the picture plane. The sculptor also depicted the god's throne at an angle, further enhancing the illusion of spatial recession.

Elam

The Babylonian Empire toppled in the face of an onslaught by the Hittites, an Anatolian people whose heavily fortified capital was

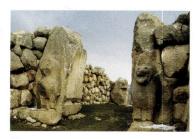

2-18A Lion Gate, Hattusa, ca. 1400 BCE.

at Hattusa (FIG. 2-18A) near modern Boghazköy, Turkey. After sacking Babylon around 1595 BCE, the Hittites abandoned Mesopotamia and returned to their homeland, leaving Babylon in the hands of the Kassites. To the east of Babylon was Elam, which appears in the Bible as early as Genesis 10:22. At the

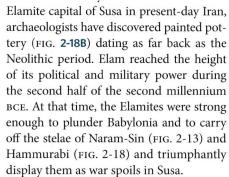

2-18B Beaker with animal decoration, Susa, ca. 4000 BCE.

NAPIR-ASU A life-size bronze-and-copper statue (FIG. 2-19) of Queen Napir-Asu, wife of one of the most powerful Elamite

kings, Untash-Napirisha (r. ca. 1345–ca. 1305 BCE) is one of the most important finds discovered in the ruins of Susa. The statue weighs 3,760 pounds even in its fragmentary and mutilated state, because the sculptor, incredibly, cast the statue with a solid bronze core inside a hollow-cast copper shell. The bronze core increased the cost of the statue enormously, but the queen wished her portrait to be a permanent, immovable votive offering in the temple where archaeologists found it. In fact, the Elamite inscription on the queen's skirt explicitly asks the gods to protect the statue:

He who would seize my statue, who would smash it, who would destroy its inscription, who would erase my name, may he be smitten by the curse of [the gods], that his name shall become extinct, that his offspring be barren. . . . This is Napir-Asu's offering. 1

Napir-Asu's portrait thus falls within the votive tradition dating back to the third-millennium BCE Eshnunna (FIG. 2-5) and Mari (FIG. 2-5A) figurines (see "Sumerian Votive Statuary," page 35). In the Elamite statue, the Mesopotamian instinct for cylindrical volume is again evident. The tight silhouette, strict frontality, and firmly crossed hands held close to the body are all enduring characteristics common to the Sumerian statuettes. Yet within these rigid conventions of form and pose, the Elamite artist incorporated features based on close observation. The sculptor conveyed the feminine softness of arm and bust, the grace and elegance of the long-fingered hands, the supple bend of the wrist, the ring and bracelets, and the gown's patterned fabric. The loss of the head is especially unfortunate. The figure presents a portrait of the ideal queen. The hands crossed over the belly may allude to fertility and the queen's role in assuring peaceful dynastic succession.

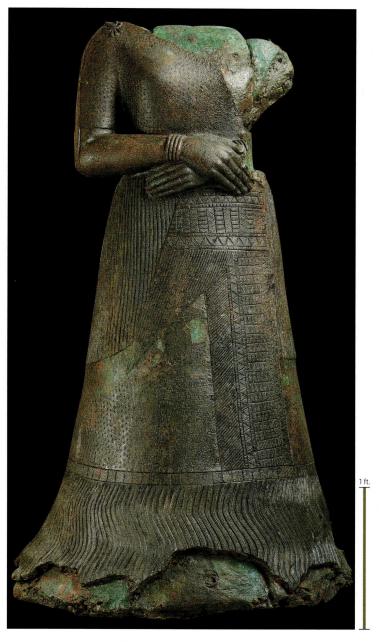

2-19 Statue of Queen Napir-Asu, from Susa, Iran, ca. 1350–1300 BCE. Bronze and copper, 4' $2\frac{3}{4}$ " high. Musée du Louvre, Paris.

This life-size bronze-and-copper statue of the wife of a powerful Elamite king weighs 3,760 pounds. The queen wanted her portrait to stand in a temple at Susa as an immovable votive offering to the deity.

Assyria

During the first half of the first millennium BCE, the fearsome Assyrians vanquished the various peoples that succeeded the Babylonians and Hittites, including the Elamites, whose capital of Susa they sacked in 641 BCE. The Assyrians took their name from Assur, the city dedicated to the god Ashur, east of the Tigris River in the Zagros Mountains of northern Iraq. At the height of their power, the Assyrians ruled an empire that extended from the Tigris River to the Nile (see page 80) and from the Persian Gulf to Asia Minor.

PALACE OF SARGON II The Assyrian kings cultivated an image of themselves as merciless to anyone who dared oppose them but

PROBLEMS AND SOLUTIONS

How Many Legs Does a Lamassu Have?

Guarding the gate to Sargon II's palace at Dur Sharrukin and many of the other Assyrian royal complexes were colossal limestone monsters (FIG. 2-20), which the Assyrians probably called *lamassu*. These winged, man-headed bulls (or lions in some instances) served to ward off the king's enemies.

The task of moving and installing these immense stone sculptures was so difficult that several reliefs in the palace of Sargon's successor, Sennacherib (r. 705–681 BCE), celebrate the feat, showing scores of men dragging lamassu figures with the aid of ropes and sledges.

Transporting these mammoth sculptures (nearly 14 feet tall in the case of the two lamassu guarding the gateway of Sargon's Dur Sharrukin palace) was not the only problem the Assyrian sculptors had to confront. The artists also had to find a satisfactory way to represent a composite beast no one had ever seen, and they had to make the monster's unfamiliar form intelligible from every angle. They came up with a solution that may seem strange to modern eyes, but one consistent with the pictorial conventions of the age and perfectly suited to the problem.

The Assyrian lamassu sculptures are partly in the round, but the sculptors nonetheless conceived them as high reliefs on adjacent sides of a corner. They combine the front view of the animal at rest with the side view of it in motion. Seeking to present a complete picture of the lamassu from both the front and the side, the sculptors of all the extant Assyrian guardian statues gave each of the monsters five legs—two seen from the front, four seen from the side.

The Assyrian lamassu sculptures, therefore, are yet another case of early artists' providing a conceptual picture of an animal or person and all its important parts, as opposed to an optical view of the composite monster as it would stand in the real, versus the pictorial, world.

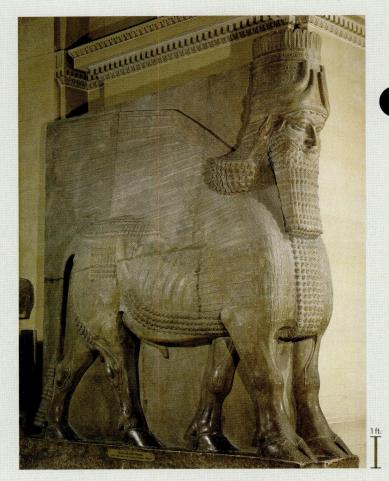

2-20 Lamassu (man-headed winged bull), from the citadel of Sargon II, Dur Sharrukin (modern Khorsabad), Iraq, ca. 721–705 BCE. Limestone, 13' 10" high. Musée du Louvre, Paris.

Ancient sculptors insisted on complete views of animals. This four-legged composite monster that guarded an Assyrian palace has five legs—two when seen from the front and four in profile view.

forgiving to those who submitted to their will. Ever mindful of possible attack, the Assyrians constructed their palaces as fortified citadels. A reconstruction on paper (FIG. **2-19A**) of the palace that Sargon II (r. 721–705 BCE) built at Dur Sharrukin gives a good idea of the original appear-

2-19A Citadel of Sargon II, Dur Sharrukin, ca. 721–705 BCE.

ance of Assyrian royal citadels, which were guarded by monstrous guardian figures (see "How Many Legs Does a Lamassu Have?" above, and FIG. **2-20**) and profusely decorated with mural paintings and relief sculptures (FIGS. 2-21 to 2-23) exalting royal power.

PALACE OF ASHURNASIRPAL II Unfortunately, few Assyrian paintings exist today. A notable exception is the panel (FIG. **2-21**) depicting King Ashurnasirpal II (r. 883–859 BCE) and his retinue

paying homage to the gods. It comes from the northwest palace at Kalhu. The painting medium is glazed brick, a much more durable format than direct painting on plastered mud-brick walls, the technique used a millennium earlier in Zimri-Lim's palace at Mari (FIG. 2-17A). The Assyrian painter first applied lines and colors to a clay panel and then baked the clay in a kiln, fusing the colors to the clay.

The Kalhu panel shows Ashurnasirpal—his name means "Ashur guards the heir"—delicately holding a cup. With it, he will make a libation in honor of the protective Assyrian gods. The artist represented the king as taller than everyone else, befitting his rank, and rendered the figures in outline, lavishing much attention on the patterns of the rich fabrics they wear. The king and the attendant behind him are in consistent profile view, but the painter adhered to the convention of showing the eye from the front in a profile head. Painted scenes such as this hint at the original appearance (before the color disappeared) of the stone reliefs (FIGS. 2-22 and 2-23) in Assyrian palaces, although the reliefs probably featured a wider range of hues than those available to the ceramic painter.

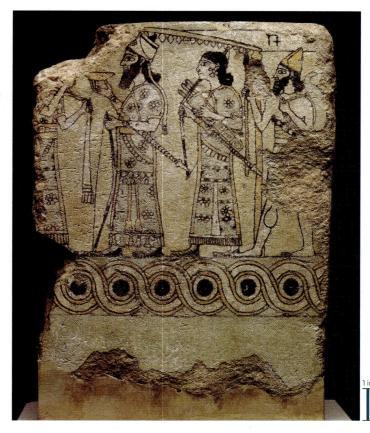

2-21 Ashurnasirpal II with attendants and soldier, from the northwest palace of Ashurnasirpal II, Kalhu (modern Nimrud), Iraq, ca. 875–860 BCE. Glazed brick, $11\frac{3}{4}$ " high. British Museum, London.

Paintings on glazed bricks adorned the walls of Assyrian palaces. This rare example shows Ashurnasirpal II paying homage to the gods. The artist represented the king as taller than his attendants.

The degree of documentary detail in the Assyrian reliefs is without parallel in the ancient world before the Roman Empire. Ashurnasirpal's Kalhu palace also boasts one of the earliest and most extensive cycles of Assyrian relief sculptures. The painted gypsum reliefs sheathed the lower parts of the mud-brick palace walls below brightly colored plaster. Rich textiles on the floors contributed to the luxurious ambience. Every relief bore an inscription naming Ashurnasirpal and describing his accomplishments.

The relief illustrated here (FIG. 2-22) probably depicts an episode that occurred in 878 BCE when Ashurnasirpal drove his enemy's forces into the Euphrates River. Two Assyrian archers shoot arrows at the fleeing foe. Three enemy soldiers are in the water. One swims with an arrow in his back. The other two attempt to float to safety by inflating animal skins. Their destination is a fort where their compatriots await them. The artist showed the fort as if it were in the middle of the river, but it was, of course, on land, perhaps at some distance from where the escapees entered the water. The artist's purpose was to tell the story clearly and economically. Ancient sculptors and painters often compressed distances and enlarged the human actors so that they would stand out from their environment. For example, literally interpreted, this relief presents the defenders of the fort as too tall to walk through its archway. (Compare Naram-Sin and his men scaling a mountain, FIG. 2-13.) The sculptor also combined different viewpoints in the same frame, just as the figures are composites of frontal and profile views. The spectator views the river from above, and the men, trees, and fort from the side. The artist also made other adjustments for clarity. The archers' bowstrings are in front of their bodies but behind their heads in order not to hide their faces. (The men will snare their heads in their bows when they launch their arrows.) All these liberties with optical reality, however, result in a vivid and easily legible retelling of a decisive moment in the king's victorious campaign. That was the sculptor's primary goal.

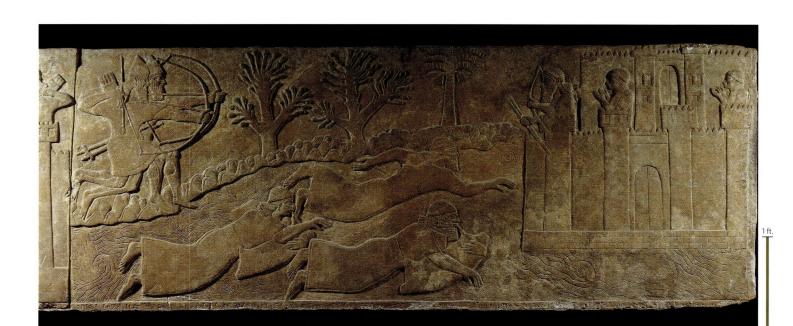

2-22 Assyrian archers pursuing enemies, relief from the northwest palace of Ashurnasirpal II, Kalhu (modern Nimrud), Iraq, ca. 875–860 BCE. Gypsum, $2' 10\frac{5}{8}"$ high. British Museum, London.

Extensive reliefs exalting the king and recounting his great deeds have been found in several Assyrian palaces. This one depicts Ashurnasirpal II's archers driving the enemy into the Euphrates River.

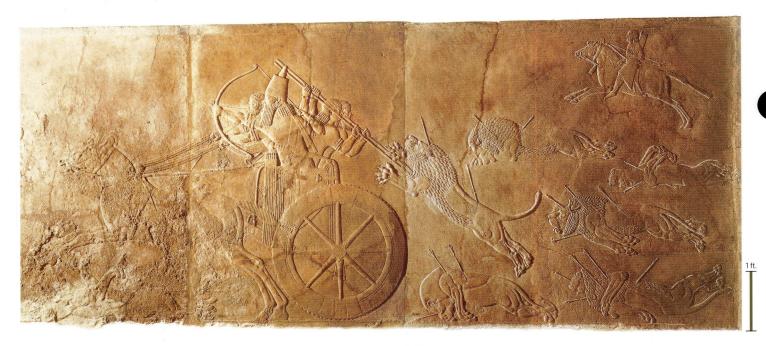

2-23 Ashurbanipal hunting lions, relief from the north palace of Ashurbanipal, Nineveh (modern Kuyunjik), Iraq, ca. 645–640 BCE. Gypsum, 5' 4" high. British Museum, London.

In addition to ceremonial and battle scenes, the hunt was a common subject of Assyrian palace reliefs. The Assyrians viewed hunting and killing lions as manly royal virtues on a par with victory in warfare.

PALACE OF ASHURBANIPAL Two centuries later, other Assyrian artists carved hunting reliefs (FIG. 2-23) for the Nineveh palace of the conqueror of Elamite Susa, Ashurbanipal (r. 668–627 BCE), whose name means "Ashur is creator of the son." The Greeks called him Sardanapalus, and the French painter Eugène Delacroix immortalized the Assyrian king in the 19th century in one of the most dramatic canvases (FIG. 27-15) of the Romantic era in Europe. The Assyrians, like many other societies before and after, regarded prowess in hunting as a manly virtue on a par with success in warfare. The royal hunt did not take place in the wild, however, but in a controlled environment, ensuring the king's safety and success. In Fig. 2-23, lions released from cages in a large enclosed arena charge the king, who, in his chariot and with his attendants, thrusts a spear into a savage lion. The animal leaps at the king even though it already has two arrows in its body. All around the royal chariot is a pathetic trail of dead and dying animals, pierced by what appear to be far more arrows than needed to kill them. Blood streams from some of the lions, but they refuse to die. The artist brilliantly depicted the straining muscles, the swelling veins, the muzzles' wrinkled skin, and the flattened ears of the powerful and defiant beasts. Modern sympathies make this scene of carnage a kind of heroic tragedy, with the lions as protagonists. It is unlikely, however, that the king's artists had any intention other than to glorify their ruler by showing the king of men pitted against and repeatedly besting the king of beasts. Portraying Ashurbanipal's beastly foes as possessing courage and nobility as well as the power to kill made the king's accomplishments that much grander.

The Assyrian Empire was never very secure, however, and most of its kings had to fight revolts throughout Mesopotamia. Assyria's conquest of Elam in the seventh century BCE and frequent rebellions in Babylonia apparently overextended its resources. During the last years of Ashurbanipal's reign, the empire began to disintegrate. Under his successors, it collapsed from the simultaneous onslaught of the Medes from the east and the resurgent Babylonians

from the south. Neo-Babylonian kings held sway over the former Assyrian Empire until the Persian conquest.

Neo-Babylonia

The most renowned of the Neo-Babylonian kings was Nebuchadnezzar II (r. 605–562 BCE), whose exploits the Book of Daniel recounts. Nebuchadnezzar restored Babylon to its rank as one of the great cities of antiquity. The Greeks and Romans counted "the hanging gardens of Babylon" among the Seven Wonders of the ancient world, and the Bible immortalized the city's enormous ziggurat as the Tower of Babel (see "Babylon, City of Wonders," page 49).

ISHTAR GATE Nebuchadnezzar's Babylon was a mud-brick city, but dazzling blue-glazed bricks faced the most important monuments, such as the Ishtar Gate (FIG. 2-24), in fact, a pair of gates, one of which has been restored and installed in the Vorderasiatisches (Near Eastern) Museum in Berlin, Germany. The Ishtar Gate consists of a large arcuated (arch-shaped) opening flanked by towers, and features glazed bricks with reliefs of animals, real and imaginary. The Babylonian builders molded and glazed each brick separately, then set them in proper sequence on the wall. On the Ishtar Gate, profile figures of Marduk and Nabu's dragon and Adad's bull alternate. Lining the processional way leading up to the gate were reliefs of Ishtar's sacred lion, glazed in yellow, brown, and red against a blue ground.

PERSIA

Although Nebuchadnezzar—the "king of kings" in the book of Daniel (2:37)—had boasted in an inscription that he "caused a mighty wall to circumscribe Babylon . . . so that the enemy who would do evil would not threaten," Cyrus of Persia (r. 559–529 BCE)

WRITTEN SOURCES

Babylon, City of Wonders

The uncontested list of the Seven Wonders of the ancient world was not codified until the 16th century. But already in the second century BCE, Antipater of Sidon, a Greek poet, compiled a roster of seven mustsee monuments, including six of the seven later Wonders. All of the Wonders were of colossal size and constructed at great expense. The oldest were of great antiquity, nearly 2,500 years old in Antipater's day: the pyramids of Gizeh (FIG. 3-8), which he described as "man-made mountains." Only one site on Antipater's list could boast two Wonders: Babylon, with its "hanging gardens" and "impregnable walls." The wondrous gardens were not in Babylon, however, but part of the Assyrian king Sennacherib's "palace without rival" at Nineveh. Later list makers preferred to distribute the Seven Wonders among seven different cities (not including Nineveh). Most of these Wonders date to Greek times the Temple of Artemis at Ephesos, with its 60-foot-tall columns; Phidias's colossal gold-and-ivory statue of Zeus at Olympia; the "Mausoleum" at Halikarnassos, the gigantic tomb (FIG. 5-63C) of the fourth-century BCE ruler Mausolus; the Colossus of Rhodes, a bronze statue of the Greek sun god 110 feet tall; and the lighthouse at Alexandria, perhaps the tallest building in the ancient world. The "Babylonian" gardens were the only Wonder in the category of "landscape architecture."

Several ancient texts describe the wondrous hanging gardens, although none of the authors had traveled to Babylon. Quintus Curtius Rufus, for example, relying on earlier unreliable sources, reported in the mid-first century CE:

On the top of the citadel are the hanging gardens, a wonder celebrated in the tales of the Greeks. . . . Columns of stone were set up to sustain the whole work, and on these was laid a floor of squared blocks, strong enough to hold the earth which is thrown upon it to a great depth, as well as the water with which they irrigate the soil; and the structure supports trees of such great size that the thickness of their trunks equals a measure of eight cubits

[about 12 feet]. They tower to a height of fifty feet, and they yield as much fruit as if they were growing in their native soil. . . . To those who look upon [the trees] from a distance, real woods seem to be overhanging their native mountains.*

Not qualifying as a Wonder, but in some ways no less impressive (and far more real), was Babylon's Marduk ziggurat, the biblical Tower of Babel, erected by King Nebuchadnezzar, who also constructed Babylon's Ishtar Gate (FIG. 2-24). According to the Bible (Gen. 11:1-9), humankind's arrogant desire to build a tower to Heaven angered God. The Lord put an end to it by causing the workers to speak different languages, preventing them from communicating with one another. The fifth-century BCE Greek historian Herodotus described the Babylonian temple complex:

In the middle of the sanctuary [of Marduk] has been built a solid tower . . . which supports another tower, which in turn supports another, and so on: there are eight towers in all. A stairway has been constructed to wind its way up the outside of all the towers; halfway up the stairway there is a shelter with benches to rest on, where people making the ascent can sit and catch their breath. In the last tower there is a huge temple. The temple contains a large couch, which is adorned with fine coverings and has a golden table standing beside it, but there are no statues at all standing there. . . . [The Babylonians] say that the god comes in person to the temple [compare the Sumerian notion of the temple as a "waiting room"] and rests on the couch; I do not believe this story myself.**

The fictional hanging gardens of Babylon are a cautionary tale about the accuracy of written sources, which are indispensable for the study of the history of art and architecture but must be examined critically before being accepted at face value.

*Quintus Curtius 5.1.31–35. Translated by John C. Rolfe, *Quintus Curtius I* (Cambridge, Mass.: Harvard University Press, 1971), 337–339.

**Herodotus 1.181–182. Translated by Robin Waterfield, Herodotus: The Histories (New York: Oxford University Press, 1998), 79–80.

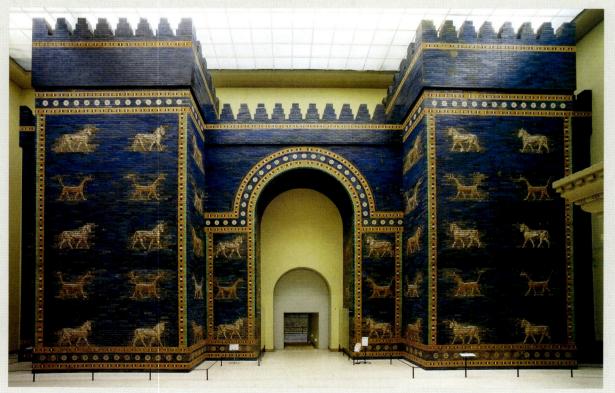

2-24 Ishtar Gate (restored), Babylon, Iraq, ca. 575 BCE. Vorderasiatisches Museum, Staatliche Museen zu Berlin, Berlin.

Nebuchadnezzar II's Babylon was one of the ancient world's greatest cities and boasted the biblical Tower of Babel. Its Ishtar Gate featured glazed-brick reliefs of Marduk and Nabu's dragon and Adad's bull.

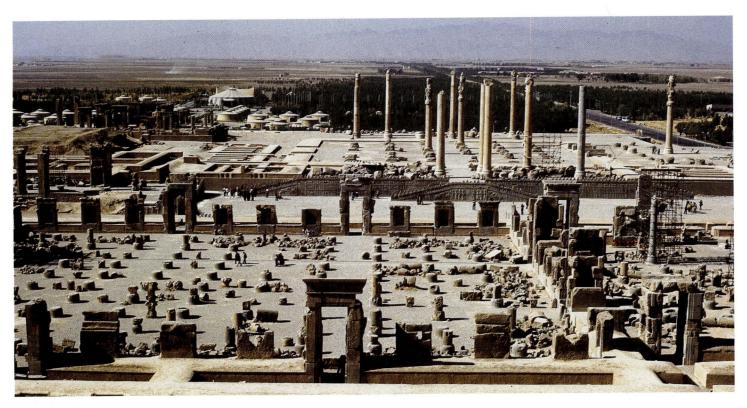

2-25 Aerial view of Persepolis (looking west with the apadana in the background), Iran, ca. 521-465 BCE.

The heavily fortified complex of Persian royal buildings on a high plateau at Persepolis included a royal audience hall, or apadana, with 36 colossal columns topped by animal protomes (FIG. 2-26).

captured the city in 539 BCE. Cyrus, who may have been descended from an Elamite line, was the founder of the Achaemenid dynasty and traced his ancestry back to a mythical King Achaemenes.

Achaemenid Empire

Babylon was but one of the Achaemenids' conquests. Egypt fell to them in 525 BCE, and by 480 BCE they boasted the largest empire the world had yet known, extending from the Indus River in South Asia to the Danube River in northeastern Europe. If the Greeks had not succeeded in turning back the Persians in 479 BCE, they would have taken control of southeastern Europe as well. The Achaemenid line ended with the death of Darius III in 330 BCE, after his defeat at the hands of Alexander the Great (see page 147 and FIG. 5-70).

PERSEPOLIS The most important source of knowledge about Persian art and architecture is the ceremonial and administrative complex within the citadel at Persepolis (FIG. 2-25), which the successors of Cyrus, Darius I (r. 522–486 BCE) and Xerxes (r. 486–465 BCE), built between 521 and 465 BCE. Situated on a high plateau, the heavily fortified complex of royal buildings stood on a wide platform overlooking the plain. Alexander the Great razed the site in a gesture symbolizing the destruction of Persian imperial power. Some said it was an act of revenge for the Persian sack of the Athenian Acropolis in 480 BCE (see page 123). Nevertheless, even in ruins, the Persepolis citadel is impressive.

The approach to the citadel led through a monumental gateway called the Gate of All Lands, a reference to the harmony among the peoples of the vast Persian Empire. Assyrian-inspired colossal manheaded winged bulls flanked the great entrance. Broad ceremonial

stairways provided access to the platform and the immense royal audience hall, or *apadana*, in which at least 10,000 guests could stand at one time. Although the hall had mud-brick walls, the floors were paved in stone or brick, and the apadana's chief feature—its forest of 36 colossal *columns* (FIG. **2-26**)—was entirely of stone. The columns consisted of tall *bases* with a ring of palm leaves, 57-foot *shafts* with *flutes*, and enormous *capitals* composed of double vertical *volutes* (see "Doric and Ionic Orders," page 114, for the architectural terminology) topped by polished and painted back-to-back animal *protomes* (the head, forelegs, and part of the body). The columns are unique in form, but the designers drew on Greek, Egyptian, and Mesopotamian traditions.

The capitals with animal protomes in the Persepolis apadana are nearly 7 feet tall, bringing the total height of the columns to almost 64 feet. The animals—griffins (eagle-headed winged lions), bulls, lions, and composite man-headed bulls—vary from capital to capital. The Persepolis architect may have wanted to suggest that the Persian king had captured the fiercest animals and monsters to hold up the roof of his palace. The paired protomes form a U-shaped socket that held massive cedar beams (imported from Lebanon), which in turn supported a timber roof sealed with mud plaster.

The reliefs (FIG. 2-27) decorating the walls of the terrace and staircases leading to the apadana represent processions of royal guards, Persian nobles and dignitaries, and representatives from 23 subject nations, including Medes, Elamites, Babylonians, Egyptians, and Nubians, bringing tribute to the king. Every emissary wears a characteristic costume and carries a typical regional gift for the conqueror. The section of the procession reproduced here represents Persian nobles (in pleated skirts) and Medes wearing their distinctive round caps, knee-length tunics, and trousers. The carving of the

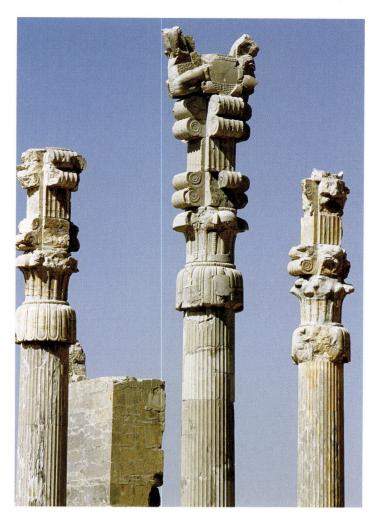

2-26 Three columns with animal protomes in the apadana of the palace (Fig. 2-25), Persepolis, Iran, ca. 521–465 BCE.

The 64-foot columns of the Persepolis apadana drew on Mesopotamian, Greek, and Egyptian models but are unique in form. The back-to-back protomes of the capitals supported gigantic cedar beams.

Persepolis reliefs is technically superb, with subtly modeled surfaces and crisply chiseled details. Traces of color prove that the reliefs were painted.

Although the Assyrian palace reliefs may have inspired those at Persepolis, the Persian sculptures differ in style. The forms are more rounded, and they project more from the background. Some of the details, notably the treatment of drapery folds, echo forms characteristic of Archaic Greek sculpture (compare Fig. 5-11), and Greek influence seems to be one of the many ingredients of Achaemenid style. Persian art testifies to the active exchange of ideas and artists among all the civilizations of Persia, Mesopotamia, and the Mediterranean at this date. In an inscription at Susa, for example, Darius I boasted of the diverse origin of the stonemasons, carpenters, and sculptors who constructed and decorated his palace. He names Medes, Egyptians, Babylonians, and Ionian Greeks. This heterogeneous workforce created a new and coherent style that perfectly suited the expression of Persian imperial ambitions.

ACHAEMENID RHYTON When the Achaemenid kings entertained guests, they served them food and drink in tableware of costly materials. Indeed, the Persians were famous for their luxurious cups and plates of gold and silver. Herodotus, for example, recounted how after the Greeks defeated the Persians at the battle of Plataea in 479 BCE, they entered the Persian camp and found tents filled with gold bowls and goblets and wagons overflowing with gold and silver basins (History, 9.80). In fact, this opulent collection was merely what the Persian king Xerxes brought with him on a military campaign. When Alexander the Great sacked Persepolis, he discovered even greater riches, including gold objects similar to the rhyton (conical pouring vessel) in the form of a winged lion illustrated here (FIG. 2-28). Although found at Hamadan in Iran instead of Persepolis, the rhyton must closely resemble the magnificent items that graced the tables of the Achaemenid royal house. Its shape is typical of these elaborate service pieces: a conical, trumpetlike container for wine, hammered (repoussé) from a thin sheet of gold inserted at a right angle into an animal protome (compare FIG. 2-26) also crafted in repoussé. In this case, the protome is a winged lion, one

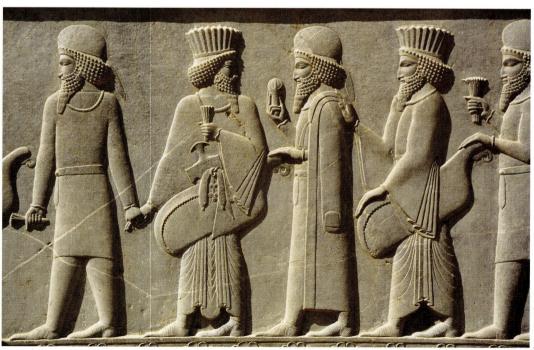

2-27 Persians and Medes, detail of the processional frieze on the east side of the terrace of the apadana of the palace (FIG. 2-25), Persepolis, Iran, ca. 521–465 BCE. Limestone, 8' 4" high.

The reliefs decorating the walls of the terrace and staircases leading up to the Persepolis apadana (Fig. 2-25) included depictions of representatives of 23 nations bringing tribute to the Persian king.

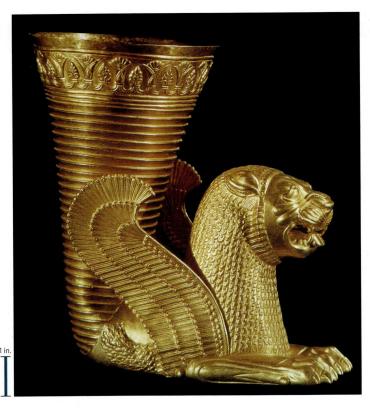

2-28 Rhyton in the form of a winged lion, from Hamadan, Iran, fifth to third century BCE. Gold, $8\frac{3}{8}$ " high. Archaeological Museum of Iran, Tehran.

This hammered-gold conical pouring vessel with a winged-lion protome is a characteristic example of the luxurious items that graced the tables of Achaemenid royal palaces.

of the many composite beasts popular in Mesopotamian art from the Sumerian era through the seventh century CE. Around the lip of the rhyton is a lotus-and-palmette band that has close parallels on painted Greek vases and in Greek architectural decoration. The Hamadan rhyton is thus another example of the varied stylistic and iconographical roots of Persian art.

2-29 Palace of Shapur I, Ctesiphon, Iraq, ca. 250 CE.

The Sasanians were the last great pre-Islamic civilization of Mesopotamia and Persia. Their palace at Ctesiphon, near Baghdad, features a brick audience hall (iwan) covered by an enormous pointed vault.

Sasanian Empire

Alexander the Great's conquest of the Achaemenid Empire in 330 BCE marked the beginning of a long period of first Greek and then Roman rule of large parts of Mesopotamia and Persia, beginning with one of Alexander's former generals, Seleucus I (r. 312–281 BCE), founder of the Seleucid dynasty. In the third century CE, however, a new power rose up in Persia that challenged the Romans and sought to force them out of Asia. The new rulers called themselves Sasanians. They traced their lineage to a legendary figure named Sasan, said to be a direct descendant of the Achaemenid kings. The first Sasanian king, Artaxerxes I (r. 211–241), founded the New Persian Empire in 224 CE after he defeated the Parthians (another of Rome's eastern enemies).

SHAPUR I The son and successor of Artaxerxes, Shapur I (r. 241–272), erected a great palace (FIG. **2-29**) at Ctesiphon, the capital his father had established near modern Baghdad in Iraq. The central feature of Shapur's palace was the monumental *iwan*, or brick audience hall, covered by a *vault* (here, a deep arch over an oblong space) that came almost to a point more than 100 feet above the ground. A series of horizontal bands made up of *blind arcades* (a series of arches without openings, applied as wall decoration) divide the *facade*

(building front) to the left and right of the iwan. Shapur was also an accomplished general who further extended Sasanian territory. In 260, he even captured the Roman emperor Valerian—a singular feat, which he immortalized in a series of reliefs (for example, FIG. 2-29A) at Bishapur, Iran.

2-29A Triumph of Shapur I, Bishapur, ca. 260 cE.

The New Persian Empire endured more than 400 years, until the Arabs drove the Sasanians out of Mesopotamia in 636 CE, just four years after the death of Muhammad. But the prestige of Sasanian art and architecture long outlasted the empire. A thousand years after Shapur I built his palace at Ctesiphon, Islamic architects still considered its soaring iwan as the standard for judging their own engineering feats (see page 300).

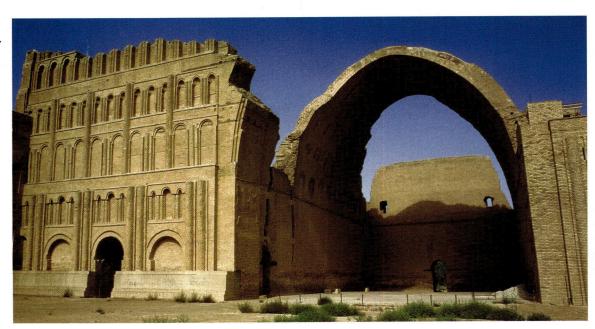

MESOPOTAMIA AND PERSIA

Sumerian Art ca. 3500-2332 BCE

- The Sumerians founded the world's first city-states in the valley between the Tigris and Euphrates Rivers
 and invented writing in the fourth millennium BCE.
- They were also the first to build communal religious shrines on towering platforms, such as Uruk's mudbrick White Temple, and to place figures in registers to tell coherent stories.

White Temple, Uruk, ca. 3200-3000 BCE

Akkadian Art ca. 2332-2150 BCE

- The Akkadians were the first Mesopotamian rulers to call themselves kings of the world and to assume divine attributes. The earliest recorded name of an author is Enheduanna, an Akkadian priestess of the god Nanna.
- Akkadian artists may have been the first to cast hollow life-size metal sculptures and to place figures at different levels in a landscape setting, as on the stelle erected by Naram-Sin to celebrate his victory over the Lullubi.

Victory stele of Naram-Sin, 2254-2218 BCE

Neo-Sumerian and Babylonian Art ca. 2150-1600 BCE

- During the Third Dynasty of Ur, the Sumerians rose again to power and constructed one of Mesopotamia's largest tiered temple platforms, or ziggurats, at Ur.
- Gudea of Lagash (r. ca. 2100 BCE) built numerous temples and placed portraits of himself in them as votive offerings to the gods.
- Babylon's greatest king, Hammurabi (r. 1792–1750 BCE), formulated wide-ranging laws for the empire he
 ruled. Babylonian artists were among the first to experiment with foreshortening.

Gudea with temple plan, ca. 2100 BCE

Assyrian and Neo-Babylonian Art ca. 900-539 BCE

- At the height of their power, the Assyrians ruled an empire that extended from the Persian Gulf to the Nile and Asia Minor.
- Assyrian palaces were fortified citadels with gates guarded by monstrous lamassu. Paintings and reliefs
 depicting official ceremonies and the king battling enemies and hunting lions decorated the walls of the
 ceremonial halls.
- In the sixth century BCE, Babylon was thought to be home to two of the Seven Wonders of the ancient world. The Ishtar Gate, with its colorful glazed brick reliefs, gives an idea of Babylon's magnificence under Nebuchadnezzar II (r. 605-562 BCE).

Lamassu, Palace of Sargon II, ca. 721-705 BCE

Achaemenid and Sasanian Art ca. 559-330 BCE and 224-636 CE

- The capital of the Achaemenid Persians was at Persepolis, where Darius I (r. 522-486 BCE) and Xerxes (r. 486-465 BCE) built a huge palace complex with an audience hall that could accommodate 10,000 guests. Painted reliefs of subject nations bringing tribute adorned the terraces.
- The Sasanians, enemies of Rome, ruled the New Persian Empire from their palace at Ctesiphon until the Arabs defeated them four years after the death of Muhammad.

Achaemenid palace, Persepolis,

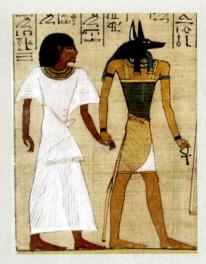

∢ 3-1a At the left, Anubis, the Egyptian god of embalming, shown with a man's body and a jackal's head, grasps the deceased Hunefer's left hand and leads him into the hall of judgment.

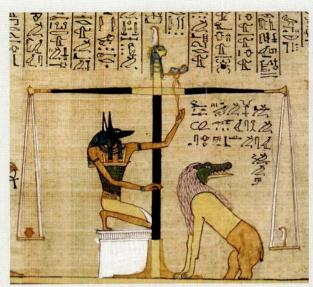

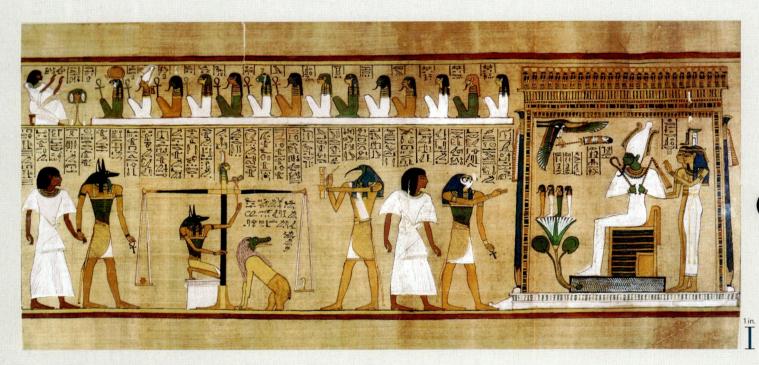

Judgment of Hunefer, detail of an illustrated *Book of the Dead*, from the tomb of Hunefer, Thebes, Egypt, 19th Dynasty, ca. 1290–1275 BCE. Painted papyrus scroll, 1' $3\frac{1}{2}$ " high; full scroll 18' $\frac{1}{2}$ " long. British Museum, London.

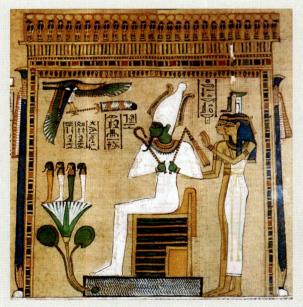

➤ 3-1c After being justified by the scales, Hunefer is led before the enthroned greenfaced god Osiris and his sisters Isis and Nephthys to receive the award of eternal life, the goal of every Egyptian.

3

Egypt from Narmer to Cleopatra

LIFE AFTER DEATH IN ANCIENT EGYPT

Blessed with abundant sources of stone of different hues suitable for carving statues and fashioning building blocks, the ancient Egyptians left to posterity a profusion of spectacular monuments spanning three millennia. Many of them glorified the gods and were set up by the Egyptian kings, whom the Egyptians believed were also divine and could serve as intermediaries with the gods. Indeed, the Egyptians devoted enormous resources to erecting countless monuments and statues to honor their god-kings during their lifetimes, and to constructing and furnishing magnificent tombs to serve as the divine kings' eternal homes in the afterlife.

Those who were not of royal birth could also aspire to an afterlife. Egyptians believed in the eternal existence of a person's ka, or life force, which continued to inhabit the corpse after an individual died. For this reason, those who could afford it lavishly furnished their tombs for the "next life." In those tombs, archaeologists have discovered not only stone and metal objects but also a vast number of items fashioned from perishable materials rarely preserved elsewhere, including illustrated *papyrus* scrolls such as the *Book of the Dead* (FIG. 3-1) found in the tomb of Hunefer, the royal scribe and steward of Seti I (r. 1306–1290 BCE).

Hunefer's scroll is a collection of spells and prayers needed to secure a happy afterlife. Illustrated scrolls (some are 70 feet long) containing these texts were essential items in the tombs of well-to-do Egyptians. At the left of the section reproduced here, Anubis, the jackal-headed god of embalming, leads Hunefer into the hall of judgment. The god then adjusts the scales to weigh the dead man's heart against a feather, the *hieroglyph* of the name of the goddess Maat and a symbol for truth and right doing. A hybrid crocodile-hippopotamus-lion monster, Ammit, devourer of the sinful, awaits the decision of the scales. If the weighing had been unfavorable to the deceased, the monster would have eaten his heart. The ibis-headed god Thoth records the proceedings. Above, the gods of the Egyptian pantheon sit in a row as witnesses, while Hunefer kneels in adoration before them.

Having been justified by the scales, Hunefer is brought by Osiris's son, the falcon-headed Horus, into the presence of the enthroned green-faced Osiris and his sisters Isis and Nephthys to receive the award of eternal life. This was the goal of every Egyptian and the concept that dictated the form and content of much of Egyptian art and architecture from its beginnings in the fourth millennium BCE and for several thousand years thereafter.

EGYPT AND EGYPTOLOGY

The backbone of Egypt was, and still is, the Nile River, which, through its annual floods, supported all life in that ancient land (MAP 3-1). Even more so than the Tigris and Euphrates Rivers of Mesopotamia (MAP 2-1), the Nile defined the cultures that developed along its banks. Originating deep in Africa, the world's longest river flows through regions that may not receive a single drop of rainfall in a decade. Yet crops thrive from the rich soil the Nile brings thousands of miles from the African hills. In antiquity, the land bordering the Nile consisted of marshes dotted with island ridges. Amphibious animals swarmed in the marshes, where the Egyptians hunted them through tall forests of papyrus and rushes (FIGS. 3-15 and 3-28). The fertility of Egypt was famous. When the Kingdom of the Nile became a province of the Roman Empire after the death of Queen Cleopatra (r. 51–30 BCE), it served as the granary of the Mediterranean world.

During the Middle Ages, the detailed knowledge the Romans possessed about the Egyptians and their gods was largely forgotten (see "The Gods and Goddesses of Egypt," page 58). With the Enlightenment of the 18th century (see page 763), scholars began to piece together Egypt's history from references in the Old Testament, from the fifth-century BCE Greek historian Herodotus and other Greco-Roman authors, and from preserved portions of a third-century BCE history of Egypt written in Greek by Manetho, an Egyptian high priest. Manetho described the succession of Egyptian rulers, dividing them into the still-useful groups of hereditary rulers called dynasties, but his chronology was inaccurate, and today historians still do not agree on the absolute dates of the kings. The chronologies that scholars have proposed for the earliest Egyptian dynasties can vary by as much as two centuries. Only after 664 BCE (26th Dynasty) are the exact years of individual reigns certain.

The modern discipline of Egyptology dates to the late 18th century, when archaeological exploration of the land of the Nile began in earnest. In 1799, on a military expedition to Egypt, Napoleon Bonaparte (1769-1821; see page 794) took with him a small troop of scholars, linguists, antiquarians, and artists. Their chance discovery of the famed Rosetta Stone, now in the British Museum, provided an essential key to deciphering Egyptian hieroglyphic writing. The stone bears an inscription in three sections: one in Greek, which Napoleon's team easily read; one in demotic (Late Egyptian); and one in formal hieroglyphic. On the assumption that the text was the same in all three sections, Jean-François Champollion (1790-1832) and other scholars attempted to decipher the two non-Greek sections. Eventually, they deduced that the hieroglyphs were not simply pictographs but the signs of a once-spoken language whose traces survived in Coptic, the language of Christian Egypt. The ability to read hieroglyphic inscriptions revolutionized the study of Egyptian civilization and art.

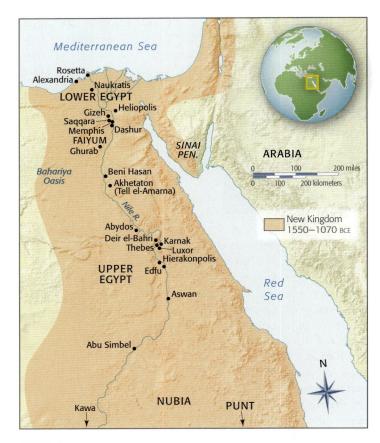

MAP 3-1 Ancient Egypt.

PREDYNASTIC AND EARLY DYNASTIC PERIODS

The prehistoric beginnings of Egyptian civilization predate writing and are consequently obscure. Nevertheless, tantalizing remains of tombs, paintings, pottery, and other artifacts attest to the existence of a sophisticated culture on the banks of the Nile around 3500 BCE. Egyptologists refer to this era as the Predynastic period.

Painting and Sculpture

In Predynastic times, Egypt was divided geographically and politically into Upper Egypt (the southern, upstream part of the Nile Valley), a narrow tract of grassland that encouraged hunting, and Lower (northern) Egypt, where the rich soil of the Nile Delta islands promoted agriculture and animal husbandry. The major finds of Predynastic art come from Upper Egypt, especially Hierakonpolis,

EGYPT FROM NARMER TO CLEOPATRA

3500-2575 BCE

Predynastic and Early Dynastic

- Egyptian artists produce narrative reliefs and paintings, including the earliest preserved labeled historical artwork, the Narmer palette
- Imhotep, the first artist whose name is recorded, builds the stepped pyramid and funerary complex of King Djoser at Saggara

2575-2134 все

Old Kingdom

- Sculptors formulate the canonical Egyptian statuary types expressing the eternal nature of divine kingship
- Workers quarry millions of blocks of stone for the construction of the three Fourth Dynasty pyramids at Gizeh

2040-1640 все

Middle Kingdom

- Egyptian sculptors introduce a new, more emotional, kind of royal portrait
- Rock-cut tombs become the preferred form of Egyptian burial monument

1550-1070 все

New Kingdom

- Architects construct grandiose pylon temples on the banks of the Nile featuring hypostyle halls with clerestory lighting
- Akhenaton introduces a new religion and new art forms during the short-lived religious and artistic revolution of the Amarna period

1000-30 BCE

First Millennium

 Egyptian artistic traditions continue under foreign (Kushite and Greek) rule

✓ 3-1A Tomb 100, Hierakonpolis, са. 3500-3200 все.

where archaeologists discovered the most extensive series of early Egyptian mural paintings (FIG. 3-1A) on the walls of a tomb dating between 3500 and 3200 BCE.

PALETTE OF KING NARMER The Predynastic period ended with the unification of Upper and Lower

Egypt, which until recently historians thought occurred during the First Dynasty kingship of Menes, identified by many Egyptologists with Narmer. King Narmer's image and name appear on both sides of a ceremonial palette (stone slab with a circular depression) found at Hierakonpolis. The palette (FIGS. 3-2 and 3-3) is one of the earliest historical (versus prehistorical) artworks preserved, but Egyptologists still debate exactly what event(s) it depicts. No longer regarded as commemorating the founding of the first of Egypt's 31 dynasties around 2920 BCE (the last ended in 332 BCE), the scenes probably record the unification of the two kingdoms. Historians now believe that this unification occurred over several centuries, but the palette presents the creation of the "Kingdom of the Two Lands" as a single great event.

Narmer's palette is an elaborate, formalized version of a utilitarian object commonly used in the Predynastic period to prepare eye makeup, which Egyptians used to protect their eyes against irritation and the glare of the sun. The palette is important not only as a document marking the transition from the prehistorical to the historical

period in ancient Egypt but also as a kind of early blueprint of the formula for figure representation that characterized most Egyptian art for 3,000 years. At the top of each side of the palette are two heads of a cow with a woman's face, whom scholars usually identify as the goddess Hathor, the divine mother of all Egyptian kings, but who is more likely a predecessor of Hathor, the sky goddess Bat. Between the heads is a hieroglyph giving Narmer's name (catfish = nar; chisel = mer) within a frame representing the royal palace, making Narmer's palette the earliest extant labeled work of historical art.

On the back (FIG. 3-2) of the palette, the king, wearing the high, white conical crown of Upper Egypt and attended by his official foot washer, who carries his sandals, is shown slaying a captured enemy. The slaying motif closely resembles the group at the lower left of the Hierakonpolis mural (FIG. 3-1A) and became the standard pictorial formula signifying the inevitable triumph of the Egyptian god-kings over their foes. Above and to the right, the king appears again in his role as the "Living Horus"—here as a falcon with one human arm. The falcon-king takes captive a man-headed hieroglyph with a papyrus plant growing from it that stands for the land of Lower Egypt—a retelling of Narmer's victory in symbolic form. Below the king are two fallen enemies.

On the front (FIG. 3-3), the elongated necks of two felines form the circular depression that would have held eye makeup in an ordinary palette not made for display. The intertwined necks of the animals (a motif common in Mesopotamian art) may be a pictorial reference to Egypt's unification. In the uppermost register,

3-2 Back of the palette of King Narmer, from Hierakonpolis, Egypt, Predynastic, ca. 3000-2920 BCE. Slate, 2' 1" high. Egyptian Museum,

Narmer's palette is the earliest surviving labeled work of historical art. The king, the largest figure in the composition, wears the crown of Upper Egypt and slays a captured enemy as his attendant looks on.

3-3 Front of the palette of King Narmer, from Hierakonpolis, Egypt, Predynastic, ca. 3000-2920 BCE. Slate, 2' 1" high. Egyptian Museum, Cairo.

Narmer, now wearing the crown of Lower Egypt, reviews beheaded enemy bodies. At the center of the palette, the intertwined animal necks may symbolize the unification of the two kingdoms.

RELIGION AND MYTHOLOGY

The Gods and Goddesses of Egypt

The worldview of the Egyptians was distinct from the outlook of their neighbors in the ancient Mediterranean, Mesopotamian, and Persian worlds. Egyptians believed that before the beginning of time, the primeval waters, called *Nun*, existed alone in the darkness. At the moment of creation, a mound rose out of the limitless waters—just as muddy mounds emerge from the Nile after the annual flood recedes. On this mound, the creator god, *Amen*, later identified with the god of the sun (*Re*), appeared and brought light to the world. In later times, the Egyptians symbolized the original mound as a pyramidal stone called the *ben-ben*.

Amen, the supreme god, also created the first of the other gods and goddesses of Egypt. According to one version of the myth, the creator masturbated and produced **Shu** and **Tefnut**, the primary male and female forces in the universe. They coupled to give birth to **Geb** (Earth) and **Nut** (Sky), who bore Osiris, Seth, Isis, and Nephthys. The eldest, **Osiris**, was the god of order, whom the Egyptians revered as the king who brought civilization to the Nile valley. His brother, **Seth**, was his evil opposite, the god of chaos. Seth murdered Osiris and cut him into pieces, which he scattered across Egypt. **Isis**, the sister and consort of Osiris, with the help of **Nephthys**, Seth's wife, succeeded in collecting

Osiris's body parts, and with her powerful magic brought him back to life. The resurrected Osiris fathered a son with Isis—*Horus*, who avenged his father's death and displaced Seth as king of Egypt. Osiris then became the lord of the Underworld. The Egyptians identified all their living kings with Horus, then with Osiris after they died. Horus appears in art either as a falcon, considered the noblest bird of the sky, or as a falcon-headed man. (However, the Egyptians did not believe that their gods had composite human-animal forms. The animal-headed images in FIG. 3-1 and elsewhere in Egyptian art are merely pictorial conventions descriptive of the various gods' characteristics.)

Other Egyptian deities include *Mut*, the consort of the sun god Amen, and *Khonsu*, the moon god, who was their son. *Thoth*, another lunar deity and the god of knowledge and writing, appears in art as an ibis, a baboon, or an ibis-headed man crowned with the crescent moon and the moon disk. When Seth tore out Horus's falcon-eye (*wedjat*), Thoth restored it. The Egyptians associated Thoth too with rebirth and the afterlife. *Hathor*, daughter of Re, was a divine mother of the Egyptian king, nourishing him with her milk. Egyptian artists represented her as a cow-headed woman or as a woman with a cow's horns. *Anubis*, a jackal or jackal-headed deity, was the god of the dead and of *mummification*. *Maat*, another daughter of Re, was the goddess of truth and justice. Her feather measured the weight of the deceased's heart on Anubis's scales to determine if the individual would be blessed in the afterlife.

Narmer, now wearing Lower Egypt's red crown topped by its distinctive wiry projection, reviews the beheaded bodies of the enemy. The dead are seen from above, a perspective reminiscent of the Paleolithic paintings (FIG. 1-8) on the ceiling of the Altamira cave in Spain representing bison lying on the ground. The Egyptian artist depicted each body with its severed head neatly placed between its legs. By virtue of his superior rank, the king, on both sides of the palette, performs his ritual task alone and towers over his men and the enemy. In the lowest band, a great bull, symbolizing the king's superhuman strength, knocks down the fortress walls of a rebellious city (also seen in an "aerial view").

As in Mesopotamian art (compare, for example, FIGS. 2-7 and 2-8), the Egyptian artist's portrayal of Narmer combines profile views of his head, legs, and arms with frontal views of his eye and torso. Although the proportions of the human figure would vary over the centuries, this composite representation of the body's parts became standard in Egyptian art as well. In the Hierakonpolis painting (FIG. 3-1A), the artist scattered the figures across the wall more or less haphazardly. On Narmer's palette, the sculptor subdivided the surface into registers and inserted the pictorial elements into their organized setting in a neat and orderly way. The horizontal lines separating the narratives also define the ground supporting the figures. This was the preferred mode for narrative art in Mesopotamia as well. Narmer's palette and other Predynastic works established this compositional scheme as the norm in Egypt for millennia. Egyptian artists who departed from this convention did so deliberately, usually to express the absence of order, as in a chaotic battle scene (for example, FIG. 3-36).

Architecture

Narmer's palette is a commemorative artwork. Far more typical of Egyptian art is the Predynastic mural (Fig. 3-1A) from tomb 100 at Hierakonpolis. In fact, the contents of Egyptian tombs provide

- 1. Chapel
- 2. False door
- 3. Shaft into burial chamber
- Serdab (chamber for statue of deceased)
- 5. Burial chamber

3-4 Section (*top*), plan (*center*), and restored view (*bottom*) of typical Egyptian mastaba tombs.

Egyptian mastabas had underground chambers, which housed the mummified body, portrait statues, and offerings to the deceased. Scenes of daily life often decorated the interior walls.

the principal, if not the exclusive, evidence for the historical reconstruction of Egyptian civilization. The majority of monuments the Egyptians left behind were dedicated to ensuring safety and happiness in the next life (see "Mummification and Immortality," page 60).

MASTABAS The standard tomb type in early Egypt was the *mastaba* (Arabic, "bench"), a rectangular brick or stone structure with sloping sides erected over an underground burial chamber (FIG. **3-4**). The form probably developed from earthen mounds that had covered even earlier burials. Although mastabas originally housed single burials, as in FIG. 3-4, they later became increasingly complex in order to accommodate members of several families. The main feature of these tombs, other than the burial chamber itself, was the chapel, which had a false door through which the ka could join the world of the living and partake in the meals placed on an offering table. Some mastabas also had a *serdab*, a small room housing a statue of the deceased.

IMHOTEP AND DJOSER One of the most renowned figures in Egyptian history was IMHOTEP, master builder for King Djoser (r. 2630–2611 BCE) of the Third Dynasty. Imhotep's is the first recorded name of an artist anywhere in the world. A man of legendary talent, Imhotep also served as Djoser's official seal bearer and as high priest of the sun god Re. After his death, the Egyptians deified Imhotep as

the son of the god Ptah and in time probably inflated the list of his achievements. Nonetheless, architectural historians accept Manetho's attribution to Imhotep of the stepped pyramid (FIG. 3-5) of Djoser at Saqqara. Saqqara was the ancient necropolis (Greek, "city of the dead") of Memphis, Egypt's capital at the time. Built before 2600 BCE, Djoser's pyramid is one of the oldest stone structures in Egypt and, in its final form, the first truly grandiose royal tomb. Begun as a large mastaba with each of its faces oriented toward one of the cardinal points of the compass, the tomb was enlarged at least twice before assuming its ultimate shape. About 200 feet high, the stepped pyramid seems to be composed of a series of mastabas of diminishing size, stacked one atop another to form a structure that resembles the great Mesopotamian ziggurats (FIGS. 2-15 and 2-19A). Unlike a ziggurat, however, Djoser's pyramid is a tomb, not a temple platform, and its dual function was to protect the mummified king and his possessions and to symbolize, by its gigantic presence, his absolute and godlike power. Beneath the pyramid was a network of several hundred underground rooms and galleries cut out of the Saqqara bedrock. The vast subterranean complex resembles a palace. It was to be Djoser's home in the afterlife.

Djoser's pyramid stands near the center of an immense (37-acre) rectangular enclosure (FIG. **3-6**) surrounded by a wall of white limestone 34 feet high and 5,400 feet long. The huge precinct, with its protective walls and tightly regulated access (FIGS. 3-6, no. 1, and

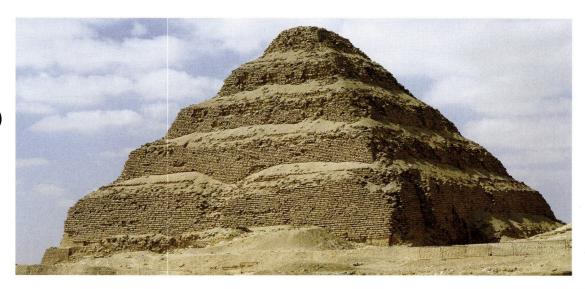

3-5 IMHOTEP, stepped pyramid (looking northwest) of Djoser, Saqqara, Egypt, Third Dynasty, ca. 2630–2611 BCE.

Imhotep, the first artist whose name is recorded, built the first pyramid during the Third Dynasty for King Djoser. The god-king's pyramid resembles a series of stacked mastabas of diminishing size.

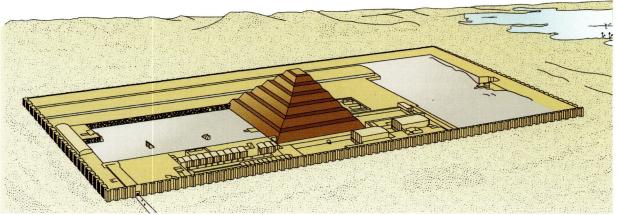

3-6 Restored view of the mortuary precinct of Djoser, Saqqara, Egypt, Third Dynasty, ca. 2630–2611 BCE. (1) entrance hall, (2) stepped pyramid, (3) north palace.

Djoser's pyramid was the centerpiece of an immense funerary complex that included several buildings connected with his funerary cult. A network of underground galleries resembled a palace.

ART AND SOCIETY

Mummification and Immortality

The Egyptians did not make the sharp distinction between body and soul that is basic to many religions. Rather, they believed that from birth a person possessed a kind of other self—the ka—which, on the death of the body, could inhabit the corpse and live on. For the ka to live securely, however, the body had to remain as nearly intact as possible. To ensure that it did, the Egyptians developed the technique of embalming (mummification) to a high art. Although they believed that the god Anubis invented embalming to preserve the body of the murdered Osiris (see "The Gods and Goddesses of Egypt," page 58), Egyptians did not practice mummification systematically until the Fourth Dynasty, when they also buried their dead in underground chambers beneath large brick or stone tombs (Fig. 3-4).

The details of the 70-day mummification process developed and changed over time, but the essential elements remained constant. The first step was the surgical removal of the lungs, liver, stomach, and intestines through an incision in the left flank. The Egyptians thought that these organs were most subject to decay, and wrapped them individually and placed them in four containers known as *canopic jars* for eventual deposit in the burial chamber with the corpse. (The jars take their name from the port of Canopus, where the Greeks believed that the Egyptians worshiped human-headed jars as personifications of Osiris. These jars were not, however, used in embalming.) Egyptian surgeons extracted the brain through the nostrils and then discarded it because they did not attach any special significance to that organ. But they left in place the heart, necessary for life and also regarded as the seat of intelligence.

Next, the body was treated for 40 days with natron, a naturally occurring salt compound that dehydrated the body. Then the embalmers filled the corpse with resin-soaked linens, and closed and covered the incision with a representation of the *wedjat* eye of Horus, a powerful

amulet (a device to ward off evil and promote rebirth). Finally, they treated the body with lotions and resins and wrapped it tightly with hundreds of yards of linen bandages to maintain its shape. The Egyptians often placed other amulets within the bandages or on the corpse. The most important were heart scarabs (gems in the shape of beetles). Spells written on them ensured that the heart would not testify against the deceased at judgment time (Fig. 3-1). Masks (Fig. 3-35) usually covered the faces of the deceased.

The Egyptian practice of mummification endured for thousands of years, even under Greek and Roman rule. Roman mummies with painted portraits (FIGS. 7-59A, 7-60, and 7-60A) have been popular attractions in museums worldwide for a long time, but the discovery in 1996 of a cemetery at Bahariya Oasis in the desert southwest of Cairo greatly expanded their number. The site, which archaeologists call the Valley of the Golden Mummies, extends for at least four square miles. The largest tomb found to date contained 32 mummies, but another held 43, some stacked on top of others because the tomb was used for generations and space ran out.

Preserving the deceased's body by mummification was only the first requirement for immortality in ancient Egypt. Food and drink also had to be provided, as did clothing, utensils, and furniture. Nothing that had been enjoyed on earth was to be lacking. The Egyptians also placed statuettes called *ushabtis* (answerers) in the tomb. These figurines performed any labor required of the deceased in the afterlife, answering whenever his or her name was called.

Beginning in the third millennium BCE, the Egyptians also set up statues of the dead (for example, FIGS. 3-13A, 3-14, 3-14A, and 3-14B) in their tombs. The statues were meant to guarantee the permanence of the person's identity by providing substitute dwelling places for the ka in case the mummy disintegrated. Wall paintings and reliefs (for example, FIGS. 3-15, 3-16, 3-28, and 3-29) recorded the recurring round of human activities. The Egyptians hoped and expected that the images and inventory of life, collected and set up within the protective stone walls of the tomb, would ensure immortality.

3-6A), stands in sharp contrast to the roughly contemporaneous Sumerian Royal Cemetery at Ur, where no barriers kept people away from the burial area. Nor did the Mesopotamian cemetery have a temple for the worship of the deified dead. At Saqqara, a funerary temple stands against the northern face of Djoser's pyramid (FIG. 3-6, no. 2). Priests performed daily rituals at the temple in celebration of the divine king.

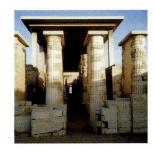

3-6A Entrance hall, Djoser precinct, Saqqara, ca. 2630–2611 BCE.

Djoser's funerary temple was but one of many buildings arranged around several courts. Most of the others were dummy structures with stone walls enclosing fills of rubble, sand, or gravel. The buildings imitated in stone various types of temporary structures made of plant stems and mats erected in Upper and Lower Egypt to celebrate the Jubilee Festival, which perpetually reaffirmed the royal existence in the hereafter. The translation into stone of structural forms previously made out of plants may be seen in the columns (FIG. **3-7**) of the north palace (FIG. **3-6**, no. 3) of Djoser's funerary precinct. The columns end in *capitals* ("heads") that

take the form of the papyrus blossoms of Lower Egypt. The column shafts resemble papyrus stalks. Djoser's columns are not freestanding, as are most later columns. They are *engaged columns* (that is, attached to walls), but are nonetheless the earliest known stone columns in the history of architecture.

OLD KINGDOM

The Old Kingdom is the first of the three great periods of Egyptian history, called the Old, Middle, and New Kingdoms, respectively. Many Egyptologists now begin the Old Kingdom with Sneferu (r. 2575–2551 BCE), the first king of the Fourth Dynasty, although the traditional division of kingdoms places Djoser and the Third Dynasty in the Old Kingdom. It ended with the breakup of the Eighth Dynasty around 2134 BCE.

Architecture

The divine rulers of the Old Kingdom amassed great wealth and expended it on grandiose architectural projects, of which the most spectacular were the Fourth Dynasty pyramids of Gizeh, the oldest

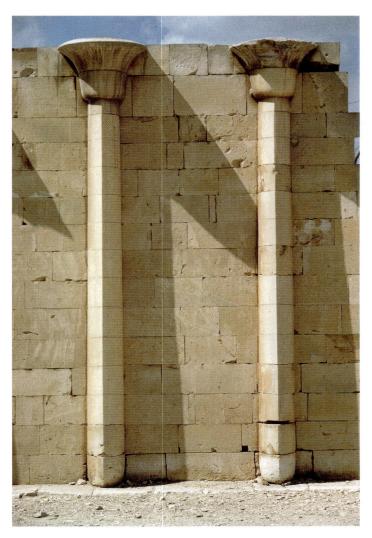

3-7 Detail of the facade of the north palace (FIG. 3-6, no. 3) of the mortuary precinct of Djoser, Saqqara, Egypt, Third Dynasty, ca. 2630–2611 BCE.

The earliest known stone columns are in Djoser's funerary precinct. Those on the north palace facade are engaged (attached) to the walls and have shafts and capitals resembling papyrus plants.

of the Seven Wonders of the ancient world (see "Babylon, City of Wonders," page 49). The prerequisites for membership in the elite club of Wonders were colossal size and enormous cost.

GIZEH The Egyptians constructed the three major pyramids (FIG. 3-8) at Gizeh in the course of about 75 years (see "Building the Pyramids of Gizeh," page 62) to serve as the tombs of the Fourth Dynasty kings Khufu (r. 2551–2528 BCE; FIG. 3-9), Khafre (r. 2520–2494 BCE), and Menkaure (r. 2490–2472 BCE). They represent the culmination of an architectural evolution that began with the mastaba (FIG. 3-4), but the classic pyramid form is not simply a refinement of the stepped pyramid (FIG. 3-5). The new tomb shape probably reflects the influence of Heliopolis, the seat of the powerful cult of Re, whose emblem was a pyramidal stone, the *ben-ben* (see "The Gods and Goddesses of Egypt," page 58). The pyramids are symbols of the sun. The Pyramid Texts, inscribed on the burial chamber walls of royal pyramids beginning with the Fifth Dynasty pyramid of Unas (r. 2356–2323 BCE), refer to the sun's rays as the ladder the god-king uses to ascend to the heavens.

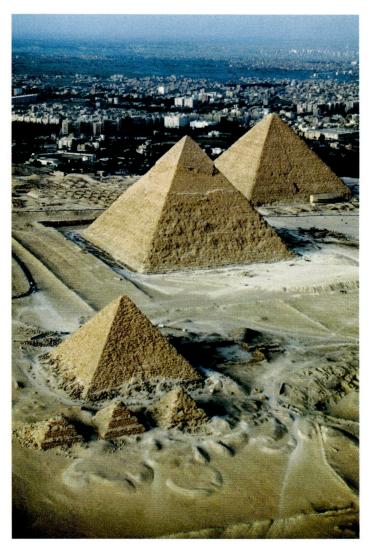

3-8 Aerial view of the Fourth Dynasty pyramids (looking north), Gizeh, Egypt. *From bottom:* pyramid of Menkaure, ca. 2490–2472 BCE; pyramid of Khafre, ca. 2520–2494 BCE; and Great Pyramid of Khufu, ca. 2551–2528 BCE.

The three pyramids of Gizeh took the shape of the ben-ben, the emblem of the sun god, Re. The sun's rays were the ramp the Egyptian kings used to ascend to the heavens after their death and rebirth.

Ho, Unas! You have not gone away dead: You have gone away alive.² So, you shall go forth, Unas, to the sky and step up on it in this its identity of the ladder.³

[Unas] has flown . . . to the sky amidst his brothers the gods. . . . Unas's seat is with you, $Sun.^4$

The pyramids were where Egyptian kings were reborn in the afterlife, just as the sun is reborn each day at dawn.

Imhotep may have conceived Djoser's stepped pyramid as a giant stairway. As with the Saqqara pyramid, the four sides of each of the Gizeh pyramids are oriented to the cardinal points of the compass. But the funerary temples associated with the three Gizeh pyramids are not on the north side, facing the stars of the northern sky, as was Djoser's temple. The Gizeh temples are on the east side, facing the rising sun and underscoring their connection with Re.

PROBLEMS AND SOLUTIONS

Building the Pyramids of Gizeh

The Fourth Dynasty pyramids (FIG. 3-8) across the Nile from modern Cairo are on every list of Wonders of the ancient world. How did the Egyptians solve the myriad problems they encountered in constructing these colossal tombs?

Like all building projects of this type, the process of erecting the pyramids began with surveying and leveling the construction site. Next, skilled masons had to quarry the millions of stone blocks needed—in this case, primarily from the limestone Gizeh plateau itself. Teams of workers had to cut into the rock and remove large blocks of roughly equal size using stone or copper chisels and wooden mallets and wedges. Often, the artisans had to cut deep tunnels to find high-quality stone free of cracks and other flaws. To remove a block, the stonemasons cut channels on all sides and partly underneath. Then they pried the stones free from the bedrock with wooden levers. New tools for this difficult work had to be manufactured constantly because the chisels and mallets broke or became dull very quickly.

After workers liberated the stones, the rough blocks had to be transported to the building site. There, the Egyptian stonemasons shaped the blocks to the exact dimensions required, with smooth faces (dressed masonry) for a perfect fit. Small blocks could be carried on a man's shoulders or on the back of a donkey, but the Egyptians moved the massive blocks for the pyramids using wooden sleds. The artisans dressed the blocks by chiseling and pounding the surfaces and, in the last stage, by rubbing and grinding the surfaces with fine polishing stones. Architectural historians call this kind of construction ashlar masonry—carefully cut and regularly shaped blocks of stone piled in successive horizontal rows, or courses.

To set the ashlar blocks in place, workers under the direction of master builders such as Hemiunu (FIG. 3-14B), who supervised the construction of Khufu's pyramid (FIG. 3-9), erected great rubble ramps against the core of the pyramid. They adjusted the ramps' size and slope as work progressed and the tomb grew in height. Scholars debate whether the Egyptians used simple linear ramps inclined at a right angle to one face of the pyramid or zigzag or spiral ramps akin to staircases. Linear ramps would have had the advantage of simplicity and would have left three sides of the pyramid unobstructed. But zigzag ramps placed against one side of the structure or spiral ramps winding around the pyramid would have greatly reduced the slope of the incline and would have made dragging the blocks easier. Some scholars also have suggested a combination of straight and spiral ramps, and one recent theory posits a system of spiral ramps within, instead of outside, the pyramid.

The Egyptians used ropes and levers both to lift and to lower the stones, guiding each block into its designated place. Finally, the pyramid received a casing of white limestone blocks (FIG. 3-9, no. 1), cut so

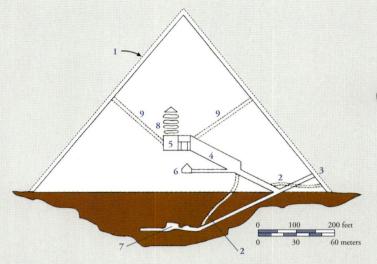

- 1. Silhouette with original facing stone
- 2. Thieves' tunnels
- 3. Entrance
- 4. Grand gallery
- 5. King's chamber

- 6. So-called Queen's chamber
- False tomb chamber
- 8. Relieving blocks
- 9. Air shafts(?)

3-9 Section of the Great Pyramid of Khufu, Gizeh, Egypt, Fourth Dynasty, ca. 2551-2528 BCE.

Khufu's pyramid is the largest at Gizeh. Constructed of roughly 2.3 million blocks of stone weighing an average of 2.5 tons, the structure is an almost solid mass of stone guarried from the Gizeh plateau itself.

precisely that the eye could scarcely detect the joints. The reflection of sunlight on the facing would have been dazzling, underscoring the pyramid's solar symbolism. Some casing stones are still in place at the peak of the pyramid of Khafre (FIG. 3-11).

Of the three Fourth Dynasty pyramids at Gizeh, the tomb of Khufu (FIGS. 3-9 and 3-10, no. 7), known as the Great Pyramid, is the oldest and largest. Except for the galleries and burial chamber, it is an almost solid mass of limestone masonry. Some dimensions will suggest its immense size: At the base, the length of one side of Khufu's tomb is approximately 775 feet, and its area is some 13 acres. Its present height is about 450 feet (originally 480 feet). Roughly 2.3 million blocks of stone, each weighing an average of 2.5 tons, make up the fabric of the Great Pyramid. Some of the stones at the base weigh about 15 tons.

The three Gizeh pyramids attest to the extraordinary engineering and mathematical expertise of the Egyptians of the mid-third millennium BCE as well as to the Old Kingdom builders' mastery of masonry construction and ability to mobilize, direct, house, and feed a huge workforce engaged in one of the most labor-intensive enterprises ever undertaken.

From the remains surrounding the pyramid of Khafre at Gizeh, archaeologists have been able to reconstruct an entire funerary complex (FIG. 3-10). The complex included the pyramid itself with the god-king's burial chamber; the mortuary temple adjoining the pyramid on the east side, where priests made offerings to the deceased and stored cloth, food, and ceremonial vessels; the roofed causeway (raised road) leading to the mortuary temple; and the valley temple at the edge of the floodplain. Many Egyptologists

believe that the complex served not only as the king's tomb and temple but also as his palace in the afterlife.

GREAT SPHINX Beside the causeway and dominating the valley temple of Khafre rises the Great Sphinx (FIG. 3-11). Carved from a spur of rock in the Gizeh quarry, the colossal statue—the largest in Egypt, Mesopotamia, or Persia—is probably an image of Khafre (originally complete with the king's ceremonial beard and nemes

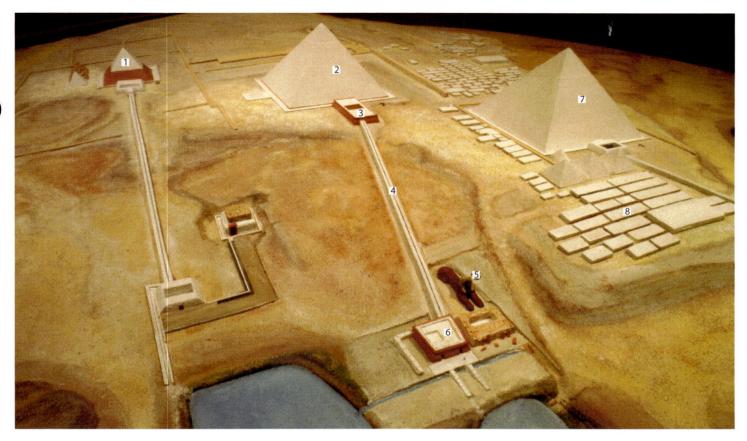

3-10 Model of the pyramid complex, Gizeh, Egypt. Harvard University Semitic Museum, Cambridge. (1) pyramid of Menkaure, (2) pyramid of Khafre, (3) mortuary temple of Khafre, (4) causeway, (5) Great Sphinx, (6) valley temple of Khafre, (7) Great Pyramid of Khufu, (8) pyramids of the royal family and mastabas of nobles.

Like Djoser's pyramid (Fig. 3-5), the Gizeh pyramids were not isolated tombs but parts of funerary complexes with a valley temple, a covered causeway, and a mortuary temple adjoining the tomb.

headdress with *uraeus* cobra), although some scholars think it portrays Khufu and predates the construction of Khafre's complex. Whomever it portrays, the *sphinx*—a lion with a human head—was an appropriate image for a king. The composite form suggests that the Egyptian king combines human intelligence with the fearsome strength and authority of the king of beasts.

Sculpture

Old Kingdom statues survive in significant numbers because they fulfilled an important function in Egyptian tombs as substitute abodes for the ka (see "Mummification and Immortality," page 60). Egyptian sculptors worked with wood, clay, and other materials, but most preserved statues are of stone.

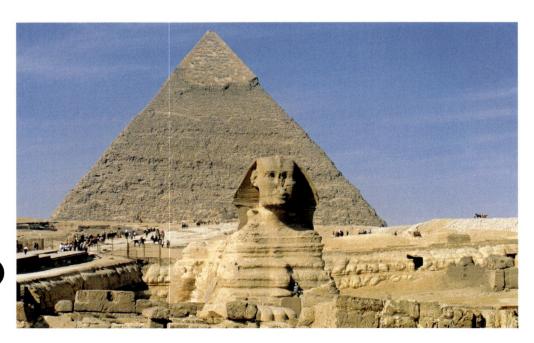

3-11 Great Sphinx (with pyramid of Khafre in the background), Gizeh, Egypt, Fourth Dynasty, ca. 2520–2494 BCE. Sandstone, 65' high.

Carved out of the Gizeh stone quarry, the Great Sphinx is of colossal size. The sphinx has the body of a lion and the head of a king (probably Khafre) and is associated with the sun god.

PROBLEMS AND SOLUTIONS

How to Portray a God-King

The Egyptian kings were divine beings, not mortal rulers, and the sculptors of the Old Kingdom needed to formulate a distinctive way to portray them in order to differentiate them from other men—beyond simply representing them wearing royal regalia. The solution they devised proved so satisfactory that, with the exception of some Middle and New Kingdom portraits (FIGS. 3-17 and 3-30), the formula persisted for millennia.

In the portrait (FIG. 3-12) from his valley temple at Gizeh, King Khafre wears a simple kilt and sits rigidly upright on a throne formed of two stylized lions' bodies. Intertwined lotus and papyrus plants—symbolic of the united Egypt—appear between the throne's legs. Khafre has the royal false beard fastened to his chin and wears the royal linen headdress. The headdress covers his forehead and falls in pleated folds over his shoulders. Behind Khafre's head is the falcon (compare FIG. 3-2) that identifies the king as the "Living Horus."

As befitting a divine ruler, the sculptor portrayed Khafre with a well-developed, flawless body and a perfect face, regardless of his real age and appearance. Because Egyptians considered ideal proportions appropriate for representing their god-kings, the statue of Khafre is not a true likeness and was not intended to be. The purpose of Egyptian royal portraiture was not to record individual features or the distinctive shapes of bodies but rather to proclaim the divine nature of Egyptian kingship.

The enthroned Khafre radiates serenity. The sculptor created this effect in part by giving the figure great compactness and solidity, with few projecting, breakable parts. The form of the statue expresses its purpose: to last for eternity. Khafre's body is one with the simple slab that forms the back of the king's throne. His arms follow the bend of his body and rest on his thighs, and his legs are close together. Part of the original stone block still connects the king's legs to his chair. Khafre's pose is frontal and, except for the hands, bilaterally symmetrical (the same on either side of an axis, in this case the vertical axis). The sculptor suppressed all movement and with it the notion of time, creating an aura of eternal stillness.

Some extant reliefs and paintings (FIG. 3-12A) show Egyptian sculptors at work and provide detailed information about the successive stages of carving a statue. To produce Khafre's statue, the artist first drew the front, back, and two profile views of the seated king on the four vertical faces of the stone block. Next, apprentices chiseled away the excess stone on each side, working inward until the planes met at right angles. Finally, the master sculpted the parts of Khafre's body, the falcon, and so forth. The polished surface was achieved by abrasion (rubbing or grinding). This method of creat-

3-12A Sculptors at work, Thebes, ca. 1425 BCE.

ing statuary accounts in large part for the blocklike look of the standard Egyptian statue. Nevertheless, other sculptors, both ancient and modern, with different aims, have transformed stone blocks into dynamic, twisting human forms (for example, FIGS. I-16 and 5-85).

3-12 Khafre enthroned, from Gizeh, Egypt, Fourth Dynasty, ca. 2520–2494 BCE. Diorite, 5' 6" high. Egyptian Museum, Cairo.

This portrait from his pyramid complex depicts Khafre as an enthroned divine ruler with a perfect body. The formality of the pose creates an aura of eternal stillness, appropriate for the timeless afterlife.

KHAFRE One of the supreme examples of Old Kingdom royal portraiture (see "How to Portray a God-King," above) is the seated statue of Khafre illustrated here (FIG. **3-12**), one of a series of similar statues carved for the god-king's valley temple (FIG. 3-10, no. 6) near the Great Sphinx. The stone is diorite, an exceptionally hard dark stone brought some 400 miles down the Nile from royal quar-

ries in the south. (The Neo-Sumerian ruler Gudea [FIG. 2-16] so admired diorite that he imported it to faraway Girsu.)

MENKAURE The seated statue, although a popular choice for royal portraits, is one of only a small number of basic formulaic types Old Kingdom sculptors employed to represent the human figure.

Another is the image of a person or deity standing, either alone or in a group—for example, the two-figure group (FIG. 3-13) of Menkaure and a female figure, usually identified as one of his wives, probably the queen Khamerernebty, but perhaps the goddess Hathor. The statue once stood in the valley temple of Menkaure's pyramid complex at Gizeh. Here, too, the figures remain wedded to the stone block. In fact, the statue could be classified as a high-relief sculpture rather than a freestanding statue. Menkaure's pose—duplicated in countless other Egyptian statues—is rigidly frontal with the arms hanging straight down and close to his well-built body. He clenches his hands into fists with the thumbs forward and advances his left leg slightly. But no shift occurs in the angle of the hips to correspond to the uneven distribution of weight. Khamerernebty(?) stands in a similar position. Her right arm, however, circles the king's waist, and her left hand gently rests on his left arm. This frozen stereotypical gesture indicates their marital status or, if king and goddess, their shared divinity. The two figures show no other sign of affection or emotion and look not at each other but out into space. As in the seated statue of Khafre (FIG. 3-12), the artist's aim was not to portray living figures but to suggest the timeless nature of the stone statue that might need to serve as an eternal substitute home for the ka.

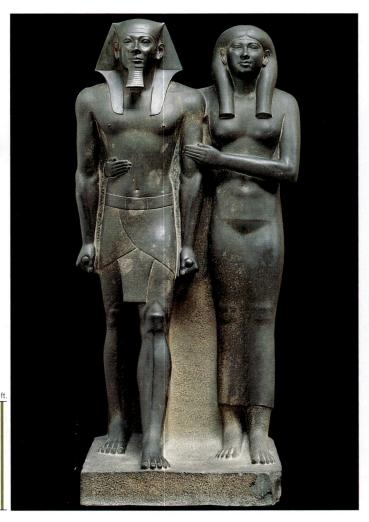

3-13 Menkaure and Khamerernebty(?), from Gizeh, Egypt, Fourth Dynasty, ca. 2490–2472 BCE. Graywacke, 4' $6\frac{1}{2}$ " high. Museum of Fine Arts, Boston.

The statue of Menkaure and his wife (or Hathor?) displays the conventional postures used for Old Kingdom royal statues. The formalized embrace denotes the close association of the two figures.

SEATED SCRIBE Traces of paint remain on the statue of Menkaure. Egyptian artists painted most of their statues, although sometimes sculptors left the natural color of the stone exposed, enhancing the sense of abstraction and timelessness. Striking examples of painted sculpture are the seated statues of Rahotep and Nofret (FIG. **3-13A**) and the statue found at Saqqara portraying a Fourth Dynasty scribe (FIG. **3-14**). Despite the stiff upright postures of all these statues and the frontality of head and body, the coloration lends a lifelike quality to the stone images.

3-13A Rahotep and Nofret, Maidum, ca. 2575-2550 BCE.

The head of the Saqqara scribe displays an extraordinary sensitivity. The sculptor conveyed the personality of a sharply intelligent and alert individual with a penetration and sympathy seldom achieved at this early date. The scribe sits directly on the ground, not on a throne or even on a chair. Although he occupied a position of honor in a largely illiterate society and performed a variety of official duties, the scribe was not as exalted a figure in the Egyptian hierarchy as the king, whose divinity made him superhuman. In the history of art, especially portraiture, it is almost a rule that as a person's importance decreases, formality is relaxed and realism increases. It is telling that the sculptor reproduced the scribe's sagging chest muscles and protruding belly. These signs of age would have been disrespectful and wholly inappropriate in a

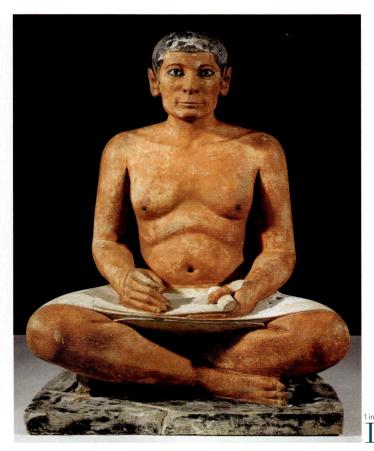

3-14 Seated scribe, from Saqqara, Egypt, Fourth Dynasty, ca. 2500 BCE. Painted limestone, 1' 9" high. Musée du Louvre, Paris.

The idealism that characterizes the portraiture of the Egyptian god-kings did not extend to the portrayal of non-elite individuals. The sculptor portrayed this seated scribe with clear signs of aging.

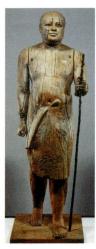

3-14AKaaper, Saqqara,
ca. 2450-2350 BCE.

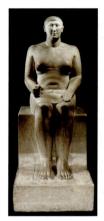

3-14BHemiunu, Gizeh,
ca. 2550-2530 BCE.

depiction of an Egyptian god-king or members of his family (see "How to Portray a God-King," page 64). But the statue of the scribe is not a true portrait either. Rather, it is a composite of conventional types. Obesity, for example, characterizes many nonroyal Old Kingdom male portraits (for example, FIGS. 3-14A and especially 3-14B), perhaps because it attested to the comfortable life of the person represented and his relatively high position in society.

TOMB OF TI In Old Kingdom tombs, images of the deceased also frequently appear in relief sculpture and in mural painting, sometimes singly (FIG. I-14), sometimes in a narrative context. The painted limestone relief scenes decorating the walls of the mastaba of a Fifth Dynasty official named Ti typify the subjects Old Kingdom patrons favored for the adornment of their final resting places. Depictions of the deceased at his funerary meal and

scenes of agriculture and hunting fill Ti's tomb. The Egyptians associated farming and hunting as well as dining with providing nourishment for the ka in the hereafter, but the subjects also had powerful symbolic overtones. In ancient Egypt, success in the hunt, for example, was a metaphor for triumph over the forces of evil.

On one wall (FIG. **3-15**) of his tomb, Ti, his men, and his boats move slowly through the marshes, hunting hippopotami and birds in a dense

growth of towering papyrus. The sculptor delineated the reedy stems of the plants with repeated fine grooves that fan out gracefully at the top into a commotion of frightened birds and stalking foxes. The water beneath the boats, signified by a pattern of wavy lines, is crowded with hippopotami and fish. Ti's men seem frantically busy with their spears, whereas Ti, depicted twice their size, stands aloof. The basic conventions of Egyptian figure representation—used a half millennium earlier for the palette of King Narmer (FIG. 3-2)—appear again here. As in the Predynastic work, the artist exaggerated the size of Ti to announce his rank, and combined frontal and profile views of Ti's body to show its most characteristic parts clearly. This approach to representation was well suited for Egyptian funerary art because it emphasizes the essential nature of the deceased, not his accidental appearance. Ti's conventional pose contrasts with the realistically rendered activities of his tiny servants and with the naturalistically carved and painted birds and animals among the papyrus buds. Ti's immobility suggests that he is not an actor in the hunt. He does not do anything. He simply is, a figure apart from time and an impassive observer of life, like his ka.

The idealized image of Ti is typical of Egyptian relief sculpture. Egyptian artists regularly ignored the endless variations in body types of real human beings. Painters and sculptors did not sketch their subjects from life but applied a strict *canon*, or system of proportions, to the human figure. They first drew a grid on the wall. Then they placed various human body parts at specific points on the network of squares. The height of a figure, for example, was a fixed number of squares, and the head, shoulders, waist, knees, and other parts of the body also had a predetermined size and place within the scheme. This approach to design lasted for more than 2,500 years. Specific proportions might vary from workshop to workshop and change over time, but the principle of the canon persisted.

On another wall (FIG. 3-16) of Ti's mastaba, goats tread in seeds in the upper register, and, below, cattle ford a canal in the Nile. Once again, the scenes may be interpreted on a symbolic as well as a literal level. The fording of the Nile, for example, was a metaphor for the deceased's passage from life to the hereafter. Ti is absent from the scenes, and all the men and animals participate in the narrative. Despite the sculptor's repeated use of similar poses for most of the human and animal figures, the reliefs are full of anecdotal details. Especially charming is the group at the lower right. A youth, depicted in a complex unconventional posture, carries a calf on his back. The animal, not a little afraid, turns its head back a full 180 degrees (compare FIG. 1-7) to seek reassurance from its mother, who returns the calf 's gaze. Scenes such as this

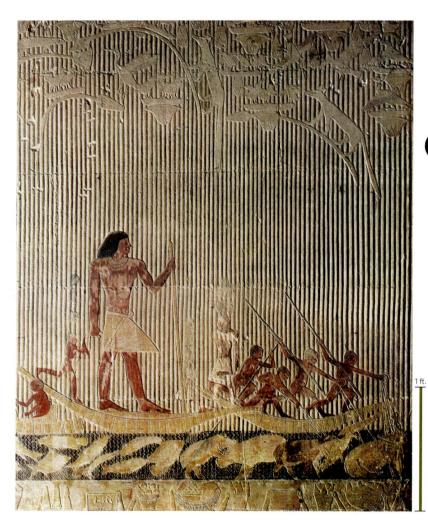

3-15 Ti watching a hippopotamus hunt, relief in the mastaba of Ti, Saqqara, Egypt, Fifth Dynasty, ca. 2450–2350 BCE. Painted limestone, 4' high.

In Egypt, a successful hunt was a metaphor for triumph over evil. In this painted tomb relief, the deceased stands aloof from the hunters busily spearing hippopotami. Ti's size reflects his high rank.

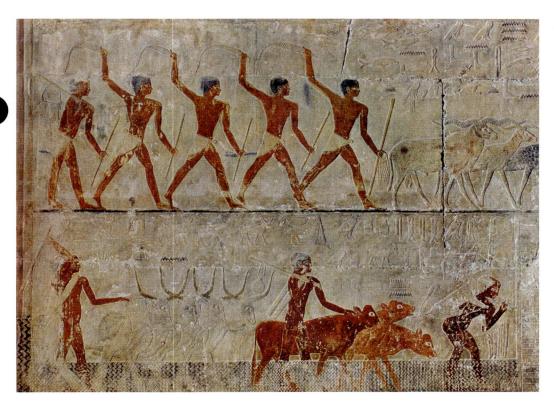

demonstrate that Egyptian artists could be close observers of daily life. The suppression of the anecdotal (that is, of the time-bound) from their representations of the deceased both in relief and in the round was a deliberate choice. Egyptian artists' primary purpose was to suggest the deceased's eternal existence in the afterlife, not to portray his activities while alive.

MIDDLE KINGDOM

About 2150 BCE, the Egyptians challenged the power of the weak kings of the Sixth Dynasty, and for more than a century the land was in a state of civil unrest and near anarchy. But in 2040 BCE, the king of Upper Egypt, Mentuhotep II (r. 2050–1998 BCE), managed to unite Egypt again under a single ruler and established the Middle Kingdom (11th to 14th Dynasties), which lasted 400 years.

Sculpture

Although in most respects Middle Kingdom sculptors adhered to the conventions established during the Old Kingdom, portraying both men and women in the familiar seated (FIG. 3-16A) and standing poses, there were some notable innovations.

SENUSRET III One of Mentuhotep II's successors was Senusret III (r. 1878–1859 BCE), who fought four brutal military campaigns in Nubia (MAP 3-1). Although Egyptian armies devastated the land and poisoned the wells, Senusret never fully achieved secure control over the Nubians. In Egypt itself, he attempted, with greater success, to establish a more powerful central government.

Senusret's portraits (FIG. **3-17**) are of special interest because they represent a sharp break from Old Kingdom practice. Although the king's

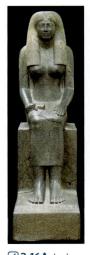

3-16A Lady Sennuwy, Kerma, ca. 1960-1916 BCE.

3-16 Goats treading seed and cattle fording a canal, painted limestone reliefs in the mastaba of Ti, Saqqara, Egypt, Fifth Dynasty, ca. 2450–2350 BCE.

The fording of the Nile was a metaphor for the passage to the afterlife. These reliefs combine stereotypical poses for humans and animals with unconventional postures and anecdotal details.

preserved statues have idealized bodies, the sculptors brought a stunning and unprecedented realism to the rendition of the king's features. His pessimistic expression reflects the dominant mood of the time, echoed in Middle Kingdom literature. The strong mouth, the drooping lines about the nose and eyes, and the shadowy brows show a determined ruler who had also shared in the cares of the world, sunk in brooding

meditation. The portrait is different in kind from the typically impassive faces of the Old Kingdom. It is personal, almost intimate, in its revelation of the mark of anxiety that a troubled age might leave on the soul of a king.

3-17 Fragmentary head of Senusret III, 12th Dynasty, ca. 1860 BCE. Red quartzite, $6\frac{1}{2}$ high. Metropolitan Museum of Art, New York.

Senusret III's portraits exhibit an unprecedented realism. The king's brooding expression reflects the mood of the time and contrasts sharply with the impassive faces of Old Kingdom pharaohs.

3-18 Tomb of Khnumhotep II (tomb 3), Beni Hasan, Egypt, 12th Dynasty, ca. 1900–1880 BCE.

The tombs of Beni Hasan are characteristic of the Middle Kingdom. Hollowed out of the cliffs, these tombs often have a shallow columnar porch, which leads into a columned hall and burial chamber.

Architecture

Senusret III's tomb, at Dashur, is a mudbrick pyramid, but the most characteristic burials of the Middle Kingdom are rock-cut tombs. This kind of tomb, documented also in the Old Kingdom, became especially popular during the Middle Kingdom and largely replaced the mastaba as the standard Egyptian tomb type.

BENI HASAN Some of the best preserved Middle Kingdom tombs are those of local officials at Beni Hasan. Hollowed out of the cliffs, the most elaborate examples, such as the 12th Dynasty tomb of Khnumhotep II (FIG. 3-18), have a shallow columnar porch, which leads into a columned hall and then into a burial chamber featuring statues of the deceased in niches, and paintings and painted reliefs on the walls. In the neighboring tomb of Amenemhet (FIG. 3-19), the columns in the hall serve no supporting function because, like the porch columns, they are continuous parts of the rock fabric. (Note the broken column in the rear suspended from the ceiling like an icicle.) The column shafts have flutes, like those in the entrance corridor (FIG. 3-6A) of Djoser's mortuary precinct at Saggara. The Beni Hasan columns are more formalized versions of Imhotep's earlier columns, which still look like bundles of reeds. The Middle Kingdom columns closely resemble later Greek columns of the Doric order (FIG. 5-13, left), and there is no doubt that the Greeks knew about and emulated many aspects of Egyptian architecture (see page 113). Archaeologists believe that the kind of fluting used for

the Beni Hasan column shafts derived from the carving of softwood trunks with the rounded cutting edge of the adze.

NEW KINGDOM

The Middle Kingdom collapsed when the Hyksos descended on Egypt from the Syrian and Mesopotamian uplands. They ruled the Nile Delta and Lower Egypt during what historians call the Sec-

3-19 Interior hall of the rock-cut tomb of Amenemhet (tomb 2), Beni Hasan, Egypt, 12th Dynasty, ca. 1900–1880 BCE.

Stonemasons carved the columnar hall of Amenemhet's tomb out of the living rock, which explains the suspended broken column at the rear. The shafts have flutes, a form that Greek architects later emulated.

ond Intermediate Period until, in the mid-16th century, native Egyptian kings of the 17th Dynasty rose up in revolt. Ahmose I (r. 1550–1525 BCE), final conqueror of the Hyksos and first king of the 18th Dynasty, ushered in the New Kingdom, the most glorious period in Egypt's long history. At this time, Egypt extended its borders by conquest from the Euphrates River in the northeast deep into Nubia to the south (MAP 3-1). A new capital—Thebes, in Upper Egypt—became a great metropolis with magnificent palaces, tombs, and temples along both banks of the Nile. During the New Kingdom, the Egyptian kings became known as *pharaohs*, the term commonly, if incorrectly, used to refer to Egyptian rulers of all periods.

Architecture

If the most impressive monuments of the Old Kingdom are its pyramids, those of the New Kingdom are its grandiose temples, some built to worship the state gods, others as mortuary temples, which

ART AND SOCIETY

Hatshepsut, the Woman Who Would Be King

In 1479 BCE, Thutmose II, the fourth pharaoh of the 18th Dynasty (r. 1492–1479 BCE), died. His principal wife (and half sister), Queen Hatshepsut (r. 1473–1458 BCE), had not given birth to any sons who survived, so the title of king went to Thutmose III, son of Thutmose II by a minor wife. Hatshepsut became regent for the boy-king. Within a few years, however, the queen proclaimed herself pharaoh and insisted that her father Thutmose I had chosen her as his successor during his lifetime. Underscoring her claim, one of the reliefs decorating Hatshepsut's enormous funerary complex (FIG. 3-20) depicts Thutmose I crowning his daughter as king in the presence of the Egyptian gods. Other reliefs (FIG. 3-22) represent her many achievements during her reign.

Hatshepsut is the first great female monarch whose name has been recorded. (In the 12th Dynasty, Sobekneferu was crowned king of Egypt, but she reigned for only a few years.) As pharaoh for two decades, Hatshepsut ruled what was then the most powerful and prosperous empire in the world.

Hatshepsut commissioned numerous building projects, and sculptors produced portraits of the female pharaoh in great numbers for display in those complexes. Unfortunately, Thutmose III (r. 1458–1425 BCE), for reasons still not fully understood, late in his reign ordered Hatshepsut's portraits destroyed. In her surviving portraits, Hatshepsut uniformly wears the costume of the male pharaohs, with royal headdress and kilt, and in some cases (FIG. 3-21) even a false ceremonial beard. (Many inscriptions refer to Hatshepsut as "His Majesty.") In other statues, however, Hatshepsut has delicate features, a slender frame, and breasts, leaving no doubt that artists also represented her as a woman.

3-20 Mortuary temple of Hatshepsut (looking southwest), Deir el-Bahri, Egypt, 18th Dynasty, ca. 1473-1458 BCE.

Hatshepsut was the first great female monarch whose name is recorded. Her immense funerary temple incorporated shrines to Amen, whom she claimed was her father, and to Hathor and Anubis.

provided the pharaohs with a place for worshiping their patron gods during their lifetimes and then served as temples in their own honor after their death. The greatest of these arose along the Nile in the Thebes district during the 18th and 19th Dynasties.

DEIR EL-BAHRI The most distinctive of the royal mortuary temples (FIG. **3-20**) is at Deir el-Bahri, erected by and for the female pharaoh Hatshepsut, one of the most remarkable women of the ancient world (see "Hatshepsut, the Woman Who Would Be King," above). Some Egyptologists attribute the temple to SENENMUT (FIG. 3-27), Hatshepsut's chancellor, described in two inscriptions as the queen's architect. His association with this project is uncertain, however. Hatshepsut's temple rises from the valley floor in three columnlined terraces connected by ramps on the central axis. It is striking

how visually well suited the structure is to its natural setting. The long horizontals and verticals of the *colonnades* and their rhythm of light and dark repeat the pattern of the limestone cliffs above.

As imposing as it is today, Hatshepsut's mortuary temple was once part of an even larger complex with a causeway connecting it to a now-lost valley temple. The multilevel funerary temple proper incorporated shrines to Amen, Hathor, and Anubis, as well as to Hatshepsut and her father, Thutmose I. As many as 200 statues in the round portraying the queen in various guises were on display throughout the vast complex. On the lowest terrace, to either side of the processional way, statues repeatedly represented Hatshepsut as a sphinx. On the uppermost level, the royal sculptors depicted the female pharaoh standing, seated, and as Osiris (compare FIG. 3-23A). At least eight colossal kneeling statues in red granite lined the way to

3-21 Hatshepsut with offering jars, from the upper court of her mortuary temple, Deir el-Bahri, Egypt, 18th Dynasty, ca. 1473–1458 BCE. Red granite, 8' 6" high. Metropolitan Museum of Art, New York.

Hatshepsut's successor destroyed many of her portraits. Conservators reassembled this one, which depicts the queen as a male pharaoh, consistent with inscriptions calling her "His Majesty."

the entrance of the Amen-Re sanctuary. The statue reproduced here (FIG. 3-21) suffered the same fate as most of Hatshepsut's portraits during the reign of Thutmose III. Vandals smashed it and threw the pieces in a dump, but conservators have skillfully reassembled the portrait. Hatshepsut holds a globular offering jar in each hand as she takes part in a ritual in honor of the gods. (A king kneels only before a god, never a mortal.) She wears the royal male nemes headdress and the pharaoh's ceremonial beard (compare FIGS. 3-12, 3-13, and 3-35). The agents of Thutmose III hacked off the uraeus cobra that once adorned the front of the headdress. The figure is also anatomically male, although other surviving portraits of Hatshepsut represent her with a woman's breasts. The male imagery, however, is consistent with the queen's formal assumption of the title of king and with the many inscriptions addressing her as a man (see "Hatshepsut," page 69).

Complementing the array of portrait statues was an extensive series of reliefs glorifying Hatshepsut and her reign—the first great tribute to a woman's achievements in the history of art. In the middle colonnade of the second level, for example, painted limestone reliefs commemorated Hatshepsut's divine birth. Hatshepsut claimed to be the daughter of Amen, who had assumed the form of the pharaoh Thutmose I in order to impregnate her mother, the king's principal wife. Other reliefs depicted the impressive engineering feat of transporting huge granite *obelisks* (tall *monolithic*—one-piece—*pillars*

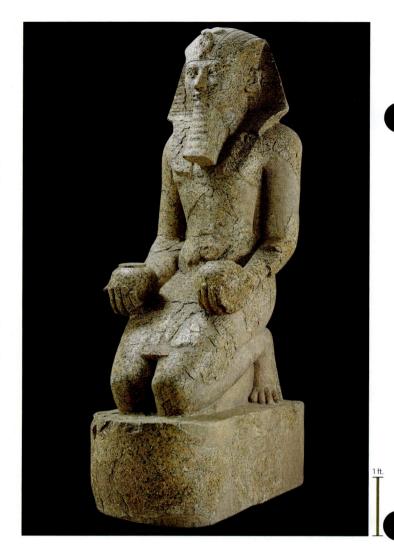

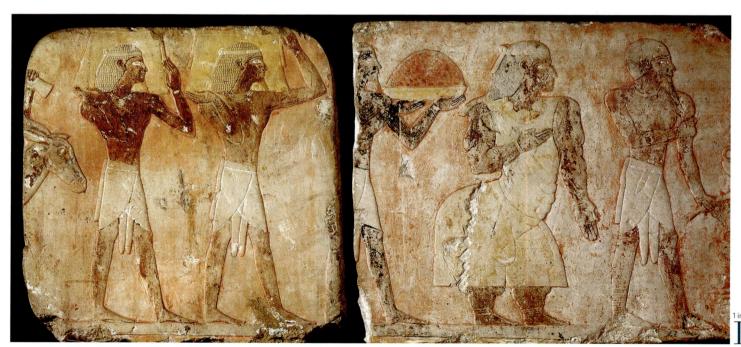

3-22 King and queen of Punt and attendants, relief from the mortuary temple of Hatshepsut, Deir el-Bahri, Egypt, 18th Dynasty, ca. 1473–1458 BCE. Painted limestone, 1' 3" high. Egyptian Museum, Cairo.

Painted limestone reliefs throughout Hatshepsut's mortuary temple complex celebrated her reign, her divine birth, and her successful expedition to the kingdom of Punt on the Red Sea.

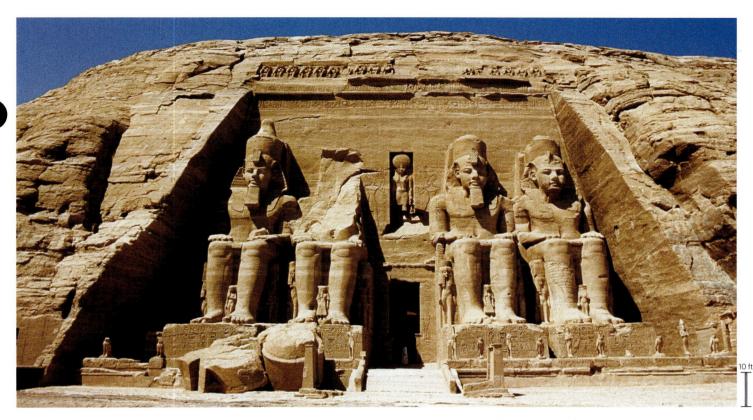

3-23 Facade of the temple of Ramses II, Abu Simbel, Egypt, 19th Dynasty, ca. 1290–1224 BCE. Sandstone, colossi 65' high.

Four rock-cut images of Ramses II dominate the facade of his mortuary temple at Abu Simbel in Nubia. The colossal portraits are a dozen times the height of a man, even though the pharaoh is seated.

with pyramidal tops, symbols of the sun god Re) from the Aswan quarries to the temple of Amen-Re (FIG. 3-24) at Karnak.

The relief illustrated here (FIG. 3-22) is one of those documenting Hatshepsut's successful expedition to Punt, famed for its gold, myrrh, and other exotic natural resources. The reliefs record the sea journey, the precious cargo of gold and frankincense trees the Egyptians brought back with them, and the people, animals, and houses the Egyptians found in Punt. In this detail, bare-chested men carry the local goods that the Egyptians will load onto their ships. Leading the procession are two figures that art historians traditionally identify as the king and queen of Punt. The Egyptian sculptor depicted the queen as an obese and misshapen woman. Scholars debate whether this is an accurate portrayal or an exaggeration designed to underscore the foreignness of the Punt queen.

ABU SIMBEL The sheer size of Hatshepsut's mortuary temple never fails to impress visitors, and this is no less true of the immense rock-cut temple (FIG. **3-23**) of Ramses II (r. 1290–1224 BCE) at Abu Simbel in Nubia, territory Ahmose I acquired after his victory over the Hyksos (see page 68). In 1968, to save the Nubian monument from submersion in the Aswan High Dam reservoir, engineers cut the temple into sections and reassembled it nearly 700 feet away, resting against a new artificial mountain they had constructed—an amazing achievement in its own right.

Ramses, Egypt's last great warrior pharaoh, ruled for twothirds of a century, an extraordinary accomplishment even in peacetime in an era when life expectancy was far shorter than it is today. The king, proud of his many campaigns to restore the empire, proclaimed his greatness by placing four colossal images of himself on the temple facade. The portraits are 65 feet tall—almost a dozen times the height of an ancient Egyptian, even though the pharaoh is seated. Spectacular as they are, the rock-cut statues nonetheless lack the refinement of earlier periods, because the sculptors sacrificed detailed carving to overwhelming size. This trade-off

3-23A Interior of temple of Ramses II, Abu Simbel, ca. 1290-1224 BCE.

is characteristic of colossal statuary of every period and every place (compare Fig. 16-16). The immense rock-cut interior (Fig. **3-23A**) of the Abu Simbel temple also makes an indelible impression.

Ramses, like other pharaohs, had many wives, and he fathered scores of sons. The pharaoh honored the most important members of his family with grandiose monuments of their own. At Abu Simbel, for example, north of his temple, Ramses ordered the construction of a temple for his principal wife, Nefertari. Huge rock-cut statues—four standing images of the king and two of the queen—dominate the temple's facade. For his sons, Ramses constructed an enormous underground tomb complex in the Valley of the Kings at Thebes, which an American team rediscovered in 1987. Robbers looted the tomb within a half century of its construction, but archaeologists have yet to find the royal burial chambers in the complex, so the tomb may yet yield important artworks.

KARNAK Distinct from the New Kingdom temples honoring pharaohs and queens are the edifices built to honor one or more of the gods. Successive kings often added to these sanctuaries until they

3-24 Aerial view of the temple of Amen-Re (looking east), Karnak, Egypt, major construction 15th–13th centuries BCE.

The vast Karnak temple complex contains a pylon temple with a bilaterally symmetrical axial plan and an artificial lake associated with the primeval waters of the Egyptian creation myth.

reached gigantic size. The temple of Amen-Re (FIG. **3-24**) at Karnak, for example, begun during the Middle Kingdom, was largely the work of 18th Dynasty pharaohs, including Thutmose I and III and Hatshepsut, but Ramses II (19th Dynasty) also contributed sec-

The Karnak temple and similar New Kingdom temples, such as the equally huge one at nearby Luxor (FIG. **3-24A**), all had similar *axial plans*. A typical *pylon temple* (the name derives from the sanctuaries' simple and massive gateways, or *pylons*, with sloping walls forming two wings flanking a central doorway) is bilaterally symmetrical along a single axis that runs from an approaching avenue through a colonnaded court and hall and then into the sanctuary proper. Axial plans are characteristic of much of Egyptian architecture. Nar-

row corridors on the longitudinal axis are also the approaches to the Gizeh pyramids (FIG. 3-10) and to Hatshepsut's multilevel mortuary temple (FIG. 3-20). Marking the end of the statuary-lined approach to a New Kingdom temple was the monumental facade of the pylon (FIG. 3-24, *bottom left*). The pylon faced the Nile, from which festi-

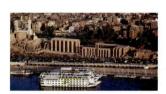

3-24A Temple of Amen-Re, Luxor, begun early 14th century BCE.

val processions arrived by boat, and served as a symbolic barrier between the chaotic world and the sacred ordered precinct within. New Kingdom sculptors routinely covered pylons with reliefs glorifying their rulers (FIG. 3-39), especially in their role as defenders of order who defeat all who pose a threat to Egypt's stability. Beyond the pylon was an open court with columns on two or more sides, followed by a hall (FIG. 3-24, center) between the court and sanctuary, its long axis placed at right angles to the corridor of the entire building complex. Only the pharaohs and the priests could enter the mysterious dark inner shrine at the culmination of the sacred path. The darkness called to mind the moment of creation out of the primeval waters. A chosen few were admitted to the great columnar hypostyle hall (a hall with a roof resting on columns; FIGS. 3-25 and 3-26), shrouded in semidarkness but with light admitted through a

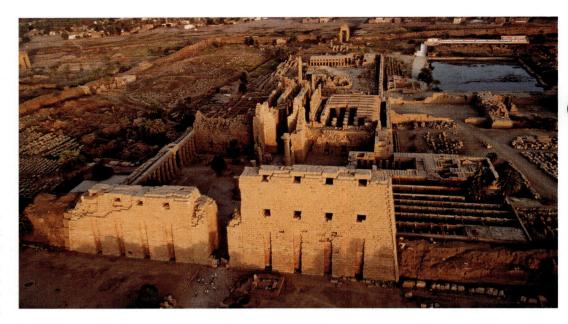

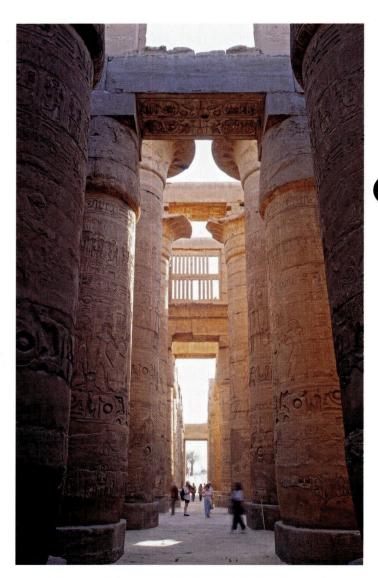

3-25 Columns and clerestory of the hypostyle hall of the temple of Amen-Re, Karnak, Egypt, 19th Dynasty, ca. 1290–1224 BCE.

Columns crowd the hypostyle hall of the Amen-Re temple. The tallest are 66 feet high and have capitals that are 22 feet in diameter. The columns support a roof of stone slabs carried on lintels.

PROBLEMS AND SOLUTIONS

Illuminating Buildings before Lightbulbs

Until the invention of the electric lightbulb, one of the central problems all architects had to confront was how to illuminate a roofed interior without depending solely on torches and lamps, which were fire hazards. As early as the Old Kingdom in the valley temple of Khafre at Gizeh, Egyptian architects experimented with a way to admit natural light using a device called the *clerestory*. One of the most effective examples of clerestory lighting is in the hypostyle hall (FIGS. 3-25 and 3-26) of the New Kingdom pylon temple at Karnak (FIG. 3-24).

Filling Karnak's gigantic (58,000-square-foot) hypostyle hall are massive columns, which support a roof of stone slabs carried on lintels. The 134 sandstone columns have bud-cluster or bell-shaped capitals resembling lotus or papyrus, the plants symbolizing Upper and Lower Egypt. The 12 central columns are 75 feet high, and the capitals are 22 feet in diameter at the top, large enough to hold a hundred people. The Egyptians, who used no mortar, depended on precise cutting of the joints and the weight of the huge stone blocks to hold the columns in place. The two central rows of columns are taller than those at the sides. The purpose of raising the roof's central section was to create a clerestory, an elevated additional story with openings enabling sunlight to filter into the interior, although the Karnak hall's stone grilles (Fig. 3-25) would have blocked much of the light.

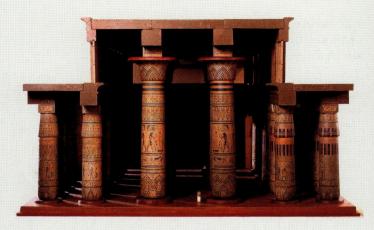

3-26 Model of the hypostyle hall, temple of Amen-Re, Karnak, Egypt, 19th Dynasty, ca. 1290–1224 BCE. Metropolitan Museum of Art, New York.

The two central rows of columns of Karnak's hypostyle hall are taller than the rest. Raising the roof's central section created a clerestory that admitted light through windows with stone grilles.

The clerestory is evidently an Egyptian innovation, and its significance cannot be overstated. Clerestories played a key role in the history of architecture until very recently.

clerestory illuminating the axial corridor (see "Illuminating Buildings before Lightbulbs," above). The majority of the people could proceed only as far as the sun-drenched open court.

Sculpture and Painting

Although the Egyptians lavishly decorated the great temple complexes of the New Kingdom with statues and painted reliefs, many of the finest examples of statuary and mural painting adorned tombs, as in the Old and Middle Kingdoms.

SENENMUT AND NEFRURA *Block statues* were popular during the New Kingdom. In these works, Egyptian sculptors expressed the idea that the ka could find an eternal home in the cubic stone image of the deceased in an even more radical simplification of form than was common in Old Kingdom statuary. In the statue illustrated here (FIG. **3-27**) depicting Senenmut, Hatshepsut's chancellor and possible lover, with her daughter, Nefrura, the streamlined design concentrates attention on the heads. The sculptor treated the two bodies as a single cubic block, given over to inscriptions. Senenmut holds the pharaoh's daughter by Thutmose II in his "lap" and envelops the girl in his cloak. The polished stone shape has its own simple beauty, with the surfaces turning subtly about smoothly rounded corners. The work—one of many surviving statues depicting Senenmut with the princess—is also a

3-27 Senenmut with Princess Nefrura, from Thebes, Egypt, 18th Dynasty, ca. 1470–1460 BCE. Granite, $3'\frac{1}{2}"$ high. Ägyptisches Museum, Staatliche Museen zu Berlin, Berlin.

Hatshepsut's chancellor holds the queen's daughter in his "lap" and envelops her in his cloak. New Kingdom block statues exhibit a more radical simplification of form than do Old Kingdom statues.

reflection of the power of Egypt's queen. The frequent depiction of Senenmut with Nefrura enhanced the chancellor's stature through his association with the pharaoh's daughter (he was her tutor) and, by implication, with Hatshepsut herself.

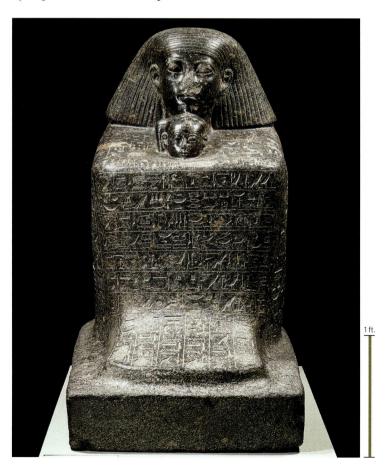

3-28 Fowling scene, from the tomb of Nebamun, Thebes, Egypt, 18th Dynasty, ca. 1400–1350 BCE. Fresco secco, 2' 8" high. British Museum, London.

Nebamun's wife and daughter—depicted smaller than the deceased—accompany him on his hunt for fowl. An inscription states that Nebamun is enjoying recreation in his eternal afterlife.

TOMB OF NEBAMUN Some of the best-preserved mural paintings of the New Kingdom come from the Theban tomb of Nebamun, whose official titles were "scribe and counter of grain." On one wall (FIG. 3-28), the painter depicted Nebamun standing in his boat, flushing birds from a papyrus swamp. The hieroglyphic text beneath his left arm says that Nebamun is enjoying recreation in his eternal afterlife. (Here, as elsewhere in Egyptian art, the accompanying text amplifies the message of the picture—and vice versa.) In contrast to the static pose of Ti watching others hunt hippopotami (FIG. 3-15), Nebamun strides forward and vigorously swings his throwing stick. In his right hand, he holds three birds he has caught. His hunting cat, impossibly perched on a papyrus stem just in front of and below him, has caught two more in its claws and is holding the wings of a third in its teeth. Nebamun's wife and daughter accompany him on this hunt and hold the lotuses (Egyptian symbols of rebirth) they have gathered. The artist scaled down the figures in proportion to their rank, as did Old Kingdom artists. As in Ti's tomb, the painter

The painting technique, also employed in earlier Egyptian tombs, is *fresco secco* (dry fresco), in which artists let the plaster dry before painting on it. This procedure, in contrast to true fresco

depicted the animals naturalistically, based on careful observation.

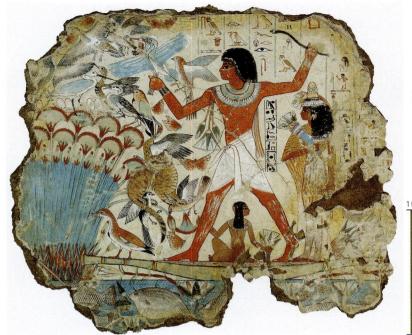

painting on wet plaster (see "Fresco Painting," page 419), enabled slower and more meticulous work than painting on fresh plaster, which had to be completed before the plaster dried. Fresco secco, however, is not as durable as true fresco painting, because the colors do not fuse with the wall surface.

Another fresco fragment (FIG. 3-29) from Nebamun's tomb shows noblewomen watching and apparently participating in a musical performance in which two nimble and almost nude girls dance in front of the guests at a banquet. When his family buried

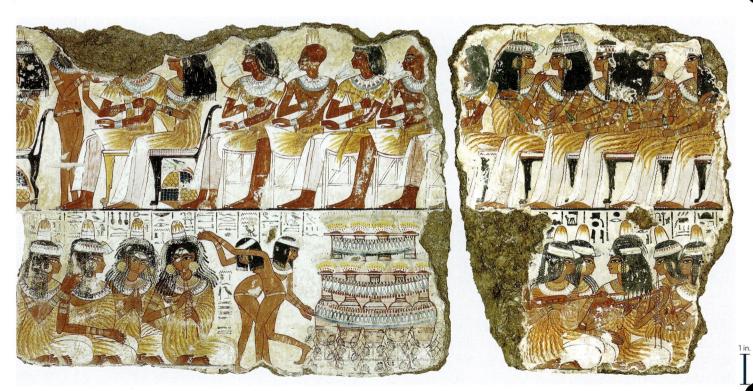

3-29 Musicians and dancers, detail of a mural from the tomb of Nebamun, Thebes, Egypt, 18th Dynasty, ca. 1400–1350 BCE. Fresco secco, 1' × 2' 3". British Museum, London.

A second fresco in Nebamun's tomb represents a funerary banquet in which the artist experimented with frontal views of faces and bodies—a relaxation of the Old Kingdom's strict rules of representation.

Nebamun, they must have eaten the customary ceremonial meal at his tomb. His relatives would have returned one day each year to partake in a commemorative banquet during which the living communed with the dead. This fresco represents one of these funerary feasts, with an ample supply of wine jars at the right. It also shows that New Kingdom artists did not always adhere to the old norms for figural representation. This painter carefully recorded the dancers' overlapping figures, their facing in opposite directions, and their rather complicated gyrations, producing a pleasing intertwined motif at the same time. The profile view of the dancers is consistent with their lower stature in the Egyptian hierarchy. The New Kingdom artist reserved the composite view for Nebamun and his family. Of the four seated women, the two at the left are represented conventionally, but the other two face the observer in what is a rarely attempted frontal pose. They clap and beat time to the dance, while one of them plays the reeds. The painter took careful note of the soles of their feet as they sit cross-legged and suggested the movement of the women's heads by the loose arrangement of their hair strands. This informality also constitutes a relaxation of the Old Kingdom's strict rules of representation.

The frescoes in Nebamun's tomb testify to the luxurious life of the Egyptian nobility, filled with good food and drink, fine musicians, lithe dancers, and leisure time to hunt and fish in the marshes. Still, as in the earlier tomb of Ti, the scenes should be read both literally and allegorically. Although Nebamun enjoys himself in the afterlife, the artist symbolically asked viewers to recall how he got there. Hunting scenes reminded Egyptians of Horus, the son of Osiris, hunting down his father's murderer, Seth, the god of disorder (see "The Gods and Goddesses of Egypt," page 58). Successful hunts were metaphors for triumphing over death and disorder, ensuring a happy existence in the afterlife. Music and dance were sacred to Hathor, who aided the dead in their passage to the other world. The sensual women at the banquet are a reference to fertility, rebirth, and regeneration.

Akhenaton and the Amarna Period

Not long after his family laid Nebamun to rest in his tomb at Thebes, a revolution occurred in Egyptian religion and society. In the mid-14th century BCE, Amenhotep IV, later known as Akhenaton (r. 1353-1335 BCE), abandoned the worship of most of the Egyptian gods in favor of Aton, identified with the sun disk, whom the pharaoh declared to be the universal and only god. Akhenaton deleted the name of Amen from all inscriptions and even from his own name and that of his father, Amenhotep III (r. 1390-1352 BCE). He emptied the great temples, enraged the priests, and moved his capital downriver from Thebes to present-day Amarna, a site he named Akhetaton ("horizon of Aton"). The pharaoh claimed to be both the son and sole prophet of Aton. To him alone did the god reveal himself. Moreover, in stark contrast to earlier practice, painters and sculptors represented Akhenaton's god neither in animal nor in human form (nor composite human-animal form; compare FIG. 3-1) but simply as the sun disk emitting life-giving rays (FIG. 3-33). The pharaohs who followed Akhenaton reestablished the Theban cult and priesthood of Amen at Karnak (FIG. 3-24) and elsewhere and restored Amen's temples and inscriptions. Akhenaton's brief religious revolution was soon undone, and his new city largely abandoned.

During the brief heretical episode of Akhenaton, profound changes also occurred in Egyptian art. A colossal statue (FIG. **3-30**) of Akhenaton, one of several from Karnak toppled and buried after his death, retains the standard frontal pose of traditional Egyptian

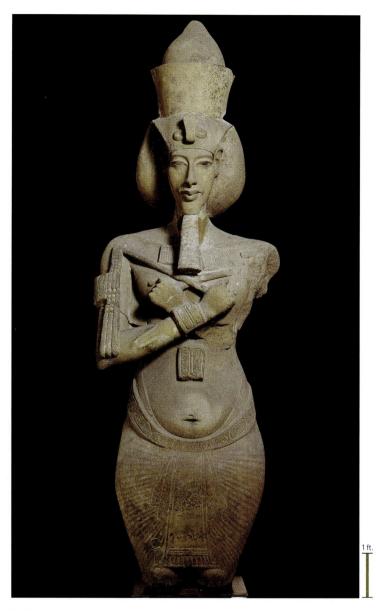

3-30 Akhenaton, colossal statue from the temple of Aton, Karnak, Egypt, 18th Dynasty, ca. 1353–1335 BCE. Sandstone, 13' high. Egyptian Museum, Cairo.

Akhenaton initiated both religious and artistic revolutions. This androgynous figure is a deliberate reaction against tradition. It may be an attempt to portray the pharaoh as Aton, the sexless sun disk.

royal portraits. But the effeminate body, with its curving contours, and the long face with full lips and heavy-lidded eyes are a far cry indeed from the heroically proportioned figures of the pharaoh's predecessors (compare Fig. 3-13). Akhenaton's body is curiously misshapen, with weak arms, a narrow waist, protruding belly, wide hips, and fatty thighs. Modern physicians have tried to explain his physique by attributing a variety of illnesses to the pharaoh. They cannot agree on a diagnosis, and their premise—that the statue is an accurate depiction of a physical deformity—is probably faulty. Some art historians think Akhenaton's portrait is a deliberate artistic reaction against the established style, paralleling the suppression of traditional religion. They argue that Akhenaton's artists tried to formulate a new androgynous image of the pharaoh as the manifestation of Aton, the sexless sun disk. But no consensus exists other than that the style was revolutionary and short-lived.

NEFERTITI AND TIYE A painted limestone bust (FIG. **3-31**) of Akhenaton's queen, Nefertiti (her name means "the beautiful one has come"), also breaks with the past. The portrait exhibits an expression of entranced musing and an almost mannered sensitivity and delicacy of curving contour. Excavators discovered the bust in the Amarna workshop of the sculptor Thutmose. Although one scholar has recently questioned its authenticity, art historians still consider the portrait to be a genuine work, a deliberately unfinished model very likely by the master's own hand. The left eye socket still lacks the inlaid eye, making the face a kind of before-and-after

demonstration piece. With this elegant bust, Thutmose may have been alluding to a heavy flower on its slender stalk by exaggerating the weight of the crowned head and the length of the almost serpentine neck. The sculptor seems to have adjusted the likeness of his subject to meet the era's standard of spiritual beauty.

In contrast, the miniature head (FIG. **3-32**) of Queen Tiye, mother of Akhenaton, is a moving portrait of old age. Although not of royal birth, Tiye was the daughter of a high-ranking official and became the chief wife of Amenhotep III. Archaeologists unearthed her portrait, carved of dark yew wood (possibly to match her

3-31 Thutmose, bust of Nefertiti, from Amarna, Egypt, 18th Dynasty, ca. 1353–1335 BCE. Painted limestone, 1' 8" high. Ägyptisches Museum, Staatliche Museen zu Berlin, Berlin.

Found in the sculptor's workshop, Thutmose's bust of Nefertiti portrays Akhenaton's influential wife as an elegant beauty with a thoughtful expression and a long, delicately curved neck.

3-32 Portrait of Tiye, from Ghurab, Egypt, 18th Dynasty, ca. 1353–1335 BCE. Yew wood, gold, silver, alabaster, faience, and lapis lazuli, $8\frac{7}{8}$ " high. Ägyptisches Museum, Staatliche Museen zu Berlin, Berlin.

This portrait of Akhenaton's mother is carved of dark yew wood, possibly to match the queen's complexion. During her son's reign, the tall gold crown with the sun disk and cow horns was added.

3-33 Akhenaton and Nefertiti with their three daughters, from Amarna, Egypt, 18th Dynasty, ca. 1353–1335 BCE. Limestone, 1' ½" high. Ägyptisches Museum, Staatliche Museen zu Berlin, Berlin.

In this sunken relief, the Amarna artist provided a rare intimate look at the royal family in a domestic setting. Akhenaton, Nefertiti, and three of their daughters bask in the life-giving rays of Aton, the sun disk.

complexion), at Ghurab with other objects connected with the funerary cult of Amenhotep III. A sculptor probably remodeled the portrait during her son's reign to eliminate all reference to deities of the old religion. That is when the head acquired the present wig of plaster and linen with small blue beads and the tall crown consisting of cow horns, Aton's sun disk, and a pair of feathers. This type of crown is worn only by goddesses in Egyptian art, and it indicates that Tiye, like Egypt's god-kings, is divine. Nonetheless, Akhenaton's mother appears as an older woman with lines and furrows, consistent with the new relaxation of artistic rules in the Amarna age. The sculptor inlaid her heavy-lidded slanting eyes with alabaster and ebony, and painted the lips red. The earrings (one is hidden by the later wig) are of gold and lapis lazuli. The wig covers what was originally a silver-foil headdress. A gold band still adorns the forehead, and the tall crown is also made of hammered gold. Luxurious materials were common for royal portraits.

Both Nefertiti and Tiye figured prominently in the art and life of the Amarna age. Tiye, for example, regularly appeared in art beside her husband during his reign, and she apparently played an important role in his administration as well as her son's. Letters survive from foreign rulers advising the young Akhenaton to seek his mother's counsel in the conduct of international affairs. Nefertiti, too, was an influential woman. She frequently appears in reliefs of this period in which she not only equals her husband in size but also sometimes wears pharaonic headgear.

FAMILY OF AKHENATON A relief stele (FIG. **3-33**), perhaps from a private shrine, provides a rare look at this royal family. The style is familiar from the colossus of Akhenaton (FIG. 3-30) and the portrait

head of Nefertiti (FIG. 3-31). Undulating curves have replaced rigid lines, and the figures possess the prominent bellies that characterize figures of the Amarna period. The pharaoh, his wife, and three of their daughters bask in the rays of Aton, the sun disk, which end in hands holding the *ankh*, the sign of life. The mood is informal and anecdotal. Akhenaton lifts one of his daughters in order to kiss her. Another daughter sits on Nefertiti's lap and gestures toward her father, while the youngest daughter reaches out to touch a pendant on her mother's crown. This kind of intimate portrayal of the pharaoh and his family is unprecedented in Egyptian art, but it typifies the radical upheaval in art that accompanied Akhenaton's religious revolution.

The Akhenaton family portrait is a *sunken relief*. In this technique, the sculptor chisels deep outlines below the stone's surface instead of cutting back the stone around the figures to make them project from the surface. Sunken reliefs are much less subject to damage than high reliefs, and when used on columns, such as those in Karnak's hypostyle hall (FIG. 3-25), have the additional advantage of maintaining the shafts' contours.

The Tomb of Tutankhamen and the Post-Amarna Period

The most famous figure of the Post-Amarna period is Tutankhamen (r. 1333–1323 BCE), who was probably Akhenaton's son by a minor wife. Tutankhamen ruled for a decade and died at age 18. (Although some have speculated foul play, examination of the king's mummy in 2005 ruled out murder.) Tutankhamen was a very unimportant figure in Egyptian history, however. The public remembers him today solely because in 1922, Howard Carter (1874–1939), a British archaeologist,

3-34 Innermost coffin of Tutankhamen, from his tomb at Thebes, Egypt, 18th Dynasty, ca. 1323 BCE. Gold with inlay of enamel and semiprecious stones, 6' 1" long. Egyptian Museum, Cairo.

The boy-king Tutankhamen owes his fame today to his treasure-laden tomb. His mummy was encased in three nested coffins. The innermost one, made of gold, portrays the pharaoh as Osiris.

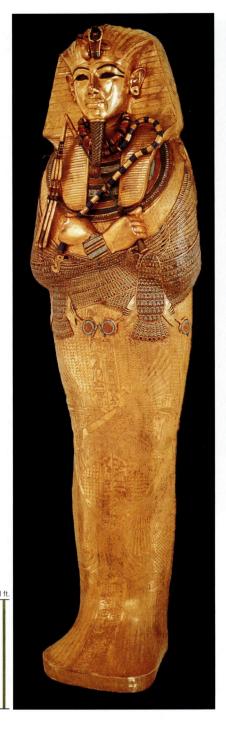

discovered the boy-king's tomb with its fabulously rich treasure of sculpture, furniture, and jewelry largely intact.

TUTANKHAMEN'S MUMMY. The principal item Carter found in Tutankhamen's tomb was the enshrined body of the pharaoh himself. The royal mummy reposed in the innermost of three coffins, nested one within the other. The innermost coffin (Fig. **3-34**) was the most luxurious of the three. Made of beaten gold (about a quarter ton of it) and inlaid with semiprecious stones such as lapis lazuli, turquoise, and carnelian, it is a supreme monument to the sculptor's and goldsmith's crafts. The portrait mask (Fig. **3-35**), which covered the king's face, is also made of gold with inlaid semiprecious stones. It is a sensitive portrayal of the serene adolescent king dressed in his official regalia, including the nemes headdress and false beard. The general effect of the mask and the tomb treasures as a whole is one

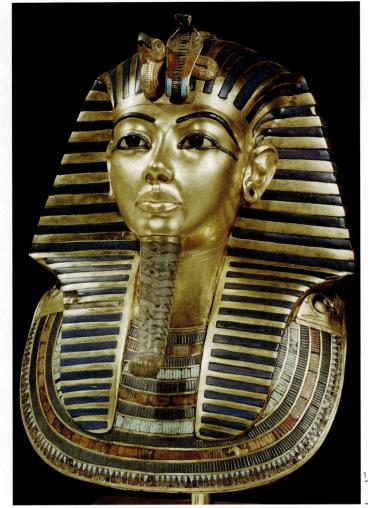

3-35 Death mask of Tutankhamen, from the innermost coffin in his tomb at Thebes, Egypt, 18th Dynasty, ca. 1323 BCE. Gold with inlay of semiprecious stones, 1' $9\frac{1}{4}$ " high. Egyptian Museum, Cairo.

The treasures in Tutankhamen's tomb include this mummy mask portraying the teenaged pharaoh with idealized features and wearing the traditional false beard and uraeus cobra headdress.

of grandeur and richness expressive of Egyptian power, pride, and limitless wealth.

TUTANKHAMEN AT WAR Although Tutankhamen probably was too young to fight, his position as king required that artists represent him as a conqueror, and he appears as a victorious general on a painted wood chest (FIG. 3-36) deposited in his tomb. The lid panel shows the king as a successful hunter pursuing droves of fleeing animals in the desert. On the side panels, the pharaoh, larger than all other figures, rides in a war chariot pulled by spirited, plumed horses. On the illustrated side, he draws his bow against a cluster of bearded Asian enemies (he battles Africans on the other side), who fall in confusion before him. (The absence of a ground line in an Egyptian painting or relief often implies chaos and death.) Tutankhamen slays the enemy, like game, in great numbers. Behind him are three tiers of smaller war chariots, which serve to magnify the king's figure and to increase the count of his warriors. The themes are traditional, but the fluid, curvilinear forms are features reminiscent of the Amarna style.

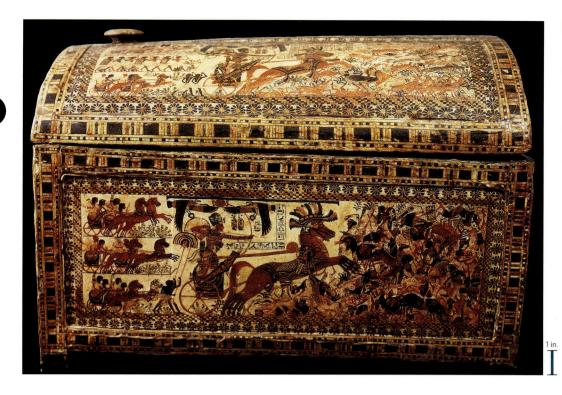

3-36 Painted chest, from the tomb of Tutankhamen, Thebes, Egypt, 18th Dynasty, ca. 1333–1323 BCE. Wood, 1'8" long. Egyptian Museum, Cairo.

In this representation of Tutankhamen triumphing over Asian enemies, the artist contrasted the orderly registers of Egyptian chariots with the chaotic pile of foreign soldiers who fall before the king.

FIRST MILLENNIUM BCE

During the first millennium BCE, Egypt lost the commanding role it had once played in the ancient world. The empire dwindled away, and foreign powers invaded and occupied the land until, beginning in the fourth century BCE, Alexander the Great of Macedon and his Greek successors and, eventually, the emperors of Rome replaced the pharaohs as rulers of the Kingdom of the Nile (see pages 142 and 195).

Kingdom of Kush

One of those foreign powers was Egypt's gold-rich neighbor to the south, the kingdom of Kush, part of which is in present-day Sudan. Called Nubia by the Romans, perhaps from the Egyptian word for *gold*, Kush appears in Egyptian texts as early as the Old Kingdom.

During the New Kingdom, the pharaohs colonized Nubia and appointed a viceroy of Kush to administer the Kushite kingdom, which included Abu Simbel (FIG. 3-23) and controlled the major trade route between Egypt and sub-Saharan Africa. But in the eighth century BCE, the Nubians conquered Egypt and established themselves as the 25th Dynasty.

TAHARQO Around 680 BCE, the Kushite pharaoh Taharqo (r. 690–664 BCE) constructed a temple at Kawa and placed a portrait of himself in it. Emulating traditional Egyptian types, the sculptor portrayed Taharqo as a sphinx (FIG. **3-37**; compare FIG. 3-11) with the ears, mane, and body of a lion but with a human face and a headdress featuring two uraeus cobras. The king's name is inscribed on his chest, and his features are distinctly African, although, as in all pharaonic portraiture, they are generic and idealized rather than a specific likeness.

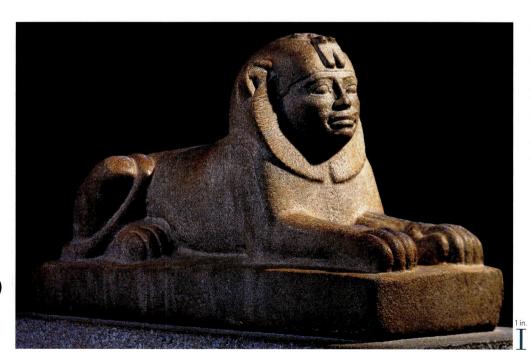

3-37 Taharqo as a sphinx, from temple T, Kawa, Sudan, 25th Dynasty, ca. 680 BCE. Granite, 1' 4" \times 2' $4\frac{3}{4}$ ". British Museum, London.

The Nubian kings who ruled Egypt during the 25th Dynasty adopted traditional Egyptian statuary types, such as the sphinx, but sculptors incorporated the Kushite pharaohs' distinctly African features.

3-38 Portrait statue of Mentuemhet, from Karnak, Egypt, 26th Dynasty, ca. 660–650 BCE. Granite, 4' 5" high. Egyptian Museum, Cairo.

Mentuemhet's portrait combines a realistic face with an idealized body. The costume and pose, however, differ only slightly from Old Kingdom statuary, a testimony to the longevity of stylistic modes in Egypt.

Thebes

The Kushite 25th Dynasty fell in turn to the Assyrians (see page 45), who sacked Thebes in 660 BCE. A rich and powerful man named Mentuemhet had the misfortune to be mayor of the city at the time.

MENTUEMHET In addition to his role as chief magistrate, Mentuemhet was the Fourth Prophet (priest) of Amen, and according to the inscriptions on works he commissioned, he was responsible for restoring the temples the Assyrians had razed. He placed portrait statues of himself in those temples and also in the tomb he constructed in a prominent place in the Theban necropolis. More than a dozen of his portraits survive, including the somewhat under lifesize granite statue illustrated here (FIG. 3-38).

Mentuemhet's portrait statues are typical of Egyptian sculpture at about the time the Greeks first encountered the art of the Nile region (see page 110). The pose is traditional, as is Mentuemhet's costume of kilt and wig, but the face, with its frank portrayal of the mayor's advanced age, is much more realistic than most earlier representations of elite men. In fact, almost all of Mentuemhet's portraits have idealized features. This one is an exception, but even here the trim, muscular body is that of a young man in the tradition of Old Kingdom royal portraits (FIG. 3-13). The sculptor removed the slab of stone that forms a backdrop to most earlier royal portraits,

3-39 Temple of Horus (looking east), Edfu, Egypt, ca. 237–47 BCE.

The pylon temple at Edfu is more than a thousand years later than that at Karnak (Fig. 3-24), but it adheres to the same basic architectural scheme. Egyptian artistic forms tended to have very long lives.

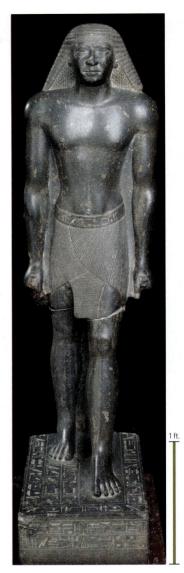

but left the stone block intact between the arms and the torso and between the legs, an artistic decision that contributes significantly to the immobile look of the statue, so appropriate for a timeless image of the deceased in his eternal afterlife. The stylistic similarity between Egyptian statues created 2,000 years apart is without parallel in the history of art.

After Alexander

Once formulated, Egyptian traditions tended to have very long lives, in architecture as in the other arts—even after Alexander the Great brought Greek rule and Greek culture to the Kingdom of the Nile.

TEMPLE OF HORUS, EDFU The temple of Horus (FIG. 3-39) at Edfu, built during the third, second, and first centuries BCE, still follows the basic pylon temple scheme that architects worked out more than a thousand years before (compare the New Kingdom temples at Karnak, Fig. 3-24, and Luxor, Fig. 3-24A). The great entrance pylon at Edfu is especially impressive. The broad surface of its massive facade, with its sloping walls, is broken only by the doorway and its overshadowing moldings at the top and sides, deep channels to hold great flagstaffs, and sunken reliefs. The reliefs celebrate King Ptolemy XIII (r. 51-47 BCE), coruler with (and younger brother and husband of) Egypt's last queen, Cleopatra VII (r. 51-30 BCE). Horus and Hathor witness a gigantic Ptolemy XIII smiting diminutive enemies—a motif first used in Egyptian reliefs and paintings in Predynastic times (FIGS. 3-1A and 3-2). The Edfu temple is eloquent testimony to the persistence of Egyptian architectural and pictorial types even under Greek rule.

Indeed, the exceptional longevity of formal traditions in Egypt is one of the marvels of the history of art. It attests to the invention of an artistic style so satisfactory that it endured in Egypt for millennia. Everywhere else in the ancient Mediterranean, stylistic change was the only common denominator.

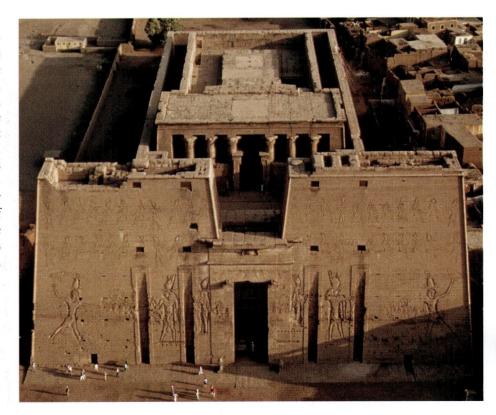

EGYPT FROM NARMER TO CLEOPATRA

Predynastic and Early Dynastic Periods ca. 3500-2575 BCE

- The unification of Upper and Lower Egypt into a single kingdom under the rule of a divine king occurred around 3000-2920 BCE. The earliest labeled work of narrative art, the palette of King Narmer, probably commemorates the event. Predynastic works such as the Narmer palette established the basic principles of most Egyptian representational art for 3,000 years.
- Imhotep, the first artist in history whose name is known, was the earliest master of monumental stone architecture. He designed the funerary complex and stepped pyramid of King Djoser (r. 2630–2611 BCE) at Saqqara.

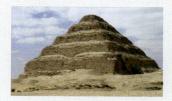

Stepped pyramid of Djoser, Saqqara, ca. 2630–2611 BCE

Old Kingdom ca. 2575-2134 BCE

- The Old Kingdom was the first golden age of Egyptian art and architecture, the time when three kings of the Fourth Dynasty erected the pyramids at Gizeh, the oldest of the Seven Wonders of the ancient world. The pyramids were emblems of the sun on whose rays the god-kings ascended to the heavens when they died.
- Old Kingdom sculptors created seated and standing statuary types in which, as in the portrait of King Khafre, all movement was suppressed in order to express the eternal nature of divine kingship. These types would dominate Egyptian art for 2,000 years.

Khafre enthroned, ca. 2520-2494 BCE

Middle Kingdom ca. 2040-1640 BCE

- After an intermediate period of civil war, Mentuhotep II (r. 2050-1998 BCE) reestablished central rule and founded the Middle Kingdom.
- The major artistic innovation of this period was a new kind of royal portrait with heightened emotional content.
- Rock-cut tombs in which sculptors hewed both the facade and interior chambers out of the living rock replaced the mastaba as the standard Egyptian burial monument.

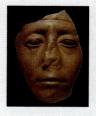

Senusret III, ca. 1860 BCE

New Kingdom ca. 1550-1070 BCE

- During the New Kingdom, Egypt extended its borders to the Euphrates River in the east and deep into Nubia in the south.
- The most significant architectural innovation of this period was the axially planned pylon temple incorporating an immense gateway, columnar courtyards, and a hypostyle hall with clerestory lighting.
- Powerful pharaohs such as Hatshepsut (r. 1473-1458 BCE) and Ramses II (r. 1290-1224 BCE) erected gigantic temples in honor of their patron gods and, after their deaths, for their own worship.
- Akhenaton (r. 1353-1335 BCE) abandoned the traditional Egyptian religion in favor of Aton, the sun disk, and initiated a short-lived artistic revolution in which undulating curves and anecdotal content replaced the cubic forms and impassive stillness of earlier Egyptian art.

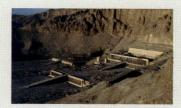

Mortuary temple of Hatshepsut, Deir el-Bahri, ca. 1473–1458 BCE

First Millennium BCE 1000-30 BCE

- After the demise of the New Kingdom, Egypt's power in the ancient world declined, and the Nile came under the control of foreigners. These included the Kushite kings of Nubia and, after 332 BCE, Alexander the Great and his Greek successors. In 30 BCE, Egypt became a province of the Roman Empire.
- The traditional forms of Egyptian art and architecture lived on even under foreign rule—for example, in the portrayal of the pharaoh as a sphinx.

Taharqo as a sphinx, ca. 680 BCE

▼ **4-1a** The Hagia Triada sarcophagus provides insight into Minoan rituals. A woman pours a liquid (ox blood?) between two double axes. Accompanying her are a second woman carrying vessels and a male harp player.

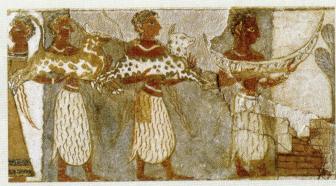

▲ **4-1b** Three men (with dark skin) moving in the opposite direction carry sculptures of two sacrificial animals and a model of a boat, offerings to the deceased man whose remains this sarcophagus housed.

▶ 4-1c The Minoan painter included the deceased himself in this depiction of the funerary rites in his honor. He stands at the far right in front of his tomb facing the three men presenting him with gifts.

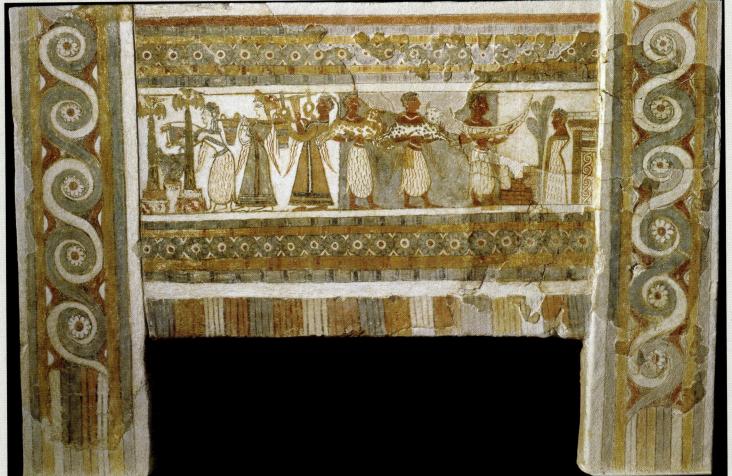

Sarcophagus, from Hagia Triada (Crete), Greece, ca. 1450-1400 BCE. Painted limestone, 4' 6" long. Archaeological Museum, Iraklion.

The Prehistoric Aegean

GREECE IN THE AGE OF HEROES

When, in the eighth century BCE, Homer immortalized in the *Iliad* and the *Odyssey* the great war between the Greeks and the Trojans and the subsequent adventure-packed journey home of Odysseus, the epic poet was describing a time long before his own—a golden age of larger-than-life heroes. Since the late 19th century, archaeologists have gradually uncovered impressive remains of that heroic age, including the palaces of the legendary King Minos at Knossos (FIGS. 4-4 to 4-6) on Crete and of King Agamemnon at Mycenae (FIGS. 4-19 to 4-21A) on the Greek mainland. But they have also recovered thousands of less glamorous objects and inscriptions that provide a contemporaneous view of life in the prehistoric Aegean unfiltered by the romantic lens of Homer and later writers.

One of the most intriguing finds to date is the painted *Minoan* (named after King Minos) *sarcophagus* (FIG. **4-1**) from Hagia Triada on the southern coast of Crete. The paintings adorning the sides of the small coffin are closely related in technique, color scheme, and figure style to the much larger frescoes on the walls of Minoan palaces, but the subject is foreign to the royal repertoire. Befitting the function of the sarcophagus as a burial container, the paintings illustrate the funerary rites in honor of the dead. They furnish welcome information about Minoan religion, which still remains obscure despite more than a century of excavation on Crete.

On one long side (not shown) of the sarcophagus, four women and a male double-flute player take part in a ritual centered on an ox tied up on a table. One of the women makes an offering at an altar. In contrast to this unified narrative, the side illustrated in Fig. 4-1 is divided into two scenes. At the left, a woman pours liquid (perhaps the blood of the ox on the other side) from a jar into a large vessel on a stand between two double axes. Behind her, a second woman carries two more jars, and a male figure plays the harp. In conformance with the common convention in many ancient cultures, the women have light skin and the man dark skin (compare Fig. 3-13A). To their right, three men carry two sculpted sacrificial animals and a model of a boat to offer to a dead man, whom the painter represented as standing in front of his tomb, just as the biblical Lazarus, raised from the dead, will later appear in medieval art.

The precise meaning of the sarcophagus paintings is uncertain, but there is no doubt that they document well-established Minoan rites in honor of the dead, which included the sacrifice of animals accompanied by music and the deposit of gifts in the tomb. Until scholars can decipher the written language of the Minoans, artworks such as the Hagia Triada sarcophagus will be the primary tools for reconstructing life on Crete, and in Greece as a whole, during the millennium before the birth of Homer.

GREECE BEFORE HOMER

In the *Iliad*, Homer describes the might and splendor of the Greek armies poised before the walls of Troy.

Clan after clan poured out from the ships and huts onto the plain . . . innumerable as the leaves and blossoms in their season . . . the Athenians from their splendid citadel, . . . the citizens of Argos and Tiryns of the Great Walls . . . troops . . . from the great stronghold of Mycenae, from wealthy Corinth, . . . from Knossos, . . . Phaistos, . . . and the other troops that had their homes in Crete of the Hundred Towns. ¹

The Greeks had come from far and wide, from the mainland and the islands (MAP 4-1), to seek revenge against Paris, the Trojan prince who had abducted Helen, wife of King Menelaus of Sparta. The *Iliad*, composed around 750 BCE, is the first great work of Greek literature. Until about 1870, the world regarded Homer's epic poem as pure fiction. Scholars paid little heed to the bard as a historian, instead attributing the profusion of names and places in his writings to the rich abundance of his imagination. The prehistory of Greece remained shadowy and lost in an impenetrable world of myth.

TROY AND MYCENAE In the late 1800s, however, Heinrich Schliemann (1822–1890), a wealthy German businessman turned archaeologist, proved that scholars had not given Homer his due. Between 1870 and his death 20 years later, Schliemann (whose methods later archaeologists have harshly criticized) uncovered some of the very cities that Homer named. In 1870, he began work at Hissarlik on the northwestern coast of Turkey, which a British archaeologist, Frank Calvert (1828–1908), had postulated was the site of Homer's Troy. Schliemann dug into a vast mound and found a number of fortified cities built on the remains of one another. Fire had destroyed one of them in the 13th century BCE. This, scholars now agree, was the Troy of King Priam and his son Paris.

Schliemann continued his excavations at Mycenae on the Greek mainland, where, he believed, King Agamemnon, Menelaus's brother, had once ruled. Here his finds were even more startling, among them a massive fortress-palace with an imposing gateway (FIG. 4-19) and a circle of royal graves (FIG. 4-21A); other tombs featuring lofty stone domes beneath earthen mounds (FIGs. 4-20 and 4-21); quantities of gold jewelry, drinking cups, and masks (FIG. 4-22); and inlaid bronze weapons (FIG. 4-23). Schliemann's discoveries revealed a magnificent civilization far older than the famous vestiges of Classical Greece that had remained visible in Athens and elsewhere. Subsequent excavations proved that Mycenae had not been the only center of this fabulous civilization.

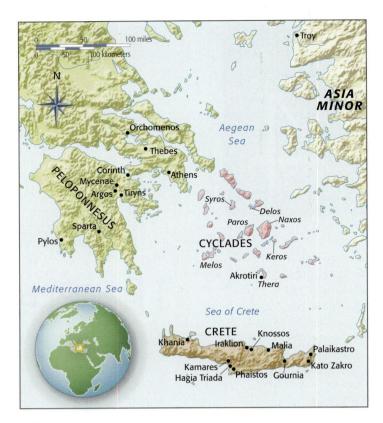

MAP 4-1 The prehistoric Aegean.

MINOAN CRETE Another legendary figure was Minos, the king of Knossos on the island of Crete, who exacted from Athens a tribute of youths and maidens to be fed to the *Minotaur*, a creature half bull and half man that inhabited a vast labyrinth. In 1900, an Englishman, Arthur Evans (1851–1941), began work at Knossos, where he uncovered a palace (FIGS. 4-4 and 4-5) resembling a maze. Evans named the people who had constructed it *Minoans* after their mythological king. Other archaeologists soon discovered further evidence of the Minoans at Phaistos (FIG. 4-11), Hagia Triada (FIGS. 4-1 and 4-14), and other sites, including Gournia, which Harriet Boyd Hawes (1871–1945), an American archaeologist (and one of the first women of any nationality to direct a major excavation), explored between 1901 and 1904.

More recently, archaeologists have excavated important Minoan remains at many other locations on Crete. They have also explored contemporaneous sites on other islands in the Aegean Sea (named after Aegeus, father of King Theseus of Athens), most

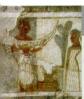

THE PREHISTORIC AEGEAN

3000-2000 BCE

 Early Cycladic sculptors create marble figurines for placement in graves to accompany the dead into the afterlife

2000-1700 BCE

- Minoans construct major palaces on Crete during the Old Palace period
- Cretan ceramists produce Kamares
 Ware painted pottery

1700-1400 BCE

- Minoans construct large administrative complexes with extensive fresco decoration during the second (New Palace) period on Crete
- Minoan potters manufacture Marine Style vases, and sculptors carve small-scale images of gods and goddesses
- Volcanic eruption destroys Thera, 1628 BCE
- Mycenaeans bury their dead in deep shaft graves that also contained gold funerary masks and cups and ornately inlaid daggers

1400-1200 BCE

- Mycenaeans erect fortification walls around their citadels at Mycenae, Tiryns, and elsewhere, and build tombs featuring corbeled domes
- Mycenaeans fashion the oldest known large-scale sculptures in Greece
- Mycenaean civilization comes to an end with the destruction of their palace-citadels, ca. 1200 BCE

ART AND SOCIETY

Archaeology, Art History, and the Art Market

One way the ancient world is fundamentally different from the world today is that ancient art is largely anonymous and undated. The systematic signing and dating of artworks—a commonplace feature in the contemporary art world—has no equivalent in antiquity. That is why the role of archaeology in the study of ancient art is so important. Only the scientific excavation of ancient artworks can establish their context. Exquisite and strikingly "modern" sculptures, such as the marble Cycladic figurines illustrated in Figs. 4-2 and 4-3, may be appreciated as masterpieces when displayed in splendid isolation in glass cases in museums or private homes. But to understand the role these or any other artworks played in ancient society—in many cases, even to determine the date of an object—the art historian must learn the *provenance* of the piece. Only when the context of an artwork is known can anyone go beyond an appreciation of its formal qualities and begin to analyze its place in art history and in the society that produced it.

The extraordinary popularity of Cycladic figurines in recent decades has had unfortunate consequences. Clandestine treasure hunters, anxious to meet the insatiable demands of collectors, have plundered many sites and smuggled their finds out of Greece to sell to the highest bidder on the international art market. This looting has destroyed entire prehistoric cemeteries and towns. Two British scholars have calculated that only about 10 percent of the known Cycladic marble statuettes come from secure archaeological contexts. Many of the rest could be forgeries produced after World War II, when developments in modern art fostered a new appreciation of these abstract renditions of human anatomy and created a boom in demand for "Cycladica" among collectors. For some categories of Cycladic sculptures—those of unusual type or size—not a single piece with a documented provenance exists. Those groups may be 20th-century inventions designed to fetch even higher prices in the marketplace due to their rarity. Consequently, most

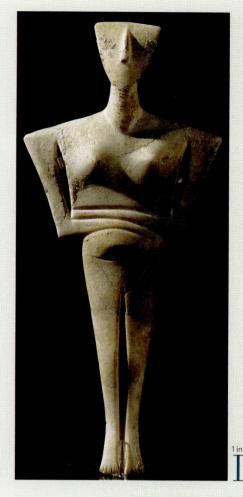

4-2 Figurine of a woman, from Syros (Cyclades), Greece, ca. 2600–2300 BCE. Marble, 1' 6" high. National Archaeological Museum, Athens.

Most Cycladic statuettes depict nude women.
This one comes from a grave, but whether it represents the deceased is uncertain. The sculptor rendered the female body schematically as a series of triangles.

of the conclusions art historians have drawn about chronology, attribution to different workshops, range of types, and how the figurines were used are highly speculative. The importance of the information that the original contexts would have provided cannot be overestimated. That information, however, can probably never be recovered.

notably Thera (FIGS. 4-9, 4-9A, and 4-10). Together, the buildings, paintings, sculptures, and other finds on the Greek mainland and on the Aegean islands attest to the wealth and sophistication of the people who occupied Greece in that once-obscure heroic age celebrated in later Greek mythology.

AEGEAN ARCHAEOLOGY TODAY Archaeologists know much more today about the prehistoric societies of the Aegean than a generation ago. Arguably more important for the understanding of Aegean prehistory than the art objects that tourists flock to see in the museums of Athens and Iraklion (near Knossos) are the many documents archaeologists have found written in scripts conventionally called Linear A and Linear B. The progress made during the past several decades in deciphering Linear B texts has provided a welcome corrective to the romantic treasure-hunting approach of Schliemann and Evans. Scholars now regard Linear B as an early form of Greek, and they have begun to reconstruct Aegean civilization by referring to records made at the time and not just to Homer's heroic account. Archaeologists now also know that humans inhabited Greece as far back as the early Paleolithic period and that village life was firmly established in Greece and on Crete in Neolithic times.

The heyday of the ancient Aegean, however, did not arrive until the second millennium BCE, well after the emergence of the river valley civilizations of Mesopotamia, Egypt, and South Asia.

The prehistoric Aegean has three geographic areas, and each has its own distinctive artistic identity. *Cycladic* art is the art of the Cyclades islands (so named because they "circle" around Delos), as well as of the adjacent islands in the Aegean, excluding Crete. *Minoan* art encompasses the art of Crete. *Helladic* art is the art of the Greek mainland (*Hellas* in Greek). Archaeologists subdivide each area chronologically into early, middle, and late periods, designating the art of the Late Helladic period *Mycenaean* after Agamemnon's great citadel of Mycenae.

CYCLADIC ART

Marble was abundantly available in the superb quarries of the Aegean islands, especially on Naxos, which the sculptors of the Early Cycladic period used to produce statuettes (FIGS. **4-2** and 4-3) that collectors revere today (see "Archaeology, Art History, and the Art Market," above) because of their striking abstract forms, which call to mind some modern sculptures (FIGS. 29-18 and 29-62A).

SYROS WOMAN Most of the Cycladic sculptures represent nude women, as do many of their Stone Age predecessors in the Aegean, Anatolia, Mesopotamia, and western Europe (FIG. 1-4). The Cycladic examples often are women with their arms folded across their abdomens. The sculptures, which excavators have found both in graves and in settlements, vary in height from a few inches to almost lifesize. The statuette illustrated here (FIG. 4-2) comes from a grave on the island of Syros and is about a foot-and-a-half tall—but only about a half-inch thick. Using obsidian tools, the sculptor carved the figurine and then polished the surface with emery. The Cycladic artist's rendition of the human body is highly schematic. Large, simple triangles dominate the form—the head, the body itself (which tapers from exceptionally broad shoulders to tiny feet), and the incised triangular pubis. The feet have the toes pointed downward, so the figurine cannot stand upright. The marble woman must have been placed on her back in the grave—lying down, like the deceased.

Archaeologists speculate whether the Syros statuette and the many other similar Cycladic figurines known today represent dead women or fertility figures or goddesses. Whether those depicted are mortals or deities, the sculptors took pains to emphasize the breasts as well as the pubic area. In the Syros statuette, a slight swelling of the belly may suggest pregnancy (compare FIG. 1-5). Traces of paint found on some of the Cycladic figurines indicate that at least parts of these sculptures were colored. The now almost featureless faces would have had painted eyes and mouths in addition to the sculpted

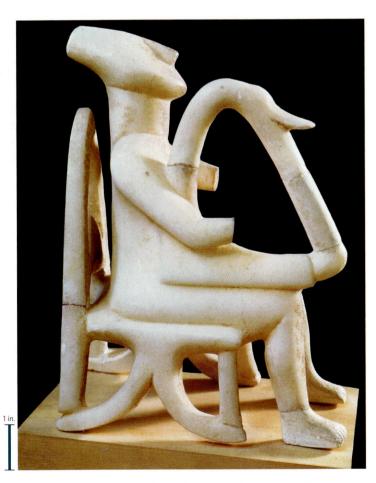

4-3 Male harp player, from Keros (Cyclades), Greece, ca. 2600–2300 BCE. Marble, 9" high. National Archaeological Museum, Athens.

The meaning of all Cycladic figurines is elusive, but this seated musician may be playing for the deceased in the afterlife. The statuette displays simple geometric shapes and flat planes.

noses. Red and blue necklaces and bracelets, as well as painted dots on the cheeks and necks (compare FIG. 4-26), characterize a number of the surviving figurines.

KEROS MUSICIAN The Cycladic statuettes also represent men. The most elaborate figurines portray seated musicians, such as the harp player (FIG. 4-3) from Keros. Wedged between the echoing shapes of chair and instrument, he may be playing for the deceased in the afterlife, although, again, the meaning of these sculptures remains elusive. The harpist reflects the same preference for simple geometric shapes and large, flat planes as do the female figures. Still, the artist showed a keen interest in recording the elegant shape of what must have been a prized possession: the harp with a duck-bill or swan-head ornament. (Compare the form of Sumerian harps, FIGS. 2-8, *top right*, and 2-9.)

One woman's grave contained figurines of both a musician and a reclining woman. The burial of a male figure together with the body of a woman suggests that the harp players are not images of dead men, but it does not prove that the female figurines represent dead women. The musician might be entertaining the deceased herself, not her image, or be engaged in commemorative rites honoring the dead. (The harp player on the Hagia Triada sarcophagus [FIG. 4-1a] may indicate some continuity in funerary customs and beliefs from the Cycladic to the Minoan period in the Aegean.) Given the absence of written documents in Greece at this date, as everywhere else in prehistoric times, and the lack of contextual information for most Cycladic sculptures, art historians cannot be sure of the meaning of these statuettes. It is likely, in fact, that the same form took on different meanings in different contexts.

MINOAN ART

During the third millennium BCE, both on the Aegean islands and on the Greek mainland, most settlements were small and consisted only of simple buildings. Rarely were the dead buried with costly offerings such as the Cycladic statuettes just examined. In contrast, the hallmark of the opening centuries of the second millennium (the Middle Minoan period on Crete) is the construction of large palaces.

Architecture

The first, or Old Palace, period ended abruptly around 1700 BCE, when fire destroyed these grand structures, probably following an earthquake. Rebuilding began almost immediately, and archaeologists consider the ensuing Late Minoan (New Palace) period the golden age of Crete, an era when the first great Western civilization emerged. Although conventionally called palaces, the rebuilt structures may not have served as royal residences. They were administrative, commercial, and religious centers with courtyards for pageants, ceremonies, and games, and dozens of offices, shrines, and storerooms for the collection and distribution of produce and goods. These huge complexes were the centers of Minoan life. The principal "palaces" on Crete are at Knossos, Phaistos, Malia, Kato Zakro, and Khania. The Minoans laid out all of them along similar lines. The size and number of these important centers, as well as the rich finds they have yielded, attest to the power and prosperity of the Minoans.

KNOSSOS The largest Cretan palace—at Knossos (FIGS. 4-4 and 4-5)—was the legendary home of King Minos. Here, the hero Theseus hunted the bull-man Minotaur in his labyrinth. According to

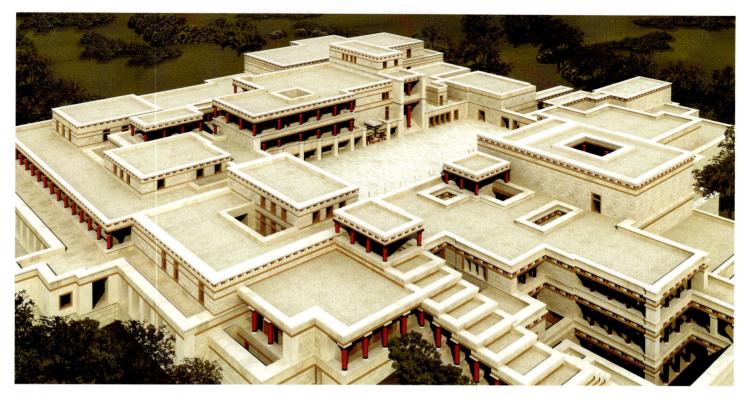

4-4 Restored view of the palace (looking northwest), Knossos (Crete), Greece, ca. 1700-1370 BCE (John Burge).

The Knossos palace, the largest on Crete, was the legendary home of King Minos. Its layout features a large central court surrounded by scores of residential and administrative units.

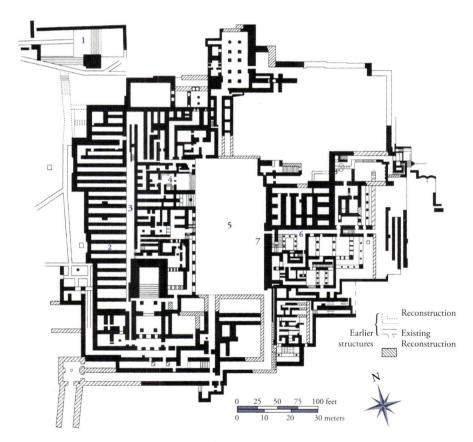

4-5 Plan of the palace, Knossos (Crete), Greece, ca. 1700–1370 BCE. (1) "theater," (2) magazines, (3) north-south corridor, (4) throne room, (5) central court, (6) east-west corridor, (7) grand stairwell.

The mazelike plan of the Knossos palace gave rise to the Greek myth of the Cretan labyrinth inhabited by the Minotaur, a half-man, half-bull monster that King Theseus of Athens slew.

the myth, after defeating the monster, Theseus found his way out of the mazelike complex only with the aid of the king's daughter, Ariadne. She had given Theseus a spindle of thread to mark his path through the labyrinth and safely find his way out again. In fact, the English word *labyrinth* derives from the intricate plan and scores of rooms of the Knossos palace. The *labrys* ("double ax") serves as a recurring motif in the Minoan palace and in Minoan art generally (FIG. 4-1, *left*), referring to sacrificial slaughter. The labyrinth was the "House of the Double Ax."

The Knossos palace was complex in elevation as well as plan (FIG. 4-4). Around the palace proper were mansions and villas of the Minoan elite. The central feature of the palace was its great rectangular court (FIG. 4-5, no. 5). The builders carefully planned the structure with clusters of rooms of similar function grouped around this primary space. A secondary organization of the palace plan involves two long corridors. On the west side of the court, a north-south corridor (FIG. 4-5, no. 3) separates official and ceremonial rooms from the magazines (no. 2), where the Minoans stored wine, grain, oil, and honey in large jars. On the east side of the court, a smaller east-west corridor (no. 6) separates the administrative areas (to the south) from the workrooms (to the north). At the northwest corner of the palace is a theater-like area (no. 1) with steps on two sides that may have served as seats. This arrangement is a possible forerunner

4-6 Stairwell in the residential quarter of the palace (FIG. 4-5, no. 7), Knossos (Crete), Greece, ca. 1700–1370 BCE.

The Knossos palace was complex in elevation as well as plan. It had at least three stories on all sides of the court. Minoan columns taper from top to bottom, the opposite of Egyptian and Greek columns.

of the later Greek theater (FIG. 5-71). Its purpose is unknown, but the feature also appears in the Phaistos palace.

The Knossos palace was complex in *elevation* (FIG. 4-4) as well as plan. Around the central court, there were as many as three stories, and on the south and east sides, where the terrain sloped off sharply, the palace had four or five stories. Interior light and air wells, some with staircases (FIGS. 4-5, no. 7, and **4-6**), provided necessary illumination and ventilation. The Minoans also addressed such issues as drainage of rainwater. At Knossos, a remarkably efficient system of *terracotta* (baked clay) pipes lies under the enormous building.

The Cretan palaces were sturdy structures, with thick walls composed of rough, unshaped fieldstones embedded in clay. For corners and around door and window openings, the builders used large *ashlar* blocks, especially for the walls facing the central court. The painted wood columns (which Evans restored in cement at Knossos) have distinctive capitals and shafts (FIG. 4-6). The bulbous, cushionlike Minoan capitals resemble those of the later Greek Doric order (FIG. 5-13, *left*), but the column shafts—essentially stylized inverted tree trunks—taper from a wide top to a narrower base, the opposite of both Egyptian and later Greek columns.

Painting

Mural paintings liberally adorned the palace at Knossos, constituting one of its most striking features. The brightly painted walls and the red shafts and black capitals of the wood columns produced an extraordinarily rich effect. The paintings depict many aspects of Minoan life (bull-leaping, processions, and ceremonies) and of nature (birds, animals, flowers, and marine life).

LA PARISIENNE From a ceremonial scene of uncertain significance comes the fragment dubbed *La Parisienne* (*The Parisian Woman*; FIG. **4-7**) on its discovery because of the elegant dress, elaborate coiffure, and full rouged lips of the young woman depicted. Some have identified her as a priestess taking part in a religious ritual, but because the figure has no arms, it is more likely a statue of a goddess. Although the representation is still convention-bound (note especially the oversized frontal eye in the profile head), the charm and freshness of the mural are undeniable. Unlike the Egyptians, who

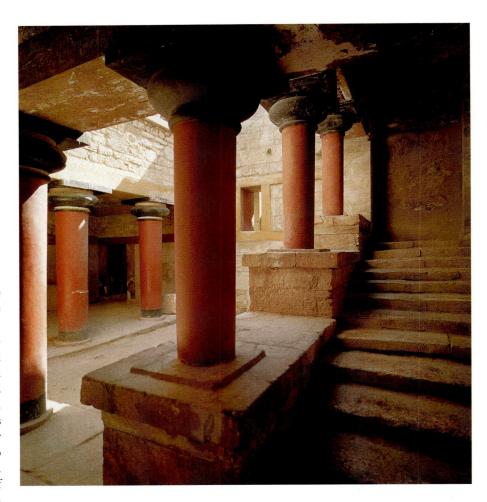

4-7 Minoan woman or goddess (*La Parisienne*), from the palace, Knossos (Crete), Greece, ca. 1500 BCE. Fragment of a fresco, 10" high. Archaeological Museum, Iraklion.

Frescoes decorated the Knossos palace walls. This fragment depicts a woman or a goddess—perhaps a statue—with a large frontal eye in her profile head, as in Mesopotamian and Egyptian art.

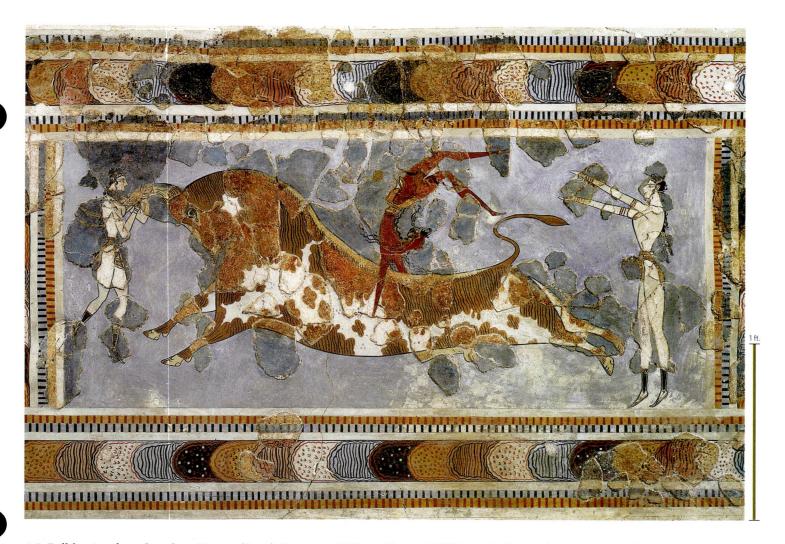

4-8 Bull-leaping, from the palace, Knossos (Crete), Greece, ca. 1500 BCE. Fresco, 2' 8" high, including border. Archaeological Museum, Iraklion.

The subjects of the Knossos frescoes are often ceremonial scenes, such as this one of bull-leaping. The women have fair skin and the man has dark skin, a common convention in ancient painting.

painted in *fresco secco* (dry fresco), the Minoans coated the rough fabric of their rubble walls with a fine white lime plaster and were apparently the first to use a true (wet) fresco method in which the painter applies the pigments while the walls are still wet (see "Fresco Painting," page 419). The color consequently becomes chemically bonded to the plaster after it dries. The Minoan painters therefore had to execute their work rapidly, in contrast to Egyptian practice, which permitted slower, more deliberate work.

BULL-LEAPING Another fresco (FIG. **4-8**) from the palace at Knossos depicts the Minoan ceremony of bull-leaping, in which young men grasped the horns of a bull and vaulted onto its back—a perilous and extremely difficult acrobatic maneuver. Excavators recovered only fragments of the full composition (the dark patches are original; the rest is a modern restoration). The Minoan artist provided no setting, instead focusing all attention on the three protagonists and the fearsome bull. The young women have fair skin and the leaping youth has dark skin, in accordance with the widely accepted ancient convention for distinguishing male and female, as on the Hagia Triada sarcophagus (FIG. 4-1) and in *La Parisienne* (FIG. 4-7; compare FIG. 3-13A). The painter brilliantly suggested the powerful charge

of the bull (which has all four legs off the ground) by elongating the animal's shape and using sweeping lines to form a funnel of energy, beginning at the very narrow hindquarters of the bull and culminating in its large, sharp horns. The highly animated human figures also have stylized shapes, with typically Minoan pinched waists. Although the profile pose with frontal eye was a familiar convention in Egypt and Mesopotamia, the elegance of the Cretan figures, with their long, curly hair and proud and self-confident bearing, distinguishes them from all other early figure styles. In contrast to the angularity of the figures in Egyptian wall paintings, the curving lines the Minoan artist employed suggest the elasticity of living and moving beings.

THERA Much better preserved than the Knossos frescoes are the mural paintings that Greek archaeologists have discovered in their ongoing excavations (reopened to the public in 2012) at Akrotiri on the volcanic island of Thera in the Cyclades, some 60 miles north of Crete. In the Late Cycladic period, Thera was artistically (and possibly also politically) within the Minoan orbit. The Akrotiri murals are invaluable additions to the fragmentary and frequently misrestored frescoes from Crete. The excellent condition of the Theran paintings is due to an enormous seismic explosion on the island that buried

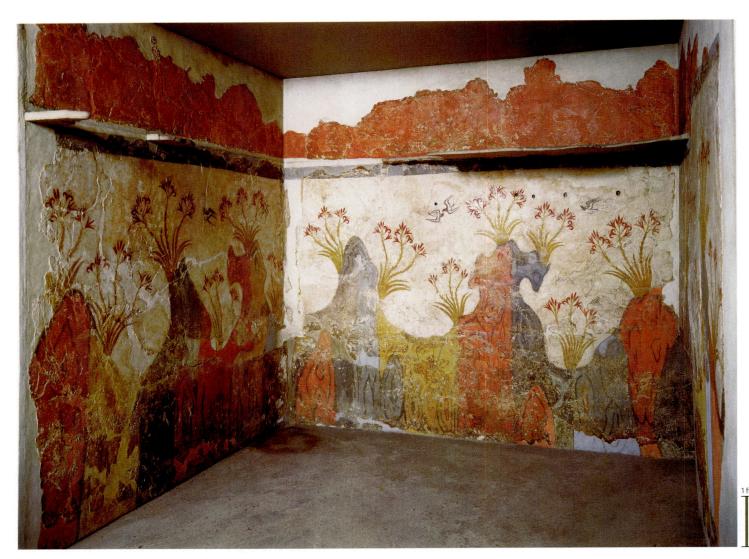

4-9 Landscape with swallows (*Spring Fresco*), south and west walls of room Delta 2, Akrotiri, Thera (Cyclades), Greece, ca. 1650–1625 BCE. Fresco, 7' 6" high. Reconstructed in National Archaeological Museum, Athens.

Aegean muralists painted in wet fresco, which required rapid execution. In this wraparound landscape, the painter used vivid colors and undulating lines to capture the essence of nature.

Akrotiri in volcanic pumice and ash, making it a kind of Pompeii of the prehistoric Aegean (see "The Theran Eruption and the Chronology of Aegean Art," page 91). The Akrotiri frescoes decorated the walls of houses and shrines, not the walls of a great palace, such as Minos's at Knossos, and therefore the number of painted walls from the site is especially impressive.

The almost perfectly preserved mural painting from Akrotiri known as the *Spring Fresco* (FIG. **4-9**) is the largest and most complete prehistoric example of a pure landscape painting (compare FIG. 1-16). Landscapes—and seascapes (FIG. **4-9A**)—are key elements of many of the mural paintings found at Akrotiri. In each case, however, the artist's aim was not to render the rocky island terrain realistically

4-9A Miniature Ships Fresco, Akrotiri, ca. 1650-1625 BCE.

but rather to capture its essence. In FIG. 4-9, the irrationally undulating and vividly colored rocks, the graceful lilies swaying in the cool island breezes, and the darting swallows

express the vigor of growth, the delicacy of flowering, and the lightness of birdsong and flight. In the lyrical language of curving line, the artist celebrated the rhythms of nature. The *Spring Fresco* represents the polar opposite of the first efforts at mural painting in the caves of Paleolithic Europe (see page 21), where animals (and occasionally humans) appeared as isolated figures with no indication of setting.

CROCUS GATHERERS A rocky landscape is also the setting for the figures depicted in room 3 of building Xeste 3 at Akrotiri. The room probably served as a shrine in which girls took part in puberty initiation rites. Frescoes decorated the walls on two levels. In one section (not illustrated), a young girl with a bleeding foot sits on a rock. Approaching her from behind is a bare-breasted woman carrying a necklace, probably a gift for the bleeding girl. In the section reproduced here (FIG. **4-10**), two elegantly dressed young women bedecked with bracelets and hoop earrings gather crocuses. One has a shaved head with a serpentine lock of hair at the back, indicating that she is a young girl. Crocus flowers produce saffron, used for the

ART AND SOCIETY

The Theran Eruption and the Chronology of Aegean Art

Today, ships bound for the beautiful Greek island of Thera (formerly Santorini), with its picture-postcard white houses, churches, shops, and restaurants, weigh anchor in a bay beneath steep cliffs. Until about 20,000 BCE, however, Thera had gentler slopes. Then, suddenly, a volcanic eruption blew out the center of the island, leaving behind the crescent-shaped main island and several lesser islands grouped around a bay that roughly corresponds to the shape of the gigantic ancient volcano. The volcano erupted again, thousands of years later, during the zenith of Aegean civilization.

The later explosion buried the site of Akrotiri, which Greek excavators have been gradually uncovering since 1967, under a layer of pumice more than a yard deep in some areas and by an even larger volume of volcanic ash (tephra) often exceeding five yards in depth, even after nearly 37 centuries of erosion. Tephra filled whole rooms, and boulders that the volcano spewed forth pelted the walls of some houses. Closer to the volcano's cone, the tephra is almost 60 yards deep in places. In fact, the force of the eruption was so powerful that sea currents carried the pumice and wind blew the ash throughout much of the eastern Mediterranean, not only to Crete, Rhodes, and Cyprus but also as far away as Anatolia, Egypt, Syria, and Israel.

A generation ago, most scholars embraced the theory formulated by Spyridon Marinatos (1901–1974), an eminent Greek archaeologist, that

the otherwise unexplained demise of Minoan civilization on Crete around 1500 BCE was the by-product of the volcanic eruption on Thera. According to Marinatos, devastating famine followed the rain of ash that fell on Crete. But archaeologists now know that after the eruption, life went on in Crete, if not on Thera.

Teams of researchers, working closely in an impressive and most welcome interdisciplinary effort, have determined that a major climatic event occurred during the last third of the 17th century BCE. In addition to collecting evidence from Thera, they have studied tree rings at sites in Europe and in North America for evidence of retarded growth and have examined ice cores in Greenland for peak acidity

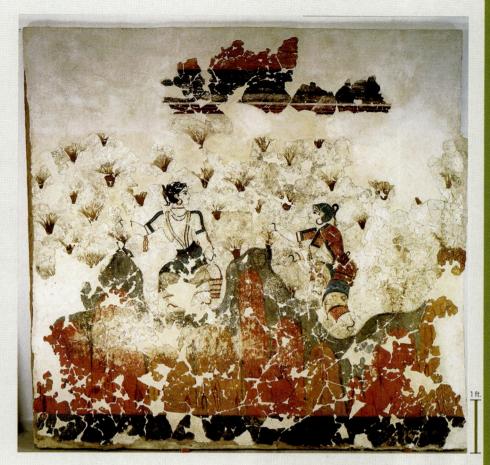

4-10 Crocus gatherers, detail of the east wall of room 3 of building Xeste 3, Akrotiri, Thera (Cyclades), Greece, ca. 1650–1625 BCE. Fresco, 8' $\frac{1}{8}$ " high. Reconstructed in National Archaeological Museum, Athens.

In a room at Akrotiri probably used for puberty rites, young girls pick crocus flowers in a rocky land-scape recalling the *Spring Fresco* (Fig. 4-9), and present them to a seated goddess (not shown).

layers. The scientific data pinpoint a significant disruption in weather patterns in 1628 BCE. Most scholars now believe that the cause of this disruption was the cataclysmic volcanic eruption on Thera. The date of the Aegean catastrophe remains the subject of much debate, however, and many archaeologists favor placing the eruption in the 16th century BCE. In either case, the date of Thera's destruction has profound consequences for determining the chronology of Aegean art. If the Akrotiri frescoes (FIGS. 4-9, 4-9A, and 4-10) date between 1650 and 1625 BCE, they are at least 150 years older than scholars thought not long ago, and are much older than the Knossos palace murals (FIGS. 4-7 and 4-8).

yellow dye of some of the garments the figures wear. Saffron may also have been used as a painkiller for menstrual cramps. In another section of the mural, girls carry baskets full of the flowers they have picked. They bring the flowers to a woman seated on a stepped platform flanked by a blue monkey and a *griffin* (a mythical winged lion with an eagle's head). Scholars have identified the seated woman as a goddess rather than a mortal, but the precise meaning of the scenes depicted in the fresco remains uncertain.

MINOAN POTTERY Even before the period of the new palaces, the love of nature manifested itself in Crete on the surfaces of painted vases. During the Middle Minoan period, Cretan potters fashioned sophisticated shapes using newly introduced potters' wheels, and decorated their vases in a distinctive and fully polychromatic style. These Kamares Ware vessels, named for the cave on the slope of Mount Ida where they were first discovered, have been found in quantity at Phaistos and Knossos. Some examples come from as

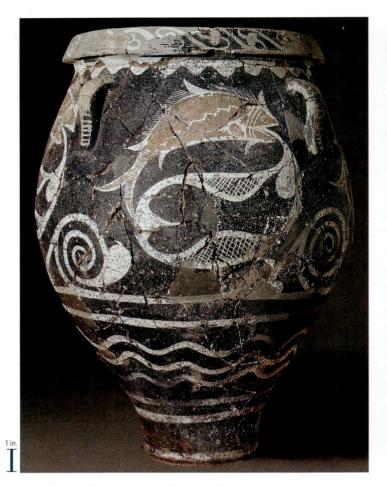

4-11 Kamares Ware jar, from Phaistos (Crete), Greece, ca. 1800–1700 BCE. 1'8" high. Archaeological Museum, Iraklion.

Kamares Ware vases have creamy white and reddish-brown decoration on a black background. This jar combines a fish (and a net?) with curvilinear abstract patterns, including spirals and waves.

far away as Egypt and testify to the expansive trade network of the Minoans. On the jar shown here (FIG. 4-11), as on other Kamares vases, the painter applied creamy white and reddish-brown decoration to a rich black ground. The central motif is a great leaping fish and perhaps a fishnet surrounded by a host of curvilinear abstract patterns, including waves and spirals. The swirling lines evoke life in the sea, and both the abstract and the natural forms beautifully complement the shape of the vessel.

The sea and the creatures inhabiting it also inspired the Late Minoan octopus flask (FIG. 4-12) from Palaikastro decorated in what art historians have dubbed the Marine Style. The tentacles of the octopus reach out over the curving surfaces of the vessel, embracing the piece and emphasizing its volume. The flask is a masterful realization of the relationship between the vessel's decoration and its shape, always an issue for the vase painter. This later jar, which is contemporaneous with the new palaces at Knossos and elsewhere, differs markedly from its Kamares Ware predecessor in color. Not only is the octopus vase more muted in tone, but the Late Minoan artist also reversed the earlier scheme and placed dark silhouettes on a light ground. Dark-on-light coloration remained the norm for about a millennium in Greece, until about 530 BCE, when light figures and a dark background emerged once again, albeit in a very different form, as the preferred manner (see "The Invention of Red-Figure Painting," page 119).

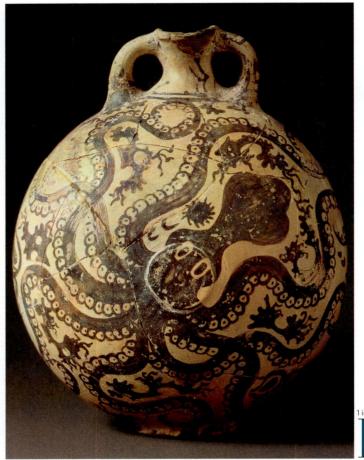

4-12 Marine-style octopus flask, from Palaikastro (Crete), Greece, ca. 1500 BCE. 11" high. Archaeological Museum, Iraklion.

Marine Style vases have dark figures on a light ground. On this octopus flask, the tentacles of the sea creature reach out over the curving surface of the vessel to fill the shape perfectly.

Sculpture

In contrast to Mesopotamia and Egypt, Minoan Crete has yielded no trace of temples or life-size statues of gods, kings, or monsters. Large painted wood images may once have existed—*La Parisienne* (FIG. 4-7) may be a depiction of one of them—but what remains of Minoan sculpture is uniformly small in scale.

SNAKE GODDESS One of the most striking finds from the palace at Knossos is the faience (low-fired opaque glasslike silicate) statuette popularly known as the Snake Goddess (FIG. 4-13). Reconstructed from many pieces and in large part modern in its present form, it is one of several similar figurines that some scholars believe may represent mortal priestesses rather than a deity. The prominently exposed breasts suggest, however, that these figurines stand in the long line of prehistoric fertility images usually considered divinities. The Knossos woman holds snakes in her hands and, as reconstructed, supports a tamed leopardlike feline on her head. When archaeologists discovered the statuette, the feline was not associated with the other fragments. If it was part of the figurine, the implied power over the animal world would be appropriate for a deity. The frontality of the figure is reminiscent of Egyptian and Mesopotamian statuary, but the costume, with its open bodice and flounced skirt, is distinctly Minoan. If the statuette represents a goddess, then the Minoan is

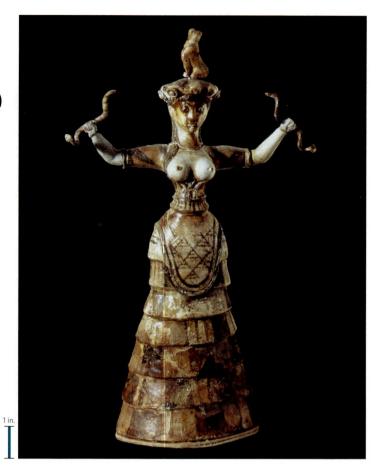

4-13 *Snake Goddess*, from the palace, Knossos (Crete), Greece, ca. 1600 BCE. Faience, $1' 1 \frac{1}{2}''$ high. Archaeological Museum, Iraklion.

This figurine may represent a priestess, but it is more likely a bare-breasted goddess. The snakes in her hands and the feline on her head imply that she has power over the animal world.

yet another example of a culture fashioning its gods in the image of its people. Another Cretan example is the gold-and-ivory statuette (FIG. **4-13A**) of a nude youth, probably a god, from Palaikastro.

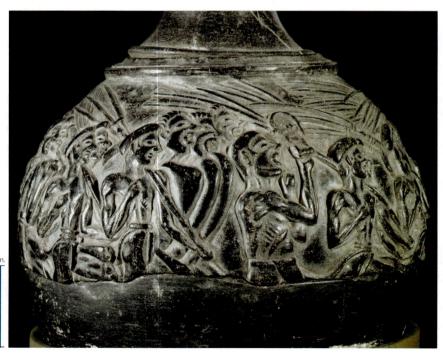

HARVESTERS VASE The so-called *Harvesters Vase* (FIG. 4-14) from Hagia Triada is the finest surviving example of Minoan relief sculpture. Only the upper half of the ostrich-egg-shaped body and neck of the vessel remain. Missing are the lower parts of the harvesters (or, as some think, sowers) and the ground on which they stand as well as the gold leaf that originally covered the relief figures. Formulaic scenes of sowing and harvesting were staples of Egyptian funerary art (FIG. 3-16), but the Minoan artist shunned static repetition in favor of a composition filled with individually characterized figures bursting with energy. The relief shows a riotous crowd singing and shouting as the harvesters go to or return from the fields. The artist vividly captured the forward movement and lusty exuberance of the youths.

4-13A
Young god(?),
Palaikastro, ca.
1500-1450 BCE.

Although most of the figures conform to the age-old convention of combined profile and frontal views, the relief sculptor singled out one figure (FIG. 4-14, *right of center*) from his companions. He shakes a *sistrum* (a percussion instrument or rattle) to beat time, and the artist depicted him in full profile with his lungs so inflated with air that his ribs show. This is one of the first instances in the history of art of a sculptor showing a keen interest in the underlying muscular and skeletal structure of the human body. The Minoan artist's painstaking study of human anatomy is a singular achievement, especially given the size of the *Harvesters Vase*, barely five inches at its greatest diameter. Equally noteworthy is how the sculptor recorded the tension and relaxation of facial muscles with astonishing exactitude, not only for this figure but for his nearest companions as well. This degree of animation of the human face is without precedent in ancient art.

MINOAN DECLINE Scholars dispute the circumstances ending the Minoan civilization, although most now believe that Mycenaeans had already moved onto Crete and established themselves at Knossos at the end of the New Palace period. From the palace at Knossos, these intruders appear to have ruled the island for at least a half century,

perhaps much longer. Parts of the palace continued to be occupied until its final destruction around 1200 BCE, but its importance as a cultural center faded soon after 1400 BCE, as the focus of Aegean civilization shifted to the Greek mainland.

MYCENAEAN ART

The origin of the Mycenaeans is also a subject of continuing debate among archaeologists and historians. The only certainty is the presence of these forerunners of the Greeks on the mainland about the time of the construction of the old palaces on Crete—that is, about the beginning of the second millennium BCE. Doubtless, Cretan civilization influenced the

4-14 *Harvesters Vase*, from Hagia Triada (Crete), Greece, ca. 1500 BCE. Steatite, originally with gold leaf, greatest diameter 5". Archaeological Museum, Iraklion.

The relief sculptor of the singing harvesters on this small stone vase was one of the first artists in history to represent the underlying muscular and skeletal structure of the human body.

PROBLEMS AND SOLUTIONS

Fortified Palaces for a Hostile World

In contrast to the Minoans, whose sprawling palaces (FIGS. 4-4 and 4-5) were unprotected by enclosing walls, the Mycenaeans inhabited a hostile world. The palatial administrative centers of their Cretan predecessors

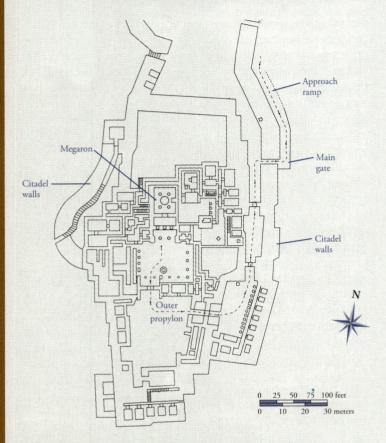

4-15 Plan of the palace and southern part of the citadel, Tiryns, Greece, ca. 1400–1200 BCE.

The plan of the Mycenaean fortress at Tiryns incorporated an entrance ramp designed to expose attacking soldiers' unprotected right sides to the spears and arrows of the defending Mycenaean warriors.

did not provide useful models for royal residences on the mainland. Consequently, the Mycenaeans had to develop an independent solution for housing—and protecting—their kings and their families and attendants.

Construction of the citadels of Tiryns (FIGS. 4-15 and 4-16) and Mycenae (FIG. 4-19) began about 1400 BCE. Both burned (along with all the other Mycenaean strongholds) between 1250 and 1200 BCE when northern invaders overran the Mycenaeans or they fell victim to internal warfare. Homer called Tiryns the city "of the great walls." In the second century CE, when Pausanias, author of an invaluable guidebook to Greece, visited the long-abandoned site, he marveled at the towering fortifications and considered the walls of Tiryns to be as spectacular as the pyramids of Egypt. Indeed, the Greeks of the historical age believed that mere humans could not have erected these enormous edifices. They attributed the construction of the great Mycenaean citadels to the mythical *Cyclopes*, a race of one-eyed giants. Architectural historians still employ the term *Cyclopean masonry* to refer to the huge, roughly cut stone blocks forming the massive fortification walls of Tiryns and other Mycenaean sites.

The Mycenaean engineers who designed the circuit wall of Tiryns compelled would-be attackers to approach the palace (FIG. 4-15) within the walls via a long ramp that forced the soldiers (usually right-handed; compare FIG. 4-27) to expose their unshielded sides to the Mycenaean defenders above. Then—if they got that far—the enemy forces had to pass through a series of narrow gates that also could be defended easily.

Inside, at Tiryns as elsewhere, the most important element in the palace plan was the *megaron*, or reception hall and throne room, of the *wanax* (Mycenaean king). The main room of the megaron had a throne against the right wall and a central hearth bordered by four Minoan-

style wood columns serving as supports for the roof. A vestibule with a columnar facade preceded the throne room. The remains of the megarons at Tiryns and Mycenae are scant, but at Pylos, home of Homer's King Nestor, archaeologists found sufficient evidence to permit a reconstruction (FIG. 4-16A) of the original appearance of its megaron, complete with mural and ceiling paintings.

4-16A Megaron, Palace of Nestor, Pylos, ca. 1300 BCE.

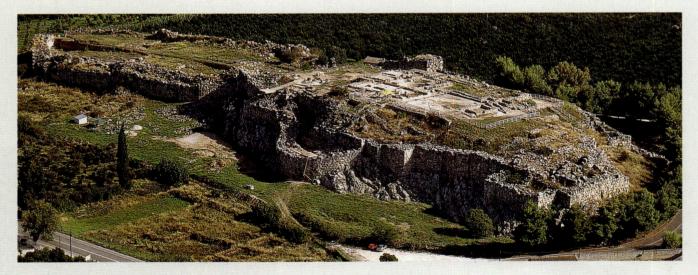

4-16 Aerial view of the citadel (looking east), Tiryns, Greece, ca. 1400-1200 BCE.

In the *lliad,* Homer called the fortified citadel of Tiryns the city "of the great walls." Its huge, roughly cut stone blocks are examples of Cyclopean masonry, named after the mythical one-eyed giants.

ARCHITECTURAL BASICS

Corbeled Arches, Vaults, and Domes

The simplest method of spanning a passageway, documented in Neolithic times and in Old Kingdom Egypt, is the *post-and-lintel system* (FIG. 1-19). A more sophisticated construction technique is the *corbeled arch* (FIG. 4-18), which, when extended, forms a *corbeled vault*, seen in

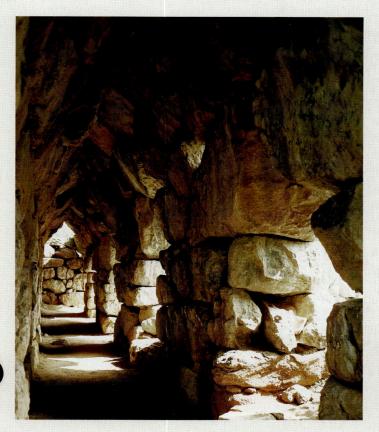

4-17 Corbel-vaulted gallery in the circuit wall of the citadel, Tiryns, Greece, ca. 1400–1200 BCE.

In this long gallery within the circuit walls of Tiryns, the Mycenaeans piled irregular Cyclopean blocks in horizontal courses and then cantilevered them until the two walls met in a corbeled arch.

primitive form at Tiryns in the galleries (FIG. 4-17) of its fortified wall circuit. At Tiryns, the Mycenaean builders piled the large, irregular blocks in horizontal courses and then cantilevered them inward until the two walls met in a *pointed arch*. The Mycenaeans used no mortar. The vault is held in place only by the weight of the blocks (often several tons each), by the smaller stones used as wedges, and by the clay filling some of the empty spaces. This crude but effective vaulting scheme possesses an earthy monumentality. It is easy to see how a later age came to believe that the uncouth Cyclopes were responsible for these massive but unsophisticated fortifications.

The corbeling principle was also used in antiquity to construct relieving triangles above lintels, as in Mycenae's Lion Gate (FIG. 4-19) and Treasury of Atreus (FIG. 4-20), and stone domes. The finest example of a corbeled dome in the ancient world is the tholos (FIG. 4-21) of the Treasury of Atreus. The Mycenaean builders probably constructed the vault using rough-hewn blocks. But after they set the stones in place, the stonemasons had to finish the surfaces with great precision to make them conform to both the horizontal and vertical curvature of the wall. Hence, although the principle involved is no different from that of the corbeled gallery of Tiryns, the problem of constructing a complete dome is far more complicated, and the execution of the vault in the Treasury of Atreus is much more sophisticated than that of the vaulted gallery at Tiryns. About 43 feet high, this Mycenaean dome was at the time the largest vaulted space without interior supports that had ever been built. The achievement was not surpassed until the Romans constructed the Pantheon (FIG. 7-51) almost 1,500 years later using a new technology-concrete construction-unknown to the Mycenaeans or their Greek successors.

4-18 Corbeled-arch construction (John Burge).

Builders construct a corbeled arch by piling stone blocks in horizontal courses and then cantilevering them inward until the walls meet in a pointed arch. The stones are held in place by their own weight.

Mycenaeans even then, and some scholars believe that the mainland was a Minoan economic dependency for a long time. In any case, Mycenaean power developed in the north in the days of the new palaces on Crete, and by the mid-second millennium BCE, a distinctive Mycenaean culture was flourishing in Greece. Several centuries later, Homer described Mycenae as "rich in gold." The dramatic discoveries of Schliemann and his successors have fully justified this characterization, even if today's archaeologists no longer view the Mycenaeans solely through the eyes of Homer.

Architecture

The destruction of the Cretan palaces left the mainland culture supreme. Although historians usually refer to this Late Helladic civilization as Mycenaean, Mycenae was but one of several large citadel complexes. Archaeologists have also unearthed Mycenaean remains at Tiryns, Orchomenos, Pylos, and elsewhere (MAP 4-1), and a section of a Mycenaean fortification wall is still in place on the Acropolis of Athens, where Theseus ruled as king. The best-preserved and most impressive Mycenaean remains are those of the citadels at Tiryns and Mycenae (see "Fortified Palaces for a Hostile World," page 94).

TIRYNS The walls of the Tiryns citadel (FIGS. 4-15 and 4-16) average about 20 feet in thickness and impress visitors today as much as they did in antiquity, when they were thought to be the work of giants. In one section, the Tiryns circuit walls incorporate a long gallery (FIG. 4-17) covered by *corbeled vaults* (see "Corbeled Arches, Vaults, and Domes," above, and FIG. 4-18). The severity of the exterior aspect of the Mycenaean citadels did not, however, extend to their interiors, where frescoed walls (FIG. 4-16A) were commonplace, as in the Cretan palaces. Sculptural decoration was nonetheless rare. Agamemnon's Mycenae was the exception.

4-19 Lion Gate (looking east), Mycenae, Greece, ca. 1300–1250 BCE. Limestone, relief panel 9' 6" high.

The largest sculpture in the prehistoric Aegean is the relief of confronting lions that fills the relieving triangle of Mycenae's main gate. The gate itself consists of two great monoliths and a huge lintel.

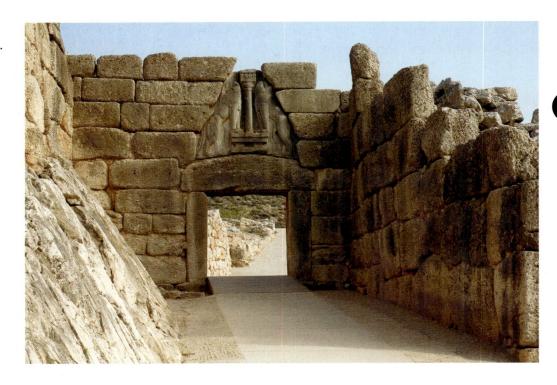

LION GATE, MYCENAE The so-called Lion Gate (FIG. **4-19**) is the outer gateway of the stronghold at Mycenae. It is protected on the left by a wall built on a natural rock outcropping and on the right by a projecting bastion of large blocks. Any approaching enemies would have had to enter this 20-foot-wide channel and face Mycenaean defenders above them on both sides. The gate itself consists of two great upright monoliths (*posts*) capped with a huge horizontal *lintel* (FIG. 1-19). Above the lintel, the masonry courses form a *corbeled arch* (FIG. 4-18), leaving an opening that lightens the weight the lintel carries. Filling this *relieving triangle* is a great limestone slab with two lions in high relief facing a central Minoan-type column. The whole design admirably matches its triangular shape, harmonizing in dignity, strength, and scale with the massive stones forming the walls and gate. Similar groups appear in miniature on

Cretan seals, but the concept of placing monstrous guardian figures at the entrances to palaces, tombs, and sacred places has its origin in Mesopotamia and Egypt (FIGS. 2-18A, 2-20, and 3-11). At Mycenae, the sculptors fashioned the animals' heads separately. Because those heads are lost, some scholars have speculated that the "lions" perhaps were composite beasts, possibly sphinxes or griffins.

TREASURY OF ATREUS The Mycenaeans erected the Lion Gate and the adjoining fortification wall circuit a few generations before the presumed date of the Trojan War. At that time, elite families buried their dead outside the citadel walls in beehive-shaped tombs covered by enormous earthen mounds. Nine such tombs remain at Mycenae and scores more at other sites. The best preserved of these *tholos tombs* is Mycenae's so-called Treasury of Atreus (FIG. **4-20**), which

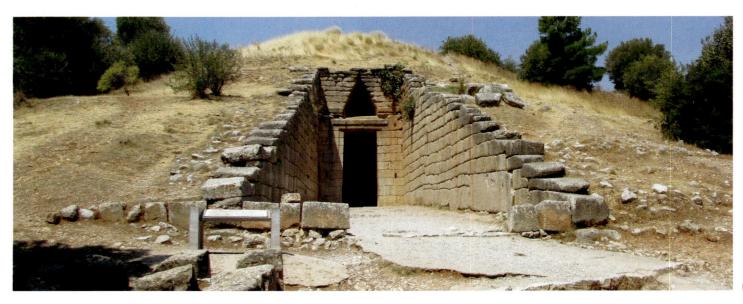

4-20 Exterior of the Treasury of Atreus (looking west), Mycenae, Greece, ca. 1300-1250 BCE.

The best-preserved Mycenaean tholos tomb is named after Homer's King Atreus. An earthen mound covers the burial chamber, reached through a doorway at the end of a long passageway.

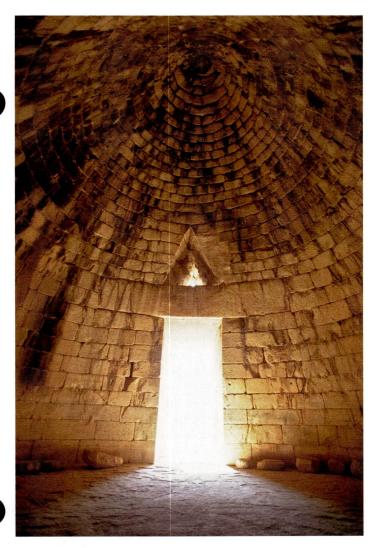

4-21 Interior of the Treasury of Atreus (looking east toward entrance), Mycenae, Greece, ca. 1300–1250 BCE.

The beehive-shaped tholos of the Treasury of Atreus consists of corbeled courses of stone blocks laid on a circular base. The 43-foot-high dome was the largest in the world for almost 1,500 years.

in the Greco-Roman era people mistakenly believed was the repository of the treasure of Atreus, father of Agamemnon and Menelaus. A long passageway (*dromos*) leads to a doorway surmounted by a relieving triangle similar to that in the roughly contemporaneous Lion Gate, but without figural ornamentation. Both the doorway and the relieving triangle, however, once had *engaged columns* on each side, preserved in fragments today. The burial chamber, or *tholos* (FIG. **4-21**), consists of a series of stone corbeled courses laid on a circular base to form a lofty dome (see "Corbeled Arches, Vaults, and Domes," page 95).

Metalwork, Sculpture, and Painting

The Treasury of Atreus was thoroughly looted long before its modern rediscovery, but archaeologists have unearthed spectacular grave goods elsewhere at Mycenae. Just inside the Lion Gate, Schliemann uncovered what archaeologists call Grave Circle A (FIG. 4-21A). It predates

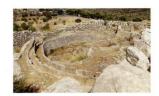

4-21A Grave Circle A, Mycenae, ca. 1600 BCE.

the Lion Gate and the walls of Mycenae by some three centuries, and encloses six deep shafts that served as tombs for the kings and their families. The royal corpses that the Mycenaeans lowered into their deep graves had masks covering the men's faces, recalling the Egyptian funerary practice (see "Mummification and Immortality," page 60). Jewelry adorned the bodies of the women, and weapons and gold cups accompanied the men into the afterlife.

MASKS AND DAGGERS The Mycenaeans used the repoussé technique to fashion the masks Schliemann found—that is, goldsmiths hammered the shape of each mask from a single sheet of metal and pushed the features out from behind. Art historians have often compared the mask illustrated here (FIG. 4-22) to Tutankhamen's gold mummy mask (FIG. 3-35), but it is important to remember that the Mycenaean metalworker was one of the first in Greece to produce a sculpted image of the human face at life-size. In contrast, Tutankhamen's mask stands in a long line of monumental Egyptian sculptures going back more than a millennium. No one knows whether the Mycenaean masks were intended as portraits, but the artists took care to record different physical types. The masks found in Grave Circle A portray youthful faces as well as mature ones. The mask shown in FIG. 4-22, with its full beard, must depict a mature man, perhaps a king—although not Agamemnon, as Schliemann wished. If Agamemnon was a real king, he lived some 300 years after the death of the man buried in Grave Circle A. Clearly the Mycenaeans were "rich in gold" long before Homer's heroes fought at Troy.

Also found in Grave Circle A were several magnificent bronze dagger blades inlaid with gold, silver, and *niello* (a black metallic alloy), again attesting to the wealth of the Mycenaean kings as well

4-22 Funerary mask, from Grave Circle A (FIG. 4-21A), Mycenae, Greece, ca. 1600–1500 BCE. Beaten gold, 1' high. National Archaeological Museum, Athens.

Homer described the Mycenaeans as "rich in gold." This beaten-gold (repoussé) mask of a bearded man comes from a royal shaft grave. It is one of the first attempts at life-size sculpture in Greece.

4-23 Inlaid dagger blade with lion hunt, from Grave Circle A (FIG. 4-21A), Mycenae, Greece, ca. 1600–1500 BCE. Bronze, inlaid with gold, silver, and niello, 9" long. National Archaeological Museum, Athens.

The burial goods in Grave Circle A included costly weapons. The lion hunters on this bronze dagger are Minoan in style, but the metalworker borrowed the subject from Egypt and Mesopotamia.

as to their warlike nature. On one side (FIG. 4-23) of the largest and most elaborate dagger from circle A is a scene of four hunters attacking a lion that has struck down a fifth hunter, while two other lions flee. The other side (not illustrated) depicts lions attacking deer. The slim-waisted, long-haired figures are Minoan in style, but the artist borrowed the subject from the repertoire of Egypt and Mesopotamia (there were no lions in Greece at this date). It is likely that a Minoan metalworker made the dagger for a Mycenaean patron who admired Minoan art but whose tastes in subject matter differed from those of his Cretan counterparts.

VAPHEIO CUPS Excavations at other Mycenaean sites have produced several more luxurious objects decorated with Minoan-style figures. Chief among them is the pair of gold drinking cups from a tholos tomb at Vapheio. The Vapheio cup illustrated here (FIG. **4-24**),

also made using the repoussé technique, is probably the work of a Cretan goldsmith. Both cups represent hunters attempting to capture wild bulls—probably for the bull games (FIG. 4-8) staged in the courtyards of the Cretan palaces. The men have long hair, bare chests, and narrow waists, and they closely resemble the figures on the Minoan *Harvesters Vase* (FIG. 4-14) and the hunters on the dagger blade (FIG. 4-23) from Grave Circle A, which many art historians have also attributed to a Cretan artist. The other cup (not illustrated) depicts hunters trying to snare bulls in nets. One bull has already been trapped. The artist's choice of an unusual contorted posture for the bull effectively suggests the animal's struggle to free itself. To either side, a bull gallops away from the trap. One of them tramples his would-be captor.

Most art historians think that the goldsmith depicted three successive episodes in the hunters' attempt to capture a bull using a cow as bait. If so, the story reads from right to left. First, the bull

4-24 Hunter capturing a bull, drinking cup from Vapheio, near Sparta, Greece, ca. 1600–1500 BCE. Gold, $3\frac{1}{2}$ " high. National Archaeological Museum, Athens.

The cups from a tholos tomb at Vapheio are probably the work of a Cretan goldsmith. They complement the finds in Grave Circle A at Mycenae and suggest that gold objects were common in elite Mycenaean burials.

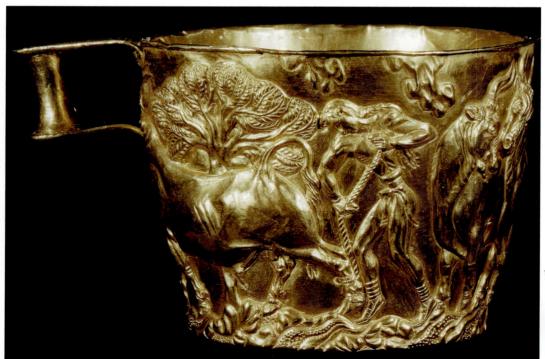

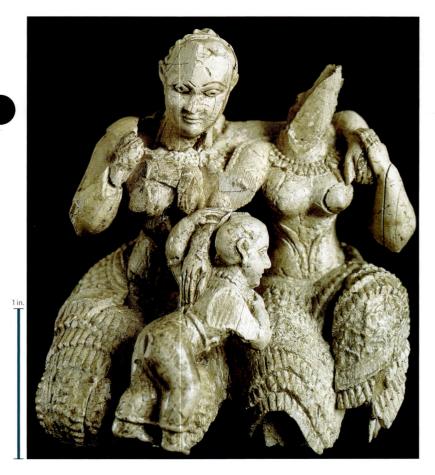

4-25 Two goddesses(?) and a child, from Mycenae, Greece, ca. 1400–1250 BCE. Ivory, $2\frac{3}{4}$ " high. National Archaeological Museum, Athens.

Made of rare imported ivory, perhaps by a Cretan artist, this statuette may represent deities later paralleled in Greek mythology, but their identity and even the gender of the child are uncertain.

agricultural goddesses Demeter and Persephone (see "The Gods and Goddesses of Mount Olympus," page 105), and that the child is Triptolemos, the hero who spread the gift of agriculture to the Greeks. That myth, however, probably postdates the Mycenaean era.

LIFE-SIZE STATUARY Large-scale figural art is very rare on the Greek mainland, as on Crete, other than the paintings that once adorned the walls of Mycenaean palaces (FIG. 4-16A). The triangular relief of the Lion Gate (FIG. 4-19) at Mycenae is exceptional, as is the painted plaster head (FIG. 4-26) of a woman, goddess, or, perhaps, sphinx found at Mycenae. The white flesh tone indicates that the head is female. The hair and eyes are dark blue, almost black, and the lips, ears, and headband are red. The artist decorated the cheeks and chin with red circles surrounded by a ring of red dots, recalling the facial paint or tattoos recorded on Early Cycladic figurines of women. Although the large, staring eyes

follows the decoy cow. Then (at the right in FIG. 4-24), the bull and cow "converse." Finally, a hunter sneaks up behind the bull and succeeds in catching its left hind leg in a noose. Whatever the significance of the theme, the setting in a carefully delineated landscape of trees and rocks is noteworthy, as is the exceptional technical and artistic quality of the cups.

IVORY GODDESSES Gold was not the only luxurious material elite Mycenaean patrons demanded for the objects they commissioned. For a shrine within the palace at Mycenae, a master sculptor carved an intricately detailed group of two women and a child (FIG. **4-25**) from a single piece of costly imported ivory. The women's costumes with breasts exposed have the closest parallels in Minoan art (FIG. 4-13), and this statuette is probably of Cretan manufacture. The intimate and tender theme also is foreign to the known Mycenaean repertoire, in which scenes of hunting and warfare dominate.

The identity of the three figures remains a mystery. Some scholars have suggested that the two women are the "two queens" mentioned in inscriptions found in the excavation of the Mycenaean palace at Pylos (FIG. 4-16A). Others have speculated that the two women are deities, Mycenaean forerunners of the Greek

4-26 Female head, from Mycenae, Greece, ca. 1300–1250 BCE. Painted plaster, $6\frac{1}{2}$ " high. National Archaeological Museum, Athens.

This painted white plaster head of a woman with staring eyes may be a fragment of a very early life-size statue of a goddess in Greece, but some scholars think that it is the head of a sphinx.

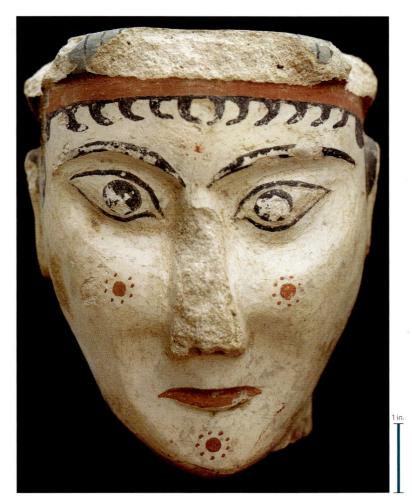

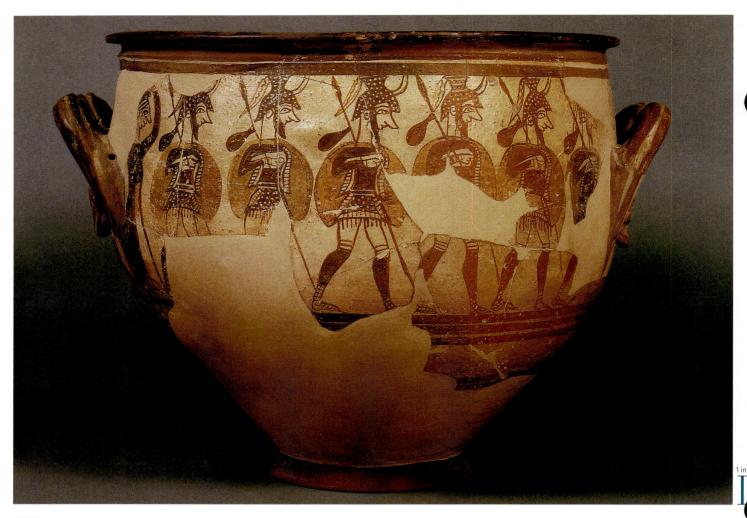

4-27 Warrior Vase (krater), from Mycenae, Greece, ca. 1200 BCE. 1' 4" high. National Archaeological Museum, Athens.

This mixing bowl shows a woman bidding farewell to a column of heavily armed Mycenaean warriors depicted using both silhouette and outline and a combination of frontal and profile views.

give the face a menacing, if not terrifying, expression appropriate for a guardian figure such as a sphinx, the closest parallels to this work in the prehistoric Aegean are terracotta images of goddesses. This head may therefore be a fragment of a very early life-size *cult statue* in Greece, many times the height of the Palaikastro youth (FIG. 4-13A).

Were it not for this plaster head and a few other exceptional pieces, art historians might have concluded, wrongly, that the Mycenaeans had no large-scale freestanding statuary—a reminder that it is always dangerous to generalize from the chance remains of an ancient civilization. Nonetheless, Mycenaean life-size statuary must have been rare, and no large stone statue has ever been found in the prehistoric Aegean world, in striking contrast to Egypt and Mesopotamia. After the collapse of Mycenaean civilization and for the next several hundred years, no attempts at large-scale statuary in any material are evident in the Aegean until, after the waning of the so-called Dark Ages, Greek sculptors became exposed to the great sculptural tradition of Egypt (see page 110).

WARRIOR VASE An art form that did continue throughout the period after the downfall of the Mycenaean palaces was vase paint-

ing. One of the latest examples of Mycenaean painting is the *krater* (bowl for mixing wine and water) commonly called the *Warrior Vase* (FIG. 4-27) after its prominent frieze of soldiers marching off to war. At the left, a woman bids farewell to the column of heavily armed warriors moving away from her. The painting on this vase has no indication of setting and lacks the landscape elements that commonly appear in earlier Minoan and Mycenaean art. Although the painter depicted the soldiers using both silhouette and outline, all repeat the same pattern of combined frontal and profile views, a far cry from the variety and anecdotal detail of the lively procession shown on the Minoan *Harvesters Vase* (FIG. 4-14).

This simplification of narrative has parallels in the increasingly schematic and abstract treatment of marine life on other painted vases. The octopus, for example, eventually became a stylized motif composed of concentric circles and spirals that are almost unrecognizable as a sea creature. By Homer's time, the greatest days of Aegean civilization were but a distant memory, and the men and women of Crete and Mycenae—Minos and Ariadne, Agamemnon and Helen—had assumed the stature of heroes from a lost golden age.

THE PREHISTORIC AEGEAN

Early Cycladic Art ca. 3000-2000 BCE

- The islands of the Aegean Sea boast excellent marble quarries, and marble statuettes are the major surviving artworks of the Cyclades during the third millennium BCE.
- Unfortunately, little is known about the function of the Cycladic figurines because few have secure provenances. Most of the statuettes represent nude women with their arms folded across their abdomens. They probably came from graves and may represent the deceased, but others—for example, musicians—almost certainly do not. Whatever their meaning, these statuettes mark the beginning of the long history of marble sculpture in Greece.

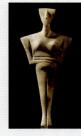

Nude woman, Syros, ca. 2600-2300 BCE

Middle and Late Minoan Art ca. 1700-1200 BCE

- The construction of the first palaces on Crete occurred during the Old Palace period (ca. 2000–1700 BCE), but the golden age of Crete was the Middle and Late Minoan period. The Minoan "palaces" were administrative, commercial, and religious centers that may not have been royal residences.
- The greatest Minoan palace was at Knossos. A vast multistory structure arranged around a central court, the Knossos palace was so complex in plan that it gave rise to the myth of the Minotaur in the labyrinth of King Minos.
- The major pictorial art form in the Minoan world was fresco painting. The murals depicted rituals (such as bull-leaping), landscapes, seascapes, and other subjects. Some of the best examples come from Thera, buried during the volcanic eruption of 1628 BCE.
- Vase painting also flourished. Sea motifs—the octopus, for example—were popular subjects.
- Surviving examples of Minoan sculpture are of small scale. They include statuettes of "snake goddesses" and reliefs on stone vases.

Palace, Knossos, ca. 1700-1370 BCE

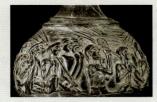

Harvesters Vase, Hagia Triada, ca. 1500 BCE

Mycenaean (Late Helladic) Art ca. 1600-1200 BCE

- As early as 1600–1500 BCE, the Mycenaeans, who with their Greek allies later waged war on Troy, buried their kings in deep shaft graves in which the excavator, Heinrich Schliemann, also found gold funerary masks and bronze daggers inlaid with gold and silver.
- By 1400 BCE, the Mycenaeans had occupied Crete, and between 1400 and 1200 BCE, they erected great citadels on the mainland at Mycenae, Tiryns, and elsewhere with "Cyclopean" walls of huge, irregularly shaped stone blocks. The Greeks of the historical period could not believe that mere humans could have constructed these fortifications.
- Masters of corbel vaulting, the Mycenaeans also erected beehive-shaped tholos tombs. One example is the Treasury of Atreus, which has the largest dome in the pre-Roman world.
- The oldest preserved large-scale sculptures in Greece, most notably Mycenae's Lion Gate, date to the end of the Mycenaean period.
- The Mycenaeans also excelled in small-scale ivory carving and pottery painting.

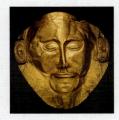

Gold funerary mask, Mycenae, ca. 1600-1500 BCE

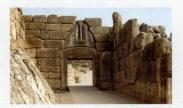

Lion Gate, Mycenae, ca. 1300-1250 BCE

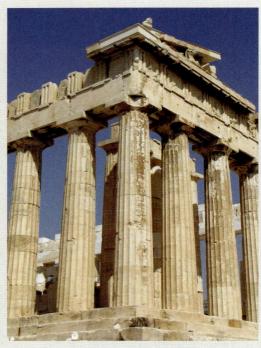

∢ 5-1a Iktinos, the architect of the Parthenon, calculated the dimensions of every part of the temple using harmonic numerical ratios, which determined, for example, the height and diameter of each column.

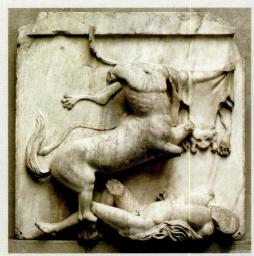

▲ 5-1b The reliefs depicting Greeks battling semihuman centaurs are allegories of the triumph of civilization and rational order over barbarism and chaos—and of the Greek defeat of the Persians in 479 BCE.

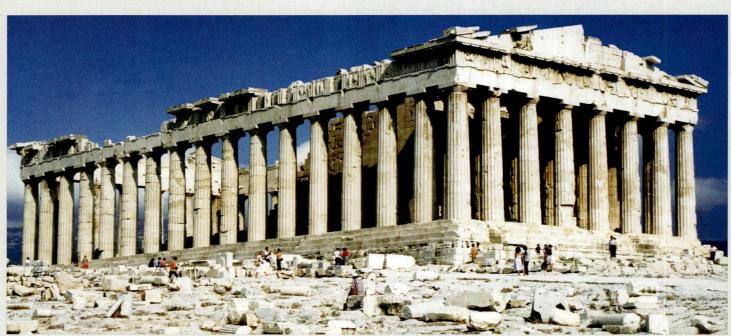

IKTINOS, Parthenon (looking southeast), Acropolis, Athens, Greece, 447-438 BCE.

▶ 5-1c The costliest part of the Parthenon's lavish sculptural program was inside—Phidias's colossal gold-and-ivory statue depicting Athena presenting the personification of Victory to Athens.

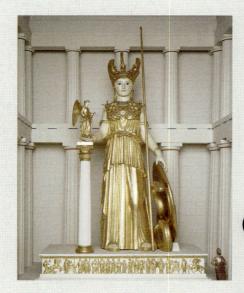

5

Ancient Greece

THE PERFECT TEMPLE

Although the Greeks borrowed many ideas from the artists and architects of Egypt and Mesopotamia, they quickly developed an independent artistic identity. Their many innovations in painting, sculpture, and architecture became the foundation of the Western tradition in the history of art. Indeed, no building type has ever had a longer and more profound impact on the later history of architecture than the Greek temple, which was itself a multimedia monument, richly adorned with painted statues and reliefs.

The greatest Greek temple was the Parthenon (FIG. 5-1)—although, ironically, it lacks some of the key features of all other Greek temples (see pages 113–115). Erected on the Acropolis of Athens in the mid-fifth century BCE, the Parthenon represents the culmination of a century-long effort by Greek architects to design a building with perfect proportions. Consistent with the thinking of the influential philosopher Pythagoras of Samos, who believed that beauty resided in harmonic numerical ratios, the architect Iktinos calculated the dimensions of every part of the Parthenon in terms of a fixed proportional scheme. Thus the ratio of the length to the width of the building, the number of columns on the long versus the short sides, and even the relationship between the diameter of a column and the space between neighboring columns conformed to an all-encompassing mathematical formula. The result was a "perfect temple."

The Athenians did not, however, construct the Parthenon to solve a purely formal problem of architectural design. Nor did the shrine honor Athena Parthenos ("the virgin") alone. The Parthenon also celebrated the Athenian people, who a generation earlier had led the Greeks to victory over the Persians after they had sacked the Acropolis in 480 BCE. Under the direction of Phidias, a team of gifted sculptors lavishly decorated the building with statues and reliefs that in many cases alluded to that triumph. For example, the sculptural program included reliefs depicting nude Greek warriors battling with the part-horse, part-human *centaurs*—an allegory of the triumph of civilization (that is, Greek civilization) over barbarism (in this case, the Persians). The statues on the front of the building told the story of the birth of Athena, who emerged from the head of her father, Zeus, king of the gods, fully armed and ready to protect her people. The costliest sculpture, and most prestigious of all, however, Phidias reserved for himself: the colossal gold-and-ivory statue of Athena inside. Phidias depicted the warrior goddess presenting the Athenians with the winged personification of Victory—an unmistakable reference to the Greek defeat of the Persians.

THE GREEKS AND THEIR GODS

Ancient Greek art occupies a special place in the history of art through the ages. Many of the cultural values of the Greeks, especially the exaltation of humans as the "measure of all things," remain fundamental principles of Western civilization today. This humanistic worldview led the Greeks to create the concept of democracy (rule by the demos, the people) and to make groundbreaking contributions in the fields of art, literature, and science. Because ancient Greek ideas are so completely part of modern Western habits of mind, most people are scarcely aware that the concepts originated in Greece 2,500 years ago.

The Greeks, or Hellenes, as they called themselves, were the product of an intermingling of Aegean and Indo-European peoples who established independent city-states, or poleis (singular, polis). The Dorians of the north, who many believe brought an end to Mycenaean civilization, settled in the Peloponnesos (MAP 5-1). The Ionians settled the western coast of Asia Minor (modern Turkey) and the islands of the Aegean Sea, possibly because they were native to Asia Minor, developing out of a mixed stock of settlers between

the 11th and 8th centuries BCE. Whatever the origins of the various regional populations, in 776 BCE the separate Greek-speaking states held their first athletic games in common at Olympia. From then on, despite their differences and rivalries, the Greeks regarded themselves as citizens of Hellas, distinct from the surrounding "barbarians" who did not speak Greek.

Even the gods of the Greeks (see "The Gods and Goddesses of Mount Olympus," page 105) were distinct from those of neighboring civilizations. Unlike Egyptian deities, the Greek gods and goddesses differed from human beings only in being immortal. The Greeks made their gods into humans and their humans into gods. The perfect individual became the Greek ideal—and the portraval of beautiful humans became the focus of many of the greatest Greek artists.

The sculptures, paintings, and buildings discussed in this chapter come from cities all over Greece and their many colonies abroad (MAP 5-1), but Athens, where the plays of Aeschylus, Sophocles, and Euripides were first performed and where many of the most famous artists and architects worked, has justifiably become the symbol of ancient Greek culture. There, Socrates engaged his fellow citizens in philosophical argument, and Plato formulated his prescription

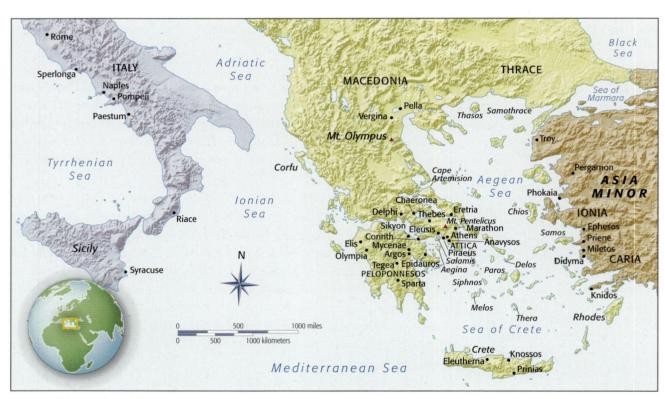

MAP 5-1 The Greek world.

ANCIENT GREECE

900-600 BCE **Geometric and Orientalizing**

- Greek artists revive figure painting during the Geometric
- Eastern motifs enter Greek art during the Orientalizing period

600-480 BCE Archaic

Greek architects erect the

- first peripteral Doric and Ionic temples
- Greek sculptors carve life-size stone statues with "Archaic smiles"
- Greek ceramists perfect black- and, later, red-figure vase painting

480-400 BCE **Early and High Classical**

Sculptors introduce contrap-

- posto in Greek statuary
- Polykleitos formulates his canon of proportions
- Pericles rebuilds the Athenian Acropolis after the Persian sack

400-323 BCE

Late Classical

- Praxiteles and other sculptors humanize the Greek gods and goddesses
- Corinthian capitals are introduced in Greek archi-
- Lysippos is appointed the official court artist of Alexander the Great

323-30 BCE

Hellenistic

- Hellenistic kingdoms replace Athens as leading cultural centers
- Artists explore new subjects in sculpture and painting
- Architects break the rules of the Classical orders

RELIGION AND MYTHOLOGY

The Gods and Goddesses of Mount Olympus

The names of scores of Greek gods and goddesses appear as early as the eighth century BCE in Homer's epic tales of the war against Troy (*Iliad*) and of the adventures of the Greek hero Odysseus on his long journey home (*Odyssey*). The poet Hesiod enumerated even more names, especially in his *Theogony* (*Genealogy of the Gods*), composed around 700 BCE.

The Greek deities most often represented in art are all ultimately the offspring of the two key elements of the Greek universe: Earth (Gaia/Ge; all names appear here in their Greek and Latin forms respectively) and Heaven (Ouranos/Uranus). Earth and Heaven mated to produce 12 Titans, including Ocean (Okeanos/Oceanus) and his youngest brother Kronos (Saturn). Kronos castrated his father in order to rule in his place, married his sister Rhea, and then swallowed all his children as they were born, because a prophecy said that one of them would seek in turn to usurp him. When Zeus (Jupiter) was born, Rhea deceived Kronos by feeding him a stone wrapped in clothes in place of the infant. After growing to manhood, Zeus forced Kronos to vomit up Zeus's siblings. Together they overthrew their father and the other Titans, and ruled the world from their home on Mount Olympus, Greece's highest peak.

This cruel and bloody tale of the origin of the Greek gods has parallels in Mesopotamian mythology and is clearly pre-Greek in origin, one of many Greek borrowings from the East. The Greek version of the creation myth, however, appears infrequently in painting and sculpture. Instead, the later 12 *Olympian* gods and goddesses figure most prominently in art—not only in antiquity but also in the Middle Ages, the Renaissance, and up to the present.

Zeus and His Siblings

- **Zeus (Jupiter)** King of the gods, Zeus ruled the sky and allotted the sea to his brother Poseidon and the Underworld to his other brother, Hades. His weapon was the thunderbolt, and with it he led the other gods to victory over the giants, who had challenged the Olympians for control of the world.
- Hera (Juno) Wife and sister of Zeus, Hera was the goddess of marriage.
- Poseidon (Neptune) Poseidon, one of the three sons of Kronos and Rhea, was lord of the sea. He controlled waves, storms, and earthquakes with his three-pronged pitchfork (trident).
- Hestia (Vesta) Sister of Zeus, Poseidon, and Hera, Hestia was goddess of the hearth.
- Demeter (Ceres) Third sister of Zeus, Demeter was the goddess of grain and agriculture.

Zeus's Children

- Ares (Mars) God of war, Ares was the son of Zeus and Hera and the lover of Aphrodite. His Roman counterpart, Mars, was the father of the twin founders of Rome, Romulus and Remus.
- Athena (Minerva) Goddess of wisdom and warfare, Athena was a virgin (parthenos in Greek), born not from a woman's womb but from the head of her father, Zeus.
- Hephaistos (Vulcan) God of fire and of metalworking, Hephaistos, son of Zeus and Hera, fashioned the armor that Achilles wore in battle against Troy. He also provided Zeus his scepter and Poseidon his trident, and was the "surgeon" who split open Zeus's head to facilitate the birth of Athena. Hephaistos was born lame and, uncharacteristically for a god, ugly. His wife, Aphrodite, was unfaithful to him.
- Apollo (Apollo) God of light and music, Apollo was the son of Zeus with Leto/Latona, daughter of one of the Titans. His epithet, phoibos, means "radiant," and the young, beautiful Apollo was sometimes identified with the sun (Helios/Sol).
- Artemis (Diana) Sister of Apollo, Artemis was goddess of the hunt and of wild animals. As Apollo's twin, she was occasionally regarded as the moon (Selene/Luna).
- Aphrodite (Venus) Daughter of Zeus and Dione (daughter of Okeanos and one of the nymphs—the goddesses of springs, caves, and woods), Aphrodite was the goddess of love and beauty. In one version of her myth, she was born from the foam (aphros in Greek) of the sea. She was the mother of Eros by Ares and of the Trojan hero Aeneas by a mortal named Anchises.
- Hermes (Mercury) Son of Zeus and another nymph, Hermes was the fleet-footed messenger of the gods and possessed winged sandals. He was also the guide of travelers, including the dead journeying to the Underworld. He carried the herald's rod (kerykeion/caduceus) and wore a winged traveler's hat.

Some Non-Olympian Deities

- Hades (Pluto) One of the children of Kronos who fought with his brothers against the Titans, Hades was equal in stature to the Olympians but never resided on Mount Olympus. He was the god of the dead and lord of the Underworld (also called Hades).
- Dionysos (Bacchus) The son of Zeus and a mortal woman, Dionysos was the god of wine.
- **Eros (Amor** or **Cupid)** The son of Aphrodite and Ares, Eros was the winged child-god of love.
- Asklepios (Aesculapius) The son of Apollo and a mortal woman, Asklepios was the Greek god of healing, whose serpent-entwined staff is the emblem of modern medicine.

for the ideal form of government in his *Republic*. Complementing the rich intellectual life of Athens was a strong interest in athletic exercise. The Athenian aim of achieving a balance of intellectual and physical discipline, an ideal of humanistic education, is well expressed in the familiar phrase "a sound mind in a sound body."

The distinctiveness and originality of Greek contributions to art, science, and politics should not, however, obscure the enormous debt the Greeks owed to the cultures of Egypt and Mesopotamia. The ancient Greeks themselves readily acknowledged borrowing ideas, motifs, conventions, and skills from those older civilizations. Nor should a high estimation of Greek art and culture blind anyone to the realities of Hellenic life and society. Even Athenian "democracy" was a political reality for only one segment of the demos. Slavery was a universal institution among the Greeks, as among other ancient peoples, and Greek women were in no way the equals of Greek men. Well-born women normally remained secluded in

their homes, emerging usually only for weddings, funerals, and religious festivals, in which they played a prominent role. Otherwise, they took little part in public or political life. Despite the fame of the poet Sappho, only a handful of female artists' names are known, and none of their works survive. The existence of slavery and the exclusion of women from public life are both reflected in Greek art. Freeborn men and women often appear with their slaves in large-scale public sculpture. The *symposium* (a dinner party only men and prostitutes attended) is a popular subject on painted vases used in private homes.

GEOMETRIC AND ORIENTALIZING PERIODS

The destruction of the Mycenaean palaces around 1200 BCE brought with it the disintegration of the traditional social order in the prehistoric Aegean. The disappearance of powerful kings and their retinues led to the loss of the knowledge of how to cut masonry, to construct citadels and tombs, to paint frescoes, and to sculpt in stone. Depopulation, poverty, and an almost total loss of contact with the outside world characterized the succeeding centuries, sometimes called the Dark Age of Greece. Only in the eighth century BCE did economic

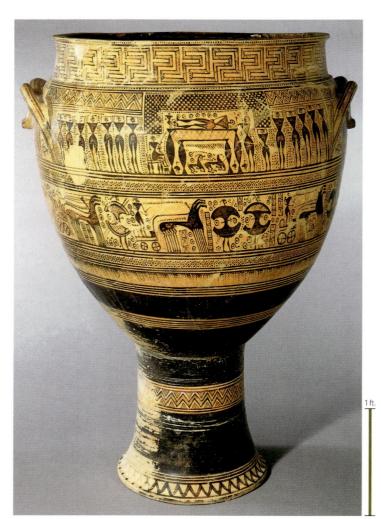

5-2 Geometric krater, from the Dipylon cemetery, Athens, Greece, ca. 740 BCE. 3' $4\frac{1}{2}$ " high. Metropolitan Museum of Art, New York.

Figure painting returned to Greek art in the Geometric period, named for the abstract motifs on vases such as this funerary krater featuring a mourning scene and procession in honor of the deceased.

conditions improve and the population begin to grow again. This era was in its own way a heroic age, when the Greeks established the Olympic Games and wrote down Homer's epic poems, formerly passed orally from bard to bard. During the eighth century BCE, the Greeks broke free of their isolation and once again began to trade with cities in both the east and the west.

Geometric Art

The eighth century also brought the return of the human figure to Greek art—not in large-scale statuary, which was exceedingly rare even in Mycenaean Greece, but in small bronze figurines and in paintings on ceramic pots.

DIPYLON KRATER One of the earliest examples of Greek figure painting is a huge *krater* (FIG. **5-2**) that marked the grave of a man buried around 740 BCE in the Dipylon cemetery of Athens. At well over 3 feet tall, this vase is a considerable technical achievement and a testament both to the potter's skill and to the wealth and position of the deceased's family in the community. The bottom of the great vessel is open, perhaps to enable visitors to the grave to pour libations in honor of the dead, perhaps simply to provide a drain for rainwater, or both.

The artist covered much of the krater's surface with precisely painted abstract angular motifs in horizontal bands. Especially prominent is the *meander*, or key, pattern around the rim of the krater. The decoration of most early Greek vases consists exclusively of abstract motifs—hence the designation of this formative phase of Greek art as the *Geometric* period. On this krater, however, abstract ornament does not dominate. Instead, the painter reserved the widest part of the vase for two bands of human figures and horse-drawn chariots rather than for geometric ornament.

₹ 5-2A DIPYLON PAINTER, Geometric funerary amphora, ca. 750 BCE.

Befitting the vase's function, the scenes depict the mourning for a man laid out on his bier and the grand chariot procession

in his honor, scenes that appear frequently on other large Geometric vessels that served as grave markers—for example, the namepiece of the Dipylon Painter, a 5-foot-tall amphora (fig. 5-2A) that also stood in the Dipylon cemetery. As also on the amphora, every empty space around the figures on the krater is filled with circles and M-shaped ornaments, negating any sense that the mourners or soldiers inhabit open space. The human figures, animals, and furniture are as two-dimensional as the geometric shapes elsewhere on the vessel. In the upper band, the shroud, raised to reveal the corpse, is an abstract checkerboard-like backdrop. The figures are silhouettes constructed of triangular (that is, frontal) torsos with attached profile arms, legs, and heads (with a single large frontal eye in the center), following the age-old convention. To distinguish male from female, the painter added a penis protruding from the deceased's right thigh. The mourning women, who tear their hair out in grief, have breasts indicated as lines beneath their armpits. In both cases, the artist's concern was specifying gender, not representing human anatomy accurately. Below, the warriors look like walking shields, and, in the old conceptual manner, the two wheels of the chariots appear side by side. The horses have the correct number of heads and legs but seem to share a common body, so that there

5-3 Hero and centaur (Herakles and Nessos?), from Olympia, Greece, ca. 750–730 BCE. Bronze, $4\frac{1}{2}$ " high. Metropolitan Museum of Art, New York (gift of J. Pierpont Morgan, 1917).

Sculpture of the Geometric period is small in scale, and the figures have simple, stylized shapes. This statuette depicts a hero battling a centaur—an early example of mythological narrative.

is no sense of overlapping or depth. Despite the highly stylized and conventional manner of representation, this krater and the Dipylon Painter's amphora (FIG. 5-2A) mark a significant turning point in the history of Greek art. Not only did the human figure reenter the painter's repertoire, but the Geometric artists also revived the art of storytelling in pictures.

HERAKLES AND NESSOS One of the most impressive surviving Geometric sculptures is a characteristically small solid-cast bronze group (FIG. 5-3) made up of two schematic figures locked in a hand-to-hand struggle. The man is a hero, probably Herakles (see "Herakles, the Greatest Greek Hero," page 124). His opponent is a centaur, possibly Nessos, who had volunteered to carry the hero's bride across a river and then assaulted her. Whether or not the hero is Herakles and the centaur is Nessos, the mythological nature of the group is certain. The repertoire of the Geometric artist was not limited to scenes inspired by daily life (and death). Composite monsters were enormously popular in Mesopotamia and Egypt, and renewed contact with foreign cultures may have inspired the human-animal monsters of Geometric Greece.

The centaur, however, is a purely Greek invention—and one that posed a problem for the artist, who had, of course, never seen such a creature. The Geometric artist conceived the centaur as a man in front and a horse in back, a rather unconvincing configura-

tion in which the forelegs and hind legs belong to different species. In this example, the sculptor rendered the figure of the hero and the human part of the centaur in a similar fashion. Both have beards and wear helmets, but (contradictory to nature) the man is larger than the horse to indicate that he will be the victor. As are other Geometric male figures, both painted and sculpted, this hero is nude, in contrast to the Mesopotamian statuettes that might have inspired the Greek works. Here, at the very beginning of Greek figural art, the Hellenic instinct for the natural beauty of the human figure is evident. Greek youths exercised without their clothes and even competed nude in the Olympic Games from very early times.

Orientalizing Art

During the seventh century BCE, the pace and scope of Greek trade and colonization accelerated, and Greek artists became exposed more than ever before to Eastern artworks, especially small portable objects such as Syrian ivory carvings. The closer contact had a profound effect on the development of Greek art. Indeed, so many motifs borrowed from or inspired by Egyptian and Mesopotamian art entered the Greek pictorial vocabulary at this time that art historians have dubbed the seventh century BCE the *Orientalizing* period.

MANTIKLOS APOLLO One of the masterworks of the early seventh century BCE is the *Mantiklos Apollo* (FIG. 5-4), a small bronze statuette dedicated to Apollo by an otherwise unknown man named

Mantiklos. Scratched into the thighs of the figure is a message to the deity: "Mantiklos dedicated me as a tithe to the far-shooting Lord of the Silver Bow; you, Phoibos [Apollo], might give some pleasing favor in return." Because the Greeks conceived their gods in human form, it is uncertain whether the figure represents the youthful Apollo or Mantiklos (or neither). But if the left hand at one time held a bow, the statuette is certainly an image of the deity. In any case, the purpose of the votive offering is clear. Equally apparent is the increased interest Greek artists

5-4 Mantiklos Apollo, statuette of a youth dedicated by Mantiklos to Apollo, from Thebes, Greece, ca. 700–680 BCE. Bronze, 8" high. Museum of Fine Arts, Boston.

Mantiklos dedicated this statuette to Apollo, and it probably represents the god. The treatment of the body reveals the interest seventh-century BCE Greek artists had in representing human anatomy.

MATERIALS AND TECHNIQUES

Greek Vase Painting

The techniques Greek ceramists used to shape and decorate fine vases required great skill, acquired over many years as apprentices in the workshops of master potters. During the sixth and fifth centuries BCE, when the art of vase painting was at its zenith in Greece, both potters and painters frequently signed their work. These signatures reveal the pride of the artists. In the ancient world, the Greeks were unique in celebrating individual artists as creative geniuses and in systematically recording artists' names for posterity. Many artists achieved great renown even during their lifetimes. No earlier civilization held artists in such high esteem (Egypt's deification of Imhotep was exceptional)—nor would any later culture bestow such high regard on painters, sculptors, and other artisans until the Renaissance in Italy 2,000 years later.

The signatures on Greek vases also might have functioned as "brand names" for a large export market. The products of the workshops in Corinth and Athens in particular were highly prized and have been found all over the Mediterranean world. For example, the Corinthian Orientalizing amphora shown here (Fig. 5-5) was found on Rhodes, an island at the opposite side of the Aegean from mainland Corinth (MAP 5-1). The Etruscans of central Italy (MAP 6-1) were especially good customers. Athenian vases were staples in Etruscan tombs, and all of the illustrated sixth-century BCE examples (Figs. 5-19 to 5-24A) came from Etruscan sites. Other painted Athenian pots have been unearthed as far away as France, Russia, and the Sudan.

The first step in manufacturing a Greek vase was to remove any impurities found in the natural clay and then to knead it, like dough, to remove air bubbles and make it flexible. The Greeks used dozens of different kinds and shapes of pots, and produced most of them in several parts. Potters constructed the vessel's body by placing the clay on a rotating horizontal wheel. While an apprentice turned the wheel by hand, the potter pulled up the clay with the fingers to form the desired shape. The master or the apprentice modeled the handles separately and attached them to the vase body by applying *slip* (liquefied clay) to the joints.

Painting was usually the job of a specialist, although many potters decorated their own work. (Today, most people tend to regard painters as more elevated artists than potters, but in ancient Greece, the potters owned the shops and employed the painters.) Art historians customarily refer to the "pigment" the painter applied to the clay surface as glaze, but the black areas on Greek pots are neither pigment nor glaze but a slip of finely sifted clay that originally was of the same rich redorange color as the clay of the pot. In the three-phase firing process Athenian ceramists used, the first (oxidizing) phase turned both pot and slip red. During the second (reducing) phase, the potter shut off the oxygen supply into the kiln, and both pot and slip turned black. In the final (reoxidizing) phase, the pot's coarser material reabsorbed oxygen

5-5 Corinthian black-figure amphora with animal friezes, from Rhodes, Greece, ca. 625–600 BCE. 1' 2" high. British Museum, London.

The Corinthians invented the black-figure technique of vase painting in which artists incised linear details into black-glaze silhouettes. This early example features Orientalizing animals.

and became red again, while the smoother, silica-laden slip did not and remained black. After long experimentation, Greek ceramists developed a velvety jet-black "glaze" of this kind, produced in kilns heated to temperatures as high as 950° Celsius (about 1742° Fahrenheit). The firing process was the same whether the painter worked in blackfigure or in red-figure (see page 119). In fact, Athenian vase painters sometimes employed both manners on the same vessel (FIGS. 5-21 and 5-22). A special advantage of the Greek manufacturing process is that the painted decoration fuses with the clay fabric of the pot. Black- and red-figure pottery can be broken, but the colors cannot fade.

at this time had in reproducing details of human anatomy, such as the pectoral and abdominal muscles, which define the stylized triangular torso. The sculptor also took care to represent the long hair framing the unnaturally elongated neck. The triangular face once had inlaid eyes, and the figure may have worn a separately fashioned helmet.

ORIENTALIZING AMPHORA The elaborate Corinthian amphora illustrated here (FIG. 5-5) typifies the new Greek fascination with

the Orient. In a series of bands recalling the organization of Geometric painted vases, animals such as the native boar appear beside exotic lions and panthers and composite creatures inspired by Eastern monsters such as the sphinx and lamassu—in this instance the *siren* (part bird, part woman) prominently displayed on the amphora's neck. The Orientalizing animal friezes of these vases had wide appeal in the marketplace, but so too did the new ceramic technique the Corinthians invented. Art historians call this type of vase decoration *black-figure painting* (see "Greek Vase Painting," above).

The black-figure painter first put down black silhouettes on the clay surface, as in Geometric times, but then used a sharp, pointed instrument to incise linear details within the forms, usually adding highlights in white or purplish red over the black figures before firing the vase. The combination of the weighty black silhouettes with the delicate detailing and the bright polychrome overlay proved to be irresistible, and Athenian painters soon copied the technique that the Corinthians pioneered.

DAEDALIC ART The founding of the Greek trading colony of Naukratis in Egypt (MAP 3-1) before 630 BCE brought the Greeks into direct contact with the impressive stone architecture of the

3-5A Plan, Temple A, Prinias, ca. 625 BCF.

Egyptians. Soon after, Greek builders began to erect the first stone edifices since the fall of the Mycenaean kingdoms. One of the oldest is Temple A (FIG. 5-5A) at Prinias on Crete. That island, once the center of Minoan civilization (see MAP 4-1), is also where an early Greek sculptor

carved the limestone statuette of a goddess or maiden (*kore*; plural, *korai*) popularly known as the *Lady of Auxerre* (FIG. **5-6**) after the French town that is her oldest recorded location. The *Lady of Auxerre* is the masterpiece of the style usually referred to as *Daedalic*, after the legendary artist Daedalus, whose name means "the skillful one." In addition to his status as a great sculptor, Daedalus reputedly built the labyrinth in Crete to house the Minotaur (see pages 86–87) and also designed a temple at Memphis in Egypt. The historical Greeks attributed to him almost all the great achievements in early sculpture and architecture.

As with the figure that Mantiklos dedicated (FIG. 5-4), it is uncertain whether the Auxerre "lady" is a mortal or a deity. She is clothed, as are all Greek goddesses and women of this period, but

₹ 5-6A Lintel, Temple A, Prinias, ca. 625 BCE.

she does not wear a headdress, as do the contemporaneous goddesses (FIG. 5-6A) of Temple A at Prinias. Moreover, the placement of the right hand across the chest is probably a gesture of prayer, also indicating that this is a kore. Some evidence suggests that the findspot of the *Lady of Auxerre* was a ceme-

tery at Eleutherna, which would confirm that the statue represents a deceased woman and not a goddess. The style is much more naturalistic than in Geometric times, but the love of abstract shapes is still evident. Note, for example, the triangular flat-topped head framed by long strands of hair that form triangles complementary to the shape of the face, and the decoration of the long skirt with its incised concentric squares, once brightly painted, as were all Greek stone statues. The modern notion that Greco-Roman statuary was pure white is mistaken. The Greeks did not, however, color their statues garishly. They left the flesh in the natural color of the stone, which they waxed and polished, and painted the eyes, lips, hair, and drapery in *encaustic* (see "Iaia of Cyzicus and the Art of Encaustic Painting," page 217, and FIG. 5-63A). In this technique, the painter mixed the pigment with hot wax and applied it to the statue to produce a durable coloration.

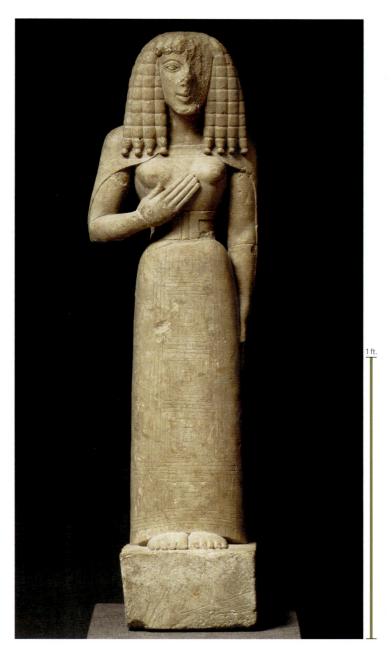

5-6 Lady of Auxerre, from Crete, probably Eleutherna, Greece, ca. 650–625 BCE. Limestone, $2' 1\frac{1}{2}''$ high. Musée du Louvre, Paris.

Carved on Crete, this praying kore (maiden) typifies the Daedalic sculptural style of the seventh century BCE with its triangular face and hair and lingering Geometric fondness for abstract pattern.

ARCHAIC PERIOD

The legend that Daedalus worked in Egypt reflects the enormous influence of Egyptian art and architecture on the Greeks not only during the Orientalizing age of the seventh century BCE but also in the succeeding *Archaic* period, which lasted from 600 to 480 BCE.

Statuary

According to the first-century BCE Greek historian Diodorus Siculus,¹ Daedalus used the same compositional patterns for his statues as the Egyptians used for their own. The earliest surviving large-scale stone statues of the Greeks do, in fact, follow very closely the standard Egyptian format.

NEW YORK KOUROS One of the earliest Greek examples of life-size statuary (FIG. 5-7) is the marble *kouros* ("youth"; plural, *kouroi*) now in New York, which emulates the stance of Egyptian statues (FIG. 3-13). In both Egypt and Greece, the figure is rigidly frontal with the left foot advanced slightly. The arms are held beside the body, and the fists are clenched with the thumbs forward. As did most Egyptian statues, the New York kouros also had a funerary function. It stood over a grave in the countryside of Attica, the region around Athens, possibly in the same cemetery as the later statue of Kroisos (FIG. 5-9). Statues such as this one replaced the huge vases (FIGs. 5-2 and 5-2A) of Geometric times as the preferred form of grave marker in the sixth century BCE. The Greeks also used kouroi as votive offerings in sanctuaries. The kouros type, because of its generic quality, could be employed in several different contexts.

Despite the adherence to Egyptian prototypes, Greek kouros statues differ from their models in two important ways. First, the Greek sculptors liberated the figures from the stone block. The Egyptian obsession with permanence was alien to the Greeks, who were preoccupied with finding ways to represent motion rather than stability in their sculpted figures. Second, the kouroi are nude (this kouros wears only a choke necklace), and in the absence of identifying attributes, they, like Mantiklos's bronze statuette (FIG. 5-4), are formally indistinguishable from Greek images of deities with their perfect bodies exposed for all to see.

The New York kouros shares many traits with the *Mantiklos Apollo* and other Orientalizing works such as the *Lady of Auxerre*, especially the triangular shape of head and hair and the flatness of the face—the hallmarks of the Daedalic style. Eyes, nose, and mouth all sit on the front of the head, and the ears on the sides. The long hair forms a flat backdrop behind the head. The placement of the various anatomical parts is the result of the sculptor's having drawn these features on four independent sides of the marble block, following the same workshop procedure used in Egypt for millennia. The New York kouros also has the slim waist of earlier Greek statues and exhibits the same love of pattern. The pointed arch of the rib cage, for example, echoes the V-shaped ridge of the hips, which suggests but does not accurately reproduce the rounded flesh and muscle of the human body.

CALF BEARER A generation later than the New York kouros is the statue (FIG. 5-8) of a moschophoros, or calf bearer, found in fragments on the Athenian Acropolis. Its inscribed base (not visible in the photograph) states that an otherwise unknown man named Rhonbos, son of Palos, dedicated the statue to Athena. Rhonbos is almost certainly the calf bearer himself, bringing an offering to the goddess. He stands in the left-foot-forward manner of the kouroi, but he is bearded and therefore no longer a youth. He wears a thin cloak (once painted to set it off from the otherwise nude body). No one dressed in this way in ancient Athens. The sculptor adhered to the artistic convention of male nudity and attributed to the calf bearer the noble perfection nudity imparts, but nevertheless indicated that this mature gentleman is clothed, as any respectable citizen would be in this context. The Archaic sculptor's love of pattern is evident once again in the handling of the difficult problem of representing man and animal together. The calf's legs and the moschophoros's arms form a bold X that unites the two bodies both physically and formally.

The calf bearer's face differs markedly from those of earlier Greek statues (and those of Egypt and Mesopotamia) in one

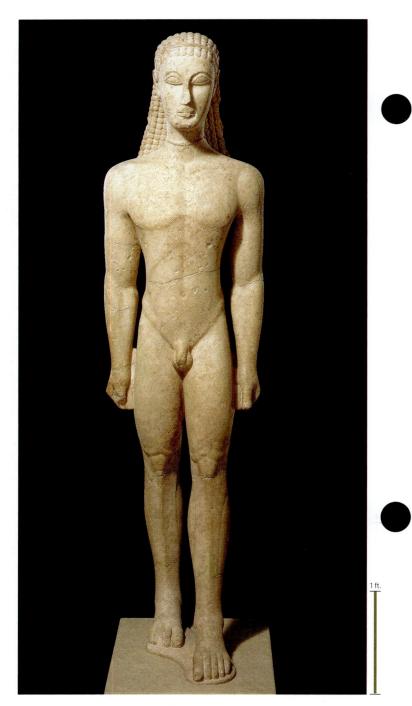

5-7 Kouros, from Attica, possibly Anavysos, Greece, ca. 600 BCE. Marble, $6'\frac{1}{2}''$ high. Metropolitan Museum of Art, New York.

The sculptors of the earliest life-size statues of kouroi (young men) adopted the Egyptian pose for standing figures (FIG. 3-13), but the kouroi are nude and liberated from the stone block.

notable way. The man smiles—or at least seems to. From this time on, Archaic Greek statues always smile, even in the most inappropriate contexts (see, for example, FIG. 5-28, which shows a dying warrior with an arrow in his chest—yet grinning broadly). Art historians have interpreted this so-called *Archaic smile* in various ways, but the happy face should not be taken literally. Rather, the Archaic smile is the way Greek sculptors of this era indicated that the person portrayed is alive. By adopting this convention, Greek artists signaled that their intentions were very different from those of their Egyptian counterparts.

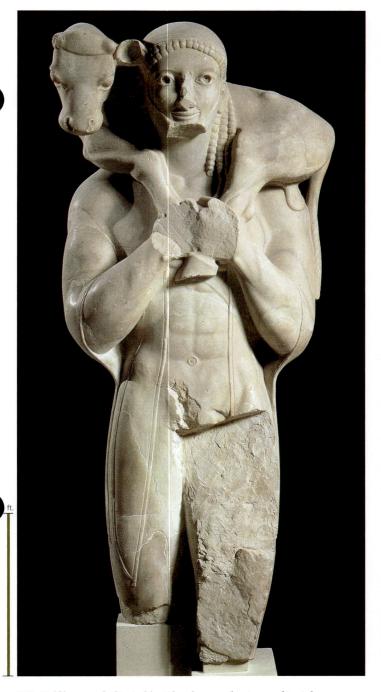

5-8 Calf bearer, dedicated by Rhonbos on the Acropolis, Athens, Greece, ca. 560 BCE. Marble, restored height 5' 5"; fragment 3' $11\frac{1}{2}$ " high. Acropolis Museum, Athens.

This statue of a bearded man bringing a calf to sacrifice to Athena is one of the first to employ the so-called Archaic smile—probably the Greek sculptor's way of indicating that a person is alive.

ANAVYSOS KOUROS Sometime around 530 BCE, a young man named Kroisos died a hero's death in battle, and, to commemorate his life, his family erected a kouros statue (FIG. **5-9**) over his grave at Anavysos, not far from Athens. Fortunately, some of the paint remains, giving a better sense of the statue's original appearance. The inscribed base invites visitors to "stay and mourn at the tomb of dead Kroisos, whom raging Ares destroyed one day as he fought in the foremost ranks." The smiling statue is no more a portrait of a specific youth than is the New York kouros. But two generations

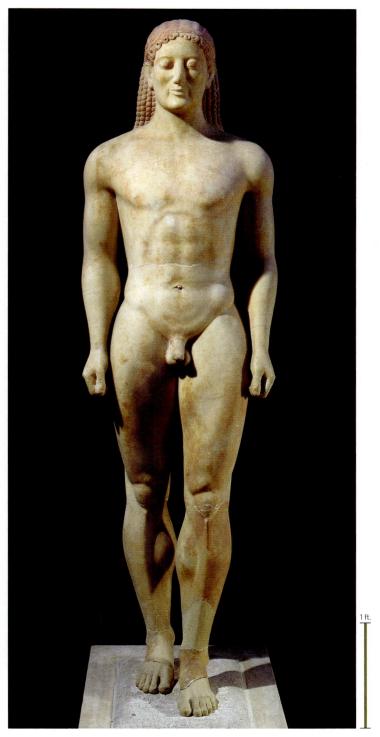

5-9 Kroisos, from Anavysos, Greece, ca. 530 BCE. Marble, 6' 4" high. National Archaeological Museum, Athens.

This later kouros stood over the grave of Kroisos, a young man who died in battle. The statue displays more naturalistic proportions and more rounded modeling of face, torso, and limbs.

later, without rejecting the Egyptian stance, the Greek sculptor rendered the human body in a far more naturalistic manner. The head is no longer too large for the body, and the face is more rounded, with swelling cheeks replacing the flat planes of the earlier work. The long hair does not form a stiff backdrop to the head but falls naturally over the back. The V-shaped ridges of the New York kouros have become rounded, fleshy hips.

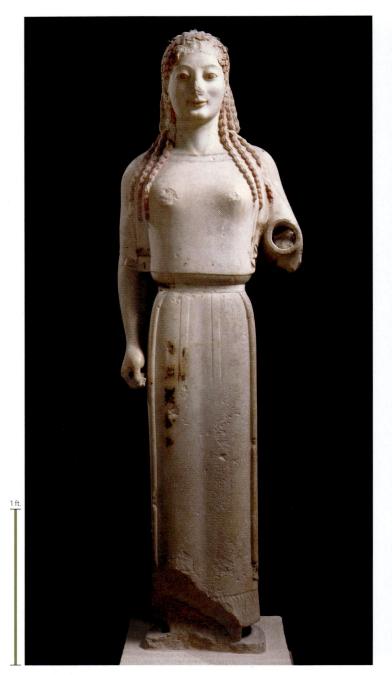

5-10 *Peplos Kore*, from the Acropolis, Athens, Greece, ca. 530 BCE. Marble, 4' high. Acropolis Museum, Athens.

Unlike men, women are always clothed in Archaic statuary. This kore is a votive statue of a goddess wearing four garments. She held her identifying attribute in her missing left hand.

PEPLOS KORE A stylistic "sister" to the Anavysos kouros is the statue of a woman traditionally known as the *Peplos Kore* (FIG. **5-10**) because until recently scholars thought this kore wore a peplos. A *peplos* is a simple, long, woolen belted garment. Careful examination of the statue has revealed, however, that she wears four different garments, one of which only goddesses wore. The attribute the goddess held in her missing left hand would immediately have identified her. Whichever goddess she is, the contrast with the *Lady of Auxerre* (FIG. 5-6) is striking. Although in both cases the drapery conceals the entire body save for head, arms, and feet, the sixth-century BCE sculptor rendered the soft female form much more naturally. This

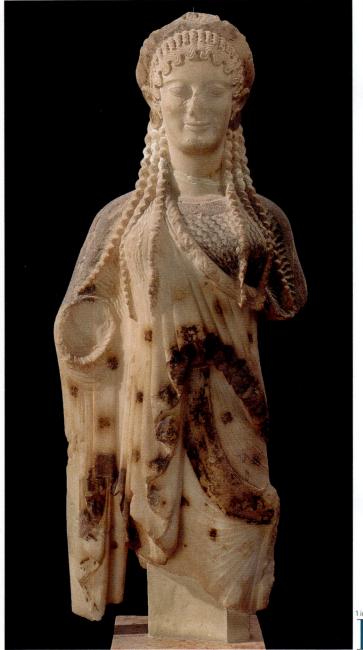

5-11 Kore in Ionian dress, from the Acropolis, Athens, Greece, ca. 520–510 BCE. Marble, 1' 9" high. Acropolis Museum, Athens.

Archaic sculptors delighted in rendering the intricate asymmetrical patterns created by the cascading folds of garments, such as the Ionian chiton and himation worn by this smiling Acropolis kore.

softer treatment of the flesh also sharply differentiates later korai from kouroi, which have hard, muscular bodies.

Traces of paint remain on the *Peplos Kore* because the statue lay buried for more than two millennia, which protected the painted surface from the destructive effects of exposure to the atmosphere and bad weather. The Persians had knocked over this statue, Rhonbos's (FIG. 5-8), and many other votive offerings in Athena's sanctuary during their sack of the Acropolis in 480 BCE (see page 123). Shortly thereafter, the Athenians buried all the damaged Archaic sculptures, which accounts for the preservation of the coloration today.

ARCHITECTURAL BASICS

Greek Temple Plans

The core of an ancient Greek temple plan (Fig. 5-12) was the *naos*, or *cella*, a windowless room that usually housed the cult statue of the deity. In front of the naos was a *pronaos*, or porch, often with two columns between the *antae*, or extended walls (columns *in antis*). A smaller second room might be placed behind the cella (Fig. 5-15), but in its canonical form, the Greek temple had a porch at the rear (*opisthodomos*) set against the blank back wall of the cella. The second porch served only a decorative purpose, satisfying the Greek passion for balance and symmetry.

Around this core, Greek builders might erect a colonnade across the front of the temple (*prostyle*; FIG. 5-52), across both front and back (*amphiprostyle*; FIG. 5-55), or, more commonly, all around the cella and its porch(es) to form a *peristyle*, as in FIG. 5-12 (compare FIGS. 5-1 and 5-14). Single (*peripteral*) colonnades were the norm, but double (*dipteral*) colonnades were features of especially elaborate temples (FIGS. 5-75 and 5-76).

The Greeks' insistence on balance and order guided their experiments with the proportions of temple plans. The earliest temples tended to be long and narrow, with the proportion of the ends to the sides roughly expressible as 1:3. From the sixth century BCE on, plans

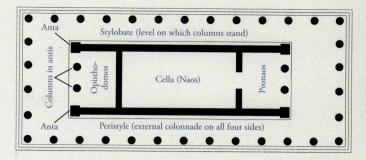

5-12 Plan of a typical Greek peripteral temple.

The basic form of the canonical Greek temple derives from that of the Mycenaean megaron (Fig. 4-15), but Greek temples housed statues of deities, and most were surrounded by columns.

approached but rarely achieved a ratio of front to side of exactly 1:2. Classical temples tended to be a little longer than twice their width. To the Greek mind, proportion in architecture and sculpture was comparable to harmony in music (see "Polykleitos's Prescription for the Perfect Statue," page 129). Both were reflections and embodiments of the cosmic order.

KORE IN IONIAN DRESS By the late sixth century BCE, the light linen Ionian *chiton*, worn in conjunction with a heavier *himation* (mantle), was the garment of choice for fashionable women. Archaic sculptors of korai in Ionian dress (FIG. 5-11) delighted in rendering the intricate patterns created by the cascading folds of thin, soft material. The asymmetry of the folds greatly relieves the stiff frontality of the body and makes the figure appear much more lifelike than the typical kouros. The sculptor achieved added variety by showing the kore grasping part of her chiton in her left hand (unfortunately broken off) to lift it off the ground in order to take a step forward. This is the equivalent of the advanced left foot of the kouroi and became standard for statues of korai. Despite the varied surface treatment of brightly colored garments on the korai, the kore postures are as fixed as those of their male counterparts.

Architecture and Architectural Sculpture

The earliest Greek temples do not survive because their builders constructed them of wood and mud brick. Pausanias noted in his second-century CE guidebook to Greece that in the eventhen-ancient Temple of Hera at Olympia, one oak column was still in place.² (Stone columns had replaced the others.) For Archaic and later Greek temples, however, Greek builders used more permanent materials—limestone or, where it was available, marble, which was more beautiful and durable (and more expensive). In Greece proper, if not in its western colonies, marble was readily at hand. Bluish-white Hymettian marble came from Mount Hymettus, just east of Athens, and glittering white Pentelic marble from Mount Pentelicus, northeast of the city, as well as from the Aegean Islands, especially Paros.

Already in the Orientalizing seventh century BCE, at Prinias, the Greeks had built a stone temple (FIG. 5-5A) embellished with

stone sculptures, but the Cretan temple resembled the megaron of a Mycenaean palace more than anything Greek traders had seen in their travels overseas. In the Archaic age of the sixth century BCE, with the model of Egyptian columnar halls such as those at Luxor (FIG. 3-24A) and Karnak (FIGS. 3-24, 3-25, and 3-26) before them, Greek architects began to build the columnar stone temples that have become synonymous with Greek architecture and influenced countless later structures in the Western world.

THE CANONICAL GREEK TEMPLE Greek temples differed in function from most later religious shrines. The altar lay outside the temple—at the east end, facing the rising sun—and the Greeks gathered outside, not inside, the building to worship. The temple proper housed the so-called *cult statue* of the deity, the grandest of all votive offerings. Both in its early and mature manifestations, the Greek temple was the house of the god or goddess, not of his or her followers.

In basic plan (see "Greek Temple Plans," above, and FIG. 5-12), the Greek temple still reveals a close affinity with the Mycenaean megaron (FIG. 4-15), and even in its most elaborate form, ringed by dozens of columns, it retains the megaron's basic simplicity. In all cases, the remarkable order, compactness, and symmetry of the Greek scheme strike the eye first, reflecting the Greeks' sense of proportion and their effort to achieve ideal forms in terms of numerical relationships and geometric rules (see "The Perfect Temple," page 103).

Figural sculpture played a major role in the exterior program of the Greek temple from early times, partly to embellish the god's shrine, partly to tell something about the deity represented within, and partly to serve as a votive offering. But Greek architects also conceived the building itself, with its finely carved *capitals* and moldings, as sculpture, abstract in form and possessing the power of sculpture to evoke human responses. To underscore the commanding importance of the sculptured temple and its inspiring function

113

ARCHITECTURAL BASICS

Doric and Ionic Orders

Architectural historians describe the elevation (FIG. 5-13) of a Greek temple in terms of the platform, the colonnade, and the superstructure (entablature). In the Archaic period, two basic systems, or orders, evolved for articulating the three units. The Greek architectural orders differ both in the nature of the details and in the relative proportions of the parts. The names of the orders derive from the Greek regions where they were most commonly employed. The Doric, formulated on the mainland, remained the preferred manner there and in Greece's western colonies. The lonic was the order of choice in the Aegean Islands and on the western coast of Asia Minor. The geographical distinctions are by no means absolute. The lonic order, for example, was a frequent choice for buildings in Athens (where, according to some ancient authors, the Athenians considered themselves Ionians who never migrated).

In both orders, the columns rest on the *stylobate*, the uppermost course of the platform. Metal clamps held together the stone blocks in each horizontal course, and metal dowels joined vertically the blocks of different courses. The columns have two or three parts, depending on the order: the *shaft*, usually marked with vertical channels (*flutes*); the *capital*; and, in the lonic order, the *base*. Greek column shafts, in contrast to Minoan and Mycenaean examples, taper gradually from

bottom to top. They usually are composed of separate *drums* joined by metal dowels to prevent turning as well as shifting, although occasionally the Greeks erected *monolithic* (single-piece) columns.

Greek column capitals have two elements. The lower part (the echinus) varies with the order. In the Doric, it is convex and cushionlike, similar to the echinus of Minoan (FIG. 4-6) and Mycenaean capitals. In the lonic, it is small and supports a bolster ending in scroll-like spirals (the volutes). The upper element, present in both orders, is a flat, square block (the abacus) that provides the immediate support for the entablature.

The entablature has three parts: the *architrave*, the main weight-bearing and weight-distributing element; the *frieze*; and the *cornice*, a molded horizontal projection that together with two sloping (*raking*) cornices forms a triangle framing the *pediment*. In the lonic order, the architrave is usually subdivided into three horizontal bands. Doric architects subdivided the frieze into *triglyphs* and *metopes*, whereas lonic builders left the frieze open to provide a continuous field for relief sculpture.

The Doric order is massive in appearance, its sturdy columns firmly planted on the stylobate. Compared with the weighty and severe Doric, the lonic order seems light, airy, and much more decorative. Its columns are more slender and rise from molded bases. The most obvious differences between the two orders are, of course, the capitals—the Doric, severely plain, and the lonic, highly ornamental.

Raking cornice Pediment Cornice Frieze Triglyph Metope Architrave Capital Echinus Stylobate

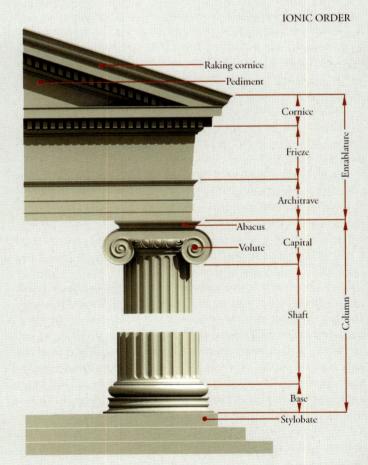

5-13 Elevations of the Doric and Ionic orders (John Burge).

The major differences between the Doric and Ionic orders are the form of the capitals and the treatment of the frieze. The Doric frieze is subdivided into triglyphs and metopes.

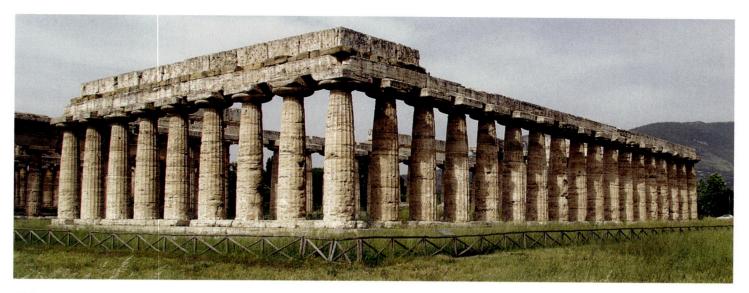

5-14 Temple of Hera I ("Basilica," looking northeast), Paestum, Italy, ca. 550 BCE.

The peristyle of this huge early Doric temple consists of heavy, closely spaced, cigar-shaped columns with bulky, pancakelike capitals, characteristic features of Archaic Greek architecture.

in public life, the Greeks usually erected their temples on elevated sites, often on a hill above the city (*acropolis* means "high city").

Most of the sculptural ornament was on the upper part of the building, in the *frieze* and *pediments* (see "Doric and Ionic Orders," page 114). The Greeks painted their architectural sculptures (FIGS. 5-17 and 5-27), as they did their freestanding statues (FIG. 5-63A), and usually placed sculpture only in the building parts that had no structural function. This is true particularly of the *Doric order* (FIG. **5-13**, *left*), in which decorative sculpture appears only in the "voids" of the *metopes* and pediments. In the *Ionic order* (FIG. 5-13, *right*) builders were willing to decorate the entire frieze and sometimes even the lower column *drums*. Occasionally, Ionic architects replaced columns with female figures (*caryatids*; FIGS. 5-17 and 5-54). The Greeks also painted capitals, decorative moldings, and other architectural elements. The original appearance of Greek temples was therefore quite different than their gleaming white, if ruined, state today.

Although the Greeks used color for emphasis and to relieve what might have seemed too bare, Greek architecture primarily depended on clarity and balance. To the Greeks, it was unthinkable to use surfaces in the way that the Egyptians used their gigantic columns—as fields for complicated ornamentation (FIGS. 3-25 and 3-26). The history of Greek temple architecture is the history of Greek architects' unflagging efforts to find the most satisfactory (that is, what they believed were perfect) proportions for each part of the building and for the structure as a whole.

BASILICA, PAESTUM The premier example of early Greek efforts at Doric temple design is not in Greece but in one of their many settlements in Italy, at Paestum (Greek Poseidonia), south of Naples. The huge (80-by-170-foot) Archaic temple (FIG. **5-14**) erected there around 550 BCE retains its entire *peripteral* colonnade, but most of the *entablature*, including the frieze, pediment, and the entire roof, has vanished. Called the "Basilica" after the Roman columnar hall building type (see page 187) early investigators felt that it resembled, the structure was a shrine to the goddess Hera—known as the Temple of Hera I to distinguish it from its neighbor, the later Temple of Hera II (FIG. 5-30). The misnomer is partly due to the building's plan (FIG. **5-15**), which differs from that of most other Greek temples.

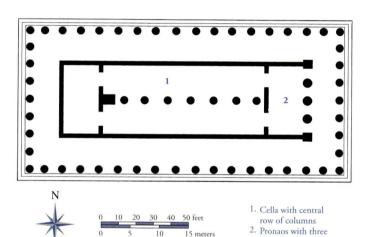

5-15 Plan of the Temple of Hera I, Paestum, Italy, ca. 550 BCE.

The Hera temple's plan also reveals its early date. The building has an odd number of columns on the facade and a single row of columns in the cella, leaving no place for a central cult statue.

The unusual feature, found only in early Archaic temples, is the central row of columns dividing the *cella* into two aisles. Placing columns underneath the *ridgepole* (the timber beam running the length of the building below the peak of the gabled roof) might seem the logical way to provide interior support for the roof structure, but it had several disadvantages. The row of columns on the cella's axis allowed no place for a central cult statue. Further, in order to correspond with the interior, the temple's facade required an odd number of columns (nine in this case). At Paestum, there are also three columns *in antis* instead of the standard two, which in turn ruled out a central doorway for viewing the statue. (This design, however, was well suited for two statues, and some scholars have speculated that the Paestum cella housed statues of Zeus and Hera.) In any case, the architect still achieved a simple 1:2 ratio of facade and flank columns by erecting 18 columns on each side of the temple.

Another early aspect of the Paestum temple is the shape of its heavy, closely spaced columns (Fig. 5-14) with their large, bulky,

columns in antis

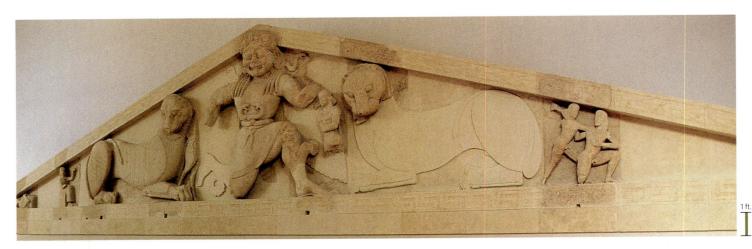

5-16 West pediment, Temple of Artemis, Corfu, Greece, ca. 600–580 BCE. Limestone, greatest height 9' 4". Archaeological Museum, Corfu.

The hideous Medusa and two panthers at the center of this early pediment served as temple guardians. To either side, and much smaller, are scenes from the Trojan War and the battle of gods and giants.

pancakelike Doric capitals, which seem compressed by the overbearing weight of what probably was a high, massive entablature. The columns have a pronounced swelling (entasis) at the middle of the shafts, giving them a profile akin to that of a cigar. The columns and capitals thus express in a vivid manner their weight-bearing function. One reason for the heaviness of the design and the narrowness of the spans between the columns might be that the Archaic builders were afraid that thinner and more widely spaced columns would result in the superstructure's collapse. In later Doric temples (FIGS. 5-1, 5-25, and 5-30), the builders placed the columns farther apart and refined the forms. The shafts became more slender, the entasis subtler, the capitals smaller, and the entablature lighter. Greek architects sought the ideal proportional relationship among the parts of their buildings. The sculptors of Archaic kouroi and korai grappled with similar problems. Architecture and sculpture developed in a parallel manner during the sixth century BCE.

TEMPLE OF ARTEMIS, CORFU Architects and sculptors frequently worked together, as at Corfu (ancient Corcyra), where, soon after 600 BCE, the Greeks constructed a large Doric temple in honor of Artemis. Corfu is an island off the western coast of Greece and was an important stop on the trade route between the mainland and the Greek settlements in Italy (MAP 5-1). Prosperity made possible the erection of one of the earliest stone peripteral temples in Greece, one also lavishly embellished with sculpture. Sculptors decorated the metopes with reliefs (unfortunately very fragmentary today) and filled both pediments with huge high-relief sculptures (more than 9 feet high at the center). It appears that the pediments on both ends of the temple were decorated in an identical manner. The west pediment (Fig. 5-16) is better preserved.

Designing figural decoration for a pediment was never an easy task for the Greek sculptor because of the pediment's awkward triangular shape. The central figures had to be of great size. In contrast, as the pediment tapered toward the corners, the available area became increasingly cramped. At the center of the Corfu pediment is the *gorgon* Medusa, a demon with a woman's body and a bird's wings. Medusa also had a hideous face and snake hair, and anyone who gazed at her turned into stone. The Corfu sculptor depicted her in the conventional Archaic bent-leg, bent-arm, pinwheel-like posture that signifies running or, for a winged creature, flying. To her left and right

are two great felines. Together they serve as temple guardians, repulsing all enemies from the sanctuary of the goddess. Similar panthers stood sentinel on the lintel (FIG. 5-6A) of the seventh-century BCE temple at Prinias. The Corfu felines are in the tradition of the guardian lions of Mycenae (FIG. 4-19) and the beasts that stood guard at the entrances to Hittite and Assyrian palaces (FIGs. 2-18A and 2-20). Medusa herself is also an *apotropaic* figure—that is, she protects the temple and wards off evil spirits. The triad of Medusa and the felines recalls as well Mesopotamian heraldic human-and-animal compositions (FIG. 2-10). The Corfu figures are, in short, still further examples of the Orientalizing manner in early Greek sculpture.

Between Medusa and the two felines are two smaller figures the human Chrysaor at her left and the winged horse Pegasus at her right (only the rear legs remain, next to Medusa's right foot). Chrysaor and Pegasus were Medusa's children. According to legend, they sprang from her head when the Greek hero Perseus severed it with his sword. Their presence here on either side of the living Medusa is therefore a chronological impossibility. The Archaic artist's interest was not in telling a coherent story but in identifying the central figure by depicting her offspring. Narration was, however, the purpose of the much smaller groups situated in the pediment corners. To the viewer's right is Zeus, brandishing his thunderbolt and slaying a kneeling giant. In the extreme corner (not preserved) was a dead giant. The gigantomachy (battle of gods and giants) was a popular theme in Greek art of all periods and was a metaphor for the triumph of reason and order over chaos. In the pediment's left corner is one of the Trojan War's climactic events: Achilles's son, Neoptolemos, kills the enthroned King Priam. The fallen figure to the left of this group may be a dead Trojan.

The master responsible for the Corfu pediments was a pioneer, and the composition shows all the signs of experimentation. The lack of narrative unity in the Corfu pediment and the figures' extraordinary diversity of scale eventually gave way to pedimental designs in which all the figures are the same size and act out a single event. But the Corfu designer already had shown the way. That sculptor realized, for example, that the area beneath the raking cornice could be filled with gods and heroes of similar size by employing a combination of standing, leaning, kneeling, seated, and prostrate figures. The Corfu master also discovered that animals could be very useful space fillers because, unlike humans, they have one end taller than the other.

SIPHNIAN TREASURY, DELPHI With the sixth century BCE also came the construction of grandiose Ionic temples on the Aegean Islands and the west coast of Asia Minor. The gem of Archaic Ionic architecture and architectural sculpture is, however, not a

temple but a *treasury* erected by the citizens of Siphnos in the Sanctuary of Apollo (FIG. **5-16A**) at Delphi. Greek treasuries were small buildings set up for the safe storage of votive offerings. At Delphi, many poleis expressed their civic pride by erecting these templelike but nonperipteral

₹5-16A Sanctuary of Apollo, Delphi.

structures. Athens built one with Doric columns in the porch and sculptured metopes in the frieze. The Siphnians equally characteristically employed the Ionic order for their Delphic treasury. Based on the surviving fragments now on display in the Delphi museum, archaeologists have been able to reconstruct the treasury's original appearance (FIG. 5-17). Wealth from the island's gold and silver mines made such a luxurious building possible. In the porch, where one would expect to find fluted Ionic columns, far more elaborate caryatids were employed instead. Caryatids are rare, even in Ionic architecture, but they are unknown in Doric architecture, where they would have been discordant elements in that much more severe order. The Siphnian statue-columns resemble korai dressed in Ionian chitons and himations (FIG. 5-11). They are generic women, not portraits of individuals, but scholars continue to debate whom the caryatids represent. Like most korai, the statue-columns may simply be elite women who are paying homage to the deity.

Another Ionic feature of the Siphnian Treasury is the continuous sculptured frieze on all four sides of the building. The north frieze represents the popular theme of the gigantomachy, but it is a much more detailed rendition than that in the corner of the Corfu pediment (FIG. 5-16, *right*). In the section reproduced here (FIG. 5-18), Apollo and Artemis pursue a fleeing giant at the center,

5-17 Restored view of the Siphnian Treasury, Sanctuary of Apollo, Delphi, Greece, ca. 530 BCE (John Burge).

Treasuries were storehouses for a city's votive offerings. The lonic treasury that the Siphnians erected in Apollo's sanctuary had caryatids in the porch, and sculptures in the pediment and frieze.

while behind them one of the lions pulling an attacking chariot bites into a giant's midsection. Paint originally enlivened the crowded composition, and painted labels identified the various protagonists, as they do on Archaic black-figure vases (FIGS. 5-19 to 5-20A). The sculptors placed metal weapons in the hands of some figures. The effect must have been dazzling. On one of the shields the sculptor inscribed his name (unfortunately lost), a clear indication of pride in accomplishment.

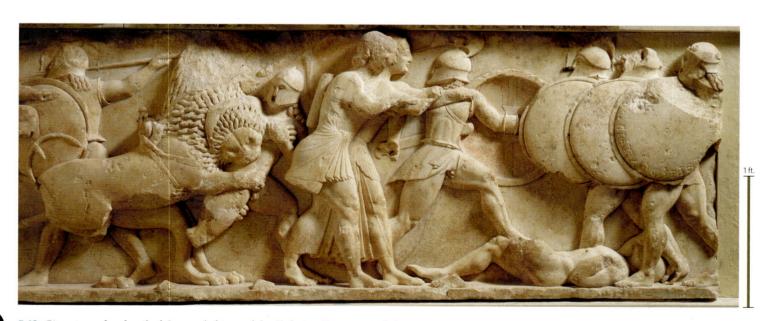

5-18 Gigantomachy, detail of the north frieze of the Siphnian Treasury, Delphi, Greece, ca. 530 BCE. Marble, 2' 1" high. Archaeological Museum, Delphi.

Greek friezes were brightly painted (FIG. 5-17). As in Archaic vase painting, the Siphnian frieze also had painted labels identifying the various gods and giants. Some of the figures held metal weapons.

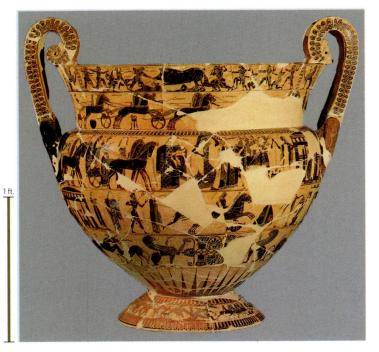

5-19 KLEITIAS and ERGOTIMOS, *François Vase* (Athenian black-figure volute krater), from Chiusi, Italy, ca. 570 BCE. 2' 2" high. Museo Archeologico Nazionale, Florence.

The painter and potter both signed this huge early black-figure krater. The vase has more than 200 mythological figures in five registers, the same format as on Geometric and Orientalizing vases.

Vase Painting

By the mid-sixth century BCE, the Athenians, having learned the black-figure technique from the Corinthians (FIG. 5-5), had taken over the export market for fine painted ceramics (see "Greek Vase Painting," page 108).

FRANÇOIS VASE The masterpiece of early Athenian black-figure painting is the *François Vase* (FIG. 5-19), named for the excavator who discovered it (in hundreds of fragments) in an Etruscan tomb at Chiusi. The vase is a new kind of krater with volute-shaped handles, probably inspired by costly metal prototypes. The signatures of both its painter ("Kleitias painted me") and potter ("Ergotimos made me") appear twice among the more than 200 figures in five registers. Labels abound, naming humans and animals alike, even some inanimate objects. The painter devoted only the lowest band to the Orientalizing repertoire of animals and sphinxes. The rest constitute a selective encyclopedia of Greek mythology, focusing on the exploits of Peleus and his son, Achilles, the great hero of Homer's *Iliad*, and of Theseus, the legendary king of Athens. Among the most prominent scenes depicted is the battle between the Lapiths (a northern Greek tribe) and centaurs (*centauromachy*; FIG. 5-19A)

3-19A KLEITIAS and ERGOTIMOS, Centauromachy, ca. 570 BCE.

after a wedding celebration at which the man-beasts, who were invited guests, got drunk and attempted to abduct the Lapith maidens and young boys. Theseus, also on the guest list, was chief among the centaurs' Greek adversaries.

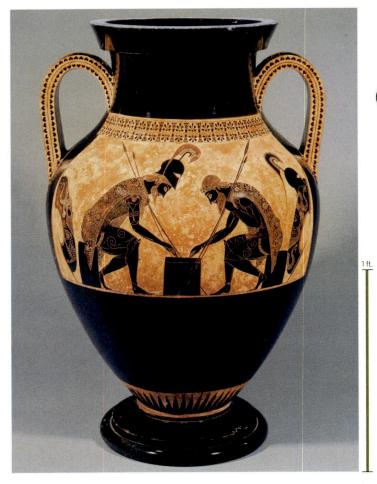

5-20 EXEKIAS, Achilles and Ajax playing a dice game (Athenian black-figure amphora), from Vulci, Italy, ca. 540–530 BCE. 2' high. Musei Vaticani, Rome.

The dramatic tension, coordination of figural poses with vase shape, and intricacy of the engraved patterns of the cloaks are hallmarks of Exekias, the greatest master of black-figure painting.

EXEKIAS The acknowledged master of the black-figure technique was an Athenian named EXEKIAS, whose vases were not only widely exported but copied as well. Perhaps his greatest work is an amphora (FIG. 5-20) found in an Etruscan tomb at Vulci, which Exekias signed as both painter and potter. Unlike Kleitias, Exekias did not

divide the surface of the vase into a series of horizontal bands. Instead, he placed figures of imposing stature in a single large framed panel. At the left is Achilles, fully armed, the mightiest Greek soldier in the war against Troy. He appears again on another of Exekias's amphoras (FIG. 5-20A) battling Penthesilea, queen of the Amazons. Here, Achilles plays a dice game with his comrade Ajax during a lull in the Trojan conflict. Out of the lips of Achilles comes the word *tesara* ("four"). Ajax calls out *tria* ("three"). Although Ajax has taken off his helmet, both men

₹ 5-20A EXEKIAS, Achilles killing Penthesilea, ca. 540-530 BCE.

hold their spears. Their shields are nearby. Each man is ready for action at a moment's notice. This depiction of "the calm before the storm" is the antithesis of the Archaic preference for dramatic action. The gravity and tension that will characterize much Clas-

PROBLEMS AND SOLUTIONS

The Invention of Red-Figure Painting

By 530 BCE, master ceramists such as Exekias (FIGS. 5-20 and 5-20A) had taken the art of black-figure painting to a level never surpassed, but that painting technique, invented in the seventh century BCE. (FIG. 5-5), presented severe limitations for artists who wished to break free of the conventions of figure drawing that had dominated art production since the third millennium BCE. The need for a new ceramic painting technique with greater versatility than black-figure, with its dark silhouettes and incised details, was pressing. The solution was red-figure painting. Its inventor was the ceramist whom art historians call the ANDOKIDES PAINTER—that is, the anonymous painter who decorated the vases signed by the potter Andokides.

The differences between the black-figure and red-figure techniques can best be studied on a series of experimental vases with the same composition painted on both sides, once in black-figure and once in red-figure. Andokides and other Athenian potters produced these so-called *bilingual vases* only for a short time. An especially interesting example is an amphora (FIGS. **5-21** and **5-22**) featuring copies of the Achilles and Ajax panel (FIG. 5-20) by Exekias. The red-figure side is

the work of the Andokides Painter. Most art historians attribute the black-figure side to a colleague in the same workshop nicknamed the LYSIPPIDES PAINTER, who was probably a pupil of Exekias. In neither black-figure nor red-figure did Exekias's emulators capture the intensity of the master's rendition of the same subject, and the treatment of details is decidedly inferior. Yet the new red-figure technique had obvious advantages over the old black-figure manner.

Red-figure is the opposite of black-figure. What was previously black became red, and vice versa. The artist used the same black glaze for the figures, but instead of using the glaze to create silhouettes, the painter outlined the figures and then colored the background black. The ceramist reserved the red clay for the figures themselves and used a soft brush instead of a stiff metal *graver* to draw the interior details. This gave the red-figure painter much greater flexibility. The artist could vary the thickness of the lines and even build up the glaze to give relief to curly hair or dilute it to create brown shades, thereby expanding the chromatic range of the Greek vase painter's craft. The Andokides Painter—possibly the potter Andokides himself—did not yet appreciate the full potential of his own invention. Still, he created a technique that, in the hands of other, more skilled artists, such as Euphronios (FIGS. 5-23 and 5-23A), helped revolutionize the art of drawing.

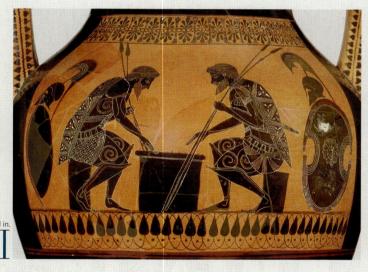

5-21 Lysippides Painter, Achilles and Ajax playing a dice game (black-figure side of an Athenian bilingual amphora), from Orvieto, Italy, ca. 525–520 BCE. Amphora,1' 9" high; detail $8\frac{1}{4}$ " high. Museum of Fine Arts, Boston.

Around 530 BCE, Greek ceramists invented the red-figure technique. Some of the earliest examples are "bilingual vases"—that is, vases with the same scene on both sides, one in black-figure and one in red-figure.

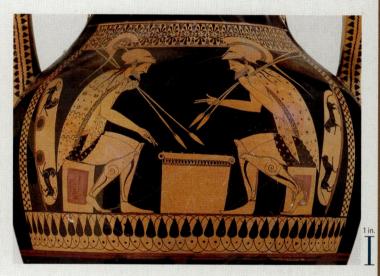

5-22 Andokides Painter, Achilles and Ajax playing a dice game (red-figure side of an Athenian bilingual amphora), from Orvieto, Italy, ca. 525–520 BCE. Amphora, 1' 9" high; detail $8\frac{1}{4}$ " high. Museum of Fine Arts, Boston.

The red-figure painter uses a soft brush instead of a metal graver and can vary the thickness of the interior lines. The glaze can also be diluted to create shades of brown and expand the color range.

sical Greek art of the next century, but that are generally absent in Archaic art, already may be seen in this vase.

Exekias had no equal as a black-figure painter. This is evident in such details as the extraordinarily intricate engraving of the patterns on the heroes' cloaks and in the brilliant composition. The arch formed by the backs of the two warriors echoes the shape of the rounded shoulders of the amphora. The shape of the vessel is echoed again in the void between the heads and spears of Achilles and Ajax. Exekias also used the spears to lead the viewer's eye toward the thrown dice, where the heroes' gazes are fixed. Of course,

Achilles's and Ajax's eyes do not really look down at the table but stare out from their profile heads in the old manner. For all his brilliance, Exekias was still wedded to many of the old conventions. Real innovation in figure drawing would have to await the invention of a new ceramic painting technique: *red-figure painting*. The first examples of red-figure painting came from the studio of the potter Andokides (see "The Invention of Red-Figure Painting," above).

EUPHRONIOS One of the earliest masters of red-figure painting was EUPHRONIOS, whose krater depicting the struggle between Herakles

5-23 EUPHRONIOS, Herakles wrestling Antaios (detail of an Athenian red-figure calyx krater), from Cerveteri, Italy, ca. 510 BCE. Krater 1' 7" high; detail $7\frac{3}{4}$ " high. Musée du Louvre, Paris.

Euphronios rejected the age-old composite view for his depiction of Herakles and the giant Antaios and instead attempted to reproduce the way the human body appears from a specific viewpoint.

and Antaios (FIG. 5-23) reveals the exciting possibilities of the new technique. Antaios was a Libyan giant, a son of Earth, and he derived his power from contact with the ground. To defeat him, Herakles had to lift him into the air and strangle him while no part of the giant's body touched the earth. In Euphronios's representation of the myth, the two wrestle on the ground, and Antaios still possesses enormous strength. Nonetheless, Herakles has the upper hand. The giant's face is a mask of pain. His eyes roll and he bares his teeth. His right arm is paralyzed, with the fingers limp.

On this krater, as on his other masterworks—including the most expensive vase ever purchased, a krater cosigned by the potter

∮ 5-23A EUPHRONIOS, Death of Sarpedon, ca. 515 BCE.

EUXITHEUS (FIG. 5-23A)—Euphronios used the new red-figure technique brilliantly. For example, he took advantage of the ability to dilute the *glaze* and produced a golden brown hue for Antaios's hair—intentionally contrasting the giant's unkempt hair with the neat coiffure and carefully trimmed beard of the emotionless Greek hero. The artist also used thinned glaze to delineate the

muscles of both figures. But rendering human anatomy convincingly was not his only interest. Euphronios also wished to show that his figures occupy space. He deliberately rejected the conventional composite posture for the human figure, which communicates so well the individual parts of the human body, and attempted instead to reproduce how a particular human body is *seen*. He presented, for example, not only Antaios's torso but also his right thigh from the front. The lower leg disappears behind the giant, and only part of the right foot is visible. The viewer must mentally make the connection between the upper leg and the foot. Euphronios did not create a two-dimensional panel filled with figures in stereotypical postures, as his Archaic and pre-Greek predecessors always did. His panel is a window into a mythological world with protagonists moving in three-dimensional space—a revolutionary new conception of what a picture is supposed to be.

EUTHYMIDES A preoccupation with the art of drawing per se is evident in a remarkable amphora (FIG. **5-24**) painted by EUTHYMIDES, a rival of Euphronios's. The subject is appropriate for a wine storage jar—three tipsy revelers. But the theme was little more than an excuse for the artist to experiment with the representation of unusual positions of the human form. It is no coincidence that the bodies do not overlap, for each is an independent figure

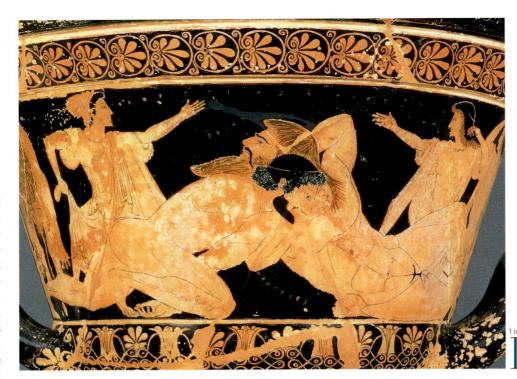

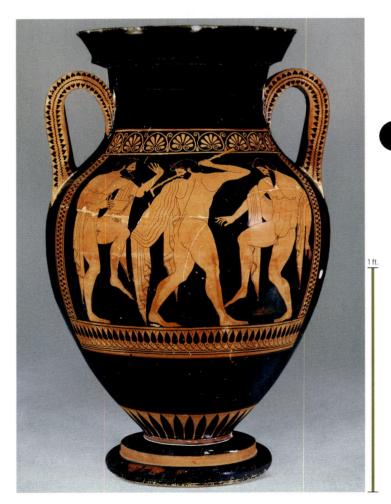

5-24 EUTHYMIDES, Three revelers (Athenian red-figure amphora), from Vulci, Italy, ca. 510 BCE. 2' high. Staatliche Antikensammlungen, Munich.

Euthymides chose this theme as an excuse to represent bodies in unusual positions, including a foreshortened three-quarter rear view. He claimed to have surpassed Euphronios as a draftsman.

study. Euthymides cast aside the conventional frontal and profile composite views. Instead, he painted torsos that are not two-dimensional surface patterns but are *foreshortened*—that is, drawn in a three-quarter view with a compression of the parts of the figure farther away. Most noteworthy is the central figure, shown from the rear with a twisting spinal column and buttocks in three-quarter view. Earlier artists had no interest in attempting to depict figures seen from behind and at an angle because those postures not only are incomplete views but also do not show the "main" side of the human body. For Euthymides, however, the challenge of drawing

a figure from this unusual viewpoint was a reward in itself. With understandable pride he proclaimed his achievement by adding to the formulaic signature "Euthymides painted me" the phrase "as never Euphronios [could do!]"

Other vase painters also challenged themselves to outdo their contemporaries in representing the human form. Onesimos, for example, successfully drew a young woman's nude torso from a three-quarter view (Fig. 5-24A).

3-24A ONESIMOS, Girl preparing to bathe, ca. 490 BCE.

Aegina and the Transition to the Classical Period

The years just before and after 500 BCE were also a time of dynamic transition in architecture and architectural sculpture. Some of the changes were evolutionary in nature, others revolutionary. Both kinds are evident in the Doric temple at Aegina dedicated to Aphaia, a local *nymph*.

TEMPLE OF APHAIA, AEGINA The temple (FIGS. **5-25**, **5-26**, and **5-27**) sits on a prominent ridge with dramatic views out to the sea. The peripteral colonnade consists of 6 Doric columns on the facade (FIG. 5-25) and 12 on the flanks. This is a much more compact structure than Paestum's impressive but ungainly Archaic temple (FIG. 5-14), even though the ratio of width to length is similar.

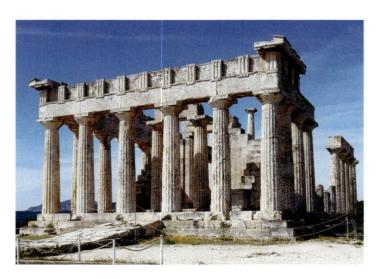

5-25 Temple of Aphaia (looking southwest), Aegina, Greece, ca. 500–490 BCE.

In this refined early-fifth-century BCE temple design (compare FIG. 5-14), the Doric columns are more slender and widely spaced, and there are only 6 columns on the facade and 12 on the flanks.

Doric architects had learned a great deal in the half-century that elapsed between the construction of the two temples. The columns of the Aegina temple are more widely spaced and more slender. The capitals create a smooth transition from the vertical shafts below to the horizontal architrave above. Gone are the Archaic flattened echinuses and bulging shafts of the Paestum columns. The Aegina

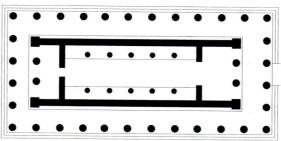

5-26 Model showing internal elevation (*top*) and plan (*bottom*) of the Temple of Aphaia, Aegina, Greece, ca. 500–490 BCE. Model: Glyptothek, Munich.

Later Doric architects also modified the plan of their temples (compare FIG. 5-15). The Aegina temple's cella has two colonnades of two stories each (originally with a statue of the deity between them).

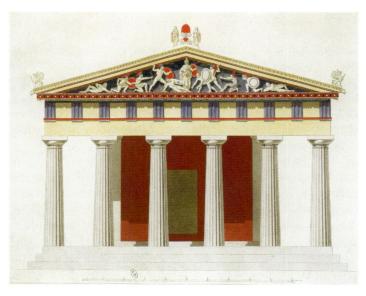

5-27 GUILLAUME-ABEL BLOUET, restored view (1828) of the facade of the Temple of Aphaia, Aegina, Greece, ca. 500–490 BCE.

The restored view suggests how colorful Greek temples were. The designer solved the problem of composing figures in a pediment by using the whole range of body postures from upright to prostrate.

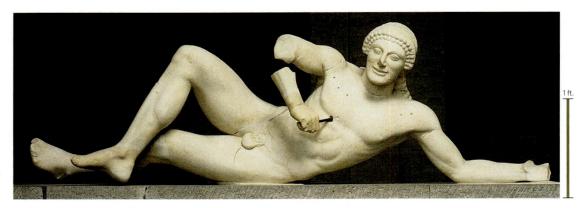

5-28 Dying warrior, from the west pediment of the Temple of Aphaia, Aegina, Greece, ca. 490 BCE. Marble, 5' $2\frac{1}{2}$ " long. Glyptothek, Munich.

The statues of the west pediment of the early-fifth-century BCE temple at Aegina exhibit Archaic features. This fallen warrior still has a rigidly frontal torso and an Archaic smile on his face.

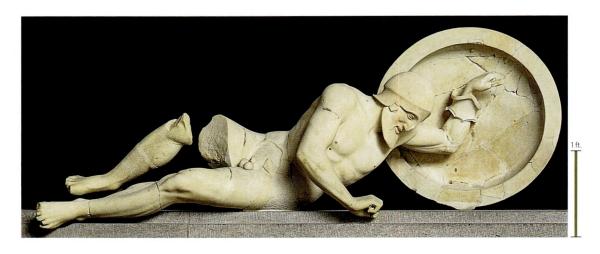

5-29 Dying warrior, from the east pediment of the Temple of Aphaia, Aegina, Greece, ca. 480 BCE. Marble, 6' 1" long. Glyptothek, Munich.

The eastern dying warrior already belongs to the Classical era. His posture is more natural, and he exhibits a new self-consciousness. Concerned with his own pain, he does not face the viewer.

architect also refined the internal elevation and plan (FIG. 5-26). In place of a single row of columns down the center of the cella is a double colonnade—and each row has two stories. This arrangement enabled the Aeginetans to place a statue on the central axis, and, because of the open space between the pair of columns in the pronaos, worshipers standing in front of the building had an unobstructed view of that cult image.

Painted life-size statuary (FIG. 5-27) filled both pediments, in contrast to the high reliefs characteristic of most Archaic temple pediments. The theme of both statuary groups was the battle of Greeks and Trojans, but the sculptors depicted different episodes. The compositions were nonetheless almost identical, with Athena at the center of the bloody combat. She is larger than all the other figures because she is superhuman, but all the mortal heroes are the same size, regardless of their position in the pediment. Unlike the experimental design at Corfu (FIG. 5-16), the Aegina pediments feature a unified theme and consistent scale. The designer was able to keep the size of the figures constant by using the whole range of body postures from upright (Athena) to leaning, falling, kneeling, and lying (Greeks and Trojans).

The Aegina sculptors set the pedimental statues in place around 490 BCE, as soon as construction of the temple concluded. Many scholars believe that the statues at the eastern end were damaged and replaced with a new group a decade or two later, although some think that both groups date after 480 BCE. In either case, it is instructive to compare the eastern and western figures. The sculptor of the west pediment's dying warrior (FIG. 5-28) still conceived the statue in the Archaic mode. The warrior's torso is rigidly frontal, and he looks out directly at the spectator—with his face set in an Archaic smile despite the bronze arrow puncturing his chest. He is like a mannequin in a store window whose arms and legs have been arranged by someone else for effective display. There is no sense whatsoever of a thinking and feeling human being.

The comparable figure (FIG. **5-29**) in the east pediment is fundamentally different. This warrior's posture is more natural and more complex, with the torso placed at an angle to the viewer (compare FIG. 5-23). Moreover, he reacts to his wound as a flesh-and-blood human would. He knows that death is inevitable, but he still struggles to rise once again, using his shield for support. He does not look out at the spectator. This dying warrior is concerned with his

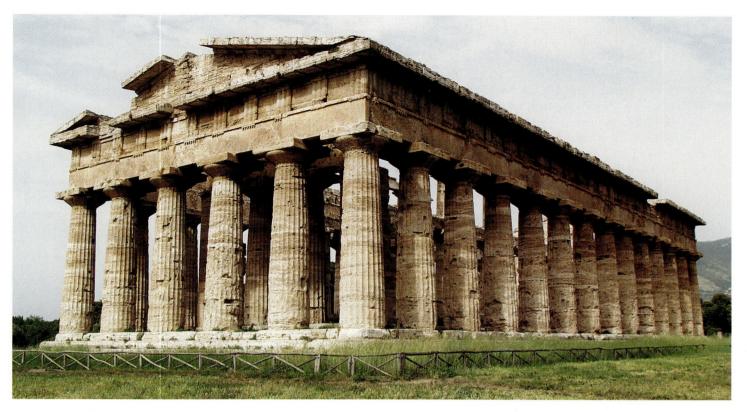

5-30 Temple of Hera II or Apollo (looking northeast), Paestum, Italy, ca. 460 BCE.

The model for the second Hera(?) temple at Paestum was Libon's Zeus temple at Olympia. The Paestum temple reflects the Olympia design but lacks the pedimental sculpture of its model.

plight, not with the viewer. No more than a decade separates the two statues, but they belong to different eras. The eastern warrior is not a creation of the Archaic world, when sculptors imposed anatomical patterns (and smiles) on statues. This statue belongs to the Classical world, where statues move as humans move and possess the self-consciousness of real men and women. This constitutes a radical change in the conception of the nature of statuary. In sculpture, as in painting, the Classical revolution had occurred.

EARLY AND HIGH CLASSICAL PERIODS

Art historians date the beginning of the Classical* age from a historical event: the defeat of the Persian invaders of Greece by the allied Hellenic city-states. Shortly after the invaders occupied and sacked Athens in 480 BCE, the Greeks won a decisive naval victory over the invaders at Salamis. It had been a difficult war, and at times it appeared that Asia would swallow up Greece and that the Persian king Xerxes (see page 50) would rule over all. When the Persians destroyed Miletos, a Greek city on the western coast of present-day Turkey, in 494 BCE, they killed the male inhabitants and sold the women and children into slavery. The narrow escape of the Greeks from domination by Asian "barbarians" nurtured a sense of Hellenic identity so strong that from then on, the history of European civilization would be distinct from the civilization of Asia, even though they continued to interact. Typical of the time were the views of the great dramatist Aeschylus (ca. 525–456 BCE), who celebrated, in

*In Art through the Ages, the adjective "Classical," with uppercase C, refers specifically to the Classical period of ancient Greece, 480–323 BCE. Lowercase "classical" refers to Greco-Roman antiquity in general—that is, the period treated in Chapters 5, 6, and 7.

his *Oresteia* trilogy, the triumph of reason and law over barbarous crimes, blood feuds, and mad vengeance. As a veteran himself of the epic battle of Marathon, Aeschylus repudiated in majestic verse all the slavish and inhuman traits of nature that the Greeks at that time of crisis associated with the Persians.

Architecture and Architectural Sculpture

Historians universally consider the decades following the removal of the Persian threat the high point of Greek civilization. This is the era of the dramatists Sophocles and Euripides, as well as Aeschylus; the historian Herodotus; the statesman Pericles; the philosopher Socrates; and many of the most famous Greek architects, sculptors, and painters.

TEMPLE OF ZEUS, OLYMPIA The first great monument of Classical art and architecture is the Temple of Zeus at Olympia, site of the Olympic Games. The architect was Libon of Elis, who began work on the temple about 470 BCE and completed it by 457 BCE. Today the structure is in ruins, its picturesque tumbled column drums an eloquent reminder of the effect of the passage of time on even the grandest monuments humans have built. A good idea of its original appearance can be gleaned, however, from a slightly later Doric temple (FIG. **5-30**) at Paestum modeled closely on the Olympian shrine of Zeus—the temple usually identified as Hera's second at the site (the Temple of Hera II) but possibly a shrine dedicated to Apollo. The plans and elevations of both temples follow the pattern of the Temple of Aphaia (FIG. 5-26) at Aegina: an even number of columns (six) on the short ends, two columns in antis, and two rows of columns in

RELIGION AND MYTHOLOGY

Herakles, the Greatest Greek Hero

Greek heroes were a class of mortals intermediate between ordinary humans and the immortal gods. Most often the children of gods, some were great warriors, such as those Homer celebrated for their exploits at Troy. Others went from one fabulous adventure to another, ridding the world of monsters and generally benefiting humankind. The Greeks worshiped many of their heroes after their death, especially in the cities with which they were most closely associated.

The greatest Greek hero was Herakles (the Roman Hercules), born in Thebes, the son of Zeus and Alkmene, a mortal woman. Zeus's jealous wife, Hera, hated Herakles and sent two serpents to attack him in his cradle, but the infant strangled them. Later, Hera caused the hero to go mad and to kill his wife and children. As punishment, he was condemned to perform 12 great labors. In the first, he defeated the legendary lion of Nemea and ever after wore its pelt. The lion's skin and his weapon, a club, are Herakles's distinctive attributes (FIGS. 5-63A, 5-66, and 7-57A). The hero's last task was to obtain the golden apples that the goddess Gaia gave to Hera at her marriage (FIG. 5-31). They grew from a tree in the garden of the Hesperides at the western edge of the ocean, where a dragon guarded them.

After completion of the 12 seemingly impossible tasks, Herakles was awarded immortality. Athena, who had watched over him carefully throughout his life and assisted him in performing the labors, introduced him into the realm of the gods on Mount Olympus. According to legend, it was Herakles who established the Olympic Games.

5-31 Athena, Herakles, and Atlas with the apples of the Hesperides, metope from the Temple of Zeus, Olympia, Greece, ca. 470–456 BCE. Marble, 5' 3" high. Archaeological Museum, Olympia.

Herakles founded the Olympic Games, and his 12 labors were the subjects of the 12 metopes of the Zeus temple. This one shows the hero holding up the sky (with Athena's aid) for Atlas.

two stories inside the cella. But the Temple of Zeus was more lavishly decorated than even the Aphaia temple. Statues filled both pediments, and narrative reliefs adorned the six metopes over the doorway in the pronaos and the matching six of the opisthodomos.

The Olympia metopes are thematically connected with the site, for they depict the 12 labors of Herakles (see "Herakles, the Greatest Greek Hero," above), the legendary founder of the Olympic Games. In the metope illustrated here (Fig. 5-31), Herakles holds up the sky (with the aid of the goddess Athena—and a cushion) in place of Atlas, who

had undertaken the dangerous journey to fetch the golden apples of the Hesperides for the hero. Herakles will soon transfer the load back to Atlas (at the right, still holding the apples), but at the moment the sculptor chose to depict, each of the very high relief figures stands quietly with serene dignity. In both attitude and dress (simple Doric peplos for Athena), these Olympia figures display a severity that contrasts sharply with the smiling and elaborately clad figures of the Late Archaic period. Consequently, many art historians call this Early Classical phase of Greek art the Severe Style.

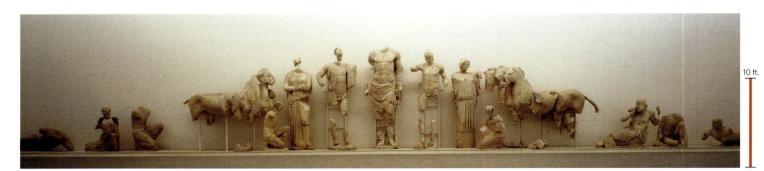

5-32 Chariot race of Pelops and Oinomaos, east pediment, Temple of Zeus, Olympia, Greece, ca. 470–456 BCE. Marble, 87' wide. Archaeological Museum, Olympia.

The east pediment of the Zeus temple depicts the legendary chariot race across the Peloponnesos from Olympia to Corinth. The actors in the pediment faced the starting point of Olympic chariot races.

The subject of the Temple of Zeus's east pediment (FIG. 5-32) is the chariot race between Pelops (from whom the Peloponnesos region takes its name) and King Oinomaos. The story, which had deep local significance, is a sinister one. Oinomaos had one daughter, Hippodameia, and a prophecy foretold that he would die if she married. Consequently, Oinomaos challenged any suitor who wished to make Hippodameia his bride to a chariot race from Olympia to Corinth. If the suitor won, he also won the hand of the king's daughter. But if he lost, Oinomaos killed him. The outcome of each race was predetermined, because Oinomaos possessed the divine horses of his father, Ares. To ensure his victory when all others had failed, Pelops resorted to bribing the king's groom, Myrtilos, to rig the royal chariot so that it would collapse during the race. Oinomaos was killed and Pelops won his bride, but he drowned Myrtilos rather than pay his debt to him. Before he died, Myrtilos brought a curse on Pelops and his descendants. This curse led to the murder of Pelops's son Atreus and to events that figure prominently in some of the greatest Greek tragedies of the Classical era, Aeschylus's three plays known collectively as the Oresteia: the sacrifice by Atreus's son Agamemnon of his daughter Iphigeneia; the slaying of Agamemnon by Aegisthus, lover of Agamemnon's wife, Clytaemnestra; and the murder of Aegisthus and Clytaemnestra by Orestes, the son of Agamemnon and Clytaemnestra.

Indeed, the pedimental statues (FIG. 5-32), which faced toward the starting point of all Olympic chariot races, are posed as though they are actors on a stage—Zeus in the center, Oinomaos and his wife on one side, Pelops and Hippodameia on the other, and their respective chariots to each side. All are quiet. The horrible events known to every spectator have yet to occur. Only one man reacts—a seer (FIG. 5-33) who knows the future. He is a remarkable figure. Unlike the gods, heroes, and noble youths and maidens who are the almost exclusive subjects of Archaic and Classical Greek statuary, this seer is a rare depiction of old age. He has a balding, wrinkled

5-33 Seer, from the east pediment (FIG. 5-32) of the Temple of Zeus, Olympia, Greece, ca. 470–456 BCE. Marble, 4' 6" high. Archaeological Museum, Olympia.

The balding seer in the Olympia east pediment is a rare depiction of old age in Classical sculpture. He has a shocked expression because he foresees the tragic outcome of the chariot race.

head and sagging musculature—and a shocked expression on his face. This is a true show of emotion, unlike the stereotypical Archaic smile, and is without precedent in earlier Greek sculpture and not a regular feature of Greek art until the Hellenistic age.

In the west pediment (FIG. **5-33A**), Apollo (FIG. **5-34**), the central figure, is also at rest, but all around him is a chaotic scene of Greeks battling centaurs. This mixture of calm, even pensive, figures and others involved in violent action also characterizes most of the narrative reliefs of the 12 metopes (FIG. 5-31) of the Zeus temple.

5-33A West pediment, Temple of Zeus, Olympia, ca. 470-456 BCE.

Statuary

The hallmark of Early Classical statuary is the abandonment of the rigid and unnatural Egyptian-inspired pose of Archaic statues. The figures in the Olympia pediments exemplify this radical break with earlier practice, but the change occurred even earlier—at the very moment Greece was under attack by the Persians.

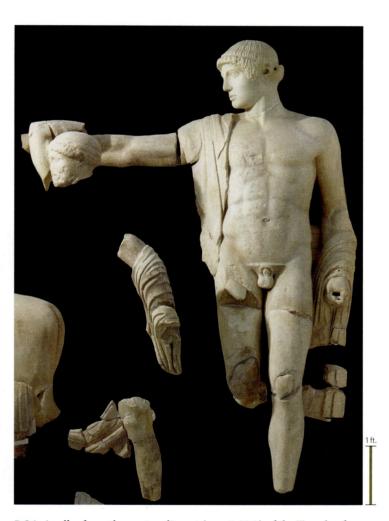

5-34 Apollo, from the west pediment (FIG. 5-33A) of the Temple of Zeus, Olympia, Greece, ca. 470–456 BCE. Marble, restored height 10' 8". Archaeological Museum, Olympia.

The model of calm rationality, Apollo, with a commanding gesture of his right hand, attempts to bring order out of the chaotic struggle all around him between the Lapiths and the beastly centaurs.

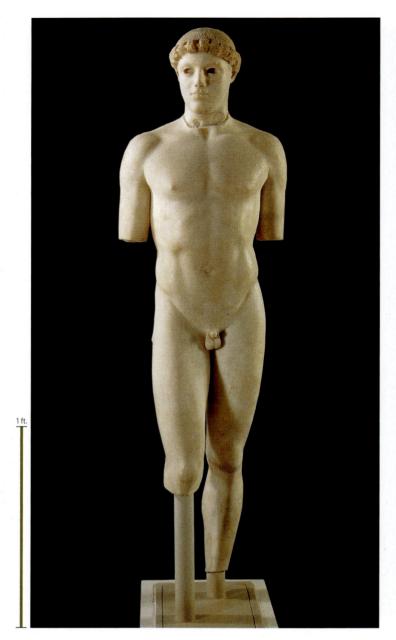

5-35 *Kritios Boy*, from the Acropolis, Athens, Greece, ca. 480 BCE. Marble, 2' 10" high. Acropolis Museum, Athens.

This is the first statue to show how a person naturally stands. The sculptor depicted the weight shift from one leg to the other (contrapposto). The head turns slightly, and the youth no longer smiles.

KRITIOS BOY Although it is well under life-size, the marble statue known as the *Kritios Boy* (FIG. **5-35**)—because art historians once thought it was the work of the sculptor Kritios—is one of the most important statues in the history of art. Never before had a sculptor been concerned with portraying how a human being (as opposed to a stone image) truly stands. Real people do not stand in the stiff-legged pose of the kouroi and korai or their Egyptian predecessors. Humans shift their weight and the position of the torso around the vertical (but flexible) axis of the spine. When humans move, the body's elastic musculoskeletal structure dictates a harmonious, smooth motion of all its parts. The sculptor of the *Kritios Boy* was the first, or one of the first, to grasp this anatomical fact and to represent it in statuary. The youth dips his right hip slightly to the right, indicating the shifting of weight onto his left leg. His right leg is bent, at ease. The head, which no longer exhibits an Archaic smile, also

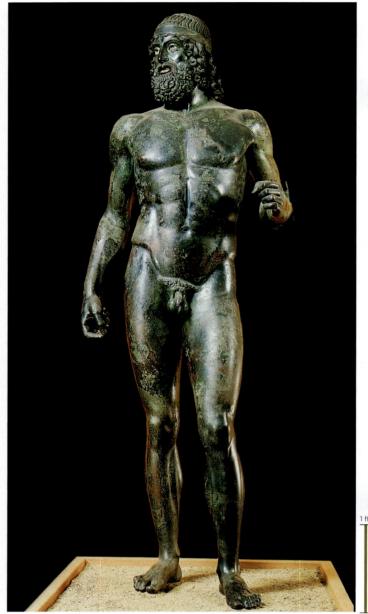

5-36 Warrior, from the sea off Riace, Italy, ca. 460–450 BCE. Bronze, 6' 6" high. Museo Archeologico Nazionale, Reggio Calabria.

The bronze Riace warrior statue has inlaid eyes, silver teeth and eyelashes, and copper lips and nipples (FIG. I-17). The contrapposto is more pronounced than in the *Kritios Boy* (FIG. 5-35).

turns slightly to the right and tilts, breaking the unwritten rule of frontality that dictated the form of virtually all earlier statues. This weight shift, which art historians describe as *contrapposto* ("counterbalance"), separates Classical from Archaic Greek statuary.

RIACE BRONZES An unknown sculptor carried the innovations of the *Kritios Boy* even further in the bronze statue (FIG. **5-36**) of a warrior found in the sea near Riace, at the "toe" of the Italian "boot." It is one of a pair of statues divers accidentally discovered in the cargo of a ship that sank in antiquity on its way from Greece probably to Rome, where Greek sculpture was much admired. Known as the *Riace Bronzes*, the two statues had to undergo several years of cleaning and restoration after nearly two millennia of submersion in salt water, but they are nearly intact. The statue shown here lacks only its shield, sword, and helmet. It is a masterpiece of hollow-casting (see "Hollow-Casting

MATERIALS AND TECHNIQUES

Hollow-Casting Life-Size Bronze Statues

Large-scale bronze statues such as the Riace warrior (FIG. 5-36), the Delphi charioteer (FIG. 5-38), and the Artemision god (FIG. 5-39) required great technical skill to produce. They could not be manufactured using a single simple mold of the sort Geometric and Archaic sculptors used for their small-scale figurines (FIGS. 5-3 and 5-4). Weight, cost, and the tendency of large masses of bronze to distort when cooling made life-size castings in solid bronze impractical, if not impossible. Instead, the Greeks hollow-cast large statues by the *cire perdue* (*lost-wax*) method. The lost-wax process entailed several steps and had to be repeated many times, because sculptors typically cast life-size and larger statues in parts—head, arms, hands, torso, and so forth. Even the long locks of hair of the Riace warrior (FIG. I-17) were cast separately from the rest of the head. The same is true for the hair over the ears of the *Charioteer of Delphi*.

First, the sculptor fashioned a full-size clay model of the intended statue. Then an assistant formed a clay master mold around the model and removed the mold in sections. When dry, the various pieces of the master mold were reassembled for each separate body part. Next, assistants applied a layer of beeswax to the inside of each mold. When the wax cooled, the sculptor removed the mold, revealing a hollow wax model in the shape of the original clay model. The artist could then correct or refine details—for example, engrave fingernails on the wax hands or individual locks of hair in a beard.

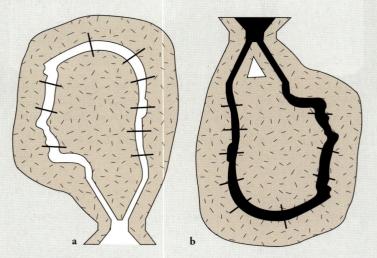

5-37 Two stages of the lost-wax method of bronze casting (after Sean A. Hemingway).

Drawing a shows a clay mold (investment), wax model, and clay core connected by chaplets. Drawing b shows the wax melted out and the molten bronze poured into the mold to form the cast bronze head.

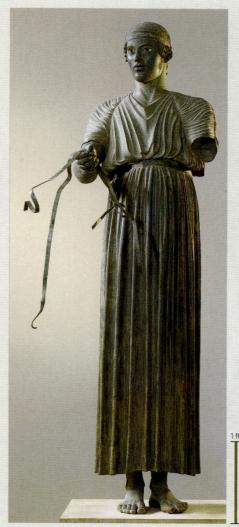

5-38 Charioteer (Charioteer of Delphi), from a group dedicated by Polyzalos of Gela in the Sanctuary of Apollo (FIG. 5-16A), Delphi, Greece, ca. 470 BCE. Bronze, 5' 11" high. Archaeological Museum, Delphi.

The charioteer was part of a large bronze group that also included a chariot, a team of horses, and a groom.
The assemblage required hundreds of individually cast pieces soldered together.

In the next stage, an assistant applied a final clay mold (*investment*) to the exterior of the wax model and poured liquid clay inside the model. Apprentices then hammered metal pins (*chaplets*) through the new mold to connect the investment with the clay core (Fig. 5-37a). Next, the wax was melted out ("lost") and molten bronze poured into the mold in its place (Fig. 5-37b). When the bronze hardened and assumed the shape of the wax model, the bronze-caster removed the investment and as much of the core as possible, completing the hollow-casting process. The last step was to fit together and solder the individually cast pieces, smooth the joins and any surface imperfections, inlay the eyes, and add teeth, eyelashes, and accessories such as swords and wreaths. Life-size bronze statues produced in this way were very costly but highly prized.

Life-Size Bronze Statues," above, and FIG. 5-37), with inlaid eyes, silver teeth and eyelashes, and copper lips and nipples (FIG. I-17). The weight shift is more pronounced than in the *Kritios Boy*. The warrior's head turns more forcefully to the right, his shoulders tilt, his hips swing more markedly, and his arms have been freed from the body. Natural motion in space has replaced Archaic frontality and rigidity.

CHARIOTEER OF DELPHI A bronze statuary group that equals or exceeds the Riace warrior in technical quality is the chariot group

set up a decade or two earlier at Delphi (FIG. 5-17A) by the tyrant Polyzalos of Gela (Sicily) to commemorate his brother Hieron's victory in the Delphic Pythian Games. Almost all that remains of the large group composed of the Sicilian driver, the chariot, the team of horses, and a young groom is the bronze charioteer popularly known as the *Charioteer of Delphi* (FIG. 5-38). He stands in an almost Archaic pose, but the turn of the head and feet in opposite directions as well as a slight twist at the waist are in keeping with the Severe Style. The moment the sculptor chose for depiction was not

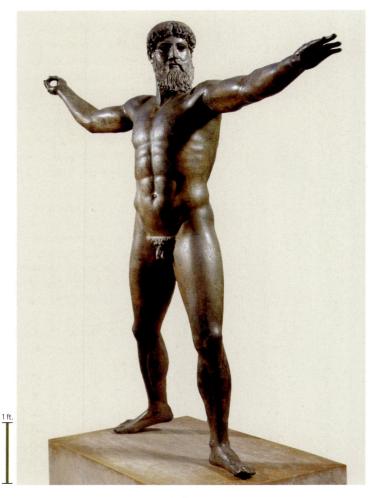

5-39 Zeus (or Poseidon?), from the sea off Cape Artemision, Greece, ca. 460–450 BCE. Bronze, 6' 10" high. National Archaeological Museum, Athens.

In this statue, the god—probably Zeus hurling a thunderbolt—boldly extends both arms and raises his right heel off the ground, underscoring the lightness and stability of hollow-cast bronze statues.

during the frenetic race but after, when the charioteer modestly held his horses quietly in the winner's circle. He grasps the reins in his outstretched right hand (the lower left arm, cast separately, is missing), and he wears the standard charioteer's garment, girdled high and held in at the shoulders and the back to keep it from flapping. The folds emphasize both the verticality and calm of the figure and recall the flutes of a Greek column. The fillet that holds the charioteer's hair in place is inlaid with silver. The eyes are glass paste, shaded by delicate bronze lashes individually cut from a sheet of bronze and soldered to the head.

ARTEMISION ZEUS The male human form in motion is, in contrast, the subject of another Early Classical bronze statue (FIG. **5-39**), which, like the Riace warrior, divers found in an ancient shipwreck, in this case off the coast of Greece itself at Cape Artemision. The bearded god once hurled a weapon held in his right hand, probably a thunderbolt, in which case he is Zeus. A less likely suggestion is that this is Poseidon with his *trident* (see "Gods and Goddesses," page 105). The pose could be employed equally well for a javelin thrower. Both arms are boldly extended, and the right heel is raised off the ground, underscoring the lightness and tensile strength of hollow-cast life-size statues.

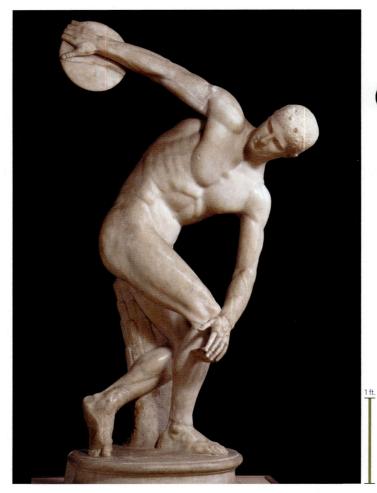

5-40 Myron, *Diskobolos* (*Discus Thrower*), from the Esquiline hill, Rome, Italy. Roman copy of a bronze statue of ca. 450 BCE. Marble, 5' 1" high. Palazzo Massimo alle Terme, Museo Nazionale Romano, Rome.

This marble copy of Myron's lost bronze statue captures how the sculptor froze the action of discus throwing and arranged the nude athlete's body and limbs so that they form two intersecting arcs.

MYRON, DISKOBOLOS A bronze statue similar to the Artemision Zeus was the renowned Diskobolos (Discus Thrower) by the Early Classical master Myron. The original is lost. Only marble copies (FIG. 5-40) survive, made in Roman times, when demand so far exceeded the supply of Greek statues that a veritable industry was born to meet the call for Greek statuary to display in public places and private villas alike. Usually, the copies were of less costly painted marble, which presented a very different appearance from shiny bronze. In most cases, the copyist also had to add an intrusive tree trunk to support the great weight of the stone statue, and to place struts between arms and body to strengthen weak points. The copies rarely approach the quality of the originals, and the Roman sculptors sometimes took liberties with their models according to their own tastes and needs. Occasionally, for example, sculptors created a mirror image of the original for a specific setting. Nevertheless, the copies are indispensable today. Without them it would be impossible to reconstruct the history of Greek sculpture after the Archaic period.

Myron's *Discus Thrower* is a vigorous action statue, like the Artemision Zeus, but the sculptor posed the body in an almost Archaic manner, with profile limbs and a nearly frontal chest, suggesting the tension of a coiled spring. Like the arm of a pendulum clock, the right arm of the *Diskobolos* has reached the apex of its

PROBLEMS AND SOLUTIONS

Polykleitos's Prescription for the Perfect Statue

In his treatise simply called the *Canon*, Polykleitos of Argos sought to define what constituted a perfect statue, one that could serve as the standard by which all other statues might be judged. How does one make a "perfect statue"? What principles guided the Greek master in formulating his canon?

One of the most influential philosophers of the ancient world was Pythagoras of Samos, who lived during the latter part of the sixth century BCE. A famous geometric theorem still bears his name. Pythagoras also is said to have discovered that harmonic chords in music are produced on the strings of a lyre at regular intervals that may be expressed as ratios of whole numbers—for example, 2:1, 3:2, 4:3. He and his followers, the Pythagoreans, believed more generally that underlying harmonic proportions could be found in all of nature, determining the form of the cosmos as well as of things on earth, and that beauty resided in harmonious numerical ratios.

Following this reasoning, Polykleitos concluded that the way to create a perfect statue would be to design it according to an all-encompassing mathematical formula. The treatise in which the Argive sculptor recorded the proportions he used is unfortunately lost, but Galen, a physician who lived during the second century CE, summarized the sculptor's philosophy as follows:

[Beauty arises from] the commensurability [symmetria] of the parts, such as that of finger to finger, and of all the fingers to the palm and the wrist, and of these to the forearm, and of the forearm to the upper arm, and, in fact, of everything to everything else, just as it is written in the Canon of Polykleitos.... Polykleitos supported his treatise [by making] a statue according to the tenets of his treatise, and called the statue, like the work, the Canon.*

This is why Pliny the Elder, whose first-century CE multivolume *Natural History* is one of the most important sources for the history of Greek art, maintained that Polykleitos "alone of men is deemed to have rendered art itself [that is, the theoretical basis of art] in a work of art." †

Polykleitos's belief that a successful statue resulted from the precise application of abstract principles is reflected in an anecdote (probably a later invention) told by the Roman historian Aelian:

Polykleitos made two statues at the same time, one which would be pleasing to the crowd and the other according to the principles of his art. In accordance with the opinion of each person who came into his workshop, he altered something and changed its form, submitting to the advice of each. Then he put both statues on display.

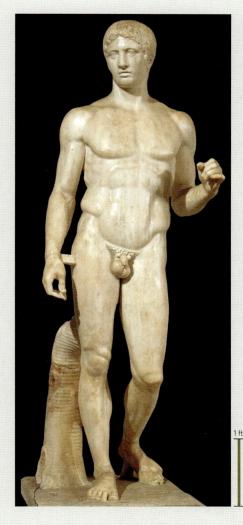

5-41 POLYKLEITOS, Doryphoros (Spear Bearer). Roman copy from the palaestra, Pompeii, Italy, of a bronze statue of ca. 450–440 BCE. Marble, 6' 11" high. Museo Archeologico Nazionale, Naples.

Polykleitos sought to portray the perfect man and to impose order on human movement. He achieved his goals through harmonic proportions and a system of cross-balancing for all parts of the body.

The one was marvelled at by everyone, and the other was laughed at. Thereupon Polykleitos said, "But the one that you find fault with, you made yourselves; while the one that you marvel at, I made."

Galen, Pliny, and Aelian are only three of the many Greek and Roman authors who wrote about Greek art and artists. Although none of those writers was an art historian in the modern sense, the existence in the Greco-Roman world of theoretical treatises by artists and of a tradition of art criticism is noteworthy and without parallel in antiquity or during the Middle Ages.

*Galen, De placitis Hippocratis et Platonis, 5. Translated by J. J. Pollitt, The Art of Ancient Greece: Sources and Documents (New York: Cambridge University Press, 1990), 76. †Pliny the Elder, Natural History, 34.55. Translated by Pollitt, 75. †Aelian, Varia historia, 14.8. Translated by Pollitt, 79.

arc but has not yet begun to swing down again. Myron froze the action and arranged the body and limbs to form two intersecting arcs (one from the discus to the left hand, one from the head to the right knee), creating the impression of a tightly stretched bow a moment before the archer releases the string. This tension, however, is not mirrored in the athlete's face, which remains expressionless. Once again, as in the warrior statue (FIG. 5-29) from the Aegina east pediment, the head is turned away from the spectator. In contrast to Archaic athlete statues, the Classical *Diskobolos* does not perform for the spectator but concentrates on the task at hand.

POLYKLEITOS, DORYPHOROS One of the most frequently copied Greek statues was the *Doryphoros* (*Spear Bearer*) by POLYKLEITOS, the sculptor whose work exemplifies the intellectual rigor of Classical art. The best marble replica (FIG. **5-41**) stood in a *palaestra* (gymnasium) at Pompeii, where it served as a model for Roman athletes. The *Doryphoros* was the embodiment of Polykleitos's vision of the ideal statue of a nude male athlete or warrior. (The *Spear Bearer* may also have held a shield.) In fact, the sculptor made it as a demonstration piece to accompany a treatise on the subject. *Spear Bearer* is a modern descriptive title for the statue. The name Polykleitos

assigned to it was Canon (see "Polykleitos's Prescription for the Perfect Statue," page 129).

The Doryphoros is the culmination of the evolution in Greek statuary from the Archaic kouros to the Kritios Boy to the Riace warrior. The contrapposto is more pronounced than ever before in a standing statue, but Polykleitos was not content with simply rendering a figure that stands naturally. His aim was to impose order on human movement, to make it "beautiful," to "perfect" it. He achieved this through a system of cross balance. What appears at first to be a casually natural pose is, in fact, the result of an extremely complex and subtle organization of the figure's various parts. Note, for instance, how the straight-hanging arm echoes the rigid supporting leg, providing the figure's right side with the columnar stability needed to anchor the left side's dynamically flexed limbs. If read anatomically, however, the tensed and relaxed limbs may be seen to oppose each other diagonally—the right arm and the left leg are relaxed, and the tensed supporting leg opposes the flexed arm, which held a spear. In like manner, the head turns to the right while the hips twist slightly to the left. And although the Doryphoros seems to take a step forward, he does not move. This dynamic asymmetrical balance, this motion while at rest, and the resulting harmony of opposites are the essence of the Polykleitan style.

The Athenian Acropolis

While Polykleitos was formulating his Canon in Argos, the Athenians, under the leadership of Pericles (ca. 495-429 BCE), were at work on one of the most ambitious building projects ever undertaken, the reconstruction of the Acropolis after the Persian sack. In September 480 BCE, the Athenian commander Themistocles decisively defeated the Persian navy off the island of Salamis, southwest of Athens, and forced it to retreat to Asia. Athens, despite the damage it suffered at the hands of the army of Xerxes, emerged from the war with enormous power and prestige. Less than two years later, in 478 BCE, the Greeks formed an alliance for mutual protection against any renewed threat from the East. The new confederacy came to be known as the Delian League, because its headquarters were on the sacred island of Delos, midway between the Greek mainland and the coast of Asia Minor. Although at the outset each league member had an equal vote, Athens was "first among equals," providing the allied fleet commander and determining which cities were to furnish ships and which were instead to pay an annual tribute to the treasury at Delos.

Continued fighting against the Persians kept the Delian alliance intact, but Athens gradually assumed a dominant role. In 454 BCE, the league's treasury was transferred to Athens, ostensibly for security reasons. Pericles, who was only in his teens when the Persians laid waste to the Acropolis, was by midcentury the recognized leader of the Athenians, and he succeeded in converting the alliance into an Athenian empire. Tribute continued to be paid, but the Athenians did not spend the surplus reserves for the common good of the allied Greek states. Instead, Pericles expropriated the money to pay the enormous cost of executing his grand plan to embellish the Acropolis of Athens.

The reaction of the allies—in reality the subjects of Athens was predictable. Plutarch, who wrote a biography of Pericles in the early second century CE, reported not only the wrath that the Greek victims of Athenian tyranny felt but also the protest voiced against Pericles's decision even in the Athenian assembly. Greece, Pericles's enemies said, had been dealt "a terrible, wanton insult" when Athens used the funds contributed out of necessity for a common war effort to "gild and embellish itself with images and extravagant temples, like some pretentious woman decked out with precious stones."3 That the Delian League was the source of the funds used for the Acropolis building program is important to keep in mind when examining those great and universally admired buildings erected to realize Pericles's vision of his polis reborn from the ashes of the Persian sack. They are not the glorious fruits of Athenian democracy but are instead the by-products of tyranny and the abuse of power. Too often art and architectural historians do not ask how patrons, whether public or private, paid for the monuments they commissioned. The answer can be very revealing—and very embarrassing.

PORTRAIT OF PERICLES A number of extant Roman marble sculptures are copies of a famous bronze portrait statue of Pericles by Kresilas, who was born on Crete but worked in Athens. The Athenians set up the portrait on the Acropolis, probably immediately after their leader's death in 429 BCE. Kresilas depicted Pericles in heroic nudity, and his portrait must have resembled the Riace warrior (FIG. 5-36). The copies reproduce the head only, sometimes in the form of a *herm* (FIG. **5-42**), that is, a bust on a square pillar. The inscription on the herm shown here reads "Pericles, son of Xanthippos, the Athenian." Pericles wears the helmet of a strategos (general), the elective position he held 15 times. The Athenian leader was said to have had an abnormally elongated skull, and Kresilas recorded this feature (while also concealing it) by providing a glimpse through the helmet's eye slots of the hair at the top of the head. This, together with the unblemished features of Pericles's aloof face and, no doubt, his body's perfect physique, led Pliny to assert that Kresilas had the

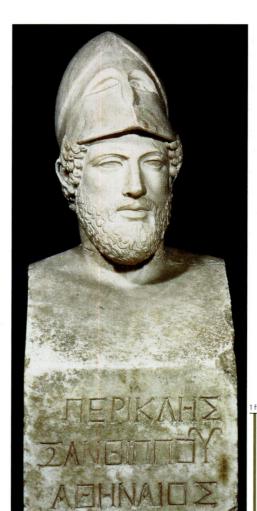

5-42 KRESILAS, Pericles. Roman herm copy of the head of a bronze statue of ca. 429 BCE. Marble, full herm 6' high; detail 4' $6\frac{3}{4}$ " high. Musei Vaticani, Rome.

In his portrait of Pericles, Kresilas was said to have made a noble man appear even nobler. Classical Greek portraits were not likenesses but idealized images in which humans appeared godlike.

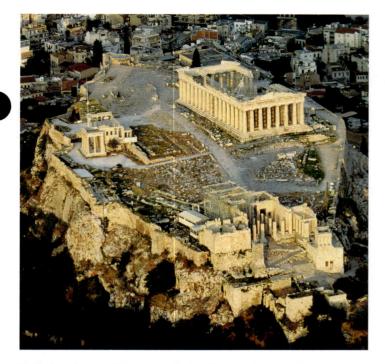

5-43 Aerial view of the Acropolis (looking southeast), Athens, Greece.

Under the leadership of Pericles, the Athenians undertook the costly project of reconstructing the Acropolis after the Persian sack of 480 BCE. The funds came from the Delian League treasury.

ability to make noble men appear even more noble in their portraits. This praise was apt because the Acropolis statue was not a portrait in the modern sense of a record of unique features, but an image of an individual that conformed to the Classical ideal of beauty. Pliny refers to Kresilas's "portrait" as "the Olympian Pericles," because the statue made Pericles appear almost godlike.⁴

PERICLEAN ACROPOLIS The centerpiece of the Periclean building program on the Acropolis (FIG. 5-43) was the Parthenon (FIGS. 5-1 and 5-44, no. 1), a magnificent marble building dedicated to Athena Parthenos that had neither a priestess nor an altar for her worship. The Parthenon was therefore not a temple in the strict sense. Construction began in 447 BCE and proceeded rapidly despite the complexity of the project. By 438 BCE, the building campaign was complete, although work on the Parthenon's ambitious sculptural ornamentation continued until 432 BCE. In 437 BCE, the Parthenon stonemasons commenced construction of the Propylaia (FIG. 5-44, no. 2), the grand new western gateway to the Acropolis (the only accessible side of the natural plateau). Work ceased, however, in 431 BCE at the outbreak of the Peloponnesian War between Athens and Sparta and never resumed. Two later temples, the Erechtheion (no. 4) and the Temple of Athena Nike (no. 5), built after Pericles died, were probably also part of the original project. The greatest Athenian architects and sculptors of the Classical period focused their attention on the construction and decoration of these four buildings.

That these ancient buildings exist at all today is something of a miracle. In the Middle Ages, the Parthenon, for example, became a Byzantine and later a Roman Catholic church and then, after the Ottoman conquest of Greece, a mosque. With each rededication, religious officials remodeled the building. The Christians early on removed the colossal statue of Athena inside. The churches had a great curved *apse* at the east end housing the altar. The Ottomans

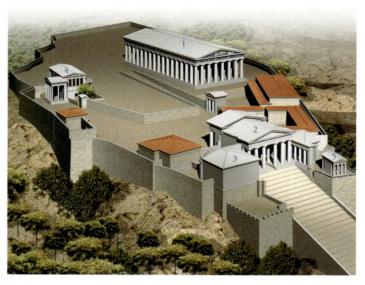

5-44 Restored view of the Acropolis, Athens, Greece (John Burge). (1) Parthenon, (2) Propylaia, (3) pinakotheke, (4) Erechtheion, (5) Temple of Athena Nike.

Of the four main fifth-century BCE buildings on the Acropolis, the first to be erected was the Parthenon, followed by the Propylaia, the Erechtheion, and the Temple of Athena Nike.

added a *minaret* (tower used to call Muslims to prayer). In 1687, the Venetians besieged the Acropolis. One of their rockets scored a direct hit on the ammunition depot the Ottomans had installed in part of the Parthenon. The resultant explosion blew out the building's center. To make matters worse, the Venetians subsequently tried to remove some of the statues from the Parthenon's pediments. In more than one case, the workmen dropped the statues, which smashed on the ground. From 1801 to 1803, Thomas Bruce (1766–1841), Lord Elgin, brought most of the surviving sculptures to England. For the past two centuries, they have been on exhibit in the British Museum (FIGS. 5-47 to 5-50), although Greece has appealed many times for the return of the "Elgin Marbles" and built a new museum near the Acropolis to house them.

Today, a uniquely modern blight threatens the Parthenon and the other buildings of the Periclean age. The corrosive emissions of factories and automobiles are decomposing the ancient marbles. A comprehensive campaign has been under way for some time to protect the columns and walls from further deterioration. What little original sculpture remained in place when modern restoration began is now in the new museum's climate-controlled rooms.

PARTHENON: ARCHITECTURE Despite the ravages of time and humans, most of the Parthenon's peripteral colonnade (FIG. 5-1) is still standing (or has been reerected), and art historians know a great deal about the building and its sculptural program. The architect was Iktinos, assisted, according to some sources, by Kallikrates, who may have played the role of contractor, supervising the construction of the building. The statue of Athena (FIG. 5-46) in the cella was the work of Phidias, who was also the overseer of the temple's sculptural decoration. In fact, Plutarch stated that Phidias was in charge of the entire Acropolis project.⁵

Just as the contemporaneous *Doryphoros* (FIG. 5-41) may be seen as the culmination of nearly two centuries of searching for the ideal proportions of the various human body parts, so, too, the Parthenon may be viewed as the ideal solution to the Greek architect's quest for

5-45 Plan of the Parthenon, Acropolis, Athens, Greece, with diagram of the sculptural program (after Andrew Stewart), 447–432 BCE.

A team of sculptors directed by Phidias lavishly decorated the Parthenon with statues in both pediments, figural reliefs in all 92 Doric metopes, and an inner 524-foot sculptured Ionic frieze.

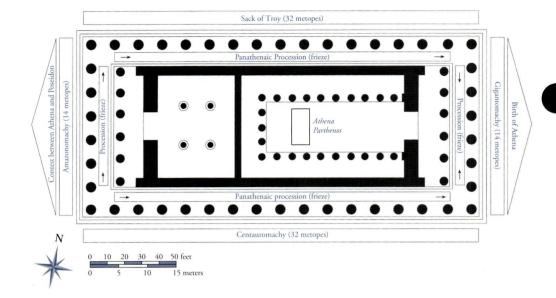

perfect proportions in Doric temple design (see "The Perfect Temple," page 103), even if the building did not function as a temple proper. Its well-spaced columns (FIG. 5-1), with their slender shafts, and the capitals, with their straight-sided conical echinuses, are the ultimate refinement of the bulging and squat Doric columns and compressed capitals of the Archaic Hera temple (FIG. 5-14) at Paestum. The Parthenon architects and Polykleitos were kindred spirits in their belief that beautiful proportions resulted from strict adherence to harmonic numerical ratios, whether in a temple more than 200 feet long or a life-size statue of a nude man. For the Parthenon, the controlling ratio for the *symmetria* of the parts may be expressed algebraically as x = x2y + 1. Thus, for example, the temple's plan (FIG. 5-45) called for 8 columns on the short ends and 17 on the long sides, because 17 = $(2 \times 8) + 1$. The stylobate's ratio of length to width is 9:4, because 9 $= (2 \times 4) + 1$. This ratio also characterizes the cella's proportion of length to width, the distance between the centers of two adjacent column drums (the interaxial) in proportion to the columns' diameter, and so forth.

The Parthenon's harmonious design and the mathematical precision of the sizes of its constituent elements tend to obscure the fact that the building is quite irregular in shape. Throughout the structure are pronounced deviations from the strictly horizontal and vertical lines assumed to be the basis of all Greek post-and-lintel designs. The stylobate, for example, curves upward at the center on the sides and both facades, forming a kind of shallow dome, and this curvature carries up into the entablature. Moreover, the peristyle columns (FIG. 5-1a) lean inward slightly. Those at the corners have a diagonal inclination and are also about 2 inches thicker than the rest. If their lines continued, they would meet about 1.5 miles above the temple. These deviations from the norm meant that virtually every Parthenon block and drum had to be carved according to the special set of specifications dictated by its unique place in the structure. This was obviously a daunting task, and the builders must have had a reason for introducing these so-called refinements in the Parthenon. Some modern observers note, for example, how the curving of horizontal lines and the tilting of vertical ones create a dynamic balance in the building-a kind of architectural contrapposto—and give it a greater sense of life. The oldest recorded explanation is that of Vitruvius, a Roman architect of the late first century BCE (see "Vitruvius's Ten Books on Architecture," page 199). Vitruvius claimed to have had access to Iktinos's treatise on the Parthenon (again, note the kinship with the *Canon* of Polykleitos), and his rationale for the refinements may be the most likely. Vitruvius maintained that these adjustments were made to compensate for optical illusions, noting, for example, that if a stylobate is laid out on a level surface, it will appear to sag at the center. He also recommended that the corner columns of a building should be thicker because they are surrounded by light and would otherwise appear thinner than their neighbors.

The Parthenon is "irregular" in other ways as well. One of the ironies of this most famous of all Doric buildings is that it incorporates Ionic elements. Although the cella (FIG. 5-46) had a two-story Doric colonnade, the back room (which housed the goddess's treasury and the tribute collected from the Delian League) had four tall and slender Ionic columns as sole supports for the superstructure (FIG. 5-45). And whereas the temple's exterior had a standard Doric frieze (FIG. 5-47), the inner frieze (FIG. 5-50) that ran around the top of the cella wall was Ionic. Perhaps this fusion of Doric and Ionic elements reflects the Athenians' belief that the Ionians of the Aegean Islands and Asia Minor were descendants of Athenian settlers and were therefore their kin. (The Ionians take their name from Ion, the grandson of King Erechtheus of Athens.) Or it may be Pericles and Iktinos's way of suggesting that Athens was the leader of all the Greeks. In any case, a mix of Doric and Ionic features characterizes the fifth-century BCE buildings of the Acropolis as a whole.

ATHENA PARTHENOS The decision to incorporate two sculptured friezes in the Parthenon's design is symptomatic of the enormous investment the Athenians made in the building project. This Pentelic marble shrine was more lavishly adorned than any Greek temple before it, Doric or Ionic. A mythological scene appears in every one of the 92 Doric metopes, and every inch of the 524-foot-long Ionic frieze depicts a procession and cavalcade. Dozens of larger-than-lifesize statues filled both pediments. And inside was the most expensive item of all—Phidias's *Athena Parthenos*, a colossal gold-and-ivory (*chryselephantine*) statue of the virgin goddess. Art historians know a great deal about Phidias's lost statue from descriptions by Greek and Latin authors and from Roman copies. A model (FIG. **5-46**) gives a good idea of its appearance and setting. Athena stood 38 feet tall, and to a large extent Iktinos designed the Parthenon around her. To accommodate the statue's huge size, the cella had to be wider than

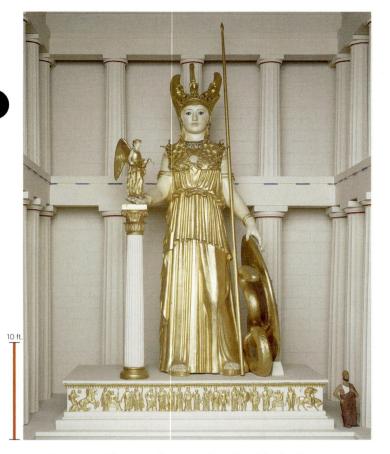

5-46 Phidias, *Athena Parthenos*, in the cella of the Parthenon, Acropolis, Athens, Greece, ca. 438 BCE. Model of the lost chryselephantine statue. Royal Ontario Museum, Toronto.

Inside the cella of the Parthenon stood Phidias's 38-foot-tall gold-and-ivory Athena Parthenos ("the virgin"). The goddess is fully armed and holds Nike (Victory) in her extended right hand.

usual. This, in turn, dictated the width of the facade—eight columns at a time when six columns were the norm (FIGS. 5-25 and 5-30).

Athena was fully armed with shield, spear, and helmet, and she held Nike (the winged female personification of Victory) in her extended right hand. No one doubts that this Nike referred to the victory of 479 BCE. The memory of the Persian sack of the Acropolis was still vivid, and the Athenians were intensely conscious that by driving back the Persians, they had saved their civilization from the Eastern "barbarians" who had committed atrocities at Miletos. In fact, Phidias's *Athena Parthenos* incorporated multiple allusions to the Persian defeat. On the thick soles of Athena's sandals was a representation of a centauromachy. High reliefs depicting the battle of Greeks and Amazons (*Amazonomachy*), in which Theseus drove the Amazons out of Athens, emblazoned the exterior of her shield. On the shield's interior, Phidias painted a gigantomachy. Each of these mythological contests was a metaphor for the triumph of order over chaos, of civilization over barbarism, and of Athens over Persia.

PARTHENON: METOPES Phidias took up these same themes again in the Parthenon's metopes. The best-preserved metopes—although the paint on these and all the other Parthenon marbles long ago disappeared—are those of the south side, which depicted the battle of Lapiths and centaurs, a combat in which Theseus played a major role. On one extraordinary slab (FIG. **5-47**), a trium-

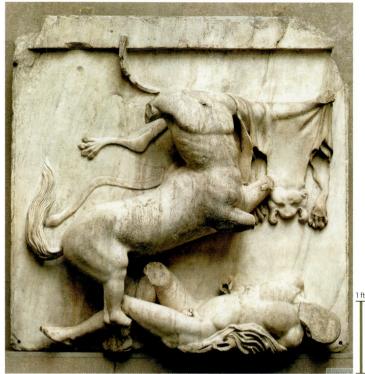

5-47 Centauromachy, metope from the south side of the Parthenon, Acropolis, Athens, Greece, ca. 447–438 BCE. Marble, 4' 8" high. British Museum, London.

The Parthenon's centauromachy metopes allude to the Greek defeat of the Persians. Here the sculptor brilliantly distinguished the vibrant living centaur from the lifeless Greek corpse.

phant centaur rises up on its hind legs, exulting over the crumpled body of the Greek whom the horse-man has defeated. The relief is so high that parts are fully in the round. Some have broken off. The sculptor brilliantly distinguished the vibrant, powerful form of the living beast from the lifeless corpse on the ground. In other metopes, the Greeks have the upper hand, but the full set suggests that the battle was a difficult one against a dangerous enemy and that losses as well as victories occurred. The same was true of the war against the Persians, and the centauromachy metopes—and also the gigantomachy, Amazonomachy, and Trojan War metopes—are allegorical references to the Greek-Persian conflict of the early fifth century BCE.

PARTHENON: PEDIMENTS The subjects of the two pediments were especially appropriate for a building that celebrated Athena—and the Athenians. The east pediment depicted the birth of the goddess. At the west was the contest between Athena and Poseidon to determine which one would become the city's patron deity. Athena won, giving her name to the polis and its citizens. It is significant that in the story and in the pediment, the Athenians are the judges of the relative merits of the two gods. The selection of this theme for the Parthenon reflects the same arrogance that led to the use of Delian League funds to adorn the Acropolis.

The Christians removed the center of the east pediment when they added an apse to the Parthenon at the time of its conversion into a church. What remains are the spectators to the left and the right who witnessed Athena's birth on Mount Olympus. At the 5-48 Helios and his horses, and Dionysos (Herakles?), from the east pediment of the Parthenon, Acropolis, Athens, Greece, ca. 438–432 BCE.

Marble, greatest height 4' 3".

British Museum, London.

The east pediment of the Parthenon depicts the birth of Athena. At the left, Helios and his horses emerge from the pediment's floor, suggesting the sun rising above the horizon at dawn.

5-49 Three goddesses (Hestia, Dione, and Aphrodite?), from the east pediment of the Parthenon, Acropolis, Athens, Greece, ca. 438–432 BCE.

Marble, greatest height 4' 5".

British Museum, London.

The statues of Hestia, Dione, and Aphrodite conform perfectly to the shape of the Parthenon's east pediment. The thin and heavy folds of the garments alternately reveal and conceal the body forms.

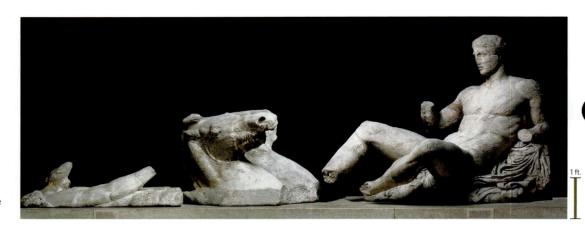

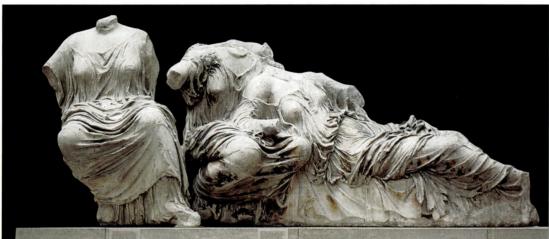

1 ft.

far left (FIG. 5-48) are part of the head and arms of Helios (the Sun) and his chariot horses rising from the pediment floor. Next to them is a powerful male figure usually identified as Dionysos or possibly Herakles, who entered the realm of the gods on completion of his 12 labors (see "Herakles," page 124). At the right (FIG. 5-49) are three goddesses, probably Hestia, Dione, and Aphrodite (see "Gods and Goddesses," page 105), and either Selene (the Moon) or Nyx (Night) and more horses, this time sinking below the pediment's floor. Here, Phidias, who must have designed the composition even if his assistants executed it, discovered an entirely new way to deal with the awkward triangular frame of the pediment. Its floor is now the horizon line, and charioteers and their horses move through it effortlessly. The individual figures, even the animals, are brilliantly characterized. The horses of the Sun, at the beginning of the day, are energetic. Those of the Moon or Night, having labored all night, are weary. (The horses also set the time of day: dawn. It is also the dawn of the age of Athena.)

The reclining figures next to the horses on each side of the pediment fill the space beneath the raking cornice beautifully. Dionysos/Herakles and Aphrodite in the lap of her mother, Dione, are imposing Olympian presences yet totally relaxed organic forms. The Athenian sculptors fully understood not only the surface appearance of human anatomy, both male and female, but also the mechanics of how muscles and bones make the body move. The Phidian workshop mastered the rendition of clothed forms as well. In the Dione-Aphrodite group, the thin and heavy folds of the garments alternately reveal and conceal the main and lesser body masses while swirling in a compositional tide that subtly unifies the two figures. The articulation and integration of the bodies produce a wonderful variation of surface and play of light and shade.

PARTHENON: IONIC FRIEZE In many ways, the most remarkable part of the Parthenon's sculptural decoration is the inner Ionic frieze (FIG. **5-50**). Scholars still debate its subject, but most agree that it represents the Panathenaic Festival procession that took place every four years in Athens. If this identification is correct, the Athenians judged themselves fit for inclusion in the Parthenon's iconographical program—a remarkable decision, because no Greek temple had ever featured a human event in its decoration. It is another example of the Athenians' extraordinarily high sense of self-worth.

The procession began at the Dipylon Gate, passed through the agora (central square), and ended on the Acropolis, where the Athenians placed a new peplos on an ancient wood statue of Athena. That statue (probably similar in general appearance to the Lady of Auxerre, FIG. 5-6) had been housed in the Archaic temple that the Persians razed in 480 BCE, but the Athenians removed it before the attack for security reasons and eventually installed it in the Erechtheion (FIG. 5-53, no. 1). On the Parthenon frieze, the procession begins on the west—that is, at the temple's rear, the side facing the gateway to the Acropolis. It then moves in parallel lines down the long north and south sides of the building and ends at the center of the east frieze, over the doorway to the cella housing Phidias's statue (FIGS. 5-45 and 5-46). It is noteworthy that the upper part of the frieze is in higher relief than the lower part so that the more distant and more shaded upper zone is as legible from the ground as the lower part of the frieze. This is another instance of how the Parthenon's builders took optical effects into consideration.

The frieze vividly communicates the procession's acceleration and deceleration. At the outset, on the west side, marshals gather, and youths mount their horses. On the north and south (FIG. 5-50,

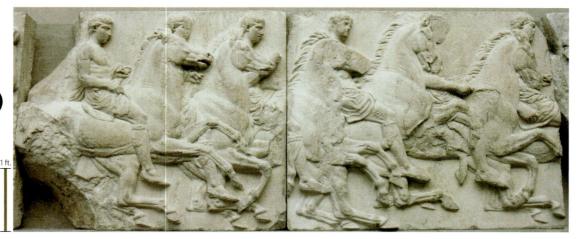

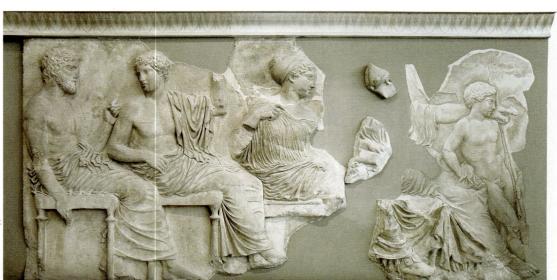

5-50 Three details of the Panathenaic Festival procession frieze, from the Parthenon, Acropolis, Athens, Greece, ca. 447–438 BCE. Marble, 3' 6" high. *Top*: horsemen (south frieze), British Museum, London. *Center*: Poseidon, Apollo, Artemis, Aphrodite, and Eros (east frieze), Acropolis Museum, Athens. *Bottom*: elders and maidens (east frieze), Musée du Louvre, Paris.

The Parthenon's Ionic frieze represents the Panathenaic procession of citizens on horseback and on foot under the gods' watchful eyes. The Parthenon celebrated the Athenians as much as Athena.

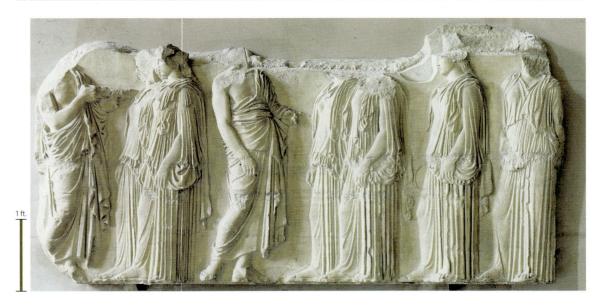

top), the momentum picks up as the cavalcade moves from the lower town to the Acropolis, accompanied by musicians, jar carriers, and animals destined for sacrifice. On the east, seated gods and goddesses (FIG. 5-50, center), the invited guests, watch the procession slow almost to a halt (FIG. 5-50, bottom) as it nears its goal at the shrine of Athena's ancient wood idol. Most remarkable of all is the role assigned to the Olympian deities. They do not take part in the festival or determine its outcome, but are merely spectators.

Aphrodite, in fact, extends her left arm to draw her son Eros's attention to the Athenians, just as today a parent at a parade would point out important people to a child. Indeed, the Athenian people *were* important—self-important, one might say. They were the masters of an empire, and in Pericles's famous funeral oration, he painted a picture of Athens that elevated its citizens almost to the stature of gods. The Parthenon celebrated the greatness of Athens and the Athenians as much as it honored Athena.

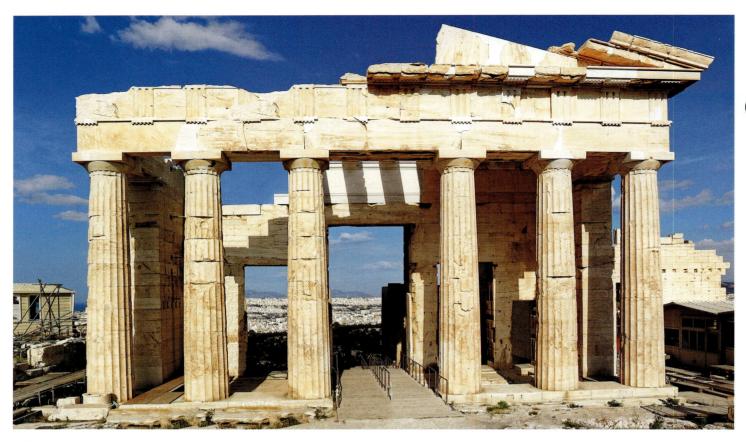

5-51 MNESIKLES, Propylaia (looking west), Acropolis, Athens, Greece, 437-432 BCE.

Mnesikles disguised the change of ground level by splitting the Propylaia into eastern and western sections. Each facade resembles a Doric temple but with a wider space between the central columns.

PROPYLAIA Even before all the sculptures were in place on the Parthenon, work began on a grandiose new entrance to the Acropolis, the Propylaia (FIG. 5-51). The architect entrusted with this important commission was MNESIKLES. The site was a difficult one, on a steep slope, but Mnesikles succeeded in disguising the change in ground level by splitting the building into eastern and western sections (FIG. 5-44, no. 2), each one resembling a Doric temple facade (hence the name "Propylaia," Greek for "gates," rather than "gate"). Practical considerations dictated that the space between the central pair of columns on each side be enlarged. This was the path that the vehicles and animals of the Panathenaic Festival procession took, and they required a wide ramped causeway. To either side of the central ramp were stairs for pedestrian traffic. Inside, tall, slender Ionic columns supported the split-level roof. Once again an Athenian architect mixed the two orders on the Acropolis. But as Iktinos did for the Parthenon, Mnesikles chose the Doric order for the stately exterior.

Mnesikles's full plan for the Propylaia was never executed because of the change in the fortunes of Athens after the outbreak of the Peloponnesian War in 431 BCE. Of the side wings that were part of the original project, only the northwest one (FIG. 5-44, no. 3) was completed. That wing is of special importance in the history of art. In Roman times it housed a *pinakotheke* (picture gallery). In it were displayed paintings on wood panels by some of the major artists of the fifth century BCE. It is uncertain whether this was the wing's original function. If it was, the Propylaia's pinakotheke is the first recorded structure built for the specific purpose of displaying paintings, and it is the forerunner of modern museums.

ERECHTHEION In 421 BCE, work finally began on the temple that was to replace the Archaic Athena temple that the Persians had destroyed. The new structure, the Erechtheion (FIG. 5-52), built to the north of the old temple's remains, was to be a multiple shrine, however. It honored Athena and housed the ancient wood image of the goddess that was the goal of the Panathenaic Festival procession. But it also incorporated shrines to a host of other gods and demigods who loomed large in the city's legendary past. Among these were Erechtheus, an early king of Athens, during whose reign the ancient statuette of Athena was said to have fallen from the heavens, and Kekrops, another king of Athens, who served as judge of the contest between Athena and Poseidon. In fact, the site chosen for the new temple was the very spot where that contest occurred. Poseidon had staked his claim to Athens by striking the Acropolis rock with his trident and producing a salt-water spring. The imprint of his trident remained for Athenians of the historical period (and visitors to the Acropolis today) to see on the north side of the Erechtheion. Nearby, Athena had miraculously caused an olive tree to grow. A tree still stands at the west end of the temple. In antiquity, Athena's tree reminded the citizens of the goddess's victory over Poseidon.

The asymmetrical plan (FIG. **5-53**) of the Ionic Erechtheion is unique for a Greek temple and the antithesis of the simple and harmoniously balanced plan of the Doric Parthenon across the way. Its irregular form reflected the need to incorporate the tomb of Kekrops and other preexisting shrines, the trident mark, and the olive tree into a single complex. The unknown architect responsible for the building also had to struggle with the problem of uneven terrain. The area could not be leveled by terracing because that would disturb the

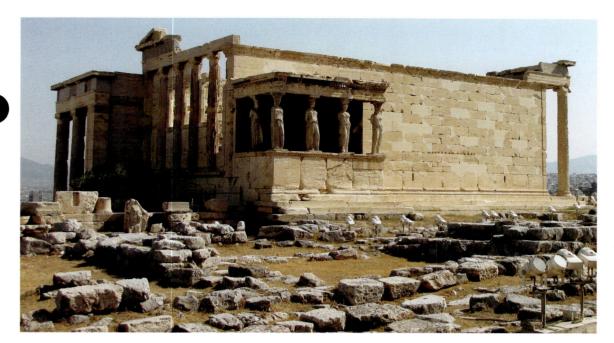

5-52 Erechtheion (looking northeast), Acropolis, Athens, Greece, ca. 421–405 BCE.

The Erechtheion is in many ways the antithesis of the Doric Parthenon directly across from it. An lonic temple, it has some of the finest decorative details of any ancient Greek building.

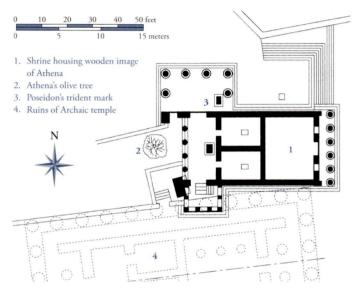

◀ 5-53 Plan of the Erechtheion, Acropolis, Athens, Greece, ca. 421–405 BCE.

The asymmetrical form of the Erechtheion is unique for a Greek temple. It reflects the need to incorporate preexisting shrines into the plan, including those of the kings Erechtheus and Kekrops.

decorative details. The Ionic capitals were inlaid with gold, rock crystal, and colored glass, and the frieze received special treatment. The stone chosen was the grey-blue limestone of Eleusis to contrast with the white Pentelic marble of the walls and columns and the marble relief figures attached to the dark frieze.

The Erechtheion's most striking and famous feature is its south porch (FIG. 5-54), where the architect replaced Ionic columns with caryatids, as on the Siphnian Treasury (FIG. 5-17) at Delphi. The Archaic caryatids resemble sixth-century BCE korai, and their Classical counterparts equally characteristically look like Phidian-era statues. Although the caryatids exhibit the weight shift that was standard for the fifth century BCE, the flutelike drapery folds concealing their stiff, weight-bearing legs underscores their role as architectural supports. The figures have enough rigidity to suggest the structural column and just the degree of flexibility needed to suggest the living body.

ancient sacred sites. As a result, the Erechtheion has four sides of very different character, and each side rests on a different ground level.

Perhaps to compensate for the awkward character of the building as a whole, the architect took great care with the Erechtheion's

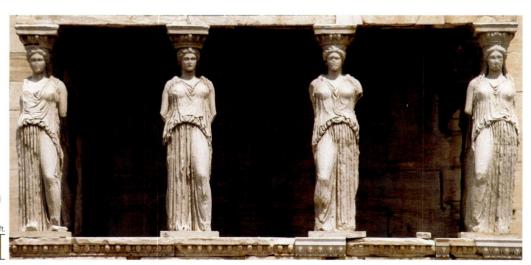

5-54 Caryatids of the south porch of the Erechtheion, Acropolis, Athens, Greece, ca. 421–405 BCE. Plaster casts of marble statues, 7' 7" high. Original statues in the Acropolis Museum, Athens, and the British Museum, London.

The south porch of the Erechtheion features caryatids, updated Classical versions with contrapposto stances of the Archaic caryatids of the porch of the Siphnian Treasury (Fig. 5-17) at Delphi.

5-55 KALLIKRATES, Temple of Athena Nike (after restoration, 2012; looking southwest), Acropolis, Athens, Greece, ca. 427–424 BCE.

The Ionic temple at the entrance to the Acropolis is an unusual amphiprostyle building. It celebrated Athena as bringer of victory, and one of the friezes depicts the Persian defeat at Marathon.

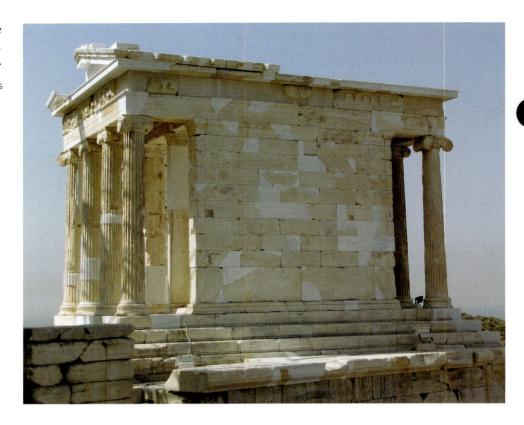

TEMPLE OF ATHENA NIKE Another Ionic building on the Athenian Acropolis is the small Temple of Athena Nike (FIG. 5-55), designed by Kallikrates, who worked with Iktinos on the Parthenon and may have been responsible for that temple's Ionic elements. The Athena Nike temple, rebuilt in 2012 after having been dismantled for restoration, is amphiprostyle (see "Greek Temple Plans," page 113) with four columns on both the east and west facades. It stands on what used to be a Mycenaean bastion near the Propylaia and greets all visitors entering Athena's great sanctuary. Like the Parthenon, this temple commemorated the victory over the Persians—and not just in its name. The sculptors devoted part of the frieze to a representation of the decisive battle at Marathon, which turned the tide against the Persians—a human event, as in the Parthenon's Panathenaic Festival procession frieze. But on the Athena Nike temple, the Athenians chronicled a specific occasion, not a recurring event involving anonymous citizens.

Around the building, at the bastion's edge, was a *parapet* decorated with exquisite reliefs, today displayed in the new Acropolis Museum. The theme of the balustrade matched that of the temple proper—victory. Dozens of images of Nike adorn the parapet, always in different attitudes. Sometimes she erects trophies bedecked with Persian spoils. Other times she brings forward sacrificial bulls for Athena. One relief (FIG. 5-56) shows Nike adjusting her sandal—an awkward posture that the sculptor rendered elegant and graceful. The artist carried the style of the Parthenon pediments (FIG. 5-49) even further and created a figure whose garments cling so tightly

5-56 Nike adjusting her sandal, from the south side of the parapet of the Temple of Athena Nike, Acropolis, Athens, Greece, ca. 410 BCE. Marble, 3' 6" high. Acropolis Museum, Athens.

Dozens of images of winged Victory adorned the parapet on three sides of the Athena Nike temple. The sculptor carved this Nike with garments that appear almost transparent.

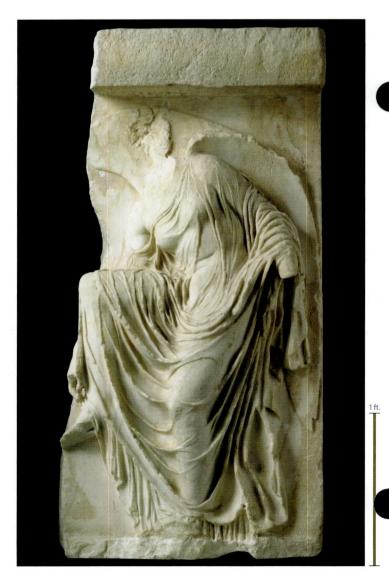

ART AND SOCIETY

The Hegeso Stele

In Geometric times, huge painted vases (FIGS. 5-2 and 5-2A) marked the graves of wealthy Athenians. In the Archaic period, the Greeks placed kouroi (FIGS. 5-7 and 5-9) and, to a lesser extent, korai, or stelae ornamented with relief depictions of the deceased over their graves. The stele (FIG. 5-57) erected in the Dipylon cemetery at the end of the fifth or beginning of the fourth century BCE to commemorate the death of Hegeso, daughter of Proxenos, is in this tradition. An inscription giving the names of the daughter and father is on the cornice of the pediment crowning the stele. *Pilasters* (flat engaged columns) at left and right complete the architectural framework.

Hegeso is the well-dressed woman seated on an elegant chair (with footstool). She examines a piece of jewelry (once rendered in paint, not now visible) selected from a box a servant girl brings to her. The maid's simple unbelted chiton contrasts sharply with the more elaborate attire of her mistress. The garments of both women reveal the body forms beneath them. The faces are serene, without a trace of sadness. Indeed, the sculptor depicted both mistress and maid during a characteristic shared moment out of daily life. Only the epitaph reveals that Hegeso is the one who has departed.

The simplicity of the scene on the Hegeso stele is deceptive, however. This is not merely a bittersweet scene of tranquil domestic life before an untimely death. The setting itself is significant—the secluded women's quarters of a Greek house, from which Hegeso rarely would have emerged. Contemporaneous grave stelae of men regularly show them in the public domain, often as warriors. The servant girl is not so much the faithful companion of the deceased in life as she is Hegeso's possession, like the jewelry box. The slave girl may look at her mistress, awaiting her next command, but Hegeso has eyes only for her ornaments. Both slave and jewelry attest to the wealth of Hegeso's father, unseen but prominently cited in the epitaph. (It is noteworthy that there is no mention of the mother's name.) Indeed, even the jewelry box carries a deeper significance, for it probably represents the dowry Proxenos would have provided to his daughter's husband when she left her father's home to enter her husband's home. In the patriarchal society of ancient Greece, the dominant position of men is manifest even when only women are depicted.

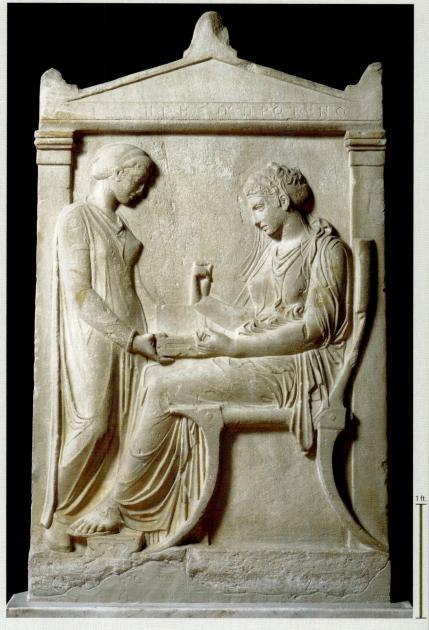

5-57 Grave stele of Hegeso, from the Dipylon cemetery, Athens, Greece, ca. 400 BCE. Marble, 5' 2" high. National Archaeological Museum, Athens.

On her tombstone, Hegeso examines jewelry from a box that her servant girl holds. Mistress and maid share a serene moment out of daily life. Only the epitaph reveals that Hegeso is the one who died.

to the body that they seem almost transparent, as if drenched with water. The sculptor was, however, interested in much more than revealing the supple beauty of the young female body. The drapery folds form intricate linear patterns unrelated to the body's anatomical structure and have a life of their own as abstract designs.

HEGESO STELE Although the decoration of the great building projects on the Acropolis must have occupied most of the finest sculptors of Athens in the second half of the fifth century BCE, other commissions were available in the city, notably in the Dipylon cemetery. There, around 400 BCE, an Athenian family set up in memory of a woman named Hegeso a beautiful and touching grave

stele (FIG. 5-57) in the style of the Temple of Athena Nike parapet reliefs. The stele's subject—a young woman in her home, attended by her maid (see "The Hegeso Stele," above)—and its composition have close parallels in Classical vase painting.

Painting

In the Classical period, some of the most renowned artists were the painters of large wood panels displayed in public buildings, both secular and religious. Those works were by nature perishable, and all of the great panels of the masters are unfortunately lost. Nonetheless, Greek vases of this period, especially those painted using

MATERIALS AND TECHNIQUES

White-Ground Painting

White-ground painting takes its name from the chalky white slip used to provide a background for the painted figures. The Andokides Painter (FIG. 5-22) was one of the first to experiment with white-ground painting in the sixth century BCE, but the method became popular only toward the middle of the fifth century BCE. One of the best examples of the white-ground technique is the lekythos (flask to hold perfumed oil) illustrated here (FIG. 5-58), painted around 440 BCE by the Achilles Painter. White-ground is essentially a variation of the red-figure technique. First the painter covered the pot with a slip of very fine white clay, then applied black glaze to outline the figures, and diluted brown, purple, red, and white to color them. The artist could use other colors for example, the yellow the Achilles Painter chose for the garments of both figures on this lekythos—but these had to be applied after firing because the Greeks did not know how to make them withstand the heat of the kiln. Despite the obvious attractions of the technique, the impermanence of the expanded range of colors discouraged whiteground painting on everyday vessels, such as drinking cups and kraters. In fact, Greek artists explored the full polychrome possibilities of the white-ground technique almost exclusively on lekythoi, which families commonly placed in graves as offerings to the deceased. For vessels designed for short-term use, the fragile nature of white-ground painting was of little concern.

The Achilles Painter, like the REED PAINTER (FIG. 5-58A) later in the century, selected a scene appropriate for the funerary purpose of a lekythos. A youthful warrior takes leave of his wife. The red scarf, mirror, and jug hanging on the wall behind the woman indicate that the setting is the interior of their home. The motif of the seated woman is strikingly similar to that of Hegeso on her grave stele (FIG. 5-57), but here the woman is the survivor. It is her husband, preparing to go to war with helmet, shield, and spear, who will depart, never to return. On his shield is a large painted eye, roughly life-size. Greek shields often bore decorative devices such as the horrific face of Medusa, intended to ward off evil spirits and frighten the enemy (compare FIG. 5-16). This eye undoubtedly recalls this tradition, but for the Achilles Painter it was little more than an excuse to display superior drawing skills. Since the late sixth century BCE, Greek painters had aban-

₹ 5-58A

REED PAINTER,

Warrior seated at his tomb,

ca. 410-400 BCE.

doned the Archaic habit of placing frontal eyes on profile faces and attempted to render the eyes in profile. The Achilles Painter's mastery of this difficult problem in foreshortening is on exhibit here.

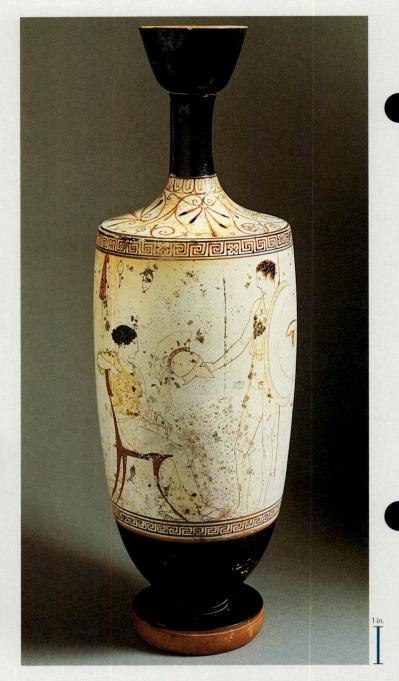

5-58 ACHILLES PAINTER, Warrior taking leave of his wife (Athenian white-ground lekythos), from Eretria, Greece, ca. 440 BCE. 1' 5" high. National Archaeological Museum, Athens.

White-ground painters applied the colors after firing because most colored glazes could not withstand the kiln's heat. The Achilles Painter here displayed his mastery of drawing an eye in profile.

the *white-ground painting* technique (see "White-Ground Painting," above), give some idea of the polychrome nature of Classical panel paintings. One of the masters of white-ground painting was the ACHILLES PAINTER (FIG. 5-58).

POLYGNOTOS The leading panel painter of the first half of the fifth century BCE was Polygnotos of Thasos, whose works adorned important buildings both in Athens and Delphi. One of these was the pinakotheke of Mnesikles's Propylaia, but the most famous was a

building in the Athenian marketplace that came to be called the Stoa Poikile (Painted Stoa; compare FIG. 5-78). Descriptions of Polygnotos's paintings make clear that he introduced a revolutionary compositional format. Before Polygnotos, figures stood on a common ground line at the bottom of the picture plane, whether they appeared in horizontal bands or single panels. Polygnotos placed his figures on different levels, staggered in tiers in the manner of Ashurbanipal's lion hunt relief (FIG. 2-23) of two centuries before. He also incorporated landscape elements into his paintings, making his

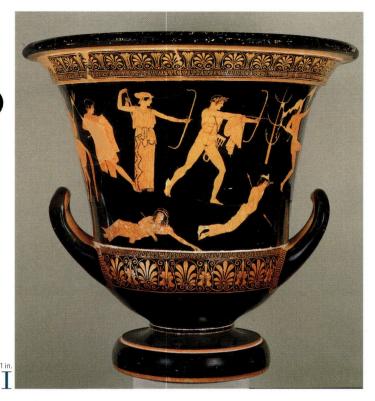

5-59 NIOBID PAINTER, Artemis and Apollo slaying the children of Niobe (Athenian red-figure calyx krater), from Orvieto, Italy, ca. 450 BCE. 1' 9" high. Musée du Louvre, Paris.

The placement of figures on different levels in a landscape on this red-figure krater depicting the massacre of the Niobids reflects the compositions of the panel paintings of Polygnotos of Thasos.

pictures true windows onto the world and not simply surface designs peopled with foreshortened figures. Polygnotos's abandonment of a single ground line was as momentous a break from the past as Early Classical Greek sculptors' rejection of frontality in statuary.

NIOBID PAINTER Polygnotos's influence is evident on a red-figure krater (FIG. 5-59) painted around the middle of the fifth century BCE

by the Niobid Painter—so named because one side of this krater depicts the massacre of the Niobids, the children of Niobe. Niobe, who had at least a dozen children, had boasted that she was superior to the goddess Leto, who had only two offspring, Apollo and Artemis. To punish her *hubris* (arrogant pride) and teach the lesson that no mortal could be superior to a god or goddess, Leto sent her two children to slay all of Niobe's many sons and daughters. On the Niobid Painter's krater, the horrible slaughter occurs in a schematic landscape setting of rocks and trees. The painter placed the figures on several levels, and they actively interact with their setting. One slain son, for example, not only has fallen upon a rocky outcropping but is partially hidden by it. The Niobid Painter also drew the son's face in a three-quarter view, something even Euphronios and Euthymides had not attempted.

PHIALE PAINTER Further insight into the appearance of the lost panel paintings of the fifth century BCE comes from a white-ground krater (FIG. 5-60) by the PHIALE PAINTER. The subject is Hermes handing over his half brother, the infant Dionysos, to Papposilenos ("Grandpa-Satyr"). The other figures represent the nymphs in the shady glens of Nysa, where Zeus had sent Dionysos, one of his numerous natural sons, to be raised, safe from the possible wrath of his wife, Hera. Unlike the decorators of funerary lekythoi, the Phiale Painter used for this krater only colors that could survive the heat of a Greek kiln—red, brown, purple, and a special snowy white reserved for the flesh of the nymphs and for the hair, beard, and shaggy body of Papposilenos. The use of diluted brown wash to color and shade the rocks may reflect the coloration of Polygnotos's landscapes. This vase and the Niobid krater together provide a shadowy idea of the character of Polygnotos's lost paintings.

TOMB OF THE DIVER, PAESTUM Although all the panel paintings of the masters disappeared long ago, some Greek mural paintings survive. An early example is in the Tomb of the Diver at Paestum. Covering the four walls of this small, coffinlike tomb are symposium scenes of the kind that appear regularly on Greek vases. On the tomb's cover slab (Fig. 5-61), a youth dives from a stone platform into a body of water. The scene most likely symbolizes the plunge from this life into the next. Trees resembling those of the Niobid krater are included within the decorative frame.

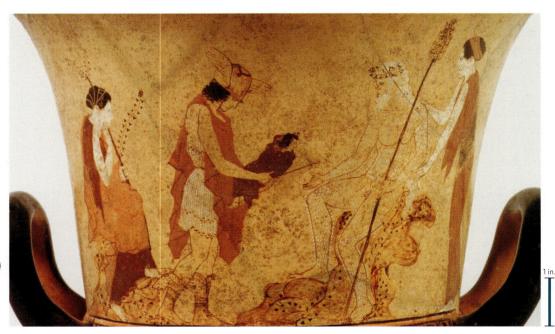

5-60 PHIALE PAINTER, Hermes bringing the infant Dionysos to Papposilenos (Athenian whiteground calyx krater), from Vulci, Italy, ca. 440–435 BCE. Krater 1' 2" high; detail $6\frac{1}{2}$ " high. Musei Vaticani, Rome.

In the Phiale Painter's white-ground representation of Hermes and the infant Dionysos at Nysa, the use of diluted brown to color and shade the rocks may reflect the panel paintings of Polygnotos.

5-61 Youth diving, cover slab of the Tomb of the Diver, from the Tempe del Prete necropolis, Paestum, Italy, ca. 480–470 BCE. Fresco, 3' 4" high. Museo Archeologico Nazionale, Paestum.

This tomb in Italy is a rare example of Classical mural painting. The diving scene most likely symbolizes the deceased's plunge into the Underworld. The trees resemble those on the Niobid krater (FIG. 5-59).

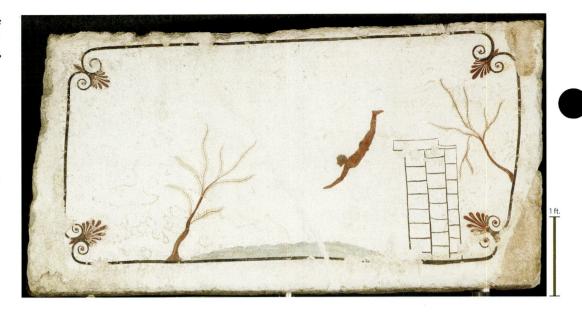

LATE CLASSICAL PERIOD

The Peloponnesian War, which began in 431 BCE, ended in 404 BCE with the complete defeat of a plague-weakened Athens. The victor, Sparta, and then Thebes undertook the leadership of Greece, both unsuccessfully. In the middle of the fourth century BCE, a threat from without caused the rival Greek states to put aside their disagreements and unite for their common defense, as they had earlier against the Persians. But at the battle of Chaeronea in 338 BCE, the Greek cities suffered a devastating loss and had to give up their independence to the Macedonian king, Philip II (r. 359–336 BCE). Philip was assassinated in 336, and his son, Alexander III (r. 336–323 BCE), better known simply as Alexander the Great, succeeded him. Alexander led a powerful army on an extraordinary campaign that overthrew the Persian Empire (the ultimate revenge for the Persian invasion of Greece in the early fifth century), wrested control of Egypt, and even reached India (see page 435).

Sculpture

The fourth century BCE in Greece was thus a time of political upheaval, which had a profound impact on the psyche of the Greeks and on the art they produced. In the fifth century BCE, Greeks had generally believed that rational human beings could impose order on their environment, create "perfect" statues such as the *Canon* of Polykleitos, and discover the "correct" mathematical formulas for constructing buildings such as the Parthenon. The Parthenon frieze celebrated the Athenians as a community of citizens with shared values. The Peloponnesian War and the unceasing strife of the fourth century BCE brought an end to the serene idealism of the previous century. Disillusionment and alienation followed. Greek thought and Greek art began to focus more on the individual and on the real world of appearances instead of on the community and the ideal world of perfect beings and perfect shrines.

PRAXITELES The new approach to art is immediately apparent in the work of PRAXITELES, one of the three greatest sculptors of the fourth century BCE. Praxiteles did not reject the favored statuary themes of the High Classical period, and his Olympian gods and goddesses retained their superhuman beauty. But in his hands, those

deities lost some of their solemn grandeur and took on a worldly sensuousness. Nowhere is this new humanizing spirit more evident than in the statue of Aphrodite (FIG. 5-62) that Praxiteles sold to the Knidians after another city had rejected it. The lost original, carved from Parian marble, is known only through copies of Roman date, but Pliny considered it "superior to all the works, not only of Praxiteles, but indeed in the whole world." It made Knidos famous, and

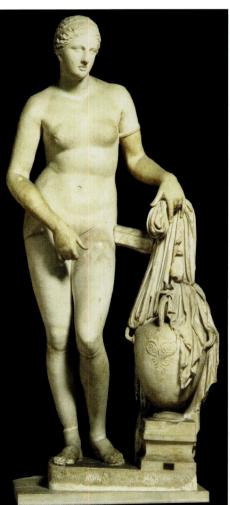

5-62 PRAXITELES, Aphrodite of Knidos. Roman copy of a marble statue of ca. 350–340 BCE. Marble, 6' 8" high. Musei Vaticani, Rome.

This first nude statue of a Greek goddess caused a sensation. But Praxiteles was also famous for his ability to transform marble into soft and radiant flesh. His Aphrodite had "dewy eyes."

many people sailed there just to see the statue in its round temple (compare FIG. 5-72), where "it was possible to view the image of the goddess from every side." According to Pliny, some visitors were "overcome with love for the statue."

The Aphrodite of Knidos caused such a sensation in its time because Praxiteles took the unprecedented step of representing the goddess of love completely nude. Female nudity was rare in earlier Greek art and had been confined almost exclusively to paintings on vases designed for symposia and household use. The women so depicted also were usually not noblewomen or goddesses but courtesans or slave girls—for example, the one Onesimos depicted on a red-figure kylix (drinking cup; FIG. 5-24A). No one had ever dared place a statue of an undressed goddess inside a temple. Moreover, Praxiteles's Aphrodite is not a cold and remote image. In fact, the goddess engages in a trivial act out of everyday life. She has removed her garment, draped it over a large hydria (water pitcher), and is about to step into the bath.

Although shocking in its day, the *Aphrodite of Knidos* is not openly erotic (the goddess modestly shields her pelvis with her right

hand), but she is quite sensuous. Lucian, writing in the second century CE, noted that she had a "welcoming look" and a "slight smile" and that Praxiteles was renowned for his ability to transform marble into soft and radiant flesh. Lucian mentioned, for example, the "dewy quality of Aphrodite's eyes." Unfortunately, the rather mechanical Roman copies do not capture the quality of the master's modeling of the stone, but some originals of the period do—for example, a female head (FIG. 5-62A) from Chios.

5-62A Head of a woman, Chios, ca. 320-300 BCE.

The Praxitelean "touch" is also evident in a statue once thought to be by the hand of the renowned artist himself but now generally considered either a copy of the highest quality or an original work by a son or grandson of Praxiteles with the same name. The statue of Hermes and the infant Dionysos (FIG. 5-63) found in the Temple of Hera at Olympia brings to the realm of life-size statuary the theme that the Phiale Painter had chosen for a white-ground krater (FIG. 5-60) a century earlier. Hermes has stopped to rest in a forest on his journey to Nysa to entrust the upbringing of Dionysos to Papposilenos and the nymphs. Hermes leans on a tree trunk (here it is an integral part of the composition and not a copyist's addition), and his slender body forms a sinuous, shallow S-curve that is the hallmark of many of Praxiteles's statues. He gazes dreamily into space while he dangles a bunch of grapes (now missing) as a temptation for the infant, who is to become the Greek god of the vine. This is the kind of tender human interaction between an adult and a child that one encounters frequently in life but that had been absent from Greek statuary before the fourth century BCE.

5-63A Artist painting a statue of Herakles, ca. 350-320 BCE.

The quality of the carving is superb. The modeling is deliberately smooth and subtle, producing soft shadows that follow the planes as they flow almost imperceptibly one into another. All that is missing to give a complete sense of the "look" of a Praxitelean statue is the original paint, which a specialist, not the sculptor, applied to the statue (compare FIG. 5-63A). The delicacy of the marble facial features stands in sharp contrast to the metallic precision of Polykleitos's bronze *Doryphoros* (FIG. 5-41).

5-63 PRAXITELES(?), Hermes and the infant Dionysos, from the Temple of Hera, Olympia, Greece. Copy of a marble statue by Praxiteles of ca. 340 BCE or an original work of ca. 330–270 BCE by a son or grandson. Marble, 7' 1" high. Archaeological Museum, Olympia.

Praxiteles humanized the Olympian deities. This Hermes is as sensuous as the sculptor's Aphrodite. The god gazes dreamily into space while he dangles grapes to tempt the infant wine god.

The High Classical sculptor even subjected the *Spear Bearer*'s locks of hair to the laws of symmetry, and the hair does not violate the skull's perfect curve. The comparison of these two statues reveals the sweeping changes in artistic attitude and intent that took place from the fifth to the fourth century BCE. In the statues of Praxiteles, the deities of Mount Olympus still possess a beauty mortals can aspire to, although not achieve, but they are no longer aloof. Praxiteles's gods have stepped off their pedestals and entered the world of human experience.

SKOPAS In the Archaic period and throughout most of the Early and High Classical periods, Greek sculptors generally shared common goals, but in the Late Classical period of the fourth century BCE, distinctive individual styles emerged. The dreamy, beautiful divinities of Praxiteles had enormous appeal, and the master had many followers (FIG. 5-62A). Other sculptors, however, pursued very different interests. One of these was Skopas of Paros, an architect

▼ 5-63B Herakles, Temple of Athena Alea, Tegea, ca. 340 BCE.

∮ 5-63C Mausoleum, Halikarnassos, ca. 353-340 BCE.

as well as a sculptor, who designed a temple at Tegea (fragments of the pedimental sculptures remain; FIG. 5-63B) and contributed to the decoration of one of the Seven Wonders of the ancient world (see page 49), the Mausoleum (FIG. 5-63C) at Halikarnassos. Although Skopas's sculptures reflect the general Late Classical trend toward the humanization of the Greek gods and heroes, his hallmark was intense emotionalism. None of his statues survives, but a grave stele (FIG. 5-64) found near the Ilissos River in Athens exhibits the psychological tension for which the master's works were famous.

The Ilissos stele was originally set into an architectural frame similar to that of the earlier Hegeso stele (FIG. 5-57). A comparison of the two works is revealing. In the later stele, the relief is much higher, with parts of the figures carved fully in the round. The major difference, however, is the pronounced change in mood, which reflects Skopas's innovations.

and the dead and depicts overt mourning. The deceased is a young hunter who, like the other figures, has the large, deeply set eyes and fleshy overhanging brows that characterized Skopas's sculptures (compare Fig. 5-63B). At his feet, a small boy, either his servant or perhaps a younger brother, sobs openly. The hunter's dog also droops its head in sorrow. Beside the youth, an old man, undoubtedly his father, leans on a walking stick and, in a gesture reminiscent of that of the Olympia seer (Fig. 5-32), ponders the irony of fate that has taken the life of his powerful son yet preserved him, the father, in his frail old age. Most remarkable of all, the hunter himself looks out at the viewer, inviting sympathy and creating an emotional bridge between the spectator and the artwork inconceivable in the art of the High Classical period.

LYSIPPOS The third great Late Classical sculptor, Lysippos of Sikyon, won such renown that Alexander the Great selected him eigher with parts of the

The Late Classical work makes a clear distinction between the living

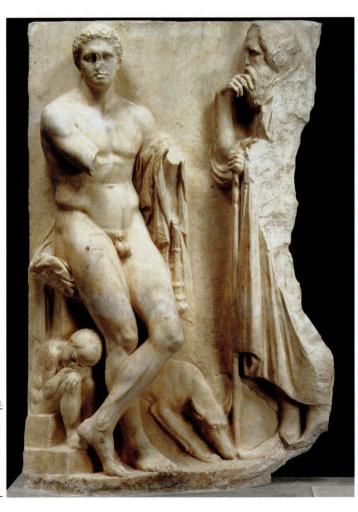

5-64 Grave stele of a young hunter, found near the Ilissos River, Athens, Greece, ca. 340–330 BCE. Marble, 5' 6" high. National Archaeological Museum, Athens.

The emotional intensity of this stele representing an old man mourning the loss of his son as well as the figures' large, deeply set eyes with fleshy overhanging brows reflect the style of Skopas of Paros.

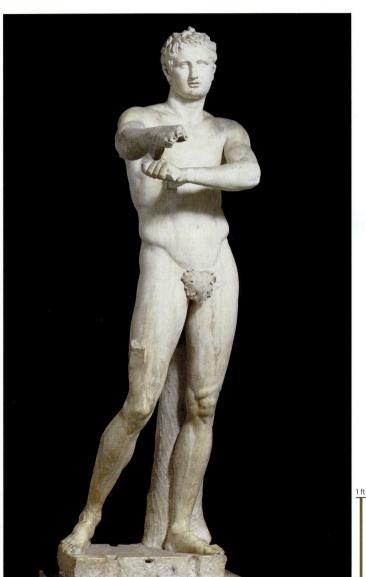

5-65 Lysippos, *Apoxyomenos* (*Scraper*), from Trastevere, Rome, Italy. Roman copy of a bronze statue of ca. 330 BCE. Marble, 6' 9" high. Musei Vaticani, Rome.

Lysippos introduced a new canon of proportions and a nervous energy to his statues. He also broke down the dominance of the frontal view and encouraged viewing his statues from multiple angles.

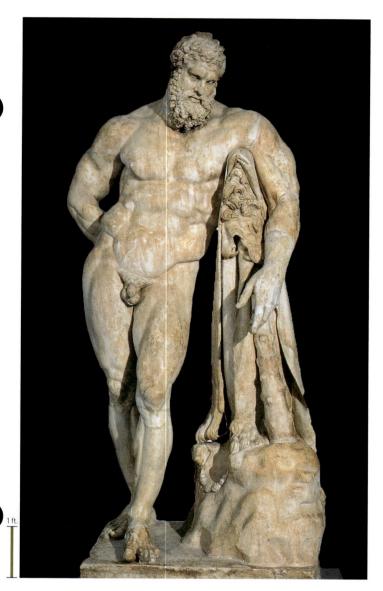

5-66 Lysippos, Weary Herakles (*Farnese Hercules*). Roman statue from the Baths of Caracalla (Fig. 7-64), Rome, Italy, signed by Glykon of Athens, based on a bronze statue of ca. 320 BCE. Marble, 10' 5" high. Museo Archeologico Nazionale, Naples.

Lysippos's portrayal of Herakles after the hero obtained the golden apples of the Hesperides ironically shows the muscle-bound hero as so weary that he must lean on his club for support.

to create his official portrait. (Alexander could afford to employ the best because the Macedonian kingdom enjoyed vast wealth. For example, King Philip was able to hire the leading thinker of his age, Aristotle, as the young Alexander's tutor.) Lysippos introduced a new canon of proportions in which the bodies were more slender than those of Polykleitos and the heads roughly one-eighth the height of the body rather than one-seventh, as in the previous century. One of Lysippos's most famous works, a bronze statue of an *apoxyomenos* (an athlete scraping oil from his body after exercising)—known, as usual, only from Roman copies in marble (FIG. 5-65)—exhibits the new proportions. A comparison with Polykleitos's *Doryphoros* (FIG. 5-41) reveals more than a change in physique, however. A nervous energy, lacking in the balanced form of the *Doryphoros*, runs through Lysippos's *Apoxyomenos*. The *strigil* (scraping tool) is about to reach the end of the right arm, and at any moment the athlete will

switch it to the other hand so that he can scrape his left arm. At the same time, he will shift his weight and reverse the positions of his legs. Lysippos also began to break down the dominance of the frontal view in statuary and encouraged the observer to view his athlete from multiple angles. Because Lysippos represented the apoxyomenos with his right arm boldly thrust forward, the figure breaks out of the shallow rectangular box that defined the boundaries of earlier statues. To comprehend the action, the observer must move to the side and view Lysippos's work at a three-quarter angle or in full profile.

To grasp the full meaning of another of Lysippos's works, a colossal statue (FIG. 5-66) depicting a weary Herakles, the viewer must walk around it. Once again, the original is lost. The most impressive of the surviving statues based on the Lysippan original is nearly twice life-size. It stood in the Baths of Caracalla in Rome, where, like the marble copy of Polykleitos's Doryphoros (FIG. 5-41) from the Roman palaestra at Pompeii, Lysippos's muscle-bound Greek hero provided inspiration for Romans who came to the baths to exercise. (The Roman sculptor, GLYKON OF ATHENS, signed the statue, but did not mention Lysippos. The educated Roman public needed no label to identify the famous work.) The exaggerated muscular development of Herakles is poignantly ironic, however. Lysippos depicted the hero as so weary that he must lean on his club for support. Without that prop, Herakles would topple over. Lysippos and other fourth-century BCE artists rejected stability and balance as goals for statuary.

Herakles holds the golden apples of the Hesperides in his right hand behind his back—unseen unless the viewer walks around the statue. Lysippos's subject is thus the same as that of the metope (FIG. 5-31) of the Early Classical Temple of Zeus at Olympia, but the fourth-century BCE Herakles is no longer serene. Instead of expressing joy, or at least satisfaction, at having completed one of the impossible 12 labors, he is almost dejected. Exhausted by his physical efforts, he can think only of his pain and fatigue. Lysippos's portrayal of Herakles in this statue is an eloquent testimony to Late Classical sculptors' interest in humanizing the Greek gods and heroes. In this respect, despite their divergent styles, Praxiteles, Skopas, and Lysippos followed a common path.

Alexander the Great and Macedonian Court Art

Alexander the Great's favorite book was the *Iliad*, and his own life very much resembled an epic saga, full of heroic battles, exotic locales, and unceasing drama. Alexander was a man of singular character, an inspired leader with boundless energy and an almost foolhardy courage. He personally led his army into battle on the back of Bucephalus (FIG. 5-70), the wild and mighty steed only he could tame and ride.

ALEXANDER'S PORTRAITS Ancient sources reveal that Alexander believed only Lysippos had captured his essence in a portrait, and thus only he was authorized to sculpt the king's image. Lysippos's most famous portrait of the Macedonian king was a full-length, heroically nude bronze statue of Alexander holding a lance and turning his head toward the sky. According to Plutarch, an epigram inscribed on the base stated that the statue depicted Alexander gazing at Zeus and proclaiming, "I place the earth under my sway; you, O Zeus, keep Olympus." Plutarch also reported that Lysippos's portrait immortalized Alexander's "leonine" hair and "melting glance." The Lysippan original is lost, and because Alexander was portrayed so many times, and long after his death, it is difficult to determine which of the many surviving images is most faithful to the fourth-century BCE portrait.

5-67 Head of Alexander the Great, from Pella, Greece, third century BCE. Marble, 1' high. Archaeological Museum, Pella.

Lysippos was the official portrait sculptor of Alexander the Great. This third-century BCE sculpture has the sharp turn of the head and thick mane of hair of Lysippos's statue of Alexander with a lance.

A leading candidate is a third-century BCE marble head (FIG. 5-67) from Pella, the capital of Macedonia and Alexander's birthplace. It has the sharp turn of the head and thick mane of hair that were key ingredients of Lysippos's portrait. The Pella sculptor's treatment of the features also is consistent with the style of the later fourth century BCE. The deep-set eyes and parted lips recall the manner of Skopas (FIG. 5-63B), and the delicate handling of the flesh brings to mind the faces of Praxitelean statues (FIG. 5-63). Although not a copy, this head very likely approximates the young king's official portrait and provides insight into Alexander's personality as well as Lysippos's art.

PELLA MOSAICS The luxurious life of the Macedonian aristocracy is evident from the costly objects found in Macedonian graves and from the abundance of mosaics uncovered in houses at Pella. The Macedonian mosaics are *pebble mosaics* (see "Mosaics," page 251). The floors consist of small stones of various colors collected from beaches and riverbanks and set into a thick coat of cement. The finest pebble mosaic yet to come to light from the Pella excavations has a stag hunt (FIG. **5-68**) as its *emblema* (central framed panel), bordered in turn by an intricate floral pattern and a stylized wave motif. The artist signed his work in the same manner as proud Greek vase painters and potters did: "Gnosis made it." This is the earliest mosaicist's signature known, and its prominence in the design—at the top of the emblema above the hunters' heads—undoubtedly attests to the artist's reputation. The home's owner wanted guests to know that Gnosis himself, not an imitator, had laid this floor.

5-68 GNOSIS, Stag hunt, from Pella, Greece, ca. 300 BCE. Pebble mosaic, figural panel 10' 2" high. Archaeological Museum, Pella.

The floor mosaics at the Macedonian capital of Pella are of the early type made with pebbles of various natural colors. This stag hunt by Gnosis bears the earliest known signature of a mosaicist.

The Pella stag hunt, with its light figures against a dark ground, has much in common with red-figure painting. In the pebble mosaic, however, thin strips of lead or terracotta define most of the contour lines and some of the interior details. Subtle gradations of yellow, brown, and red, as well as black, white, and gray pebbles, suggest the interior volumes. Gnosis used shading to model the musculature of the hunters, their billowing cloaks, and the animals' bodies. The use of light and dark to suggest volume is rare on Greek painted vases, although examples exist. Panel painters, however, commonly used shading, the Greek term for which was *skiagraphia* (literally, "shadow painting"). The Greeks attributed the invention of shading to an Athenian painter of the fifth century BCE named Apollodoros. Gnosis's emblema, with its sparse landscape setting, probably reflects contemporaneous panel painting.

HADES AND PERSEPHONE Excavations at Vergina have provided valuable additional information about Macedonian art and about Greek mural painting. One of the most important finds is a painted tomb (possibly the tomb of Philip II) with a fresco (FIG. 5-69) representing Hades, lord of the Underworld, abducting Persephone, the daughter of Demeter, the goddess of grain. The mural is remarkable for its intense drama and for the painter's use of foreshortening and shading. Hades holds the terrified seminude Persephone in his left arm and steers his racing chariot with his right as Persephone's garments and hair blow in the wind. The artist depicted the heads of both figures and even the chariot's wheels in three-quarter views. The chariot, in fact, seems to be bursting into the viewer's space. Especially noteworthy is the way the painter used short, dark brushstrokes to suggest shading on the underside of Hades's right arm, on Persephone's torso, and elsewhere. Although fragmentary, the

5-69 Hades abducting Persephone, detail of a wall painting in tomb 1, Vergina, Greece, ca. 336 BCE. Fresco, detail 3' $3\frac{1}{2}$ " high.

The intense drama, three-quarter views, and shading in this representation of the lord of the Underworld kidnapping Demeter's daughter are characteristics of mural painting at the time of Alexander.

Vergina mural is a precious document of the almost totally lost art of large-scale wall and panel painting in ancient Greece.

BATTLE OF ISSUS Further insight into developments in painting at the time of Alexander comes from a large mosaic (FIG. 5-70) that decorated the floor of a room in a lavishly appointed Roman house at Pompeii. The mosaicist was a master of a later mosaic technique employing tesserae (cubical pieces of glass or tiny stones cut to the desired size and shape) instead of pebbles (see "Mosaics," page 251). The subject is a great battle between the armies of Alexander the Great and the Achaemenid Persian king Darius III (r. 336–330 BCE), probably the battle of Issus in southeastern Turkey, when Darius fled in his chariot in humiliating defeat. The mosaic dates to the late second or early first century BCE. Most art historians believe that it is a reasonably faithful copy of Battle of Issus, a famous panel painting of about 310 BCE made by PHILOXENOS OF ERETRIA for King Cassander, one of Alexander's successors. Some scholars have proposed, however, that the Alexander Mosaic, as it is commonly called, is a copy of a painting by one of the few Greek woman artists whose name is known, HELEN OF EGYPT.

Battle of Issus is notable for the artist's technical mastery of problems that had long fascinated Greek painters. Even Euthymides would have marveled at the fourth-century BCE painter's depiction of the rearing horse seen in a three-quarter rear view below Darius. The

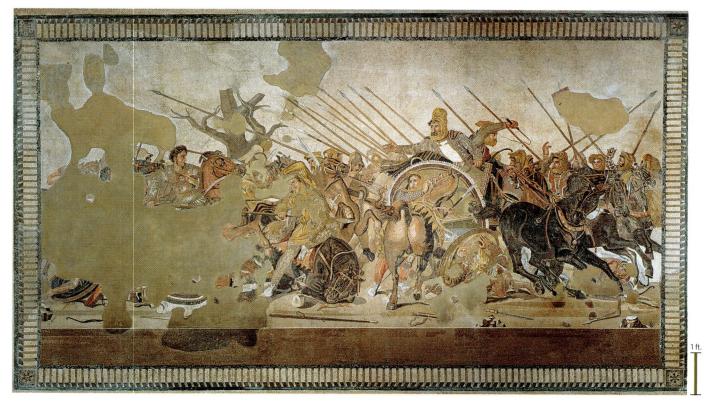

5-70 PHILOXENOS OF ERETRIA, *Battle of Issus*, ca. 310 BCE. Roman copy (*Alexander Mosaic*) from the House of the Faun, Pompeii, Italy, late second or early first century BCE. Tessera mosaic, 8' $10'' \times 16'$ 9". Museo Archeologico Nazionale, Naples.

Battle of Issus reveals Philoxenos's mastery of foreshortening, of modeling figures in color, and of depicting reflections and shadows, as well as his ability to capture the psychological intensity of warfare.

5-71 POLYKLEITOS THE YOUNGER, aerial view of the theater (looking southwest), Epidauros, Greece, ca. 350 BCE.

The Greeks always situated theaters on hillsides to support the cavea of stone seats overlooking the circular orchestra. The Epidauros theater is the finest in Greece. It accommodated 12,000 spectators.

subtle modulation of the horse's rump through shading in browns and yellows is much more accomplished than the comparable attempts at shading in the Pella mosaic (FIG. 5-68) or the Vergina mural (FIG. 5-69). Other details

are even more impressive. The Persian to the right of the rearing horse has fallen to the ground and raises, backward, a dropped Macedonian shield to protect himself from being trampled. Philoxenos recorded the reflection of the man's terrified face on the polished surface of the shield. Everywhere in the scene, men, animals, and weapons cast shadows on the ground. This interest in the reflection of insubstantial light on a shiny surface, and in the absence of light (shadows), stands in sharp contrast to earlier painters' preoccupation with the clear presentation of weighty figures seen against a blank background. Philoxenos here truly opened a window into a world filled not only with figures, trees, and sky but also with light. This new, distinctly Greek notion of what a painting should be characterizes most of the history of art in the Western world from the Renaissance on.

Perhaps most impressive, however, about *Battle of Issus* is the psychological intensity of the drama unfolding before the viewer's eyes. Alexander, riding Bucephalus, leads his army into battle, recklessly one might say, without even a helmet to protect him. He drives his spear through one of Darius's trusted "Immortals," who swore to guard the king's life, while the Persian's horse collapses beneath him. The Macedonian king is only a few yards away from Darius, and Alexander directs his gaze at the Persian king, not at the man impaled on his now-useless spear. Darius has called for retreat. In fact, his charioteer is already whipping the horses and speeding the king to safety. Before he escapes, Darius looks back at Alexander and in a pathetic gesture reaches out toward his brash foe. But the victory has slipped from his hands. In Pliny's opinion, Philoxenos's painting of the battle between Alexander and Darius was "inferior to none."

Architecture

In architecture, as in sculpture and painting, the Late Classical period was a time of innovation and experimentation.

THEATER OF EPIDAUROS In ancient Greece, actors did not perform plays repeatedly over months or years as they do today, but only during sacred festivals. Greek drama was closely associated with religious rites and was not pure entertainment. In the fifth century BCE, for example, the Athenians staged performances of the tragedies of Aeschylus, Sophocles, and Euripides during the Dionysos festival in the theater dedicated to the god on the southern slope of the Acropolis. Yet it is Epidauros, in the Peloponnesos, that boasts the finest theater (FIG. **5-71**) in Greece. Constructed shortly after the birth of Alexander, the theater

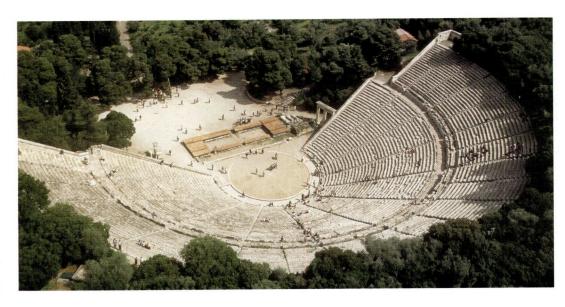

is still the setting for performances of ancient Greek dramas. The architect was Polykleitos the Younger, possibly a later-generation member of the famous fifth-century BCE sculptor's family.

The precursor of the formal Greek theater was a circular patch of earth where actors performed sacred rites, songs, and dances. This circular hard and level surface later became the orchestra of the theater. Orchestra literally means "dancing place." The actors and the chorus performed there, and, at Epidauros, an altar to Dionysos stood at the center of the circle. The spectators sat on a slope overlooking the orchestra—the theatron, or "place for seeing." When the Greek theater took architectural shape, the builders always situated the auditorium (cavea, Latin for "hollow place, cavity") on a hillside. The cavea at Epidauros, composed of wedge-shaped sections (cunei, singular cuneus) of stone benches separated by stairs, is somewhat greater than a semicircle in plan. The auditorium is 387 feet in diameter, and its 55 rows of seats accommodated about 12,000 spectators. They entered the theater via a passageway between the seating area and the scene building (skene), which housed dressing rooms for the actors and also formed a backdrop for the plays. The design is simple but perfectly suited to its function. Even in antiquity, the Epidauros theater was famous for the

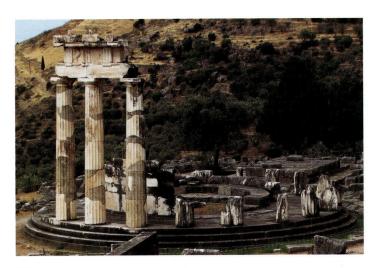

5-72 Theodoros of Phokaia, Tholos (looking northwest), Delphi, Greece, ca. 375 BCE.

The tholos at Delphi, although in ruins, is the best-preserved example of a round temple of the Classical period. It had Doric columns on the exterior and Corinthian columns inside.

ARCHITECTURAL BASICS

The Corinthian Capital

The Corinthian capital (FIG. 5-73) is more ornate than either the Doric or Ionic (FIG. 5-13). It consists of a double row of acanthus leaves, from which tendrils and flowers emerge, wrapped around a bell-shaped echinus. Although architectural historians often cite this capital as the distinguishing feature of the Corinthian order, strictly speaking no Corinthian order exists. The new capital type was simply a substitute for the Ionic order's volute capital.

The sculptor Kallimachos invented the Corinthian capital during the second half of the fifth century BCE. Vitruvius recorded the circumstances that supposedly led to its creation:

A maiden who was a citizen of Corinth . . . died. After her funeral, her nurse collected the goblets in which the maiden had taken delight while she was alive, and after putting them together in a basket, she took them to the grave monument and put them on top of it. In order that they should remain in place for a long time, she covered them with a tile. Now it happened that this basket was placed over the root of an acanthus. As time went on the acanthus root, pressed down in the middle by the weight, sent forth, when it was about springtime, leaves and stalks; its stalks growing up along the sides of the basket and being pressed out from the angles because of the weight of the tile, were forced to form volute-like curves at their extremities. At this point, Kallimachos happened to be going by and noticed the basket with this gentle growth of leaves around it. Delighted with the order and the novelty of the form, he made columns using it as his model and established a canon of proportions for it.*

Kallimachos worked on the Acropolis in Pericles's great building program. Many scholars believe that a Corinthian column supported the outstretched right hand of Phidias's Athena Parthenos (FIG. 5-46) because one appears in some of the Roman copies of the lost statue. In any case, the earliest preserved Corinthian capital dates to the time of Kallimachos. The new type was rarely used before the mid-fourth century BCE, however, and did not become popular until Hellenistic and especially Roman times. Later architects favored the Corinthian capital because of its ornate character and because it eliminated certain problems of both the Doric and Ionic orders.

The lonic capital, unlike the Doric, has two distinct profiles—the front and back (with the volutes) and the sides. The volutes always faced outward on a Greek temple, but architects met with a vexing problem at the corners of their buildings, which had two adjacent "fronts." They solved the problem by placing volutes on both outer faces of the corner capitals—as on the Temple of Athena Nike (FIG. 5-55)—but that was an awkward solution.

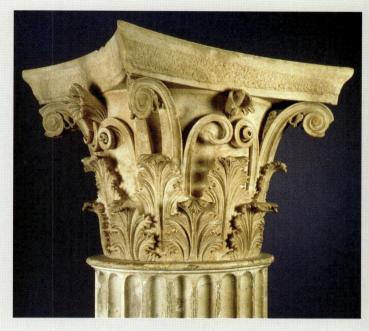

5-73 POLYKLEITOS THE YOUNGER, Corinthian capital, from the tholos, Epidauros, Greece, ca. 350 BCE. Archaeological Museum, Epidauros.

Corinthian capitals, invented by the fifth-century BCE sculptor Kallimachos, are more ornate than Doric and Ionic capitals. They feature a double row of acanthus leaves with tendrils and flowers.

Doric design rules also presented problems for Greek architects at the corners of buildings. Doric friezes had to satisfy three supposedly inflexible rules:

- A triglyph must be exactly over the center of each column.
- A triglyph must be over the center of each intercolumniation (the space between two columns).
- Triglyphs at the corners of the frieze must meet so that no space is left over.

These rules are contradictory, however. If the corner triglyphs must meet, then they cannot be placed over the center of the corner column (FIGS. 5-1, 5-25, and 5-30).

The Corinthian capital eliminated both problems. Because the capital's four sides have a similar appearance, corner Corinthian capitals do not have to be modified, as do corner lonic capitals. And because the Corinthian "order" incorporates an lonic frieze, architects do not have to contend with corner triglyphs.

*Vitruvius, De architectura, 4.1.8-10. Translated by J. J. Pollitt, The Art of Ancient Greece: Sources and Documents (New York: Cambridge University Press, 1990), 193-194.

harmony of its proportions. Although spectators sitting in some of the seats would have had a poor view of the skene, all had unobstructed views of the orchestra. Because of the open-air cavea's excellent acoustics, everyone could hear the actors and chorus.

CORINTHIAN CAPITALS The theater at Epidauros is about 500 yards southeast of the sanctuary of Asklepios, and Polykleitos the Younger worked there as well. He was the architect of the *tholos*, the circular shrine that probably housed the sacred snakes

of the healing god. That building lies in ruins today, but the Greek archaeological service is in the process of reconstructing it. One can get an approximate idea of the Epidauros tholos's original appearance from the somewhat earlier and already partially rebuilt tholos (Fig. 5-72) at Delphi that Theodoros of Phokaia designed. Both tholoi had an exterior colonnade of Doric columns, but the interior columns had molded bases and *Corinthian capitals* (Fig. 5-73; see "The Corinthian Capital," above), an invention of the second half of the fifth century BCE.

5-74 Choragic Monument of Lysikrates, Athens, Greece, 334 BCE.

The first known use of Corinthian capitals on the exterior of a building is on the monument Lysikrates erected in Athens to commemorate the victory his chorus won in a theatrical contest.

Consistent with the extremely conservative nature of Greek temple design, architects did not readily embrace the Corinthian capital. Until the second century BCE, Greek builders used Corinthian capitals only for the interiors of sacred buildings, as at Delphi and Epidauros. The earliest instance of a Corinthian capital on the exterior of a Greek build-

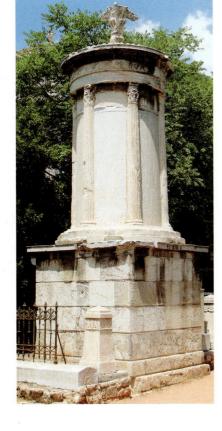

ing is the Choragic Monument of Lysikrates (FIG. 5-74), which is not really a building at all. Lysikrates had sponsored a chorus in a theatrical contest in 334 BCE, and after he won, he erected a monument to commemorate his victory. The monument consists of a cylindrical drum resembling a tholos on a square base. Engaged Corinthian columns adorn the drum of Lysikrates's monument, and a huge Corinthian capital sits atop the roof. The freestanding capital once supported the victor's trophy, a bronze *tripod*, a deep basin on a tall three-legged stand, traditionally associated with Apollo, the patron god of music.

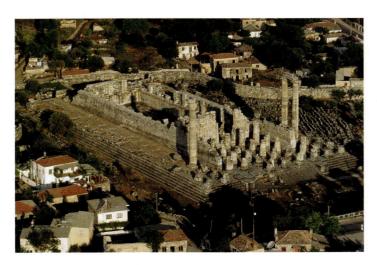

5-75 PAIONIOS OF EPHESOS and DAPHNIS OF MILETOS, aerial view of the Temple of Apollo (looking east), Didyma, Turkey, begun ca. 300 BCE.

A theatrical element of surprise is one of the key features of Didyma's immense Early Hellenistic Ionic Apollo temple—a building project so ambitious that it continued for more than five centuries.

HELLENISTIC PERIOD

Alexander the Great's conquest of Mesopotamia and Egypt ushered in a new cultural age that historians and art historians alike call *Hellenistic*. The Hellenistic period opened with the death of Alexander in 323 BCE and lasted nearly three centuries, until the double suicide of Queen Cleopatra of Egypt and her Roman consort, Mark Antony, in 30 BCE after their decisive defeat at the battle of Actium by Antony's rival Augustus (see page 195). That year, Augustus made Egypt a province of the Roman Empire.

The cultural centers of the Hellenistic period were the court cities of the Greek kings who succeeded Alexander and divided his far-flung empire among themselves. Chief among them were Antioch in Syria, Alexandria in Egypt (named after Alexander, and the site of his tomb), and Pergamon in Asia Minor (MAP 5-1). An international culture united the Hellenistic world, and its language was Greek. Hellenistic kings became enormously rich on the spoils of the East, priding themselves on their libraries, art collections, scientific enterprises, and skills as critics and connoisseurs, as well as on the learned men they could assemble at their courts. The world of the small, austere, and heroic city-state passed away, as did the power and prestige of its center, Athens. A cosmopolitan ("citizen of the world," in Greek) civilization, much like today's, replaced it.

Architecture

The greater variety, complexity, and sophistication of Hellenistic culture called for an architecture on a grandiose scale and of wide diversity, something far beyond the requirements of the Classical polis, even beyond that of Athens at the height of its power. Building activity shifted from the old centers on the Greek mainland to the opulent cities of the Hellenistic monarchs in the East.

TEMPLE OF APOLLO, DIDYMA Great scale, a theatrical element of surprise, and a willingness to break the traditional rules of Greek temple design characterize one of the most ambitious projects of the Hellenistic period, the Temple of Apollo (FIG. **5-75**) at Didyma. The Hellenistic temple replaced the Archaic temple at the site the

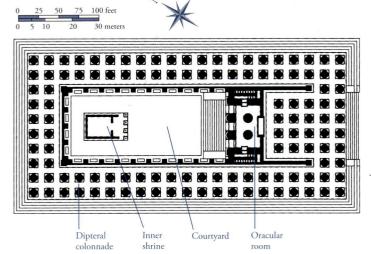

5-76 PAIONIOS OF EPHESOS and DAPHNIS OF MILETOS, plan of the Temple of Apollo, Didyma, Turkey, begun ca. 300 BCE.

Apollo's temple at Didyma was hypaethral (open to the sky) and featured a dipteral (double peripteral) colonnade framing an interior courtyard with a small shrine that housed a statue of Apollo.

PROBLEMS AND SOLUTIONS

Hippodamos's Plan for the Ideal City

When the Greeks finally expelled the Persians from Asia Minor in 479 BCE, they returned to cities in near ruin. Reconstruction of Miletos began after 466 BCE, but the Classical city did not follow the plan of its Archaic predecessor. Hippodamos of Miletos, whom Aristotle singled out as the father of rational city planning, was the designer of the new Miletos as well as the port city of Athens, Piraeus. Hippodamos had to address the problem of what an ideal city plan should be. His solution was to impose a strict grid of streets on the site, regardless of the terrain, so that all streets met at right angles.

Although such *orthogonal plans* predate Hippodamos, and can be found in Archaic Greece and Etruscan Italy as well as in ancient Mesopotamia and Egypt, the Greek city planner became so famous that his name has ever since been synonymous with urban grid plans. The so-called *Hippodamian plan* was not, however, solely a grid of streets.

Hippodamos also designated separate quarters for public, private, and religious functions. A "Hippodamian city" was logically as well as regularly planned. This desire to impose order on nature and to assign a proper place in the whole to each of the city's constituent parts was very much in keeping with the philosophical principles of the fifth century BCE. Hippodamos's formula for the ideal city was another manifestation of the same outlook that produced Polykleitos's *Canon* and the Parthenon.

Hippodamian planning was still the norm in Late Classical and Hellenistic Greece. The city of Priene (Fig. 5-77), also in Asia Minor, was laid out during the fourth century BCE. It had fewer than 5,000 inhabitants. (Hippodamos thought 10,000 was the ideal number. Fifthcentury BCE. Athens had a population of 150,000 to 200,000.) Situated on sloping ground, many of its narrow north-south streets were little more than long stairways. Uniformly sized city blocks, the standard planning unit, were nonetheless imposed on the irregular terrain. More than one unit was reserved for major structures, such as the Temple of Athena and the theater. The central agora occupied six blocks.

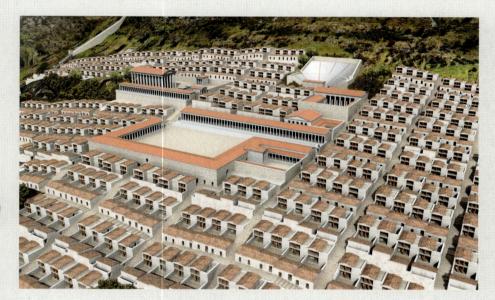

5-77 Restored view of Priene, Turkey, fourth century BCE and later (John Burge).

Despite its irregular terrain, Priene had a strict grid plan conforming to the principles of Hippodamos of Miletos, whom Aristotle singled out as the father of rational city planning.

Persians burned in 494 BCE when they sacked nearby Miletos. Construction began around 300 BCE under the direction of two architects native to the area, PAIONIOS OF EPHESOS and DAPHNIS OF MILETOS. So vast was the undertaking, however, that work on the temple continued off and on for more than 500 years—and still the project was never completed.

The temple was *dipteral* in plan (FIG. **5-76**) and had an unusually broad facade of 10 Ionic columns almost 65 feet tall. The sides had 21 columns, consistent with the Classical formula for perfect proportions used for the Parthenon $(21 = [2 \times 10] + 1)$, but nothing else about the design is Classical. One anomaly immediately apparent to anyone who approached the building was that it had no pediment and no roof—it was *hypaethral*, or open to the sky. Also, the grand doorway to what should have been the temple's cella was nearly 5 feet off the ground and could not be entered. The explanation for the peculiar elevated doorway is that it served as a kind of stage where the oracle of Apollo could be announced to those assembled in front of the temple. Further, the unroofed dipteral colonnade did not surround a traditional cella. The columns were instead an elaborate frame for a central courtyard in which was a small prostyle

shrine with a statue of Apollo inside. Entrance to the interior court was through two smaller doorways to the left and right of the great portal and down two narrow vaulted tunnels that could accommodate only a single file of people. From these dark and mysterious lateral passageways, worshipers emerged into the clear light of the courtyard, which also had a sacred spring and laurel trees in honor of Apollo. Opposite Apollo's inner temple, a stairway some 50 feet wide rose majestically toward three portals leading into the oracular room that also opened onto the front of the temple. This complex spatial planning marked a sharp departure from Classical Greek architecture, which stressed a building's exterior almost as a work of sculpture and left its interior relatively undeveloped.

STOAS AND CITY PLANNING One of the most important—and certainly the most versatile—secular Greek buildings was the *stoa*. These covered colonnades, or *porticos*, which often housed shops and civic offices, were ideal vehicles for shaping urban spaces, and they were staples of Late Classical and Hellenistic cities (see "Hippodamos's Plan for the Ideal City," above). Priene (FIG. **5-77**) had stoas framing each side of its agora, and even the marketplace of

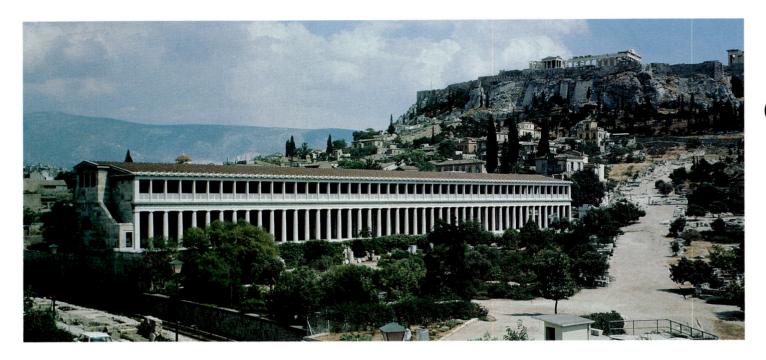

5-78 Stoa of Attalos II (looking southeast with the Acropolis in the background), Agora, Athens, Greece, ca. 150 BCE.

The Stoa of Attalos II in the Athenian agora has been meticulously restored. Greek stoas were covered colonnades that housed shops and civic offices. They were also ideal vehicles for shaping urban spaces.

Athens, an ancient city notable for its haphazard, unplanned development, was eventually framed to the east and south by stoas placed at right angles to one another. These new porticos joined the famous Painted Stoa (see page 140), where the Hellenistic philosopher Zeno and his successors taught. The *Stoic* school of Greek philosophy took its name from that building.

The finest of the new Athenian stoas was the Stoa of Attalos II (FIG. **5-78**), a gift to the city by a grateful alumnus, the king of Pergamon (r. 159–138 BCE), who had studied at Athens in his youth. The stoa was meticulously reconstructed under the direction of the American School of Classical Studies at Athens and today has a second life as a museum housing more than seven decades of finds from

the Athenian agora, as well as the offices of the American excavation team. The stoa has two stories, each with 21 shops opening onto the colonnade. The facade columns are Doric on the ground level and Ionic on the second story. The mixing of the two orders on a single facade had occurred even in the Late Classical period. But it became increasingly common in the Hellenistic period, when respect for the old rules of Greek architecture was greatly diminished and a desire for variety and decorative effects often prevailed. Practical considerations also governed the form of the Stoa of Attalos II. The columns are far more widely spaced than in Greek temple architecture, to enable easy access. Also, the builders left the lower third of every Doric column shaft unfluted to guard against damage from constant traffic.

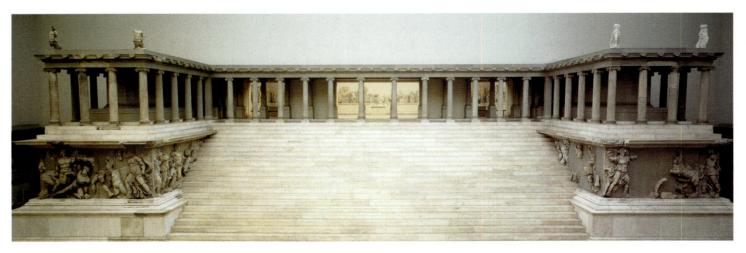

5-79 Reconstructed west front of the Altar of Zeus, Pergamon, Turkey, ca. 175 BCE. Pergamonmuseum, Staatliche Museen zu Berlin, Berlin.

The gigantomachy frieze of Pergamon's monumental Altar of Zeus is almost 400 feet long. The battle of gods and giants alluded to the victory of King Attalos I over the Gauls of Asia Minor.

Pergamon

Pergamon, the kingdom of Attalos II, was born in the early third century BCE after the breakup of Alexander's empire. Founded by Philetairos (r. 282–263 BCE), the Pergamene kingdom embraced almost all of western and southern Asia Minor. Upon the death in 133 BCE of its last king, Attalos III (r. 138–133 BCE), Pergamon was bequeathed to Rome, which by then was the greatest power in the Mediterranean world. The Attalids enjoyed immense wealth and expended much of it on the embellishment of their capital city, especially its acropolis. Located there were the royal palace, an arsenal and barracks, a great library and theater, an agora, and the sacred precincts of Athena and Zeus.

ALTAR OF ZEUS The Altar of Zeus at Pergamon, erected about 175 BCE, is the most famous Hellenistic sculptural ensemble. The monument's west front (FIG. **5-79**) has been reconstructed in Berlin. The altar proper was on an elevated platform, framed by an Ionic stoalike colonnade with projecting wings on either side of a broad central staircase. All around the altar platform was a sculptured frieze almost 400 feet long, populated by about a hundred larger-than-life-size figures. The subject is the battle of Zeus and the gods against the giants. It is the most extensive representation Greek

artists ever attempted of that epic conflict for control of the world. The gigantomachy also appeared on the shield of Phidias's Athena Parthenos and on the east metopes of the Parthenon, because the Athenians wished to draw a parallel between the defeat of the giants and the defeat of the Persians. In the third century BCE, King Attalos I (r. 241-197 BCE) had successfully turned back an invasion of the Gauls in Asia Minor. The gigantomachy of the Altar of Zeus alluded to that Attalid victory over those barbarians. The Pergamene designers also used the gigantomachy frieze to establish a connection with Athens, whose earlier defeat of the Persians was by then legendary, and with the Parthenon, which the Hellenistic Greeks already recognized as a Classical monument-in both senses of the word. The figure of Athena (FIG. 5-80), for example, closely resembles the Athena from the Parthenon's east pediment. While Gaia, the earth goddess and mother of the giants, emerges from the ground and looks on with horror, Athena grabs the hair of the giant Alkyoneos as Nike flies in to crown her. Zeus (not illustrated) derives from the Poseidon of the west pediment.

The Pergamene frieze, however, is not a dry series of borrowed motifs. On the contrary, its tumultuous narrative has an emotional intensity without parallel in earlier sculpture. The battle rages everywhere, even up and down the steps used to reach Zeus's altar (FIG. 5-79). Violent movement, swirling draperies, and vivid

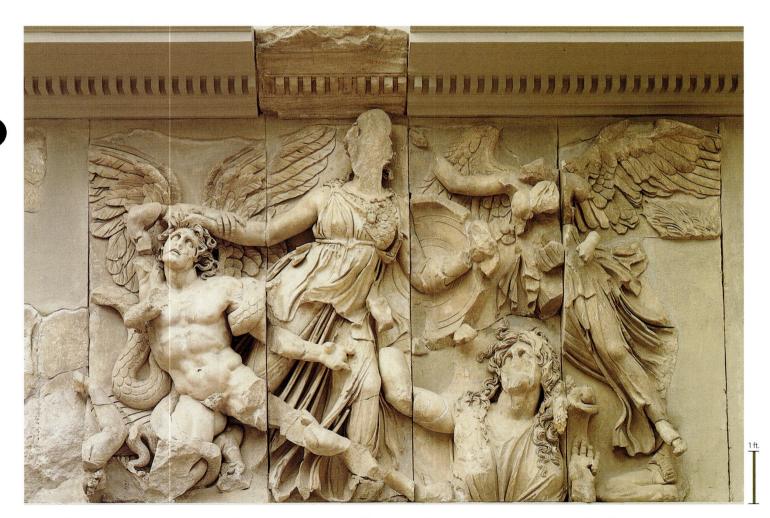

5-80 Athena battling Alkyoneos, detail of the gigantomachy frieze, Altar of Zeus, Pergamon, Turkey, ca. 175 BCE. Marble, 7' 6" high. Pergamonmuseum, Staatliche Museen zu Berlin, Berlin.

The tumultuous battle scenes of the Pergamon altar have an emotional power unparalleled in earlier Greek art. Violent movement, swirling draperies, and vivid depictions of suffering fill the frieze.

5-81 EPIGONOS(?), Gallic chieftain killing himself and his wife. Roman copy of a bronze statue of ca. 230–220 BCE. Marble, 6' 11" high. Palazzo Altemps, Museo Nazionale Romano, Rome.

The defeat of the Gauls was also the subject of Pergamene statuary groups. The centerpiece of one group was a chieftain committing suicide after taking his wife's life. He preferred death to surrender.

depictions of death and suffering fill the frieze. Wounded figures writhe in pain, and their faces reveal their anguish. Deep carving creates dark shadows. The figures project from the background like bursts of light. Art historians have justly described these features as *baroque*, borrowing the term from 17th-century Italian sculpture (see page 703). Indeed, there perhaps can be no greater contrast than between the Pergamene gigantomachy frieze and the comparable frieze (FIG. 5-18) of the Archaic Siphnian Treasury at Delphi.

DYING GAULS On the Altar of Zeus, Pergamene sculptors presented the victory of Attalos I over the Gauls in mythological disguise. An earlier Pergamene statuary group explicitly depicted the defeat of the barbarians. Roman copies of some of these figures show that Hellenistic sculptors carefully studied and reproduced the distinctive features of the foreign Gauls, most notably their long, bushy hair and mustaches and the *torques* (neck bands) they frequently wore. The Pergamene victors were apparently not part of this group. The viewer saw only their Gallic foes and their noble and moving response to defeat.

In what was probably the centerpiece of the group, a heroic Gallic chieftain (FIG. **5-81**) defiantly drives a sword into his own chest just below the collarbone, preferring suicide to surrender. He already has taken the life of his wife, who, if captured, would have been sold as a slave. In the best Lysippan tradition, the group can be fully appreciated only by walking around it. From one side, the observer sees the Gaul's intensely expressive face, from another his

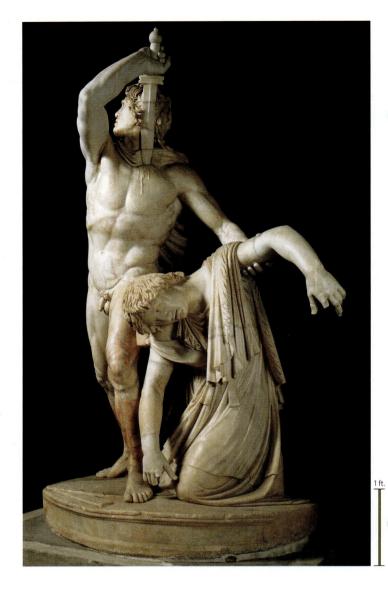

5-82 EPIGONOS(?), Dying Gaul. Roman copy of a bronze statue of ca. 230–220 BCE. Marble, 3' ½" high. Museo Capitolino, Rome.

A Pergamene sculptor depicted this defeated Gallic trumpeter and the other Gauls as barbarians with bushy hair, mustaches, and neck bands, but also as noble foes who fought to the death.

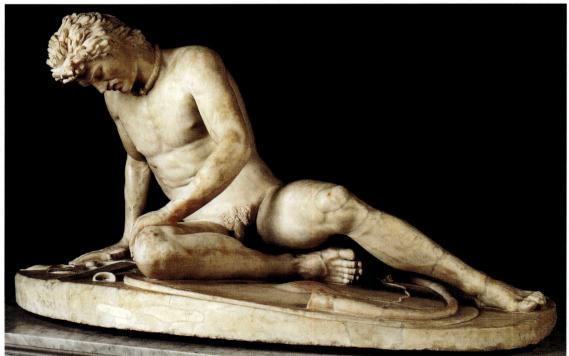

5-83 Nike alighting on a warship (*Nike of Samothrace*), from Samothrace, Greece, ca. 190 BCE. Marble, Nike 8' 1" high. Musée du Louvre, Paris.

Victory lands on a ship's prow to crown a naval victor. Her wings still beat, and the wind sweeps her drapery. The statue's placement in a fountain of splashing water heightened the dramatic visual effect.

powerful torso, and from a third the woman's limp, lifeless body. The man's twisting posture, the almost theatrical gestures, and the emotional intensity of the suicidal act are hallmarks of the Pergamene baroque style and have close parallels in the later frieze of Zeus's altar.

The third Gaul from this group is a trumpeter (FIG. 5-82) who collapses upon his large oval shield as blood pours from the gash in his chest. He stares at the ground with a pained expression. The Hellenistic figure recalls the dying warrior (FIG. 5-29) from the east pediment of the Temple of Aphaia at Aegina, but the pathos and drama of the suffering Gaul are far more pronounced. As in the suicide group and the gigantomachy frieze, the sculptor rendered the male musculature in an exaggerated manner. Note the tautness of the chest and the bulging veins of the left legimplying that the unseen Pergamene warrior who has struck down this noble and savage foe must have been an extraordinarily powerful man. If this figure is the tubicen (trumpeter) Pliny mentioned as the work of the Pergamene master Epigonos,10 then Epigonos may be the sculptor of the entire group and the creator of the dynamic Hellenistic baroque style.

Sculpture

In different ways, Praxiteles, Skopas, and Lysippos had already taken bold steps in redefining the nature of Greek statuary. Still, Hellenistic sculptors went further both in terms of style

sculptors went further, both in terms of style and in expanding the range of subjects considered suitable for large-scale public sculpture.

NIKE OF SAMOTHRACE One of the masterpieces of Hellenistic baroque sculpture is the statue of winged Victory set up in the Sanctuary of the Great Gods on the island of Samothrace. The *Nike of Samothrace* (Fig. **5-83**) has just alighted on the prow of a Greek warship. She raises her (missing) right arm to crown the naval victor, just as Nike places a wreath on Athena's head on the Altar of Zeus (Fig. 5-80). But the Pergamene relief figure seems calm by comparison. The Samothracian Nike's wings still beat, and the wind sweeps her drapery. Her himation bunches in thick folds around her right leg, and her chiton is pulled tightly across her abdomen and left leg.

The statue's setting amplified this theatrical effect. The sculptor set the war galley in the upper basin of a two-tiered fountain. In the lower basin were large boulders. The fountain's flowing water created the illusion of rushing waves hitting the prow of the ship. The statue's reflection in the shimmering water below accentuated the sense of lightness and movement. The sound of splashing water added another dimension to the visual drama. Art and nature combined here to create one of the most successful sculptures ever fashioned. In the *Nike of Samothrace* and other works in the Hellenistic baroque manner, sculptors resoundingly rejected the Polykleitan conception of a statue as an ideally proportioned, self-contained entity on a bare pedestal. The Hellenistic statues interact with their environment and appear as living, breathing, and intensely emotive human (or divine) presences.

5-84 ALEXANDROS OF ANTIOCH-ON-THE-MEANDER, Aphrodite (*Venus de Milo*), from Melos, Greece, ca. 150–125 BCE. Marble, 6' 7" high. Musée du Louvre, Paris.

Displaying the eroticism of many Hellenistic statues, this Aphrodite is more overtly sexual than the Knidian Aphrodite (FIG. 5-62). The goddess's slipping garment teases the spectator.

VENUS DE MILO In the Hellenistic period, sculptors regularly followed Praxiteles's lead in undressing Aphrodite, but they also openly explored the eroticism of the nude female form. The famous *Venus de Milo* (FIG. **5-84**) is a larger-than-life-size marble statue of

Aphrodite found on Melos together with its inscribed base (now lost) signed by the sculptor Alexandros of Antioch-onthe-Meander. In this statue, the goddess of love is more modestly draped than the *Aphrodite of Knidos* (Fig. 5-62) but is more overtly sexual. Her left hand (separately preserved) holds the apple that Paris awarded her when he judged her the most beautiful goddess. Her right hand may have lightly grasped the edge of her drapery near the left hip in a halfhearted attempt to keep it from slipping farther down her body. The sculptor intentionally designed the work to tease the spectator, instilling this partially

5-84A Aphrodite, Eros, and Pan, ca. 100 BCE.

draped Aphrodite with a sexuality absent from Praxiteles's entirely nude image of the goddess. Other Hellenistic sculptors (FIG. **5-84A**), especially when creating works for private patrons, went even further in depicting the goddess of love as an object of sexual desire.

5-85 Sleeping satyr (*Barberini Faun*), from Castel Sant'Angelo, Rome, Italy, ca. 230–200 BCE. Marble, 7' 1" high. Glyptothek, Munich.

Here, a Hellenistic sculptor represented a restlessly sleeping, drunken satyr, a semihuman in a suspended state of consciousness—the antithesis of the Classical ideals of rationality and discipline.

BARBERINI FAUN Archaic statues smile at the viewer, and even when Classical statues look away, they are always awake and alert.

Hellenistic sculptors often portrayed sleep (FIG. 5-84B). The suspension of consciousness and the entrance into the fantasy world of dreamsthe antithesis of the Classical ideals of rationality and discipline-had great appeal for them. This newfound interest is evident in a marble statue (FIG. 5-85) of a drunken, restlessly sleeping satyr (a semihuman follower

★ 5-84B Sleeping Eros, са. 150-100 все.

of Dionysos) known as the Barberini Faun, after Cardinal Francesco Barberini (1597-1679), who acquired the statue when it was unearthed in Rome in the 17th century. Barberini hired Gianlorenzo

Bernini, the great Italian Baroque sculptor (see page 701), to restore the statue. Bernini no doubt felt that this dynamic statue in the Pergamene manner was the work of a kindred spirit. The satyr has consumed too much wine and has thrown down his panther skin on a convenient rock, then fallen into a disturbed, intoxicated sleep. His brows are furrowed, and one can almost hear him snore.

Eroticism also comes to the fore in this statue. Although men had been represented naked in Greek art for hundreds of years, Archaic kouroi and Classical athletes and gods do not exude sexuality. Sensuality surfaced in the works of Praxiteles and his followers in the fourth century BCE. But the dreamy and supremely beautiful Hermes playfully dangling grapes before the infant Dionysos (FIG. 5-63) has nothing of the blatant sexuality of the Barberini Faun, whose wantonly spread legs focus attention on his genitals. Homosexuality was common in the male world of ancient Greece. It is not surprising that

> when Hellenistic sculptors began to explore the sexuality of the human body, they turned their attention to men as well as women. In the Greek world, the "male gaze" was directed at both sexes.

> **DEFEATED BOXER** Although Hellenistic mighty fighter.

> sculptors tackled an expanded range of subjects, they did not abandon traditional themes, such as the Greek athlete. Nevertheless, they often treated the old subjects in novel ways. This is certainly true of the magnificent bronze statue (FIG. 5-86) of a seated boxer, a Hellenistic original found in Rome and perhaps at one time part of a group. The boxer is not a victorious young athlete with a perfect face and body but a heavily battered, defeated veteran whose upward glance may have been directed at the man who had just beaten him. Too many punches from powerful hands wrapped in leather thongs—Greek boxers did not use the modern sport's cushioned gloves—have distorted the boxer's face. His nose is broken, as are his teeth. He has smashed "cauliflower" ears. Inlaid copper blood drips from the cuts on his forehead, nose, and cheeks. How different is this rendition of a powerful bearded man from that of the noble Riace warrior (FIGS. I-17 and 5-36) of the Early Classical period. The Hellenistic sculptor appealed not to the intellect but to the emotions when striving to evoke compassion for the pounded hulk of a once-

> 5-86 Seated boxer, from the Baths of Constantine, Quirinal hill, Rome, Italy, ca. 100-50 BCE. Bronze, 4' 2" high. Palazzo Massimo alle Terme, Museo Nazionale Romano, Rome.

Even when Hellenistic artists treated traditional themes, they approached them in novel ways. This bronze statue depicts an older, defeated boxer with a broken nose and battered ears.

Consistent with the realism of much Hellenistic art, many statues portray the elderly of the lowest rungs of society. Earlier Greek artists did not consider them suitable subjects for statuary.

OLD MARKET WOMAN The realistic bent of much Hellenistic sculpture—the very opposite of the Classical period's idealism—is evident above all in a series of statues of old men and women from the lowest rungs of the social order. Shepherds, fishermen, and drunken beggars are common—the kinds of people pictured earlier on red-figure vases but never before thought worthy of life-size statuary. One of the finest preserved statues of this type depicts a

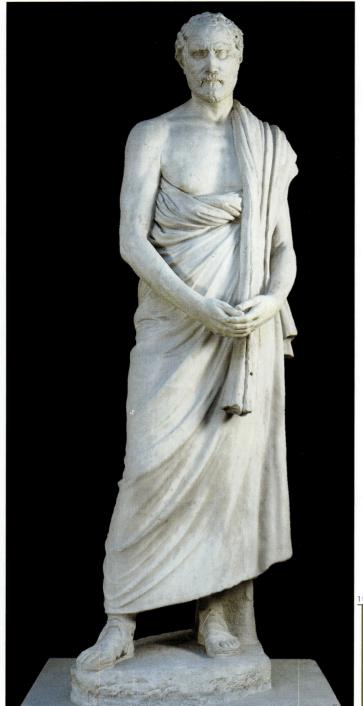

5-88 Polyeuktos, Demosthenes. Roman copy of a bronze original of ca. 280 BCE. Marble, 6' $7\frac{1}{2}$ " high. Ny Carlsberg Glyptotek, Copenhagen.

One of the earliest Hellenistic portraits, frequently copied, was Polyeuktos's representation of the great orator Demosthenes as a frail man who possessed great courage and moral conviction.

haggard old woman (FIG. **5-87**) bringing chickens and a basket of fruits and vegetables to sell in the market or, according to a recent interpretation suggested by the ivy wreath in her hair, bringing gifts to the god Dionysos at one of his festivals. In either case, the woman's face is wrinkled and her body bent with age. Whatever the purpose of this and similar statues, they attest to an interest in social realism absent in earlier Greek statuary.

Statues of the aged and the ugly are, of course, the polar opposites of the images of the young and the beautiful that dominated Greek art until the Hellenistic age, but they are consistent with the period's changed character. The Hellenistic world was a cosmopolitan place, and the highborn could not help but encounter the poor and a growing number of foreigners (non-Greek "barbarians") on a daily basis. Hellenistic art reflects this different social climate in the depiction of a much wider variety of physical types, including different ethnicities. The sensitive portrayal of Gallic warriors with their shaggy hair, strange mustaches, and golden torques (FIGS. 5-81 and 5-82) has already been noted. Africans, Scythians, and others, formerly only the occasional subject of vase painters, also entered the realm of large-scale sculpture in Hellenistic art.

DEMOSTHENES These sculptures of foreigners and the urban poor, however realistic, are not portraits. Rather, they are sensitive studies of physical types. But the growing interest in the individual beginning in the Late Classical period did lead in the Hellenistic era to the production of true likenesses of specific persons. In fact, one of the great achievements of Hellenistic artists was the redefinition of portraiture. In the Classical period, Kresilas won fame for having made the noble Pericles appear even nobler in his portrait (FIG. 5-42). In contrast, in Hellenistic times, sculptors sought not only to record the true appearance of their subjects in bronze and stone but also to capture the essence of their personalities in likenesses both accurate and moving.

One of the earliest of these, perhaps the finest of the Hellenistic age and frequently copied in Roman times, was a bronze portrait statue of Demosthenes (FIG. 5-88) by POLYEUKTOS. The original, commissioned in 280 BCE, 42 years after the great orator's death, stood in the Athenian agora. Demosthenes was a frail man and in his youth even suffered from a speech impediment, but he had enormous courage and great moral conviction. A veteran of the disastrous battle against Philip II at Chaeronea, he repeatedly tried to rally opposition to Macedonian imperialism, both before and after Alexander's death. In the end, when it was clear that the Macedonians would capture him, he took his own life by drinking poison.

Polyeuktos rejected Kresilas's and Lysippos's notions of the purpose of portraiture and did not attempt to portray a supremely confident leader with a magnificent physique. His Demosthenes has an aged and slightly stooped body. The orator clasps his hands nervously in front of him as he looks downward, deep in thought. His face is lined, his hair is receding, and his expression is one of great sadness. Whatever physical discomfort Demosthenes felt is here joined by an inner pain, his deep sorrow over the tragic demise of democracy at the hands of the Macedonian conquerors.

Hellenistic Art under Roman Patronage

In the opening years of the second century BCE, the Roman general Flamininus defeated the Macedonian army and declared the old poleis of Classical Greece free once again. The city-states never

regained their former glory, however. Greece became a Roman province in 146 BCE. When Athens 60 years later sided with King Mithridates VI of Pontus (r. 120–63 BCE) in his war against Rome, the general Sulla crushed the Athenians. Thereafter, although Athens retained some of its earlier prestige as a center of culture and learning, politically it was merely another city in the ever-expanding Roman Empire. Nonetheless, Greek artists continued to be in great demand, both to furnish the Romans with an endless stream of copies of Classical and Hellenistic masterpieces and to create new statues in Greek style for Roman patrons.

LAOCOÖN One work of this type is the famous group (FIG. **5-89**) of the Trojan priest Laocoön and his sons, unearthed in Rome in 1506 in the presence of the great Italian Renaissance artist Michelangelo (see page 623). The marble group, long believed to be an original of the second century BCE, was found in the remains of the palace of the emperor Titus (r. 79–81 CE), exactly

5-89 ATHANADOROS, HAGESANDROS, and POLYDOROS OF RHODES, Laocoön and his sons, from Rome, Italy, early first century CE. Marble, 7' $10\frac{1}{2}''$ high. Musei Vaticani, Rome.

Hellenistic style lived on in Rome. Although stylistically akin to Pergamene sculpture, this statue of sea serpents attacking Laocoön and his two sons matches the account given only in the *Aeneid*.

5-90 Athanadoros, Hagesandros, and Polydoros of Rhodes, head of Odysseus, from the villa of Tiberius, Sperlonga, Italy, early first century CE. Marble, $2' \, 1\frac{1}{4}"$ high. Museo Archeologico, Sperlonga.

This emotionally charged depiction of Odysseus was part of a mythological statuary group that the three Laocoön sculptors made for a grotto at the emperor Tiberius's seaside villa at Sperlonga.

where Pliny had seen it more than 14 centuries before. Pliny attributed the statue to three sculptors—Athanadoros, Hagesandros, and POLYDOROS OF RHODES—who most art historians now think worked in the early first century CE. These artists probably based their group on a Hellenistic masterpiece depicting Laocoön and only one son. Their variation on the original added the son at Laocoön's left (note the greater compositional integration of the other two figures) to conform with the Roman poet Vergil's account in the Aeneid. Vergil vividly described the strangling of Laocoön and his two sons by sea serpents while sacrificing at an altar. The gods who favored the Greeks in the war against Troy had sent the serpents to punish Laocoön, who had tried to warn his compatriots about the danger of bringing the Greeks' wooden horse within the walls of their city.

In Vergil's graphic account, Laocoön suffered in terrible agony. Athanadoros and his colleagues communicated the torment of the priest and his sons in spectacular fashion in the marble group. The three Trojans writhe in pain as they struggle to free themselves from the death grip of the serpents. One bites into

Laocoön's left hip as the priest lets out a ferocious cry. The serpent-entwined figures recall the suffering giants of the great frieze of the Altar of Zeus at Pergamon, and Laocoön himself is strikingly similar to Alkyoneos (FIG. 5-80), Athena's opponent. In fact, many scholars believe that a Pergamene statuary group of the second century BCE was the inspiration for the three Rhodian sculptors.

SPERLONGA That the work seen by Pliny and displayed in the Vatican Museums today was made for Romans rather than Greeks was confirmed in 1957 by the discovery of fragments of several Hellenistic-style groups illustrating scenes from Homer's *Odyssey*. Archaeologists found the sculptures in a grotto that served as the picturesque summer banquet hall of the seaside villa of the Roman emperor Tiberius (r. 14–37 CE) at Sperlonga, some 60 miles south of Rome. One of these groups—depicting the monster Scylla attacking Odysseus's ship—bears the signatures of the same three sculptors Pliny cited as the creators of the Laocoön group. Another group,

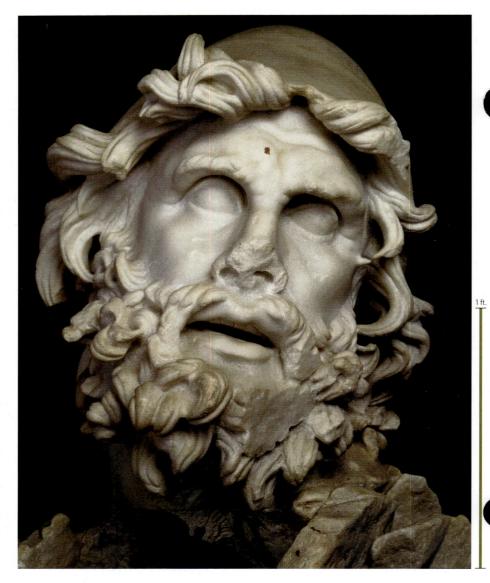

installed around a central pool in the grotto, depicted the blinding of the Cyclops Polyphemos by Odysseus and his comrades, an incident also set in a cave in the Homeric epic. The figure of Odysseus (FIG. **5-90**) from this theatrical group is one of the finest sculptures of antiquity. The hero's cap can barely contain his swirling locks of hair. Even Odysseus's beard seems to be swept up in the emotional intensity of the moment. The parted lips and the deep shadows produced by sharp undercutting add drama to the head, which complemented Odysseus's agitated body.

At Tiberius's villa in Sperlonga and in Titus's palace in Rome, the baroque style of Hellenistic sculpture lived on long after Greece ceased to be a political force. When Rome inherited the Pergamene kingdom from the last of the Attalids in 133 BCE, it also became heir to the Greek artistic legacy. What Rome adopted from Greece it passed on to the medieval and modern worlds. If Greece was peculiarly the inventor of the European spirit, Rome was its propagator and amplifier.

ANCIENT GREECE

Geometric and Orientalizing Art ca. 900-600 BCE

- Homer lived during the eighth century BCE, the era when the city-states of Classical Greece took shape, the Olympic Games were founded (776 BCE), and the Greeks began to trade with their neighbors to both east and west. At the same time, the human figure returned to Greek art in the form of simple silhouettes amid other abstract motifs on Geometric vases and in bronze statuettes.
- Increasing contact with the civilizations of Egypt and Mesopotamia inspired the so-called Orientalizing phase (ca. 700-600 BCE) of Greek art, when Eastern monsters began to appear on black-figure vases.

Geometric krater, ca. 740 BCE

Archaic Art ca. 600-480 BCE

- Around 600 BCE, the first life-size stone statues appeared in Greece. The earliest kouroi emulated the frontal poses of Egyptian statues, but artists depicted the young men nude, the way Greek athletes competed at Olympia. During the course of the sixth century BCE, Greek sculptors refined the proportions and added "Archaic smiles" to the faces of their statues to make them seem more lifelike.
- The Archaic age also brought the construction of the first stone temples with peripteral colonnades and the codification of the Doric and Ionic orders.
- Greek ceramists perfected black-figure painting and then, around 530 BCE, red-figure vase painting, which
 encouraged experimentation with foreshortening.

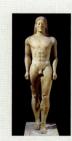

Kroisos, from Anavysos, ca. 530 BCE

Early and High Classical Art ca. 480-400 BCE

- The Classical period opened with the Persian sack of the Athenian Acropolis in 480 BCE and the Greek victory a year later. During the Early Classical period (480-450 BCE), sculptors revolutionized statuary by introducing contrapposto (weight shift) to their figures.
- In the High Classical period (450-400 BCE), Polykleitos developed a canon of proportions for the perfect statue. Iktinos similarly applied mathematical formulas to temple design in the belief that beauty resulted from the use of harmonic numbers.
- Under the patronage of Pericles and the artistic directorship of Phidias, the Athenians rebuilt the Acropolis after 447 BCE. The Parthenon, Phidias's statue of Athena Parthenos, and the works of Polykleitos have defined what it means to be "Classical" ever since.

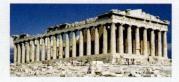

Parthenon, Acropolis, Athens, 447-438 BCE

Late Classical Art ca. 400-323 BCE

- In the aftermath of the Peloponnesian War, which ended in 404 BCE, Greek artists, though still adhering to the philosophy that humans are the "measure of all things," began to focus more on the real world of appearances than on the ideal world of perfect beings. Late Classical sculptors humanized the remote deities, athletes, and heroes of the fifth century BCE. Praxiteles, for example, caused a sensation when he portrayed Aphrodite undressed. Lysippos depicted Herakles as muscle-bound but so weary that he needed to lean on his club for support.
- In architecture, the ornate Corinthian capital became increasingly popular, breaking the monopoly of the Doric and Ionic orders.
- The period closed with Alexander the Great, who transformed the Mediterranean world politically and ushered in a new artistic age as well.

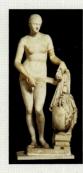

Praxiteles, Aphrodite of Knidos, ca. 350-340 BCE

Hellenistic Art ca. 323-30 BCE

- The Hellenistic age extended from the death of Alexander until the death of Cleopatra, when Egypt became a province of the Roman Empire.
- In art, both architects and sculptors broke most of the rules of Classical design. At Didyma, for example, the Temple of Apollo had no roof and contained a smaller temple within it. Hellenistic sculptors explored new subjects, such as aged, bent women, and Gauls with strange mustaches and necklaces, and treated traditional subjects in new ways—for example, athletes with battered bodies and faces, and openly erotic goddesses. Artists delighted in depicting violent movement and unbridled emotion.

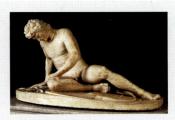

Dying Gaul, ca. 230-220 BCE

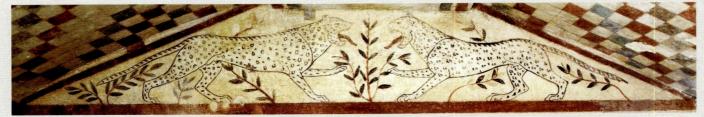

▲ 6-1a The Tomb of the Leopards takes its name from the pair of leopards in the pediment of the rear wall of the burial chamber. They are in the long tradition of guardian figures in gateways, tombs, and temples.

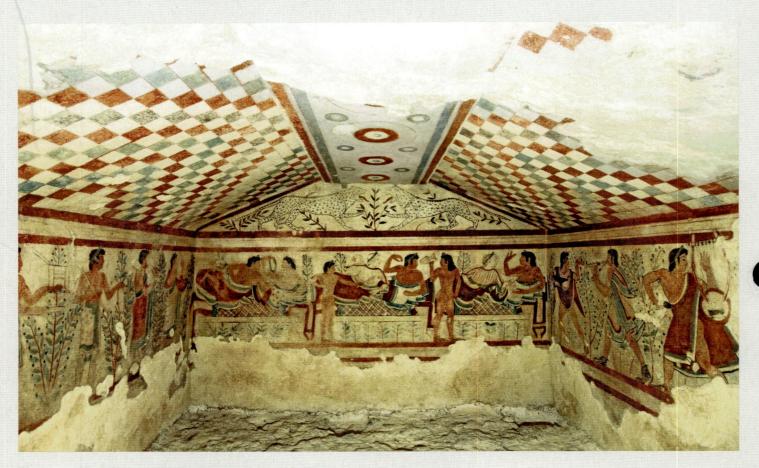

Interior of the Tomb of the Leopards, Monterozzi necropolis, Tarquinia, Italy, ca. 480 BCE.

▶ 6-1b Men (with dark skin) and women (with light skin) dine together at Etruscan banquets, in striking contrast to the all-male Greek symposia. The egg that the man holds is a symbol of regeneration.

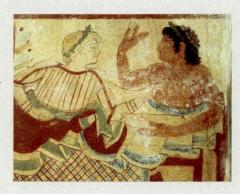

▶ 6-1c The musicians reveal the influence of Greek experiments with foreshortening. This Etruscan lyre player has a frontal chest, but the painter attempted to place a profile eye in his profile head.

The Etruscans

THE PAINTED TOMBS OF TARQUINIA

"The Etruscans, as everyone knows, were the people who occupied the middle of Italy in early Roman days, and whom the Romans, in their usual neighborly fashion, wiped out entirely." So opens D. H. Lawrence's witty and sensitive *Etruscan Places* (1929), one of the earliest modern essays to place a high value on Etruscan art and treat it as much more than a debased form of Greek art. ("Most people despise everything B.C. that isn't Greek, for the good reason that it ought to be Greek if it isn't," Lawrence quipped.) Fortunately, scholars and the public at large soon also came to admire the Etruscans, and it has been a long time since anyone had to argue for the importance and originality of Etruscan art. Indeed, although influenced by Greek art, Etruscan art differs in many fundamental ways.

The Tomb of the Leopards (Fig. 6-1), constructed around 480 BCE, makes that point forcefully. It is one of thousands of underground tombs laboriously carved out of the bedrock at the important Etruscan city of Tarquinia at a time when the Greeks still buried their dead in simple graves with a statue or stele as a commemorative marker. The Etruscan tomb also has fresco paintings on all four walls, an art form virtually unknown in sixth-century BCE Greece. And although the Tarquinian painters adopted many Late Archaic Greek stylistic features, such as the tentative exploration of foreshortening and the attempt to depict profile eyes in the profile heads, the subject they represented is distinctly Etruscan.

The tomb takes its name from the leopards guarding the burial chamber from their perch within the pediment of the rear wall. The confronting felines are reminiscent of the panthers on each side of Medusa in the pediment (FIG. 5-16) of the temple of Artemis at Corfu. But mythological figures, whether Greek or Etruscan, are uncommon in Tarquinian murals, and there are none here. Instead, banqueting couples (unheard of in Greece; see "Etruscan Women," page 167) are the protagonists. The men have dark skin, the women light skin, in conformity with the age-old convention. Unlike Greek banquet scenes, the Tarquinian meal takes place in the open air or perhaps in a tent set up for the occasion. Pitcher- and cup-bearers serve the guests, and musicians entertain them. In characteristic Etruscan fashion, the banqueters, servants, and entertainers all make exaggerated gestures with unnaturally enlarged hands. The man on the couch at the far right on the rear wall holds up an egg, the symbol of regeneration. The tone is joyful, rather than somber. The banqueters do not contemplate death. They celebrate the good life of the privileged Etruscan elite.

ETRURIA AND THE ETRUSCANS

The heartland of the Etruscans (who called themselves Rasenna) was the territory between the Arno and Tiber rivers of central Italy (MAP 6-1). The lush green hills still bear their name—Tuscany, the land of the people the Romans called Etrusci or Tusci, the region centered on Florence. So, too, do the blue waters that splash against the western coastline of the Italian peninsula, for the Greeks referred to the Etruscans as Tyrsenoi or Tyrrhenoi and gave their name to the Tyrrhenian Sea. Both ancient and modern commentators have debated whether the Etruscans were an indigenous people or immigrants. Their language, although written in a Greekderived script, is unrelated to the Indo-European linguistic family and remains largely undeciphered. The fifth-century BCE Greek historian Herodotus claimed that the Etruscans came from Lydia in Asia Minor and that Tyrsenos was their king-hence their Greek name. But Dionysius of Halikarnassos, a first-century BCE Greek historian, maintained that the Etrusci were native Italians. Some modern researchers have theorized that the Etruscans emigrated to Italy from the north.

No doubt some truth exists in each theory. The Etruscans of historical times—the Rasenna—were very likely the result of a gradual fusion of native and immigrant populations. This mixing of peoples occurred in the early first millennium BCE during the so-called Villanovan period, named for an archaeological site near present-day Bologna. At that time—contemporaneous with the Geometric period in Greece (see page 106)—the Etruscans emerged as a people with an art-producing culture related to but distinct from those of other Italic peoples and from the civilizations of Greece and the Orient.

During the eighth and seventh centuries BCE, the Etruscans, as highly skilled seafarers, enriched themselves through trade abroad. By the sixth century BCE, they controlled most of northern and central Italy. Their most powerful cities included Tarquinia, Cerveteri, Vulci, and Veii. These and the other Etruscan cities never united to form a state, however, so it is inaccurate to speak of an Etruscan "nation" or "kingdom," but only of Etruria, the territory the Etruscans occupied. Any semblance of unity among the independent Etruscan cities was based primarily on common linguistic ties and religious beliefs and practices.

EARLY ETRUSCAN ART

Although art historians now universally acknowledge the distinctive character of Etruscan painting, sculpture, and architecture, they still usually divide the history of Etruscan art into periods mirroring those of Greek art. The seventh century BCE is the Orientalizing period of Etruscan art (followed by the Archaic, Classical, and Hellenistic periods).

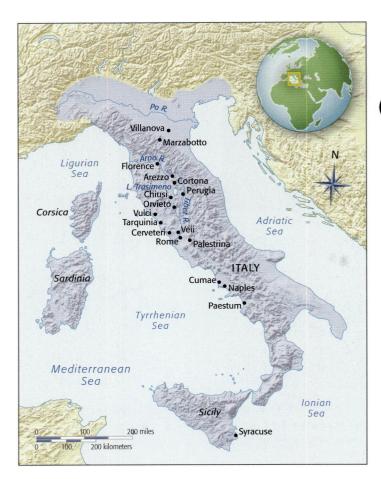

MAP 6-1 Italy in Etruscan times.

Orientalizing Art

During the Orientalizing period, the Etruscans successfully mined iron, tin, copper, and silver, creating great wealth and, in the process, transforming Etruscan society. Villages with agriculture-based economies gave way in the seventh century BCE to prosperous cities engaged in international commerce. Wealthy families could afford to acquire foreign goods, and the Etruscan elite quickly developed a taste for luxury objects incorporating Eastern motifs. To satisfy the demand, local artisans, inspired by imported goods, produced magnificent objects for both homes and tombs. As in Greece at the same time, the locally manufactured Orientalizing artifacts cannot be mistaken for their foreign models.

REGOLINI-GALASSI TOMB About 650–640 BCE, a wealthy Etruscan family in Cerveteri stocked the Regolini-Galassi Tomb (named for its excavators) with bronze cauldrons and gold jewelry produced

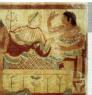

THE ETRUSCANS

700-600 BCE

Orientalizing

- The Etruscans emerge as a distinct artistic culture
- during the Villanovan period (ca. 900-700 BCE)

 During the seventh century BCE, trade with
- Mesopotamia inspires the incorporation of monsters and other Orientalizing motifs in Etruscan funerary goods

600-480 все

Archaic

- The Etruscans construct temples of mud brick and wood, with columns and stairs only on the front and terracotta statuary on the roof
- At Cerveteri, the Etruscans bury their dead beneath huge earthen tumuli in multichambered tombs resembling houses
- Tarquinian tombs feature fresco paintings depicting banquets and funerary games

480-89 BCE

Classical and Hellenistic

- Etruscan artists excel in bronze-casting, engraving mirrors and cistae, and carving stone sarcophagi
- Etruscan architects construct arcuated gateways, often with engaged columns or pilasters framing the arched passageway

6-2 Fibula with Orientalizing lions, from the Regolini-Galassi Tomb, Sorbo necropolis, Cerveteri, Italy, ca. 650–640 BCE. Gold, $1'\frac{1}{2}"$ high. Musei Vaticani, Rome.

This huge gold pin found with other Orientalizing jewelry in a Cerveteri tomb combines repoussé and granulation and is the work of an Etruscan artist, but the lions are Egyptian and Mesopotamian motifs.

in Etruria but of Orientalizing style. The most spectacular of the many luxurious objects found in the tomb is a gold *fibula* (clasp or safety pin; FIG. 6-2) of unique shape used to fasten a woman's gown at the shoulder. The gigantic disk-shaped fibula is in the Italic tradition, but the five lions striding across its surface are motifs originating in the Orient. The technique, also emulating Eastern imports, is masterful, combining repoussé and *granulation* (the fusing of tiny metal balls, or granules, to a metal surface). The

6-3 Model of a typical Etruscan temple of the sixth century BCE, as described by Vitruvius. Istituto di Etruscologia e di Antichità Italiche, Università di Roma, Rome.

Etruscan temples resembled Greek temples but had widely spaced, unfluted wood columns placed only at the front, walls of sun-dried mud brick, and a narrow staircase at the center of the facade.

RELIGION AND MYTHOLOGY

Etruscan Counterparts of Greco-Roman Gods and Heroes

Etruscan	Greek	Roman
Tinia	Zeus	Jupiter
Uni	Hera	Juno
Menrva	Athena	Minerva
Apulu	Apollo	Apollo
Artumes	Artemis	Diana
Hercle	Herakles	Hercules

Regolini-Galassi fibula equals or exceeds in quality anything that might have served as a model.

The jewelry from the Regolini-Galassi Tomb also includes a gold *pectoral* that covered a deceased woman's chest, and two gold circlets that may be earrings, although they are large enough to be bracelets. A taste for this kind of ostentatious display is frequently the hallmark of newly acquired wealth, and this was certainly the case in seventh-century BCE Etruria.

Archaic Art and Architecture

The art and architecture of Greece also impressed Etruscan artists looking eastward for inspiration. Still, however eager those artists may have been to emulate Greek works, their distinctive Etruscan temperament always manifested itself.

ETRUSCAN TEMPLES In religious architecture, for example, the differences between Etruscan temples and their Greek prototypes outweigh the similarities. Because of the materials Etruscan architects employed, usually only the foundations of their temples have survived. These are nonetheless sufficient to reveal the buildings' plans. Supplementing the archaeological record is the Roman architect Vitruvius's treatise on architecture written near the end of the first century BCE (see "Vitruvius's *Ten Books on Architecture*," page 199). In it, Vitruvius provided an invaluable chapter on Etruscan temple design.

Archaeologists have constructed a model (FIG. 6-3) of a typical Archaic Etruscan temple based on Vitruvius's account. The sixthcentury BCE Etruscan temple resembled contemporaneous Greek stone gable-roofed temples, but it had wood columns, a tile-covered timber roof, and walls of sun-dried mud brick. Entrance was possible only via a narrow staircase at the center of the front of the temple, which sat on a high podium, the only part of the building made of stone. The proportions also differed markedly. Greek temples were about twice as long as wide. Vitruvius reported that the typical ratio for Etruscan temples was 6:5. Greek and Etruscan architects also arranged the columns in distinct ways. The columns in Etruscan temples were usually all at the front of the building, creating a deep porch occupying roughly half the podium and setting off one side of the structure as the main side. In contrast, the front and rear of Greek temples were indistinguishable, and builders placed steps and columns on all sides (FIG. 5-12). The Etruscan temple was not meant to be seen as a sculptural mass from all directions, as Greek temples were.

Furthermore, although the columns of Etruscan temples resembled Greek Doric columns (FIG. 5-13, *left*), *Tuscan columns* were made of wood, were unfluted, and had bases. Also, because of the lightness

WRITTEN SOURCES

Etruscan Artists in Rome

In 616 BCE, according to the traditional chronology, Tarquinius Priscus of Tarquinia became Rome's first Etruscan king. He ruled for almost 40 years. His grandson, Tarquinius Superbus ("the Arrogant"), was Rome's last king. Outraged by his tyrannical behavior, the Romans drove him from power in 509 BCE. Before his expulsion, however, Tarquinius Superbus embarked on a grand program to embellish the city.

The king's most ambitious undertaking was the construction on the Capitoline Hill of a magnificent temple, roughly 60 yards long and almost as wide, for the joint worship of Jupiter, Juno, and Minerva. For this grandiose commission, Tarquinius summoned architects, sculptors, and workers from all over Etruria. Rome's first great religious shrine was therefore Etruscan in patronage, manufacture, and form. The architect's name is unknown, but several sources preserve the identity of the Etruscan sculptor brought in to adorn the temple—Vulca of Veii, who may also have made a statue of the god Apulu (FIG. 6-4) for his native city. Pliny the Elder described Vulca's works as "the finest images of deities of that era . . . more admired than gold."* The Romans entrusted Vulca with creating the statue of Jupiter that stood in the central cella (one for each of the three deities) in the Capitoline temple. He also fashioned the enormous terracotta statuary group of Jupiter in a four-horse chariot, which he mounted on the roof at the highest point, directly over the center of the temple facade. The fame of Vulca's red-faced (painted terracotta) portrayal of Jupiter was so great that when Roman generals paraded in triumph through Rome after a battlefield victory, they would paint their faces red in emulation of the ancient statue. (The model of a typical three-cella Etruscan temple in FIG. 6-3 also serves to give an approximate idea of the appearance of the Capitoline Jupiter temple and of Vulca's roof statue.)

Vulca is the only Etruscan artist named in any ancient text, but the signatures of other Etruscan artists appear on extant artworks. One of these is Novios Plautios (Fig. 6-14), who also worked in Rome, although

6-4 Apulu (Apollo of Veii), from the roof of the Portonaccio temple, Veii, Italy, ca. 510–500 BCE. Painted terracotta, 5' 11" high. Museo Nazionale di Villa Giulia, Rome.

This statue of Apulu was part of a group depicting a Greek myth. Distinctly Etruscan, however, are the god's vigorous motion and gesticulating arms and the placement of the statue on a temple roof.

a few centuries later. By then the Etruscan kings of Rome were a distant memory, and the Romans had captured Veii and annexed its territory.

*Pliny, Natural History, 35.157.

of the superstructure, fewer, more widely spaced columns were the rule in Etruscan temples. Unlike their Greek counterparts, Etruscan temples also frequently had three cellas—one for each of their chief gods: Tinia, Uni, and Menrva (see "Etruscan Counterparts of Greco-Roman Gods and Heroes," page 165). Pedimental statuary was also rare in Etruria. The Etruscans normally placed life-size narrative statuary (in terracotta instead of stone) on the roofs of their temples.

APOLLO OF VEII The finest surviving Etruscan temple statue is a life-size image of Apulu (FIG. 6-4), which displays the energy and excitement that characterize Archaic Etruscan art in general. The statue comes from the rooftop of a temple in the Portonaccio sanctuary at Veii. Popularly known as the *Apollo of Veii*, it is but one of a group of at least four painted terracotta figures that adorned the temple's *ridgepole* (the beam running the length of a building beneath the gabled roof). The statues depicted one of the 12 labors of Herakles (see "Herakles," page 124). Apulu confronted Hercle for

6-5 Schematic city plan of Marzabotto, Italy, early fifth century BCE (after Giuseppe Sassatelli).

Marzabotto's plan features blocks of elongated rectangular shape and streets that meet at right angles and run on either a precise north-south or east-west axis. Major streets are almost 50 feet wide.

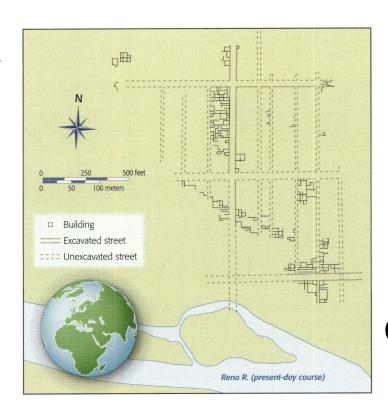

ART AND SOCIETY

The "Audacity" of Etruscan Women

At the instigation of the emperor Augustus at the end of the first century BCE, Titus Livy wrote a history of Rome from its legendary founding in 753 BCE to his own day. In the first book of his great work, Livy recounted the tale of Tullia, daughter of Servius Tullius, an Etruscan king of Rome in the sixth century BCE. The princess had married the less ambitious of two brothers of the royal Tarquinius family, while her sister had married the bolder of the two princes. Together, Tullia and her brother-in-law, Tarquinius Superbus (see "Etruscan Artists in Rome," page 166), arranged for the murder of their spouses. They then married each other and plotted the overthrow and death of Tullia's father. After the king's murder, Tullia ostentatiously drove her carriage over her father's corpse, spraying herself with his blood. (The Romans still call the road where the evil deed occurred the Street of Infamy.) Livy, though condemning Tullia's actions, placed them in the context of the famous "audacity" of Etruscan women.

The independent spirit and relative freedom women enjoyed in Etruscan society similarly horrified (and threatened) other Greco-Roman male authors. The stories the fourth-century BCE Greek historian Theopompus heard about the debauchery of Etruscan women appalled him. Etruscan women personified immorality for Theopompus, but much of what he reported is untrue. Etruscan

women did not, for example, exercise naked alongside Etruscan men. But archaeological evidence confirms the accuracy of at least one of his "slurs": Etruscan women did attend banquets and recline with their husbands on a common couch (FIGS. 6-1 and 6-6). Aristotle also remarked on this custom. It was so foreign to the Greeks that it both shocked and frightened them. Only men, boys, slave girls, and prostitutes attended Greek symposia. The wives remained at home, excluded from most aspects of public life. In Etruscan Italy, in striking contrast to Greece, women also regularly attended sporting events with men. Etruscan paintings and reliefs document this as well.

6-6 Sarcophagus with reclining couple, from the Banditaccia necropolis, Cerveteri, Italy, ca. 520 BCE. Painted terracotta, 3' $9\frac{1}{2}$ " \times 6' 7". Museo Nazionale di Villa Giulia, Rome

Sarcophagi in the form of a husband and wife on a dining couch have no parallels in Greece. The artist's focus on the upper half of the figures and the emphatic gestures are Etruscan hallmarks.

Etruscan inscriptions also reflect the higher status of women in Etruria as compared to Greece. They often give the names of both the father and mother of the person commemorated (for example, the inscribed portrait of Aule Metele, Fig. 6-18), a practice unheard of in Greece (witness the grave stele of "Hegeso, daughter of Proxenos," Fig. 5-57). Etruscan women, moreover, retained their own names (Ramtha Visnai, Fig. 6-15A) and could legally own property independently of their husbands. The frequent use of inscriptions on Etruscan mirrors and other toiletry items (Fig. 6-14) buried with women seems to attest to a high degree of female literacy as well.

possession of the hind of Ceryneia, a wondrous gold-horned beast sacred to the god's sister Artumes. The bright paint and the rippling folds of Apulu's garment call to mind Archaic Greek korai in Ionian garb (FIG. 5-11). But Apulu's vigorous striding motion, gesticulating arms, fanlike calf muscles, rippling drapery, and animated face are distinctly Etruscan. Some scholars have attributed the Apulu statue to Vulca of Veii, the most famous Etruscan sculptor of the time (see "Etruscan Artists in Rome," page 166). The statue's discovery in 1916 was instrumental in prompting a reevaluation of the originality of Etruscan art.

CITY PLANNING Because of the impermanent materials used in their construction, only scant remains of Etruscan civic and domestic buildings exist today. But archaeologists have nonetheless been able to glean important information about the character of Etruscan cities from the excavation of several urban sites, especially Marzabotto, an Etruscan settlement near Bologna.

Marzabotto's city plan (FIG. 6-5) dates to the beginning of the fifth century BCE and predates or is contemporaneous with Hippodamos's rebuilding of Miletos after the Persian sack (see "Hippodamos's Plan for the Ideal City," page 151). Rigorous in its regularity, Marzabotto features blocks of elongated rectangular shape and streets that meet at right angles and run on either a precise north-south or east-west axis. The major thoroughfares are almost 50 feet wide, the minor streets about 15 feet wide. The rationality of this kind of city plan was an outgrowth of the highly developed and codified rules of Etruscan religion—what Roman authors called the disciplina Etrusca, or "Etruscan [religious] practice"—which also prescribed the orientation of temples and the layout of cities.

CERVETERI SARCOPHAGUS Statues in terracotta were not confined to temples and other public structures in Etruria. One of the masterworks of Archaic Etruscan sculpture, a terracotta sarcophagus (FIG. 6-6), comes from a tomb, as do so many other important

PROBLEMS AND SOLUTIONS

Houses of the Dead in a City of the Dead

Many ancient civilizations did not permit families to bury their dead within the boundaries of cities. They strictly separated the city of the living from the cemetery or *necropolis* (Greek, "city of the dead"). The Etruscan solution to the problem of disposing of the remains of their deceased in *extramural* (outside the walls) cities of the dead was to construct tombs that mirrored the layout and furnishings of Etruscan houses of the living. Today, tourists can visit dozens of these "houses of the dead" in the Banditaccia necropolis at Cerveteri.

The Cerveteri tumuli (FIG. 6-7) resemble Mycenaean tholos tombs, such as the Treasury of Atreus (FIG. 4-20). But whereas the Mycenaeans built their tombs with masonry blocks and then covered the burial chambers with an earthen mound, each Etruscan tumulus stood over one or more subterranean multichambered tombs cut out of the dark local limestone called tufa. The largest burial mounds at

Cerveteri are of truly colossal size, exceeding 130 feet in diameter and reaching nearly 50 feet in height. Arranged in an orderly manner along a network of streets spread over 200 acres, the Banditaccia tombs truly constitute a city of the dead.

The aptly named Tomb of the Shields and Chairs (FIGS. 6-8 and 6-8A) is one of the most elaborate in the Banditaccia necropolis. Sculptors carved out of the tufa bedrock six beds and two high-backed chairs with footstools, as well as door frames and ceiling beams, in imitation of the wood furniture and timber architecture of Archaic Etruscan homes. Evidence from other tombs suggests that terracotta figures of the deceased were probably placed on the sculptured chairs. Reliefs of 14 shields adorn the walls. The technique recalls that of rock-cut Egyptian tombs such as Amenemhet's (FIG. 3-19) at Beni Hasan and highlights the very different values of the Etruscans and the Greeks. The Etruscans' temples no longer stand because they constructed them of wood and mud brick, but their grand subterranean tombs are as permanent as the bedrock itself. The Greeks employed stone for the shrines of their gods, but only rarely built monumental tombs for their dead.

6-7 Tumuli in the Banditaccia necropolis, Cerveteri, Italy, seventh to second centuries BCE.

In the Banditaccia necropolis at Cerveteri, the Etruscans buried several generations of families in multichambered rock-cut underground tombs covered by great earthen mounds (tumuli).

Etruscan artworks. Found at Cerveteri, the sarcophagus takes the form of a husband and wife reclining on a banqueting couch. It consists of four separately cast and fired sections, once brightly painted. Although the man and woman on the couch are life-size, the sarcophagus contained only the ashes of the husband or wife, or perhaps both. Cremation was the most common means of disposing of the dead in Archaic Italy. This kind of funerary monument has no parallel at this date in Greece, where there were no tombs big enough to house large sarcophagi. The Greeks buried their dead in simple graves marked by a stele or a statue. Moreover, although banquets were common subjects on Greek vases (which, by the late sixth century BCE, the Etruscans imported in great quantities and regularly deposited in their tombs), only men dined at Greek symposia. The image of a husband and wife sharing the same banqueting couch is uniquely Etruscan (see "The 'Audacity' of Etruscan Women," page 167).

The man and woman on the Cerveteri sarcophagus are as animated as the *Apollo of Veii* (FIG. 6-4), even though they are at rest.

The woman may have held a perfume flask and a pomegranate in her hands, the man an egg (compare FIG. 6-1b). They are the antithesis of the stiff and formal figures encountered in Egyptian funerary sculpture (compare FIGS. 3-13 and 3-13A). Also typically Etruscan, and in sharp contrast to contemporaneous Greek statues with their emphasis on proportion and balance, is the manner in which the Cerveteri sculptor rendered the upper and lower parts of each body. The artist shaped the legs only summarily, and the transition to the torso at the waist is unnatural. The sculptor's interest focused on the upper half of the figures, especially on the vibrant faces and gesticulating arms. The Cerveteri banqueters and the Veii Apulu speak to the viewer in a way that Greek statues of similar date, with their closed contours and calm demeanor, never do.

BANDITACCIA NECROPOLIS The exact findspot of the Cerveteri sarcophagus is unrecorded, but it came from the Banditaccia necropolis, where, beginning in the seventh century BCE, wealthy

6-8 Interior of the Tomb of the Shields and Chairs, Banditaccia necropolis, Cerveteri, Italy, ca. 550–500 BCE.

Terracotta statues of the deceased probably "sat" in the chairs cut out of the bedrock of this subterranean tomb chamber. The tomb's plan (FIG. **6-8A**) follows that of a typical Etruscan house.

6-8A Plan, Tomb of the Shields and Chairs, ca. 550–500 BCE.

Etruscan families constructed enormous tombs (FIG. 6-7) in the form of a mound, or *tumulus* (see "Houses of the Dead in a City of the Dead," page 168). Two of the most elaborate Cerveteri tombs are the Tomb of the Shields and Chairs (FIGs. 6-8 and 6-8A) and the Tomb of the Reliefs (FIG. 6-9), both of which accommodated several generations of a single family. The Etruscans created the elaborate interiors of both tombs by gouging the burial chambers out of the bedrock. In the Tomb of the Reliefs, they covered the sculpted walls and piers with painted stucco reliefs, hence the tomb's modern name. The stools, mirrors, drinking cups, pitchers, and knives effectively suggest a domestic context,

underscoring the connection between Etruscan houses of the dead and those of the living. Other reliefs—for example, the helmet and shields over the main funerary couch (the pillows are also shallow reliefs)—are signs of the elite status of this Cerveteri family. The three-headed dog beneath the same couch is Cerberus, guardian of the gate to the Underworld, a reference to the passage from this life to the next.

TARQUINIA Large underground burial chambers hewn out of the natural rock were also the norm in the Monterozzi necropolis at Tarquinia. Earthen mounds may once have covered the

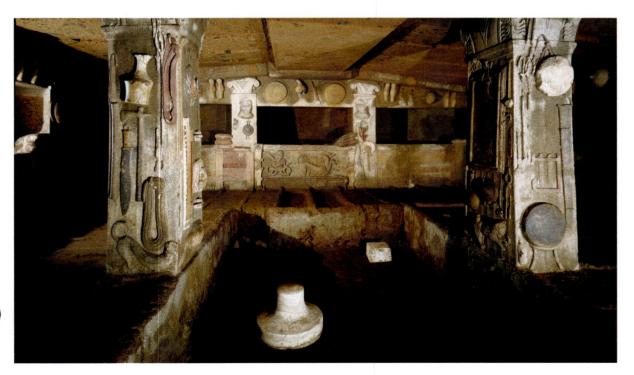

6-9 Interior of the Tomb of the Reliefs, Banditaccia necropolis, Cerveteri, Italy, late fourth or early third century BCE.

The Tomb of the Reliefs takes its name from the painted stucco reliefs covering its walls and piers. The stools, mirrors, drinking cups, and other items are reminders of the houses of the living.

6-10 Interior of the Tomb of the Augurs, Monterozzi necropolis, Tarquinia, ca. 520 BCE.

The murals in this Tarquinian tomb depict the funerary games in honor of the deceased and two gesturing men flanking a large door that is probably the symbolic entrance to the Underworld.

Tarquinian tombs too, but the tumuli no longer exist. In contrast to Cerveteri, the subterranean rooms at Tarquinia lack carvings imitating the appearance of Etruscan houses. In approximately 200 tombs, however, paintings decorate the walls, as in the Tomb of the Leopards (FIG. 6-1). Painted tombs are nonetheless statistically rare, the privilege of only the wealthiest Tarquinian families. Archaeologists have succeeded in locating such a large number of them because they use periscopes

to explore tomb interiors from the surface before considering timeconsuming and costly excavation. Consequently, art historians have an almost unbroken series of mural paintings in Etruria from Archaic to Hellenistic times.

TOMB OF THE AUGURS The Tomb of the Augurs (FIG. 6-10) dates around 520 BCE—that is, it is about a half century older than the Tomb of the Leopards. At the center of the rear wall is a large door, probably the symbolic portal to the Underworld. To either side of it, a man extends one arm toward the door and places one hand against his forehead. Etruscologists have interpreted this double gesture in various ways. It may signify both salute and mourning. At the far end of the right wall is a man in a purple robe (a mark of his elevated stature) and two attendants. One carries a chair, the official seat of the man's high office. The other sleeps, or more likely weeps, crouched on the ground (compare FIG. 5-64). The official is likely the one who has died. The rest of the right wall as well as the left and front walls depict the funerary games in honor of the dead man. To the right of the official and his attendants is a man with a curved staff similar to the lituus of the Roman priests called augurs, hence the modern name of the tomb. Etruscan priests studied the flight patterns of birds to predict the future. But the Etruscan "augur" in this tomb is really an umpire at the wrestling match depicted at the center of the wall. To the right, a masked man labeled phersu (another phersu is at the far end of the left wall) controls a fearsome dog on a leash (not visible in FIG. 6-10). The phersu's leash also entangles and restrains the legs of a club-wielding man. A sack covers his head, rendering him an almost helpless victim of the dog, which has already drawn blood. Some historians regard this gruesome contest as a direct precursor of Roman gladiatorial shows (see "Spectacles in the Colosseum," page 202).

In stylistic terms, the Etruscan figures are comparable to those on sixth-century BCE Greek vases before Late Archaic painters

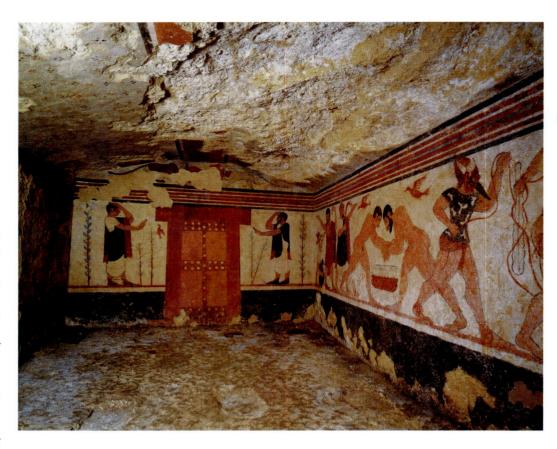

became preoccupied with the problem of foreshortening. Etruscan painters were somewhat backward in this respect, but in other ways they outpaced their counterparts in Greece, especially in their interest in rendering nature. In the Tomb of the Augurs, as in the early fifth-century BCE Tomb of the Leopards and

♂ 6-10A Tomb of the Triclinium, Tarquinia, ca. 480-470 BCE.

Tomb of the Triclinium (FIG. **6-10A**), the "landscape" is but a few trees and shrubs placed between the figures and behind the banqueting couches. But in at least one Tarquinian tomb, the natural environment was the painters' chief interest.

TOMB OF HUNTING AND FISHING In the Tomb of Hunting and Fishing, scenes of Etruscans enjoying the pleasures of nature decorate all the walls of the main chamber. In the detail reproduced here (FIG. 6-11), a youth dives off a rocky promontory, while others fish from a boat. Brightly painted birds fly freely overhead. On another wall, youthful hunters aim their slingshots at the birds. The scenes of hunting and fishing recall the paintings in Egyptian tombs (FIGS. 3-15 and 3-28) and may indicate knowledge of that Eastern funerary tradition. The multicolored rocks evoke those of the Akrotiri Spring Fresco (FIG. 4-9), but art historians know of nothing similar in contemporaneous Greek art save the Tomb of the Diver (FIG. 5-61) at Paestum. That exceptional Greek work, however, is from a Greek tomb in Italy about a half century later than the Tarquinian tomb. In fact, the Paestum painter probably based the diving motif on older Etruscan designs, undermining the outdated art historical judgment that Etruscan art was merely derivative and that Etruscan artists never set the standard for Greek artists.

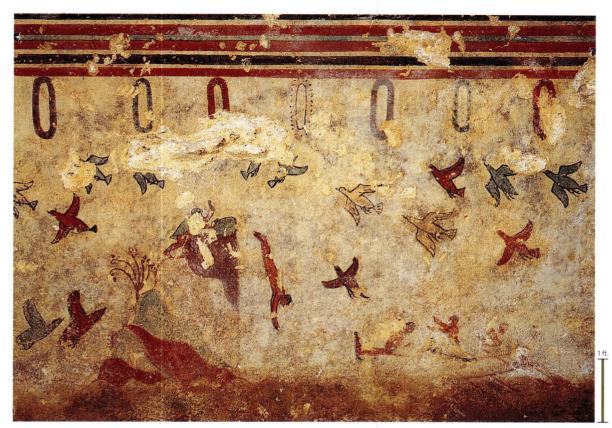

6-11 Diving and fishing, detail of the left wall of the Tomb of Hunting and Fishing, Monterozzi necropolis, Tarquinia, Italy, ca. 530–520 BCE. Fresco, detail 5' $6\frac{1}{2}$ " high.

Scenes of young men enjoying the pleasures of nature cover the walls of this Tarquinian tomb. The Etruscan diving scene predates a similar landscape painting (FIG. 5-61) in a Greek tomb at Paestum.

LATER ETRUSCAN ART

The fifth century BCE was a golden age in Greece, but not in Etruria. In 509 BCE, the Romans expelled the last of their Etruscan kings, Tarquinius Superbus (see "Etruscan Artists in Rome," page 166), and replaced the monarchy with a republican form of government. In 474 BCE, the allied Greek forces of Cumae and Syracuse won a victory over the Etruscan fleet off Cumae, effectively ending Etruscan dominance of the seas—and with it Etruscan prosperity.

Classical Art

These events had important consequences in the world of art and architecture. The number of grandiose Etruscan tombs, for example, decreased sharply, and the quality of the furnishings declined markedly. No longer did the Etruscan elite fill their tombs with gold jewelry and imported Greek vases or decorate the walls with paintings of the first rank. But art did not cease in Etruria. Indeed, in the areas in which Etruscan artists excelled, especially the casting of

statues in bronze and terracotta, they continued to produce impressive works, even though fewer in number.

CAPITOLINE WOLF The best-known Etruscan statue of the Classical period is the *Capitoline Wolf* (FIG. **6-12**), one of the most memorable portrayals of an animal in the history of art. The statue is a somewhat larger than life-size hollow-cast bronze image of the she-wolf that, according to legend, nursed Romulus and Remus after they were abandoned as infants. When the twins grew to adulthood, they quarreled,

6-12 Capitoline Wolf, from Rome, Italy, ca. 500–480 BCE. Bronze, 2' $7\frac{1}{2}$ " high. Palazzo dei Conservatori, Musei Capitolini, Rome.

An Etruscan sculptor cast this bronze statue of the she-wolf that nursed the infants Romulus and Remus, founders of Rome. The animal has a tense, gaunt body and an unforgettable psychic intensity.

6-13 Chimera of Arezzo, from Arezzo, Italy, first half of fourth century BCE. Bronze, 2' $7\frac{1}{2}$ " high. Museo Archeologico Nazionale, Florence.

The chimera was a composite monster, which the Greek hero Bellerophon slew. In this Etruscan statue, the artist depicted the wounded beast poised to attack and growling ferociously.

and Romulus killed his brother. On April 21, 753 BCE, Romulus founded Rome and became the city's king. The statue of the she-wolf seems to have been made for the new Roman Republic after the expulsion of Tarquinius

Superbus. It became the new government's totem. The appropriately defiant image has remained the emblem of Rome to this day.

The Capitoline Wolf is not, however, a work of Roman art, which had not yet developed a distinct identity, nor is it likely a medieval sculpture, as one scholar has argued. It is the product of an Etruscan workshop. (The suckling infants are 15th-century additions.) The sculptor brilliantly characterized the she-wolf physically and psychologically. The body is tense, with spare flanks, gaunt ribs, and taut, powerful legs. The lowered neck and head, alert ears, glaring eyes, and ferocious muzzle capture the psychic intensity of the fierce and protective beast as danger approaches. Not even the magnificent animal reliefs of Assyria (FIG. 2-23) match this profound characterization of animal temperament.

CHIMERA OF AREZZO Another masterpiece of Etruscan bronze-casting is the Late Classical Chimera of Arezzo (FIG. 6-13), found at Arezzo in 1553 and inscribed tinscvil (Etruscan, "gift to [the god] Tinia"), indicating that the chimera was a votive offering in a sanctuary. The chimera is a monster of Greek invention with a lion's head and body and a serpent's tail (restored in this case). A second head, that of a goat, grows out of the lion's left side. The goat's neck bears the wound that the Greek hero Bellerophon inflicted when he hunted and slew the mythical beast. As rendered by the Etruscan sculptor, the chimera, although injured and bleeding, refuses to surrender. Like the earlier Capitoline Wolf, the fourth-century bronze chimera has muscles stretched tightly over its rib cage. The monster prepares to attack, and a ferocious cry emanates from its open jaws. Some scholars have postulated that the statue was part of a group originally including Bellerophon, but the chimera could easily have stood alone. The menacing gaze upward toward an unseen adversary need not have been answered. In this respect, too, the chimera is in the tradition of the Capitoline Wolf.

6-14 Novios Plautios, *Ficoroni Cista*, from Palestrina, Italy, late fourth century BCE. Bronze, 2' 6" high. Museo Nazionale di Villa Giulia, Rome.

Novios Plautios made this container for a woman's toiletry articles in Rome and engraved it with the Greek myth of the Argonauts. The composition is probably an adaptation of a Greek painting.

Hellenistic Art and the Rise of Rome

At about the time an Etruscan sculptor cast the *Chimera of Arezzo*, Rome began to appropriate Etruscan territory. Veii fell to the Romans in 396 BCE after a terrible 10-year siege. The Tarquinians forged a peace treaty with the Romans in 351 BCE, but by the beginning of the next century, Rome had annexed Tarquinia too, and in 273 BCE, the Romans conquered Cerveteri.

FICORONI CISTA An inscription on the *Ficoroni Cista* (FIG. **6-14**) reflects Rome's growing power in central Italy. In the fourth century BCE, Etruscan artists began to produce large numbers of *cistae*

(cylindrical containers for a woman's toiletry articles) made of sheet bronze with cast handles and feet and elaborately engraved bodies. Along with engraved bronze mirrors (FIG. 6-14A), they were popular gifts for both the living and the dead. The *Ficoroni Cista*, found at Palestrina, takes its name from its original owner, Francesco de' Ficoroni. The inscription on the cista's handle states that Dindia Macolnia, a

6-14A Chalchas examining a liver, ca. 400–375 BCE.

local noblewoman, gave the cista (the largest found to date) to her daughter and that the artist was Novios Plautios. According to the inscription, his workshop was not in Palestrina but in Rome, which by this date was becoming an important Italian cultural, as well as political, center.

The engraved frieze of the *Ficoroni Cista* depicts an episode from the Greek story of the expedition of the Argonauts (the crew of the ship *Argo*) in search of the Golden Fleece. Art historians generally agree that the composition is an adaptation of a lost Greek panel painting, perhaps one on display in Rome—another testimony to the growing wealth and prestige of the city that Etruscan kings once ruled. The Greek source for Novios Plautios's engraving is evident in

the figures seen entirely from behind or in three-quarter view and in the placement of the protagonists on several levels in the Polygnotan manner (compare FIG. 5-59).

PORTA MARZIA In the third century BCE, the Etruscans of Perugia formed an alliance with Rome and were spared the destruction that Veii, Cerveteri, and other Etruscan cities suffered. Portions of Perugia's ancient walls still stand, as do some of its gates. One of these, the so-called Porta Marzia (Gate of Mars), was dismantled during the Renaissance, but the upper part of the gate (FIG. 6-15) is preserved, embedded in a later wall. A series of trapezoidal stone *voussoirs* held in place by being pressed against each other (FIG. 6-16) form the *arcuated* (*arch*-shaped) gateway. The central voussoir is called a *keystone*. Arches of similar construction have been documented earlier in Greece as well as in Mesopotamia (FIG. 2-24), but Italy, first under the Etruscans and later under the Romans, is where arcuated gates and freestanding ("triumphal") arches became a major architectural type.

The use of *pilasters* to frame the rounded opening of the Porta Marzia typifies the Etruscan adaptation of Greek motifs. Arches bracketed by *engaged columns* or pilasters have a long and distinguished history in Roman and later times. In the Porta Marzia, sculptured half-figures of Jupiter and his sons Castor and Pollux and their steeds look out from between the fluted pilasters. The divine twins had appeared miraculously on a battlefield in 484 BCE to turn the tide in favor of the Romans. The presence of these three deities above the arched passageway of the Porta Marzia may reflect the new Roman practice of erecting triumphal arches with gilded bronze statues on top.

LARS PULENA In Hellenistic Etruria, the descendants of the magnificent Archaic terracotta sarcophagus (FIG. 6-6) from Cerveteri were coffins of local stone. The leading production center was Tarquinia, and that is where, during the late third or early second century BCE, an Etruscan sculptor carved the sarcophagus

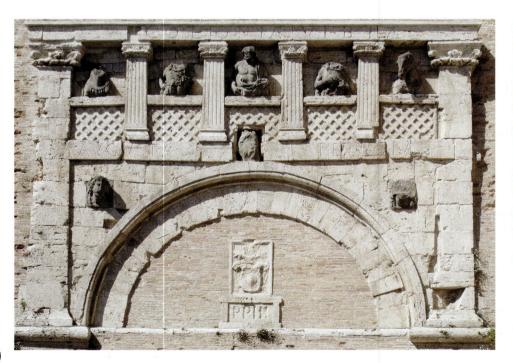

The Porta Marzia was one of the gates in Perugia's walls. The use of fluted pilasters or engaged columns to frame arches typifies Etruscan builders' adaptation of Greek architectural motifs.

6-16 Arch construction (John Burge).

The Etruscans, and later the Romans, often constructed arches, which consist of a series of trapezoidal voussoirs held in place by being pressed against each other. The central voussoir is called a keystone.

6-17 Sarcophagus of Lars Pulena, from Tarquinia, Italy, late third or early second century BCE. Tufa, 6' 6" long. Museo Archeologico Nazionale, Tarquinia.

Images of the deceased on late Etruscan sarcophagi are more somber than those on Archaic examples (FIG. 6-6), but Lars Pulena proudly displays a list of his life's achievements on an open scroll.

(FIG. 6-17) containing the remains of Lars Pulena. The scene sculpted on the front of the coffin shows the deceased in the Underworld between two charuns (Etruscan death demons) swinging hammers. Two vanths (winged female demons) stand to the left and right. The representation signifies that Lars Pulena has successfully made the journey to the afterlife. Above, the deceased reclines on a couch, as do the couple on the Cerveteri sarcophagus and their counterparts in the Tomb of the Leopards and the Tomb of the Triclinium (FIGS. 6-1 and 6-10A), but this Etruscan gentleman is not at a festive banquet, and his wife is not present. The somber expression on his middle-aged face contrasts sharply with the smiling, confident faces of the Archaic era when Etruria enjoyed its greatest prosperity. Similar heads—realistic but generic types, not true portraits-can be found on most later Etruscan sarcophagi (FIG. 6-17A) and in tomb paintings. They are symptomatic of the economic and political decline of the oncemighty Etruscan city-states. Nonetheless, Lars Pulena was a proud man. He wears a fillet on his head and a wreath around his neck, and he displays a partially unfurled scroll inscribed with his name and those of his ancestors as well as a record of his life's accomplishments.

AULE METELE One of the latest extant works produced for an Etruscan patron is the bronze

statue (FIG. 6-18) portraying the magistrate Aule Metele raising his arm to address an assembly-hence his modern nickname Arringatore (Orator). This life-size statue, which dates to the early first century BCE, proves that Etruscan artists continued to be experts at bronze-casting long after the heyday of Etruscan prosperity. The time coincides with the Roman achievement of total domination of Etruria. The so-called Social War ended in 89 BCE with the conferring of Roman citizenship on all of Italy's inhabitants. In fact, Aule Metele—identifiable because the sculptor inscribed the magistrate's Etruscan name and those of his father and mother on the hem of his garment—wears the short toga and high, laced boots of a Roman magistrate. His head, with its close-cropped hair and signs of age in the face, resembles portraits produced in Rome at the same time. This orator is Etruscan in name only. If the origin of the Etruscans remains the subject of debate, the question of their demise has a ready answer. Aule Metele and his compatriots became Roman citizens, and Etruscan art became Roman art.

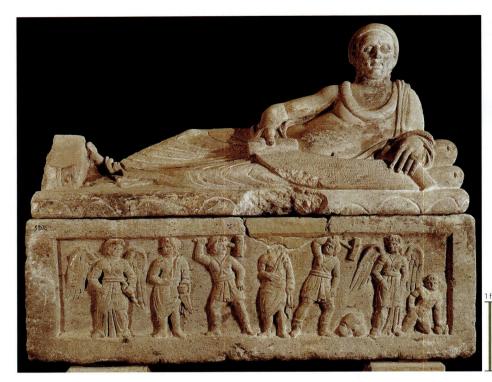

♂ 6-17A Sarcophagus of Ramtha Visnai and Arnth Tetnies, ca. 350-300 BCE.

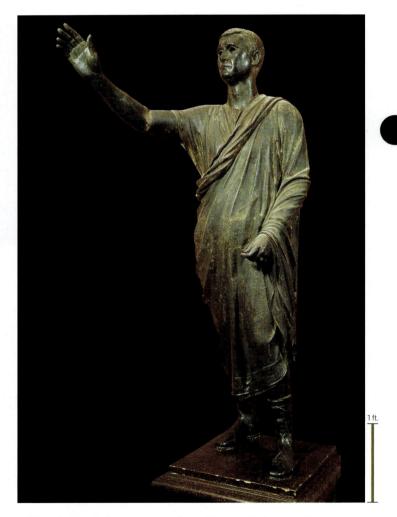

6-18 Aule Metele (*Arringatore*), from Cortona, Italy, early first century BCE. Bronze, 5' 7" high. Museo Archeologico Nazionale, Florence.

This life-size bronze statue portraying Aule Metele is Etruscan in name only. The orator wears the short toga and high boots of a Roman magistrate, and the portrait style is Roman as well.

THE ETRUSCANS

Orientalizing Art ca. 700-600 BCE

- During the Villanovan period of the early first millennium BCE, the Etruscans emerged as a people with
 a culture distinct from those of other Italic peoples and the Greeks. Their language, although written in
 a Greek-derived script, is unrelated to the Indo-European linguistic family.
- In the seventh century BCE, the Etruscans traded metals from their mines for foreign goods and began to produce jewelry and other luxury objects decorated with motifs modeled on those found on imports from Mesopotamia. The Regolini-Galassi Tomb at Cerveteri contained a treasure trove of Orientalizing Etruscan jewelry.

Regolini-Galassi fibula, Cerveteri, ca. 650-640 BCE

Archaic Art ca. 600-480 BCE

- Etruscan power in Italy was strongest during the sixth century BCE. Etruscan kings even ruled Rome until 509 BCE, when the Romans expelled Tarquinius Superbus and established the Roman Republic.
- The Etruscans admired Greek art and architecture, but did not copy Greek works. They constructed their temples of wood and mud brick instead of stone and placed the columns and stairs only at the front. Terracotta statuary decorated the roof.
- Most surviving Etruscan artworks come from underground tomb chambers. In the Banditaccia necropolis at Cerveteri, great earthen mounds (tumuli) covered tombs such as the Tomb of the Shields and Chairs, the sculptured interiors of which imitate the houses of the living.
- At Tarquinia, painters covered the tomb walls with large-scale frescoes, often depicting banquets attended by both men and women, as in the Tomb of the Leopards and the Tomb of the Triclinium. The murals in other tombs depict funerary games and hunting and fishing.

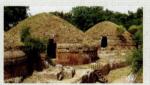

Banditaccia necropolis, Cerveteri, seventh to second centuries BCE

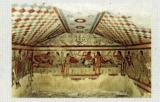

Tomb of the Leopards, Tarquinia, ca. 480 BCE

Classical and Hellenistic Art ca. 480-89 BCE

- The Greek victory over the Etruscan fleet off Cumae in 474 BCE ended Etruscan domination of the sea and marked the beginning of the decline of Etruria.
- Rome destroyed Veii in 396 BCE and conquered Cerveteri in 273 BCE. All of Italy became Romanized by 89 BCE.
- Later Etruscan tombs are not as richly furnished as those of the Archaic period, but Classical and Hellenistic Etruscan sculptors continued to excel in bronze-casting. The Chimera of Arezzo is a Late Classical masterwork.
- A more somber mood characterizes many Late Classical and Hellenistic Etruscan artworks—for example, the sarcophagus of Lars Pulena.
- Later Etruscan architecture is noteworthy for the widespread use of the stone arch, often framed with Greek pilasters or engaged columns, as on the Porta Marzia at Perugia.

Chimera of Arezzo, first half of fourth century BCE

Porta Marzia, Perugia, second century BCE

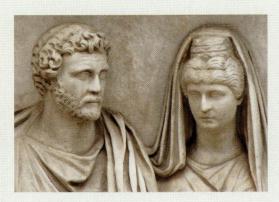

∢ 7-1a On the pedestal of the memorial column erected in his honor, Antoninus Pius ascends to the realm of the gods with his wife, Faustina the Elder. The empress, however, died 20 years before her husband.

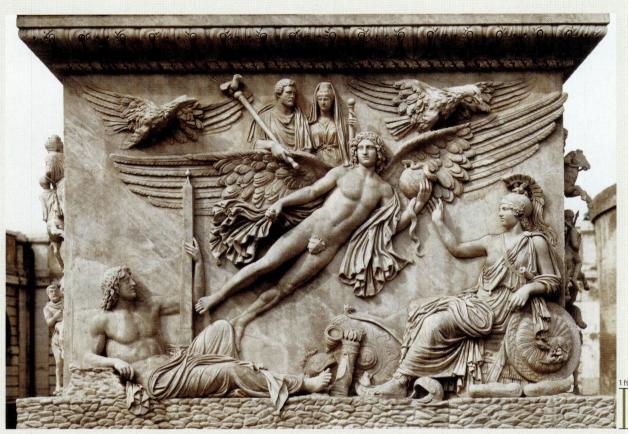

Apotheosis of Antoninus Pius and Faustina, relief on the rear of the pedestal of the Column of Antoninus Pius, Rome, Italy, ca. 161 ce. Marble, 8' $1\frac{1}{2}$ " high. Musei Vaticani, Rome.

▶ 7-1b The setting of Antoninus's apotheosis is the Campus Martius, here personified by a reclining long-haired, seminude young man holding the Egyptian obelisk that was an important local landmark.

∢7-1c Bidding farewell to the emperor and empress is the seated goddess Roma (Rome personified), leaning on a shield decorated with the she-wolf suckling Rome's two founders, Romulus and Remus.

• 7

The Roman Empire

ROMAN ART AS HISTORICAL FICTION

The name "Rome" almost invariably conjures images of power and grandeur, of mighty armies and fearsome gladiators, of marble cities and far-flung roads. Indeed, at the death of the emperor Trajan in 117 CE, the "eternal city" was the capital of the greatest empire the world had ever known. For the first time in history, a single government ruled an empire extending from the Strait of Gibraltar to the Nile, from the Tigris and Euphrates to the Rhine, Danube, Thames, and beyond (MAP 7-1). The Romans presided over prosperous cities and frontier outposts on three continents, ruling virtually all of Europe, North Africa, and West Asia.

No government, before or after, ever used art more effectively as a political tool. Indeed, the Romans were masters at creating pictorial fictions to glorify their emperors and advance their political agendas. For example, after the death of Antoninus Pius (r. 138–161 CE) in 161, the emperor's two adopted sons, Marcus Aurelius (r. 161–180 CE) and Lucius Verus (r. 161–169 CE), erected a memorial column in his honor. Atop the column was a gilded bronze portrait statue of Antoninus. The pedestal had a dedicatory inscription on the front and sculpted reliefs on the other three sides. The relief on the back of the pedestal (Fig. 7-1) represents one of the central themes of Roman imperial ideology—the *apotheosis*, or ascent to Heaven, of the emperor after his death, when he takes his place among the other gods. Empresses could also become goddesses.

The setting of Antoninus's apotheosis is the Campus Martius (Field of Mars) in Rome, here personified by a reclining long-haired, seminude young man holding the Egyptian obelisk that was an important local landmark. Opposite him is the seated goddess Roma (Rome personified), leaning on a shield decorated with the she-wolf suckling Rome's two founders, Romulus and Remus (compare FIG. 6-12). Roma waves farewell to Antoninus and his wife, Faustina the Elder (ca. 100–141 CE), whom a winged youthful male personification of uncertain identity lifts into the realm of the gods. The representation of the apotheosis of Antoninus and Faustina is an example of what art historians generally refer to as "Roman historical reliefs," but there is nothing historical about this scene. Not only is the very notion of apotheosis historical fiction, but this joint apotheosis is doubly so. Faustina died 20 years before Antoninus. By depicting the emperor and empress ascending to Heaven together, the Roman artist wished to suggest not only the divinity of the deceased rulers but also that Antoninus, who by all accounts had been absolutely faithful to his wife before and after her death, would now be reunited with her in the afterlife.

ROME, CAPUT MUNDI

The Roman Empire was unlike any other ancient civilization. Within its borders lived millions of people of numerous races, religions, languages, and cultures: Britons and Gauls, Greeks and Egyptians, Africans and Syrians, Jews and Christians, to name but a few. Of all early cultures, the Roman most closely approximated today's world in its multicultural character.

Roman monuments of art and architecture are the most conspicuous and numerous remains of antiquity worldwide. In Europe, the Middle East, and Africa today, Roman temples and basilicas have an afterlife as churches. The powerful concrete vaults of ancient Roman buildings form the cores of modern houses, stores, restaurants, factories, and museums. Bullfights, sports events, operas, and rock concerts are staged in Roman amphitheaters. Ships dock in what were once Roman ports, and Western Europe's highway system still closely follows the routes of Roman roads. Ancient Rome also lives on in the Western world in concepts of law and government, in languages, in the calendar—even in the coins used daily.

The art of the ancient Romans speaks a language almost every Western viewer today can readily understand. Indeed, the diversity and complexity of Roman art foreshadowed the art of the modern world. The Roman use of art, especially portraits and narrative reliefs, to manipulate public opinion is similar to the carefully crafted imagery of contemporary political campaigns (see "Roman Art as Historical Fiction," page 177). And the Roman mastery of concrete construction began an architectural revolution still felt

The center of the far-flung Roman Empire was the city on the Tiber River that, according to legend, Romulus and his twin brother, Remus, founded on April 21, 753 BCE. Hundreds of years later, it would become the caput mundi, the "head [capital] of the world,"

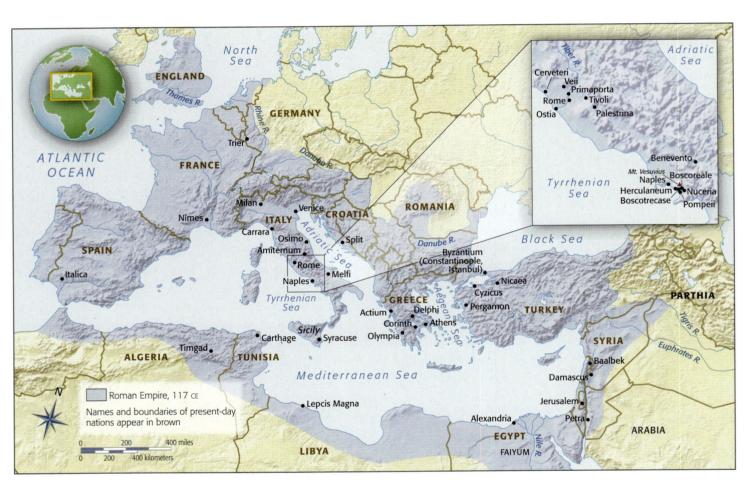

MAP 7-1 The Roman Empire at the death of Trajan in 117 CE.

THE ROMAN EMPIRE

753-27 BCE

Monarchy and Republic

- Republican architects mix Hellenistic and Etruscan features
- Republican sculptors depict patricians in superrealistic portraits
- Republican painters decorate walls in the First and Second Styles

27 BCE-14 CE

Augustus

- Augustan artists and architects revive the Classical style
- Augustan painters introduce the Third Style of Pompeian painting

Julio-Claudians and Flavians

- Neronian and Flavian architects realize the full potential of concrete
- Neronian painters develop the Fourth Style of Pompeian painting

96-192 CE

High Empire

- Trajan extends the Empire and builds a new forum in Rome
- Hadrian builds the Pantheon
- Domination of the Classical style erodes under the Antonines

192-337 CE

Late Empire

- Late Antique style takes root under the Severans
- Portraits of soldier emperors reveal the insecurity of the age
- Constantine founds a New Rome at Constantinople

ART AND SOCIETY

Who's Who in the Roman World

MONARCHY (753-509 BCE)

Latin and Etruscan kings ruled Rome from the city's founding by Romulus and Remus until the revolt against Tarquinius Superbus (exact dates of rule unreliable).

REPUBLIC (509-27 BCE)

The Republic lasted from the expulsion of Tarquinius Superbus until the bestowing of the title of Augustus on Octavian, the grandnephew of Julius Caesar and victor over Mark Antony in the civil war that ended the Republic. Some major figures are

- Marcellus, b. 268(?), d. 208 BCE; consul
- Marius, b. 157, d. 86 BCE; consul
- Sulla, b. 138, d. 79 BCE; consul and dictator
- Pompey, b. 106, d. 48 BCE; consul (FIG. 7-9A)
- Julius Caesar, b. 100, d. 44 BCE; consul and dictator (FIG. 7-10)
- Mark Antony, b. 83, d. 30 BCE; consul

EARLY EMPIRE (27 BCE-96 CE)

The Early Empire began with the rule of Augustus and his Julio-Claudian successors and continued until the end of the Flavian dynasty. Selected emperors and their dates of rule (with names of the most influential empresses in parentheses) are

- Augustus (Livia), r. 27 BCE-14 ce (FIGS. 7-27 and 7-28)
- Tiberius, r. 14-37
- Caligula, r. 37-41
- Claudius (Agrippina the Younger), r. 41-54

but in the eighth century BCE, Rome consisted only of small huts clustered together on the Palatine Hill overlooking what was then uninhabited marshland. In the Archaic period, Rome was essentially an Etruscan city, both politically and culturally. Its first great shrine, the Temple of Jupiter *Optimus Maximus* (Best and Greatest) on the Capitoline Hill, was built by an Etruscan king, designed by an Etruscan architect, made of wood and mud brick in the Etruscan manner, and decorated with terracotta statuary fashioned by an Etruscan sculptor (see "Etruscan Artists in Rome," page 166).

REPUBLIC

In 509 BCE, the Romans overthrew Tarquinius Superbus, the last of Rome's Etruscan kings, and established a constitutional government. The new Roman Republic vested power mainly in a *senate* (literally, "a council of elders," *senior* citizens) and in two elected *consuls* (see "Who's Who in the Roman World," above). Under extraordinary circumstances, a *dictator* could be appointed for a limited time and specific purpose, such as commanding the army during a crisis. All leaders came originally from among the wealthy landowners, or *patricians*, but later also from the *plebeian* class of small farmers, merchants, and freed slaves.

Before long, the descendants of Romulus conquered Rome's neighbors one by one: the Etruscans and the Gauls to the north,

- Nero, r. 54-68
- Vespasian, r. 69-79 (FIG. 7-38)
- Titus, r. 79–81 (FIGS. 7-40A and 7-42)
- Domitian, r. 81-96

HIGH EMPIRE (96-192 CE)

The High Empire began with the rule of Nerva and the Spanish emperors, Trajan and Hadrian, and ended with the last emperor of the Antonine dynasty. The emperors (and empresses) of this period are

- Nerva, r. 96-98
- Trajan (Plotina), r. 98-117 (FIG. 7-45B)
- Hadrian (Sabina), r. 117-138 (FIG. 7-48)
- Antoninus Pius (Faustina the Elder), r. 138–161 (FIG. 7-1)
- Marcus Aurelius (Faustina the Younger), r. 161-180 (Fig. 7-57)
- Lucius Verus, coemperor with Marcus Aurelius, r. 161-169
- Commodus, r. 180–192 (FIG. 7-57A)

LATE EMPIRE (193-337 CE)

The Late Empire began with the Severan dynasty and included the so-called soldier emperors of the third century; the tetrarchs; and Constantine, the first Christian emperor. Emperors (and empresses) discussed in this chapter are

- Septimius Severus (Julia Domna), r. 193–211 (FIGS. 7-61 and 7-63)
- Caracalla (Plautilla), r. 211–217 (FIGS. 7-62 and 7-62A)
- Severus Alexander, r. 222–235
- Philip the Arabian, r. 244-249 (FIG. 7-66A)
- Trajan Decius, r. 249–251 (Fig. 7-66)
- Trebonianus Gallus, r. 251–253 (Fig. 7-67)
- Diocletian, r. 284-305 (FIG. 7-71)
- Constantine I, r. 306–337 (FIGS. 7-74 and 7-75)

the Samnites and the Greek colonists to the south. Even the Carthaginians of North Africa, who under Hannibal's dynamic leadership had destroyed some of Rome's legions and almost brought down the Republic, fell before the mighty Roman armies.

Architecture

The year 211 BCE was a turning point both for Rome and for Roman art. Breaking with precedent, Marcellus, conqueror of the fabulously wealthy Sicilian Greek city of Syracuse, brought back to Rome not only the usual spoils of war—captured arms and armor, gold and silver coins, and the like—but also the city's artistic patrimony. Thus began, in the words of the historian Livy, "the craze for works of Greek art."

Exposure to Greek sculpture and painting and to the splendid marble temples of the Greek gods increased as the Romans expanded their conquests beyond Italy. Greece became a Roman province in 146 BCE, and in 133 BCE the last king of Pergamon willed his kingdom to Rome (see page 153).

Nevertheless, although the Romans developed a virtually insatiable taste for Greek "antiques," the influence of Etruscan art and architecture persisted. The artists and architects of the Roman Republic drew on both Greek and Etruscan traditions for their paintings, sculptures, and buildings.

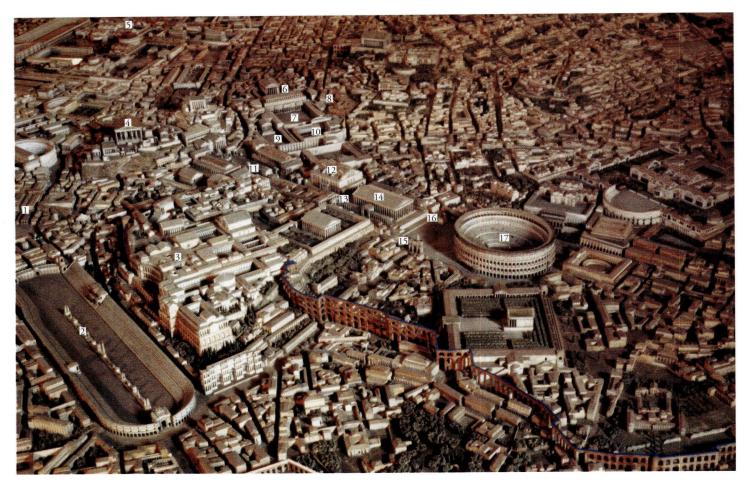

7-2 Model of the city of Rome during the early fourth century CE. Museo della Civiltà Romana, Rome. (1) Temple of Portunus, (2) Circus Maximus, (3) Palatine Hill, (4) Temple of Jupiter Capitolinus, (5) Pantheon, (6) Column of Trajan, (7) Forum of Trajan, (8) Markets of Trajan, (9) Forum of Julius Caesar, (10) Forum of Augustus, (11) Forum Romanum, (12) Basilica Nova, (13) Arch of Titus, (14) Temple of Venus and Roma, (15) Arch of Constantine, (16) Colossus of Nero, (17) Colosseum.

By the time of Constantine, the city of Rome was densely packed with temples, fora, triumphal arches, theaters, baths, racetracks, aqueducts, markets, private homes, and apartment houses.

TEMPLE OF PORTUNUS The mixing of Greek and Etruscan forms is the primary characteristic of the Republican-era Temple of Portunus (FIGS. 7-2, no. 1, and 7-3), the Roman god of harbors, on the east bank of the Tiber River in Rome. Its plan follows the Etruscan pattern with a high podium and a flight of steps only at the front (FIG. 6-3). As in Etruscan temples, the only freestanding columns are in the deep porch, but the temple's ratio of length to width is closer to that of Greek temples. The Portunus temple is also built of stone (local tufa and travertine), overlaid originally with stucco in imitation of Greek marble. The columns are not Tuscan but Ionic, complete with flutes and bases, and there is a matching Ionic frieze. Moreover, in an effort to approximate a peripteral Greek temple yet maintain the basic Etruscan plan, the architect added a series of engaged Ionic half columns to the sides and back of the cella. The result was a pseudoperipteral temple. Although the design combines Etruscan and Greek elements, the resultant mix is distinctively Roman.

7-3 Temple of Portunus (looking south, after restoration, 2013), Rome, Italy, ca. 75 BCE.

Republican temples combined Etruscan plans and Greek elevations. This pseudoperipteral stone temple employs the lonic order, but it has a staircase and freestanding columns only at the front.

7-4 Temple of Vesta (looking north), Tivoli, Italy, early first century BCE.

The round temple type is unknown in Etruria. The models for the Tivoli temple's builders were Greek tholoi (FIG. 5-72), but the Roman building has a frontal orientation and a concrete cella.

TEMPLE OF VESTA The Romans' admiration for the Greek temples they encountered in their conquests also led to the importation into Republican Italy of a temple type unknown in Etruscan architecture—the round, or *tholos*, temple.

At Tivoli, east of Rome, on a dramatic site overlooking a deep gorge, a Republican architect erected a Greek-inspired round temple (FIG. **7-4**) early in the first century BCE. The circular plan is standard for shrines of Vesta, and she was probably the deity honored here. The temple has travertine Corinthian columns and a frieze carved with garlands held up by ox heads, also in emulation of Greek models. But the high podium can be reached only via a narrow stairway leading to the cella door. This arrangement introduced an axial alignment not found in Greek tholoi (FIG. 5-72), where, as in Greek rectangular temples, steps continue all around the structure. Also in contrast with the Greeks, the Roman builders did not construct the cella wall using masonry blocks. Instead, they used a new material of recent invention: *concrete*.

SANCTUARY OF FORTUNA The most impressive and innovative use of concrete during the Republic was in the Sanctuary of Fortuna Primigenia (FIG. **7-5**), the goddess of good fortune, at Palestrina, southeast of Rome. Spread out over several terraces leading up the hillside to a tholos at the peak of an ascending triangle, the layout reflects the new Republican familiarity with the terraced sanctuaries

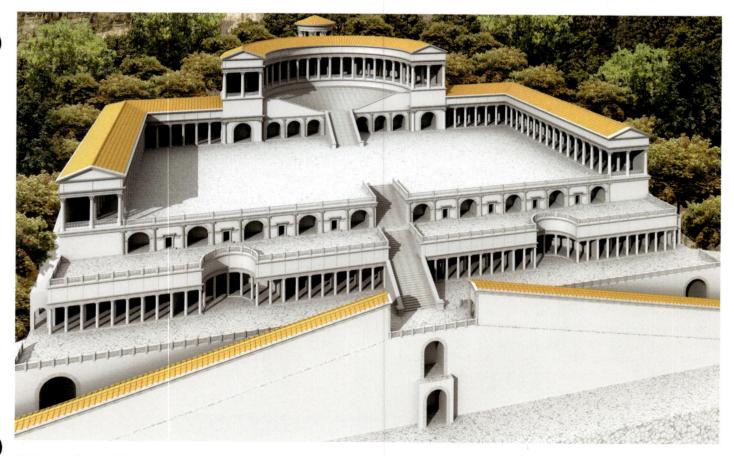

7-5 Restored view of the Sanctuary of Fortuna Primigenia, Palestrina, Italy, late second century BCE (John Burge).

Concrete construction made possible Fortuna's hillside sanctuary at Palestrina with its terraces, ramps, shops, and porticos spread out over several levels. A tholos temple crowned the complex.

ARCHITECTURAL BASICS

Roman Concrete Construction

The history of Roman architecture would be very different had the Romans been content to use the same building materials that the Greeks, Etruscans, and other ancient peoples did. Instead, the Romans developed concrete construction, which revolutionized architectural design. Roman builders mixed concrete according to a changing recipe of lime mortar, volcanic sand, water, and small stones (caementa, from which the English word cement derives). After mixing the concrete, the builders poured it into wood frames and left it to dry. When the concrete hardened completely, they removed the wood molds, revealing a solid mass of great strength, though rough in appearance. The Romans often covered the coarse concrete surfaces with stucco or with marble revetment (facing). Despite this lengthy procedure, concrete walls were much less costly to construct than walls of imported Greek marble or even local tufa and travertine.

The advantages of concrete went well beyond cost, however. It was possible to fashion concrete shapes unachievable in masonry construction, especially huge vaulted and domed rooms without internal supports. The new medium became a vehicle for shaping architectural space and enabled Roman architects to design buildings in revolutionary ways.

The most common types of Roman concrete vaults and domes are

■ Barrel Vaults Also called the tunnel vault, the barrel vault (FIG. 7-6a) is an extension of a simple arch, creating a semicylindrical ceiling over parallel walls. Pre-Roman builders constructed barrel vaults using traditional ashlar masonry (FIG. 2-24), but those earlier vaults were less stable than concrete barrel vaults. As with arches (FIG. 6-16), if even a single block of a cut-stone vault comes loose, the whole vault may collapse. Also, masonry barrel vaults can be illuminated only by light entering at either end of the tunnel. Using concrete, Roman builders could place windows at any point in a barrel vault, because once the concrete hardened, it formed a seamless sheet of "artificial stone" in which the openings do not lessen the vault's structural integrity. Whether made of stone or concrete, barrel vaults require

buttressing (lateral support) of the walls below the vaults to counteract their downward and outward thrust.

■ **Groin Vaults** A groin (or cross) vault (FIG. 7-6b) is formed by the intersection at right angles of two barrel vaults of equal size. Besides appearing lighter than the barrel vault, the groin vault needs less buttressing. Whereas the barrel vault's thrust is continuous along the entire length of the supporting wall, the groin vault's thrust is concentrated along the groins, the lines at the juncture of the two barrel vaults. Buttressing is needed only at the points where the groins meet the vault's vertical supports, usually piers. The system leaves the area between the piers open, enabling light to enter. Builders can construct groin vaults as well as barrel vaults using stone blocks, but stone groin vaults have the same structural limitations as stone barrel vaults do compared to their concrete counterparts.

When a series of groin vaults covers an interior hall (FIG. 7-6c; compare FIG. 7-47), the open lateral arches of the vaults form the equivalent of a *clerestory* of a traditional timber-roofed structure (for example, FIGS. 8-18 and 8-23). A *fenestrated* (with openings or windows) sequence of groin vaults has a major advantage over a timber clerestory: concrete vaults are relatively fireproof, always an important consideration because throughout history fires have been common occurrences (see "Timber Roofs and Stone Vaults," page 345).

Wernispherical Domes The largest domed space in the ancient world for more than a millennium was the corbeled, beehive-shaped tholos (FIG. 4-21) of the Treasury of Atreus at Mycenae. The Romans were able to surpass the Mycenaeans by using concrete to construct hemispherical domes (FIG. 7-6d), which usually rested on concrete cylindrical drums. If a barrel vault is a round arch extended in a line, then a hemispherical dome is a round arch rotated around the full circumference of a circle. Masonry domes, like masonry vaults, cannot accommodate windows without threat to their stability. Concrete domes, in contrast, can be opened up even at their apex with a circular oculus ("eye"), enabling light to reach the vast spaces beneath (FIGS. 7-35 and 7-51).

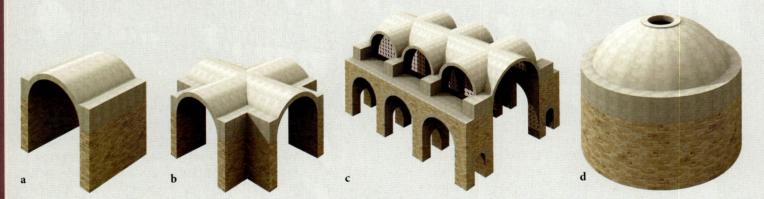

7-6 Roman concrete construction. (a) barrel vault, (b) groin vault, (c) fenestrated sequence of groin vaults, (d) hemispherical dome with oculus (John Burge).

Concrete domes and vaults of varying designs enabled Roman builders to revolutionize the history of architecture by shaping spaces in novel ways.

ART AND SOCIETY

Roman Ancestor Portraits

In Republican Rome, ancestor portraits separated the old patrician families not only from the plebeian middle and lower classes of working citizens and former slaves but also from the newly wealthy and powerful of more modest origins. The case of Marius, a renowned Republican general who lacked a long and distinguished genealogy, is instructive. When his patrician colleagues in the Senate ridiculed him as a man who had no *imagines* (portrait masks) in his home, he defended himself by saying that his battle scars were his masks, the proof of his nobility.

Patrician pride in genealogy was unquestionably the motivation for a unique portrait statue (FIG. 7-7), datable to the late first century BCE, in which a man wearing a toga, the badge of Roman citizenship, holds in each hand a bust of one of his male forebears. The head of the man is ancient, but unfortunately does not belong to this statue. The two heads he holds, which are probably likenesses of his father and grandfather, are characteristic examples of Republican portraiture of the first century BCE (compare FIG. 7-8). The heads may be reproductions of wax or terracotta portraits. Marble or bronze heads would have been too heavy to support with one hand. They are not, however, wax *imagines*, because they are sculptures in the round, not masks. The statue nonetheless would have had the same effect on the observer as the spectacle of parading ancestral portraits at a patrician funeral.

Polybius, a Greek author who wrote a history of Rome in the middle of the second century BCE, described these patrician funerals in detail:

For whenever one of the leading men amongst [the Romans] dies ... they place a likeness of the dead man in the most public part of the house [the atrium; Fig. 7-15, no. 2], keeping it in a small wooden shrine. The likeness is a mask especially made for a close resemblance. . . . And whenever a leading member of the family dies, they introduce [the wax masks] into the funeral procession, putting them on men who seem most like them in height and as regards the rest of their general appearance. . . . It is not easy for an ambitious and high-minded young man to see a finer spectacle than this. For who would not be won over at the sight of all the masks together of those men who had been extolled for virtue as if they were alive and breathing?*

*Polybius, History of Rome, 6.5. Translated by Harriet I. Fowler, Ancestor Masks and Aristocratic Power in Roman Culture (Oxford: Clarendon Press, 1996), 309.

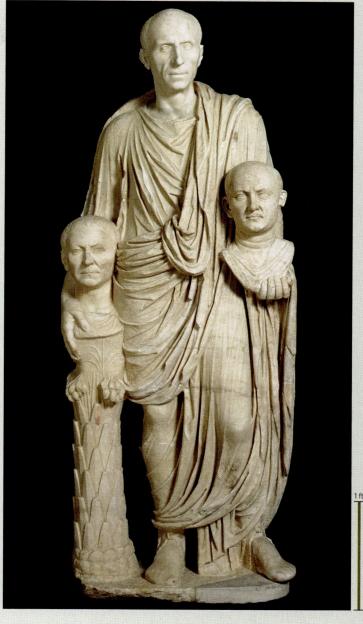

7-7 Man with portrait busts of his ancestors, from Rome, Italy, late first century BCE. Marble, 5' 5" high. Centro Montemartini, Musei Capitolini, Rome.

Reflecting the importance that patricians placed on genealogy, this toga-clad man proudly displays the portrait busts of his father and grandfather. Both are characteristically realistic likenesses.

of the Hellenistic East. The construction method, however, was distinctly Roman.

The builders used concrete *barrel vaults* (see "Roman Concrete Construction," page 182, and FIG. **7-6a**) of enormous strength to support the imposing terraces and to cover the great ramps leading to the grand central staircase, as well as to give shape to the shops aligned on two levels that sold food and souvenirs to those who came to the festivals in honor of the goddess. In this way, Roman engineers transformed the entire hillside, subjecting nature itself to human will and rational order.

Sculpture

The patrons of Republican temples and sanctuaries were in almost all cases men from old and distinguished families. Often they were victorious generals who used the spoils of war to finance public works. These aristocratic patricians were fiercely proud of their lineage. They kept likenesses of their ancestors in wood cupboards in their homes and paraded them at the funerals of prominent relatives (see "Roman Ancestor Portraits," above, and Fig. **7-7**). Portraiture was one way the patrician class celebrated its elevated position in society.

7-8 Head of an old man, from Osimo, Italy, mid-first century BCE. Marble, life-size. Palazzo del Municipio, Osimo.

Veristic (superrealistic) portraits of old men from distinguished families were the norm during the Republic. The sculptor of this head painstakingly recorded every detail of the elderly man's face.

VERISM The subjects of these portraits were almost exclusively men (and, to a lesser extent, women) of advanced age, for generally only elders held power in the Republic. These patricians did not ask sculptors to make them appear nobler than they were, as Kresilas portrayed Pericles (FIG. 5-42). Instead, they requested images memorializing their distinctive features, in the tradition of the treasured household *imagines*.

One of the most striking of these so-called *veristic* (superrealistic) portraits is the head (FIG. **7-8**) of an unidentified patrician from Osimo. The sculptor painstakingly recorded each rise and fall, each bulge and fold, of the facial surface, like a mapmaker who did not want to miss the slightest detail of surface change. Scholars debate whether Republican veristic portraits were truly blunt records of individual features or exaggerated types designed to make a statement about personality: serious, experienced, determined, loyal to family and state—the most admired virtues during the Republic.

TIVOLI GENERAL The Osimo head (FIG. 7-8) illustrates that the Romans believed that the head or bust alone (FIGS. 7-7 and 7-11) was enough to constitute a portrait. The Greeks, in contrast, believed that head and body were inseparable parts of an integral whole, so their portraits were always full length (FIG. 5-88), although Roman copies often reproduced only the head (FIG. 5-42). In fact, Republican sculptors often placed veristic heads on bodies to which they could not possibly belong, as in the seminude portrait statue (FIG. **7-9**) from Tivoli representing a Republican general. The *cuirass* (leather breastplate) at his side, which acts as a prop for the heavy marble statue, is the emblem of his rank. But the general does not appear as

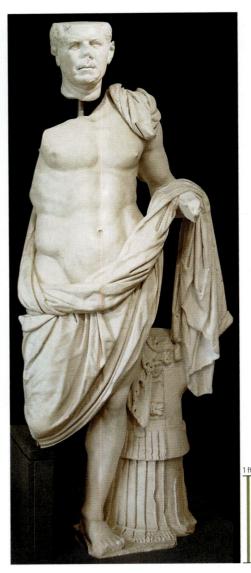

7-9 Portrait of a Roman general, from the Sanctuary of Hercules, Tivoli, Italy, ca. 75–50 BCE. Marble, 6' 2" high. Palazzo Massimo alle Terme, Museo Nazionale Romano, Rome.

The sculptor based this life-size portrait of a general on idealized Greek statues of heroes and athletes, but the man's head is a veristic likeness. The combination is typical of Republican portraiture.

he would in life. Although he has a typically Republican stern and lined face, the head sits atop a powerful youthful body. The sculptor modeled the portrait on the statues of Greek athletes and heroes the Romans admired so much and often copied. The incorporation of references to Greek art in these portrait statues evoked the notion of patrician cultural superiority. To be portrayed nude also suggested that the person possessed a heroic character.

To modern eyes, the juxtaposition of a veristic head and an idealized body may seem incongruous and discordant, but the purpose of the portrait was to characterize different aspects of the man portrayed—and the sculptor succeeded admirably.

JULIUS CAESAR Beginning early in the first century BCE, the Roman desire to advertise distinguished ancestry led to the placement of portraits of illustrious forebears on Republican coins. These ancestral portraits supplanted the earlier Roman tradition (based on Greek convention) of using images of divinities on coins. No Roman, however, not even Pompey "the Great" (FIG. 7-9A), who likened himself to Alexander the Great, dared to place his own likeness on a coin until 44 BCE, when Julius

7-9A Pompey the Great, ca. 55-50 BCE.

Caesar, shortly before his assassination on the Ides of March, issued coins featuring his portrait and his newly acquired title, *dictator*

7-10 Denarius with portrait of Julius Caesar, 44 BCE. Silver, diameter $\frac{3}{4}$ ". American Numismatic Society, New York.

Julius Caesar was the first to place his own portrait on Roman coinage during his lifetime. This denarius, issued just before his assassination, shows the dictator with a deeply lined face and neck.

perpetuo ("dictator for life"). The denarius (the standard Roman silver coin, from which the word penny ultimately derives) illustrated here (FIG. **7-10**) records Caesar's aging face and receding hairline in conformity with the Republican veristic tradition. But placing the likeness of a living person on a coin violated all the norms of Republican propriety. Henceforth, Roman coins, which circulated throughout the vast territories under Roman control, would be used to mold public opinion in favor of the ruler by announcing his achievements—both real and fictional (see "Roman Art as Historical Fiction," page 177).

NON-ELITE PORTRAITURE In stark contrast to patricians, who traditionally displayed portraits of themselves and their ancestors in homes and public places, slaves and former slaves could not possess any family portraits, because, under Roman law, their parents and

grandparents were not people but property. Freed slaves, however, often ordered portrait (FIG. 7-11) and narrative (FIG. 7-11A) reliefs for their tombs to commemorate their new status as Roman citizens (see "Art for Former Slaves," below).

7-11A Funerary procession, Amiternum, ca. 50-1 BCE.

ART AND SOCIETY

Art for Former Slaves

Historians and art historians alike tend to focus on the lives and monuments of famous individuals, but some of the most interesting remains of ancient Roman civilization are the artworks that ordinary people commissioned, especially former slaves—freedmen and freedwomen. Slavery was common in the Roman world. Indeed, at the end of the Republic, there were approximately two million slaves in Italy—roughly one slave for every three citizens. The very rich might own hundreds of slaves, but slaves could also be found in all but the poorest households. The practice was so much a part of Roman society that even slaves often became slave owners when their former masters freed them. Some gained freedom in return for meritorious service, others as bequests in their masters' wills. Most slaves died as slaves in service to their original or new owners.

The most noteworthy artworks that Roman freedmen and freedwomen commissioned are the stone reliefs that regularly adorned their tomb facades. One of these reliefs (FIG. 7-11) depicts two men and a woman, all named Gessius. At the left is Gessia Fausta and at the

right, Gessius Primus. Both are the freed slaves of Publius Gessius, the freeborn citizen in the center, shown wearing a general's cuirass and portrayed in the standard Republican superrealistic fashion (FIGS. 7-7 and 7-8). As slaves, this couple had no legal standing. They were the property of Publius Gessius. According to Roman law, however, after gaining freedom the ex-slaves became people. These stern frontal portraits proclaim their new status as members of Roman society—and their gratitude to Publius Gessius for granting them their freedom.

As was the custom, the ex-slaves bear their patron's name. Therefore, whether they are sister and brother, wife and husband, or unrelated is unclear. The inscriptions on the relief, however, explicitly state that Gessius Primus provided the funds for the monument in his will and that Gessia Fausta, the only survivor of the three, directed the work. The relief thus depicts the living and the dead side by side, indistinguishable without the accompanying inscriptions. This theme is common in Roman art and proclaims that death does not break the bonds formed in life and that families will be reunited in the afterlife, as the emperor Antoninus Pius expected to join his wife, Faustina, among the gods after his death (see "Roman Art as Historical Fiction," page 177, and FIG. 7-1).

7-11 Funerary relief with portraits of the Gessii, from Rome(?), Italy, ca. 30 BCE. Marble, 2' 1½" high. Museum of Fine Arts, Boston.

Roman freedmen often placed reliefs depicting themselves and their former owners on the facades of their tombs. The portraits and inscriptions celebrated their freedom and new status as citizens.

WRITTEN SOURCES

An Eyewitness Account of the Eruption of Mount Vesuvius

One of the world's most famous archaeological sites is Pompeii, which owes its preservation today to the devastating volcanic eruption of Mount Vesuvius in August 79 ce. The Oscans, one of the many early Italic population groups, were the first to settle at Pompeii, but toward the end of the fifth century BCE, the Samnites took over the town. Under the influence of their Greek neighbors, the Samnites greatly expanded the original settlement and gave monumental shape to the city center (FIG. 7-12). Pompeii fought with other Italian cities on the losing side against Rome in the so-called Social War (from the Latin word for "allies"-socii) that ended in 89 BCE, and in 80 BCE the Roman consul Sulla founded a new Roman colony on the site, with Latin as its official language. The colony's population had grown to between 10,000 and 15,000 when, in February 62 CE, an earthquake shook the city, causing extensive damage. Vesuvius erupted 17 years later, bringing an end to the life of the city and all its inhabitants who did not flee in time.

Pliny the Elder, whose *Natural History* is one of the most important sources for the history of Greek art, was among those who tried to rescue others from danger when Vesuvius erupted. Overcome by the volcano's fumes, he died. His nephew, Pliny the Younger (ca. 61—ca. 112 cE), a government official under the emperor Trajan, left an account of the eruption and his uncle's demise:

[The volcanic cloud's] general appearance can best be expressed as being like a pine . . . for it rose to a great height on a sort of trunk and then split off into branches. . . . Sometimes it looked white, sometimes blotched and dirty, according to the amount of soil and ashes it carried with it. . . . The buildings were now shaking with

7-12 Aerial view of the forum (looking northeast), Pompeii, Italy, second century BCE and later. (1) forum, (2) Temple of Jupiter (Capitolium), (3) basilica.

Before the Vesuvian eruption, the forum was the center of civic life at Pompeii. At the north end was the city's main temple, the Capitolium, and at the southwest corner, the basilica (law court).

violent shocks, and seemed to be swaying to and fro as if they were torn from their foundations. Outside, on the other hand, there was the danger of falling pumice-stones, even though these were light and porous. . . . Elsewhere there was daylight, [but around Vesuvius, people] were still in darkness, blacker and denser than any night that ever was. . . . When daylight returned on the 26th—two days after the last day [my uncle] had been seen—his body was found intact and uninjured, still fully clothed and looking more like sleep than death.*

*Betty Radice, trans., *Pliny the Younger: Letters and Panegyricus*, vol. 1 (Cambridge, Mass.: Harvard University Press, 1969), 427-433.

POMPEII AND THE CITIES OF VESUVIUS

On August 24, 79 CE, Mount Vesuvius, a long-dormant volcano, suddenly erupted (see "An Eyewitness Account of the Eruption of Mount Vesuvius," above). Many prosperous towns around the Bay of Naples (the ancient Greek city of Neapolis), among them Pompeii, were buried in a single day. The eruption was a catastrophe for the inhabitants of the Vesuvian cities, but a boon for archaeologists and art historians. When researchers first systematically explored the buried cities in the 18th century, the ruins had lain largely undisturbed for nearly 1,700 years, enabling a reconstruction of the art and life of Roman towns of the Late Republic and Early Empire to a degree impossible anywhere else.

Architecture

Walking through Pompeii today is an unforgettable experience. The streets, with their heavy flagstone pavements and sidewalks, are still there, as are the stepping-stones pedestrians used to cross the streets

without having to step in puddles. Ingeniously, the city planners placed these stones in such a way that vehicle wheels could straddle them, enabling supplies to be brought directly to the shops, taverns, and bakeries. Tourists still can visit the impressive concrete-vaulted rooms of Pompeii's public baths, sit in the seats of its theater and amphitheater, enter private homes with statue-filled gardens and dining- and bedrooms with elaborate frescoes, even walk among the tombs outside the city's walls. Pompeii has been called the living city of the dead for good reason.

FORUM The center of civic life in any Roman town was its *forum*, or public square. Usually located at the city's geographical center at the intersection of the main north-south street, the *cardo*, and the main east-west avenue, the *decumanus*, as at Timgad (FIG. 7-43), the forum was nevertheless generally closed to all but pedestrian traffic. Pompeii's forum (FIG. **7-12**, no. 1) lies in the southwest corner of the expanded Roman city but at the heart of the original town. The forum probably took on monumental form in the second century BCE when the Samnites, inspired by Hellenistic architecture, erected

two-story colonnades on three sides of the long and narrow plaza. At the north end, they constructed a temple of Jupiter (FIG. 7-12, no. 2). When Pompeii became a Roman colony in 80 BCE, the Romans converted the temple into a *Capitolium*—a triple shrine of Jupiter, Juno, and Minerva, the chief Roman gods. The temple is of standard Republican type, constructed of tufa covered with fine white stucco and combining an Etruscan plan with Corinthian columns. It faces into the civic square, dominating the area. This contrasts with the siting of Greek temples (FIGS. 5-43 and 5-44), which stood in isolation and could be approached and viewed from all sides, like colossal statues on giant stepped pedestals. The Roman forum, like the Etrusco-Roman temple, had a chief side, a focus of attention.

The area within the porticos of the forum at Pompeii was empty, except for statues portraying local dignitaries and, later, Roman emperors. This is where the citizens conducted daily commerce and held festivities. All around the square, behind the colonnades, were secular and religious structures, including the town's administrative offices. Most important was the *basilica* (FIG. 7-12, no. 3) at the southwest corner. It is the earliest well-preserved building of its kind. Constructed during the late second century BCE, the basilica was Pompeii's law court and chief administrative building. In plan it resembled the forum itself: long and narrow, with two stories of internal columns dividing the space into a central *nave* and flanking *aisles*. This scheme had a long afterlife in architectural history and will be familiar to anyone who has ever entered a church (compare, for example, FIG. 8-18, *top*).

AMPHITHEATER Shortly after the Romans took control of Pompeii, two of the town's officials, Quinctius Valgus and Marcus Porcius, used their own funds (a common expectation of wealthy magistrates) to erect a large amphitheater (FIG. **7-13**) at the southeastern end of town. The earliest amphitheater known, it could seat

some 20,000 spectators—more than the entire population of the town even a century and a half after its construction. The donors would have had choice reserved seats in the new entertainment center. In fact, seating was by civic and military rank. The Roman social hierarchy was therefore on display at every event.

The word amphitheater means "double theater," and Roman amphitheaters resemble two Greek theaters put together. Amphitheaters nonetheless stand in sharp contrast, both architecturally and functionally, to Greco-Roman theaters, where actors performed comedies and tragedies. Amphitheaters were where the Romans staged bloody gladiatorial combats and wild animal hunts (see "Spectacles in the Colosseum," page 202). Greek theaters were always on natural hillsides (FIG. 5-71), but supporting an amphitheater's continuous elliptical cavea (seating area) required building an artificial mountain. Only concrete, unknown to the Greeks, could easily meet that challenge. In the Pompeii amphitheater, shallow concrete barrel vaults form a giant retaining wall holding up the earthen mound and stone seats. Barrel vaults running all the way through the elliptical mountain of earth form the tunnels leading to the arena, the central area where the violent contests took place. (Arena is Latin for "sand," which soaked up the blood of the wounded and killed.)

A painting (FIG. **7-14**) found in one of Pompeii's houses records a brawl that occurred in the amphitheater during a gladiatorial contest in 59 CE. The fighting—between the Pompeians and their neighbors, the Nucerians—left many seriously wounded and led to the closing of the amphitheater for a decade. The painting shows the cloth awning (*velarium*) that could be rolled down from the top of the cavea to shield spectators from sun and rain. Also featured are the distinctive external double staircases (FIG. 7-13, *lower right*) that enabled large numbers of people to enter and exit the cavea in an orderly fashion.

7-13 Aerial view of the amphitheater (looking southeast), Pompeii, Italy, ca. $70~{\rm BCE}$.

Pompeii's amphitheater is the oldest known and an early example of Roman concrete technology. In the arena, bloody gladiatorial combats and wild animal hunts took place before 20,000 spectators.

7-14 Brawl in the Pompeii amphitheater, wall painting from House I,3,23, Pompeii, Italy, ca. 60–79 CE. Fresco, 5' $7'' \times 6'$ 1". Museo Archeologico Nazionale, Naples.

This wall painting records a brawl that broke out in the Pompeii amphitheater in 59 ce. The painter included the awning (velarium) that could be rolled down to shield the spectators from sun and rain.

ART AND SOCIETY

The Roman House

The Roman house (Fig. **7-15**) was not only a place to live. It played an important role in societal rituals. In the Roman world, individuals were frequently bound to others in a patron-client relationship whereby a wealthier, better-educated, and more powerful patronus would protect the interests of a cliens, sometimes large numbers of them. The size of a patron's clientele was one measure of his standing in society. Being seen in public accompanied by a crowd of clients was a badge of honor. In this system, a plebeian might be bound to a patrician, a freed slave to a former owner, or even one patrician to another. Regardless of rank, all clients were obligated to support their patron in political campaigns and to perform specific services on request, as well as to call on and salute the patron at the patron's home.

A client calling on a patron would enter the typical Roman domus ("private house") through a narrow foyer (fauces, the "jaws" of the house), which led to a large central reception area, the atrium, which, in the case of an old patrician family's house, would feature cupboards with wax ancestor masks; see "Roman Ancestor Portraits," page 183). The rooms flanking the fauces could open onto the atrium, as in Fig. 7-15, or onto the street, in which case the owner could operate or rent them as shops. The roof over the atrium was partially open to the sky, not only to admit light but also to channel rainwater into a basin (impluvium) below to be stored in cisterns for household use. Opening onto the atrium were small bedrooms called cubicula ("cubicles"). At the back were two recessed areas (alae, "wings") and the patron's tablinum, or home office; one or more triclinia ("dining rooms"); a kitchen; and sometimes a small garden.

Extant houses, for example, the House of the Vettii (Fig. 7-16), display endless variations of the same basic plan, dictated by the owners' personal tastes and means, the size and shape of the lot, and so forth, but all Roman houses of this type were inward-looking in nature. The design shut off the street's noise and dust, and all internal activity focused on the brightly illuminated atrium at the center of the

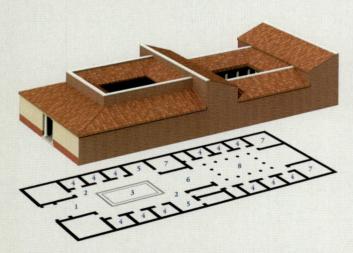

7-15 Restored view and plan of a typical Roman house of the Late Republic and Early Empire (John Burge). (1) fauces, (2) atrium, (3) impluvium, (4) cubiculum, (5) ala, (6) tablinum, (7) triclinium, (8) peristyle.

Older Roman houses closely followed Etruscan models and had atria and small gardens, but during the Late Republic and Early Empire, peristyles with Greek columns became common.

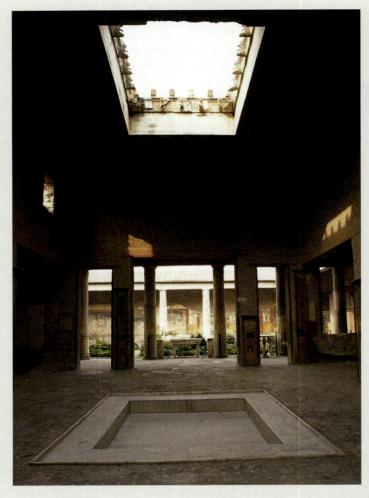

7-16 Atrium of the House of the Vettii, Pompeii, Italy, second century BCE, rebuilt 62–79 CE.

The house of the Vettius brothers was of the later Hellenized type with a peristyle garden behind the atrium. The impluvium below the open roof collected rainwater for domestic use.

residence. This basic module (only the front half of the typical house in Fig. 7-15) resembles the plan of the typical Etruscan house as reflected in the tombs of Cerveteri (Figs. 6-8 and 6-8A). The early Roman house, like the early Roman temple, grew out of the Etruscan tradition.

During the second century BCE, when Roman architects were beginning to construct stone temples with Greek columns, the Roman

house also took on Greek airs. Builders added a garden framed by a peristyle (FIG. **7-16A**) behind the Etruscan-style house, providing a second internal source of illumination as well as a pleasant setting for meals served in a summer triclinium. The axial symmetry of the plan meant that on entering the fauces of the house, a visitor had a view through the atrium directly into the

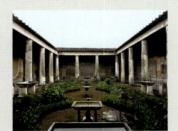

7-16A Peristyle, House of the Vettii, second century BCE.

colonnaded garden (as in Fig. 7-16), which often boasted a fountain or pool, marble statuary, mural paintings, and mosaic floors (Fig. 5-70).

Private houses of this type were typical of Pompeii and other Italian towns, but they were very rare in cities such as Rome, where the masses lived instead in multistory apartment houses (FIG. 7-54).

HOUSE OF THE VETTII The evidence from Pompeii regarding Roman domestic architecture (see "The Roman House," page 188, and FIG. 7-15) is unparalleled anywhere else and is the most precious by-product of the volcanic eruption of 79 ce. One of the best-preserved houses at Pompeii, partially rebuilt by the Italian excavators, is the House of the Vettii, an old second-century BCE house remodeled and repainted (FIG. 7-22) after the earthquake of 62 CE. A photograph (FIG. 7-16) taken in the fauces shows the impluvium in the center of the atrium; the opening in the roof above; and, in the background, the peristyle garden (FIG. 7-16A) with its marble tables and splendid mural paintings dating to the last years of the Vesuvian city. At that time, two brothers, Aulus Vettius Restitutus and Aulus Vettius Conviva, owned the house. They were freedmen who probably had made their fortune as merchants. Their wealth enabled them to purchase and furnish the kind of fashionable townhouse that in an earlier era only patricians could have acquired.

Painting

The houses of Pompeii and neighboring cities and the villas in the countryside around Mount Vesuvius have yielded a treasure trove of mural paintings—the most complete record of the changing fashions in interior decoration found anywhere in the ancient world. The sheer quantity of these paintings tells a great deal about both the prosperity and the tastes of the times. How many homes today, even of the very wealthy, have custom-painted murals in nearly every room? Roman wall paintings were true *frescoes* (see "Fresco Painting," page 419), with the colors applied while the plaster was still damp. The process was painstaking. First, the painter prepared the wall by using a trowel to apply several layers of plaster (mixed with marble dust if the patron could afford it). Only then could painting begin. Finally, when the painter completed work and the surface dried, an assistant polished the wall to achieve a marblelike finish.

In the early years of exploration at Pompeii and nearby Herculaneum, interest in Roman wall paintings focused almost exclusively on the figural panels that formed part of the overall mural designs, especially those depicting Greek myths. The excavators cut the panels out of the walls and transferred them to the Naples Archaeological Museum. In time, more enlightened archaeologists put an end to the practice of cutting pieces out of the walls and began to give serious attention to the mural designs as a whole. Toward the end of the 19th century, August Mau (1840–1909), a German art historian, turned scholars' attention to the overall compositions of the Roman wall paintings. He divided the various mural painting schemes into four "Pompeian Styles." Mau's classification system, although later refined and modified in detail, was an important contribution to the study of Roman art and still serves as the basis for describing Roman frescoes.

FIRST STYLE In Mau's *First Style*, the decorator's aim was to imitate costly marble panels using painted stucco relief. The fauces (FIG. **7-17**) of an old mansion at Herculaneum, the so-called Samnite House, greets visitors with a stunning illusion of walls faced with marbles imported from quarries all over the Mediterranean. This approach to wall decoration is comparable to the modern practice, employed in private libraries and corporate meeting rooms alike, of using inexpensive manufactured materials to approximate the look and shape of genuine wood paneling. The practice was not, however, uniquely Roman. First Style walls are well documented in Greece from the late fourth century BCE on. The use of the First Style in Italian houses is yet another example of the Hellenization of Republican architecture.

7-17 First Style wall painting in the fauces of the Samnite House, Herculaneum, Italy, late second century BCE.

In First Style murals, the aim was to imitate costly marble panels using painted stucco relief. The style is Greek in origin and another example of the Hellenization of Republican architecture.

SECOND STYLE The First Style never went completely out of fashion, but after 80 BCE, a new approach to mural design became more popular. The *Second Style* is in most respects the antithesis of the First Style. Some scholars have argued that the Second Style also has precedents in Greece, but most believe it is a Roman invention. Certainly, the Second Style evolved in Italy, where it was the preferred manner until around 15 BCE, when Roman painters introduced the Third Style. Second Style painters did not aim to create the illusion of an elegant marble wall, as First Style painters sought to do. Rather, they wanted to dissolve a room's confining walls and replace them with the illusion of an imaginary three-dimensional world.

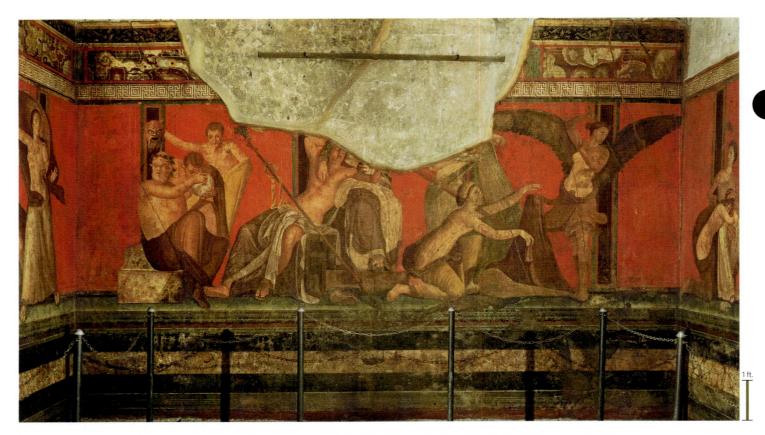

7-18 Dionysiac mystery frieze, Second Style wall paintings in room 5 of the Villa of the Mysteries, Pompeii, Italy, ca. 60–50 BCE. Fresco, frieze 5' 4" high.

Second Style painters created the illusion of an imaginary three-dimensional world on the walls of Roman houses. The figures in this room are acting out the initiation rites of the Dionysiac mysteries.

VILLA OF THE MYSTERIES An early example of the new style is the room (FIG. 7-18) that gives its name to the Villa of the Mysteries at Pompeii. Many archaeologists believe that this chamber was used to celebrate, in private, the rites of the Greek god Dionysos (Roman Bacchus). Dionysos was the focus of an unofficial mystery religion popular among women in Italy at this time. The precise nature of the Dionysiac rites is unknown, but the figural cycle in the Villa of the Mysteries, illustrating mortals (all female save for one boy) interacting with mythological figures, probably provides some evidence for the cult's initiation rites. In these rites, young women, emulating Ariadne, daughter of King Minos (see page 87), united in marriage with Dionysos.

The backdrop for the nearly life-size figures is a series of painted panels imitating marble revetment, just as in the First Style but without the modeling in relief. In front of this painted marble wall, the artist created the illusion of a shallow ledge on which the human and divine actors move around the room. Especially striking is the way some of the figures interact across the corners of the room. For example, a seminude winged woman at the far right of the rear wall lashes out with her whip across the space of the room at a kneeling woman with a bare back (the initiate and bride-to-be of Dionysos) on the left end of the right wall. Nothing comparable to this room existed in Hellenistic Greece. Despite the presence of Dionysos, satyrs, and other Greek mythological figures, this is a Roman design.

BOSCOREALE In the early Second Style Dionysiac mystery frieze, the spatial illusionism is confined to the painted platform that

projects into the room. But in mature Second Style designs, Roman painters created a three-dimensional setting that also extends beyond the wall, as in a cubiculum (FIG. **7-19**) from the Villa of Publius Fannius Synistor at Boscoreale, near Pompeii. The excavators removed the frescoes soon after their discovery, and today they are part of a reconstructed Roman bedroom in the Metropolitan Museum of Art in New York. All around the room, the Second Style painter opened up the walls with vistas of Italian towns, marble temples, and colonnaded courtyards. Painted doors (FIG. 7-19, *left*, near the far right corner of the room; compare FIG. 6-9) and gates (FIG. 7-19, *right*) invite the viewer to walk through the wall into the magnificent world the painter created.

Although the Boscoreale painter was inconsistent in applying it, this Roman artist, like many others around the Bay of Naples, demonstrated familiarity with single-point linear perspective, often incorrectly said to be an innovation of Italian Renaissance artists (see "Linear Perspective," page 587). In this kind of perspective, all the receding lines in a composition converge on a single point along the painting's central axis to show depth and distance. Ancient writers state that Greek painters of the fifth century BCE first used linear perspective for the design of Athenian stage sets (hence its Greek name, skenographia, "scene painting"). In the Boscoreale cubiculum, the painter most successfully employed skenographia in the far corners, where a low gate leads to a peristyle framing a tholos temple (FIG. 7-19, right). Linear perspective was a favored tool of Second Style painters seeking to transform the usually windowless walls of Roman houses into "picture-window" vistas that expanded the apparent space of the rooms.

7-19 Second Style wall paintings (general view, *left*, and detail of tholos, *right*), from cubiculum M of the Villa of Publius Fannius Synistor, Boscoreale, Italy, ca. 50–40 BCE. Fresco, 8' 9" high. Metropolitan Museum of Art, New York.

In this Second Style bedroom, the painter opened up the walls with vistas of towns, temples, and colonnaded courtyards. The convincing illusionism is due in part to the use of linear perspective.

PRIMAPORTA The ultimate example of a Second Style picture-window mural (FIG. **7-20**) comes from the villa of the emperor Augustus's third wife, Livia (FIG. 7-28), at Primaporta, just north of Rome. There, in a barrel-vaulted room, imperial painters decorated all four walls with a lush gardenscape. The only architectural element is the flimsy fence of the garden itself. To suggest recession, the painter employed another kind of perspective, *atmospheric*

perspective, in which the illusion of depth is achieved by the increasingly blurred appearance of objects in the distance. At Primaporta, the muralist precisely painted the fence, trees, and birds in the foreground, whereas the details of the dense foliage in the background are indistinct. Among the wall paintings examined so far, only the landscape fresco (FIG. 4-9) from Akrotiri offers a similar wraparound view of nature devoid of human actors (in contrast to

7-20 Gardenscape, Second Style wall paintings, from the Villa of Livia, Primaporta, Italy, ca. 30–20 BCE. Fresco, 6' 7" high. Palazzo Massimo alle Terme, Museo Nazionale Romano, Rome.

The ultimate example of a Second Style "picture-window" wall is Livia's gardenscape. To suggest recession, the painter used atmospheric perspective, intentionally blurring the most distant forms.

7-21 Detail of a Third Style wall painting, from cubiculum 15 of the Villa of Agrippa Postumus, Boscotrecase, Italy, ca. 10 BCE. Fresco, 7' 8" high. Metropolitan Museum of Art, New York.

In the Third Style, Roman painters decorated walls with delicate linear fantasies sketched on monochromatic backgrounds. Here, a tiny floating landscape on a black ground is the central motif.

the Etruscan Tomb of Hunting and Fishing; FIG. 6-11). But the Theran fresco's white sky and red, yellow, and blue rock formations do not create a successful illusion of a world filled with air and light just a few steps away.

THIRD STYLE The Primaporta gardenscape is the polar opposite of First Style designs, which reinforce, rather than deny, the heavy presence of confining walls. But tastes changed rapidly in the Roman world, as in society today. Not long after Livia hired painters to decorate her villa, Roman patrons began to favor mural designs that reasserted the primacy of the wall surface. In the *Third Style* of Pompeian painting, artists no longer attempted to replace the walls

with three-dimensional worlds of their own creation. Nor did they seek to imitate the appearance of the marble walls of Hellenistic palaces. Instead they adorned walls with delicate linear fantasies sketched on predominantly *monochromatic* (one-color) backgrounds.

BOSCOTRECASE One of the earliest examples of the Third Style dating around 10 BCE—is a cubiculum (FIG. 7-21) in the Villa of Agrippa Postumus at Boscotrecase. Nowhere did the artist use illusionistic painting to penetrate the wall. In place of the stately columns of the Second Style are insubstantial and impossibly thin colonnettes supporting featherweight canopies barely reminiscent of pediments. In the center of this delicate and elegant architectural frame is a tiny floating landscape painted directly on the jet-black ground. It is hard to imagine a sharper contrast with the panoramic gardenscape at Livia's villa. On other Third Style walls, landscapes and mythological scenes appear in frames, like modern easel paintings hung on walls. Never could these framed panels be mistaken for windows opening onto a world beyond the room. Not everyone approved of the new Roman mural style. One of those who disliked the Third Style was the Augustan architect Vitruvius, author of the most important extant ancient treatise on architecture (see "Vitruvius's Ten Books on Architecture," page 199).

FOURTH STYLE A taste for illusionism returned in the *Fourth Style* of Roman mural painting, which became popular in the 50s ce. Characterized by the reintroduction of architectural vistas seen through the painted walls, the Fourth Style nonetheless can-

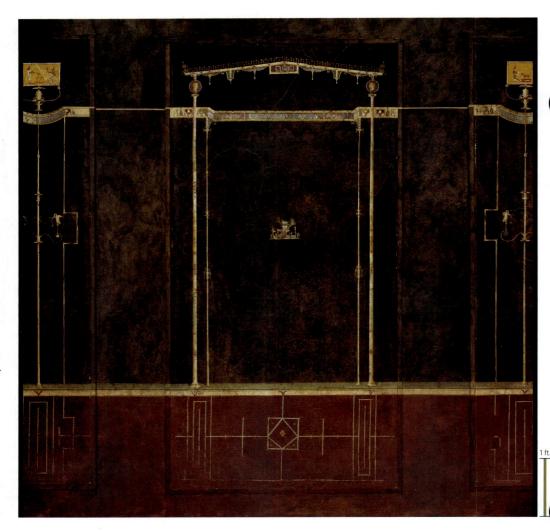

not be confused with the Second Style. In the later style, the views of buildings are irrational fantasies, as in the Ixion Room (FIG. 7-22) of the House of the Vettii at Pompeii. In this late Fourth Style design dating to just before the eruption of Mount Vesuvius, the painter rejected the quiet elegance of the Third Style in favor of a crowded and complex multicolor composition. The decorative scheme of the Vettius brothers' triclinium opening onto the peristyle (FIG. 7-16A) of their Pompeian house is a kind of summation of all the previous mural schemes, another instance of the mixing of styles noted earlier as characteristic of Roman art in general. The lowest zone, for example, is one of the most successful imitations anywhere of costly multicolored imported marbles, despite the fact that the painter created the illusion without recourse to relief, as in the First Style. The large white panels in the corners of the room, with their delicate floral frames and floating central motifs, would fit naturally into the most elegant Third Style design. Unmistakably Fourth Style, however, are the fragmentary architectural vistas of the central and upper zones of the walls. They are unrelated to one another and do not constitute a unified cityscape beyond the wall. Moreover, the figures depicted would tumble into the room if they took a single step forward.

The Ixion Room takes its name from the mythological panel painting at the center of the rear wall. Ixion had attempted to seduce Zeus's wife Hera, and the king of the gods punished Ixion by binding him to a perpetually spinning wheel. The panels on the two side walls also have Greek myths as subjects. The Ixion Room is a kind of private art gallery. Many art historians believe that lost Greek panel paintings were the models for the many mythological paintings on

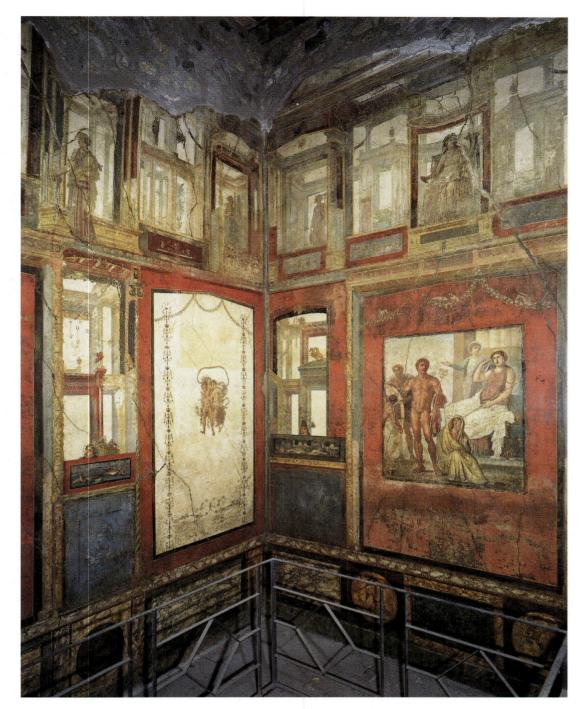

7-22 Fourth Style wall paintings in the Ixion Room (triclinium P) of the House of the Vettii (FIG. 7-16), Pompeii, Italy, ca. 70–79 CE.

Late Fourth Style murals are often multicolored, crowded, and confused compositions with a mixture of architectural views, framed mythological panels, and First and Third Style motifs.

Third and Fourth Style walls. The mythological paintings on Pompeian walls attest to the Romans' continuing admiration for Greek artworks three centuries after Marcellus brought the treasures of Syracuse to Rome. But few (if any) of these mythological paintings can be described as true copies of famous Greek works. Unlike the replicas of Greek statues that have been found throughout the Roman world, including Pompeii (FIG. 5-41), these panels seem to be merely variations on standard compositions. The themes chosen no doubt reflected the individual owners' tastes and the impressions they wished to make on their guests.

WALL MOSAICS Mythological themes were on occasion also the subject of Roman mosaics. In the ancient world, mosaics usually covered floors. For example, the *Battle of Issus* mosaic (FIG. 5-70) was the floor of an *exedra* (recessed area) opening onto a peristyle in the largest house at Pompeii, the so-called House of the Faun, named for a Hellenistic-style bronze statue in its atrium. But occasionally Roman mosaics decorated walls and even ceilings, foreshadowing the extensive use of wall and vault mosaics in the Middle Ages (see "Mosaics," page 251). An early example of a wall mosaic is in the House of Neptune and Amphitrite at

7-23 Neptune and Amphitrite, wall mosaic in the summer triclinium of the House of Neptune and Amphitrite, Herculaneum, Italy, ca. 62–79 CE.

In the ancient world, mosaics usually decorated floors, but this example adorns a wall. The sea deities Neptune and Amphitrite fittingly overlook cascading water in an elaborate private fountain.

Herculaneum (FIG. **7-23**). The statuesque figures of the sea god and his wife appropriately presided over the flowing water of the fountain in the courtyard in front of them, where the house's owners and guests enjoyed outdoor dining in warm weather.

PRIVATE PORTRAITS The subjects that Roman patrons preferred for mural paintings and mosaics were diverse, as expected in private contexts. Although mythological compositions were immensely popular, Roman homeowners commissioned a vast range of other subjects for the walls of their houses and villas. As noted, landscape paintings frequently appear on Second, Third, and Fourth Style walls. Paintings and mosaics depicting scenes from history include the *Battle of Issus* (FIG. 5-70)

and the brawl in the Pompeii amphitheater (FIG. 7-14). Given the Roman custom of keeping *imagines* of illustrious ancestors in atria, it is not surprising that painted portraits also appear in Pompeian houses. The double portrait (FIG. **7-24**) of a husband and wife

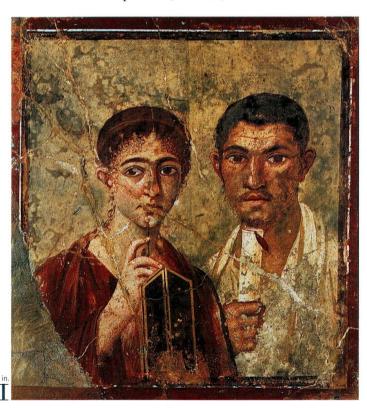

7-24 Portrait of a husband and wife, wall painting from House VII,2,6, Pompeii, Italy, ca. 70–79 CE. Fresco, 1' $11'' \times 1' 8\frac{1}{2}''$. Museo Archeologico Nazionale, Naples.

This husband and wife wished to present themselves to their guests as thoughtful and well read. The portraits are individualized likenesses, but the poses and attributes are conventional.

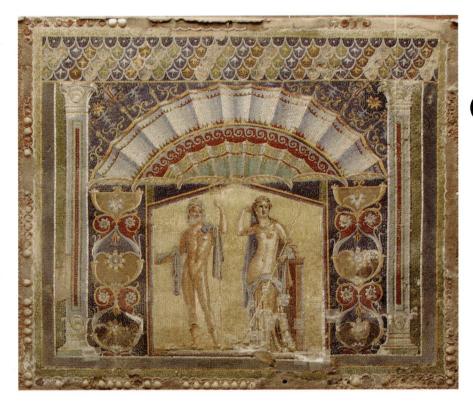

illustrated here originally formed part of a Fourth Style wall of an exedra opening onto the atrium of a Pompeian house. The man,

who may be the lawyer Terentius Neo, holds a scroll, and the woman holds a stylus (writing instrument) and wax writing tablet, standard attributes in Roman marriage portraits (FIG. **7-24A**). The scroll and stylus suggest the fine education of those depicted—even if, as was sometimes true, the individuals were minimally educated or even illiterate. These portraits were the Roman equivalent of modern wedding photographs of a bride and groom posing in

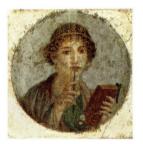

7-24A Woman with stylus, Pompeii, ca. 55-70 ce.

rented formal garments never worn by them before or afterward. In contrast, the heads are not standard types but sensitive studies of the couple's individual faces.

MENANDER Rarer on Pompeian walls are portraits of famous men and women of earlier eras, but several examples survive. The most famous is the seated portrait of the Greek poet Menander (FIG. 7-25) on the right wall of an exedra facing the peristyle in the House of the Menander, which takes its modern name from this mural. On the open scroll that the poet holds in his left hand is a label identifying him as Menander, "the first to write New Comedy." On the opposite wall, poorly preserved, is a portrait of a bearded man with theatrical masks—possibly Euripides but definitely a tragedian as a counterpart to the writer of comic plays across from him. The portrait of Menander is probably an enlarged version of the kind of author portrait that art historians believe was a standard feature of ancient books, comparable to the photographs of authors that appear inside or on the dust jackets of modern books. These portraits of ancient authors seated at their writing tables had a long afterlife in the countless medieval Gospel books with full-page illustrations of the Gospel authors, the four evangelists (FIGS. 11-8, 11-14, 11-15, and 12-17A).

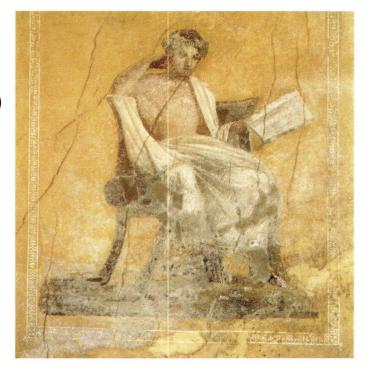

7-25 Seated portrait of the Greek poet Menander, detail of a Fourth Style mural painting in exedra 23 of the House of the Menander, Pompeii, ca. 62–79 CE.

This seated Menander is an enlarged version of the kind of author portrait that was a standard feature of ancient books. Classical author portraits had an afterlife in medieval portrayals of the four evangelists.

STILL-LIFE PAINTING Another genre Roman mural painters explored was *still-life* painting (the representation of inanimate objects, artfully arranged). A still life with peaches and a carafe (FIG. **7-26**), a detail of a Fourth Style wall from a house in Herculaneum, is one of the finest extant examples. The painter was a master of illusionism and devoted as much attention to the shadows and highlights on the fruit, the stem and leaves, and the glass jar as to the objects themselves. Roman still lifes of this type are without precedent and have few successors until the 17th-century Dutch studies of food and other inanimate objects (FIGS. 25-21 to 25-23).

EARLY EMPIRE

The murder of Julius Caesar on the Ides of March, 44 BCE, plunged the Roman world into a bloody civil war. The fighting lasted until 31 BCE, when Octavian, Caesar's grandnephew and adopted son, crushed the naval forces of Mark Antony and Queen Cleopatra of Egypt at Actium in northwestern Greece. Antony and Cleopatra committed suicide, and in 30 BCE, Egypt, once the wealthiest and most powerful kingdom of the ancient world, became another province in the ever-expanding Roman Empire.

Historians mark the passage from the Roman Republic to the Roman Empire from the day in 27 BCE when the Senate conferred the title of *Augustus* (the Majestic, or Exalted, One; r. 27 BCE–14 CE) on Octavian. The Empire was ostensibly a continuation of the Republic, with the same constitutional offices, but in fact Augustus, whom the Senate recognized as *princeps* ("first citizen"), occupied all the key positions. He was consul and *imperator* ("commander in chief"; root of the word *emperor*) and even, after 12 BCE, *pontifex maximus* ("chief priest"). These offices gave Augustus control of all aspects of Roman public life.

7-26 Still life with peaches, detail of a Fourth Style wall painting, from Herculaneum, Italy, ca. 62–79 CE. Fresco, 1' 2" \times 1' $1\frac{1}{2}$ ". Museo Archeologico Nazionale, Naples.

The Roman interest in illusionism explains the popularity of still-life paintings. This painter paid scrupulous attention to the play of light and shadow on different shapes and textures.

PAX ROMANA With powerful armies keeping order on the Empire's frontiers and no opposition at home, Augustus brought peace and prosperity to a war-weary Mediterranean world. Known in his day as the Pax Augusta (Augustan Peace), the peace that Augustus established prevailed for two centuries. It came to be called simply the *Pax* Romana (Roman Peace). During this time, the emperors commissioned a huge number of public works throughout the Empire: roads and bridges, theaters, amphitheaters, and bathing complexes, all on an unprecedented scale. The erection of imperial portrait statues and monuments covered with inscriptions and reliefs recounting the rulers' great deeds reminded people everywhere that the emperors were the source of peace and prosperity. These portraits and reliefs, however, often presented a picture of the emperors and their achievements that bore little resemblance to historical fact (see "Roman Art as Historical Fiction," page 177). Their purpose was not to provide an objective record but to mold public opinion. The Roman emperors and the artists they employed have had few equals in the effective use of art and architecture for propagandistic ends.

Augustus and the Julio-Claudians

When Augustus vanquished Antony and Cleopatra at Actium and became undisputed master of the Mediterranean world, he was not yet 32 years old. The rule by elders that had characterized the Roman Republic for nearly 500 years came to an abrupt end. Suddenly, Roman portraitists had to produce images of a youthful head of state. But Augustus was not merely young. The Senate had declared Caesar a god after his death, and Augustus, though never claiming to be a god himself, widely advertised himself as the son of a god. His portraits were designed to present the image of a godlike leader who miraculously never aged. Although Augustus lived until

ART AND SOCIETY

Role Playing in Roman Portraiture

In every town throughout the vast Roman Empire, portraits of the emperors and empresses and their families were on display—in fora, basilicas, baths, and markets; in front of temples; atop triumphal arches—anywhere a statue could be placed. The rulers' heads varied little from Britain to Syria. All were replicas of official images, either imported or scrupulously copied by local artists. But the imperial sculptors combined portrait heads with many different statuary types. The type chosen depended on the position the person held in Roman society or the various fictitious guises members of the imperial family assumed. Portraits of Augustus, for example, show him not only as armed general (FIG. 7-27) but also as recipient of the civic crown for

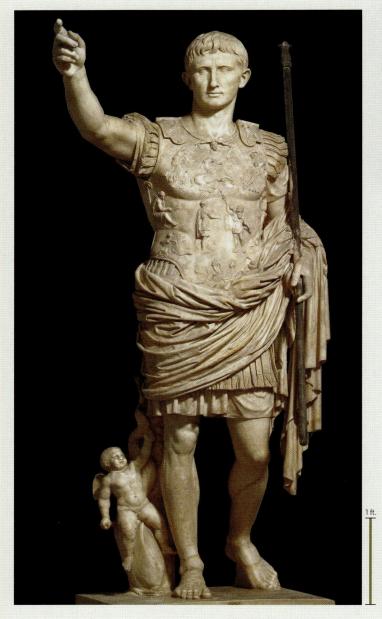

7-27 Portrait of Augustus as general, from Primaporta, Italy, early-first-century CE copy of a bronze original of ca. 20 BCE. Marble, 6' 8" high. Musei Vaticani, Rome.

The models for Augustus's idealized portraits, which depict him as a neveraging god, were Classical Greek statues (FIG. 5-41). This portrait presents the armor-clad emperor in his role as general.

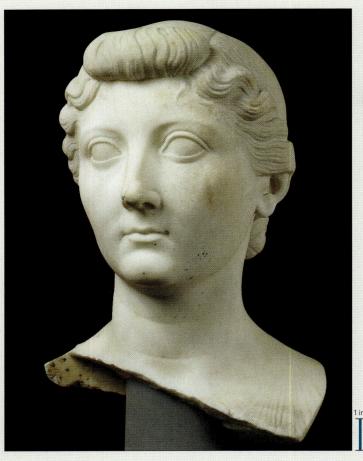

7-28 Portrait bust of Livia, from Arsinoe, Egypt, early first century CE. Marble, $1' 1\frac{1}{2}''$ high. Ny Carlsberg Glyptotek, Copenhagen.

Although Livia sports the latest Roman coiffure, her youthful appearance and sharply defined features derive from images of Greek goddesses. She died at 87, but never aged in her portraits.

saving the lives of fellow citizens (FIG. I-10), hooded priest, toga-clad magistrate, traveling commander on horseback, heroically nude warrior, and various Roman gods, including Jupiter, Apollo, and Mercury. Nero, Augustus's most notorious successor, had himself portrayed as Sol, the sun god, in a colossal gilded-bronze statue (see page 201). Commodus, a late-second-century CE emperor, considered himself Hercules reincarnate and appeared in the guise of that Greek hero in his portraits (FIG. 7-57A).

Role playing was not the exclusive prerogative of emperors and princes but extended to their wives, daughters, sisters, and mothers. Portraits of Livia (Fig. 7-28) depict her as many goddesses, including Ceres, Juno, Venus, and Vesta. She also appeared as the personification of Health, Justice, and Piety. In fact, it was common for imperial women to be represented on Roman coins as goddesses or as embodiments of feminine virtue. Faustina the Younger, for example, the wife of Marcus Aurelius and mother of 13 children, including Commodus, frequently took on the roles of Venus and Fecundity, among many others. Some portraits of Julia Domna (Fig. 7-61), Septimius Severus's wife, equated her with Juno, Venus, Peace, or Victory.

Ordinary citizens also engaged in role playing. Many assumed literary pretensions in the painted portraits (FIGS. 7-24 and 7-24A) they commissioned for the walls of their homes. Others likened themselves to Greek heroes (FIG. 7-58) or Roman deities (FIG. 7-59) on their coffins. The common people followed the lead of the emperors and empresses.

THE PATRON'S VOICE

The Res Gestae of Augustus

Shortly before he died, the emperor Augustus reflected on his achievements during his 76 years and summarized them for posterity in a lengthy document called the *Res Gestae Divi Augusti (Achievements of the Deified Augustus)*. The *Res Gestae* recounts Augustus's successes in all of the many arenas in which he made his mark—political, military, religious, economic, social, and artistic.

The document opens with Augustus's claim to have restored liberty to the Republic by freeing the Roman people from the tyranny of Mark Antony. He goes on to enumerate the wars he fought and the territories he added to the empire, including Egypt; the triumphs he celebrated and the numerous other honors the Senate awarded him, including those he chose to decline; and the many occasions on which he distributed gifts of cash or grain to the people. He also describes the extensive building program he undertook, including a temple for the worship of the deified Julius Caesar in the Republican Forum Romanum (FIG. 7-2, no. 11); two new fora bearing the names of Caesar and

Augustus (FIG. 7-2, nos. 9 and 10); the restoration of the temple of Jupiter Capitolinus (FIG. 7-2, no. 4) and the theater of Pompey; an altar celebrating the Augustan Peace (FIG. 7-29); and roads, aqueducts, and bridges throughout Italy.

The following selections highlight the fictive nature of Augustan constitutional government, the emperor's role as a great patron of architecture, and his professed modesty in not taking credit for some of his achievements.

[W]hen I had extinguished the flames of civil war, after receiving by universal consent the absolute control of affairs, I transferred the republic from my own control to the will of the senate and the Roman people. For this service I was given the title of Augustus by decree of the senate. . . . After that time I took precedence of all in rank [princeps], but of power I possessed no more than those who were my colleagues in any magistracy. [6.34]

The Capitolium and the theatre of Pompey, both works involving great expense, I rebuilt without any inscription of my own name. . . . I rebuilt in the city eighty-two temples of the gods, omitting none which at that time stood in need of repair. [4.20]

When I returned from Spain and Gaul... the senate voted in honor of my return the consecration of an altar to Pax Augusta in the Campus Martius. [2.12]*

*All passages translated by Frederick W. Shipley, Res gestae divi Augusti, rev. ed. (Cambridge, Mass.: Harvard University Press, 1979), 365, 379, 399, 401.

7-29 West facade of the Ara Pacis Augustae (Altar of the Augustan Peace), Rome, Italy, 13–9 BCE.

Augustus sought to present his new order as a Golden Age equaling that of Athens under Pericles. The Ara Pacis celebrates the emperor's most important achievement, the establishment of peace.

14 CE, even official portraits made near the end of his life show him as a handsome youth (FIG. I-10). Such fictional likenesses might seem ridiculous today, when everyone can easily view photographs of world leaders as they truly appear, but in antiquity few people ever saw the emperor. His official image was all that most knew. It therefore could be manipulated at will.

AUGUSTUS AS GENERAL The portraits of Augustus depict him in his many different roles in the Roman state (see "Role Playing in Roman Portraiture," page 196), but the models for many of them were Classical Greek statues. The statue (FIG. **7-27**) of the emperor found at his wife Livia's villa at Primaporta (FIG. **7-20**) portrays Augustus as general, standing like Polykleitos's *Doryphoros* (FIG. **5-41**) but with his right arm raised to address his troops in the manner of the orator Aule Metele (FIG. **6-18**). Augustus's head, although depicting a recognizable individual, also emulates the idealized Polykleitan youth's head in its overall shape, the sharp ridges of the brows, and the tight cap of layered hair. Augustus is not nude, however, and the details of the statue carry political messages. The

reliefs on his cuirass advertise an important diplomatic victory—the return of the Roman legionary banners that the Parthians had captured from a Republican general—and the Cupid at Augustus's feet proclaims his divine descent. Caesar's family, the Julians, traced their ancestry back to Venus. Cupid was the goddess's son.

LIVIA A marble portrait (FIG. **7-28**) of Livia reveals that the imperial women of the Augustan age shared the emperor's eternal youthfulness. Although the empress sports the latest Roman coiffure, with the hair rolled over the forehead and knotted at the nape of the neck, her blemish-free skin and sharply defined features derive from images of Classical Greek goddesses. Livia outlived Augustus by 15 years, dying at age 87. In her portraits, the coiffure changed with the introduction of each new fashion, but her face remained ever young, befitting her exalted position in the Roman state.

ARA PACIS AUGUSTAE On Livia's birthday in 9 BCE, the Senate dedicated the Ara Pacis Augustae (Altar of the Pax Augusta, the Augustan Peace; FIG. **7-29**), the monument celebrating the emperor's

7-30 Female personification (Tellus?), panel on the east facade of the Ara Pacis Augustae, Rome, Italy, 13–9 BCE. Marble, 5' 3" high.

This female personification with two babies on her lap embodies the fruits of the Pax Augusta. All around her, the bountiful earth is in bloom, and animals of different species live together peacefully.

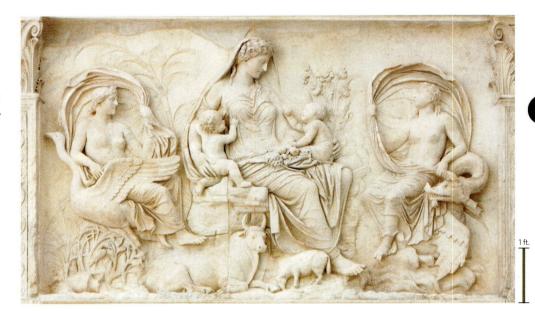

7-31 Procession of the imperial family, detail of the south frieze of the Ara Pacis Augustae, Rome, Italy, 13–9 BCE. Marble, 5' 3" high.

Although inspired by the frieze (FIG. 5-50, bottom) of the Parthenon, the Ara Pacis processions depict recognizable individuals, including children. Augustus promoted marriage and childbearing.

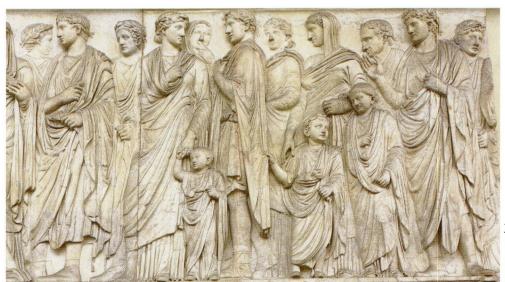

1 ft.

most significant achievement, the establishment of peace (see "The Res Gestae" of Augustus," page 197). Figural reliefs and acanthus tendrils adorn the altar's marble precinct walls. Four panels on the east and west ends depict carefully selected mythological subjects, including a relief (FIG. 7-29, right) of Aeneas making a sacrifice. Aeneas was the son of Venus and one of Augustus's forefathers. The connection between the emperor and Aeneas was a key element of Augustus's political ideology for his new Golden Age. It is no coincidence that Vergil wrote the Aeneid during the rule of Augustus. Vergil's epic poem glorified the young emperor by celebrating the founder of the Julian line.

A second panel (FIG. **7-30**), on the other end of the altar enclosure, depicts a seated matron with two lively babies on her lap. Her identity is uncertain. Art historians usually call her Tellus (Mother Earth), although some scholars have identified her as Pax (Peace), Ceres (goddess of grain), or even Venus. Whoever she is, she embodies the fruits of the Pax Augusta. All around her, the bountiful earth is in bloom, and animals of different species live peacefully side by side. Personifications of refreshing breezes (note their windblown drapery) flank her. One rides a bird, the other a sea creature. Earth, sky, and water are all elements of this picture of peace and fertility in the Augustan cosmos.

Processions of the imperial family (FIG. **7-31**) and other important dignitaries appear on the long north and south sides of the Ara Pacis. The inspiration for these parallel friezes was very likely the Panathenaic procession frieze (FIG. 5-50, *bottom*) of the Parthenon. Augustus sought to present his new order as a Golden Age equaling that of Athens under Pericles. The emulation of Classical models thus made a political as well as an artistic statement.

Even so, the Roman procession is very different in character from its presumed Greek model. On the Parthenon, anonymous figures act out an event that recurred every four years. The frieze stands for all Panathenaic Festival processions. The Ara Pacis depicts a specific event—probably the inaugural ceremony of 13 BCE when work on the altar began—and recognizable historical figures. Among those portrayed are children, who restlessly tug on their elders' garments and talk to one another when they should be quiet on a solemn occasion—in short, children who act like children and not like miniature adults, as they frequently do in the history of art. Their presence lends a great deal of charm to the procession, but that is not why the imperial sculptors included children on the Ara Pacis when they had never before appeared on any Greek or Roman state monument. Augustus was concerned about a decline in the birthrate among the Roman nobility, and he enacted a series of laws

WRITTEN SOURCES

Vitruvius's Ten Books on Architecture

Little is known about the Augustan architect Vitruvius, including his full name. He was probably born in the 70s BCE, either in Campania (the area around the Bay of Naples) or in Rome, and most likely wrote his De architectura (On Architecture) between 25 and 15 BCE—that is, in the years following Augustus's defeat of Mark Antony and the establishment of the Pax Augusta. There are few mentions of Vitruvius's architectural treatise in other extant ancient Greek or Latin texts, but his Ten Books on Architecture became the handbook of classical architecture during the Renaissance, and it has remained so to the present day.

De architectura is noteworthy both for what it includes and what it does not. One of the treatise's most interesting features is Vitruvius's insistence on the broad training that an architect must receive, not only in engineering and architectural design but in the liberal arts. As a

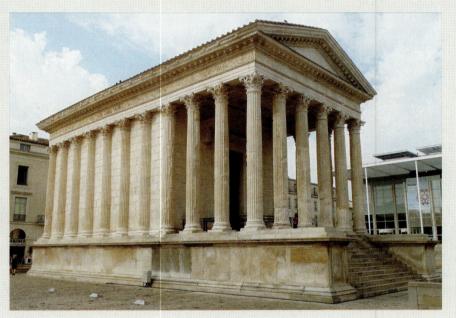

how-to manual, it focuses on traditional means of construction and on the classical orders (FIG. 5-13) as used in Greek, Etruscan (FIG. 6-3), and Roman buildings. Vitruvius's tastes were quite conservative and fully in accord with the classicism of the Augustan building program in the capital (FIG. 7-29) and in the provinces (FIG. 7-32). In the preface to Book I, Vitruvius dedicated his treatise to Augustus, citing the emperor's interest in "the construction of suitable buildings" in the new era of peace he brought to the Romans. Vitruvius rarely refers, for example, to concrete vaulting, the most innovative mode of Roman construction, and he complained bitterly about the latest developments in mural painting of the late Second and early Third Styles (FIG. 7-21), which he described as examples of

deprayed taste. For monsters are now painted in frescoes rather than reliable images of definite things. Reeds are set up in place of columns, as pediments, little scrolls, striped with curly leaves and volutes, candelabra hold up the figures of aediculae [pediment-

capped niches], and above the pediments of these, several tender shoots, sprouting in coils from roots, have little statues nestled in them for no reason, or shoots split in half, some holding little statues with human heads, some with the heads of beasts. No, these things do not exist nor can they exist nor have they ever existed, and thus this new fashion has brought things to such a pass that bad judges have condemned the right practice of the arts [that is, Second Style painting] as lack of skill.*

*Vitruvius, *De architectura*, 7.5.3-4. Translated by Ingrid D. Rowland, *Vitruvius*. *Ten Books on Architecture* (New York: Cambridge University Press, 1999), 91.

7-32 Maison Carrée (looking northwest), Nîmes, France, ca. 1–10 CE.

This well-preserved Corinthian pseudoperipteral temple in France, modeled on the temple in the Forum of Augustus in Rome, exemplifies the Augustan classical architectural style.

designed to promote marriage, marital fidelity, and raising children. The portrayal of men with their families on the Altar of Peace served as a moral exemplar. The emperor used relief sculpture as well as portraiture to further his political and social agendas.

FORUM OF AUGUSTUS Augustus's most ambitious project in the capital was the construction of a new forum (FIG. 7-2, no. 10) next to Julius Caesar's forum (FIG. 7-2, no. 9), which Augustus completed (see "*Res Gestae*," page 197). The temples and porticos in both fora were white marble from Carrara. Prior to the opening of those quarries in the second half of the first century BCE, marble had to be imported at great cost from abroad, and the Romans used it sparingly. The ready availability of Italian marble under Augustus made possible the emperor's famous boast that he found Rome a city of brick and transformed it into a city of marble.

The extensive use of Carrara marble for public monuments (including the Ara Pacis) must be seen as part of Augustus's larger program to make his city the equal of Periclean Athens. In fact, the Forum of Augustus incorporated several explicit references to

Classical Athens and to the Acropolis in particular, most notably copies of the caryatids (FIG. 5-54) of the Erechtheion in the upper story of the porticos. The forum also evoked Roman history. The porticos contained dozens of portrait statues, including images of all the major figures of the Julian family going back to Aeneas. Augustus's forum became a kind of public atrium filled with *imagines*. His family history thus became part of the Roman state's official history.

NîMES The Forum of Augustus is in ruins today, but many scholars believe that some of the stonemasons from that project also constructed the so-called Maison Carrée (Square House; FIG. **7-32**) at Nîmes in southern France (Roman Gaul). This exceptionally well-preserved Corinthian pseudoperipteral temple, which dates to the opening years of the first century CE, is the best surviving example of Augustan classicism in architecture (see "Vitruvius's *Ten Books on Architecture*," above), paralleling the emperor's preference for emulating Classical models in statuary and relief sculpture.

An earlier Augustan project in France was the construction over the Gard River near Nîmes of the great aqueduct-bridge known

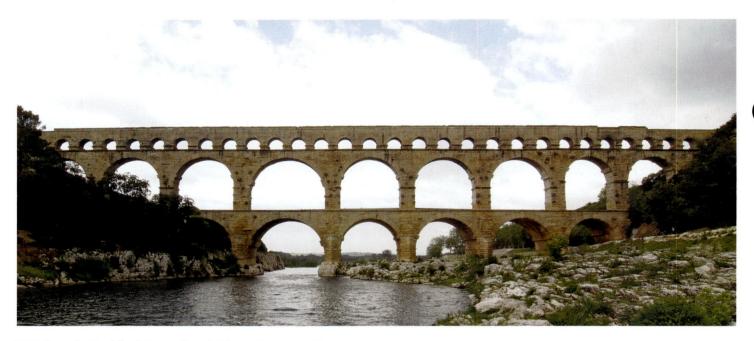

7-33 Pont-du-Gard (looking northeast), Nîmes, France, ca. 16 BCE.

Roman engineers constructed roads and bridges throughout the Empire. This aqueduct-bridge brought water from a distant mountain spring to Nîmes—about 100 gallons a day for each inhabitant.

today as the Pont-du-Gard (FIG. **7-33**). In the fourth century BCE, the Romans began to build *aqueducts* to carry water from mountain sources to their city on the Tiber River. As Rome's power spread through the Mediterranean world, its engineers constructed aqueducts, roads, and bridges to serve colonies throughout the far-flung empire. The Pont-du-Gard aqueduct provided about 100 gallons of water a day for each inhabitant of Nîmes from a source some 30 miles away. The water flowed over the considerable distance by gravity alone, which required channels built with a continuous gradual decline over the entire route from source to city. The three-story Pont-du-Gard maintained the height of the water channel where the

water crossed the river. Each large arch spans some 82 feet and consists of blocks weighing up to two tons each. The bridge's uppermost level is a row of smaller arches, three above each of the large openings below. They carry the water channel itself. The harmonious proportional relationship between the larger and smaller arches reveals that the Roman hydraulic engineer who designed the aqueduct-bridge also had a keen aesthetic sense.

PORTA MAGGIORE The demand for water in the capital required the construction of many aqueducts. The emperor

7-34 East facade of the Porta Maggiore, Rome, Italy, ca. 50 CE.

This double gateway, which supports the water channels of two important aqueducts, is the outstanding example of Roman rusticated (rough) masonry, which was especially popular under Claudius.

Claudius (r. 41–54 CE) erected a grandiose gate, the Porta Maggiore (FIG. **7-34**), at the point where two of Rome's water lines (and two major intercity roads) converged. Its huge *attic* (uppermost story) bears a lengthy dedicatory inscription concealing the stacked conduits of both aqueducts. The gate is the outstanding example of the Roman *rusticated* (rough) masonry style. Instead of using the precisely shaped blocks that Greek and Augustan architects preferred, the designer of the Porta Maggiore combined smooth and rusticated surfaces. These created an exciting, if eccentric, facade with crisply carved (*dressed masonry*) pediments resting on engaged columns composed of rusticated drums.

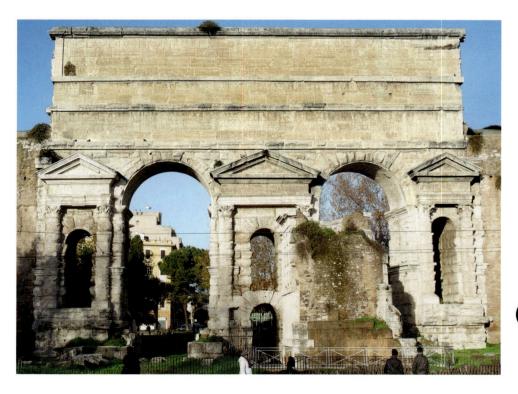

NERO'S GOLDEN HOUSE In 64 CE, when Nero (r. 54–68 CE), stepson and successor of Claudius, was emperor, a great fire destroyed large sections of Rome. Afterward, Nero enacted a new building code requiring greater fireproofing, resulting in the widespread use of concrete and more opportunities for Roman architects to explore the possibilities opened up by the still relatively new building material. The fire also enabled the emperor to construct a luxurious new

7-34A Room 78, Domus Aurea, 64-68 CE.

palace on a huge confiscated plot of fire-ravaged land near the Forum Romanum. Nero chose two brilliant architectengineers, SEVERUS and CELER, to design and build his new home (see "The Golden House of Nero," below). The palace they provided the emperor had scores of rooms, many adorned with frescoes (FIG. 7-34A) in

the Fourth Style, others with marble paneling or painted and gilded stucco reliefs. Structurally, most of these rooms, although made of concrete, are unremarkable. One octagonal hall (FIG. **7-35**), however, stands apart from the rest and testifies to Severus and Celer's bold new approach to architectural design.

The ceiling of the octagonal room is a dome that modulates from an eight-sided to a hemispherical form as it rises toward the *oculus*—the circular opening that admits light to the room. Radiating outward from the five inner sides (the other three, directly or indirectly, face the outside) are smaller, rectangular rooms, three covered by barrel vaults, two others (marked on the plan [Fig. 7-35, *right*] by X's composed of broken lines) by the earliest known concrete groin vaults (Fig. 7-6b). Severus and Celer ingeniously lit these satellite rooms by leaving spaces between their vaulted ceilings and the central dome's exterior. But the most significant aspect of the design is that here, for the first time, the architects appear to have thought of the walls and vaults not as limiting space but as shaping it.

WRITTEN SOURCES

The Golden House of Nero

Nero's Domus Aurea, or Golden House, was a vast and notoriously extravagant country villa in the heart of Rome. The Roman biographer Suetonius (ca. 69-ca. 135 cE) described it vividly:

The entrance-hall was large enough to contain a huge statue [of Nero in the guise of Sol, the sun god; FIG. 7-2, no. 16], 120 feet high; and the pillared arcade ran for a whole mile. An enormous pool, like a sea, was surrounded by buildings made to resemble cities, and by a landscape garden consisting of plowed fields, vineyards, pastures, and woodlands—where every variety of domestic and wild animal roamed about. Parts of the house were overlaid with gold and studded with precious stones and mother-of-pearl. All the diningrooms had ceilings of fretted ivory, the panels of which could slide

back and let a rain of flowers, or of perfume from hidden sprinklers, shower upon [Nero's] guests. The main dining-room was circular, and its roof revolved, day and night, in time with the sky. Sea water, or sulphur water, was always on tap in the baths. When the palace had been decorated throughout in this lavish style, Nero dedicated it, and condescended to remark: "Good, now I can at last begin to live like a human being!"*

Suetonius's description is a welcome reminder that the Roman ruins that millions of tourists flock to see are but a dim reflection of the magnificence of the original structures. Only in rare instances, such as the Pantheon, with its marble-faced walls and floors (FIG. 7-51), can visitors experience anything approaching the architects' intended effects. Even there, much of the marble paneling is of later date, and the gilding is missing from the dome.

*Suetonius, Nero, 31. Translated by Robert Graves, Suetonius: The Twelve Caesars (New York: Penguin, 1957; illustrated edition, 1980), 197-198.

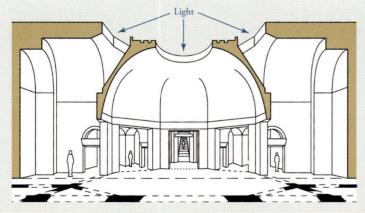

7-35 SEVERUS and CELER, section (*left*) and plan (*right*) of the octagonal hall (room 85) of the Domus Aurea of Nero, Rome, Italy, 64–68 CE.

Nero's architects illuminated this octagonal room by placing an oculus in its concrete dome, and ingeniously lit the rooms around it by leaving spaces between their yaults and the dome's exterior.

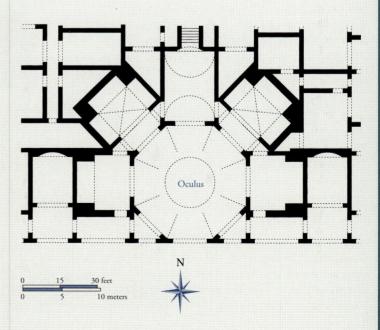

ART AND SOCIETY

Spectacles in the Colosseum

A favorite pastime throughout the Roman Empire was going to the amphitheater to see two immensely popular kinds of spectacles: gladiatorial combats and animal hunts.

Gladiators were professional fighters, usually slaves who had been purchased to train in gladiatorial schools as hand-to-hand combatants. Their owners, seeking to turn a profit, rented them out for performances. Beginning with Domitian, however, all gladiators who competed in Rome were owned by the state to ensure that they could not be used as a private army to overthrow the government. Although every gladiator faced death each time he entered the arena, some had long careers and achieved considerable fame. Others, for example, criminals or captured enemies, entered the amphitheater without any training and without any defensive weapons. Those "gladiatorial games" were a form of capital punishment coupled with entertainment for the masses.

The participants in wild animal hunts (*venationes*) were also professionals, but often the hunts, like the gladiatorial games, were executions in thin disguise involving helpless prisoners who were easy prey for the animals. Sometimes no one entered the arena with the animals. Instead, skilled archers in the stands shot the beasts with arrows. Other times animals would be pitted against other animals—bears versus bulls, lions versus elephants, and the like—to the delight of the crowds.

The Colosseum (Figs. 7-36 and 7-37) was the largest and most important amphitheater in the world, and the kinds of spectacles staged there were costlier and more impressive than those held anywhere else. Some ancient accounts, such as the one quoted below, even mention the flooding of the Colosseum so that naval battles could be staged in the arena. Many scholars, however, doubt that the arena could be made watertight or that ships could maneuver in the space available.

The games celebrating Titus's inauguration of the Colosseum in 80 were especially lavish. In the early third century, the historian Dio Cassius (ca. 164–235 cE) described them:

There was a battle between cranes and also between four elephants; animals both tame and wild were slain to the number of nine thousand; and women . . . took part in dispatching them. As for the men, several fought in single combat and several groups contended together both in infantry and naval battles. For Titus suddenly filled [the arena] with water and brought in horses and bulls and some other domesticated animals that had been taught to behave in the liquid element just as on land. He also brought in people on ships, who engaged in a sea-fight there. . . . On the first day there was a gladiatorial exhibition and wild-beast hunt. . . . On the second day there was a horse-race, and on the third day a naval battle between three thousand men, followed by an infantry battle. . . . These were the spectacles that were offered, and they continued for a hundred days.*

*Dio Cassius, Roman History, 66.25. Translated by Earnest Cary, Dio's Roman History, vol. 8 (Cambridge, Mass.: Harvard University Press, 1925), 311, 313.

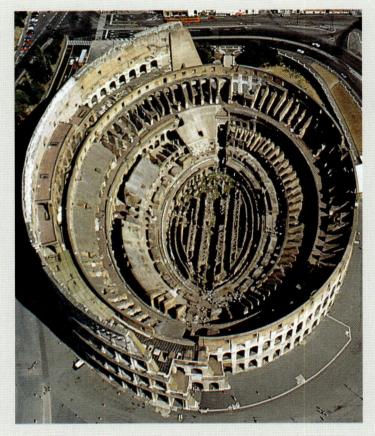

7-36 Aerial view of the Colosseum (Flavian Amphitheater, looking east), Rome, Italy, ca. 70–80 CE.

A complex system of concrete barrel vaults once held up the seats in the world's largest amphitheater, where 50,000 spectators could watch gladiatorial combats and wild animal hunts.

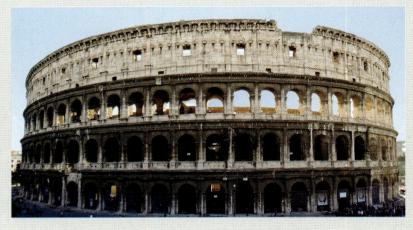

7-37 Facade of the Colosseum (Flavian Amphitheater; looking south), Rome, Italy, ca. 70–80 CE.

For the facade of the Colosseum, an unknown architect mixed Roman arches and Greek columns—Tuscan on the lowest story, then lonic and Corinthian. Wood poles held up an awning over the cavea.

Today, the octagonal hall is deprived of its stucco decoration and marble *incrustation* (veneer). The concrete shell stands bare, but this serves to focus the visitor's attention on the design's spatial complexity. Anyone walking into the domed hall perceives that the space is defined not by walls but by eight angled piers. The openings between the piers are so large that the rooms beyond look like extensions of the central hall. The grouping of spatial units of different sizes and proportions under a variety of vaults creates a dynamic

three-dimensional composition that is both complex and unified. Nero's architects were not only inventive but also progressive in their recognition of the malleable nature of concrete, a material not limited to the rectilinear forms of traditional architecture.

The Flavians

Facing certain assassination as a result of his outrageous behavior, Nero committed suicide in 68 CE, bringing the Julio-Claudian dynasty to an end. A year of renewed civil strife followed. The man who emerged triumphant in this brief but bloody conflict was Vespasian (r. 69–79 CE), a general who had served under Claudius and Nero. Vespasian, whose family name was Flavius, had two sons, Titus (r. 79–81 CE) and Domitian (r. 81–96 ce). Both became emperor in turn after their father's death. The Flavian dynasty ruled Rome for more than a quarter century.

COLOSSEUM The Flavians left their mark on the capital in many ways, not the least being the construction of the Colosseum (FIGS. 7-2, no. 17; 7-36; and 7-37), the gigantic amphitheater that, for most people, still represents Rome more than any other building. The Flavian Amphitheater, as it was then known, was one of Vespasian's first undertakings after becoming emperor. The decision to build the Colosseum was politically shrewd. The site chosen was the artificial lake on the grounds of Nero's Domus Aurea, which engineers drained to make way for the new entertainment center. By building his amphitheater there, Vespasian reclaimed for the public the land that Nero had confiscated for his private pleasure and provided Romans with the largest arena for gladiatorial combats and other lavish spectacles ever constructed. The Colosseum takes its name, however, not from its size—it could hold more than 50,000 spectators—but from its location beside the Colossus of Nero (FIG. 7-2, no. 16), the 120-foottall statue at the entrance to his urban villa. Vespasian did not live to see the Colosseum in use. But his elder son, Titus, completed and formally dedicated the amphitheater in the year 80 with great fanfare (see "Spectacles in the Colosseum," page 202).

The Colosseum, like the much earlier Pompeian amphitheater (FIG. 7-13), could not have been built without concrete. Concrete engineering had, however, advanced rapidly during the century and a half since the Pompeians constructed the earliest known amphitheater. In the Colosseum, instead of an earthen mound, a complex system of barrel-vaulted corridors held up the enormous oval seating area. This concrete "skeleton" is exposed today because in the centuries following the fall of Rome, the Colosseum served as a convenient quarry for ready-made building materials. All of its marble seats were hauled away (the remaining ones are restorations of the Mussolini era in Rome), revealing the network of vaults below (FIG. 7-36). Also visible today but hidden in antiquity are the arena substructures, which in their present form date to the third century CE. They housed waiting rooms for the gladiators, animal cages, and machinery for raising and lowering stage sets as well as animals and humans. Cleverly designed lifting devices brought beasts from their dark dens into the arena's bright light. Above the seats, a great velarium, as at Pompeii (FIG. 7-14), once shielded the spectators.

The exterior travertine shell (FIG. 7-37) is approximately 160 feet high, the height of a modern 16-story building. In antiquity, 76 numbered gateways provided efficient entrance and exit paths leading to and from the cavea, where, as at Pompeii, the spectators sat according to their place in the social hierarchy. The decor of the exterior, however, had nothing to do with function. The architect divided the facade into four bands, with large arched openings piercing the lower three.

Ornamental Greek orders frame the arches in the standard Roman sequence for multistory buildings: from the ground up, Tuscan, Ionic, and then Corinthian. The diverse proportions of the orders formed the basis for this progression, with the Tuscan viewed as capable of supporting the heaviest load. Corinthian pilasters (and between them the brackets for the wood poles that held up the velarium; compare FIG. 7-14) circle the uppermost story.

The use of engaged columns and a lintel to frame the openings in the Colosseum's facade is a variation of the scheme used on the Etruscan Porta Marzia (FIG. 6-15) at Perugia. The Romans commonly used this scheme from Late Republican times on—for example, at Palestrina (FIG. 7-5). Just as the Roman pseudoperipteral temple combines Greek orders with an Etruscan plan, this manner of decorating a building's facade mixed Greek orders with an architectural form foreign to Greek post-and-lintel architecture—namely, the arch. The Roman practice of framing an arch with an applied Greek order had no structural purpose, but it added variety to the surface. In the Colosseum, it also unified a multistory facade by casting a net of verticals and horizontals over it.

FLAVIAN PORTRAITURE Vespasian was an unpretentious career army officer who desired to distance himself from Nero's extravagant misrule. His portraits (FIG. **7-38**) reflect his much simpler tastes.

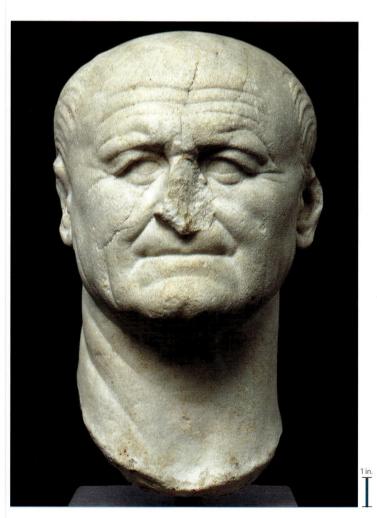

7-38 Portrait of Vespasian, ca. 75–79 CE. Marble, 1' 4" high. Ny Carlsberg Glyptotek, Copenhagen.

Vespasian's sculptors revived the veristic tradition of the Republic to underscore the elderly new emperor's Republican values in contrast to Nero's self-indulgence and extravagance.

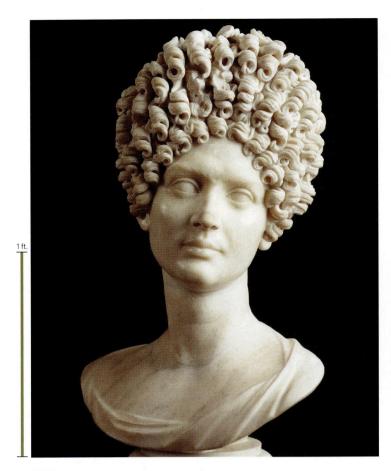

7-39 Portrait bust of a Flavian woman, from Rome, Italy, ca. 90 CE. Marble, 2' 1" high. Museo Capitolino, Musei Capitolini, Rome.

The Flavian sculptor reproduced the elaborate coiffure of this elegant woman by drilling deep holes for the corkscrew curls, and carved the rest of the hair and the face with hammer and chisel.

They also made an important political statement. Breaking with the tradition Augustus established of depicting the Roman emperor as godlike and eternally youthful, Vespasian's sculptors resuscitated the veristic tradition of the Republic, possibly at his specific direction. Although not as brutally descriptive as many Republican likenesses (FIG. 7-8), Vespasian's portraits frankly recorded his receding hairline and aging, leathery skin—proclaiming his traditional Republican values in contrast to Nero's extravagant excesses.

Numerous portraits of people of all ages survive from the Flavian period, in contrast to the Republic, when few but the elderly were deemed worthy of depiction. A portrait bust (FIG. **7-39**) of a young woman is a case in point. Its purpose was not to project Republican virtues but to present the sitter as beautiful—in terms of current fashion rather than by emulating the idealized images of Greek goddesses. The portrait is especially notable for the virtuoso way the sculptor rendered the elaborate Flavian coiffure, with its corkscrew curls punched out using a drill instead of a chisel. The sculptor brilliantly set off the dense mass of hair from the softly modeled and highly polished skin of the face and elegant, swanlike neck. The drill played an increasing role in Roman sculpture in succeeding periods, and when much longer hair and full beards became fashionable for men, sculptors used drills for their portraits as well.

ARCH OF TITUS When Titus died in 81 CE, only two years after becoming emperor, his younger brother, Domitian, succeeded him. Domitian erected an arch (FIGS. 7-2, no. 13, and **7-40**) in Titus's

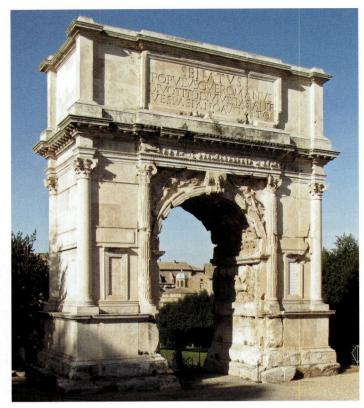

7-40 East facade of the Arch of Titus, Rome, Italy, after 81 CE.

Domitian built this arch on the road leading into the Roman Forum to honor his brother, the emperor Titus, who became a god after his death. Victories fill the spandrels of the arcuated passageway.

honor on the Sacred Way leading into the Republican Forum Romanum (FIG. 7-2, no. 11). This type of freestanding arch, the so-called *triumphal arch*, has a long history in Roman art and architecture, beginning in the second century BCE. The term is something of a misnomer, however, because Roman arches did not celebrate only military victories. Usually crowned by gilded bronze statues, they commemorated a wide variety of events, ranging from victories abroad to the building of roads and bridges at home.

The Arch of Titus is a typical early triumphal arch in having only one passageway. As on the Colosseum, engaged columns frame the arcuated opening. The capitals are not Greek, however, but Roman *Composite capitals*, an ornate combination of Ionic volutes and Corinthian acanthus leaves. The new type became popular at about the same time as the Fourth Style in Roman painting. Reliefs depicting personified Victories (winged women, as in Greek art) fill the *spandrels* (the area between the arch's curve and the

framing columns and entablature). The dedicatory inscription on the attic states that the Senate erected the arch to honor the god Titus, son of the god Vespasian. To underscore Titus's divinity, at the center of the vault of the passageway is a relief (FIG. **7-40A**) showing Titus's apotheosis—a forerunner of the later, more expansive, representation of Antoninus Pius's ascent to Heaven (FIG. **7-1**). The Senate normally

7-40A Apotheosis of Titus, after 81 CE.

proclaimed Roman emperors gods after they died, unless they ran afoul of the senators and were damned. The statues of those who suffered *damnatio memoriae* were torn down, and their names were erased from public inscriptions. This was Nero's fate.

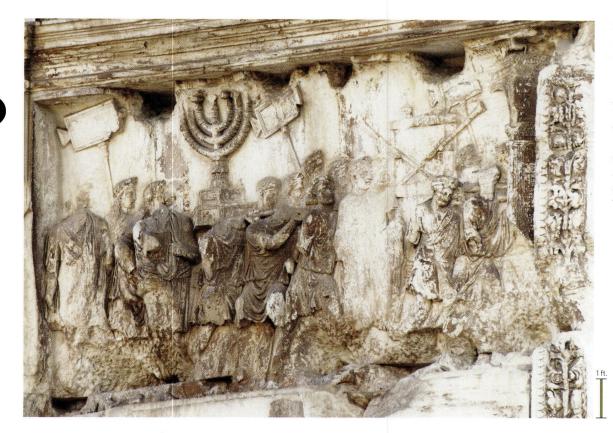

7-41 Spoils of Jerusalem, relief panel in the passageway of the Arch of Titus, Rome, Italy, after 81 CE. Marble, 7' 10" high.

The reliefs inside the bay of the Arch of Titus commemorate the emperor's conquest of Judaea. Here, Roman soldiers carry in triumph the spoils taken from the Jewish temple in Jerusalem.

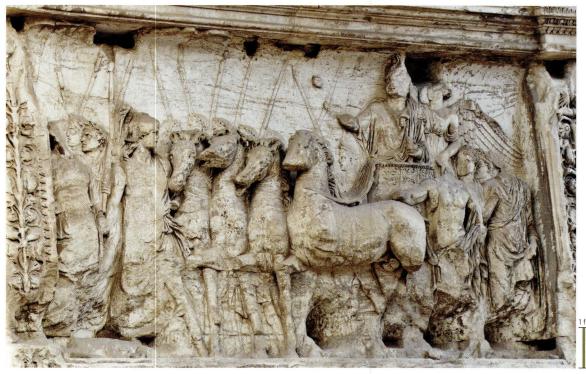

7-42 Triumph of Titus, relief panel in the passageway of the Arch of Titus, Rome, Italy, after 81 CE. Marble, 7' 10" high.

Victory crowns Titus in his triumphal chariot. Also present are personifications of Honor and Valor in this first known instance of the intermingling of human and divine figures in a Roman historical relief.

Inside the passageway of the Arch of Titus are two great relief panels. They represent the triumphal parade of Titus down the Sacred Way after his return from the conquest of Judaea at the end of the Jewish wars in 70 ce. One of the reliefs (FIG. **7-41**) depicts Roman soldiers carrying the spoils—including the sacred seven-branched candelabrum, the *menorah* (compare FIG. 8-5)—from the Jewish temple in Jerusalem. Despite considerable damage to the relief, the illusion of movement is convincing. The parade emerges from the left background into the center foreground and disappears through the obliquely placed arch in the right background. The energy and swing

of the column of soldiers suggest a rapid march. The sculptor rejected the Classical low-relief style of the Ara Pacis (FIG. 7-31) in favor of extremely deep carving, which produces strong shadows. The heads of the forward figures have broken off because they stood free from the block. Their high relief emphasized their different placement in space compared with the heads in low relief, which are intact. The play of light and shadow across the protruding foreground and receding background figures enhances the sense of movement.

On the other side of the passageway, the panel (FIG. 7-42) shows Titus in his triumphal chariot. The seeming historical

accuracy of the spoils panel, which closely corresponds to the contemporaneous description of Titus's triumph by the Jewish historian Josephus (37-ca. 100 cE), gave way in this panel to allegory. Victory rides with Titus in the four-horse chariot and places a wreath on his head. Below her is a bare-chested youth who is probably a personification of Honor (Honos). A female personification of Valor (Virtus) leads the horses. These allegorical figures transform the relief from a record of Titus's battlefield success into a celebration of imperial virtues. A comparable intermingling of divine and human figures characterized the Dionysiac frieze (FIG. 7-18) of the Villa of the Mysteries at Pompeii, but the Arch of Titus panel is the first known instance of divine beings interacting with humans on an official Roman historical relief. (On the Ara Pacis [FIG. 7-29], Aeneas and "Tellus" appear in separate framed panels, carefully segregated from the procession of living Romans.) The Arch of Titus, however, honors the deified Titus, not the living emperor. This kind of interaction between mortals and immortals soon became a staple of Roman narrative relief sculpture, even on monuments erected in honor of living emperors.

HIGH EMPIRE

In the second century CE, under Trajan, Hadrian, and the Antonines, the Roman Empire reached its greatest geographic extent (MAP 7-1) and the height of its power. Rome's might was unchallenged in the Mediterranean world, although the Germanic peoples in Europe, the Berbers in Africa, and the Parthians and Persians in the East constantly applied pressure. Within the Empire's secure boundaries, the Pax Romana meant unprecedented prosperity for all who came under Roman rule.

Trajan

Domitian's extravagant lifestyle and ego resembled Nero's. He demanded to be addressed as dominus et deus ("lord and god"), and so angered the Senate that he was assassinated in 96 CE. The senators chose the elderly Nerva (r. 96-98 CE), one of their own, as emperor. Nerva ruled for only 16 months, but before he died he established a pattern of succession by adoption that endured for almost a century. Nerva picked Trajan, a capable and popular general born in Italica, Spain, as the next emperor. Under Trajan, the first non-Italian to rule Rome, imperial armies brought Roman rule to ever more distant areas, and the imperial government took on ever greater responsibility for its people's welfare by instituting a number of farsighted social programs. Trajan was so popular that the Senate granted him the title Optimus (the Best), an epithet he shared with Jupiter (who was said to have instructed Nerva to choose Trajan as his successor). In time, Trajan, along with Augustus, became the yardsticks for measuring the success of later emperors, who strove to be felicior Augusto, melior Traiano ("luckier than Augustus, better than Trajan").

TIMGAD In 100 CE, as part of his program to extend and strengthen Roman rule on three continents, Trajan founded a new colony for army veterans at Timgad (FIG. 7-43), in what is today Algeria. Like other colonies, Timgad became the physical embodiment of Roman

7-43 Satellite view of Timgad, Algeria, founded 100 CE.

The plan of Trajan's new colony of Timgad in North Africa features a strict grid scheme, with the forum at the intersection of the two main thoroughfares, the cardo and the decumanus

> authority and civilization for the local population. Roman engineers laid out the town with great precision, on the pattern of a Roman military encampment, or castrum, although some scholars think that the castrum plan followed the scheme of Roman colonies, not vice versa. Unlike the sprawling unplanned cities of Rome and Pompeii, Timgad is a square divided into equal quarters by its two colonnaded main streets, the cardo and the decumanus, which cross at right angles. The forum is at the point where the two avenues intersect, and monumental gates marked the ends of both streets. The quarters are subdivided into square blocks, and the forum and public buildings, such as the theater and baths, occupy areas sized as multiples of these blocks. The Roman plan is a modification of the Hippodamian plan of Greek cities (see "Hippodamos's Plan for the Ideal City," page 151), though more rigidly ordered. The Romans laid out most of their new settlements in the same manner, regardless of whether they were in Africa, Mesopotamia, or Britain. This uniformity expresses concretely the centralized power of the Roman Empire at its height. But even the Romans could not regulate human behavior completely. As the satellite view reveals, when the population of Timgad grew sevenfold and burst through the Trajanic colony's walls, the colonists abandoned rational planning, and the city and its streets branched out haphazardly.

> FORUM OF TRAJAN Trajan completed several major building projects in Rome, including the remodeling of the Circus Maximus (FIGS. 7-2, no. 2, and 7-43A), Rome's giant chariot-racing

7-44 APOLLODORUS OF DAMASCUS, Forum of Trajan (restored view), Rome, Italy, dedicated 112 CE (James E. Packer and John Burge). (1) Temple of Trajan, (2) Column of Trajan, (3) libraries, (4) Basilica Ulpia, (5) forum, (6) equestrian statue of Trajan.

Funded by the spoils from two Dacian wars, Rome's largest forum featured a basilica with clerestory lighting, two libraries, a commemorative column (FIG. 7-45), and a temple of the deified Trajan.

7-43A Funerary relief of a circus official, ca. 110–130 ce.

stadium, and the construction of a vast new bathing complex near the Colosseum constructed on top of Nero's Golden House. His most important undertaking, however, was a huge new forum (FIGS. 7-2, no. 7, and 7-44), roughly twice the size of the century-old Forum of

Augustus (FIG. 7-2, no. 10)—even excluding the enormous adjoining market complex.

The new forum glorified Trajan's victories in his two wars against the Dacians in present-day Romania, the spoils of which paid for Trajan's building program in the capital. The architect was Apollodorus of Damascus, Trajan's chief military engineer during the Dacian wars. Apollodorus's plan incorporated the main features of most early fora (Fig. 7-12), except that a huge basilica (Fig. 7-44, no. 4), not a temple, dominated the colonnaded open square. The temple (Fig. 7-44, no. 1; completed after the emperor's death and dedicated to the newest god in the Roman pantheon, Trajan himself) stood instead behind the basilica facing two libraries and a giant commemorative column (Figs. 7-44, no. 2, and 7-45). Entry to Trajan's forum was through an impressive gateway resembling a triumphal arch. (Trajan also erected freestanding triumphal arches in Rome and elsewhere in Italy—for example,

at Benevento [FIG. **7-44A**], northeast of Naples.) Inside the forum were other reminders of Trajan's military prowess. A larger-than-life-size gilded bronze equestrian statue (FIG. 7-44, no. 6) of the emperor stood at the center of the great court in front of the basilica. Statues of captive Dacians stood above the columns of the forum porticos.

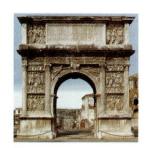

7-44A Arch of Trajan, Benevento, ca. 114–118 ce.

and far more ornate version of the basilica in the forum of Pompeii (FIG. 7-12, no. 3). As shown in FIG. 7-44, no. 4, it had *apses*, or semicircular recesses, on each short end. Two aisles flanked the nave on each side. In contrast to the Pompeian basilica, the Basilica Ulpia was entered through doorways on the long side facing the forum. The building was vast: about 400 feet long (without the apses) and 200 feet wide. Light entered through clerestory windows, made possible by elevating the timber-roofed nave above the colonnaded aisles. In the Republican-era basilica at Pompeii, light reached the nave only indirectly through aisle windows. The clerestory (used more than a thousand years before at Karnak in Egypt; FIG. 3-26) was a much better solution.

PROBLEMS AND SOLUTIONS

The Spiral Frieze of the Column of Trajan

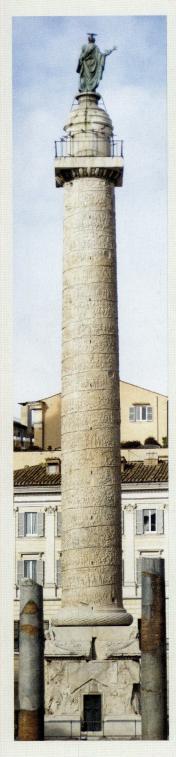

The Column of Trajan (FIG. 7-45) is the only part of the Forum of Trajan preserved in anything approaching its original form. Probably the brainchild of Apollodorus of Damascus, Trajan's official architect and designer of the emperor's forum (FIG. 7-44) and markets (FIGS. 7-46 and 7-47), the column celebrates Trajan's successes in Dacia (roughly equivalent to present-day Romania). The problem Apollodorus faced was how to incorporate a pictorial record of the emperor's military campaigns in a monument—a freestanding column-ill-suited for narrative relief sculpture except on its pedestal. Apollodorus's solution was to invent a new (widely imitated; compare FIGS. 11-25A and 26-3A) artistic mode: a 625-foot frieze winding 23 times around the shaft of Trajan's Column from bottom to

Carving the frieze was a complex process. First, the stonemasons had to fashion enormous marble column drums, hollowed out to accommodate an internal spiral staircase running the entire length of the column shaft. The sculp-

7-45 Column of Trajan (looking west), Forum of Trajan, Rome, Italy, dedicated 112 CE.

The spiral frieze of Trajan's Column tells the story of the Dacian wars in 150 episodes. The reliefs depict all aspects of the campaigns, from battles to sacrifices to road and fort construction.

7-45A Battle scene, Column of Trajan, 112 CE.

7-45B Beheaded Dacians, Column of Trajan, 112 cE.

7-45C Wounded Romans, Column of Trajan, 112 ce.

₹7-45D Fort construction, Column of Trajan, 112 ce.

tors carved the relief scenes after the drums were in place to ensure that the figures and buildings lined up perfectly. The sculptors carved the last scenes in the narrative first, working from the top to the bottom of the shaft so that falling marble chips or a dropped chisel would not damage the reliefs below.

Art historians have likened the sculptured frieze winding around the column to an illustrated scroll (FIG. 3-1) of the type housed in the neighboring libraries (FIG. 7-44, no. 3) of the Forum of Trajan. The reliefs (FIGS. 7-45A, 7-45B, 7-45C, and 7-45D) recount Trajan's two successful campaigns against the Dacians in more than 150 episodes, in which some 2,500 figures appear. The band increases in width as it winds to the top of the column in order to make the upper portions easier to see. Throughout, the relief is very low so as not to distort the contours of the shaft. Paint enhanced the legibility of the figures, but it still would have been very difficult for anyone to follow the narrative from beginning to end.

Easily recognizable compositions such as those found on coin reverses and on historical relief panels—Trajan addressing his troops, sacrificing to the gods, and so on—fill most of the frieze. The narrative is not a reliable chronological account of the Dacian wars, as once thought. The sculptors nonetheless accurately recorded the general character of the campaigns. Notably, battle scenes take up only about a quarter of the frieze. As is true of

modern military operations, the Romans spent more time constructing forts, transporting men and equipment, and preparing for battle than fighting. The focus is always on the emperor, who appears repeatedly in the frieze. From every vantage point, Trajan can be seen directing the military operation. His involvement in all aspects of the Dacian campaigns—and in expanding Rome's empire on all fronts—is one of the central messages of the Column of Trajan.

COLUMN OF TRAJAN Behind the ruins of the Basilica Ulpia still stands, almost perfectly preserved, the 128-foot-tall Column of Trajan (FIG. **7-45**), which once had a heroically nude statue of the emperor at the top. (The present statue of Saint Peter dates to the 16th century.) The tall pedestal, decorated with captured Dacian arms and armor, served as Trajan's tomb. The Column of Trajan is most noteworthy, however, for its spiral frieze (FIGS. 7-45A to

7-45D), which was often copied in antiquity, during the Middle Ages (FIG. 11-25A), and even as late as the 19th century (see "The Spiral Frieze of the Column of Trajan," above).

MARKETS OF TRAJAN On the Quirinal Hill overlooking the forum, Apollodorus built the Markets of Trajan (FIGS. 7-2, no. 8, and **7-46**) to house both shops and administrative offices. As earlier

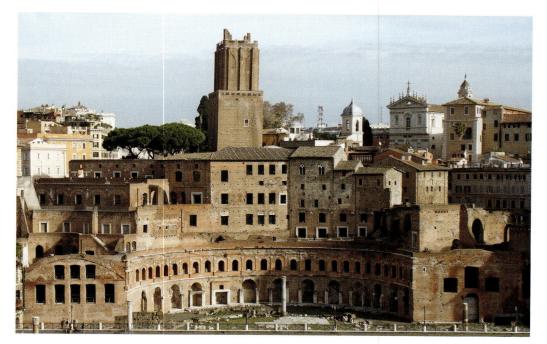

7-46 APOLLODORUS OF DAMASCUS, Markets of Trajan (looking northeast), Rome, Italy, ca. 100–112 CE.

Apollodorus of Damascus used brickfaced concrete to transform the Quirinal Hill overlooking Trajan's forum into a vast multilevel complex of barrel-vaulted shops and administrative offices.

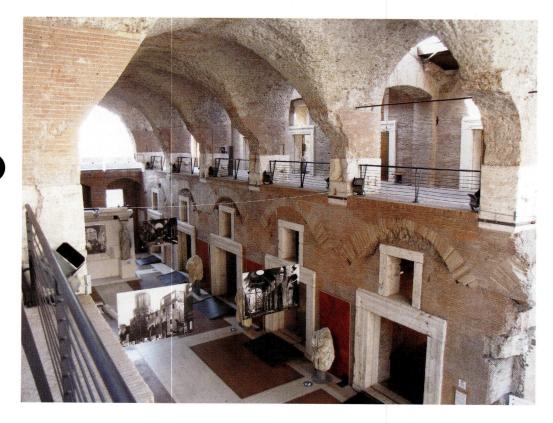

7-47 APOLLODORUS OF DAMASCUS, interior of the great hall, Markets of Trajan, Rome, Italy, ca. 100–112 CE.

The great hall of Trajan's markets resembles a modern shopping mall. It housed two floors of shops, with the upper ones set back and lit by skylights. Concrete groin vaults cover the central space.

at Palestrina (FIG. 7-5), concrete made possible the transformation of a natural slope into a multilevel complex. Trajan's architect was a master of this modern medium as well as of the traditional stone-and-timber post-and lintel architecture of the forum below. The basic unit was the *taberna*, a single-room shop covered by a barrel vault. Each taberna had a wide doorway, usually with a window above it. The shops were on several levels. They opened either onto a concave semicircular facade winding around one of the forum's large exedras, onto a paved street farther up the hill, or onto a great indoor market hall (FIG. 7-47) resembling a modern shopping mall. The hall housed two floors of shops, with the upper shops set back on each side and lit by skylights. Light from the same sources reached the ground-floor shops through arches beneath the great

umbrella-like groin vaults (FIG. 7-6c) covering the hall. (Today, as FIG. 7-47 reveals, the hall serves as a museum housing finds from the area, including those from the fora of Augustus and Trajan.)

Hadrian

Hadrian, Trajan's chosen successor and fellow Spaniard, was a connoisseur and lover of all the arts, as well as an author, architect, and avid hunter (FIG. **7-47A**). He greatly admired Greek

7-47A Hadrianic hunting tondi, ca. 130-138 cE.

7-48 Portrait bust of Hadrian, from Rome, Italy, ca. 117–120 CE. Marble, 1' $4\frac{3}{4}$ " high. Palazzo Massimo alle Terme, Museo Nazionale Romano, Rome.

Hadrian, a lover of all things Greek, was the first Roman emperor to wear a beard. His artists modeled his idealizing official portraits on Classical Greek statues such as Kresilas's Pericles (FIG. 5-42).

culture and traveled widely as emperor, often in the Greek East. Everywhere he went, local officials set up statues and arches in his honor. That is why more portraits of Hadrian exist today than of any

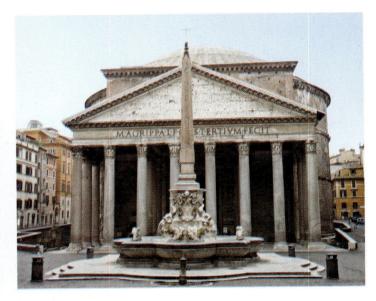

7-49 Pantheon (looking south), Rome, Italy, 118-125 CE.

The Pantheon's traditional facade masked its revolutionary cylindrical drum and its huge hemispherical dome. The interior symbolized both the orb of the earth and the vault of the heavens.

other emperor except Augustus. Hadrian, who was 41 years old at the time of Trajan's death and who ruled for more than two decades, always appears in his portraits as a mature man, but one who never ages. Those likenesses—for example, the marble bust illustrated here (FIG. 7-48)—more closely resemble Kresilas's portrait of Pericles (FIG. 5-42) than those of any Roman emperor before him. Fifthcentury BCE statues also provided the prototypes for the idealized official portraits of Augustus (FIG. 7-27), but the Augustan models were Greek images of youthful athletes (FIG. 5-41). The models for Hadrian's artists were Classical statues of bearded adults (FIG. 5-36). Hadrian's beard was a Greek affectation at the time, but thereafter beards became the norm for all Roman emperors for more than a century and a half.

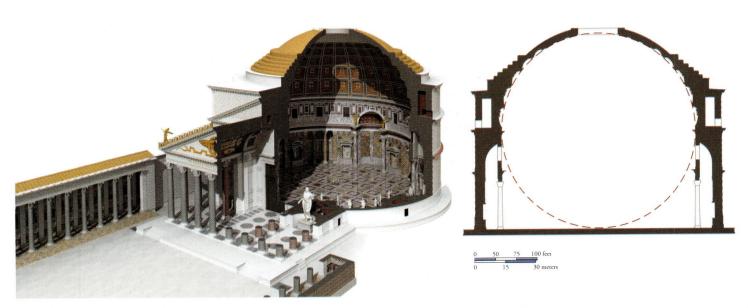

7-50 Restored cutaway view (left) and lateral section (right) of the Pantheon, Rome, Italy, 118-125 CE (John Burge).

Originally, the approach to Hadrian's "temple of all gods" was from a columnar courtyard. Like a temple in a Roman forum (FIG. 7-12), the Pantheon stood at one narrow end of the enclosure.

PROBLEMS AND SOLUTIONS

The Ancient World's Largest Dome

If the design of the dome of Hadrian's Pantheon (FIGS. 7-49 to 7-51) is simplicity itself (a dome whose diameter and height from the floor are equal), executing that design took all the ingenuity of Hadrian's engineers. The builders were faced with the problem of constructing the largest dome in the world up to that time—a feat not surpassed until the 16th century. Their solution was to build up the cylindrical drum level by level using concrete of varied composition. Extremely hard and durable basalt went into the mix for the foundations, and the recipe gradually changed until, at the top of the dome, featherweight pumice replaced stones to lighten the load. The dome's thickness also decreases as it nears the oculus, the circular opening 30 feet in diameter that is the only light source for the interior. The use of coffers (sunken decorative panels) lessened the dome's weight without weakening its structure, further reduced its mass, and even provided a handsome pattern of squares within the vast circle. Renaissance drawings suggest that each coffer once had a glistening gilded-bronze rosette at its center, enhancing the symbolism of the dome as the starry heavens.

Below the dome, much of the original marble veneer of the walls, niches, and floor has survived. In the Pantheon, visitors can appreciate, as almost nowhere else (compare FIG. 7-65), how magnificent the interiors of Roman concrete buildings could be. But despite the luxurious skin of the Pantheon's interior, on first entering the structure, visitors do not sense the weight of the walls but the vastness of the space they enclose. In pre-Roman architecture, the form of the enclosed space was determined by the placement of the solids, which did not so much shape space as interrupt it. Roman architects were the first to conceive of architecture in terms of units of space that could be shaped by the enclosures. The Pantheon's interior is a single unified, self-sufficient whole, uninterrupted by supporting solids. It encloses people without imprisoning them, opening through the oculus to the drifting clouds, the blue sky, the sun, and the gods.

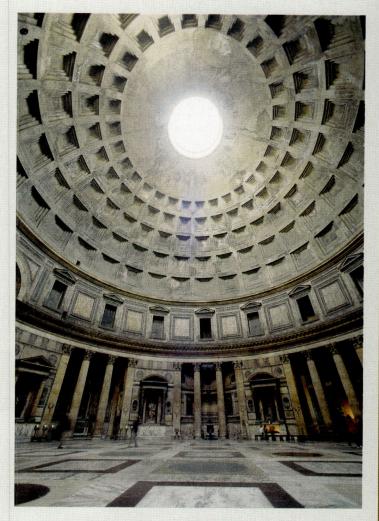

7-51 Interior of the Pantheon (looking south), Rome, Italy, 118-125 CE.

The coffered dome of the Pantheon is 142 feet in diameter and 142 feet high. Light entering through its oculus forms a circular beam that moves across the dome as the sun moves across the sky.

PANTHEON Soon after Hadrian became emperor, work began on the Pantheon (FIGS. 7-2, no. 5, and **7-49**), the temple of all the gods, one of the best-preserved buildings of antiquity. It also has been one of the most influential designs in architectural history. Hadrian did not take credit for the building, however, preferring, as Augustus before him (see "*Res Gestae*," page 197), to dedicate the temple in the name of Marcus Agrippa, who had erected an earlier Pantheon on this site in the late first century BCE. Unfortunately, neither the inscription on the Pantheon facade nor any historical source gives the name of the brilliant architect who in this building revealed the full potential of concrete, both as a construction material and as a means for shaping architectural space.

The original approach to the temple was from a columnar court-yard, and, like a temple in a Roman forum, the Pantheon stood at one narrow end of the enclosure (FIG. **7-50**, *left*). Its facade of eight Corinthian columns—almost all that could be seen from the ancient ground level, which was lower than today's—was a bow to tradition. Everything else about the Pantheon was revolutionary. Behind the columnar porch is an immense concrete cylinder covered by a huge hemispherical

dome (FIG. **7-51**), unseen from the portico. That dome is 142 feet in diameter (see "The Ancient World's Largest Dome," above) and its top is an identical 142 feet from the floor (FIG. 7-50, *right*). The design is thus based on the intersection of two circles (one horizontal, the other vertical). The interior space can be imagined as the orb of the earth, and the dome as the vault of the heavens. The unknown architect enhanced this impression by using light not merely to illuminate the darkness but to create drama and underscore the symbolism of the building's shape. On a sunny day, the light passing through the oculus forms a circular beam, a disk of light that moves across the coffered dome in the course of the day as the sun moves across the sky itself. Escaping from the noise and heat of a Roman summer day into the Pantheon's cool, calm, and mystical immensity is an experience not to be missed.

HADRIAN'S VILLA Although some have speculated that Hadrian himself was the architect of the Pantheon, that is extremely unlikely. The emperor was, however, an amateur architect, and he became deeply involved with the development of the country villa he owned at Tivoli. One of his projects there was the construction of a pool and

WRITTEN SOURCES

Hadrian and Apollodorus of Damascus

Dio Cassius, the third-century cE senator who described the games celebrating the opening of the Colosseum (see page 202) in his history of Rome from its founding to his day, recounted a revealing anecdote about Hadrian and Apollodorus of Damascus, architect of the Forum of Trajan (FIG. 7-44):

Hadrian first drove into exile and then put to death the architect Apollodorus who had carried out several of Trajan's building projects. . . . When Trajan was at one time consulting with Apollodorus about a certain problem connected with his buildings, the architect said to Hadrian, who had interrupted them with some advice, "Go away and draw your pumpkins. You know nothing about these problems." For it so happened that Hadrian was at that time priding himself on some sort of drawing. When he became emperor he remembered this insult and refused to put up with

Apollodorus's outspokenness. He sent him [his own] plan for the temple of Venus and Roma [Fig. 7-2, no. 14], in order to demonstrate that it was possible for a great work to be conceived without his [Apollodorus's] help, and asked him if he thought the building was well designed. Apollodorus sent a [very critical] reply. . . . [The emperor did not] attempt to restrain his anger or hide his pain; on the contrary, he had the man slain.*

The story says a great deal both about the absolute power Roman emperors wielded and about how seriously Hadrian took his architectural designs. But perhaps the most interesting detail is the description of Hadrian's drawings of "pumpkins." These must have been drawings of concrete domes similar to the one in the Serapeum (FIG. 7-52) at Hadrian's Tivoli villa. Such vaults were too adventurous for Apollodorus, or at least for a public building in Trajanic Rome, and Hadrian had to try them out later at home at his own expense.

*Dio Cassius, Roman History, 69.4.1–5. Translated by J. J. Pollitt, The Art of Rome, c. 753 B.C.-A.D. 337: Sources and Documents (New York: Cambridge University Press, 1983), 175–176.

7-52 Canopus and Serapeum (looking south), Hadrian's Villa, Tivoli, Italy, ca. 125–128 CE.

Hadrian was an architect and may have personally designed some buildings at his private villa at Tivoli. The Serapeum features the kind of pumpkin-shaped concrete dome the emperor favored.

an artificial grotto, called the Canopus and Serapeum (FIG. 7-52), respectively. Canopus was an Egyptian city connected to Alexandria by a canal. Its most famous temple was dedicated to the god Serapis. Nonetheless, nothing about the Tivoli design derives from Egyptian architecture. The grotto at the end of the pool is made of concrete and has an unusual pumpkin-shaped dome that Hadrian probably designed himself (see "Hadrian and Apollodorus of Damascus," above). Yet, in keeping with the persistent mixing of styles in Roman art and architecture as well as with Hadrian's love of Greek art, traditional Greek columns and marble copies of famous Greek statues, including the Erechtheion caryatids (FIG. 5-54), lined the pool. The Corinthian colonnade at the curved end of the pool is, however, of a type unknown in Classical Greek architecture. The colonnade not only lacks a superstructure but has arcuated lintels (arch-shaped lintels), as opposed to traditional Greek horizontal lintels, between alternating pairs of columns. This simultaneous respect for Greek architecture and willingness to break the rules of Greek design typifies much Roman architecture of the High and Late Empire.

AL-KHAZNEH An even more extreme example of what many have called Roman "baroque" architecture (because of the striking parallels with 17th-century Italian buildings; see page 702) is the second-century CE tomb nicknamed Al-Khazneh, the "Treasury" (Fig. **7-53**), at Petra, Jordan. It is one of the most elaborate of many tomb facades cut into the sheer rock faces of the local rose-colored mountains. As at Hadrian's Tivoli villa, the architect used Greek architectural elements in a purely ornamental fashion and with a studied disregard for Classical rules.

The Treasury's facade is more than 130 feet high and consists of two stories. The lower story resembles a temple facade with six columns, but the columns are unevenly spaced, and the pediment is only wide enough to cover the four central columns. On the upper level, a temple-within-a-temple sits atop the lower temple. Here the facade and roof split in half to make room for a central tholoslike cylinder, which contrasts sharply with the rectangles and triangles of the rest of the design. On both levels, the rhythmic alternation of deep projection and indentation creates

7-53 Al-Khazneh (Treasury), Petra, Jordan, second century CE.

This rock-cut tomb facade is a prime example of Roman "baroque" architecture. The designer used Greek architectural elements in a purely ornamental fashion and with a studied disregard for Classical rules.

dynamic patterns of light and shadow. At Petra, as at Tivoli, the architect used the vocabulary of Greek architecture, but the syntax is new and distinctively Roman. In fact, the design recalls some of the architectural fantasies painted on the walls of Roman houses—for example, the tholos seen through columns surmounted by a broken pediment (FIG. 7-19, *right*) in the Second Style cubiculum from Boscoreale.

Ostia

The average Roman, of course, did not own a luxurious country villa and was not buried in a grand tomb. About 90 percent of Rome's population of close to one million lived in multistory apartment blocks (*insulae*). After the great fire of 64 CE, these were brick-faced concrete buildings. The rents were not inexpensive, as the law of supply and demand in real estate was just as valid in antiquity as it is today. The Roman satirist Juvenal (ca. 55–ca. 140 CE), writing in the early second century, commented that people willing to give up chariot races and the other diversions Rome had to offer could purchase a fine home in the countryside "for a year's rent in a dark hovel" in a city so noisy that "the sick die mostly from lack of sleep." Conditions were much the same for the inhabitants of Ostia, Rome's harbor city.

After its new port opened under Trajan, Ostia's fortunes boomed, and so did its population. A burst of building activity began under Trajan and continued under Hadrian and throughout the second century CE. Visitors to Ostia today can see temples, a theater, public baths (FIG. **7-53A**), warehouses, and apartment houses that all mirror buildings of similar date in Rome.

₹7-53A Baths of Neptune mosaic, Ostia, ca. 140 ce.

APARTMENT HOUSES The most common buildings in second-century Ostia were its multistory insulae (FIG. **7-54**). Shops occupied the ground floors. Above were up to four floors of apartments. Although many of the apartments were large and had frescoed walls and ceilings, as in the aptly named Insula of the Painted Vaults (FIG. **7-54A**), they had neither the space nor the light of the typical Pompeian private domus (see "The Roman House," page 188). In place of

₹ 7-54A Insula of the Painted Vaults, Ostia, ca. 200–220 ce.

peristyles, insulae had only narrow light wells or small courtyards. Consequently, instead of looking inward, large numbers of windows faced the city's noisy streets. The residents cooked their food in the hallways. Only deluxe apartments had private toilets. Others shared

7-54 Model of an insula, Ostia, Italy, second century CE. Museo della Civiltà Romana, Rome.

Rome and Ostia were densely populated cities, and most Romans lived in multistory brick-faced concrete insulae (apartment houses) with shops on the ground floor. Private toilet facilities were rare.

7-55 Funerary relief of a vegetable vendor, from Ostia, Italy, second half of second century CE. Painted terracotta, 1' 5" high. Museo Archeologico Ostiense, Ostia.

Terracotta plaques illustrating the activities of middle-class merchants frequently adorned Ostian tomb facades. In this relief of a vegetable seller, the artist tilted the counter to display the produce clearly.

7-56 Decursio, pedestal of the Column of Antoninus Pius, Rome, Italy, ca. 161 CE. Marble, 8' $1\frac{1}{2}$ " high. Musei Vaticani, Rome.

In contrast to the apotheosis scene (FIG. 7-1), the decursio reliefs break sharply with Classical art conventions. The ground is the whole surface of the relief, and the figures stand on floating patches of earth.

latrines, often on a different floor from their apartments. Still, these insulae were quite similar to modern apartment houses, which also sometimes have shops on the ground floor.

Another strikingly modern feature of these multifamily residences is their brick facades, which were not concealed by stucco or marble veneers. When builders desired to incorporate a Classical motif, they added brick pilasters or engaged columns, but always left the brick exposed. Ostia and Rome have many examples of apartment houses, warehouses, and tombs with intricate moldings and contrasting colors of brick. In the second century CE, brick came to be appreciated as attractive facing material in its own right.

ISOLA SACRA Brick-faced concrete was also the preferred medium for the tombs in Ostia's Isola Sacra cemetery. The Ostian tombs were not the final resting places of the very wealthy. Rather, they were communal houses for the deceased members of middle-class families. The tombs resembled the multifamily insulae of most Ostians. Small painted terracotta plaques immortalizing the activities of merchants and professional people frequently adorned the facades of those tombs. A characteristic example (FIG. **7-55**) depicts a vegetable seller behind a counter. The artist had little interest in the Classical-revival style that the emperors favored, and tilted the counter forward so that the observer could see the produce clearly. Comparable scenes of daily life appear on Roman funerary reliefs from sites throughout Europe. They were as much a part of the Roman artistic legacy to the later history of Western art as the emperors' monuments, which until recently were the almost exclusive interest of art historians.

The Antonines

Early in 138 CE, Hadrian adopted the 51-year-old Antoninus Pius (r. 138–161 CE). At the same time, he required Antoninus to adopt Marcus Aurelius (r. 161–180 CE) and Lucius Verus (r. 161–169 CE),

thereby assuring a peaceful succession for at least another generation. When Hadrian died later in the year, the Senate proclaimed him a god, and Antoninus Pius became emperor. Antoninus ruled the Roman world with distinction for 23 years. After his death and deification, Marcus Aurelius and Lucius Verus became the Roman Empire's first coemperors and erected a memorial column in their adoptive father's honor.

COLUMN OF ANTONINUS PIUS On the two sides of the pedestal adjacent to the relief (FIG. 7-1) depicting the emperor and empress rising to the heavens from their funerary pyre in the Campus Martius are identical representations of the decursio (FIG. 7-56), or ritual circling of the imperial pyre. The two figural compositions are very different. The apotheosis relief remains firmly in the Classical tradition with its elegant, well-proportioned figures, personifications, and single ground line corresponding to the panel's lower edge. The decursio reliefs, however, break strongly with Classical convention. The figures are much stockier than those in the apotheosis relief, and the sculptor did not conceive the panel as a window onto the world. The ground is the whole surface of the relief, and marching soldiers and galloping horses alike stand on floating patches of earth. This pictorial convention had been used earlier in the art of freedmen (FIG. 7-11A), but not in imperial commissions. After centuries of following the rules of Classical design, elite Roman artists and patrons finally were becoming dissatisfied with them. When seeking a new direction, they adopted some of the non-Classical conventions of the art of freedmen. This stylistic shift, still tentative and used for only one of the compositions on Antoninus's column pedestal, nonetheless represents a major turning point in the history of Roman art.

MARCUS AURELIUS Another break with the past occurred in the official portraits of Marcus Aurelius, although his images retain the pompous trappings of imperial iconography. In a larger-thanlife-size gilded-bronze equestrian statue (FIG. 7-57), the emperor possesses a superhuman grandeur and is much larger than any normal human would be in relation to his horse. Marcus stretches out his right arm in a gesture that is both a greeting and an offer of clemency. Beneath the horse's raised right foreleg, an enemy once cowered, begging the emperor for mercy. The statue is a rare example of an imperial equestrian portrait, but the type was common in antiquity. For example, an equestrian statue of Trajan stood in the middle of his forum (FIG. 7-44, no. 6). Marcus's portrait survived the wholesale melting down of ancient bronze statues during the Middle Ages because it was mistakenly thought to portray Constantine, the first Christian emperor of Rome (see page 225). Perhaps more than any other statuary type, the equestrian portrait expresses the Roman emperor's majesty and authority.

This message of supreme confidence is not, however, conveyed by the portrait head of Marcus's equestrian statue or any of the other portraits of the emperor in the years just before his death. Portraits of aged emperors were not new (FIG. 7-38), but Marcus's were the first ones in which a Roman emperor appeared weary, saddened, and even worried. For the first time, the strain of constant warfare on the frontiers and the burden of ruling a worldwide empire show in the emperor's face. The Antonine sculptor ventured beyond Republican verism, exposing the ruler's character, his thoughts, and his soul for all to see, as Marcus revealed them himself in his *Meditations*, a deeply moving philosophical treatise setting forth the emperor's personal worldview. This too was a major turning point in the history of ancient art, and, coming as it did when relief sculptors were also

7-57 Equestrian statue of Marcus Aurelius, from Rome, Italy, ca. 175 CE. Bronze, 11' 6" high. Palazzo dei Conservatori, Musei Capitolini, Rome.

In this equestrian portrait of Marcus Aurelius as omnipotent conqueror, the emperor stretches out his arm in a gesture of clemency. An enemy once cowered beneath the horse's raised foreleg.

challenging the Classical style (FIG. 7-56), it marked the beginning of the end of Classical art's domination in the Greco-Roman world.

FROM CREMATION TO BURIAL Other profound changes were taking place in Roman art and society at this time. Under Trajan and Hadrian and especially during the rule of the Antonines, Romans began to favor burial over cremation. This reversal of funerary practices may reflect the influence of Christianity and other Eastern religions, whose adherents believed in an afterlife for the human body, as did the ancient Egyptians (see "Mummification and Immortality," page 62). Although the emperors themselves continued to be cremated in the traditional Roman manner, many private citizens opted for burial. Thus they required larger containers for their remains than the ash urns that were the norm until the second century CE. This in turn led to a sudden demand for *sarcophagi*, which are more similar to modern coffins than any other ancient type of burial container.

7-58 Sarcophagus with the myth of Orestes, from Rome, Italy, ca. 140–150 CE. Marble, 2' $7\frac{1}{2}$ " high. Cleveland Museum of Art, Cleveland.

Under the Antonines, Romans began to favor burial over cremation, and sarcophagi became very popular. Themes from Greek mythology, such as the tragic saga of Orestes, were common subjects.

1 ft

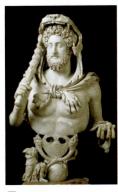

7-57A Commodus as Hercules, ca. 190–192 ce.

ORESTES SARCOPHAGUS Greek mythology was one of the most popular subjects for the decoration of these sarcophagi. In many cases, especially in the late second and third centuries CE, Roman men and women identified themselves on their coffins with Greek heroes and heroines, whose heads often were portraits of the deceased. These private patrons were following the model of imperial portraiture, in which emperors and empresses frequently masqueraded as gods and goddesses and heroes and heroines (see "Role Playing in Roman Portraiture," page 196, and FIG. **7-57A**, a

portrait of Commodus, son and successor of Marcus Aurelius, in the guise of Hercules). An early example of the type (although it lacks any portraits) is a sarcophagus (FIG. **7-58**) now in Cleveland, one of many decorated with the story of the tragic Greek hero Orestes. All the examples of this type use the same basic composition. Orestes appears more than once in every case. Here, at the center, Orestes slays his mother, Clytaemnestra, and her lover, Aegisthus, to avenge

their murder of his father, Agamemnon. At the right, Orestes takes refuge at Apollo's sanctuary at Delphi (symbolized by the god's *tripod*).

The repetition of sarcophagus compositions indicates that Roman sculptors had access to pattern books. In fact, sarcophagus production was a major industry during the High and Late Empire. Several important regional manufacturing centers existed. The sarcophagi produced in the Latin West,

7-59 Asiatic sarcophagus with kline portrait of a woman, from Rapolla, near Melfi, Italy, ca. 165–170 CE. Marble, 5' 7" high. Museo Nazionale Archeologico del Melfese, Melfi.

The Romans produced sarcophagi in several regions. Western sarcophagi have carvings on the front and sides. Eastern sarcophagi, such as this one with a woman's portrait on the lid, feature reliefs also on the back.

such as the Cleveland Orestes sarcophagus, differ in format from those made in the Greek-speaking East. Western sarcophagi have reliefs only on the front and sides, because they were placed in floor-level niches inside Roman tombs. Eastern sarcophagi have reliefs on all four sides and stood in the center of the burial chamber. This contrast parallels the essential difference between the Etrusco-Roman and the Greek temple. The former was set against the wall of a forum or sanctuary and approached from the front, whereas the latter could be reached (and viewed) from every side.

MELFI SARCOPHAGUS An elaborate sarcophagus (FIG. **7-59**) of the Eastern type found at Rapolla, near Melfi in southern Italy, but manufactured in Asia Minor, attests to the vibrant export market for these luxury items in Antonine times. The characteristically Asiatic decoration of all four sides of the marble box consists of statuesque images of Greek deities and heroes in architectural frames. The figures portrayed include Venus and the legendary beauty, Helen of Troy. The lid portrait, which carries on the tradition of Etruscan sarcophagi (FIGS. 6-6, 6-17, and 6-17A), is also a feature of the most expensive Western Roman coffins. Here, the deceased woman reclines on a *kline*, or couch. (The triclinium [FIG. 7-15, no. 7], or dining room, of a

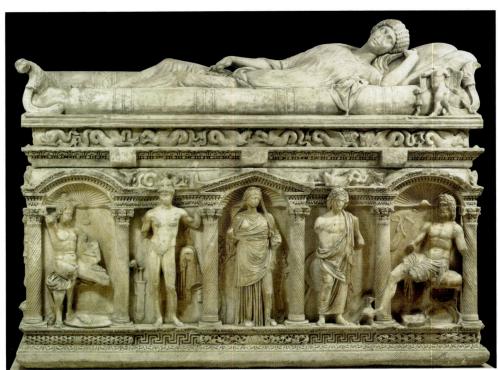

MATERIALS AND TECHNIQUES

Iaia of Cyzicus and the Art of Encaustic Painting

The names of very few Roman artists survive, and the known names tend to be those of artists and architects who directed major imperial building projects (Severus and Celer, Domus Aurea; Apollodorus of Damascus, Forum of Trajan), worked on a gigantic scale (Zenodorus, Colossus of Nero), or made precious objects for famous patrons (Dioscurides, gem cutter for Augustus).

An interesting exception to this rule is laia of Cyzicus. Pliny the Elder reported the following about this renowned painter from Asia Minor who worked in Italy during the Republic:

laia of Cyzicus, who remained a virgin all her life, painted at Rome during the time when M. Varro [116–27 BCE; a renowned Republican scholar and author] was a youth, both with a brush and with a cestrum on ivory, specializing mainly in portraits of women; she also painted a large panel in Naples representing an old woman and a portrait of herself done with a mirror. Her hand was quicker than that of any other painter, and her artistry was of such high quality that she commanded much higher prices than the most celebrated painters of the same period.*

₹7-59A Mummy of Artemidorus, ca. 100-120 cE.

The cestrum Pliny mentioned is a small spatula used in encaustic painting, a technique of mixing colors with hot wax and then applying them to the surface. Pliny knew of encaustic paintings of considerable antiquity, including those of Polygnotos of Thasos (see page 140). The best evidence for the technique comes, however, from Roman Egypt, where mummy cases routinely incorporated encaustic portraits on wood panels (FIGS. 7-59A, 7-60, and 7-60A).

Artists applied encaustic to marble (FIG. 5-63A) as well as to wood. According to Pliny, when Praxiteles was asked which of his statues he preferred, the fourth-century BCE Greek artist, perhaps the ancient world's greatest marble sculptor, replied: "Those that Nikias painted." This anecdote underscores the importance of coloration in ancient statuary.

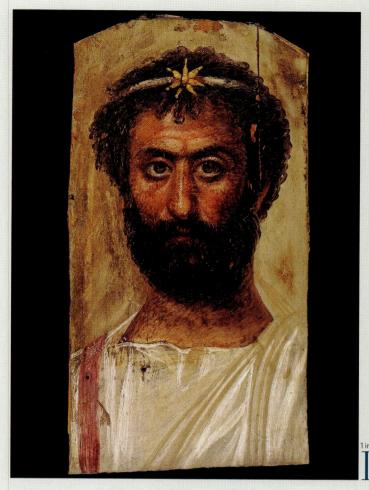

7-60 Mummy portrait of a priest of Serapis, from Hawara (Faiyum), Egypt, ca. 140–160 CE. Encaustic on wood, 1' $4\frac{3}{4}$ " $\times 8\frac{3}{4}$ ". British Museum, London.

In Roman times, the Egyptians continued to bury their dead in mummy cases, but painted portraits replaced the traditional masks. The painting medium is encaustic—colors mixed with hot wax.

*Pliny the Elder, *Natural History*, 35.147–148. Translated by J. J. Pollitt, *The Art of Rome*, c. 753 B.C.-A.D. 337: Sources and Documents (New York: Cambridge University Press, 1983), 87.

†Pliny the Elder, Natural History, 35.133.

Roman house takes its name from the standard arrangement of one dining couch on each of three walls of the room.) With her are her faithful little dog (only its forepaws remain at the left end of the lid) and Cupid (at the right). The winged infant god mournfully holds a downturned torch, a reference to the death of a woman whose beauty rivaled that of his mother, Venus, and of Homer's Helen.

MUMMY PORTRAITS In Egypt, as noted, burial had been practiced for millennia. Even after Augustus reduced the Kingdom of the Nile to a Roman province in 30 BCE, Egyptians continued to bury their dead in mummy cases (for example, FIG. **7-59A**). In Roman times, however, painted portraits on wood panels often replaced the traditional stylized portrait masks (see "Iaia of Cyzicus and the Art of Encaustic Painting," above). One of the hundreds of Roman mummy portraits unearthed in the cemeteries of the Faiyum dis-

trict depicts a priest of the Egyptian god Serapis (FIG. **7-60**). The priest's curly hair and beard closely emulate the Antonine fashion in Rome, but the corkscrew curls of hair on his forehead are distinctive to images of Serapis and his followers. The mummy portrait exhibits the painter's masterful use of the brush and spatula to depict different textures and the play of light over the soft and delicately modeled face. The Faiyum mummies enable art historians to trace the history of portrait painting after Mount Vesuvius erupted in 79 CE. (Compare, for example, FIGS. **7-24** and **7-24A** with FIGS. **7-60** and **7-60A.**)

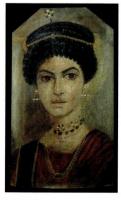

7-60A Young woman, Hawara, ca. 110-120 ce.

LATE EMPIRE

By the time of Marcus Aurelius, two centuries after Augustus established the Pax Romana, Roman power was beginning to erode. The Roman legions found it increasingly difficult to keep order on the frontiers, and even within the Empire, many challenged the authority of Rome. The assassination of Marcus's son Commodus (FIG. 7-57A) in 192 CE brought the Antonine dynasty to an end. The economy was in decline, and the efficient imperial bureaucracy was disintegrating. Even the official state religion was losing ground to Eastern cults, Christianity among them. The Late Empire was a pivotal era in world history, during which the classical world and its multitude of gods gradually gave way to the Christian Middle Ages.

The Severans

Civil conflict followed Commodus's death. When it ended, an African-born general named Septimius Severus (r. 193–211 CE) was master of the Roman world. He succeeded in establishing a new dynasty that ruled the Empire for nearly a half century.

SEVERAN PORTRAITURE Anxious to establish his legitimacy after the civil war, Septimius Severus adopted himself into the Antonine dynasty, declaring that he was Marcus Aurelius's son. It is not surprising, then, that to underscore his fictional lineage, the official portraits of the emperor in bronze and marble depict him with the

long hair and beard of his Antonine "father"—whatever Severus's actual appearance may have been (see "Roman Art as Historical Fiction," page 177). That is also how Severus appears in the only preserved painted portrait (FIG. **7-61**) of an emperor. Discovered in Egypt and painted in *tempera* (pigments in egg yolk) on wood (as were many of the mummy portraits from Faiyum), the portrait is of *tondo* (circular) format. It shows Severus with his wife, Julia Domna, the daughter of a Syrian priest, and their two sons, Caracalla and Geta. Painted likenesses of the imperial family must have been quite common in Italy and the provinces, but their perishable nature explains their almost total loss.

The Severan family portrait is of special interest for two reasons beyond its survival. Severus's hair is tinged with gray, suggesting that his marble portraits—which, like all marble sculptures in antiquity, were painted—also may have revealed his advancing age in this way. (The same was very likely true of the marble likenesses of the elderly Marcus Aurelius.) The group portrait is also notable because of the erasure of Geta's face. When Caracalla (r. 211-217 CE) succeeded his father as emperor, he ordered his younger brother murdered and had the Senate damn Geta's memory. (Caracalla also arranged the death of his own wife, Plautilla.) The Severan family portrait is an eloquent testimony to that damnatio memoriae and to the long arm of Roman authority, which reached all the way to Egypt in this case. This kind of defacement of a rival's image is not unique to ancient Rome, but the Roman government employed damnatio memoriae as a political tool more often and more systematically than any other civilization.

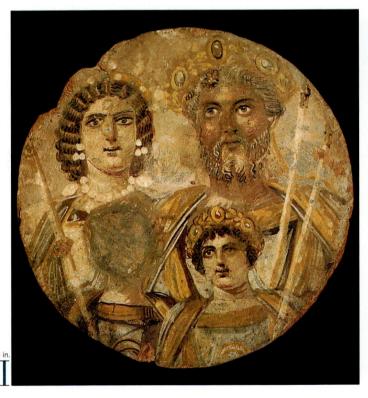

7-61 Painted portrait of Septimius Severus and his family, from Egypt, ca. 200 CE. Tempera on wood, 1' 2" diameter. Altes Museum, Staatliche Museen zu Berlin, Berlin.

The only known painted portrait of an emperor shows Septimius Severus with gray hair. With him are his wife, Julia Domna, and their two sons, but Geta's head was removed after his damnatio memoriae.

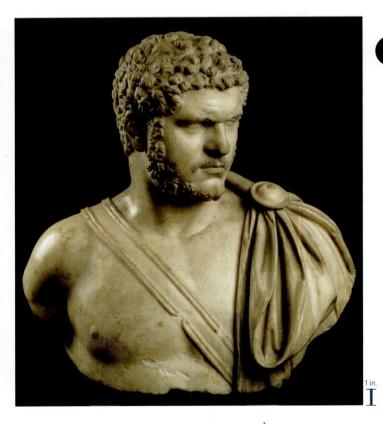

7-62 Bust of Caracalla, ca. 211–217. Marble, 1' $10\frac{3}{4}$ " high. Altes Museum, Staatliche Museen zu Berlin, Berlin.

Caracalla's portraits introduced a new fashion in male coiffure, but are more remarkable for the dramatic turn of the emperor's head and the moving characterization of his personality.

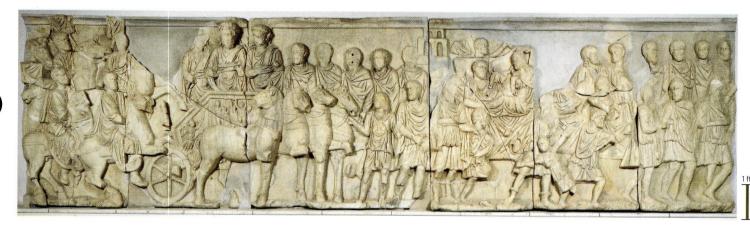

7-63 Chariot procession of Septimius Severus, relief from the attic of the Arch of Septimius Severus, Lepcis Magna, Libya, 203 CE. Marble, 5' 6" high. Castle Museum, Tripoli.

A new non-naturalistic aesthetic emerged in later Roman art. In this relief from a triumphal arch, Septimius Severus and his two sons face the viewer even though their chariot is moving to the right.

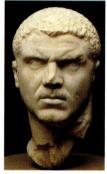

7-62A Caracalla, ca. 211-217 ce.

CARACALLA In the Severan painted tondo, the artist portrayed Caracalla as a boy with long, curly Antonine hair. The portraits of Caracalla (FIGS. **7-62** and **7-62A**) as emperor are very different. In the Berlin bust (FIG. 7-62), Caracalla appears in heroic nudity save for a mantle over one shoulder and a *baldric* across his chest. His hair and beard, although still curly, are much shorter—initiating a new fashion in male coiffure during the third century CE. More remarkable, however, is the moving characterization of Caracalla's personality, a further development from the groundbreak-

ing introspection of the portraits of Marcus Aurelius. Caracalla's brow is knotted, and he abruptly turns his head over his left shoulder. The sculptor probably intended the facial expression and the dramatic movement to suggest energy and strength, but it appears to modern viewers as if Caracalla suspects danger from behind. The emperor had reason to be fearful. An assassin's dagger felled him in the sixth year of his rule. Assassination would be the fate of many Roman emperors during the turbulent third century CE.

LEPCIS MAGNA The hometown of the Severans was Lepcis Magna, on the coast of what is now Libya. In the late second and early third centuries CE, the Severans constructed a modern harbor there, as well as a new forum, basilica, arch, and other monuments. The rebuilt Arch of Septimius Severus has friezes on the attic on all four sides. One (FIG. **7-63**) depicts the chariot procession of the emperor and his two sons on the occasion of their homecoming in 203. Unlike the triumph panel (FIG. 7-42) on the Arch of Titus in Rome, this relief gives no sense of rushing motion. Rather, it has a stately stillness. The chariot and the horsemen behind it move forward, but the emperor and his sons are frozen in place and face the viewer. Also different is the way the figures in the second row, whether on horseback or on foot, have no connection with the ground. The sculptor elevated them above the heads of those in the first row so that they could be seen more clearly.

Both the frontality and the floating figures were new to official Roman art in Antonine and Severan times, but both appeared long before in the private art of freed slaves (FIGS. 7-11 and 7-11A). Once

these non-Classical elements were embraced by sculptors in the emperor's employ, they had a long afterlife, largely (although never totally) displacing the Classical style that the Romans adopted from Greece. As is often true in the history of art, the emergence of this new aesthetic was a by-product of a period of social, political, and economic upheaval. Art historians call this new non-naturalistic, more abstract style the *Late Antique* style.

BATHS OF CARACALLA The Severans were also active builders in the capital. The Baths of Caracalla (FIG. **7-64**) in Rome were the

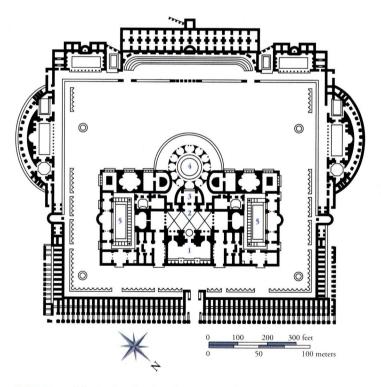

7-64 Plan of the Baths of Caracalla, Rome, Italy, 212–216 CE. (1) natatio, (2) frigidarium, (3) tepidarium, (4) caldarium, (5) palaestra.

Caracalla's baths could accommodate 1,600 bathers. They resembled a modern health spa and included libraries, lecture halls, and exercise courts in addition to bathing rooms and a swimming pool.

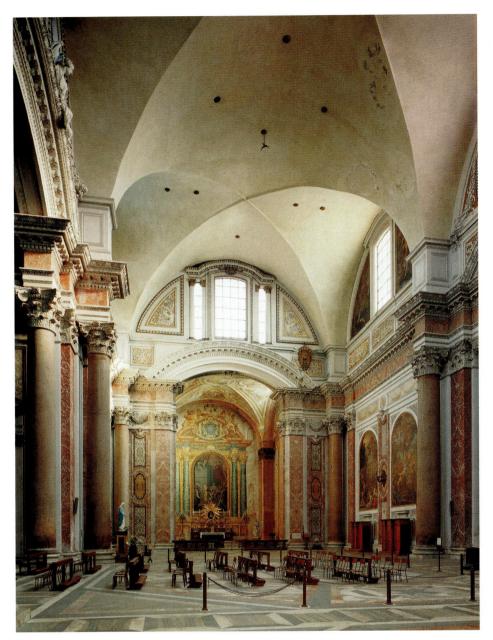

7-65 Frigidarium, Baths of Diocletian, Rome, Italy, ca. 298–306 (remodeled by MICHELANGELO BUONARROTI as the nave of Santa Maria degli Angeli, 1563).

The groin-vaulted nave of the church of Santa Maria degli Angeli in Rome was once the frigidarium of the Baths of Diocletian. It gives an idea of the lavish adornment of imperial Roman baths.

white (compare FIG. 7-53A) and polychrome. One of the statues on display was the 10-foottall marble version of Lysippos's Herakles (FIG. 5-66), whose muscular body must have inspired Romans to exercise vigorously. The concrete vaults of the Baths of Caracalla collapsed long ago, but visitors can approximate the original appearance of the central bathing hall, the frigidarium, by entering the nave (FIG. 7-65) of the church of Santa Maria degli Angeli in Rome, which was once the frigidarium of the later Baths of Diocletian. The Renaissance interior (remodeled in the 18th century) of that church has, of course, many features foreign to a Roman bath, including a painted altarpiece. The ancient mosaics and marble revetment are long gone, but the present-day interior—with its rich wall treatment, colossal columns with Composite capitals, immense groin vaults, and clerestory lighting—provides a better sense of what it was like to be in a Roman imperial bathing complex than does any other building in the world. It takes a powerful imagination to visualize the original appearance of Roman concrete buildings from the pathetic ruins of brick-faced walls and fallen vaults at ancient sites today, but Santa Maria degli Angeli (and the Pantheon, FIG. 7-51) make the task much easier.

greatest in a long line of bathing and recreational complexes constructed, beginning with Augustus, with imperial funds to win the public's favor. Caracalla's baths dwarfed the typical baths of cities and towns such as Ostia (FIG. 7-54A) and Pompeii. All the rooms had thick, brick-faced concrete walls up to 140 feet high, covered by enormous concrete vaults. The design was symmetrical along a central axis, facilitating the Roman custom of taking sequential plunges in warm-, hot-, and cold-water baths in, respectively, the tepidarium, caldarium, and frigidarium. The caldarium (FIG. 7-64, no. 4) was a huge circular chamber with a concrete drum even taller than the Pantheon's (FIGS. 7-49 to 7-51) and a dome almost as large. Caracalla's 50-acre bathing complex also included landscaped gardens, lecture halls, libraries, colonnaded exercise courts (palaestras), and a giant swimming pool (natatio). Archaeologists estimate that up to 1,600 bathers at a time could enjoy this Roman equivalent of a modern health spa. A branch of one of the city's major aqueducts supplied water, and furnaces circulated hot air through hollow floors and walls throughout the bathing rooms.

The Baths of Caracalla also featured stuccoed vaults, marble-faced walls, marble statuary, and mosaic floors—both black-and-

The Soldier Emperors

The Severan dynasty ended with the murder of Severus Alexander (r. 222–235 ce). The next half century was one of almost continuous civil war. The Roman legions declared as emperor one general after another, only to have each murdered in turn by another general a few years or even a few months later. (In the year 238, two coemperors selected by the Senate were dragged from the imperial palace and murdered in public after only three months of rule.) In such unstable times, no emperor could begin ambitious architectural projects. The only significant building activity in Rome during the era of the "soldier emperors" occurred under Aurelian (r. 270–275 ce). He constructed a new defensive circuit wall for the capital—a military necessity and a poignant commentary on the decay of Roman power.

TRAJAN DECIUS If architects went hungry in third-century Rome, engravers and sculptors had much to do. The mint produced great quantities of coins (in debased metal) to ensure that the troops could be paid with money stamped with the current emperor's

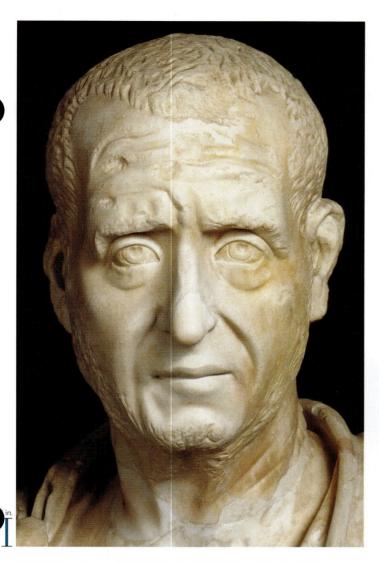

7-66 Portrait bust of Trajan Decius, 249–251 CE. Marble, full bust 2' 7" high. Museo Capitolino, Musei Capitolini, Rome.

This portrait of a short-lived soldier emperor depicts an older man with bags under his eyes and a sad expression. The eyes glance away nervously, reflecting the anxiety of an insecure ruler.

portrait and not with the likeness of his predecessor or rival. Each new ruler set up portrait statues and busts everywhere to assert his authority. The sculpted portraits of the third century CE are among the most moving ever made, as notable for their emotional content as they are for their technical virtuosity. Portraits of Trajan Decius (r. 249–251 CE), such as the marble bust illustrated here (FIG. **7-66**), show the emperor best known for persecuting Christians as an old man with bags under his eyes and a sad expression. The eyes glance away nervously rather than engage the viewer directly, revealing the anxiety of a man who knows he can do little to restore order to an out-of-control world. The sculptor modeled the marble as if it were pliant clay, compressing the sides of the head at the level of the eyes, etching the hair and beard into the stone, and chiseling deep lines in the forehead and around the mouth. The portrait reveals the anguished soul of the man—and of the times.

TREBONIANUS GALLUS Portraits of Decius's short-lived predecessor, Philip the Arabian (r. 244–249 CE), and successor, Trebonia-

nus Gallus (r. 251–253 ce), also have survived. Philip's busts (Fig. **7-66A**) are marble and typical of the era, but the portrait of Trebonianus illustrated here (Fig. **7-67**) is a larger-than-life-size bronze statue. Trebonianus, who ruled Rome for only two years, appears in heroic nudity, as had so many emperors and generals (Fig. 7-9) before him. His physique, however, is not that of the strong but graceful Greek athletes whom Augustus and

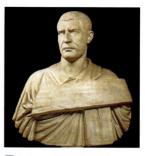

7-66A Philip the Arabian, 244-249 cE.

his successors admired so much. Instead, his is a wrestler's body with massive legs and a swollen trunk. The heavyset body dwarfs the head, with its nervous expression. In this portrait, the Greek ideal of the keen mind in the harmoniously proportioned body gave way to an image of brute force—an image well suited to the age of the soldier emperors.

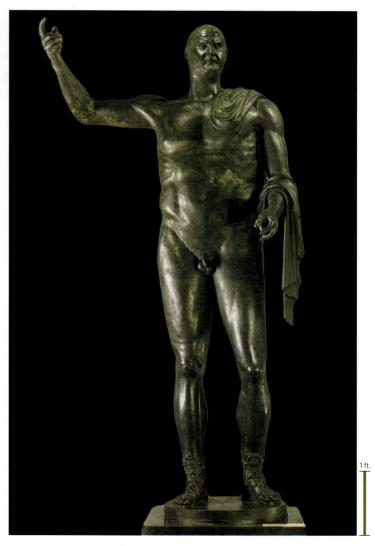

7-67 Heroic portrait of Trebonianus Gallus, from Rome, Italy, 251–253 CE. Bronze, 7' 11" high. Metropolitan Museum of Art, New York.

In this over-life-size heroically nude statue, Trebonianus Gallus projects an image of brute force. He has the massive physique of a powerful wrestler, but his face expresses nervousness.

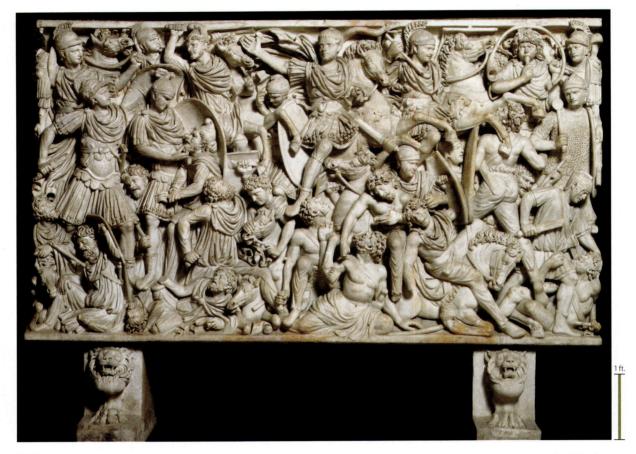

7-68 Battle of Romans and barbarians (*Ludovisi Battle Sarcophagus*), from Rome, Italy, ca. 250–260 CE. Marble, 5' high. Palazzo Altemps, Museo Nazionale Romano, Rome.

A chaotic scene of battle between Romans and barbarians decorates the front of this sarcophagus. The sculptor piled up the writhing, emotive figures in an emphatic rejection of Classical perspective.

LUDOVISI BATTLE SARCOPHAGUS By the third century CE, burial of the dead had become so widespread that even the imperial family practiced it in place of cremation. Sarcophagi were more popular than ever. The unusually large sarcophagus illustrated here (Fig. **7-68**) was discovered in Rome in 1621 and purchased by Cardinal Ludovico Ludovisi (1595–1632), a great collector of antiquities. On the front of the *Ludovisi Battle Sarcophagus* is a chaotic scene of Romans fighting one of their northern foes, probably the Goths. The sculptor spread the writhing and highly emotive figures evenly across the entire relief, with no illusion of space behind them. This piling of figures is an even more extreme rejection of Classical perspective than was the use of floating ground lines in the decursio panel (Fig. 7-56) of the Column of Antoninus Pius. It underscores the increasing dissatisfaction of Late Antique artists with the Classical style.

Within this dense mass of intertwined bodies, the central horseman stands out vividly. He wears no helmet and thrusts out his open right hand to demonstrate that he holds no weapon. Several scholars have identified him as one of the sons of Trajan Decius. In an age when the Roman army was far from invincible and Roman emperors were constantly felled by other Romans, the young general on the *Ludovisi Battle Sarcophagus* boasts that he is a fearless commander assured of victory. His self-assurance may stem from his having embraced one of the increasingly popular Oriental mystery religions. On the youth's forehead, the sculptor carved the emblem of Mithras, the Persian god of light, truth, and victory over death.

PHILOSOPHER SARCOPHAGUS The insecurity of the times led some Romans to seek solace in philosophy. On many third-century sarcophagi, the deceased assumed the role of the learned intellectual. One especially large example (FIG. **7-69**) depicts a seated Roman philosopher holding a scroll. Two standing women (also with portrait features) gaze at him from left and right, confirming his importance. In the background are other philosophers, students or colleagues of the central deceased teacher. The two women may be the deceased's wife and daughter, two sisters, or some other combination of family members. The composition, with a frontal central figure and two subordinate flanking figures, is typical of the Late Antique style (compare FIG. 7-63). This type of sarcophagus became popular for Christian burials. Sculptors used the wise-man motif to portray not only the deceased (FIG. 8-7) but also Christ flanked by saints (FIG. 8-1b).

BAALBEK Significant deviations from the norms of Classical art also are evident in third-century architecture. At Baalbek in present-day Lebanon, the architect of the Temple of Venus (Fig. **7-70**), following in the "baroque" tradition of the Petra Treasury (Fig. 7-53), ignored almost every rule of Classical design. Although made of stone, the building, with its circular domed cella set behind a gabled columnar facade, is in many ways a critique of the concrete Pantheon (Fig. 7-49), which by then had achieved the status of a "classic." Many features of the Baalbek temple intentionally depart from the norm. The platform, for example, is scalloped all

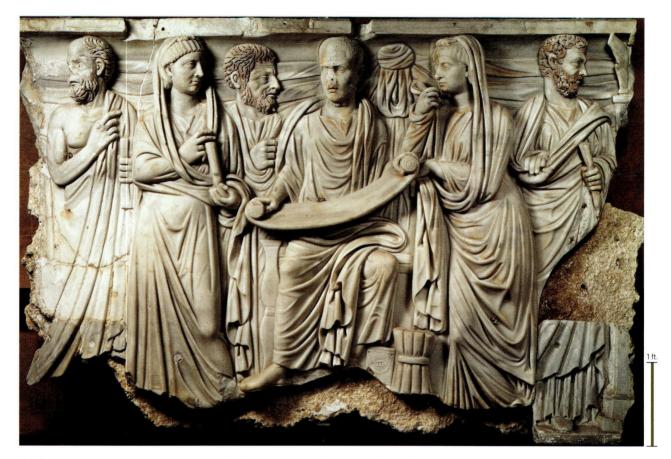

7-69 Sarcophagus of a philosopher, ca. 270-280 CE. Marble, 4' 11" high. Musei Vaticani, Rome.

On many third-century cE sarcophagi, the deceased appears as a learned intellectual. Here, the seated philosopher is the central frontal figure. His two female muses also have portrait features.

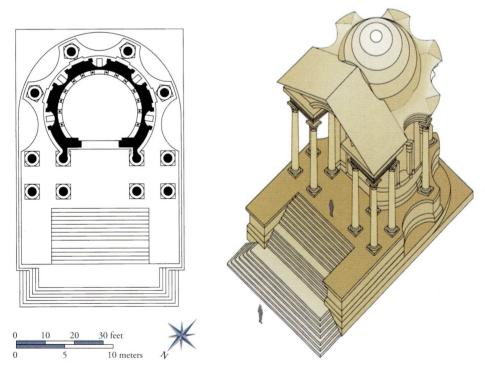

7-70 Plan (*left*) and restored view (*right*) of the Temple of Venus, Baalbek, Lebanon, third century CE.

This "baroque" temple violates almost every rule of Classical design. It has a scalloped platform and entablature, five-sided Corinthian capitals, and a facade with an arch inside the pediment.

around the cella. The columns—the only known instance of five-sided Corinthian capitals with corresponding pentagonal bases—support a matching scalloped entablature (which serves to buttress the shallow stone dome). These concave forms and those of the niches in the cella walls play off against the cella's convex shape. Even the "traditional" facade of the Baalbek temple is eccentric. The unknown architect inserted an arch within the triangular pediment.

Diocletian and the Tetrarchy

In an attempt to restore order to the Roman Empire, Diocletian (r. 284–305 cE), whose troops proclaimed him emperor, decided to share power with his potential rivals. In 293, he established the *tetrarchy* (rule by four) and adopted the title of Augustus of the East. The other three *tetrarchs* were a corresponding Augustus of the West, and Eastern and Western Caesars (whose allegiance to the two Augusti was cemented by marriage to their daughters). The four coemperors ruled without strife until Diocletian retired in 305, and they often appeared together in group

PROBLEMS AND SOLUTIONS

Tetrarchic Portraiture

With the establishment of the tetrarchy in 293 cE, the sculptors in the emperors' employ suddenly had to grapple with a new problem—namely, how to represent four individuals who oversaw different regions of a vast empire but were equal partners in power. Although in life the four tetrarchs were rarely in the same place, in art they usually appeared together, both on coins and in statues. Artists did not try to capture their individual appearances and personalities—the norm in portraiture of the preceding soldier emperors (FIGS. 7-66, 7-66A, and 7-67)—but sought instead to represent the power-sharing nature of the tetrarchy itself.

The finest extant tetrarchic portraits are the two pairs of porphyry (purple marble) statues (Fig. 7-71) that have since medieval times adorned the southwestern corner of the great church (Fig. 9-27) dedicated to Saint Mark in Venice. In this and similar tetrarchic group portraits, it is impossible to name the rulers. Each of the four emperors has lost his identity as an individual and been absorbed into the larger entity of the tetrarchy.

All the tetrarchs are identically clad in cuirass and cloak. Each grasps a sheathed sword in his left hand. With their right arms, the corulers embrace one another in an overt display of concord. The figures, like those on the decursio relief (FIG. 7-56) of the Column of Antoninus Pius, have large cubical heads and squat bodies. The drapery is schematic, the bodies are shapeless, and the faces are emotionless masks, distinguished only by the beards of two of the tetrarchs (probably the older Augusti, differentiating them from the younger Caesars). Other than the presence or absence of facial hair, each pair is as alike as free-hand carving can achieve.

In this group portrait, carved eight centuries after Greek sculptors first freed the human form from the rigidity of the Egyptian-inspired kouros stance, an artist or artists once again conceived the human figure in iconic terms. Idealism, naturalism, individuality, and personality have disappeared.

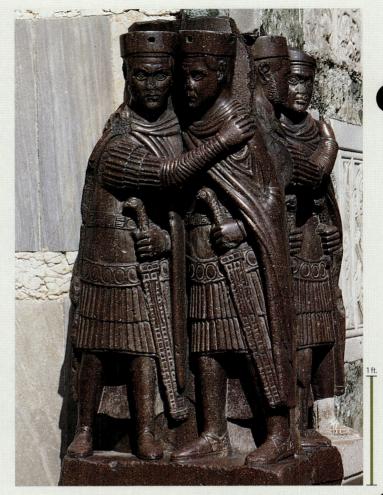

7-71 Portraits of the four tetrarchs, from Constantinople, ca. 300 CE. Porphyry, 4' 3" high. Saint Mark's, Venice.

Diocletian established the tetrarchy to bring order to the Roman world. In group portraits, artists always depicted the four corulers as nearly identical partners in power, not as distinct individuals.

portraits (FIG. **7-71**) to underscore their harmonious partnership (see "Tetrarchic Portraiture," above). Without Diocletian's leadership, however, the tetrarchic form of government collapsed, and renewed civil war followed. Nonetheless, the division of the Roman Empire into eastern and western spheres persisted throughout the Middle Ages, setting the Greek East (Byzantium) apart from the Latin West.

PALACE OF DIOCLETIAN When Diocletian abdicated in 305, he returned to his birthplace, Dalmatia (roughly the former Yugoslavia), where he built a palace (FIG. 7-72) at Split on the Adriatic coast. Just as Aurelian had felt it necessary to girdle Rome with fortress walls, Diocletian instructed his architects to provide him with a walled suburban palace. The fortified complex, which covers about 10 acres, has the layout of a Roman castrum, complete with watchtowers flanking the gates. It gave the retired emperor a sense of security in the most insecure of times.

Within the high walls, two avenues (comparable to the cardo and decumanus of a Roman city; FIG. 7-43) intersected at the palace's center. Where a city's forum would have been situated, Diocletian's palace had a colonnaded court leading to the entrance to the imperial residence, which had a templelike facade with an arch within

its pediment, as in Baalbek's Temple of Venus (FIG. 7-70). Diocletian presented himself as if he were a god in his temple when he appeared before those who gathered in the court to pay homage to him. On one side of the court was a Temple of Jupiter. On the other side was Diocletian's domed octagonal *mausoleum* (FIG. 7-72, *center right*), which towered above all the other structures in the complex. Domed tombs of this type became very popular in Late Antiquity not only for mausoleums but eventually also for churches, especially in the Byzantine Empire (FIGS. 9-10 and 9-11). In fact, Diocletian's mausoleum is a church today.

Constantine

An all-too-familiar period of conflict followed the short-lived concord among the tetrarchs that ended with Diocletian's abdication. This latest war among rival Roman armies lasted two decades. The eventual victor was Constantine I, son of Constantius Chlorus, Diocletian's Caesar of the West. After the death of his father, Constantine (r. 306–337 CE), later called Constantine the Great, invaded Italy. In 312 CE, in a decisive battle at Rome's Milvian Bridge, he defeated and killed Maxentius and took control of the capital. Con-

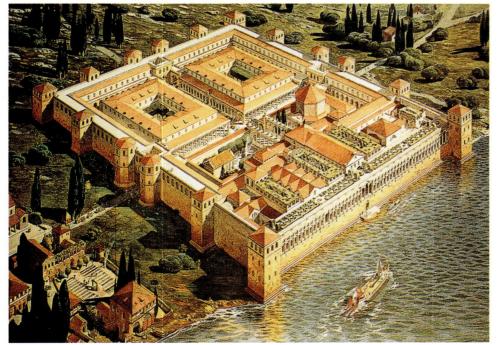

Diocletian, Split, Croatia, ca. 298–306.

Diocletian's palace resembled a fortified Roman city (compare Fig. 7-43). Within its high walls,

7-72 Restored view of the palace of

city (compare FIG. 7-43). Within its high walls, two avenues intersected at the forumlike colonnaded courtyard leading to the emperor's residential quarters.

the Roman Empire. From this point on, the ancient cults declined rapidly. Constantine dedicated Constantinople on May 11, 330, "by the commandment of God," and in 337 the emperor was baptized on his deathbed. For many scholars, the transfer of the seat of power from Rome to Constantinople and the recognition of Christianity mark the end of antiquity and the beginning of the Middle Ages.

Constantinian art is a mirror of this transition from the ancient to the medieval world. In Rome, for example, Constantine was a builder in the grand tradition of the

emperors of the first, second, and early third centuries, erecting public baths, a basilica on the road leading into the Roman Forum, and a triumphal arch. But he was also the patron of the city's first churches (see page 240).

ARCH OF CONSTANTINE Between 312 and 315, the Senate erected a grandiose triple-passageway arch (FIGS. 7-2, no. 15, and **7-73**) next to the Colosseum to commemorate Constantine's defeat of Maxentius. The arch was the largest erected in Rome since the end of

the Severan dynasty. The builders, however, took much of the sculptural decoration from earlier monuments of Trajan, Hadrian (FIG. 7-47A), and Marcus Aurelius, and all of the columns and other architectural elements date to an earlier era. Constantine's sculptors refashioned the second-century reliefs to honor him by recutting the heads of the earlier emperors with his features. They also added labels to the old reliefs, such as Liberator Urbis (Liberator of the City) and Fundator Quietus (Bringer of Peace), references to the downfall of Maxentius and the end of civil war. Art historians have often cited this reuse of statues and reliefs as evidence of a decline in creativity and technical skill in the Late Roman Empire. Although such a judgment is in part deserved, it

stantine attributed his victory to the aid of the Christian god. The next year, he and Licinius, Constantine's coemperor in the East, issued the Edict of Milan, ending the persecution of Christians.

In time, Constantine and Licinius became foes, and in 324 Constantine defeated and executed Licinius near Byzantium (modern Istanbul, Turkey). Constantine, now unchallenged ruler of the whole Roman Empire, founded a "New Rome" at Byzantium and named it Constantinople (City of Constantine). In 325, at the Council of Nicaea, Christianity became the de facto official religion of

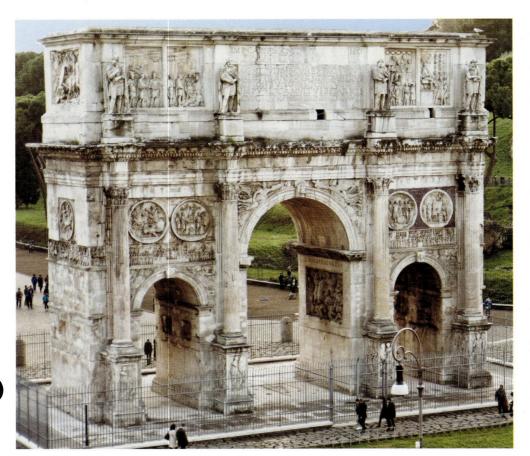

7-73 Arch of Constantine (looking southwest), Rome, Italy, 312–315 CE.

Much of the sculptural decoration of Constantine's arch came from monuments of Trajan, Hadrian, and Marcus Aurelius. Sculptors recut the heads of the earlier emperors to substitute Constantine's features.

7-74 Distribution of largesse, detail of the north frieze of the Arch of Constantine, Rome, Italy, 312–315 CE. Marble, 3' 4" high.

This Constantinian frieze is less a narrative of action than a picture of actors frozen in time.

The composition's rigid formality reflects the new values that would come to dominate medieval art.

ignores the fact that the reused sculptures, or *spolia* ("spoils"), were carefully selected to associate Constantine with the "good emperors" of the second century CE. One of the arch's few Constantinian reliefs (FIG. 7-47A, *bottom*), underscores that message. It shows Constantine on the speaker's platform in the Roman Forum between statues of Hadrian and Marcus Aurelius.

In another Constantinian relief (FIG. 7-74), the emperor distributes largesse to grateful citizens, who approach him from

right and left. Constantine is a frontal and majestic presence, elevated on a throne above the recipients of his generosity. The figures are squat in proportion, as are the tetrarchs (FIG. 7-71). They move, not according to any Classical principle of naturalistic motion, but, rather, with the mechanical and repeated stances and gestures of puppets. The relief is very shallow, the forms are not fully modeled, and the details are incised. The frieze is less a narrative of action than a picture of actors frozen in time so that the viewer can instantly distinguish the all-important imperial donor (the largest figure, enthroned at the center) from his attendants (to the left and right above) and the recipients of the largesse (below), both of smaller stature than the emperor.

An eminent art historian once characterized this approach to pictorial narrative as a "decline of form," and when judged by the standards of Classical art, it was. But the composition's rigid formality, determined by the rank of those portrayed, was consistent with a new set of values. It soon became the preferred mode, supplanting the Classical notion that a picture is a window onto a world of anecdotal action. Comparing this Constantinian relief with a Byzantine icon (FIG. 9-19) reveals that the compositional principles of the Late Antique style became those of early medieval art. They were very different from, but not "better" or "worse" than, those of Greco-Roman art. The Arch of Constantine is the quintessential monument of its era, exhibiting a respect for the past in its use of second-century spolia while rejecting the norms of Classical design in its frieze and thereby paving the way for the iconic art of the Middle Ages.

COLOSSUS OF CONSTANTINE After Constantine's victory over Maxentius, his official portraits broke with tetrarchic tradition as well as with the style of the soldier emperors, and resuscitated the Augustan image of a perpetually youthful head of state. The most impressive of Constantine's preserved portraits is an eight-and-one-half-foot-tall head (Fig. 7-75), one of several fragments of a colossal enthroned statue of the emperor composed of a brick core, a wood torso covered with bronze, and a head and limbs of marble. Constantine's artist modeled the seminude seated portrait on Roman images of Jupiter. The emperor held an orb (possibly surmounted by the cross of Christ), the symbol of global power, in his extended left hand. The sideways glance of third-century portraits is absent, replaced by a frontal mask with enormous eyes set into the broad and simple planes of the head. The emperor's personality is lost in this immense image

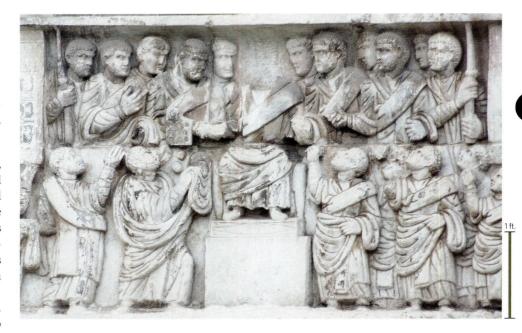

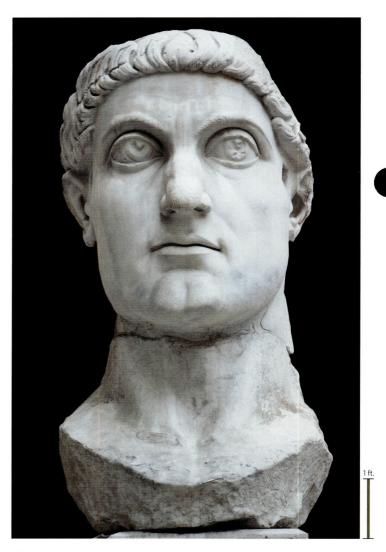

7-75 Portrait of Constantine, from the Basilica Nova, Rome, Italy, ca. 315–330 CE. Marble, 8' 6" high. Palazzo dei Conservatori, Musei Capitolini, Rome.

Constantine's portraits revive the Augustan image of a perpetually youthful ruler. This colossal head is one fragment of an enthroned Jupiter-like statue of the emperor holding the orb of world power.

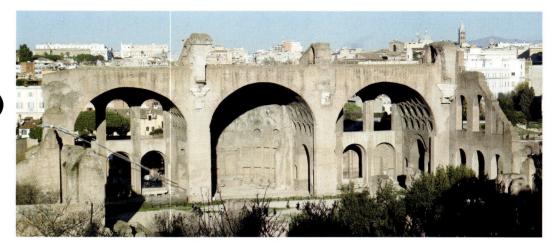

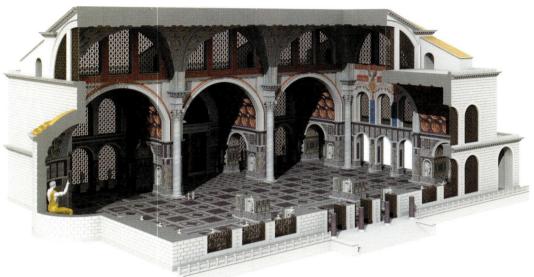

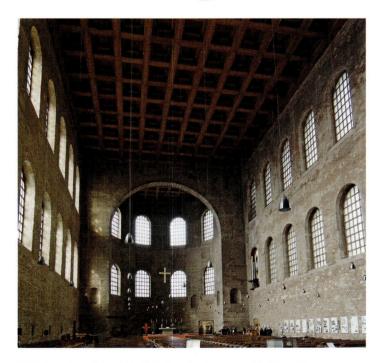

7-77 Interior of the Aula Palatina (looking north), Trier, Germany, early fourth century CE.

The interior of the audience hall of Constantine's palace in Germany resembles a timber-roofed basilica with an apse at one end, but it has no aisles. The large windows provide ample illumination.

7-76 Basilica Nova, Rome, Italy, ca. 306–312 CE. *Top*: looking northeast; *bottom*: restored cutaway view (John Burge).

Roman builders applied the lessons learned constructing baths and market halls to the Basilica Nova, in which fenestrated concrete groin vaults replaced the clerestory of a stoneand-timber basilica.

of eternal authority. The colossal size, the likening of the emperor to Jupiter, the eyes directed at no person or thing of this world—all combine to produce a formula of overwhelming power appropriate to Constantine's exalted position as absolute ruler.

BASILICA NOVA Constantine's gigantic portrait sat in the western apse of the Basilica Nova (New Basilica) in Rome (FIGS. 7-2, no. 12, and 7-76), a project Maxentius had begun and Constantine completed. From its position in the apse, the emperor's image dominated the interior of the basilica in much the same way that statues of Greco-Roman divinities loomed over awestruck mortals in temple cellas (compare FIG. 5-46).

The Basilica Nova ruins (FIG. 7-76, *top*) never fail to impress tourists with their size and mass. The original structure was 300 feet long and 215 feet wide. Brick-faced concrete walls 20 feet thick supported coffered barrel vaults in the aisles. These vaults also buttressed the groin vaults of the nave, which was 115 feet high. Marble slabs and stuccoes covered the walls and floors. The reconstruction (FIG. 7-76, *bottom*) effectively suggests the immensity of the interior, where the great vaults dwarf even the emperor's colossal portrait. The drawing also clearly reveals the *fenestration* of the groin vaults (FIG. 7-6c), a lighting system akin to the clerestory of a traditional stone-and-timber basilica. The architect here applied to basilica design the lessons learned in the design and construction of such buildings as Trajan's great market hall (FIG. 7-47) and the Baths of Caracalla and Diocletian (FIG. 7-65).

AULA PALATINA Few architects, however, followed suit. At Trier on the Moselle River in Germany, the imperial seat of Constantius Chlorus as Caesar of the West, Constantine built a traditional basilica-like audience hall, the Aula Palatina, as part of his new palace complex. The Trier basilica measures about 190 feet long and 95 feet wide. Inside (FIG. **7-77**), the audience hall was very simple, unlike the contemporaneous Basilica Nova in Rome. Its flat, coffered wood ceiling is some 95 feet above the floor. The interior has no aisles, only a wide space with two stories of large windows that provide ample light. At the narrow north end, a *chancel arch* divides the main hall from the semicircular apse (which also has a flat ceiling). The Aula Palatina's interior is quite severe, although mosaics and marble plaques

7-78 Exterior of the Aula Palatina (looking southeast), Trier, Germany, early fourth century CE.

The austere brick exterior of Constantine's Aula Palatina at Trier is typical of later Roman architecture. Two stories of windows with lead-framed panes of glass take up most of the surface area.

originally covered the arch and apse to provide a magnificent frame for the enthroned emperor.

The exterior (FIG. **7-78**) of the Trier basilica is also austere, with brick walls enlivened somewhat by highlighting in grayish-white stucco. The use of lead-framed panes of glass for the windows enabled the builders to give life and movement to the blank exterior surfaces. The design of the exterior of the Aula Palatina has close parallels in many Early Christian churches (FIG. 8-18, bottom).

CONSTANTINIAN COINS The two portraits of Constantine on the coins in FIG. **7-79** reveal both the essential character of Roman imperial portraiture and the special nature of Constantinian art. The first

(FIG. 7-79, *left*) dates shortly after the death of Constantine's father, when Constantine was in his early 20s and his position was still insecure. Here, in his official portrait, he appears considerably older, because he adopted the imagery of the tetrarchs. Indeed, were it not for the accompanying label identifying this Caesar as Constantine, it would be impossible to know whom the coin engraver portrayed. Eight years later (FIG. 7-79, *right*)—after the defeat of Maxentius and the Edict of Milan—Constantine, now the unchallenged Augustus of the West, is clean-shaven and looks his real age, having rejected the mature tetrarchic look in favor of youth. These two coins should dispel any uncertainty about the often fictive nature of imperial portraiture and the ability of Roman emperors to choose any official image that suited their needs. In Roman art, "portrait" is often not synonymous with "likeness."

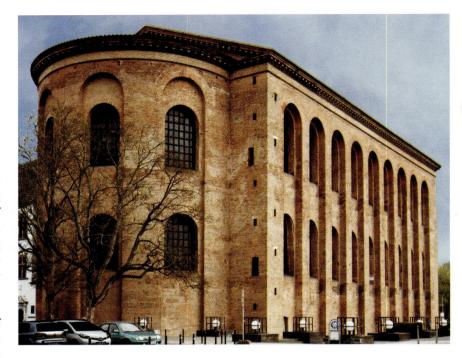

The later coin is also an eloquent testimony to the dual nature of Constantinian rule. The emperor appears in his important role as *imperator*, dressed in armor, wearing an ornate helmet, and carrying a shield bearing the enduring emblem of the Roman state—the she-wolf nursing Romulus and Remus (compare Fig. 6-12 and Roma's shield in Fig. 7-1c). Yet he does not carry the traditional eagle-topped scepter of the Roman emperor. Rather, he holds a cross crowned by an orb. At the crest of his helmet, at the front, just below the grand plume, is a disk containing the *Christogram*, the monogram made up of *chi* (X), *rho* (P), and *iota* (I), the initial letters of Christ's name in Greek (compare the shield held by a soldier in Fig. 9-13). The artist portrayed Constantine as both Roman emperor and soldier in the army of the Lord. The coin, like Constantinian art in general, belongs both to the ancient and to the medieval worlds.

7-79 Two coins with portraits of Constantine. *Left:* nummus, 307 CE. Billon, diameter 1". American Numismatic Society, New York. *Right:* medallion, ca. 315 CE. Silver, diameter 1". Staatliche Münzsammlung, Munich.

These two coins underscore that portraits of Roman emperors were rarely true likenesses. On the earlier coin, Constantine appears as a bearded tetrarch. On the later coin, he appears eternally youthful.

THE ROMAN EMPIRE

Monarchy and Republic 753-27 BCE

- According to legend, Romulus and Remus founded Rome on April 21, 753 BCE. In the sixth century BCE,
 Etruscan kings ruled the city, and Roman art was Etruscan in character.
- In the centuries following the establishment of the Republic in 509 BCE, Rome conquered its neighbors in Italy and then moved into Greece, gaining exposure to Greek art and architecture.
- Republican temples combined Etruscan plans with the Greek orders, and houses had peristyles with Greek columns. The Romans, however, pioneered the use of concrete as a building material.
- The First Style of mural painting derived from Greece, but the illusionism of the Second Style is distinctly Roman
- Republican portraits usually depicted elderly patricians. The superrealistic likenesses celebrated traditional Roman values.

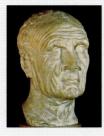

Head of an old man, mid-first century BCE

Early Empire 27 BCE-96 CE

- Augustus (r. 27 BCE-14 CE) defeated Mark Antony and Cleopatra at Actium in 31 BCE and became the first Roman emperor.
- Augustan art revived the Classical style with frequent references to Periclean Athens. Augustus's ambitious building program made lavish use of marble, and his portraits always represented him as an idealized youth.
- Under the Julio-Claudians (r. 14-68 cE), builders began to realize the full potential of concrete in such buildings as the Golden House of Nero.
- The Flavian emperors (r. 69–96 cE) built the Colosseum, the largest Roman amphitheater, and other grandiose buildings in Rome. The Arch of Titus celebrated the Flavian victory in Judaea and Titus's apotheosis.
- The eruption of Mount Vesuvius in 79 CE buried Pompeii and Herculaneum. During the quarter century before the disaster, painters decorated the walls of houses in the Third and Fourth Styles.

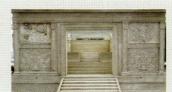

Ara Pacis Augustae, Rome, 13–9 BCE

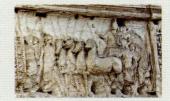

Arch of Titus, Rome, after 81 ce

High Empire 96-192 CE

- The Roman Empire reached its greatest extent under Trajan (r. 98-117 ce). The emperor's new forum and markets transformed the civic center of Rome. The Column of Trajan commemorated his two campaigns in Dacia in a 625-foot-long spiral frieze.
- Hadrian (r. 117–138 cE), emulating Greek statesmen and philosophers, was the first emperor to wear a beard. He built the Pantheon, a triumph of concrete technology.
- Under the Antonines (r. 138–192 cE), the dominance of Classical art began to erode, and imperial artists introduced new compositional schemes in relief sculpture and a psychological element in portraiture.

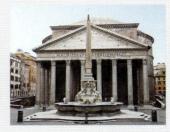

Pantheon, Rome, 118-125 CE

Late Empire 193-337 CE

- In the art of the Severans (r. 193–235 cE), the non-naturalistic Late Antique style took root. Artists represented the emperor as a central frontal figure disengaged from the action around him.
- During the chaotic era of the soldier emperors (r. 235–284 cE), artists revealed the anxiety and insecurity of the emperors in moving portraits.
- Diocletian (r. 284-305 cE) reestablished order by sharing power. Statues of the tetrarchs portray the four coemperors as identical and equal rulers, not as individuals.
- Constantine (r. 306–337 cE) restored one-man rule, ended persecution of Christians, and transferred the capital of the Empire from Rome to Constantinople in 330. The abstract formality of Constantinian art paved the way for the iconic art of the Middle Ages.

Tetrarchs, Venice, ca. 300 ce

Notes

INTRODUCTION

- Quoted in George Heard Hamilton, Painting and Sculpture in Europe, 1880–1940, 6th ed. (New Haven, Conn.: Yale University Press, 1993), 345.
- 2. Quoted in *Josef Albers: Homage to the Square* (New York: Museum of Modern Art, 1964), n.p.

CHAPTER 2

Translated by Françoise Tallon, in Prudence O. Harper et al., *The Royal City of Susa* (New York: Metropolitan Museum of Art, 1991), 132.

CHAPTER 3

- The chronology adopted in this chapter is that of John Baines and Jaromír Malék, Atlas of Ancient Egypt (Oxford: Oxford University Press, 1980), 36–37. The division of kingdoms is that of, among others, Mark Lehner, The Complete Pyramids (New York: Thames & Hudson, 1997), 89, and David P. Silverman, ed., Ancient Egypt (New York: Oxford University Press, 1997), 20–39.
- 2. Translated by James P. Allen, *The Ancient Egyptian Pyramid Texts* (Atlanta, Ga.: Society of Biblical Literature, 2005), 31.
- 3. Ibid., 57.
- 4. Ibid., 56.

CHAPTER 4

1. Homer, *Iliad*, 2.466–649. Translated by E. V. Rieu, *Homer: The Iliad* (Harmondsworth: Penguin, 1950), 32–36.

CHAPTER 5

- 1. Diodorus Siculus, Library of History, 1.91.
- 2. Pausanias, Description of Greece, 5.16.1.
- 3. Plutarch, Life of Pericles, 12.
- 4. Pliny, Natural History, 34.74.
- 5. Plutarch, Life of Pericles, 13.4.
- 6. Pliny, 36.20.
- 7. Lucian, Amores, 13-14; Imagines, 6.
- 8. Plutarch, Moralia, 335A–B. Translated by J. J. Pollitt, The Art of Ancient Greece: Sources and Documents (New York: Cambridge University Press, 1990), 99.
- 9. Pliny, 35.110.
- 10. Ibid., 34.88.

CHAPTER 7

- 1. Livy, History of Rome, 25.40.1-3.
- 2. Juvenal, Satires, 3.225, 232.
- 3. Bernard Berenson, *The Arch of Constantine: The Decline of Form* (London: Chapman & Hall, 1954).

Glossary

NOTE: *Text page references are in parentheses. References to bonus image online essays are in blue.*

abacus—The uppermost portion of the *capital* of a *column*, usually a thin slab. (114)

abrasion—The rubbing or grinding of stone or another material to produce a smooth finish. (64)

abstract—Nonrepresentational; forms and colors arranged without reference to the depiction of an object. (5)

acropolis—Greek, "high city." In ancient Greece, usually the site of the city's most important temple(s). (115)

additive light—Natural light, or sunlight, the sum of all the wavelengths of the visible *spectrum*. See also *subtractive light*. (7)

additive sculpture—A kind of sculpture *technique* in which materials (for example, clay) are built up or "added" to create form. (11)

agora—An open square or space used for public meetings or business in ancient Greek cities. (134)

aisle—The portion of a *basilica* flanking the *nave* and separated from it by a row of *columns* or *piers*. (12, 187)

ala (pl. alae)—One of a pair of rectangular recesses at the back of the atrium of a Roman domus. (188)

Amazonomachy—In Greek mythology, the battle between the Greeks and Amazons. (133)

amphiprostyle—A classical temple *plan* in which the *columns* are placed across both the front and back but not along the sides. (113, 138)

amphitheater—Greek, "double theater." A Roman building type resembling two Greek theaters put together. The Roman amphitheater featured a continuous elliptical *cavea* around a central *arena*. (187)

amphora—An ancient Greek two-handled jar used for general storage purposes, usually to hold wine or oil. (106, 5-2A)

amulet—An object worn to ward off evil or to aid the wearer. (60) **ankh**—The Egyptian sign of life. (77)

antae—The molded projecting ends of the walls forming the *pronaos* or *opisthodomos* of an ancient Greek temple. (113)

apadana—The great audience hall in ancient Persian palaces. (50) **aphros**—Greek, "foam." (105)

apotheosis—Elevated to the rank of gods, or the ascent to Heaven. (177) **apotropaic**—Capable of warding off evil. (116)

apoxyomenos—Greek, "athlete scraping oil from his body." (145)

apse—A recess, usually semicircular, in the wall of a building, commonly found at the east end of a church. (28, 131, 207)

aqueduct—A channel for carrying water, often elevated on arches. (200)
 arch—A curved structural member that spans an opening and is generally composed of wedge-shaped blocks (voussoirs) that transmit the downward pressure laterally. See also thrust. (48, 173)

Archaic—The artistic style of 600–480 BCE in Greece, characterized in part by the use of the *composite view* for painted and *relief* figures and of Egyptian stances for *statues*. (109)

Archaic smile—The smile that appears on all *Archaic* Greek *statues* from about 570 to 480 BCE. The smile is the Archaic sculptor's way of indicating that the person portrayed is alive. (110)

architrave—The *lintel* or lowest division of the *entablature*; also called the epistyle. (114)

arcuated—Arch-shaped. (48, 173, 212)

arcuated lintel—A lintel with alternating horizontal and arcuated sections. (212)

arena—In a Roman *amphitheater*, the central area where bloody *gladiator* combats and other boisterous events took place. (187)

armature—The crossed, or diagonal, *arches* that form the skeletal framework of a Gothic rib vault. In sculpture, the framework for a clay form. (11)

arringatore—Italian, "orator." (174)

ashlar masonry—Carefully cut and regularly shaped blocks of stone used in construction, fitted together without mortar. (62, 88)

atlantid—A male figure that functions as a supporting *column* or *pier*. See also *caryatid*. (3-23A)

atmospheric perspective—See perspective. (191)

atrium (pl. **atria**)—The central reception room of a Roman *domus* that is partly open to the sky. Also, the open, *colonnaded* court in front of and attached to a Christian *basilica*. (188, 189)

attic—The uppermost story of a building, *triumphal arch*, city gate, or *aqueduct*. (200)

attribute—(n.) The distinctive identifying aspect of a person—for example, an object held, an associated animal, or a mark on the body. (v.) To make an *attribution*. (5)

attribution—Assignment of a work to a maker or makers. (6)

augur—A Roman priest who determined the will of the gods from the flight of birds and whose attribute is the *lituus*. (170)

augustus—Latin, "majestic" or "exalted." (195)

axial plan—See plan. (72)

baldric—A sashlike belt worn over one shoulder and across the chest to support a sword. (219)

Baroque/baroque—The traditional blanket designation for European art from 1600 to 1750. Uppercase *Baroque* refers to the art of this period, which features dramatic theatricality and elaborate ornamentation in contrast to the simplicity and orderly rationality of Renaissance art, and is most appropriately applied to Italian art. Lowercase *baroque* describes similar stylistic features found in the art of other periods—for example, the *Hellenistic* period in ancient Greece. (154)

barrel vault—See vault. (182, 183)

base—In ancient Greek architecture, the molded projecting lowest part of *Ionic* and *Corinthian columns*. (*Doric* columns do not have bases.) (51, 114)

basilica (adj. **basilican**)—In Roman architecture, a public building for legal and other civic proceedings, rectangular in plan, with an entrance usually on a long side. In Christian architecture, a church somewhat resembling the Roman basilica, usually entered from one end and with an *apse* at the other. (187)

bas-relief—See relief. (12)

beam—A horizontal structural member that carries the load of the superstructure of a building; a timber *lintel*. (28)

ben-ben—A pyramidal stone; an emblem of the Egyptian god Re. (58, 61)

bent-axis plan—A *plan* that incorporates two or more angular changes of direction, characteristic of Sumerian architecture. (33)

- **bilateral symmetry**—Having the same *forms* on either side of a central axis. (64)
- **bilingual vases**—Experimental Greek vases produced for a short time in the late sixth century BCE; one side featured *black-figure* decoration, the other *red-figure*. (119)
- **black-figure painting**—In early Greek pottery, the silhouetting of dark figures against a light background of natural, reddish clay, with linear details *incised* through the silhouettes. (108)
- **blind arcade**—An *arcade* having no true openings, applied as decoration to a wall surface. (52)
- **block statue**—In ancient Egyptian sculpture, a cubic stone image with simplified body parts. (73)
- **bucranium** (pl. **bucrania**)—Latin, "bovine skull." A common motif in classical architectural ornament. (1-14A)
- **burin**—A pointed tool used for *engraving* or *incising*. (17)
- **bust**—A freestanding sculpture of the head, shoulders, and chest of a person. (11)
- buttress—An exterior masonry structure that opposes the lateral *thrust* of an *arch* or a *vault*. A pier buttress is a solid mass of masonry. A flying buttress consists typically of an inclined member carried on an arch or a series of arches and a solid buttress to which it transmits lateral thrust. (182)
- caduceus—See kerykeion. (105)
- caementa—Latin, "small stones." A key ingredient of Roman concrete. (182)
- **caldarium**—The hot-bath section of a Roman bathing establishment. (220)
- **canon**—A rule (for example, of proportion). The ancient Greeks considered beauty to be a matter of "correct" proportion and sought a canon of proportion, for the human figure and for buildings. The fifth-century BCE sculptor Polykleitos wrote the *Canon*, a treatise incorporating his formula for the perfectly proportioned *statue*. Also, a church official who preaches, teaches, administers sacraments, and tends to pilgrims and the sick. (10, 66)
- **canopic jar**—In ancient Egypt, the container in which the organs of the deceased were placed for later burial with the mummy. (60)
- **capital**—The uppermost member of a *column*, serving as a transition from the *shaft* to the *lintel*. In classical architecture, the form of the capital varies with the *order*. (50, 60, 113, 114)
- Capitolium—An ancient Roman temple dedicated to the gods Jupiter, Juno, and Minerva. (187)
- caput mundi—Latin, "head (capital) of the world." (178)
- cardo—The north-south street in a Roman town, intersecting the decumanus at right angles. (186)
- **carving**—A sculptural *technique* in which the artist cuts away material (for example, from a stone block) in order to create a *statue* or a *relief*. (11)
- **caryatid**—A female figure that functions as a supporting *column*. See also *atlantid*. (115, 3-23A)
- **casting**—A sculptural *technique* in which the artist pours liquid metal, plaster, clay, or another material into a *mold*. When the material dries, the sculptor removes the cast piece from the mold. (11)
- castrum—A Roman military encampment. (206)
- causeway—A raised roadway. (62)
- **cavea**—Latin, "hollow place or cavity." The seating area in ancient Greek and Roman theaters and *amphitheaters*. (148, 187)
- **cella**—The chamber at the center of an ancient temple; in a classical temple, the room (Greek, *naos*) in which the *cult statue* usually stood. (33, 113, 115)
- **centaur**—In ancient Greek mythology, a creature with the front or top half of a human and the back or bottom half of a horse. (103, 107)
- **centauromachy**—In ancient Greek mythology, a battle between the Greeks and *centaurs*. (118)
- cestrum—A small spatula used in encaustic painting. (217, 5-63A)
- **chancel arch**—The arch separating the chancel (the *apse* or *choir*) or the *transept* from the *nave* of a basilica or church. (227)

- **chaplet**—A metal pin used in hollow-casting to connect the *investment* with the clay core. (127)
- chapter house—The meeting hall in a monastery. (127)
- charun—An Etruscan death demon. (174)
- **chimera**—A monster of Greek invention with the head and body of a lion and the tail of a serpent. A second head, that of a goat, grows out of one side of the body. (172)
- chisel—A tool with a straight blade at one end for cutting and shaping stone or wood. (18)
- **chiton**—A Greek tunic, the essential (and often only) garment of both men and women, the other being the *himation*, or mantle. (113)
- choir—The space reserved for the clergy and singers in the church, usually east of the *transept* but, in some instances, extending into the *nave*. (12)
- Christogram—The monogram comprising the three initial letters (chi-rho-iota, ⊀) of Christ's name in Greek. (228)
- **chronology**—In art history, the dating of art objects and buildings. (2) **chryselephantine**—Fashioned of gold and ivory. (132, 4-13A)
- cire perdue—See lost-wax process. (127)
- cista (pl. cistae)—An Etruscan cylindrical container made of sheet bronze with cast handles and feet, often with elaborately engraved bodies, used for women's toiletry articles. (173)
- city-state—An independent, self-governing city. (31)
- **clerestory**—The *fenestrated* part of a building that rises above the roofs of the other parts. The oldest known clerestories are Egyptian. In Roman *basilicas* and medieval churches, clerestories are the windows that form the *nave*'s uppermost level below the timber ceiling or the *vaults*. (73, 182)
- **coffer**—A sunken panel, often ornamental, in a *vault* or a ceiling.
- **collage**—A composition made by combining on a flat surface various materials, such as newspaper, wallpaper, printed text and illustrations, photographs, and cloth. (8)
- **colonnade**—A series or row of *columns*, usually spanned by *lintels*. (69) **colonnette**—A thin *column*. (192)
- **color**—The value, or tonality, of a color is the degree of its lightness or darkness. The intensity, or saturation, of a color is its purity, its brightness or dullness. See also *primary colors*, *secondary colors*, and *complementary colors*. (7)
- **column**—A vertical, weight-carrying architectural member, circular in cross-section and consisting of a base (sometimes omitted), a shaft, and a capital. (10, 50)
- **complementary colors**—Those pairs of *colors*, such as red and green, that together embrace the entire *spectrum*. The complement of one of the three *primary colors* is a mixture of the other two. (7)
- compose—See composition. (7)
- **Composite capital**—A capital combining *Ionic* volutes and *Corinthian* acanthus leaves, first used by the ancient Romans. (204)
- **composite view**—A convention of representation in which part of a figure is shown in profile and another part of the same figure is shown frontally; also called twisted perspective. (22)
- **composition**—The way in which an artist organizes *forms* in an artwork, either by placing shapes on a flat surface or arranging forms in space. (7, 21)
- **conceptual representation**—The representation of the fundamental distinguishing properties of a person or object, not the way a figure or object appears in space and light at a specific moment. See also *composite view.* (36)
- concrete—A building material invented by the Romans and consisting of various proportions of lime mortar, volcanic sand, water, and small stones. (181, 182)
- **connoisseur**—An expert in *attributing* artworks to one artist rather than another. More generally, an expert on artistic *style*. (6)
- **consuls**—In the Roman Republic, the two chief magistrates. (179)
- **continuous narration**—The depiction of the same figure more than once in the same space at different stages of a story. (7-43A)

contour line—In art, a continuous *line* defining the outer shape of an object. (7)

contrapposto—The disposition of the human figure in which one part is turned in opposition to another part (usually hips and legs one way, shoulders and chest another), creating a counterpositioning of the body about its central axis. Sometimes called "weight shift" because the weight of the body tends to be thrown to one foot, creating tension on one side and relaxation on the other. (126)

corbeled arch—An *arch* formed by the piling of stone blocks in horizontal *courses*, cantilevered inward until the blocks meet at a *keystone*. (95, 96)

corbeled dome—A dome formed by the piling of stone blocks in successive circles of horizontal courses, cantilevered inward to form a conical dome. (95)

corbeled vault—A *vault* formed by the piling of stone blocks in horizontal *courses*, cantilevered inward until the two walls meet in an *arch*. (27, 95)

Corinthian capital—A more ornate form than *Doric* or *Ionic*; it consists of a double row of acanthus leaves from which tendrils and flowers grow, wrapped around a bell-shaped *echinus*. Although this *capital* is often cited as the distinguishing feature of the Corinthian *order*, in strict terms no such order exists. The Corinthian capital is a substitute for the standard capital used in the Ionic order. (149)

cornice—The projecting, crowning member of the *entablature* framing the *pediment*; also, any crowning projection. (114)

cornucopia—Horn of plenty. (7-57A)

corona civica—Latin, "civic crown." A Roman honorary wreath worn on the head. (7)

course—In masonry construction, a horizontal row of stone blocks. (27, 62)

cross vault—See vault. (182)

cubiculum (pl. cubicula)—A small cubicle or bedroom that opened onto the atrium of a Roman domus. Also, a chamber in an Early Christian catacomb that served as a mortuary chapel. (188)

cuirass—A military leather breastplate. (184)

cult statue—The *statue* of the deity that stood in the *cella* of an ancient temple. (100, 113)

cuneiform—Latin, "wedge-shaped." A system of writing used in ancient Mesopotamia, in which wedge-shaped characters were produced by pressing a *stylus* into a soft clay tablet, which was then baked or otherwise allowed to harden. (32)

cuneus (pl. **cunei**)—In ancient Greek and Roman theaters and *amphitheaters*, the wedge-shaped section of stone benches separated by stairs. (148)

cutaway—An architectural drawing that combines an exterior view with an interior view of part of a building. (12)

Cycladic—The prehistoric art of the Aegean Islands around Delos, excluding Crete. (85)

Cyclopean masonry—A method of stone construction, named after the mythical *Cyclopes*, using massive, irregular blocks without mortar, characteristic of the Bronze Age fortifications of Tiryns and other *Mycenaean* sites. (94)

Cyclops (pl. Cyclopes)—A mythical Greek one-eyed giant. (94)

cylinder seal—A cylindrical piece of stone usually about an inch or so in height, decorated with an *incised* design, so that a raised pattern is left when the seal is rolled over soft clay. In the ancient Near East, documents, storage jars, and other important possessions were signed, sealed, and identified in this way. Stamp seals are an earlier, flat form of seal used for similar purposes. (39)

Daedalic—The Greek *Orientalizing* sculptural style of the seventh century BCE named after the legendary artist Daedalus. (109)

damnatio memoriae—The Roman decree condemning those who ran afoul of the Senate. Those who suffered damnatio memoriae had their memorials demolished and their names erased from public inscriptions. (204)

decumanus—The east-west street in a Roman town, intersecting the *cardo* at right angles. (186)

decursio—The ritual circling of a Roman funerary pyre. (215)

demos—Greek, "the people," from which the word *democracy* derives. (104)

demotic—Late Egyptian writing. (56)

denarius—The standard Roman silver coin from which the word *penny* ultimately derives. (185)

dictator—In the Roman Republic, the supreme magistrate with extraordinary powers, appointed during a crisis for a specified period. Julius Caesar eventually became dictator perpetuo, dictator for life. (179)

dictator perpetuo—See dictator. (184–185)

dipteral—See peristyle. (113, 151)

disciplina Etrusca—Latin, "Etruscan [religious] practice." (167)

diskobolos-Greek, "discus thrower." (128)

documentary evidence—In art history, the examination of written sources in order to determine the date of an artwork, the circumstances of its creation, or the identity of the artist(s) who made it. (2)

dome—A hemispherical vault; theoretically, an arch rotated on its vertical axis. In Mycenaean architecture, domes are beehiveshaped. (27, 182)

dominus et deus-Latin, "lord and god." (206)

domus—A Roman private house. (188)

Doric—One of the two systems (or *orders*) invented in ancient Greece for articulating the three units of the *elevation* of a classical building—the platform, the *colonnade*, and the superstructure (*entablature*). The Doric order is characterized by, among other features, *capitals* with funnel-shaped *echinuses*, *columns* without *bases*, and a *frieze* of *triglyphs* and *metopes*. See also *Ionic*. (114, 115)

doryphoros—Greek, "spear bearer." (129)

dressed masonry—Stone blocks shaped to the exact dimensions required, with smooth faces for a perfect fit. (62, 200)

dromos—The passage leading to a tholos tomb. (97)

drum—One of the stacked cylindrical stones that form the *shaft* of a *column*. Also, the cylindrical wall that supports a *dome*. (114, 115, 182)

dry masonry—A mortarless stone construction *technique* in which the stones are held in place by their own weight. (24)

echinus—The convex element of a *capital* directly below the *abacus*. (114)

elevation—In architecture, a head-on view of an external or internal wall, showing its features and often other elements that would be visible beyond or before the wall. (12, 88)

emblema—The central framed figural panel of a mosaic floor. (146)

encaustic—A painting *technique* in which pigment is mixed with melted wax and applied to the surface while the mixture is hot. (109, 217)

engaged column—A half-round column attached to a wall. See also pilaster. (60, 97, 173)

engraving—The process of *incising* a design in hard material, often a metal plate (usually copper); also, the *print* or impression made from such a plate. (17)

ensi—A Sumerian ruler. (36)

entablature—The part of a building above the *columns* and below the roof. The entablature has three parts: *architrave*, *frieze*, and *pediment*. (114, 115)

entasis—The convex profile (an apparent swelling) in the *shaft* of a *column*. (116)

eunuch—A castrated male. (2-5A)

exedra—Recessed area, usually semicircular. (193)

extramural—Outside the walls (of a city). (168)

facade—Usually, the front of a building; also, the other sides when they are emphasized architecturally. (52)

faience—A low-fired opaque glasslike silicate. (92)

fauces—Latin, "jaws." In a Roman *domus*, the narrow foyer leading to the *atrium*. (188, 189)

felicior-Latin, "luckier." (206)

fenestrated—Having windows. (182)

fenestration—The arrangement of the windows of a building. (182)

233

fibula (pl. fibulae)—A decorative pin, usually used to fasten garments. (165)

findspot—Place where an artifact was found; provenance. (18)

First Style mural—The earliest style of Roman mural painting. The aim of the artist was to imitate, using painted stucco relief, the appearance of costly marble panels. (189)

flute or fluting—Vertical channeling, roughly semicircular in cross-section and used principally on columns and pilasters. (50, 68, 114, 3-6A) flying buttress—See buttress. (12)

foreshortening (adj. foreshortened)—The use of perspective to represent in art the apparent visual contraction of an object that extends back in space at an angle to the perpendicular plane of sight.

form—In art, an object's shape and structure, either in two dimensions (for example, a figure painted on a surface) or in three dimensions (such as a *statue*). (7)

formal analysis—The visual analysis of artistic *form*. (7)

forum (pl. fora)—The public square of an ancient Roman city. (186) foundry—A workshop for casting metal. (41)

Fourth Style mural—In Roman mural painting, the Fourth Style marks a return to architectural illusionism, but the architectural vistas of the Fourth Style are irrational fantasies. (192)

freedmen, freedwomen—In ancient and medieval society, men and women who had been freed from servitude, as opposed to having been born free. (185)

freestanding sculpture—See sculpture in the round. (11, 18, 65)

fresco-Painting on lime plaster, either dry (dry fresco, or fresco secco) or wet (true, or buon, fresco). In the latter method, the pigments are mixed with water and become chemically bound to the freshly laid lime plaster. Also, a painting executed in either method. (189)

fresco secco—See fresco. (74, 89)

frieze—The part of the entablature between the architrave and the cornice; also, any sculptured or painted band. See register. (31, 114, 115)

frigidarium—The cold-bath section of a Roman bathing establishment. (220)

fundator quietis—Latin, "bringer of peace." (225)

genre—A style or category of art; also, a kind of painting that realistically depicts scenes from everyday life. (5)

Geometric—The style of Greek art during the ninth and eighth centuries BCE, characterized by abstract geometric ornament and schematic figures. (106)

gigantomachy—In ancient Greek mythology, the battle between gods and giants. (116)

gladiator—An ancient Roman professional fighter, usually a slave, who competed in an amphitheater. (202)

glaze—A vitreous coating applied to pottery to seal and decorate the surface; it may be colored, transparent, or opaque, and glossy or matte. (108)

gorgon—In ancient Greek mythology, a hideous female demon with snake hair. Medusa, the most famous gorgon, was capable of turning anyone who gazed at her into stone. (116)

granulation—A decorative technique in which tiny metal balls (granules) are fused to a metal surface. (165)

graver—An engraving tool. See also burin. (119)

griffin—An eagle-headed winged lion. (50, 91)

groin—The edge formed by the intersection of two barrel vaults. (182)

groin vault—See vault. (182)

ground line—In paintings and reliefs, a painted or carved baseline on which figures appear to stand. (21, 31)

haruspex (pl. haruspices)—An Etruscan priest who foretells events by studying animal livers. (6-14A)

Helladic-The prehistoric art of the Greek mainland (Hellas in Greek). (85)

Hellas—The ancient name of Greece. (85, 104)

Hellenes (adj. Hellenic)—The name the ancient Greeks called themselves as the people of Hellas. (104)

Hellenistic-The term given to the art and culture of the roughly three centuries between the death of Alexander the Great in 323 BCE and the death of Queen Cleopatra in 30 BCE, when Egypt became a Roman province. (150)

henge—An arrangement of megalithic stones in a circle, often surrounded by a ditch. (28)

heraldic composition—A composition that is symmetrical on either side of a central figure. (38)

herm—A bust on a quadrangular pillar. (130)

hierarchy of scale—An artistic convention in which greater size indicates greater importance. (11, 31)

hieroglyph—A symbol or picture used to confer meaning in hieroglyphic writing. (55)

hieroglyphic (n., adj.)—A system of writing using hieroglyphs. (55) high relief—See relief. (12, 65)

himation—An ancient Greek mantle worn by men and women over the chiton and draped in various ways. (113)

Hippodamian plan—A city plan devised by Hippodamos of Miletos ca. 466 BCE, in which a strict grid was imposed on a site, regardless of the terrain, so that all streets would meet at right angles. (151)

hubris—Greek, "arrogant pride." (141)

hue—The name of a color. See also primary colors, secondary colors, and complementary colors. (7)

hydria—An ancient Greek three-handled water pitcher. (143)

hypaethral—A building having no *pediment* or roof, open to the sky. (151)

hypostyle hall—A hall with a roof supported by columns. (72)

iconography—Greek, the "writing of images." The term refers both to the content, or subject, of an artwork and to the study of content in art. It also includes the study of the symbolic, often religious, meaning of objects, persons, or events depicted in works of art. (5)

ikegobo—A Benin royal shrine. (10)

illusionism (adj. illusionistic)—The representation of the threedimensional world on a two-dimensional surface in a manner that creates the illusion that the person, object, or place represented is three-dimensional. See also perspective. (8)

imagines—In ancient Rome, portraits of ancestors displayed in the atrium of a domus. (183, 184, 194, 199)

imperator-Latin, "commander in chief," from which the word emperor derives. (195, 228)

impluvium—In a Roman domus, the basin located in the atrium that collected rainwater. (188, 189)

in antis—In ancient Greek architecture, the area between the antae. (113, 115)

incise—To cut into a surface with a sharp instrument, especially to decorate metal and pottery. (17)

incrustation—Wall decoration consisting of bright panels of different colors. (202)

insula (pl. insulae)—In Roman architecture, a multistory apartment house, usually made of brick-faced concrete; also refers to an entire city block. (213)

intensity—See color. (7)

interaxial—The distance between the center of the lowest drum of a column and the center of the next. Also called the intercolumniation. (132)

intercolumniation—See interaxial. (149)

internal evidence-In art history, the examination of what an artwork represents (people, clothing, hairstyles, and so on) in order to determine its date. Also, the examination of the style of an artwork to identify the artist who created it. (3)

invenzione—Italian, "invention." One of several terms used in Italian Renaissance literature to praise the originality and talent of artists. (2-17A)

investiture—Ceremony in which a ruler receives the authority to govern. (43)

investment—In hollow-casting, the final clay *mold* applied to the exterior of the wax model. (127)

Ionic—One of the two systems (or *orders*) invented in ancient Greece for articulating the three units of the *elevation* of a classical building: the platform, the *colonnade*, and the superstructure (*entablature*). The Ionic order is characterized by, among other features, *volutes*, *capitals*, *columns* with *bases*, and an uninterrupted *frieze*. (115)

iwan—In Islamic architecture, a vaulted rectangular recess opening onto a courtyard. (52)

ka—In ancient Egypt, the immortal human life force. (55)

kerykeion—In ancient Greek mythology, a serpent-entwined herald's rod (Latin, *caduceus*), the attribute of Hermes (Roman Mercury), the messenger of the gods. (105)

kevstone—See voussoir. (173)

kiva—A square or circular underground structure that is the spiritual and ceremonial center of Pueblo Indian life. (1-14A)

kline (pl. **klinai**)—A couch or funerary bed. A type of *sarcophagus* with a reclining portrait of the deceased on its lid. (216)

kore (pl. korai)—Greek, "young woman." An Archaic Greek statue of a young woman. (109)

kouros (pl. **kouroi**)—Greek, "young man." An *Archaic* Greek *statue* of a young man. (110)

krater—An ancient Greek wide-mouthed bowl for mixing wine and water. (100, 106)

kylix—An ancient Greek drinking cup with a wide bowl and two horizontal handles. (143, 5-24A)

labrys—Minoan double ax. (87)

labyrinth—Maze. The English word derives from the mazelike plan of the *Minoan* palace at Knossos. (87)

lamassu—Assyrian guardian in the form of a man-headed winged bull or lion. (46)

landscape—A picture showing natural scenery, without narrative content. (5, 26)

Late Antique—The non-*naturalistic* artistic *style* of the Late Roman Empire. (219)

lateral section—See section. (12)

lekythos (pl. **lekythoi**)—A flask containing perfumed oil; lekythoi were often placed in Greek graves as offerings to the deceased. (140)

libation—The pouring of liquid as part of a religious ritual. (35)

liberator urbis—Latin, "liberator of the city." (225)

line—The extension of a point along a path, made concrete in art by drawing on or chiseling into a *plane*. (7)

linear perspective—See perspective. (190)

lintel—A horizontal beam used to span an opening. (28, 95, 96)

lituus—The curved staff carried by an *augur.* (170)

longitudinal section—See section. (12)

lost-wax process—A bronze-*casting* method in which a figure is modeled in wax and covered with clay; the whole is fired, melting away the wax (French, *cire perdue*) and hardening the clay, which then becomes a *mold* for molten metal. Also called the cire perdue process. (127)

low relief—See *relief.* (12)

lunette—A semicircular area (with the flat side down) in a wall over a door, niche, or window; also, a painting or *relief* with a semicircular frame. (7-54A)

mass—The bulk, density, and weight of matter in space. (8)

mastaba—Arabic, "bench." An ancient Egyptian rectangular brick or stone structure with sloping sides erected over a subterranean tomb chamber connected with the outside by a shaft. (59)

mausoleum (pl. mausolea)—A monumental tomb. The name derives from the mid-fourth-century BCE tomb of Mausolos at Halikarnassos, one of the Seven Wonders of the ancient world. (224, 5-63C)

maximus—Latin, "greatest." (179)

meander—An ornament, usually in bands but also covering broad surfaces, consisting of interlocking geometric motifs. An ornamental pattern of contiguous straight lines joined usually at right angles. (106)

medium (pl. **media**)—The material (for example, marble, bronze, clay, *fresco*) in which an artist works; also, in painting, the vehicle (usually liquid) that carries the pigment. (7)

megalith (adj. megalithic)—Greek, "great stone." A large, roughly hewn stone used in the construction of monumental prehistoric structures. (27)

megaron—The large reception hall and throne room in a *Mycenaean* palace, fronted by an open, two-*columned* porch. (94)

melior—Latin, "better." (206)

menorah—In antiquity, the Jewish sacred seven-branched candelabrum. (205)

Mesolithic—The "middle" Stone Age, between the *Paleolithic* and the *Neolithic* ages. (23)

metope—The square panel between the *triglyphs* in a *Doric frieze*, often sculpted in *relief*. (114, 115)

mina—A unit of ancient Mesopotamian currency. (44)

minaret—A distinctive feature of mosque architecture, a tower from which the faithful are called to worship. (131)

Minoan—The prehistoric art of Crete, named after the legendary King Minos of Knossos. (83, 84)

Minotaur—The mythical beast, half man and half bull, that inhabited the *labyrinth* of the *Minoan* palace at Knossos. (84)

modeling—The shaping or fashioning of three-dimensional forms in a soft material, such as clay; also, the gradations of light and shade reflected from the surfaces of matter in space, or the illusion of such gradations produced by alterations of *value* in a drawing, painting, or print. (35, 111, 143)

module (adj. **modular**)—A basic unit of which the dimensions of the major parts of a work are multiples. The principle is used in sculpture and other art forms, but it is most often employed in architecture, where the module may be the dimensions of an important part of a building, such as the diameter of a *column*. (10)

mold—A hollow form for casting. (11)

molding—In architecture, a continuous, narrow surface (projecting or recessed, plain or ornamented) designed to break up a surface, to accent, or to decorate. (80)

monochrome (adj. monochromatic)—One color. (192)

monolith (adj. **monolithic**)—A stone *column shaft* that is all in one piece (not composed of *drums*); a large, single block or piece of stone used in *megalithic* structures. Also, a colossal *statue* carved from a single piece of stone. (70, 114)

mortuary temple—In Egyptian architecture, a temple erected for the worship of a deceased *pharaoh*. (62)

moschophoros—Greek, "calf bearer." (110)

mummification—A *technique* used by ancient Egyptians to preserve human bodies so that they may serve as the eternal home of the immortal *ka*. (58, 60)

mummy—An embalmed Egyptian corpse; see *mummification*. (60, 217)

mural—A wall painting. (16)

muralist—A mural painter. (20)

Mycenaean—The prehistoric art of the Late *Helladic* period in Greece, named after the citadel of Mycenae. (85)

naos—See cella. (113)

natatio—The swimming pool in a Roman bathing establishment. (220)

naturalism (adj. **naturalistic**)—The *style* of painted or sculpted representation based on close observation of the natural world that was at the core of the classical tradition. (18)

nave—The central area of an ancient Roman *basilica* or of a church, demarcated from *aisles* by *piers* or *columns*. (187)

necropolis—Greek, "city of the dead." A large burial area or cemetery. (59, 168)

nemes—In ancient Egypt, the linen headdress worn by the *pharaoh*, with the *uraeus* cobra of kingship on the front. (62)

Neolithic—The "new" Stone Age. (23)

niello-A black metallic alloy. (97)

nomarch—Egyptian, "great overlord." A regional governor during the Middle Kingdom. (3-16A)

Nun—In ancient Egypt, the primeval waters from which the creator god emerged. (58)

nymphs—In classical mythology, female divinities of springs, caves, and woods. (105, 121)

obelisk—A tall four-sided *monolithic pillar* with a pyramidal top—symbolic of the Egyptian sun god Re. (70)

oculus (pl. oculi)—Latin, "eye." The round central opening of a *dome*. (182, 201)

opisthodomos—In ancient Greek architecture, a porch at the rear of a temple, set against the blank back wall of the *cella*. (113)

optical representation—The representation of people and objects seen from a fixed viewpoint. (36)

optimus—Latin, "best." (206)

oracle—A prophetic message. (5-17A)

orchestra—Greek, "dancing place." In ancient Greek theaters, the circular piece of earth with a hard and level surface on which the performance took place. (148)

order—In classical architecture, a *style* represented by a characteristic design of the *columns* and *entablature*. See also *superimposed orders*. (114)

Orientalizing—The early phase of *Archaic* Greek art (seventh century BCE), so named because of the adoption of forms and motifs from ancient Mesopotamia, Persia, and Egypt. See also *Daedalic*. (107)

orthogonal plan—The imposition of a strict grid *plan* on a site, regardless of the terrain, so that all streets meet at right angles. See also *Hippodamian plan*. (151)

oxidizing—The first phase of the ancient Greek ceramic firing process, which turned both the pot and the clay *slip* red. During the second (reducing) phase, the oxygen supply into the kiln was shut off, and both pot and slip turned black. In the final (reoxidizing) phase, the pot's coarser material reabsorbed oxygen and became red again, whereas the smoother slip did not and remained black. (108)

palaestra—An ancient Greek and Roman exercise area, usually framed by a *colonnade*. In Greece, the palaestra was an independent building; in Rome, palaestras were also frequently incorporated into a bathing complex. (129, 220)

Paleolithic—The "old" Stone Age, during which humankind produced the first sculptures and paintings. (15)

palette—A thin board with a thumb hole at one end on which an artist lays and mixes *colors*; any surface so used. Also, the colors or kinds of colors characteristically used by an artist. In ancient Egypt, a slate slab used for preparing makeup. (20, 57)

papyrus—A plant native to Egypt and adjacent lands used to make paperlike writing material; also, the material or any writing on it. (55)

parapet—A low, protective wall along the edge of a balcony, roof, or bastion. (138)

parthenos—Greek, "virgin." The epithet of Athena, the virgin goddess. (105)

passage grave—A prehistoric tomb with a long stone corridor leading to a burial chamber covered by a great *tumulus*. (27)

pastel—A powdery paste of pigment and gum used for making crayons; also, the pastel crayons themselves.

patrician—A Roman freeborn landowner. (179)

patron—The person or entity that pays an artist to produce individual artworks or employs an artist on a continuing basis. (188)

pebble mosaic—A mosaic made of irregularly shaped stones of various *colors*. (146)

pectoral—An ornament on the chest. (165)

pediment—In classical architecture, the triangular space (gable) at the end of a building, formed by the ends of the sloping roof above the *colonnade*; also, an ornamental feature having this shape. (114, 115, 139)

peplos (pl. **peploi**)—A simple, long, belted garment of wool worn by women in ancient Greece. (112)

period style—See style. (3)

peripteral—See peristyle. (113, 115)

peristyle—In classical architecture, a *colonnade* all around the *cella* and its porch(es). A peripteral colonnade consists of a single row of *columns* on all sides; a dipteral colonnade has a double row all around. (113, 188, 189)

personal style—See style. (4)

personification—An abstract idea represented in bodily form. (5)

perspective—A method of presenting an illusion of the three-dimensional world on a two-dimensional surface. In linear perspective, the most common type, all parallel lines or surface edges converge on one, two, or three vanishing points located with reference to the eye level of the viewer (the horizon line of the picture), and associated objects are rendered smaller the farther from the viewer they are intended to seem. Atmospheric, or aerial, perspective creates the illusion of distance by the greater diminution of *color* intensity, the shift in color toward an almost neutral blue, and the blurring of contours as the intended distance between eye and object increases. (8)

pharaoh (adj. pharaonic)—An ancient Egyptian king. (68)

phersu—A masked man who appears in scenes of Etruscan funerary games. (170)

Phoibos—Greek, "radiant." The epithet of the Greek god Apollo. (105) **physical evidence**—In art history, the examination of the materials used to produce an artwork in order to determine its date. (2)

pictograph—A picture, usually stylized, that represents an idea; also, writing using such means; also, painting on rock. See also *hiero-glyphic*. (31, 32)

pier—A vertical, freestanding masonry support. (12, 182, 3-23A)

pilaster—A flat, rectangular, vertical member projecting from a wall of which it forms a part. It usually has a *base* and a *capital* and is often *fluted*. (139, 173)

pillar—Usually a weight-carrying member, such as a *pier* or a *column*; sometimes an isolated, freestanding structure used for commemorative purposes. (70, 3-23A)

pinakotheke—Greek, "picture gallery." An ancient Greek building for the display of paintings on wood panels. (136)

plan—The horizontal arrangement of the parts of a building or of the buildings and streets of a city or town, or a drawing or diagram showing such an arrangement. In an axial plan, the parts of a building are organized longitudinally, or along a given axis; in a central plan, the parts of the structure are of equal or almost equal dimensions around the center. (12)

plane—A flat surface. (7)

plebeian—The Roman social class that included small farmers, merchants, and freed slaves. (179)

pointed arch—A narrow *arch* of pointed profile, in contrast to a semicircular arch. (3, 95)

polis (pl. **poleis**)—An independent *city-state* in ancient Greece. (104)

pontifex maximus—Latin, "chief priest." The high priest of the Roman state religion, often the emperor himself. (195)

portico—A roofed colonnade; also an entrance porch. (151)

post-and-lintel system—A system of construction in which two posts support a *lintel*. (27, 95)

primary colors—Red, yellow, and blue—the *colors* from which all other colors may be derived. (7)

princeps—Latin, "first citizen." The title Augustus and his successors as Roman emperor used to distinguish themselves from Hellenistic monarchs. (195)

pronaos—The space, or porch, in front of the *cella*, or naos, of an ancient Greek temple. (113)

proportion—The relationship in size of the parts of persons, buildings, or objects, often based on a *module*. (10)

propylaia—Greek, "gates." (136)

prostyle—A classical temple *plan* in which the *columns* are only in front of the *cella* and not on the sides or back. (113)

protome—The head, forelegs, and part of the body of an animal. (50) **provenance**—Origin or source; *findspot.* (3, 85)

pseudoperipteral—In Roman architecture, a pseudoperipteral temple has a series of *engaged columns* all around the sides and back of the *cella* to give the appearance of a *peripteral colonnade*. (180)

pylon—The wide entrance gateway of an Egyptian temple, characterized by its sloping walls. (72)

radiocarbon dating—A method of measuring the decay rate of carbon isotopes in organic matter to determine the age of organic materials such as wood and fiber. (16)

raking cornice—The *cornice* on the sloping sides of a *pediment*. (114)

red-figure painting—In later Greek pottery, the silhouetting of red figures against a black background, with painted linear details; the reverse of *black-figure painting*. (119)

reducing—See oxidizing. (108)

regional style—See style. (3)

register—One of a series of superimposed bands or *friezes* in a pictorial narrative, or the particular levels on which motifs are placed. (31)

relief—In sculpture, figures projecting from a background of which they are part. The degree of relief is designated high, low (bas), or sunken. In the last, the artist cuts the design into the surface so that the highest projecting parts of the image are no higher than the surface itself. See also *repoussé*. (12)

relief sculpture—See relief. (11, 18)

relieving triangle—In *Mycenaean* architecture, the triangular opening above the *lintel* that serves to lighten the weight to be carried by the lintel itself. (95, 96)

reoxidizing—See oxidizing. (108)

repoussé—Formed in *relief* by beating a metal plate from the back, leaving the impression on the face. The metal sheet is hammered into a hollow *mold* of wood or some other pliable material and finished with a *graver*. See also *relief*. (51, 97)

res gestae-Latin, "achievements." (197)

revetment—In architecture, a wall covering or facing. (182)

rhyton—A drinking vessel. (51)

ridgepole—The *beam* running the length of a building below the peak of the gabled roof. (115, 166)

rustication (adj. rusticated)—To give a rustic appearance by roughening the surfaces and beveling the edges of stone blocks to emphasize the joints between them. Rustication is a technique employed in ancient Roman architecture, and was also popular during the Renaissance, especially for stone courses at the ground-floor level. (200)

sarcophagus (pl. **sarcophagi**)—Greek, "consumer of flesh." A coffin, usually of stone. (215)

saturation—See color. (7)

satyr—A Greek mythological follower of Dionysos having a man's upper body, a goat's hindquarters and horns, and a horse's ears and tail. (157)

scarab—An Egyptian gem in the shape of a beetle. (60)

school—A chronological and stylistic classification of works of art with a stipulation of place. (6)

sculpture in the round—Freestanding figures, *carved* or *modeled* in three dimensions. (11, 18)

secco-Italian, "dry." See also fresco. (74, 89)

Second Style mural—The *style* of Roman *mural* painting in which the aim was to dissolve the confining walls of a room and replace them with the illusion of a three-dimensional world constructed in the artist's imagination. (189)

secondary colors—Orange, green, and purple, obtained by mixing pairs of *primary colors* (red, yellow, blue). (7)

section—In architecture, a diagram or representation of a part of a structure or building along an imaginary *plane* that passes through it vertically. Drawings showing a theoretical slice across a structure's

width are lateral sections. Those cutting through a building's length are longitudinal sections. See also *elevation* and *cutaway*. (12)

senate—Latin senatus, "council of elders." The Senate was the main legislative body in Roman constitutional government. (179)

serdab—A small concealed chamber in an Egyptian *mastaba* for the *statue* of the deceased. (59)

Severe Style—The Early Classical *style* of Greek sculpture, ca. 480–450 BCE. (124)

shaft—The tall, cylindrical part of a *column* between the *capital* and the *base.* (50, 114)

shekel—A unit of ancient Mesopotamian currency. (44)

siren—In ancient Greek mythology, a creature that was part bird and part woman. (108)

sistrum—An Egyptian percussion instrument or rattle. (93)

skene—Greek, "stage." The stage of a classical theater. (148)

skenographia—Greek, "scene painting"; the Greek term for *perspective* painting. (190)

skiagraphia—Greek, "shadow painting." The Greek term for shading, said to have been invented by Apollodoros, an Athenian painter of the fifth century BCE. (146)

slip—A mixture of fine clay and water used in ceramic decoration. (108)

socii—Latin, "allies." (186)

space—In art history, both the actual area that an object occupies or a building encloses and the *illusionistic* representation of space in painting and sculpture. (8)

spandrel—The roughly triangular space enclosed by the curves of adjacent *arches* and a horizontal member connecting their vertexes; also, the space enclosed by the curve of an *arch* and an enclosing right angle. The area between the arch proper and the framing *columns* and *entablature*. (204)

spectrum—The range or band of visible *colors* in natural light. (7)

sphinx—A mythical Egyptian beast with the body of a lion and the head of a human. (63)

spolia—Latin, "spoils." Older statues and reliefs reused in Late Antique monuments. (226)

spur wall—A short wall extending from the principal wall outward to a *column* or *pilaster*. (3-6A)

stained glass—In Gothic architecture, the colored glass used for windows. (12)

stamp seal—See cylinder seal. (39)

statue—A three-dimensional sculpture. (11)

stele (pl. **stelae**)—A *carved* stone slab used to mark graves or to commemorate historical events. (34)

still life—A picture depicting an arrangement of inanimate objects. (5, 195)

stoa—In ancient Greek architecture, an open building with a roof supported by a row of *columns* parallel to the back wall. A covered *colonnade* or *portico*. (151)

Stoic—A philosophical school of ancient Greece, named after the *stoas* in which the philosophers met. (152)

strategos—Greek, "general." (130)

strigil—A tool ancient Greek athletes used to scrape oil from their bodies after exercising. (145)

stucco—A type of plaster used as a coating on exterior and interior walls. Also used as a sculptural *medium*. (180)

style—A distinctive artistic manner. Period style is the characteristic style of a specific time. Regional style is the style of a particular geographical area. Personal style is an individual artist's unique manner. (3)

stylistic evidence—In art history, the examination of the *style* of an artwork in order to determine its date or the identity of the artist. (3)

stylobate—The uppermost course of the platform of a classical Greek temple, which supports the *columns*. (114)

stylus—A needlelike tool used in *engraving* and *incising*; also, an ancient writing instrument used to inscribe clay or wax tablets. (32, 194)

subtractive light—The painter's light in art; the light reflected from pigments and objects. See also *additive light*. (7)

subtractive sculpture—A kind of sculpture *technique* in which materials are taken away from the original mass; *carving*. (11)

sunken relief—See relief. (77)

symbol—An image that stands for another image or encapsulates an idea. (5)

symmetria—Greek, "commensurability of parts." Polykleitos's treatise on his *canon* of proportions incorporated the principle of symmetria. (129, 132)

symposium (pl. **symposia**)—An ancient Greek banquet attended solely by men (and female servants and prostitutes). (106)

taberna—In Roman architecture, a single-room shop usually covered by a *barrel vault.* (209)

tablinum—The study or office in a Roman domus. (188)

technique—The processes artists employ to create *form*, as well as the distinctive, personal ways in which they handle their materials and tools. (7)

tempera—A *technique* of painting using pigment mixed with egg yolk, glue, or casein; also, the *medium* itself. (218)

tephra—The volcanic ash produced by the eruption on the *Cycladic* island of Thera. (91)

tepidarium—The warm-bath section of a Roman bathing establishment. (220)

terminus ante quem—Latin, "point [date] before which." (2)

terminus post quem—Latin, "point [date] after which." (2)

terracotta—Hard-baked clay, used for sculpture and as a building material. It may be *glazed* or painted. (88)

tesara—Greek, "four." (118)

tessera (pl. **tesserae**)—Greek, "cube." A tiny stone or piece of glass cut to the desired shape and size for use in forming a mosaic. (147)

tetrarch—One of four corulers. (223)

tetrarchy—Greek, "rule by four." A type of Roman government established in the late third century ce by Diocletian in an attempt to foster order by sharing power with potential rivals. (223)

texture—The quality of a surface (rough, smooth, hard, soft, shiny, dull) as revealed by light. In represented texture, a painter depicts an object as having a certain texture even though the pigment is the real texture. (8)

theatron—Greek, "place for seeing." In ancient Greek theaters, the slope overlooking the *orchestra* on which the spectators sat. (148)

Third Style mural—In Roman *mural* painting, the *style* in which delicate linear fantasies were sketched on predominantly *monochromatic* backgrounds. (192)

tholos (pl. **tholoi**)—A temple with a circular plan. Also, the burial chamber of a *tholos tomb*. (95, 97, 149, 181)

tholos tomb—In *Mycenaean* architecture, a beehive-shaped tomb with a circular plan. (96)

thrust—The outward force exerted by an *arch* or a *vault* that must be counterbalanced by a *buttress*. (182)

tinscvil—Etruscan, "gift to [the god] Tinia." (172)

toga—The garment worn by an ancient Roman male citizen. (174) tonality—See *color*. (7)

tondo (pl. tondi)—A circular painting or relief sculpture. (218)

torque—The distinctive necklace worn by the Gauls. (154)

treasury—In ancient Greece, a small building set up for the safe storage of *votive offerings*. (117)

tria-Greek, "three." (118)

triclinium (pl. **triclinia**)—The dining room of a Roman *domus*. (188, 6-10A)

trident—The three-pronged pitchfork associated with the ancient Greek sea god Poseidon (Roman Neptune). (105, 128)

triglyph—A triple projecting, grooved member of a *Doric frieze* that alternates with *metopes*. (114)

trilithon—A pair of *monoliths* topped with a *lintel*; found in *megalithic* structures. (28)

tripod—An ancient Greek deep bowl on a tall three-legged stand. (150, 216)

triumphal arch—In Roman architecture, a freestanding *arch* commemorating an important event, such as a military victory or the opening of a new road. (204)

true fresco-See fresco. (74, 189)

tubicen—Latin, "trumpet player." (155)

tumulus (pl. **tumuli**)—Latin, "burial mound." In Etruscan architecture, tumuli cover one or more subterranean multichambered tombs cut out of the local tufa (limestone). Tumuli are also characteristic of the Japanese Kofun period of the third and fourth centuries CE. (27, 169)

tunnel vault—See vault. (182)

Tuscan column—The standard type of Etruscan *column*. It resembles ancient Greek *Doric* columns but is made of wood, is un*fluted*, and has a *base*. Also a popular motif in Renaissance and *Baroque* architecture. (165)

twisted perspective—See composite view. (22)

uraeus—An Egyptian cobra; one of the emblems of *pharaonic* kingship. (63)

ushabti—In ancient Egypt, a figurine placed in a tomb to act as a servant to the deceased in the afterlife. (60)

valley temple—The temple closest to the Nile River, associated with each of the Old Kingdom pyramids at Gizeh in ancient Egypt. (62)

value—See color. (7)

vanth—An Etruscan female winged demon of death. (174)

vault (adj. vaulted)—A masonry roof or ceiling constructed on the arch principle, or a concrete roof of the same shape. A barrel (or tunnel) vault, semicylindrical in cross-section, is in effect a deep arch or an uninterrupted series of arches, one behind the other, over an oblong space. A quadrant vault is a half-barrel vault. A groin (or cross) vault is formed at the point at which two barrel vaults intersect at right angles. In a ribbed vault, there is a framework of ribs or arches under the intersections of the vaulting sections. A sexpartite vault is one whose ribs divide the vault into six compartments. A fan vault is a vault characteristic of English Perpendicular Gothic architecture, in which radiating ribs form a fanlike pattern. (12, 52)

velarium—In a Roman *amphitheater*, the cloth awning that could be rolled down from the top of the *cavea* to shield spectators from sun or rain. (187)

venationes—Ancient Roman wild animal hunts staged in an amphitheater. (202)

veristic—True to natural appearance; super-realistic. (184)

vizier—An Egyptian pharaoh's chief administrator. (3-12A)

volume—The space that mass organizes, divides, or encloses. (8)

volute—A spiral, scroll-like form characteristic of the ancient Greek Ionic and the Roman Composite capital. (50, 114)

votive offering—A gift of gratitude to a deity. (31)

voussoir—A wedge-shaped stone block used in the construction of a true arch. The central voussoir, which sets the arch, is called the keystone. (173)

wanax—Mycenaean king. (94)

wedjat—The eye of the Egyptian falcon-god Horus, a powerful *amulet*. (58, 60)

weld—To join metal parts by heating, as in assembling the separate parts of a *statue* made by *casting*. (11)

white-ground painting—An ancient Greek vase-painting technique in which the pot was first covered with a slip of very fine white clay, over which black glaze was used to outline figures, and diluted brown, purple, red, and white were used to color them. (140)

Bibliography

This list of books is very selective, but comprehensive enough to satisfy the reading interests of the beginning art history student and general reader. Significantly expanded from the previous edition, the 15th edition bibliography can also serve as the basis for undergraduate research papers. The resources listed range from works that are valuable primarily for their reproductions to those that are scholarly surveys of schools and periods or monographs on individual artists. The emphasis is on recent in-print books and on books likely to be found in college and municipal libraries. No entries for periodical articles appear, but the bibliography begins with a list of some of the major journals that publish art historical scholarship in English.

Selected Periodicals African Arts

American Art American Indian Art American Journal of Archaeology Antiquity Archaeology Archives of American Art Archives of Asian Art Ars Orientalis Art Bulletin Art History Art in America Art Journal Artforum International Artnews Burlington Magazine History of Photography Journal of Egyptian Archaeology Journal of Roman Archaeology Journal of the Society of Architectural Historians Journal of the Warburg and Courtauld Institutes Latin American Antiquity Oxford Art Journal Women's Art Journal

General Studies

- Baxandall, Michael. *Patterns of Intention: On the Historical Explanation of Pictures*. New Haven, Conn.: Yale University Press, 1985.
- Bindman, David, ed. *The Thames & Hudson Encyclopedia of British Art.* London: Thames & Hudson, 1988.
- Boström, Antonia. *The Encyclopedia of Sculpture*. 3 vols. London: Routledge, 2003. Broude, Norma, and Mary D. Garrard, eds. *The Expanding Discourse: Feminism and Art History*. New York: Harper Collins, 1992.
- Bryson, Norman. Vision and Painting: The Logic of the Gaze. New Haven, Conn.: Yale University Press, 1983.
- Bryson, Norman, Michael Ann Holly, and Keith Moxey. Visual Theory: Painting and Interpretation. New York: Cambridge University Press, 1991.
- Burden, Ernest. Illustrated Dictionary of Architecture. 2d ed. New York: McGraw-Hill. 2002.
- Büttner, Nils. *Landscape Painting: A History*. New York: Abbeville, 2006. Carrier, David. *A World Art History and Its Objects*. University Park: Pennsylvania State University Press, 2012.
- Chadwick, Whitney. Women, Art, and Society. 5th ed. New York: Thames & Hudson, 2012.

- Cheetham, Mark A., Michael Ann Holly, and Keith Moxey, eds. *The Subjects of Art History: Historical Objects in Contemporary Perspective.* New York: Cambridge University Press, 1998.
- Chilvers, Ian, and Harold Osborne, eds. *The Oxford Dictionary of Art.* 3d ed. New York: Oxford University Press, 2004.
- Ching, Francis D. K., Mark Jarzombek, and Vikramaditya Prakash. *A Global History of Architecture*. 2d ed. Hoboken, NJ: Wiely, 2010.
- Corbin, George A. Native Arts of North America, Africa, and the South Pacific: An Introduction. New York: Harper Collins, 1988.
- Crouch, Dora P., and June G. Johnson. *Traditions in Architecture: Africa, America, Asia, and Oceania*. New York: Oxford University Press, 2000.
- Curl, James Stevens. Oxford Dictionary of Architecture and Landscape Architecture. 2d ed. New York: Oxford University Press, 2006.
- Davis, Whitney. A General Theory of Visual Culture. Princeton, N.J.: Princeton University Press, 2011.
- Duby, Georges, ed. Sculpture: From Antiquity to the Present. 2 vols. Cologne: Taschen, 1999.
- Encyclopedia of World Art. 17 vols. New York: McGraw-Hill, 1959-1987.
- Evers, Bernd, and Christof Thoenes. *Architectural Theory from the Renaissance to the Present.* Cologne: Taschen, 2011.
- Fielding, Mantle. *Dictionary of American Painters, Sculptors, and Engravers.* 2d ed. Poughkeepsie, N.Y.: Apollo, 1986.
- Fine, Sylvia Honig. Women and Art: A History of Women Painters and Sculptors from the Renaissance to the 20th Century. Rev. ed. Montclair, N.J.: Alanheld & Schram, 1978.
- Fleming, John, Hugh Honour, and Nikolaus Pevsner. *The Penguin Dictionary of Architecture and Landscape Architecture*. 5th ed. New York: Penguin, 2000.
- Frazier, Nancy. *The Penguin Concise Dictionary of Art History*. New York: Penguin, 2000.
- Freedberg, David. The Power of Images: Studies in the History and Theory of Response. Chicago: University of Chicago Press, 1989.
- Gaze, Delia, ed. Dictionary of Women Artists. 2 vols. London: Routledge, 1997.
 Hall, James. Dictionary of Subjects and Symbols in Art. 2d ed. Boulder, Colo.: Westview, 2008.
- Harris, Anne Sutherland, and Linda Nochlin. *Women Artists:* 1550–1950. Los Angeles: Los Angeles County Museum of Art; New York: Knopf, 1977.
- Hauser, Arnold. The Sociology of Art. Chicago: University of Chicago Press, 1982.
- Hults, Linda C. *The Print in the Western World: An Introductory History.* Madison: University of Wisconsin Press, 1996.
- Ingersoll, Richard, and Spiro Kostof. World Architecture: A Cross-Cultural History. New York: Oxford University Press, 2012.
- Kemp, Martin. The Science of Art: Optical Themes in Western Art from Brunelleschi to Seurat. New Haven, Conn.: Yale University Press, 1990.
- Kirkham, Pat, and Susan Weber, eds. History of Design: Decorative Arts and Material Culture, 1400–2000. New Haven, Conn.: Yale University Press, 2013.
- Kostof, Spiro, and Gregory Castillo. A History of Architecture: Settings and Rituals. 2d ed. Oxford: Oxford University Press, 1995.
- Kultermann, Udo. The History of Art History. New York: Abaris, 1993.
- Le Fur, Yves, ed. Musée du Quai Branly: The Collection. Art from Africa, Asia, Oceania, and the Americas. Paris: Flammarion, 2009.
- Lucie-Smith, Edward. The Thames & Hudson Dictionary of Art Terms. 2d ed. New York: Thames & Hudson, 2004.
- Moffett, Marian, Michael Fazio, and Lawrence Wadehouse. 3d ed. *A World History of Architecture*. London: Laurence King, 2013.
- Morgan, Anne Lee. Oxford Dictionary of American Art and Artists. New York: Oxford University Press, 2008.
- Murray, Peter, and Linda Murray. *The Penguin Dictionary of Art and Artists*. 7th ed. New York: Penguin, 1998.

- Nelson, Robert S., and Richard Shiff, eds. Critical Terms for Art History. Chicago: University of Chicago Press, 1996.
- Pazanelli, Roberta, ed. *The Color of Life: Polychromy in Sculpture from Antiquity to the Present.* Los Angeles: J. Paul Getty Museum, 2008.
- Penny, Nicholas. The Materials of Sculpture. New Haven, Conn.: Yale University Press, 1993.
- Pevsner, Nikolaus. A History of Building Types. London: Thames & Hudson, 1987. Reprint of 1979 ed.
- ——. An Outline of European Architecture. 8th ed. Baltimore: Penguin, 1974. Pierce, James Smith. From Abacus to Zeus: A Handbook of Art History. 7th ed. Upper Saddle River, N.J.: Pearson Prentice Hall, 1998.
- Placzek, Adolf K., ed. *Macmillan Encyclopedia of Architects*. 4 vols. New York: Macmillan, 1982.
- Podro, Michael. *The Critical Historians of Art.* New Haven, Conn.: Yale University Press, 1982.
- Pollock, Griselda. Vision and Difference: Femininity, Feminism, and Histories of Art. London: Routledge, 1988.
- Pregill, Philip, and Nancy Volkman. Landscapes in History Design and Planning in the Eastern and Western Traditions. 2d ed. Hoboken, N.J.: Wiley, 1999.
- Preziosi, Donald, ed. *The Art of Art History: A Critical Anthology.* New York: Oxford University Press, 1998.
- Read, Herbert. *The Thames & Hudson Dictionary of Art and Artists.* Rev. ed. New York: Thames & Hudson, 1994.
- Reid, Jane D. *The Oxford Guide to Classical Mythology in the Arts 1300–1990s.* 2 vols. New York: Oxford University Press, 1993.
- Rogers, Elizabeth Barlow. Landscape Design: A Cultural and Architectural History. New York: Abrams, 2001.
- Roth, Leland M. Understanding Architecture: Its Elements, History, and Meaning. 2d ed. Boulder, Colo.: Westview, 2006.
- Schama, Simon. The Power of Art. New York: Ecco, 2006.
- Slatkin, Wendy. Women Artists in History: From Antiquity to the 20th Century. 4th ed. Upper Saddle River, N.J.: Prentice Hall, 2000.
- Squire, Michael. *The Art of the Body: Antiquity and Its Legacy.* New York: Oxford University Press, 2011.
- Steer, John, and Antony White. Atlas of Western Art History: Artists, Sites, and Monuments from Ancient Greece to the Modern Age. New York: Facts on File, 1994.
- Stratton, Arthur. *The Orders of Architecture: Greek, Roman, and Renaissance.* London: Studio, 1986.
- Summers, David. Real Spaces: World Art History and the Rise of Western Modernism. London: Phaidon, 2003.
- Sutcliffe, Antony. Paris: An Architectural History. New Haven, Conn.: Yale University Press, 1996.
- Sutton, Ian. Western Architecture: From Ancient Greece to the Present. New York: Thames & Hudson, 1999.
- Trachtenberg, Marvin, and Isabelle Hyman. Architecture, from Prehistory to Post-Modernism. 2d ed. Upper Saddle River, N.J.: Prentice Hall, 2003.
- Turner, Jane, ed. *The Dictionary of Art.* 34 vols. New ed. New York: Oxford University Press, 2003.
- Watkin, David. A History of Western Architecture. 5th ed. London: Laurence King, 2011.
- Wescoat, Bonna D., and Robert G. Ousterhout, eds. Architecture of the Sacred: Space, Ritual, and Experience from Classical Greece to Byzantium. New York: Cambridge University Press, 2012.
- West, Shearer. Portraiture. New York: Oxford University Press, 2004.
- Wittkower, Rudolf. Sculpture Processes and Principles. New York: Harper & Row, 1977.
- Wren, Linnea H., and Janine M. Carter, eds. Perspectives on Western Art: Source Documents and Readings from the Ancient Near East through the Middle Ages. New York: Harper & Row, 1987.
- Zijlmans, Kitty, and Wilfried van Damme, eds. World Art Studies: Exploring Concepts and Approaches. Amsterdam: Valiz, 2008.

Ancient Art, General

- Aruz, Joan, and Ronald Wallenfels, eds. *Art of the First Cities: The Third Millennium вс from the Mediterranean to the Indus.* New York: Metropolitan Museum of Art, 2003.
- Beard, Mary, and John Henderson. Classical Art: From Greece to Rome. New York: Oxford University Press, 2001.
- Boardman, John. *The World of Ancient Art*. London: Thames & Hudson, 2006.
 ——, ed. *The Oxford History of Classical Art*. New York: Oxford University Press, 1997.
- Chitham, Robert. *The Classical Orders of Architecture*. 2d ed. Boston: Architectural Press, 2005.

- Clayton, Peter A., and Martin J. Price, eds. *The Seven Wonders of the Ancient World*. New York: Routledge, 1988.
- Connolly, Peter, and Hazel Dodge. *The Ancient City: Life in Classical Athens and Rome.* New York: Oxford University Press, 1998.
- De Grummond, Nancy Thomson, ed. *An Encyclopedia of the History of Classical Archaeology.* 2 vols. Westport, Conn.: Greenwood, 1996.
- Dunbabin, Katherine. Mosaics of the Greek and Roman World. New York: Cambridge University Press, 1999.
- Gates, Charles. Ancient Cities: The Archaeology of Urban Life in the Ancient Near East and Egypt, Greece, and Rome. 2d ed. London: Routledge, 2011.
- Grossman, Janet Burnett. Looking at Greek and Roman Sculpture in Stone: A Guide to Terms, Styles, and Techniques. Los Angeles: J. Paul Getty Museum, 2003.
- Kampen, Natalie B., ed. Sexuality in Ancient Art. New York: Cambridge University Press, 1996.
- Lexicon Iconographicum Mythologiae Classicae. 10 vols. Zurich: Artemis, 1981-1999.
- Ling, Roger. Ancient Mosaics. Princeton, N.J.: Princeton University Press, 1998.Lloyd, Seton, and Hans Wolfgang Muller. Ancient Architecture: Mesopotamia, Egypt, Crete. New York: Electa/Rizzoli, 1980.
- Malacrino, Carmelo. Constructing the Ancient World: Architectural Techniques of the Greeks and Romans. Los Angeles: J. Paul Getty Museum, 2010.
- Oleson, John Peter, ed. The Oxford Handbook of Engineering and Technology in the Classical World. New York: Oxford University Press, 2008.
- Oliphant, Margaret. The Atlas of the Ancient World: Charting the Great Civilizations of the Past. New York: Simon & Schuster, 1992.
- Onians, John. Classical Art and the Cultures of Greece and Rome. New Haven, Conn.: Yale University Press, 1999.
- Renfrew, Colin, and Paul G. Bahn. Archaeology: Theories, Methods, and Practices. London: Thames & Hudson, 1991.
- Stillwell, Richard, William L. MacDonald, and Marian H. McAllister, eds. *The Princeton Encyclopedia of Classical Sites*. Princeton, N.J.: Princeton University Press, 1976.
- Trigger, Bruce. *Understanding Early Civilizations: A Comparative Study.* New York: Cambridge University Press, 2003.
- Ward-Perkins, John B. Cities of Ancient Greece and Italy: Planning in Classical Antiquity. Rev. ed. New York: Braziller, 1987.
- Wolf, Walther. The Origins of Western Art: Egypt, Mesopotamia, the Aegean. New York: Universe, 1989.

CHAPTER 1

Art in the Stone Age

- Aujoulat, Norbert. Lascaux: Movement, Space, and Time. New York: Abrams, 2005
- Bahn, Paul G. *The Cambridge Illustrated History of Prehistoric Art.* New York: Cambridge University Press, 1998.
- ——. Cave Art: A Guide to the Decorated Ice Age Caves of Europe. London: Frances Lincoln, 2007.
- Bahn, Paul G., and Jean Vertut. *Journey through the Ice Age.* Berkeley: University of California Press, 1997.
- Beltrán, Antonio, ed. The Cave of Altamira. New York: Abrams, 1999.
- Berhgaus, Guner. New Perspectives on Prehistoric Art. Westport, Conn.: Praeger, 2004.
- Burl, Aubrey. *Great Stone Circles*. New Haven, Conn.: Yale University Press, 1999.
- Chauvet, Jean-Marie, Eliette Brunel Deschamps, and Christian Hillaire. *Dawn of Art: The Chauvet Cave.* New York: Abrams, 1996.
- Chippindale, Christopher. Stonehenge Complete. 3d ed. New York: Thames & Hudson, 2004.
- Clottes, Jean. Cave Art. London: Phaidon, 2008.
- ——. Chauvet Cave: The Art of Earliest Times. Salt Lake City: University of Utah Press, 2003.
- Cunliffe, Barry, ed. *The Oxford Illustrated Prehistory of Europe*. New York: Oxford University Press, 2001.
- Guthrie, R. Dale. *The Nature of Paleolithic Art.* Chicago: University of Chicago Press, 2005.
- Hodder, Ian. The Leopard's Tale: Revealing the Mysteries of Çatalhöyük. London: Thames & Hudson, 2006.
- Kenyon, Kathleen M. Digging up Jericho. New York: Praeger, 1974.
- Leroi-Gourhan, André. The Dawn of European Art: An Introduction to Paleolithic Cave Painting. Cambridge: Cambridge University Press, 1982.
- Marshack, Alexander. The Roots of Civilization: The Cognitive Beginnings of Man's First Art, Symbol and Notation. 2d ed. Wakefield, R.I.: Moyer Bell, 1991.
- Pfeiffer, John E. The Creative Explosion: An Inquiry into the Origins of Art and Religion. New York: Harper & Row, 1982.

- Renfrew, Colin, ed. *British Prehistory: A New Outline*. London: Noyes, 1975. Ruspoli, Mario. *The Cave of Lascaux: The Final Photographs*. New York: Abrams, 1987.
- Scarre, Chris. Exploring Prehistoric Europe. New York: Oxford University Press, 1998.
- Wainwright, Geoffrey. The Henge Monuments: Ceremony and Society in Prehistoric Britain. London: Thames & Hudson, 1990.
- White, Randall. Prehistoric Art: The Symbolic Journey of Humankind. New York: Abrams, 2003.

Ancient Mesopotamia and Persia

Akurgal, Ekrem. Art of the Hittites. New York: Abrams, 1962.

Allen, Lindsay. *The Persian Empire*. Chicago: University of Chicago Press, 2005.

Amiet, Pierre. Art of the Ancient Near East. New York: Abrams, 1980.

Ascalone, Enrico. *Mesopotamia: Assyrians, Sumerians, Babylonians.* Berkeley and Los Angeles: University of California Press, 2007.

Bahrani, Zainab. *The Graven Image: Representation in Babylonia and Assyria*. Philadelphia: University of Pennsylvania Press, 2003.

Bienkowski, Piotr, and Alan Millard, eds. *Dictionary of the Ancient Near East*. Philadelphia: University of Pennsylvania Press, 2000.

Collins, Paul. Assyrian Palace Sculptures. Austin: University of Texas Press, 2008.

Collon, Dominique. Ancient Near Eastern Art. Berkeley: University of California Press, 1995.

nia Press, 1995.— First Impressions: Cylinder Seals in the Ancient Near East. 2d ed. London: British Museum, 1993.

Crawford, Harriet. Sumer and the Sumerians. 2d ed. New York: Cambridge University Press, 2004.

-----, ed. The Sumerian World. London: Routledge, 2013.

Curatola, Giovanni, ed. *The Art and Architecture of Mesopotamia*. New York: Abbeville, 2007.

Curtis, John E. Ancient Persia. Cambridge, Mass.: Harvard University Press, 1990.

Curtis, John E., and Julian E. Reade. Art and Empire: Treasures from Assyria in the British Museum. New York: Metropolitan Museum of Art, 1995.

Curtis, John E., and Nigel Tallis, eds. Forgotten Empire: The World of Ancient Persia. Berkeley: University of California Press, 2005.

Finkel, Irving L., and Michael J. Seymour, eds. *Babylon*. New York: Oxford University Press, 2008.

Foster, Benjamin R., and Karen Polinger Foster. Civilizations of Ancient Iraq. Princeton, N.J.: Princeton University Press, 2009.

Frankfort, Henri. *The Art and Architecture of the Ancient Orient.* 5th ed. New Haven, Conn.: Yale University Press, 1996.

Ghirshman, Roman. The Arts of Ancient Iran: From Its Origins to the Time of Alexander the Great. New York: Golden, 1964.

— Persian Art: The Parthian and Sassanian Dynasties, 249 BC-AD 651.

New York: Golden, 1962.

Gunter, Ann C., ed. *Investigating Artistic Environments in the Ancient Near East.* Washington, D.C.: Arthur M. Sackler Gallery, 1990.

Harper, Prudence O., Joan Aruz, and Françoise Tallon, eds. *The Royal City of Susa: Ancient Near Eastern Treasures in the Louvre.* New York: Metropolitan Museum of Art, 1992.

Leick, Gwendolyn. Mesopotamia: The Invention of the City. New York: Penguin, 2003.

Lloyd, Seton. The Archaeology of Mesopotamia: From the Old Stone Age to the Persian Conquest. London: Thames & Hudson, 1984.

Macqueen, James G. *The Hittites and Their Contemporaries in Asia Minor.* Rev. ed. New York: Thames & Hudson, 1986.

Meyers, Eric M., ed. *The Oxford Encyclopedia of Archaeology in the Near East.* 5 vols. New York: Oxford University Press, 1997.

Moortgat, Anton. *The Art of Ancient Mesopotamia*. New York: Phaidon, 1969. Oates, Joan. *Babylon*. Rev. ed. London: Thames & Hudson, 1986.

Parrot, André. The Arts of Assyria. New York: Golden, 1961.

——. Sumer: The Dawn of Art. New York: Golden, 1961.

Porada, Edith. Man and Images in the Ancient Near East. Wakefield, R.I.: Moyer Bell, 1995.

Porada, Edith, and Robert H. Dyson. *The Art of Ancient Iran: Pre-Islamic Cultures*. Rev. ed. New York: Greystone, 1969.

Postgate, J. Nicholas. Early Mesopotamia: Society and Economy at the Dawn of History. London: Routledge, 1992.

Potts, Daniel T. *The Archaeology of Elam: Formation and Transformation of an Ancient Iranian State.* New York: Cambridge University Press, 1999.

Reade, Julian E. Assyrian Sculpture. Cambridge, Mass.: Harvard University Press, 1999.

----. Mesopotamia. Cambridge, Mass.: Harvard University Press, 1991.

Roaf, Michael. Cultural Atlas of Mesopotamia and the Ancient Near East. New York: Facts on File, 1990.

Russell, John M. Sennacherib's Palace without Rival at Nineveh. Chicago: University of Chicago Press, 1991.

Saggs, H.W.F. Babylonians. London: British Museum, 1995.

Sasson, Jack M., ed. *Civilizations of the Ancient Near East.* 4 vols. New York: Scribner, 1995.

Snell, Daniel C. Life in the Ancient Near East: 3100–332 BC. New Haven, Conn.: Yale University Press, 1997.

Strommenger, Eva, and Max Hirmer. 5,000 Years of the Art of Mesopotamia. New York: Abrams, 1964.

Van de Mieroop, Marc. *The Ancient Mesopotamian City.* New York: Oxford University Press, 1997.

Zettler, Richard L., and Lee Horne. *Treasures from the Royal Tombs of Ur.* Philadelphia: University of Pennsylvania Museum of Archaeology and Anthropology, 1998.

CHAPTER 3

Egypt from Narmer to Cleopatra

Allen, James P., ed., Egyptian Art in the Age of the Pyramids. New York: Abrams, 1999.

Arnold, Dieter. *Building in Egypt: Pharaonic Stone Masonry.* New York: Oxford University Press, 1991.

Arnold, Dorothea. *The Royal Women of Amarna*. New York: Metropolitan Museum of Art, 1996.

——. When the Pyramids Were Built: Egyptian Art of the Old Kingdom. New York: Rizzoli, 1999.

Baines, John, and Jaromír Málek. *Atlas of Ancient Egypt*. New York: Facts on File, 1980.

Bard, Kathryn A. An Introduction to the Archaeology of Ancient Egypt. Oxford: Blackwell, 2007.

—, ed. Encyclopedia of the Archaeology of Ancient Egypt. London: Routledge, 1999.

Bianchi, Robert S. Cleopatra's Egypt: Age of the Ptolemies. Brooklyn: Brooklyn Museum, 1988.

——. Splendors of Ancient Egypt from the Egyptian Museum, Cairo. London: Booth-Clibborn, 1996.

Capel, Anne K., and Glenn E. Markoe, eds. Mistress of the House, Mistress of Heaven: Women in Ancient Egypt. New York: Hudson Hills, 1996.

D'Auria, Sue, Peter Lacovara, and Catharine H. Roehrig. *Mummies and Magic:*The Funerary Arts of Ancient Egypt. Boston: Museum of Fine Arts, 1988.

Davis, Whitney. *The Canonical Tradition in Ancient Egyptian Art.* New York: Cambridge University Press, 1989.

Dodson, Aidam, and Salima Ikram. *The Tomb in Ancient Egypt*. New York: Thames & Hudson, 2008.

Emberling, Geoff. Nubia: Ancient Kingdoms of Africa. Princeton, N.J.: Princeton University Press, 2011.

Hawass, Zahi. Valley of the Golden Mummies. New York: Abrams, 2000.

Ikram, Salima, and Aidan Dodson. *The Mummy in Ancient Egypt: Equipping the Dead for Eternity.* New York: Thames & Hudson, 1998.

Kemp, Barry J. Ancient Egypt: Anatomy of a Civilization. 2d ed. New York: Routledge, 2006.

Kozloff, Arielle P., and Betsy M. Bryan. *Egypt's Dazzling Sun: Amenhotep III and His World*. Cleveland: Cleveland Museum of Art, 1992.

Lange, Kurt, and Max Hirmer. *Egypt: Architecture, Sculpture, and Painting in Three Thousand Years.* 4th ed. London: Phaidon, 1968.

Lehner, Mark. The Complete Pyramids: Solving the Ancient Mysteries. New York: Thames & Hudson, 1997.

Mahdy, Christine, ed. *The World of the Pharaohs: A Complete Guide to Ancient Egypt.* London: Thames & Hudson, 1990.

Málek, Jaromír. Egypt: 4,000 Years of Art. New York: Phaidon, 2003.

. Egyptian Art. London: Phaidon, 1999.

——, ed. *Egypt: Ancient Culture, Modern Land.* Norman: University of Oklahoma Press, 1993.

O'Neill, John P., ed. Egyptian Art in the Age of the Pyramids. New York: Abrams, 1999.

Redford, Donald B. Akhenaton, the Heretic King. Princeton, N.J.: Princeton University Press, 1984.

——, ed. The Oxford Encyclopedia of Ancient Egypt. 3 vols. New York: Oxford University Press, 2001.

Reeves, C. Nicholas. *The Complete Tutankhamun: The King, the Tomb, the Royal Treasure*. London: Thames & Hudson, 1990.

- Robins, Gay. *The Art of Ancient Egypt*. Rev. ed. Cambridge, Mass.: Harvard University Press, 2008.
- . Egyptian Painting and Relief. Aylesbury: Shire, 1986.
- Proportion and Style in Ancient Egyptian Art. Austin: University of Texas Press, 1994.
- . Women in Ancient Egypt. London: British Museum, 1993.
- Romer, John. Valley of the Kings: Exploring the Tombs of the Pharaohs. New York: Holt, 1994.
- Russmann, Edna R. Egyptian Sculpture: Cairo and Luxor. Austin: University of Texas Press, 1989.
- Schäfer, Heinrich. Principles of Egyptian Art. Rev. ed. Oxford: Clarendon, 1986
- Schulz, Regina, and Matthias Seidel, eds. *Egypt: The World of the Pharaohs*. Cologne: Könemann, 1999.
- Shafer, Byron E., ed. Temples of Ancient Egypt. Ithaca, N.Y.: Cornell University Press, 1997.
- Shaw, Ian, and Paul Nicholson. *The Dictionary of Ancient Egypt.* London: British Museum, 1995.
- Silverman, David P., ed. *Ancient Egypt*. New York: Oxford University Press, 1997. Smith, William Stevenson, and William Kelly Simpson. *The Art and Architecture of Ancient Egypt*. Rev. ed. New Haven, Conn.: Yale University Press, 1998.
- Snape, Steven. Ancient Egyptian Tombs: The Culture of Life and Death. Oxford: Wiley-Blackwell, 2011.
- Taylor, John H. Journey through the Afterlife: The Ancient Egyptian Book of the Dead. Cambridge, Mass.: Harvard University Press, 2010.
- Tiradritti, Francesco. Egyptian Wall Paintings. New York: Abbeville, 2008.
- Weeks, Kent R. The Treasures of Luxor and the Valley of the Kings. Vercelli: White Star, 2005.
- , ed. Valley of the Kings. Vercelli: White Star, 2001.
- Wenke, Robert J. *The Ancient Egyptian State: The Origins of Egyptian Culture* (c. 8000–2000 BC). New York: Cambridge University Press, 2009.
- Wildung, Dietrich. Egypt: From Prehistory to the Romans. Cologne: Taschen, 1997.
- Wilkinson, Toby. The Egyptian World. London: Routledge, 2009.

The Prehistoric Aegean

- Andreadaki-Vlazaki, Maria, ed. From the Land of the Labyrinth: Minoan Crete 3000–1100 B.C. New York: Alexander S. Onassis Public Benefit Foundation. 2008.
- Barber, R.L.N. *The Cyclades in the Bronze Age.* Iowa City: University of Iowa Press, 1987.
- Betancourt, Philip P. A History of Minoan Pottery. Princeton, N.J.: Princeton University Press, 1965.
- _____. Introduction to Aegean Art. New York: Institute for Aegean Prehistory, 2007.
- Cadogan, Gerald. Palaces of Minoan Crete. London: Methuen, 1980.
- Castleden, Rodney. Mycenaeans. London: Routledge, 2005.
- Chadwick, John. *The Mycenaean World*. New York: Cambridge University Press, 1976.
- Cline, Eric H., ed. *The Oxford Handbook of the Bronze Age Aegean*. New York: Oxford University Press, 2010.
- Cullen, Tracey, ed. *Aegean Prehistory: A Review.* Boston: Archaeological Institute of America, 2001.
- Demargne, Pierre. The Birth of Greek Art. New York: Golden, 1964.
- Dickinson, Oliver P.T.K. *The Aegean Bronze Age.* New York: Cambridge University Press, 1994.
- Doumas, Christos. Thera, Pompeii of the Ancient Aegean: Excavations at Akrotiri, 1967–1979. New York: Thames & Hudson, 1983.
- Fitton, J. Lesley. Cycladic Art. 2d ed. Cambridge, Mass.: Harvard University Press, 1999.
- —. The Discovery of the Greek Bronze Age. London: British Museum, 1995. Forsyth, Phyllis Young. Thera in the Bronze Age. New York: Peter Lang, 1997.
- Getz-Preziosi, Patricia. Sculptors of the Cyclades: Individual and Tradition in the Third Millennium BC. Ann Arbor: University of Michigan Press, 1987.
- Graham, James W. *The Palaces of Crete*. Princeton, N.J.: Princeton University Press, 1987.
- Hampe, Roland, and Erika Simon. *The Birth of Greek Art: From the Mycenaean to the Archaic Period.* New York: Oxford University Press, 1981.
- Higgins, Reynold. *Minoan and Mycenaean Art.* Rev. ed. New York: Thames & Hudson, 1997.
- Hood, Sinclair. *The Arts in Prehistoric Greece*. New Haven, Conn.: Yale University Press, 1992.

- Immerwahr, Sarah A. Aegean Painting in the Bronze Age. University Park: Pennsylvania State University Press, 1990.
- MacGillivray, J. A. Minotaur: Sir Arthur Evans and the Archaeology of the Minoan Myth. New York: Hill and Wang, 2000.
- Marinatos, Nanno. Art and Religion in Thera: Reconstructing a Bronze Age Society. Athens: Mathioulakis, 1984.
- Marinatos, Spyridon, and Max Hirmer. *Crete and Mycenae*. London: Thames & Hudson, 1960.
- McDonald, William A., and Carol G. Thomas. *Progress into the Past: The Rediscovery of Mycenaean Civilization*. 2d ed. Bloomington: Indiana University Press, 1990.
- McEnroe, John. Architecture of Minoan Crete: Constructing Identity in the Aegean Bronze Age. Austin: University of Texas Press, 2010.
- Preziosi, Donald, and Louise A. Hitchcock. *Aegean Art and Architecture*. New York: Oxford University Press, 1999.
- Schofield, Louise. The Mycenaeans. London: British Museum, 2007.
- Shelmerdine, Cynthia W., ed. *The Cambridge Companion to the Aegean Bronze Age.* New York: Cambridge University Press, 2008.
- Taylour, Lord William. The Mycenaeans. London: Thames & Hudson, 1990.
- Vermeule, Emily. Greece in the Bronze Age. Chicago: University of Chicago Press. 1972.
- Warren, Peter. The Aegean Civilizations: The Making of the Past. New York: Peter Bedrick, 1989.

CHAPTER 5

Ancient Greece

- Arias, Paolo. A History of One Thousand Years of Greek Vase Painting. New York: Abrams, 1962.
- Ashmole, Bernard. *Architect and Sculptor in Classical Greece*. New York: New York University Press, 1972.
- Barletta, Barbara A. *The Origins of the Greek Architectural Orders*. New York: Cambridge University Press, 2001.
- Berve, Helmut, Gottfried Gruben, and Max Hirmer. *Greek Temples, Theatres, and Shrines*. New York: Abrams, 1963.
- Biers, William. *The Archaeology of Greece: An Introduction*. 2d ed. Ithaca, N.Y.: Cornell University Press, 1996.
- Boardman, John. Athenian Black Figure Vases. Rev. ed. New York: Thames & Hudson, 1991.
- —. Athenian Red Figure Vases: The Archaic Period. New York: Thames & Hudson, 1988.
- ——. Early Greek Vase Painting, 11th-6th Centuries BC. New York: Thames & Hudson, 1998.
- Greek Sculpture: The Archaic Period. Rev. ed. New York: Thames & Hudson, 1985.
- Greek Sculpture: The Classical Period. New York: Thames & Hudson, 1987.
- ——. Greek Sculpture: The Late Classical Period and Sculpture in Colonies and Overseas. New York: Thames & Hudson, 1995.
- . The Parthenon and Its Sculpture. Austin: University of Texas Press, 1985. Camp, John M. The Archaeology of Athens. New Haven, Conn.: Yale University Press, 2001.
- Carpenter, Thomas H. Art and Myth in Ancient Greece. New York: Thames & Hudson, 1991.
- Charbonneaux, Jean, Roland Martin, and François Villard. *Archaic Greek Art.* New York: Braziller, 1971.
- -----. Classical Greek Art. New York: Braziller, 1972.
- Clark, Andrew J., Maya Elston, and Mary Louise Hart. *Understanding Greek Vases: A Guide to Terms, Styles, and Techniques*. Los Angeles: J. Paul Getty Museum, 2002.
- Cohen, Beth, ed. *The Colors of Clay: Special Techniques in Athenian Vases*. Los Angeles: J. Paul Getty Museum, 2006.
- Coldstream, J. Nicholas. *Geometric Greece*: 900–700 BC. 2d ed. London: Routledge, 2003.
- Coulton, J. J. Ancient Greek Architects at Work. Ithaca, N.Y.: Cornell University Press, 1982.
- Donohue, A. A. *Greek Sculpture and the Problem of Description*. New York: Cambridge University Press, 2005.
- Fullerton, Mark D. *Greek Art.* New York: Cambridge University Press, 2000. Gunter, Ann C. *Greek Art and the Orient.* New York: Cambridge University
- Haynes, Denys E. L. The Technique of Greek Bronze Statuary. Mainz: von Zabern, 1992.

- Houser, Caroline. *Greek Monumental Bronze Sculpture*. New York: Vendome, 1983.
- Hurwit, Jeffrey M. *The Acropolis in the Age of Pericles*. New York: Cambridge University Press, 2004.
- ——. The Art and Culture of Early Greece, 1100–480 вс. Ithaca, N.Y.: Cornell University Press, 1985.
- The Athenian Acropolis: History, Mythology, and Archaeology from the Neolithic Era to the Present. New York: Cambridge University Press, 1999.
- Jenkins, Ian. *Greek Architecture and Its Sculpture*. Cambridge, Mass.: Harvard University Press, 2006.
- —. The Parthenon Frieze. Austin: University of Texas Press, 1994.
- Junker, Klaus. Interpreting the Images of Greek Myths: An Introduction. New York: Cambridge University Press, 2012.
- Keesling, Catherine M. *The Votive Statues of the Athenian Acropolis*. New York: Cambridge University Press, 2008.
- Lawrence, Arnold W., and R. A. Tomlinson. *Greek Architecture*. Rev. ed. New Haven, Conn.: Yale University Press, 1996.
- Martin, Roland. Greek Architecture: Architecture of Crete, Greece, and the Greek World. New York: Electa/Rizzoli, 1988.
- Mattusch, Carol C. Classical Bronzes: The Art and Craft of Greek and Roman Statuary. Ithaca, N.Y.: Cornell University Press, 1996.
- Greek Bronze Statuary from the Beginnings through the Fifth Century BC. Ithaca, N.Y.: Cornell University Press, 1988.
- Mee, Christopher. *Greek Archaeology*. Hoboken, N.J.: Wiley-Blackwell, 2011.
- Mee, Christopher, and Tony Spawforth. *Greece: An Oxford Archaeological Guide.* New York: Oxford University Press, 2001.
- Morris, Sarah P. *Daidalos and the Origins of Greek Art.* Princeton, N.J.: Princeton University Press, 1992.
- Neer, Richard T. The Emergence of the Classical Style in Greek Sculpture. Chicago: University of Chicago Press, 2010.
- . Greek Art and Archaeology: A New History, c. 2500–150 BCE. New York: Thames & Hudson, 2011.
- Osborne, Robin. Archaic and Classical Greek Art. New York: Oxford University Press, 1998.
- Palagia, Olga. The Pediments of the Parthenon. Leiden: E. J. Brill, 1993.
- ——, ed. Greek Sculpture: Functions, Materials, and Techniques in the Archaic and Classical Periods. New York: Cambridge University Press, 2006.
- Palagia, Olga, and Jerome J. Pollitt. Personal Styles in Greek Sculpture. New York: Cambridge University Press, 1996.
- Pedley, John Griffiths. *Greek Art and Archaeology.* 4th ed. Upper Saddle River, N.J.: Prentice Hall, 2007.
- Sanctuaries and the Sacred in the Ancient Greek World. New York: Cambridge University Press, 2005.
- Petrakos, Vasileios. *Great Moments in Greek Archaeology.* Los Angeles: J. Paul Getty Museum, 2007.
- Pollitt, Jerome J. Art and Experience in Classical Greece. New York: Cambridge University Press, 1972.
- Art in the Hellenistic Age. New York: Cambridge University Press, 1986.
 The Art of Ancient Greece: Sources and Documents. 2d ed. New York: Cambridge University Press, 1990.
- Pugliese Carratelli, G. *The Greek World: Art and Civilization in Magna Graecia and Sicily.* New York: Rizzoli, 1996.
- Reeder, Ellen D., ed. *Pandora: Women in Classical Greece*. Baltimore: Walters Art Gallery, 1995.
- Rhodes, Robin F. Architecture and Meaning on the Athenian Acropolis. New York: Cambridge University Press, 1995.
- Richter, Gisela M. *The Portraits of the Greeks*. Rev. ed. by R.R.R. Smith. Ithaca, N.Y.: Cornell University Press, 1984.
- Ridgway, Brunilde S. *The Archaic Style in Greek Sculpture*. 2d ed. Chicago: Ares, 1993.
- Fifth-Century Styles in Greek Sculpture. Princeton, N.J.: Princeton University Press, 1981.
- Fourth-Century Styles in Greek Sculpture. Madison: University of Wisconsin Press, 1997.
- ——. Hellenistic Sculpture I: The Styles of ca. 331–200 вс. Madison: University of Wisconsin Press, 1990.
- Hellenistic Sculpture II: The Styles of ca. 200–100 BC. Madison: University of Wisconsin Press, 2000.
- Prayers in Stone: Greek Architectural Sculpture. Berkeley: University of California Press, 1999.
- ——. Roman Copies of Greek Sculpture: The Problem of the Originals. Ann Arbor: University of Michigan Press, 1984.
- The Severe Style in Greek Sculpture. Princeton, N.J.: Princeton University Press, 1970.

- Robertson, Martin. *The Art of Vase-Painting in Classical Athens.* New York: Cambridge University Press, 1992.
- A History of Greek Art. Rev. ed. 2 vols. New York: Cambridge University Press, 1986.
- . A Shorter History of Greek Art. New York: Cambridge University Press, 1981.
- Shapiro, H. Alan. Art and Cult in Athens under the Tyrants. Mainz: von Zabern, 1989.
- Myth into Art: Poet and Painter in Classical Greece. New York: Routledge, 1994.
- Smith, R.R.R. Hellenistic Sculpture. New York: Thames & Hudson, 1991.
- Spawforth, Tony. The Complete Greek Temples. London, Thames & Hudson, 2006.
- Spivey, Nigel. Greek Art. London: Phaidon, 1997.
- Stansbury-O'Donnell, Mark D. *Looking at Greek Art.* New York: Cambridge University Press, 2011.
- ——. Pictorial Narrative in Ancient Greek Art. New York: Cambridge University Press, 1999.
- Stewart, Andrew. Art, Desire, and the Body in Ancient Greece. New York: Cambridge University Press, 1997.
- Classical Greece and the Birth of Western Art. New York: Cambridge University Press, 2008.
- Greek Sculpture: An Exploration. 2 vols. New Haven, Conn.: Yale University Press, 1990.
- Whitley, James. *The Archaeology of Ancient Greece*. New York: Cambridge University Press, 2001.
- Wycherley, Richard E. How the Greeks Built Cities. New York: Norton, 1976.

The Etruscans

- Banti, Luisa. *The Etruscan Cities and Their Culture*. Berkeley: University of California Press, 1973.
- Barker, Graeme, and Tom Rasmussen. *The Etruscans*. Oxford: Blackwell, 1998. Boethius, Axel. *Etruscan and Early Roman Architecture*. 2d ed. New Haven, Conn.: Yale University Press, 1978.
- Bonfante, Larissa, ed. Etruscan Life and Afterlife: A Handbook of Etruscan Studies. Detroit: Wayne State University Press, 1986.
- Brendel, Otto J. Etruscan Art. 2d ed. New Haven, Conn.: Yale University Press,
- Cristofani, Mauro. The Etruscans: A New Investigation. London: Orbis, 1979.
- De Grummond, Nancy Thomson. *Etruscan Myth, Sacred History, and Legend*. Philadelphia: University of Pennsylvania Museum, 2006.
- De Grummond, Nancy Thomson, and Erika Simon. *The Religion of the Etrus*cans. Austin: University of Texas Press, 2006.
- De Grummond, Nancy Thomson, and Ingrid Edlund-Berry, eds. *The Archaeology of Sanctuaries and Ritual in Etruria*. Portsmouth, R.I.: Journal of Roman Archaeology, 2011.
- Hall, John F. Etruscan Italy: Etruscan Influences on the Civilizations of Italy from Antiquity to the Modern Era. Bloomington: Indiana University Press, 1996
- Haynes, Sybille. Etruscan Civilization: A Cultural History. Los Angeles: J. Paul Getty Museum, 2000.
- Heurgon, Jacques. Daily Life of the Etruscans. London: Weidenfeld & Nicolson, 1964.
- Izzet, Vedia. The Archaeology of Etruscan Society. New York: Cambridge University Press, 2007.
- Lulof, Patricia S., and Iefke van Kampen, eds. Etruscans: Eminent Women, Powerful Men. Zwolle, the Netherlands: W Books, 2011.
- Pallottino, Massimo. The Etruscans. Harmondsworth: Penguin, 1978.
- Richardson, Emeline. *The Etruscans: Their Art and Civilization*. Rev. ed. Chicago: University of Chicago Press, 1976.
- Ridgway, David, and Francesca Ridgway, eds. *Italy before the Romans*. New York: Academic, 1979.
- Spivey, Nigel. Etruscan Art. New York: Thames & Hudson, 1997.
- Spivey, Nigel, and Simon Stoddart. Etruscan Italy: An Archaeological History. London: Batsford, 1990.
- Sprenger, Maja, Gilda Bartoloni, and Max Hirmer. *The Etruscans: Their History, Art, and Architecture.* New York: Abrams, 1983.
- Steingräber, Stephan. Abundance of Life: Etruscan Wall Painting. Los Angeles: J. Paul Getty Museum, 2006.
- Torelli, Mario, ed. The Etruscans. New York: Rizzoli, 2001.
- Turfa, Jean Macintosh, ed. The Etruscan World. London: Routledge, 2013.

The Roman Empire

- Aldrete, Gregory S. Daily Life in the Roman City: Rome, Pompeii, and Ostia. Westport, Conn.: Greenwood, 2004.
- Anderson, James C., Jr. Roman Architecture and Society. Baltimore: Johns Hopkins University Press, 1997.
- Andreae, Bernard. The Art of Rome. New York: Abrams, 1977.
- Barton, Ian M., ed. Roman Domestic Buildings. Exeter: University of Exeter Press, 1996.
- Roman Public Buildings. 2d ed. Exeter: University of Exeter Press, 1995. Bianchi Bandinelli, Ranuccio. Rome: The Center of Power: Roman Art to AD 200. New York: Braziller, 1970.
- Yale University Press, 1979. Claridge, Amanda. *Rome: An Oxford Archaeological Guide*. 2d ed. New York: Oxford University Press, 2010.
- Clarke, John R. Art in the Lives of Everyday Romans: Visual Representation and Non-Elite Viewers in Italy, 100 B.C.-A.D. 315. Berkeley: University of California Press. 2003.
- . The Houses of Roman Italy, 100 BC-AD 250. Berkeley: University of California Press, 1991.
- Coarelli, Filippo. *Rome and Environs: An Archaeological Guide.* Berkeley and Los Angeles: University of California Press, 2007.
- Cornell, Tim, and John Matthews. *Atlas of the Roman World*. New York: Facts on File, 1982.
- D'Ambra, Eve. Roman Art. New York: Cambridge University Press, 1998.
- ed. Roman Art in Context. Upper Saddle River, N.J.: Prentice Hall,
- Dobbins, John J., and Pedar W. Foss, eds. *The World of Pompeii*. London: Routledge, 2007.
- Dyson, Stephen L. *Rome: A Living Portrait of an Ancient City.* Baltimore: Johns Hopkins University Press, 2010.
- Gazda, Elaine K., ed. *Roman Art in the Private Sphere*. Ann Arbor: University of Michigan Press, 1991.
- Grant, Michael. Cities of Vesuvius: Pompeii and Herculaneum. Harmondsworth: Penguin, 1976.
- Hannestad, Niels. Roman Art and Imperial Policy. Aarhus: Aarhus University Press, 1986.
- Henig, Martin, ed. A Handbook of Roman Art. Ithaca, N.Y.: Cornell University Press, 1983.
- Kent, John P. C., and Max Hirmer. Roman Coins. New York: Abrams, 1978.
- Kleiner, Diana E. E. Roman Sculpture. New Haven, Conn.: Yale University Press, 1992.
- Kleiner, Diana E. E., and Susan B. Matheson, eds. *I Claudia: Women in Ancient Rome*. New Haven, Conn.: Yale University Art Gallery, 1996.
- Kleiner, Fred S. A History of Roman Art. Enhanced ed. Belmont, Calif.: Wadsworth, 2010.
- Kraus, Theodor. Pompeii and Herculaneum: The Living Cities of the Dead. New York: Abrams, 1975.
- Lancaster, Lynne. Concrete Vaulted Construction in Imperial Rome. New York: Cambridge University Press, 2006.
- Ling, Roger. Roman Painting. New York: Cambridge University Press,
- L'Orange, Hans Peter. *The Roman Empire: Art Forms and Civic Life.* New York: Rizzoli, 1985.

- MacCormack, Sabine G. Art and Ceremony in Late Antiquity. Berkeley: University of California Press, 1981.
- MacDonald, William L. The Architecture of the Roman Empire I: An Introductory Study. Rev. ed. New Haven, Conn.: Yale University Press, 1982.
- . The Architecture of the Roman Empire II: An Urban Appraisal. New Haven, Conn.: Yale University Press, 1986.
- . The Pantheon: Design, Meaning, and Progeny. Cambridge, Mass.: Harvard University Press, 1976.
- Mattusch, Carol C., ed. Pompeii and the Roman Villa: Art and Culture around the Bay of Naples. New York: Thames & Hudson, 2008.
- Mazzoleni, Donatella. *Domus: Wall Painting in the Roman House.* Los Angeles: J. Paul Getty Museum, 2004.
- McKay, Alexander G. Houses, Villas, and Palaces in the Roman World. Ithaca, N.Y.: Cornell University Press, 1975.
- Meiggs, Russell. *Roman Ostia*. New York: Oxford University Press, 1985. Reprint of 1973 ed.
- Nash, Ernest. Pictorial Dictionary of Ancient Rome. 2d ed. 2 vols. New York:
- Praeger, 1962.
 Pollitt, Jerome J. The Art of Rome, 753 BC-AD 337: Sources and Documents.
- Rev. ed. New York: Cambridge University Press, 1983. Potter, T. W. *Roman Italy.* Berkeley and Los Angeles: University of California Press, 1990.
- Richardson, Lawrence, Jr. A New Topographical Dictionary of Ancient Rome. Baltimore: Johns Hopkins University Press, 1992.
- ——. Pompeii: An Architectural History. Baltimore: Johns Hopkins University Press, 1988.
- Sear, Frank. Roman Architecture. Rev. ed. Ithaca, N.Y.: Cornell University
- Press, 1989. Stambaugh, John E. *The Ancient Roman City.* Baltimore: Johns Hopkins
- University Press, 1988. Stamper, John W. The Architecture of Roman Temples: The Republic to the
- Middle Empire. New York: Cambridge University Press, 2005. Stewart, Peter. The Social History of Roman Art. New York: Cambridge
- University Press, 2008. Taylor, Rabun. *Roman Builders*. New York: Cambridge University Press, 2003. Toynbee, Jocelyn M. C. *Death and Burial in the Roman World*. London:
- Thames & Hudson, 1971.
 Wallace-Hadrill, Andrew. *Herculaneum: Past and Future.* London: Frances Lincoln, 2011.
- —. Houses and Society in Pompeii and Herculaneum. Princeton, N.J.: Princeton University Press, 1994.
- Ward-Perkins, John B. Roman Architecture. New York: Electa/Rizzoli, 1988.
- ——. Roman Imperial Architecture. 2d ed. New Haven, Conn.: Yale University Press, 1981.
- Wilson-Jones, Mark. *Principles of Roman Architecture*. New Haven, Conn.: Yale University Press, 2000.
- Wood, Susan. Roman Portrait Sculpture AD 217–260. Leiden: E. J. Brill, 1986.
 Yegül, Fikret. Baths and Bathing in Classical Antiquity. Cambridge, Mass.: MIT Press, 1992.
- Zanker, Paul. *Pompeii: Public and Private Life.* Cambridge, Mass.: Harvard University Press, 1998.
- —. The Power of Images in the Age of Augustus. Ann Arbor: University of Michigan Press, 1988.
- -----. Roman Art. Los Angeles: J. Paul Getty Museum, 2010.
- Zanker, Paul, and Bjorn Ewald. Living with Myths: The Imagery of Roman Sarcophagi. New York: Oxford University Press, 2012.

Credits

The author and publisher are grateful to the proprietors and custodians of various works of art for photographs of these works and permission to reproduce them in this book. Sources not included in the captions are listed here.

NOTE: All references in the following credits are to figure numbers unless otherwise indicated.

Introduction—Opener: National Gallery, London/Art Resource, NY; I-2: Hirshhorn Museum and Culture Garden, Smithsonian Institution, Washington, DC, Joseph H. Hirshhorn Purchase Fund, 1992 @ City and county of Denver, courtesy the Clyfford Still Museum. Photo: akg images; I-3: Interior view of the choir, begun after 1284 (photo), French School, (13th century)/Beauvais Cathedral, Beauvais, France/© Paul Maeyaert/The Bridgeman Art Library; I-4: akg-images/Rabatti-Domingie; I-5: National Gallery of Art, Alfred Stieglitz Collection, Bequest of Georgia O'Keeffe 1987.58.3; I-6: Art © Estate of Ben Shahn/Licensed by VAGA, New York, NY. Photo: Whitney Museum of American Art, New York (gift of Edith and Milton Lowenthal in memory of Juliana Force); I-7: © Jonathan Poore/Cengage Learning; I-8: akg-images; I-9: The Metropolitan Museum of Art/Art Resource, NY; I-10: Courtesy Saskia Ltd., © Dr. Ron Wiedenhoeft; I-11: © 2011 The Josef and Anni Albers Foundation/ Artists Rights Society (ARS), New York. Photo: © Whitney Museum of American Art; I-12: Photograph © 2011 Museum of Fine Arts, Boston. 11.4584; I-13: bpk, Berlin/Staatsgemaeldesammlungen, Munich, Germany/Art Resource, NY; I-14: Jürgen Liepe, Berlin; I-15: The Trustees of the British Museum/Art Resource, NY; I-16: Nimatallah/Art Resource, NY; I-17: Scala/Art Resource, NY; I-18: Cengage Learning; I-19 left: Portrait of Te Pehi Kupe wearing European clothes, c.1826 (w/c), Sylvester, John (fl.1826)/© National Library of Australia, Canberra, Australia/The Bridgeman Art Library; I-19 right: Public Domain.

Chapter 1—Opener: Jean Vertut; 1-2: With permission: Namibia Archaeological Trust; 1-3: akg-images; 1-4: Erich Lessing/Art Resource, NY; 1-4A: RMN-Grand Palais/Art Resource, NY; 1-5: Venus with a horn, from Laussel in the Dordogne (stone), Prehistoric/Musee des Antiquites Nationales. St. Germain-en-Laye, France/Giraudon/The Bridgeman Art Library International; 1-5A: Louis de Seille/Courtesy Jean Clottes; 1-6: Jean Vertut; 1-7: RMN-Grand Palais/Art Resource, NY; 1-8: Jean Vertut; 1-9: Jean Vertut; 1-9A: akg-images; 1-10: Jean Vertut; 1-11: French Ministry of Culture and Communication, Regional Direction for Cultural Affairs-Rhone-Alpes region-Regional Department of Archaeology; 1-11A: © Michele Burgess/Alamy; 1-12: Zev Radovan www.biblelandpictures.com; 1-13: The Art Archive/Archaeological Museum Amman Jordan/Gianni Dagli Orti/Picture Desk; 1-14: Erich Lessing/ Art Resource, NY; 1-14A: John Swogger/The Çatalhöyük Research Project; 1-15: Gianni Dagli Orti/Fine Art/Corbis; 1-16: Cartographic Images and James Mellaart/Çatalhöyük Research Project; 1-17: The Art Archive/Gianni Dagli Orti/Picture Desk; 1-17A: Adam Woolfitt/Documentary Value/Corbis; 1-18: Bob Krist/Encyclopedia/Corbis; 1-19: John Burge/Cengage Learning; 1-20: F1 ONLINE/SuperStock.

Chapter 2—Opener: Erich Lessing/Art Resource, NY; 2-2: Richard Ashworth/ Robert Harding; 2-3: Cengage Learning; 2-4: akg-images/Bildarchiv Steffens; 2-5: Erich Lessing/Art Resource, NY; 2-5A: Hirmer Fotoarchiv, Munich; 2-6: RMN-Grand Palais/Art Resource, NY; 2-7: The Trustees of the British Museum/ Art Resource, NY; 2-8: © The Trustees of The British Museum/Art Resource, NY; 2-9: The Trustees of the British Museum/Art Resource, NY; 2-10: University of Pennsylvania Museum of Archaeology and Anthropology, Philadelphia; 2-11: © The Trustees of the British Museum; 2-12: Iraq Museum/akg-images; 2-13: RMN-Grand Palais/Art Resource, NY; 2-14: University of Pennsylvania Museum of Archaeology and Anthropology, Philadelphia; 2-15: Silvio Fiore/SuperStock; 2-16: Erich Lessing/Art Resource, NY; 2-17: Erich Lessing/Art Resource, NY; 2-17A: Erich Lessing/Art Resource, NY; 2-18: Rmn-Grand Palais/Art Resource, NY; 2-18A: © Iberfoto/The Image Works; 2-18B: Vase, Style I, from Susa, Iran, 5000-4000 вс (ceramic), Mesopotamian/Louvre, Paris, France/Giraudon/The Bridgeman Art Library; 2-19: RMN-Grand Palais/Art Resource, NY; 2-19A: Cengage Learning; 2-20: © The Bridgeman Art Library Ltd./Alamy; 2-21: © The Trustees of The British Museum/Art Resource, NY; 2-22: The Trustees of The British Museum/Art Resource, NY; 2-23: © The Trustees of the British Museum; 2-24: Bildarchiv Preussischer Kulturbesitz/Art Resource, NY; 2-25: The Art

Archive/Alfredo Dagli Orti/Picture Desk; 2-26: age fotostock/SuperStock; 2-27: David Poole/Robert Harding Picture Library; 2-28: Scala/Art Resource, NY; 2-29: Gérard Degeorge/akg-images; 2-29A:

MARKA/Alamy.

Chapter 3—Introduction: The Trustees of the British Museum/Art Resource, NY; 3-ÎA: J. E. Quibell and F. W. Geen, Hierakonpolis vol. 2 (London 1902) p. 76/ Egyptian Museum; 3-2: Werner Forman/Art Resource, NY; 3-3: Werner Forman/ Art Resource, NY; 3-4: Cengage Learning; 3-5: akg-images; 3-6: Cengage Learning; 3-6A: Ancient Art and Architecture Collection; 3-7: Erich Lessing/Art Resource, NY; 3-8: Yann Arthus-Bertrand/Terra/Corbis; 3-9: Cengage Learning; 3-10: Courtesy of the Semitic Museum, Harvard University; 3-11: © Jon Arnold Images Ltd/Alamy; 3-12: Araldo de Luca; 3-12A: Erich Lessing/Art Resource, NY; 3-13: Photograph © 2011 Museum of Fine Arts, Boston. 11.1738; 3-13A: akg-images/Andrea Jemolo; 3-14: Erich Lessing/Art Resource, NY; 3-14A: Jürgen Liepe, Berlin; 3-14B: Roemer-und Pelizaeus Museum Hildesheim; 3-15: Jean Vertut; 3-16: Men herding sheep and cattle from the Mastaba Chapel of Ti, Old Kingdom (wall painting), Egyptian 5th Dynasty (c. 2494–2345 BC)/Saggara Memphis, Egypt/The Bridgeman Art Library; 3-16A: Photograph © 2011 Museum of Fine Arts, Boston; 3-17: © The Metropolitan Museum of Art/Art Resource, NY; 3-18: DEA/G. SIOEN/Getty Images; 3-19: akg-images/Francois Guenet; 3-20: De Agostini/SuperStock; 3-21: © The Metropolitan Museum of Art/Art Resource, NY; 3-22: Scala/Art Resource, NY; 3-23: akg-images/Robert O'Dea; 3-23A: Carmen Redondo/Documentary Value/Corbis; 3-24: Yann Arthus-Bertrand/Corbis; 3-24A: Yann Arthus-Bertrand/Encyclopedia/Corbis; 3-25: Jon Arnold Images Ltd/Alamy; 3-26: © The Metropolitan Museum of Art/ Art Resource, NY; 3-27: bpk, Berlin/Aegyptisches Museum, Staatliche Museen, Berlin, Germany/Jürgen Liepe/Art Resource, NY; 3-28: © The Trustees of The British Museum/Art Resource, NY; 3-29: © The Trustees of The British Museum/ Art Resource, NY; 3-30: Araldo de Luca; 3-31: Sean Gallup/Getty Images; 3-32: Egyptian Museum and Papyrus Collection Berlin; 3-33: bpk, Berlin/Aegyptisches Museum, Staatliche Museen, Berlin, Germany/Art Resource, NY; 3-34: The innermost coffin of the king, from the Tomb of Tutankhamun (c. 1370-1352 BC) New Kingdom (gold inlaid with semi-precious stones) (for detail see 343642), Egyptian 18th Dynasty (c. 1567-1320 BC)/Egyptian National Museum, Cairo, Egypt/Photo © Boltin Picture Library/The Bridgeman Art Library; 3-35: Robert Harding World Imagery/Getty Images; 3-36: The Art Archive/Egyptian Museum Cairo/Gianni Dagli Orti/Picture Desk; 3-37: The Trustees of The British Museum/Art Resource, NY; 3-38: Jürgen Liepe, Berlin; 3-39: Yann Arthus-Bertrand/Corbis.

Chapter 4—Opener: Nimatallah/Art Resource, NY; 4-2: Erich Lessing/Art Resource, NY; 4-3: The Art Archive/National Archaeological Museum Athens/ Gianni Dagli Orti/Picture Desk; 4-4: John Burge; 4-5: Cengage Learning; 4-6: Roger Wood/Fine Art/Corbis; 4-7: Courtesy Saskia Ltd., © Dr. Ron Wiedenhoeft; 4-8: The Art Archive/Heraklion Museum/Gianni Dagli Orti/Picture Desk; 4-9: Nimatallah/Art Resource, NY; 4-9A: Copyright: Photo Henri Stierlin, Geneve; 4-10: Ch. Doumas, The Wall Paintings of Thera, Idryma Theras-Petros M. Nomikos, Athens, 1992; 4-11: STUDIO KONTOS/PHOTOSTOCK; 4-12: Scala/Art Resource, NY; 4-13: The Art Archive/Heraklion Museum/Gianni Dagli Orti/Picture Desk; 4-13A: British School at Athens; 4-14: Erich Lessing/Art Resource, NY; 4-15: Cengage Learning; 4-16: STUDIO KONTOS/PHOTOSTOCK; 4-16A: The Art Archive/Archaeological Museum Chora Greece/Gianni Dagli Orti/Picture Desk; 4-17: Erich Lessing/Art Resource, NY; 4-18: Cengage Learning; 4-19: © Bildarchiv Monheim GmbH/Alamy; 4-20: © Fred S. Kleiner 2012; 4-21: © Vanni Archive/ CORBIS; 4-21A: © Fred S. Kleiner 2012; 4-22: Joe Vogan/SuperStock; 4-23: The Art Archive/National Archaeological Museum Athens/Gianni Dagli Orti/Picture Desk; 4-24: Erich Lessing/Art Resource, NY; 4-25: Nimatallah/Art Resource, NY; 4-26: The Art Archive/National Archaeological Museum Athens/Gianni Dagli Orti/Picture Desk; 4-27: akg-images.

Chapter 5—Opener: Carolyn Clarke/Alamy; 5-1a: © Fred S. Kleiner 2012; 5-1b: A Centaur triumphing over a Lapith, metope XXVIII from the south side of the Parthenon, 447–432 BC (marble), Greek, (5th century BC)/British Museum, London, UK/The Bridgeman Art Library; 5-1c: Royal Ontario Museum; 5-2: The Metropolitan Museum of Art/Art Resource, NY; 5-2A: Nimatallah/Art Resource, NY; 5-3: © The Metropolitan Museum of Art/Art Resource, NY; 5-4: Photograph © 2011 Museum of Fine Arts, Boston; 5-5: Copyright the Trustees of The British Museum; 5-5A: Cengage Learning, 2014; 5-6: RMN-Grand Palais/Art Resource, NY; 5-6A: © 2005 Trustees of Dartmouth College; 5-7: The Metropolitan Museum of Art/Art Resource, NY; 5-8: Nimatallah/Art Resource, NY; 5-9: Gianni Dagli Orti/Fine Art/Corbis; 5-10: Nimatallah/Art Resource, NY; 5-11: Marie

Mauzy/Art Resource, NY; 5-12: Cengage Learning, 2014; 5-13: John Burge/ Cengage Learning; 5-14: © 2008 Fred S. Kleiner; 5-15: Cengage Learning; 5-16: Vanni/Art Resource, NY; 5-16A: De Agostini Picture Library/Learning Pictures; 5-17: Cengage Learning; 5-18: Nimatallah/Art Resource, NY; 5-19: Canali Photobank; 5-19A: Scala/Art Resource, NY; 5-20: Scala/Art Resource, NY; 5-2A: © The Trustees of The British Museum/Art Resource, NY; 5-21: Photograph © 2011 Museum of Fine Arts, Boston; 5-22: Photograph © 2011 Museum of Fine Arts, Boston; 5-23: Bridgeman-Giraudon/Art Resource, NY; 5-23A: Scala/Ministero per i Beni e le Attività culturali/Art Resource, NY; 5-24: Courtesy Saskia Ltd., © Dr. Ron Wiedenhoeft; 5-24A: Musées royaux d'Art et d'Histoire; 5-25: Marie Mauzy/Art Resource, NY; 5-26: Courtesy Saskia Ltd., © Dr. Ron Wiedenhoeft and Cengage Learning; 5-27: Gianni Dagli Orti/Fine Art/Corbis; 5-28: Saskia Ltd., © Dr. Ron Wiedenhoeft; 5-29: SASKIA Ltd. Cultural Documentation. © Dr. Ron Wiedenhoeft; 5-30: © 2008 Fred S. Kleiner; 5-31: The Art Archive/Olympia Museum Greece/Gianni Dagli Orti/Picture Desk; 5-32: STUDIO KONTOS/ PHOTOSTOCK; 5-33: akg-images/John Hios; 5-33A: Vanni Archive/Art Resource, NY; 5-34: The Art Archive/Olympia Museum Greece/Gianni Dagli Orti/Picture Desk; 5-35: Marie Mauzy/Art Resource, NY; 5-36: Scala/Art Resource, NY; 5-37: Cengage Learning, 2014; 5-38: Erich Lessing/Art Resource, NY; 5-39: Nimatallah/Art Resource, NY; 5-40: Scala/Art Resource, NY; 5-41: Scala/ Ministero per i Beni e le Attività culturali/Art Resource, NY; 5-42: bpk, Berlin/ Vatican Museums, Vatican State/Alfredo Dagli Orti/Art Resource, NY, 5-43: Yann Arthus-Bertrand/Terra/Corbis; 5-44: Cengage Learning; 5-45: Cengage Learning, 2014; 5-46: Royal Ontario Museum; 5-47: A Centaur triumphing over a Lapith, metope XXVIII from the south side of the Parthenon, 447-432 BC (marble), Greek, (5th century BC)/British Museum, London, UK/The Bridgeman Art Library; 5-48: STUDIO KONTOS/PHOTOSTOCK; 5-49: R Sheridan/Ancient Art & Architecture Collection Ltd.; 5-50: © Ancient Art and Architecture Collection Ltd. (bottom) STUDIO KONTOS/PHOTOSTOCK (middle) © Chao-Yang Chan/Alamy (top); 5-51: © Constantinos Iliopoulos/Alamy; 5-52: © Fred S. Kleiner 2012; 5-53: Cengage Learning, 2014; 5-54: © Jon Bower Europe/Alamy; 5-55: © Fred S. Kleiner 2012; 5-56: Marie Mauzy/Art Resource, NY; 5-57: Nimatallah/Art Resource, NY; 5-58: Scala/Art Resource, NY; 5-58A: Scala/Art Resource, NY; 5-59: RMN-Grand Palais/Art Resource, NY; 5-60: Scala/Art Resource, NY; 5-61: Mimmo Jodice/Fine Art/Corbis; 5-62: Scala/Art Resource, NY; 5-62A: Photograph © 2011 Museum of Fine Arts, Boston; 5-63: Statue of Hermes and the Infant Dionysus, c. 330 BC (parian marble), Praxiteles (c. 400c. 330 BC)/Archaeological Museum, Olympia, Archaia, Greece/The Bridgeman Art Library; 5-63A: © The Metropolitan Museum of Art/Art Resource, NY; 5-63B: Archaeological Receipts Fund; 5-63C: Nevit Dilmen; 5-64: Marie Mauzy/ Art Resource, NY; 5-65: Canali Photobank; 5-66: Scala/Ministero per i Beni e le Attività culturali/Art Resource, NY; 5-67: Art Resource, NY; 5-68: bpk, Berlin/Art Resource, NY; 5-69: The Rape of Persephone, from the Tomb of Persephone (wall painting), Macedonian School/Vergina, Macedonia, Greece/The Bridgeman Art Library; 5-70: Canali Photobank; 5-71: © Duby Tal/Albatross/Alamy; 5-72: © Fred S. Kleiner 2012; 5-73: Vanni/Art Resource, NY; 5-74: © Fred S. Kleiner 2012; 5-75: Yann Arthus-Bertrand/Encyclopedia/Corbis; 5-76: Cengage Learning; 5-77: John Burge/Cengage Learning; 5-78: STUDIO KONTOS/PHOTOSTOCK; 5-79: Antikensammlung, Staatliche Museen, Berlin, Germany/Jürgen Liepe/Art Resource, NY; 5-80: bpk, Berlin/Antikensammlung, Staatliche Museen, Berlin, Germany/Johannes Laurentius/Art Resource, NY; 5-81: Araldo de Luca/Fine Art/ Corbis; 5-82: Dying Gaul/Fine Art/Corbis; 5-83: The Victory of Samothrace (Parian marble) (see also 92583 & 94601-03 & 154093), Greek, (2nd century BC)/ Louvre, Paris, France/Giraudon/The Bridgeman Art Library; 5-84: RMN-Grand Palais/Art Resource, NY; 5-84A: Nimatallah/Art Resource, NY; 5-84B: © The Metropolitan Museum of Art/Art Resource, NY; 5-85: Saskia Ltd.; 5-86: Erich Lessing/Art Resource, NY; 5-87: © The Metropolitan Museum of Art/Art Resource, NY; 5-88: Ny Carlsberg Glyptotek, Copenhagen; 5-89: Araldo de Luca/ Fine Art Premium/Corbis; 5-90: Araldo de Luca.

Chapter 6—Opener: Charles Bowman/Getty Images; 6-1a: © BeBa/Iberfoto/
The Image Works; 6-1b: Scala/Art Resource, NY Image; 6-1c: Scala/Art Resource,
NY; 6-2: Hirmer Fotoarchiv; 6-3: Model of an Etruscan temple, reconstruction,
4th–5th century BC (plastic)/Institute of Etruscology, University of Rome, Italy/
The Bridgeman Art Library; 6-4: Araldo de Luca/Corbis Art/Corbis; 6-5: Cengage
Learning; 6-6: Araldo de Luca/Corbis Art/Corbis; 6-7: © 2006 Fred S. Kleiner;

6-8: Scala/Ministero per i Beni e le Attività culturali/Art Resource, NY; 6-8A: Cengage Learning; 6-9: Leemage/Getty Images; 6-10: The Art Archive/The Picture Desk Limited/Corbis; 6-1A: akg-images; 6-11: Hirmer Fotoarchiv, Munich; 6-12: Araldo de Luca/Corbis art/Corbis; 6-13: Scala/Art Resource, NY; 6-14: Araldo de Luca/Corbis art/Corbis; 6-14A: Back of a bronze mirror decorated with a scene showing an old man examining the liver of an animal, bears the name of Chalenas (Greek soothsayer) early 4th century Bc/Vatican Museums and Galleries, Vatican City, Italy/The Bridgeman Art Library; 6-15: © Jonathan Poore/Cengage Learning; 6-16: John Burge/Cengage Learning; 6-17: Gianni Dagli Orti/CORBIS; 6-17A: Photograph © 2011 Museum of Fine Arts, Boston, 1975.799; 6-18: Scala/Art Resource, NY.

Chapter 7—Opener: Scala/Art Resource, NY; 7-1a: © Fred S. Kleiner 2010; 7-1b: Scala/Art Resource, NY; 7-1c: © Fred S. Kleiner 2010; 7-2: Charles & Josette Lenars/Encyclopedia/Corbis; 7-3: © Fred S. Kleiner 2013; 7-4: © Fred S. Kleiner 2011; 7-5: Cengage Learning; 7-6: John Burge; 7-7: Araldo de Luca/CORBIS; 7-8: Valentino Renzoni; 7-8: 2006 Fred S. Kleiner; 7-9A: Bust of Pompey (106-48 BC) с. 60 вс (marble), Roman, (1st century вс)/Ny Carlsberg Glyptotek, Copenhagen, Denmark/The Bridgeman Art Library; 7-10: The American Numismatic Society; 7-11: Bettmann/Corbis; 7-11A: Alinari/Art Resource, NY; 7-12: Alinari/Art Resource, NY; 7-13: © Guido Alberto Rossi/AGE Fotostock; 7-14: Erich Lessing/ Art Resource, NY; 7-15: John Burge/Cengage Learning; 7-16: Copyright: Photo Henri Stierlin, Geneve; 7-16A: Araldo De Luca; 7-17: Wayne Howes/Photographer's Direct; 7-18: Scala/Art Resource, NY; 7-19 left: © The Metropolitan Museum of Art/Art Resource, NY; 7-19 right: The Metropolitan Museum of Art/Art Resource, NY; 7-20: Luciano Romano; 7-21: © The Metropolitan Museum of Art/Art Resource, NY; 7-22: Canali Photobank; 7-23: Fred S. Kleiner; 7-24: Scala/Art Resource, NY; 7-24A: Scala/Art Resource, NY; 7-25: Scala/Art Resource, NY; 7-26: Canali Photobank; 7-27: Scala/Art Resource, NY; 7-28: Ny Carlsberg Glyptotek; 7-29: Brenda Kean/Alamy; 7-30: Christian Handl/imagebroker/ Alamy; 7-31: SASKIA Ltd. Cultural Documentation; 7-32: Fred Kleiner, 2013; 7-33: © Jonathan Poore/Cengage Learning; 7-34: © Jonathan Poore/Cengage Learning; 7-34A: Canali Photobank; 7-35 left: Cengage Learning; 7-35 right: Cengage Learning, 2016; 7-36: Robert Harding Picture Library; 7-37: © Jonathan Poore/Cengage Learning; 7-38: Ny Carlsberg Glyptotek, Copenhagen; 7-39: Araldo de Luca/Corbis art/Corbis; 7-40: © Jonathan Poore/Cengage Learning; 7-40A: © Jonathan Poore/Cengage Learning; 7-41: © Jonathan Poore/Cengage Learning; 7-42: © Jonathan Poore/Cengage Learning; 7-43: © Google Maps; 7-43A: Scala/Art Resource, NY; 7-44: John Burge and James Packer/Cengage Learning; 7-44A: Scala/Art Resource, NY; 7-45: © Jonathan Poore/Cengage Learning; 7-45A: © Jonathan Poore/Cengage Learning; 7-45B: © Fred S. Kleiner 2013; 7-45C: © Jonathan Poore/Cengage Learning; 7-45D: © Jonathan Poore/ Cengage Learning; 7-46: © Jonathan Poore/Cengage Learning; 7-47: © Fred S. Kleiner 2011; 7-47A: © Jonathan Poore/Cengage Learning; 7-48: © 2006 Fred S. Kleiner; 7-49: © Jonathan Poore/Cengage Learning; 7-50: John Burge/Cengage Learning; 7-51: Copyright: Photo Henri Stierlin, Geneve; 7-52: © 2006 Fred S. Kleiner; 7-53: Jon Sparks/Encyclopedia/Corbis; 7-53A: © Fred S. Kleiner 2011; 7-54: Scala/Art Resource, NY; 7-54A: Andrea Matone; 7-55: Erich Lessing/Art Resource, NY; 7-56: Scala/Art Resource, NY; 7-57: © 2006 Fred S. Kleiner; 7-57A: Araldo de Luca/CORBIS; 7-58: Image © The Cleveland Museum of Art; 7-59: Scala/Art Resource, Inc.; 7-59A: © The Trustees of The British Museum/Art Resource, NY; 7-60: The Trustees of The British Museum; 7-60A: Mummy portrait of a young woman, from Hawara, Egypt, ca. 110-120 ce. Encaustic on wood, 1'5 1/4" × 1' 1 3/8". Royal Museum of Scotland, Edinburgh; 7-61: Bildarchiv Preussischer Kulturbesitz/Art Resource, NY; 7-62: Bildarchiv Preussischer Kulturbesitz/ Art Resource, NY; 7-62A: The Metropolitan Museum of Art/Art Resource, NY; 7-63: Araldo de Luca; 7-64: Cengage Learning; 7-65: Scala/Art Resource, NY; 7-66: Araldo de Luca; 7-66A: Scala/Art Resource, NY; 7-67: © The Metropolitan Museum of Art/Art Resource, NY; 7-68: Araldo de Luca/CORBIS; 7-69: Scala/Art Resource, NY; 7-70: Cengage Learning; 7-71: © Fred S. Kleiner 2010; 7-72: © 2006 Fred S. Kleiner; 7-73: © Jonathan Poore/Cengage Learning; 7-74: © Jonathan Poore/Cengage Learning; 7-75: © Jonathan Poore/Cengage Learning; 7-76 bottom: John Burge/Cengage Learning, Originally published in A History of Roman Art by © Fred S. Kleiner (Belmont, Calif.: Thomson Wadsworth, 2007); 7-76 top: © Jonathan Poore/Cengage Learning; 7-77: © Jonathan Poore/Cengage Learning; 7-78: © Jonathan Poore/Cengage Learning; 7-79: The American Numismatic Society.

Index

NOTE: Figure numbers in blue indicate bonus images found in the book and their accompanying online essays. Italic numbers indicate figures.

1948-C (Still), 1, 2 Aachen Gospels, 5, 5 Abu Simbel (Egypt), Temple of Ramses II, 71, 71, 3 Achaemenid art, 48, 50-52, 53 Achilles and Ajax playing a dice game (Andokides Painter and Lysippides Painter), Orvieto (vase painting), Achilles and Ajax playing a dice game (Exekias), Vulci (vase painting), 118-119, 118 Achilles killing Penthesilea (Exekias), Vulci (vase painting), 5-20A Achilles Painter, 6; warrior taking leave of his wife, Eretria (vase painting), 140, 140 Acropolis, Athens, 131; Erechtheion, 131, 134, 136–137, *137*, 199, 212; Parthenon. See Parthenon; Pericles (Kresilas), 130-131, 130, 159, 184, 210; Propylaia (Mnesikles), 131, 136, 136; Temple of Athena Nike (Kallikrates), 131, 138-139, 138, 149 Aegean (prehistoric), 84map Aegina (Greece), Temple of Aphaia, 121-123, 121, 122, 123-124 Aeneas, 105, 198, 206 Aeneid (Vergil), 160, 198 Aeschylus, 104, 123, 125, 148 Agamemnon (king of Mycenae), 83, Ahmose I (pharaoh of Egypt), 68, 71 Ain Ghazal (Palestine), human figure (sculpture), 25, 25 Akhenaton (pharaoh of Egypt), 75, 77 Akhenaton, Karnak (sculpture), 75, Akhenaton and Nefertiti with their three daughters, Amarna (relief

Akkadian art, 40-41, 53 Akrotiri (Cyclades), 89-91; landscape with swallows (Spring Fresco), 90, 90, 170, 191-192; Miniature Ships Fresco, 4-9A Albers, Josef, Homage to the Square,

sculpture), 77, 77

7-8,8

Alexander Mosaic (Battle of Issus) (Philoxenos of Eretria), 147-148, 147, 193, 194,

Alexander of Antioch-on-the-Meander, Aphrodite (Venus de Milo) (sculpture), 156, 156

Alexander the Great, 79, 80, 144-145, 147-148, 150, 159; and Persia, 50, 51, 52, 142; portraits of, 145-146,

Altamira (Spain), cave paintings, 20-21, 20, 22, 58

Altar of Zeus, Pergamon, 152, 153-155, 153, 154, 155, 160

Altar to the Hand, Benin (cast bronze), 10, 11, 12

Amarna (Egypt), Akhenaton and Nefertiti with their three daughters (relief sculpture), 77, 77

Amarna period Egyptian art, 75-77 Amen-Re temple, Karnak, 70, 71-73, 72, 73, 77, 80, 113, 3-24A

Amen-Re temple, Luxor, 72, 80, 113,

Amenemhet, tomb of, Beni Hasan, 68,

68, 168, 3-23A Amenhotep II (pharaoh of Egypt), 3-12A Amenhotep III (pharaoh of Egypt),

Amenhotep IV. See Akhenaton amphitheater, Pompeii, 187, 187 Anatolia, 24, 24map, 25–26, 1-14A Anavysos (Greece), Kroisos (sculpture),

111, 111, 112 Ancestral Puebloan art, 1-14A

Andokides Painter, Achilles and Ajax playing a dice game, Orvieto (vase painting), 119, 119

animal facing left, Apollo 11 Cave (painting), 16, 17, 17 animal hunts (venationes), 187, 202

Antonine period, 176, 177, 214-217, 57A. See also Roman High Empire art

Antoninus Pius (Roman emperor), 176, 177, 214-215, 222

Aphrodite (Venus) (Greek/Roman deity), 105, 134, 135, 142-143, 156,

Aphrodite (Venus de Milo) (Alexander of Antioch-on-the-Meander) (sculpture), 156, *156* Aphrodite, Eros, and Pan, Delos

(sculpture), 5-84A, 5-84B

Aphrodite of Knidos (Praxiteles), 142-143, 142, 156, 5-62A, 5-84A Apollo (Greek/Roman deity), 105,

107-108, 117, 125, 165, 5-33A,

Apollo, Temple of Zeus west pediment, Olympia (sculpture), 125, 125 Apollo 11 Cave (Namibia), animal facing

left (painting), 16, 17, 17 Apollo of Veii (Apulu) (sculpture),

166-167, 166, 168 Apollodoros (Athenian painter), 146 Apollodorus of Damascus, 212; Forum of Trajan, 206-207, 207; Markets of

Trajan, Rome, 208-209, 209, 227 apotheosis, 177, 204, 214, 215, 7-40A

Apotheosis of Antoninus Pius and Faustina, Column of Antoninus Pius, Rome (relief sculpture), 176, 177, 215, 7-40A, 7-

Apotheosis of Titus, relief panel, Arch of Titus, 204, 7-40A

Apoxyomenos (Scraper) (Lysippos of Sikyon), 144-145, 144

Apulia (Italy), Artist painting a marble statue of Herakles (vase painting),

Apulu (Apollo of Veii) (sculpture), 166-167, 166, 168

Apulu (Etruscan deity), 165, 166-167 aqueducts, 200

Ara Pacis Augustae (Altar of Augustan Peace), Rome, 197-199, 197, 198, 205, 206

Arch of Constantine, Rome, 225-226, 225, 226, 7-47A

Arch of Septimius Severus, Lepcis Magna, 219, 219

Arch of Titus, Rome, 204-206, 204, 205, 219, 7-40A

Arch of Trajan, Benevento, 207, 7-43A,

Archaic period Etruscan art, 162, 163, 165-170, 175, 192, 6-8A, 6-10A

architectural drawings, 12, 12 Arena Chapel (Cappella Scrovegni), Padua (Giotto), 4-11A

Ares (Mars) (Greek/Roman deity), 105 Arezzo (Italy), Chimera of Arezzo (sculpture), 172, 172

Ariadne, 87, 190

Aristotle, 145, 151, 167

Arringatore (Aule Metele) (sculpture), 167, 174, 174, 197

Artemis (Diana) (Greek/Roman deity), 105, 116, 117, 165

Artemis and Apollo slaying the children of Niobe (Niobid Painter), Orvieto (vase painting), 141, 141

Artemision Zeus, 128, 128

Artist painting a marble statue of Herakles, Apulia (vase painting), 5-63A

Ashurbanipal (king of Assyria), 48 Ashurbanipal hunting lions, palace of Ashurbanipal, Nineveh (relief sculpture), 32, 48, 48, 140

Ashurnasirpal II (king of Assyria), 46 - 47

Ashurnasirpal II with attendants and soldier, Kalhu (mural), 46, 47 Asklepios (Aesculapius) (Greek/Roman

deity), 105 Assyrian archers pursuing enemies, Kalhu (relief sculpture), 32, 47, 47 Assyrian art, 32, 45-48, 53, 2-18A,

2-19A Athanadoros: head of Odysseus, Sperlonga (sculpture), 160, 160; Laocoön and his sons (sculpture), 159-160,

Athena (Minerva) (Greek/Roman deity), 102, 103, 105, 122, 124, 132-133,

136, 153, 165, 187 Athena, Herakles, and Atlas with the apples of the Hesperides, Temple of Zeus metope, Olympia (sculpture), 124, 124, 145

Athena battling Alkyoneos, Pergamon (relief sculpture), 153, 153, 160 Athena Parthenos (Phidias), 102, 103,

132-133, 133, 149, 153

Athens (Greece), 104-105, 198, 199; Acropolis. See Acropolis; calf bearer (sculpture), 110–111, 111, 112; Choragic Monument (Lysikrates), 150, 150; Erechtheion, 131, 134, 136-137, 137, 199, 212; Geometric amphora with mourning scene, Dipylon cemetery (Dipylon Painter), 106, 107, 5-2A; Geometric krater, Dipylon cemetery, 106-107, 106; grave stele of Hegeso, Dipylon cemetery, 139, 139, 140, 144, 167; Illisos stele (grave stele of a young hunter), 144, 144, 5-63B; Kore in Ionian dress (sculpture), 112, 113;

Kritios Boy (sculpture), 126, 126; Parthenon. See Parthenon; Peplos Kore (sculpture), 112, 112; Persian sack of (480 BCE), 112, 123, 130, 133; Propylaia (Mnesikles), 131, 136, 136; Stoa of Attalos II, 152, 152; Stoa Poikile (Painted Stoa) (Polygnotos of Thasos), 140-141, 152; Temple of Athena Nike (Kallikrates), 131, 138-139, 138, 149 atlantids, 3-23,

Attalos I, II, and III (kings of Pergamon), 152, 153

Attica (Greece), New York Kouros (sculpture), 110, 110, 111

Augustan/Julio-Claudian period Roman art, 7, 195-203, 210 Augustus (Roman emperor), 6, 7, 13,

150, 167, 195, 196, 197-198, 199-200, 210; Res Gestae Divi Augusti, 197

Aula Palatina, Trier, 227-228, 227, 228 Aule Metele (Arringatore) (sculpture),

167, 174, 174, 197 aurochs, horses, and rhinoceroses, Chauvet Cave (cave painting), 23, 23 Australopithecus, 1-1A

Autun (France), Saint-Lazare, 5, 5, 10, 12 Axial Gallery, Lascaux, 22, 1-9A

Baalbek (Lebanon), Temple of Venus, 222-223, 223, 224

Babel, Tower of (Babylon ziggurat), 34,

Babylon (city): hanging gardens, 48, 49; Ishtar Gate, 34, 48, 49; Neo-Babylonian restoration, 48, 49; ziggurat, 34, 48, 49. See also Babylonian art

Babylonian art, 34, 42-44, 48, 49, 53. See also Neo-Babylonian art

Baghdad (Iraq): statuettes of two worshipers, Eshnunna, 35; Warka Vase, 30, 31, 35

Banditaccia necropolis, Cerveteri, 167-169, 167, 168, 169, 188, 6-8A

banquet scene cylinder seal, tomb of Pu-abi, Ur, 39-40, 39

Barberini Faun (sleeping satyr) (sculpture), 156, 157 Baroque/baroque (terms), 154

"Basilica" (Temple of Hera I), Paestum, 115-116, 115, 121, 132

basilica, Pompeii, 186, 187 Basilica Nova, Rome, 227, 227 Basilica Ulpia, Rome, 207, 207

Baths of Caracalla, Rome, 219-220, 219,

Baths of Diocletian, Rome, 220, 220, 227 Baths of Neptune, Ostia, 7-53A Battle of Issus (Alexander Mosaic)

(Philoxenos of Eretria), 147-148, 147, 193, 194, 7-53A battle of Romans and barbarians (Ludo-

visi Battle Sarcophagus), 222, 222 battle scene, Column of Trajan, Rome (relief sculpture), 7-45A

battle scenes, victory stele of Eannatum (Stele of the Vultures), Girsu, 34,

beaker with animal decoration, Susa,

Beauvais Cathedral, 3-4, 3, 12 beheaded Dacians, Column of Trajan, Rome (relief sculpture), 7-45A Benevento (Italy), Arch of Trajan, 207, Beni Hasan (Egypt), rock-cut tombs, 68, 68, 168, 3-Benin art, 10, 11, 12 Bernini, Gianlorenzo, Barberini Faun restoration, 157 Bible, 34, 45, 48, 49. See also Christianity Bishapur (Iran), Triumph of Shapur I over Valerian (relief sculpture), 52, bison, painted cave ceiling, Altamira, 20-21, 20, 58 bison licking its flank, fragmentary spear-thrower, La Madeleine, 19-20, 19 Blouet, Guillaume-Abel, Temple of Aphaia restored view, 121 boar hunt, Hadrianic tondo, 7-47A Book of the Dead (Egyptian), 54, 55 books, 5 Boscoreale (Italy), Villa of Publius Fannius Synistor, 190, 191, 213 Boscotrecase (Italy), Villa of Agrippa Postumus, 192, 192, 7 Brassempouy (France), head of a woman (ivory carving), 1-4A brawl in the Pompeii amphitheater, wall painting from House I,3,23, Pompeii, 187, 187, 194 bronze casting, 10, 11, 12, 40–41, 45, 107, 126–128, 171–172, 174 Brunelleschi, Filippo, San Lorenzo, Florence, 66-67 bull-headed harp, tomb 789 ("King's Grave"), Ur, 38-39, 38, 86 bull-headed harp with inlaid sound box, tomb of Pu-abi, Ur, 38, 38, 86 bull-leaping, palace, Knossos (fresco), 89, 89 Buonarroti, Michelangelo. See Michelangelo Buonarroti bust of Augustus wearing the corona civica (sculpture), 6, 7 bust of Caracalla, 218, 219 calf bearer (dedicated by Rhonbos), Athens (sculpture), 110-111, 111, 112 Canon (Polykleitos). See Doryphoros Canopus and Serapeum, Hadrian's Villa, Tivoli, 212, 212 Capitoline Wolf (sculpture), 171-172, Capitolium, Pompeii, 186, 187 Carolingian art, 5 carving, 11, 42, 64 caryatids, Erechtheion, Athens, 137, 137, 199, 212 catacombs, 7-54A Çatal Höyük (Anatolia): deer hunt mural (cave painting), 26, 26, 3-1A; landscape with volcanic eruption (?), 26, 26; restored view of, 1-14A cave paintings: Altamira, 20-21, 22, 58; Apollo 11 Cave, Namibia, 16, 17; Çatal Höyük, 26, 26, 3-1A; Chauvet Cave. 22, 23: Lascaux, 14, 15, 20, 22-23, 26; painting techniques, 20, 22, 1-9A; Pech-Merle, France, 21-22 cave sculptures, 19, 1-5A Celer, Domus Aurea (Golden House), 201-203, 201, 203, 7-34A

Cerveteri (Italy): Banditaccia necropolis, 167-169, 167, 168, 169, 188, 6-8A; fibula, Regolini-Galssi Tomb, 165, 165; Herakles wrestling Antaios (Euphronios) (vase painting), 119-120, 120; sarcophagus with reclining couple, 167-168, 167; Tomb of the Reliefs, 169, 169; Tomb of the Shields and Chairs, 168, 169, Chalchas examining a liver, Vulci (engraved mirror), 6-14A Chalgrin, Jean François Thérèse, Arc de Triomphe, Paris, 809 chariot procession of Septimius Severus, Arch of Septimius Severus, Lepcis Magna (relief sculpture), 219, 219 chariot race of Pelops and Oinomaos, Temple of Zeus east pediment, Olympia (sculpture), 124, 125 charioteer (dedicated by Polyzalos of Gela), Delphi (sculpture), 127-128, 127 Chauvet Cave, Vallon-Pont-d'Arc, aurochs, horses, and rhinoceroses (cave painting), 23, 23 Chimera of Arezzo (sculpture), 172, 172 "Chinese horse," Lascaux (cave painting), Chios (Greece), head of a woman (sculpture), 143, 5-62 Chiusi (Italy), girl preparing to bathe (Onesimos) (vase painting), 121, Choragic Monument (Lysikrates), 150, Christianity, 215, 218, 225, 228. See also four evangelists Circus Maximus, Rome, 206-207, 7-43A cire perdue (lost-wax) process, 127 citadel of Sargon II, Dur Sharrukin (Khorsabad), 32, 46, 46, 2-19A citadel of Tiryns (Greece), 94, 94, 95, 95 Classical period Etruscan art, 171-172, Claude Lorrain (Claude Gellée), Embarkation of the Queen of Sheba, xvi, 8 Cleopatra (queen of Egypt), 56, 80, 150, coffin, tomb of Tutankhamen, Thebes, coins, 184-185, 196, 220-221, 228, 7-9A collage, 8 Colosseum, Rome, 202, 202, 203 Colossus of Nero, Rome, 203 Colossus of Rhodes, 49 Column of Antoninus Pius, Rome, 176, 177, 214, 215, 222, 224, 7-40A, Column of Trajan, Rome, 207, 208, 208, columns with animal protomes, Persepolis, 50, 51 Commodus (Roman emperor), 196, 216, 218, 7 conceptual representation: in Egyptian art, 10, 58, 66, 75; in Etruscan art, 162, 163; in Greek art, 106, 119, 5-19A, 5-20A; in Mesopotamian art, 36, 38, 40, 41, 44, 46, 47; in Minoan art, 88, 89; in Paleolithic art, 15, 22, 26 concrete, 181, 182, 187, 201, 203, 209, 211, 220 Constantine (Roman emperor), 224-228, -47A Corfu (Greece), Temple of Artemis, 116, 116, 122, 163 Corinthian black-figure amphora with animal friezes, Rhodes, 108–109, 108 Corinthian capital, tholos, Epidauros (Polykleitos the Younger), 149, 149 Corinthian capitals, 149-150, 181, 187, 204, 211, 212 Crete, 84-85, 93, 95, 109 the Cross, 5 Ctesiphon (Iraq), palace of Shapur I, 52. 52

Cycladic art, 85-86, 101

Daedalic style (Greek art), 109, 110, Daphnis of Miletos, Temple of Apollo, Didyma, 150-151, 150 death mask, tomb of Tutankhamen, Thebes, 78, 78, 97 Death of Sardanapalus (Delacroix), 48 death of Sarpedon (Euphronios and Euxitheos), Greppe Sant'Angelo (vase painting), 120, 5-23A decursio, Column of Antoninus Pius, Rome (relief sculpture), 214, 215, 222 224 deer hunt mural, Çatal Höyük (cave painting), 26, 26, 3 Deir el-Bahri (Egypt): Hatshepsut mortuary temple, 69–71, 69, 70, 72; Hatshepsut with offering jars (sculpture), 70, 70 Delacroix, Eugène, 48; Death of Sardanapalus, 48 Delos (Greece), Aphrodite, Eros, and Pan (sculpture), 5-84A, 5-84B Delphi (Greece): charioteer (dedicated by Polyzalos of Gela) (sculpture), 127–128, *127*; Sanctuary of Apollo, 117, 5-16A; Siphnian Treasury, 117, 117, 137, 154; tholos (Theodoros of Phokaia), 148, 149 Demeter (Ceres) (Greek/Roman deity), 99, 105 Demosthenes (Polyeuktos) (sculpture), 158, 159 denarius with portrait of Julius Caesar (coin), 184-185, 185 Diana. See Artemis Didyma (Turkey), Temple of Apollo (Paionios of Ephesos and Daphnis of Miletos), 150–151, 150 Diocletian (Roman emperor), 223-224 Diocletian, palace of, Split, 224, 225 Dionysiac mystery frieze, Villa of the Mysteries, Pompeii (fresco), 190, 190, 206 Dionysos (Bacchus) (Greek/Roman deity), 105, 134, 141, 143, 148, 190 diorite carvings, 42, 64 Dipylon Painter, Geometric amphora with mourning scene, Athens, 106, 107. Diskobolos (Discus Thrower) (Myron), 128-129, 128 distribution of largesse, Arch of Constantine, Rome (relief sculpture), 226, 226 Djoser (pharaoh of Egypt), 59-60, 3-6A Djoser mortuary precinct, Saqqara (Imhotep), 59–60, 59, 61, 68, 3-6A Domitian (Roman emperor), 202, 203, 204, 206 Domus Aurea (Golden House) (Severus and Celer), Rome, 201-203, 201, 203, 7-34A Doryphoros (Spear Bearer) (Polykleitos), 128–129, 128, 131, 143, 145, 197 Dur Sharrukin (Khorsabad) (Iraq): citadel of Sargon II, 46, 2-19A; lamassu (man-headed winged bull), citadel of Sargon II (sculpture), 32, 46, 46 Dürer, Albrecht, The Four Horsemen of

the Apocalypse, 5-6, 6, 7

122-123, 122

dying Gaul (Epigonos[?]) (sculpture),

dying warrior, Temple of Aphaia east

dying warrior, Temple of Aphaia west

Edfu (Egypt), Temple of Horus, 80, 80,

and mythology, 54, 55, 58, 60, 72,

Elgin Marbles, 131. See also Acropolis

75, 3-24A; and Roman Empire, 56,

Edo period Japanese art, 8-9

195, 217, 7-59A

Elamite art, 45, 2-18B

pediment, Aegina (sculpture),

43, 45 pediment, Aegina (sculpture), 122, Fourth Style wall paintings, Domus Aurea (Golden House) (Severus Egypt (ancient): and Greece, 105; religion

Embarkation of the Queen of Sheba (Claude Lorrain), xvi, 8 encaustic painting, 109, 217, 5-63A, engraving, 17 Enlightenment, 56 Epic of Gilgamesh, 33 Epidauros (Greece): theater of Epidauros (Polykleitos the Younger), 148-149, 148, 149; tholos, 149, 149 Epigonos(?): dying Gaul (sculpture), 154, 155; Gallic chieftain killing himself and his wife (sculpture), 154-155, 154 equestrian statue of Marcus Aurelius, Rome, 215, 215 Erechtheion, Athens, 131, 134, 136-137, 137, 199, 212 Eretria (Greece): warrior seated at his tomb (Reed Painter) (vase painting), 5-58A; warrior taking leave of his wife (Achilles Painter) (vase painting), 140, 140 Ergotimos, François Vase, Chiusi, 118, 118, 5-19A Eros (Amor, Cupid) (Greek/Roman deity), 105, 135, 5-84A, 5-84B Eshnunna (Iraq), Square Temple, 35, Etruscan Places (Lawrence), 163 Etruscan temple model, 165 Euphronios, 5-24A; death of Sarpedon, Greppe Sant'Angelo (vase painting), 120, 5-23A; Herakles wrestling Antaios, Cerveteri (vase painting), 119-120, 120 Euripides, 104, 123, 148 Euthymides, 5-23A, 5-24A; three revelers, Vulci (vase painting), 120-121, 120 Euxitheos, death of Sarpedon, Greppe Sant'Angelo (vase painting), 120, Evans, Arthur, 84, 85, 88 Exekias: Achilles and Ajax playing a dice game, Vulci (vase painting), 118-119, 118; Achilles killing Penthesilea, Vulci (vase painting), 5-20A Farnese Hercules (weary Herakles) (Lysippos of Sikyon), 145, 145 female head (Inanna?), Uruk (sculpture), 34-35, 34 female head, Mycenae (sculpture), 99-100, 99 female personification (Tellus?), Ara Pacis Augustae, Rome (relief sculpture), 198, 198 fibula, Regolini-Galssi Tomb, Cerveteri, 165, 165 Ficoroni Cista (Novios Plautios) (bronze container), 172, 173, 6-14A figurine of a woman, Syros, 85, 86 First Style mural painting, 189 Flavian Amphitheater (Colosseum), Rome, 202, 202, 203 Flavian period Roman art, 203-206, Florence (Italy), San Lorenzo, 66-67 fort construction, Column of Trajan, Rome (relief sculpture), 7-45A forum, Pompeii, 186-187, 186 Forum of Augustus, Rome, 199, 207, Forum of Trajan, Rome (Apollodorus of Damascus), 206-207, 207 four evangelists, 5, 194 The Four Horsemen of the Apocalypse (Dürer), 5-6, 6, 7 Fourth Style mural painting, 192-193, 204, 7-16A, 7

133, 133

centauromachy, detail of François Vase

centauromachy, Parthenon metope,

centauromachy, Temple of Zeus west

ceramics, 45, 91-92, 108-109, 2-18B.

See also vase painting

pediment, Olympia (sculpture),

(Kleitias and Ergotimos), Chiusi,

Athens (relief sculpture), 102, 103,

fragmentary head of Senusret III (sculpture), 67, 67 François Vase, Chiusi (Kleitias and Ergotimos), 118, 118, 5-19A funerary chapel of Rekhmire, Thebes,

funerary mask, Grave Circle A, Mycenae, 97, 97

funerary relief of a vegetable vendor, Ostia, 207, 214, 214, 7-43A

funerary relief of an official in the Circus Maximus, 7-43A funerary relief with portraits of the

Gessii, 185, 185

Gaia/Ge (Greek/Roman deity), 105, 124, 153

Gallic chieftain killing himself and his wife (Epigonos[?]) (sculpture), 154-155, 154

gardens, 48, 49

3-12A

gardenscape, Villa of Livia, Primaporta (mural), 191-192, 191

Geometric amphora with mourning scene, Dipylon cemetery, Athens (Dipylon Painter), 106, 107, 5-2A

Geometric krater, Dipylon cemetery, Athens, 106-107, 106 Geometric period Greek art, 106-107,

161, 5-2A, 7-11A Ghurab (Egypt), portrait of Tiye (sculp-

ture), 76–77, 76 gigantomachy, Siphnian Treasury, Del-

phi (relief sculpture), 117, 117, 154 Giotto di Bondone, Arena Chapel, Padua, 4-11A

girl preparing to bathe (Onesimos), Chiusi (vase painting), 121, 143, 5-24A

Girsu (Telloh) (Iraq): Gudea seated, holding the plan of a temple (sculpture), 42, 42; Gudea standing, holding an overflowing water jar (sculpture), 43, 43; Stele of the Vultures, 34, 35-36, 36

Gislebertus, Last Judgment, Saint-Lazare, 5, 5, 10, 12

Gizeh (Egypt): Great Pyramids, 49, 60–62, *61*, *62*, *63*, 72, 3-14B; Great Sphinx, 62–63, *63*; Hemiunu seated statue, 66, 3-14B; Khafre enthroned (sculpture), 64, 64, 3-12A, 3-13, Menkaure and Khamerernebty(?) (sculpture), 64-65, 65, 3-13A

Glykon of Athens, copy of weary Herakles (Farnese Hercules) (Lysippos of Sikyon), 145, 145

Gnosis, stag hunt, Pella (mosaic), 146, 146, 148

goats treading seed and cattle fording a canal, mastaba of Ti, Saqqara (relief sculpture), 66-67, 67, 74

Göbekli Tepe (Turkey), 24, 25, 1-11A Golden House (Domus Aurea) (Severus and Celer), Rome, 201-203, 201,

Grave Circle A, Mycenae, 97-98, 97, 98,

grave stele of a young hunter (Illisos stele), Athens, 144, 144, 5-63B

grave stele of Hegeso, Dipylon cemetery, Athens, 139, 139, 140, 144, 167

Great Pyramids of Gizeh, 49, 60-62, 61, 62, 63, 72, 3-14B

Great Sphinx, Gizeh, 62-63, 63 Greece (ancient), 104map

Greek Archaic period art, 109-123, 161; architecture, 113-117, 113, 121-122, 3-6A, 5-16A; and Etruscan art, 163; and Roman art, 7-53A; sculpture, 109–113, 115, 116, 117, 122–123; vase painting, 118-121, 170, 5-19A,

Greek Early/High Classical period art, 123-141, 161; architecture, 123-124, 131–132, 136–139; painting, 139–141, 142, 5-58A; sculpture, 11, 102, 103, 124–131, 133–135, 137, 138–139, 5-33A; societal contexts, 123; urban planning, 152, 206

Greek Late Classical period art, 142-150, 161; architecture, 49, 148-150, 5-63B, 5-63C; mural painting, 146-147, 189; sculpture, 142-146, 5-62A, 5-63A, 5-63B; societal contexts, 142; vase painting, 5-63

Greppe Sant'Angelo (Italy), death of Sarpedon (Euphronios) (vase painting), 120,

Gudea seated, holding the plan of a temple, Girsu (sculpture), 42, 42

Gudea standing, holding an overflowing water jar, Girsu (sculpture), 43, 43

Hacilar (Turkey), 25

Hades abducting Persephone, Vergina (fresco), 146-147, 147, 148

Hadrian (Roman emperor), 209-212, 214

Hadrian's Villa, Tivoli, 211–212, 212 Hagar Qim (Malta), 27-28, 27

Hagesandros: head of Odysseus, Sperlonga (sculpture), 160, 160; Laocoön and his sons (sculpture), 159-160, 159

Hagia Triada (Crete): Harvesters Vase, 93, 93, 98, 100; sarcophagus, 82, 83, 86. 89

Halikarnassos (Turkey), tomb of Mausolos (Mausoleum), 49, 144, 5-63B,

Hall of the Bulls, Lascaux, 14, 15, 20, 22-23, 22

Hamadan (Iran), rhyton in the form of a winged lion, 51-52, 52

Hammurabi (king of Babylon), 34, 43-44, 2-1

Harvesters Vase, Hagia Triada, 93, 93, 98, 100

Hatshepsut mortuary temple, Deir el-Bahri, 69-71, 69, 70, 72

Hatshepsut with offering jars, Deir el-Bahri (sculpture), 70, 70

Hattusa (Turkey), Lion Gate, 2-18A head of a warrior, sea off Riace (sculpture), 11, 11

head of a woman, Brassempouy (ivory carving), 1-4A

head of a woman, Chios (sculpture), 143, 5-62A

head of Alexander the Great, Pella (sculpture), 146, 146

head of an Akkadian ruler, Nineveh (sculpture), 40-41, 40

head of an old man, Osimo (sculpture), 184, 184

head of Caracalla (sculpture), 7-62A head of Herakles or Telephos (school of Skopas of Paros), Temple of Athena Alea, Tegea (sculpture), 5-63B

head of Odysseus, Sperlonga (Athanadoros, Hagesandros, and Polydoros of Rhodes) (sculpture), 160, 160 head of Pompey the Great (sculpture),

Hegeso grave stele, Dipylon cemetery, Athens, 139, 139, 140, 144, 167

Helios and his horses, and Dionysos (Herakles?), Parthenon east pediment, Athens (sculpture), 133-134,

Hemiunu seated statue, Gizeh, 66, 3-14B Herakles wrestling Antaios (Euphronios), Cerveteri (vase painting), 119-120, 120

Herculaneum (Italy): House of Neptune and Amphitrite, 193-194, 194; Samnite House, 189, 189

Hermes and the infant Dionysos (Praxiteles[?]) (sculpture), 143, 143, 157

Hermes bringing the infant Dionysos to Papposilenos (Phiale Painter), Vulci (vase painting), 141, 141, 143

hero and centaur (Herakles and Nessos?), Olympia (sculpture), 107, 107 heroic portrait of Trebonianus Gallus,

221, 221 Hesire, relief from his tomb at Saqqara (relief sculpture), 10, 10, 12

hieroglyphics, 55, 56, 74, 3-14B Hohle Fels (Germany), ivory figurine,

Hohlenstein-Stadel (Germany), human with feline head (sculpture), 16-17, 17, 18, 25

Homage to the Square (Albers), 8, 8 Homage to the Square: "Ascending" (Albers), 7–8, 8

Horus temple, Edfu, 80, 80, 3-1A House of Neptune and Amphitrite, Herculaneum, 193-194, 194

House of the Faun, Pompeii, 193 House of the Menander, Pompeii, 194,

House of the Vettii, Pompeii, 188, 188, 189, 192-193, 193, 7-16A

human figure, Ain Ghazal (sculpture),

human skull with restored features, Jericho, 25, 25

human with feline head, Hohlenstein-Stadel (sculpture), 16-17, 17, 18, 25 Hunefer's scroll, Thebes, 54, 55 hunter capturing a bull, Vapheio (drink-

ing cup), 98-99, 98 Iktinos. See Parthenon

Iliad (Homer), 83, 84, 94, 105, 118, 145, 4-16A, 6-14A

Illisos stele (grave stele of a young hunter), Athens, 144, 144, 5-63B illusionism, 8, 190-192, 195

Imhotep: mortuary precinct of Djoser, 59-60, 59, 61, 68, 3-6A; stepped pyramid of Djoser, 59, 59

inlaid dagger blade with lion hunt, Grave Circle A, Mycenae, 97-98, 98 innermost coffin, tomb of Tutankhamen, Thebes, 78, 78

Insula of the Painted Vaults, Ostia, 213,

investiture of Zimri-Lim, palace, Mari (mural), 43, 45, 46, 2

Ishtar Gate, Babylon, 34, 48, 49, 49 Ishtar temple, Mari, 36, 2-5A Isola Sacra, Ostia, 214, 214 ivory carvings, 16-17, 18, 19-20, 99,

ivory figurine, Hohle Fels, 18 Ixion Room, House of the Vettii, Pompeii, 192-193, 193, 7-16A

Jack in the Pulpit No. 4 (O'Keeffe), 4, 4 Jericho (Palestine), 24-25, 24; human skull with restored features, 25, 25 Jerusalem, 205

Judaism, 34

judgment of Hunefer, Thebes (scroll), 54, 55

Kaaper portrait statue, Saqqara, 66,

Kalhu (Iraq): Ashurnasirpal II with attendants and soldier (mural), 46, 47; Assyrian archers pursuing ene-

mies (relief sculpture), 32, 47, 47 Kallikrates: Temple of Athena Nike, Athens, 131, 138-139, 138, 149. See also Parthenon

Kamares Ware jar, Phaistos, 91-92, 92 Karnak (Egypt): Akhenaton statue, 75, 75, 77; Amen-Re temple, 70, 71-73, 72, 73, 77, 80, 113, 3-24A; Mentuemhet portrait statue, 80, 80

Kawa (Sudan), Taharqo as a sphinx (sculpture), 79, 79

Kerma (Sudan), Lady Sennuwy seated statue, 3-16A

Keros (Greece), male harp player (sculpture), 86, 86

Khafre (pharaoh of Egypt), 61, 64, 3-12A, 3-13A

Khafre enthroned, Gizeh (sculpture), 64, 64, 3-12A, 3-13A

Khamerernebty (queen of Egypt), 64-65, 3-13/

Al-Khazneh (Treasury), Petra, 212-213, 213, 222

Khnumhotep II, tomb of, Beni Hasan, 68, 68,

Khorsabad (Iraq). See Dur Sharrukin Khufu (pharaoh of Egypt), 61, 62, 3-14B king and queen of Punt and attendants, Deir el-Bahri (relief sculpture), 70,

"King's Grave" bull-headed harp, Ur, 38-39, 38, 86

Kleitias, François Vase, Chiusi, 118, 118,

Knidos (Greece), Aphrodite of Knidos (Praxiteles), 142-143, 142, 156,

Knossos (Crete): bull-leaping, palace (fresco), 89, 89; Minoan woman or goddess (La Parisienne) (fresco), 88-89, 88, 92; palace, 86-88, 87, 88, 92-93, 93; Snake Goddess (sculpture), 92-93, 93

Kore in Ionian dress, Athens (sculpture), 112, 113

Korin, Waves at Matsushima, 8-9, 9 kouros, Attica (New York Kouros) (sculpture), 110, 110, 111

Kresilas, Pericles, 130-131, 130, 159, 184, 210

Kritios Boy, Athens (sculpture), 126, 126 Kroisos, Anavysos (sculpture), 111, 111,

La Madeleine (France), bison licking its flank, fragmentary spear-thrower, 19-20, 19

La Magdeleine (France) (cave), reclining woman (relief sculpture), 22, 1-5/

Lady of Auxerre (sculpture), 109, 109, 110, 112, 134, 5-6,

lamassu (man-headed winged bull), citadel of Sargon II, Dur Sharrukin (Khorsabad) (sculpture), 32, 46, 46

landscape with swallows (Spring Fresco), Akrotiri, 90, 90, 170, 191-192

landscape with volcanic eruption(?), Çatal Höyük (mural), 26, 26

landscapes, xvi, 5, 8, 26, 90–91, 140–141, 191–192, 7-34A

Laocoön and his sons (Athanadoros, Hagesandros, and Polydoros of Rhodes) (sculpture), 159-160, 159

Lars Pulena sarcophagus, Tarquinia, 173-174, 174

Lascaux (France): Axial Gallery, 22, 1-9A; "Chinese horse" (cave painting), 22, 1-9A; Hall of the Bulls, 14, 15, 20, 22-23, 22; rhinoceros, wounded man, and disemboweled bison, 22-23, 22, 26

Last Judgment, 5, 10, 12

Last Judgment (Gislebertus), Saint-Lazare, 5, 5, 10, 12

Laussel (France), woman holding a bison horn (relief sculpture), 18-19, 18, 1-5

Le Tuc D'Audoubert (France), two bison reliefs, 19, 19

Lepcis Magna (Libya), Arch of Septimius Severus, 219, 219

Libon of Elis, Temple of Zeus, Olympia, 123-125, 124, 125, 144, 5-33

lintel of Temple A, Prinias, 5-6A Lion Gate, Hattusa, 2-18A

Lion Gate, Mycenae, 95, 96, 96, 99, 4-16A

Lion Hunt (Rubens), 9, 9, 10 Lorrain, Claude. See Claude Lorrain Ludovisi Battle Sarcophagus (battle of

Romans and barbarians), 222, 222 Luxor (Egypt): Amen-Re temple, 72, 80, 113, 3-24A. See also Thebes (Egypt)

luxury arts, 164-165. See also ceramics; ivory carvings; metalwork

Lysikrates, Choragic Monument, Athens, 150, 150

Lysippos of Sikyon: Apoxyomenos (Scraper), 144-145, 144; portrait of Alexander the Great, 145; weary Herakles (Farnese Hercules), 145, 145

- Lyssipides Painter, Achilles and Ajax playing a dice game, Orvieto (vase painting), 119, 119
- Maidum (Egypt), seated statues of Rahotep and Nofret, 65, 3-13A,
- Maison Carrée (Square House), Nîmes, 199, 199
- Makapansgat (South Africa), waterworn pebble resembling a human face, 1-1A
- male harp player, Keros (sculpture), 86, 86
- man with ancestor busts, Rome (sculpture), 183, 183
- Mantiklos Apollo, Thebes (sculpture), 107–108, 107, 110
- Marcus Aurelius (Roman emperor), 177, 214, 215, 7-57A
- Mari (Syria): investiture of Zimri-Lim, palace (mural), 43, 45, 46, 2-17A; Ishtar temple, 35, 2-5A
- Marine Style octopus flask, Palaikastro, 92, 92
- Markets of Trajan, Rome (Apollodorus of Damascus), 208–209, 209, 227
 Marzabotto, Italy, city plan, 166, 167,
- Mausoleum, Halikarnassos, 49, 144, 5-63B, 5-63C
- Maxentius (Roman emperor), 224, 225, 227
- medallion with portrait of Constantine, 228, 228
- Meditations (Marcus Aurelius), 215 Melfi sarcophagus, 216–217, 216 Menander portrait, Pompeii, 194, 195
- Menes (pharaoh of Egypt), 57 Menkaure (pharaoh of Egypt), 61, 64–65, 3-13A
- Menkaure and Khamerernebty(?), Gizeh (sculpture), 64–65, 65, 3-13A
- Mentuemhet portrait statue, Karnak, 80, 80
- Mesopotamia, 32map
- metalwork: Aegean, 97–99, 4-13A, 4-21A; Akkadian, 40–41; Egyptian, 77, 78; Etruscan, 165, 172, 173, 6-14A; Greek, 107–108, 132–133; Persian, 51–52. See also bronze casting
- Michelangelo Buonarroti: and Laocoön and his sons (Athanadoros, Hagesandros, and Polydoros of Rhodes) (sculpture), 159; Santa Maria degli Angeli, 220, 220; unfinished statues, 11, 11
- Middle Kingdom period Egyptian art, 67–68, 81, 168, 3-16A
- Miniature Ships Fresco, Akrotiri, 4-9A Minoan woman or goddess (La Parisienne), Knossos (fresco), 88–89, 88, 92
- Minoans, 84, 3-12A
- Mnesikles, Propylaia, Athens, 131, 136, 136
- Monterozzi necropolis, Tarquinia, 164, 165, 169–170, 170, 171, 174, 192, 6-10A, 6-17A
- mortuary precinct of Djoser, Saqqara, 59–60, *59*, *61*, 68, 3-6A
- mosaics, 146, 147–148, 193–194, 7-53A Moses, 34
- mummy portrait of a priest of Serapis, Hawara (encaustic painting), 217, 217
- mummy portrait of a young woman, Hawara (encaustic painting), 7-60A mummy portrait of Artemidorus,
- Hawara (encaustic painting), 7-59A musicians and dancers, tomb of Nebamun, Thebes (mural), 74–75, 74
- Mycenae (Greece): female head (sculpture), 99–100, 99; funerary mask, Grave Circle A, 97, 97; Grave Circle A, 97–98, 97, 98, 4–21A; inlaid dagger blade with lion hunt, 97–98, 98; Lion Gate, 95, 96, 96, 99, 4–16A;

- Treasury of Atreus, 95, 96–97, 96, 97, 168, 182; two goddesses(?) and a child (sculpture), 99, 99; *Warrior Vase*, 100, 100
- Myron, Diskobolos (Discus Thrower), 128-129, 128
- Napoleon Bonaparte, 56 Naram-Sin victory stele, Susa, 40, 41, 44, 45, 47, 2-17 A
- Narmer (pharaoh of Egypt), 57–58 Nebamun, tomb of, Thebes, 74–75, 74 Nefertiti, bust of (Thutmose), 76, 76, 77 Neo-Babylonian art, 48, 49, 53, 2-18A Neo-Sumerian art, 41–42, 43, 53, 2-17A
- Neptune and Amphitrite wall mosaic, House of Neptune and Amphitrite, 193–194, 194
- Neptune and creatures of the sea, Baths of Neptune, Ostia (mosaic), 7-53A Nero (Roman emperor), 201, 203, 204
- New Kingdom period Egyptian art, 68–75, 81, 3-24A
- New York Kouros (sculpture), Attica, 110, 110, 111
- New Zealand art, 13
- Newgrange (Ireland), passage grave, 27, 27 Nike adjusting her sandal, Temple of Athena Nike parapet (Kallikrates) (relief sculpture), 138–139, 138
- Nike of Samothrace (Nike alighting on a warship) (sculpture), 155, 155
- Nîmes (France): Maison Carrée (Square House), 199, 199; Pont-du-Gard, 200, 200
- Nineveh (Iraq): Ashurbanipal hunting lions, palace of Ashurbanipal (relief sculpture), 32, 48, 48, 140; head of an Akkadian ruler (sculpture), 40–41, 40
- Niobid Painter, Artemis and Apollo slaying the children of Niobe, Orvieto (vase painting), 141, *141*
- Nofret (Egyptian princess), 3-13A Novios Plautios, 166; *Ficoroni Cista* (bronze container), 172, 173, 6-14A
- nude woman (*Venus of Willendorf*), 17–18, 18, 25 nummus with portrait of Constantine,
- Octavian (Roman emperor). See Augustus
- Odyssey (Homer), 83, 105, 160 Ogata Korin. See Korin

228, 228

- Okeanos (Oceanus) (Greek/Roman deity), 105
- O'Keeffe, Georgia, Jack in the Pulpit No.
- Old Kingdom period Egyptian art, 49, 60–67, 81, 3-12A, 3-13A, 3-14A, 3-14B
- old market woman (sculpture), 158–159, *158*
- Olympia (Greece): Athena, Herakles, and Atlas with the apples of the Hesperides, Temple of Zeus metope, Olympia (sculpture), 124, 124, 145; chariot race of Pelops and Oinomaos, Temple of Zeus east pediment (sculpture), 124, 125; hero and centaur (Herakles and Nessos?) (sculpture), 107, 107; seer, Temple of Zeus east pediment (sculpture), 125, 125, 144; Temple of Hera, 113, 143; Temple of Zeus (Libon of Elis), 123–125, 124, 125, 144, 145, 5-33A; Zeus (Phidias) (sculpture), 49
- Onesimos, girl preparing to bathe, Chiusi (vase painting), 121, 143, 5-24A Op Art, 7-8
- Oresteia (Aeschylus), 123, 125 Orestes sarcophagus, 216, 216 Orientalizing period Etruscan art,
- 164–165, 175 Orientalizing period Greek art, 107–109, 113, 161, 168, 5-5A, 5-6A,

- Orvieto (Italy): Achilles and Ajax playing a dice game (Andokides Painter and Lysippides Painter) (vase painting), 119, 119; Artemis and Apollo slaying the children of Niobe (Niobid Painter) (vase painting), 141, 141
- Osimo (Italy), head of an old man (sculpture), 184, 184
- Ostia (Italy): Baths of Neptune, 7-53A; funerary relief of a vegetable vendor, 207, 214, 214, 7-43A; Insula of the Painted Vaults, 213, 7-54A; insulae, 213–214, 213, 7-54A; Isola Sacra, 214, 214
- Ouranus (Uranus) (Greek/Roman deity), 105
- Paestum (Italy): Temple of Hera I ("Basilica"), 115–116, 115, 121, 132; Temple of Hera II or Apollo, 123–124, 123; Tomb of the Diver, 141, 142, 170
- painted chest, tomb of Tutankhamen, Thebes, 78, 79
- painted portrait of Septimius Severus and family, 218, 218
- Paionios of Ephesos, Temple of Apollo, Didyma, 150–151, *150*
- palace, Knossos, 86–88, 87, 88, 92–93, 93
- palace of Diocletian, Split, 224, 225 Palace of Nestor, Pylos, 94, 99, 4-16A palace of Shapur I, Ctesiphon, 52, 52 Palaikastro (Crete): Marine Style octopus flask, 92, 92; young god(?)

(sculpture), 93, 4-13A

- Palestrina (Italy), Sanctuary of Fortuna Primigenia, 181, 181, 183, 203, 209 palette of King Narmer, Hierakonpolis, 57–58, 57, 66, 3-1A
- Panathenaic Festival procession frieze, Parthenon, Athens, 134–135, *135*, 142, 198
- Pantheon, Rome, 95, 201, 210, 211, 211, 222
- La Parisienne (Minoan woman or goddess), Knossos (fresco), 88–89, 88, 92 Parthenon (Iktinos and Kallikrates),
 - Athens: architecture, 102, 102, 103, 131–132, 132; Athena Parthenos, 102, 103, 132–133, 133, 149, 153; gigantomachy (relief sculpture), 153; metope reliefs, 102, 103, 133, 133; Panathenaic Festival procession frieze, 134–135, 135, 142, 198; pediment statuary, 133–134, 134, 138; proportion in, 102, 103, 131–132, 151; statuary, 102, 133–134
- passage grave, Newgrange, 27, 27 The Passion of Sacco and Vanzetti (Shahn), 4, 4, 6
- Pech-Merle (France), cave paintings, 21–22, 21
- Pella (Greece): head of Alexander the Great (sculpture), 146, 146; stag hunt (Gnosis) (mosaic), 146, 146,
- people, boats, and animals, Tomb 100, Hierakonpolis (mural), 57, 58, 3-1A
- Peplos Kore, Athens (sculpture), 112, 112 Pergamon (Turkey), 152, 153–155; Altar of Zeus, 152, 153–155, 153, 154, 155, 160; and Roman Empire, 160, 179
- Pericles (Kresilas), 130–131, 130, 159, 184, 210
- Persepolis (Iran), 50–51, 50; columns with animal protomes, palace, 50, 51; Persians and Medes, processional frieze, palace, 50–51, 51
- Persia, 48, 50; and Alexander the Great, 50, 51, 52, 142, 147–148; and Greece, 50, 103, 123, 130, 133, 151, 153
- Persians and Medes, processional frieze, Persepolis, 50–51, *51*
- Perugia (Italy), Porta Marzia, 173, 173, 203

- Petra (Jordan), Al-Khazneh (Treasury), 212–213, 213, 222
- Phaistos (Crete), 84; Kamares Ware jar, 91–92, 92
- Phiale Painter, Hermes bringing the infant Dionysos to Papposilenos, Vulci (vase painting), 141, 141, 143
- Phidias: Athena Parthenos, 102, 103, 132–133, 133, 149, 153; Parthenon sculptures, 102, 103, 131, 133–135, 133, 134, 135, 149, 153; Zeus, Olympia (sculpture), 49
- philosopher sarcophagus (Roman Late Empire), 222, 223
- Philoxenos of Eretria, *Battle of Issus* (Alexander Mosaic), 147–148, 147, 193, 194, 7-53A
- Plato, 104-105
- Pliny the Elder, 129, 130–131, 142, 143, 148, 155, 160, 166, 186, 217, 5-63A
- Polydoros of Rhodes: head of Odysseus, Sperlonga (sculpture), 160, 160; Laocoön and his sons (sculpture), 159–160, 159
- Polyeuktos, *Demosthenes* (sculpture), 158, 159
- Polygnotos of Thasos, 140–141, 173, 217; Stoa Poikile (Painted Stoa), Athens, 140–141, 152
- Polykleitos, 5-62A; canon of, 129, 131, 132, 142, 151, 155; *Doryphoros* (*Spear Bearer*), 128–129, *128*, 131, 143, 145, 197
- Polykleitos the Younger: Corinthian capital, tholos, Epidauros, 149, 149; Theater of Epidauros, 148, 148, 149
- Polyzalos of Gela, 5-16A; charioteer dedicated by, Delphi (sculpture), 127-128, 127
- Pompeian/Vesuvius area art, 186–195, 206, 6-8A, 7-16A, 7-24A
- Pompeii (Italy): amphitheater, 187, 187; basilica, 186, 187; Capitolium, 186, 187; House of the Faun, 193; House of the Menander, 194, 195; House of the Vettii, 188, 188, 189, 192–193, 193, 7-16A; Villa of the Mysteries, 190, 190, 206. See also Pompeian/ Vesuvius area art
- Pont-du-Gard, Nîmes (aqueduct), 200,
- Porta Maggiore, Rome, 200, 200 Porta Marzia, Perugia, 173, 173, 203 portrait bust of a Flavian woman, Rome,
- 204, 204 portrait bust of Commodus as Hercules, 216, 7-57A
- portrait bust of Hadrian, 210, 210 portrait bust of Livia, Arsinoe (sculpture),
- 196, 196, 197 portrait bust of Philip the Arabian, 221,
- portrait bust of Trajan Decius, 220–221, 221, 7-66A
- portrait of a husband and wife, House VII,2,6, Pompeii, 194, 194
- portrait of a Roman general, Sanctuary of Hercules, Tivoli (sculpture), 184, 184
- portrait of an Akkadian king, Nineveh, 40–41, 40
- portrait of Augustus as general, Primaporta (sculpture), 198, 198, 199
- portrait of Constantine (sculpture), 226–227, 226 Portrait of Te Pehi Kupe (Sylvester), 13, 13
- portrait of Vespasian (sculpture), 203–204,
- portraits of the four tetrarchs (sculpture), 224, 224
- Portunus (Roman deity), 180 Poseidon (Neptune) (Greek/Roman deity), 105, 128, 136, 7-53A
- post-Amarna period Egyptian art, 54, 55, 77–78, 79
- Post-Painterly Abstraction, 1, 2 Praxiteles, 146, 217, 5-63A; *Aphrodite of Knidos*, 142–143, 142, 156, 5-62A, 5-84A; followers of, 143, 5-62A

Praxiteles(?), Hermes and the infant Dionysos (sculpture), 143, 143, 157 Predynastic period Egyptian art, 10, 12, 56-60, 81, 3-1A, 3-6A presentation of offerings to Inanna (Warka Vase), Uruk, 30, 31, 35 Priene (Turkey), urban planning, 151, Primaporta (Italy), Villa of Livia, 191-192, Prinias (Crete), Temple A, 109, 113, 5-5A, 5-6A procession of the imperial family, Ara Pacis Augustae, Rome (relief sculpture), 198-199, 198 Propylaia (Mnesikles), Athens, 131, 136, 136 Pylos (Greece), Palace of Nestor, 94, 99, Pyramid Texts, 61 Ramses II (pharaoh of Egypt), 71, 72, Ramtha Visnai and Arnth Tetnies, sarcophagus of, Ponte Rotto necropolis, Vulci, 167, 6-17 reclining woman, La Magdeleine (relief sculpture), 22, 1-5A Reed Painter, warrior seated at his tomb, Eretria (vase painting), 5-58A Regolini-Galassi tomb, Červeteri, 164-165, 165 Rekhmire (Egyptian vizier), 3-12A relief with funerary procession, Amiternum, 7-11A Rembrandt van Rijn, 6 Republic (Plato), 104-105 Res Gestae Divi Augusti (Augustus), 197 Rhea (Greek/Roman deity), 105 rhinoceros, wounded man, and disemboweled bison, Lascaux (cave painting), 22-23, 22, 26 Rhodes (Greece): Colossus of Rhodes, 49; Corinthian black-figure amphora with animal friezes, 108–109, 108; sleeping Eros (sculpture), 5-84B Rhonbos, calf bearer sculpture dedicated by, Athens (sculpture), 110-111, 111, 112 rhyton in the form of a winged lion, Hamadan, 51-52, 52 Riace (Italy), sea near: head of a warrior (sculpture), 11, 11; warrior (sculpture), 126-127, 126, 157 rock-cut buildings, 68, 71, 168, 212-213, 222, 3-23A rock-cut tombs, Beni Hasan, 68, 68, 168, Roman Early Empire art, 195-206, 229; Augustan/Julio-Claudian period, 7, 195-203, 210; Flavian period, 203-206, 7-40A Roman Empire, 178map; and Christianity, 215, 218, 225, 228; and Egypt, 56, 195, 217, 7-59A; and Etruscans, 173; and Hellenistic period Greek art, 159-160; and Pergamon, 153; sack of Jerusalem (70), 205 Roman High Empire art, 206-217, 229; Antonine period, 176, 177, 214-217, 57A; Hadrian, 209-214, 7-45A, 7-45B, 7-45C, 7-45D, 7-47A; Ostia, 207, 213-214, 7-53A, 7-54A; Trajan, 206-209, 7-43A, 7-44A Roman Late Empire art, 218-228, 229; Constantine, 224-228; Severan period, 218-220, 7-62A; soldier emperor period, 220–223, 7-66A; tetrarchy period, 223–224 Roman Republic art, 179–185, 203, 229,

Rome (Italy): Ara Pacis Augustae (Altar

Titus, 204-206, 204, 205, 219,

7-40A; Basilica Nova, 227, 227

Basilica Ulpia, 207, 207; Baths of

of Augustan Peace), 197-199, 197,

198, 205, 206; Arch of Constantine,

225-226, 225, 226, 7-47A; Arch of

Caracalla, 219-220, 219, 227: Baths of Diocletian, 220, 220, 227; Circus Maximus, 206–207, 7-43A; Colosseum, 202, 202, 203; Colossus of Nero, 203; Column of Antoninus Pius, 176, 177, 214, 215, 222, 224, 7-40A, 7-43A; Column of Trajan, 207, 208, 208, 7-43A, 7-45A, 7-45B, 7-45C, 7-45D; Domus Aurea (Golden House) (Severus and Celer), 201-203, 201, 203, 7-34A; and Etruscans, 166; Forum of Augustus, 199, 207, 7-40A; Forum of Trajan (Apollodorus of Damascus), 206-207, 207; Markets of Trajan (Apollodorus of Damascus), 208-209, 209, 227; model of (4th century), 180; Pantheon, 95, 201, 210, 211, 211, 222; Porta Maggiore, 200, 200; Santa Maria degli Angeli (Michelangelo Buonarroti), 220, 220; seated boxer (sculpture), 157, 157; Temple of Jupiter Optimus Maximus, Capitoline Hill, Rome (Vulca of Veii), 166, 179; Temple of Portunus (Temple of Fortuna Virilis), 180, 180 Royal Cemetery, Ur, 32, 60 Rubens, Peter Paul, Lion Hunt, 9, 9, 10 sacrifice to Apollo, Hadrianic tondo, Saint-Lazare, Autun, Last Judgment (Gislebertus), 5, 5, 10, 12 Saint Mark's, Venice, 224, 224 Samnite House, Herculaneum, 189, 189 Sanctuary of Apollo, Delphi, 117, 5-16A Sanctuary of Fortuna Primigenia, Palestrina, 181, 181, 183, 203, 209 Santa Croce, Florence, 3-4, 3 Santa Maria degli Angeli, Rome, 220, 220 Saqqara (Egypt): Hesire relief (relief sculpture), 10, 10, 12; Kaaper portrait statue, 66, 3-14A; mastaba of Ti, 66-67, 66, 67, 74, 75; mortuary precinct of Djoser (Imhotep), 59-60, 59, 61, 68, 3-6A; seated scribe (sculpture), 65-66, 65; stepped pyramid of Djoser (Imhotep), 59, 59 173-174, 174

sarcophagus, Hagia Triada, 82, 83, 86, 89

sarcophagus of Lars Pulena, Tarquinia,

sarcophagus of Ramtha Visnai and Arnth Tetnies, Ponte Rotto necropolis, Vulci, 167, 6-17A

sarcophagus with reclining couple, Banditaccia necropolis, Cerveteri, 167-168, 167

Sasanian art, 52, 53 Schliemann, Heinrich, 84, 85, 95, 97,

scroll of Hunefer, Thebes, 54, 55 sculptors at work, funerary chapel of

Rekhmire, Thebes (mural), 3-12A seated boxer, Rome (sculpture), 157, 157 seated portrait of the Greek poet

Menander, House of the Menander, Pompeii (mural), 194, 195

seated scribe, Saqqara (sculpture), 65-66, 65

seated statue of Lady Sennuwy, Kerma, 3-16A

seated statues of Rahotep and Nofret, Maidum, 65, 3-13A, 3-14B seated statuette of Urnanshe, Mari, 36,

43, 45, 2-5A Second Style mural painting, 189-192,

199, 213 Second Style wall paintings, Villa of

Publius Fannius Synistor, Boscoreale, 190, 191, 213

seer, Temple of Zeus east pediment, Olympia (sculpture), 125, 125, 144 Selene (Luna) (Greek/Roman deity), 105, 134

Self-Portrait (Te Pehi Kupe), 13, 13 Senenmut with Princess Nefrura, Thebes (sculpture), 73, 73

Senusret I (pharaoh of Egypt), 3-16A Senusret III (pharaoh of Egypt), 67 Seti I (pharaoh of Egypt), 55 Seven Wonders of the ancient world, 48, 49, 60-61, 144, 5-63C Severan period, 218-220, 7-62A. See also Roman Late Empire art Severe Style (Greek art), 124 Severus, Domus Aurea (Golden House), 201-203, 201, 203, 7-34A Shahn, Ben, The Passion of Sacco and Vanzetti, 4, 4, 6 Shamash (Utu) (Mesopotamian deity), 34, 44 Shapur I, palace of, Ctesiphon, 52, 52 silver. See metalwork Siphnian Treasury, Delphi, 117, 117, 137, 154 Skara Brae (Scotland), 27, 1-17A Skopas of Paros, 146; frieze, Mausoleum, Halikarnassos, 144, 5-63B, 5-63C; Temple of Athena Alea, Tegea, sleeping Eros, Rhodes (sculpture), 5-84B sleeping satyr (Barberini Faun) (sculpture), 156, 157 Snake Goddess, Knossos (sculpture), 92-93, 93

Sobekneferu (pharaoh of Egypt), 69 soldier emperor period art, 220-223,

Southwest Native American art, 1-14A Sperlonga (Italy), 160

Split (Croatia), palace of Diocletian, 224, 225

Spoils of Jerusalem, relief panel, Arch of Titus, 205, 205 spotted horses and negative hand imprints, Pech-Merle (cave painting),

21-22, 21 Spring Fresco (landscape with swallows), Akrotiri, 90, 90, 170, 191–192 Square Temple, Eshnunna, 35, 43, 45

stag hunt, Pella (Gnosis) (mosaic), 146,

146, 148 stained-glass windows, 12 The Standard of Ur, 36-38, 37, 40,

statue of Queen Napir-Asu, Susa, 45, statuettes of two worshipers, Eshnunna,

35, 35, 43, 45 Stele of the Vultures (battle scenes,

victory stele of Eannatum), Girsu, 34, 35-36, 36 stele with the laws of Hammurabai,

Susa, 34, 44, 44, 45 stepped pyramid of Djoser (Imhotep), 59, 59

Still, Clyfford, 1948-C, 1, 2 still life with peaches, Herculaneum, 195, 195

Stoa of Attalos II, Athens, 152, 152 Stoa Poikile (Painted Stoa) (Polygnotos of Thasos), Athens, 140-141, 152

Stonehenge (England), 28, 28 Sumerian art, 30-31, 32-40, 53, 86,

Susa (Iran): beaker with animal decoration, 2-18B; statue of Queen Napir-Asu, 45, 45; stele with the laws of Hammurabai, 34, 44, 44, 45; victory stele of Naram-Sin, 40, 41, 44, 45, 47, 2-17A

Sylvester, John Henry, Portrait of Te Pehi Kupe, 13, 13

Syros (Greece), figurine of a woman, 85,

T-shaped stone pillar with animal reliefs, Göbekli Tepe, 1-11A Taharqo (pharaoh of Egypt), 79 Taharqo as a sphinx, Kawa (sculpture), 79, 79

Tarquinia (Italy): Monterozzi necropolis, 164, 165, 169-170, 170, 171, 174, 192, 6-10A, 6-17A; sarcophagus of Lars Pulena, 173-174, 174; Tomb of Hunting and Fishing, 170, 171, 192,

6-10A; Tomb of the Augurs, 170, 170, 6-10A; Tomb of the Leopards, 162, 163, 170, 174, 6-10A; Tomb of the Tricliniumm, 174, 6-10A Te Pehi Kupe, Self-Portrait, 13, 13 Tegea (Greece), Temple of Athena Alea (Skopas of Paros), 5-63B Temple A, Prinias, 109, 113, 5-5A, 5-6A Temple of Aphaia, Aegina, 121-123, 121, 122, 123-124 Temple of Apollo, Didyma (Paionios of Ephesos and Daphnis of Miletos), 150-151, 150 Temple of Artemis, Corfu, 116, 116, 122, Temple of Artemis, Ephesos, 49 Temple of Athena Alea (Skopas of Paros), Tegea, 5-63B

Temple of Athena Nike (Kallikrates), Athens, 131, 138-139, 138, 149 Temple of Fortuna Virilis (Temple of Portunus), Rome, 180, 180 Temple of Geshtinanna, Girsu, 43 Temple of Hera, Olympia, 113, 143 Temple of Hera I ("Basilica"), Paestum, 115-116, *115*, 121, 132 Temple of Hera II or Apollo, Paestum, 123-124, 123

Temple of Horus, Edfu, 80, 80, 3-1A Temple of Jupiter Optimus Maximus, Capitoline Hill, Rome (Vulca of Veii), 166, 179

Temple of Portunus (Temple of Fortuna Virilis), Rome, 180, 180 Temple of Ramses II, Abu Simbel, 71,

71, 3-23A Temple of Venus, Baalbek, 222-223,

223, 224 Temple of Vesta(?), Tivoli, 181, 181 Temple of Zeus, Olympia (Libon of

Elis), 123-125, 124, 125, 144, 145, Ten Books on Architecture (Vitruvius),

165, 199. See also Vitruvius theater of Epidauros (Polykleitos the Younger), 148-149, 148, 149

Thebes (Egypt), 68, 80; funerary chapel of Rekhmire, 3-12A; Senenmut with Princess Nefrura (sculpture), 73, 73; tomb of Hunefer, 54, 55; tomb of Nebamun, 74-75, 74; tomb of Tutankhamen, 78, 78, 79, 97; Valley of the Kings, 71. See also Luxor

Thebes (Greece), Mantiklos Apollo (sculpture), 107-108, 107, 110 Theodoros of Phokaia, tholos, Delphi,

148, 149 Theogony (Genealogy of the Gods)

(Hesiod), 105 Third Style mural painting, 192, 199,

Third Style wall painting, Villa of

Agrippa Postumus, Boscotrecase, 192, 192, 7-34A

tholos, Delphi (Theodoros of Phokaia), 148, 149

Three goddesses (Hestia, Dione, and Aphrodite?), Parthenon east pediment, Athens (sculpture), 134, 134 three revelers (Euthymides), Vulci (vase

painting), 120-121, 121 Thutmose (sculptor), bust of Nefertiti, 76, 76, 77

Thutmose I (pharaoh of Egypt), 69, 70,

Thutmose II (pharaoh of Egypt), 69 Thutmose III (pharaoh of Egypt), 69, 70, 72, 3-12

Ti, mastaba of, Saqqara, 66-67, 66, 67, 74, 75

Ti watching a hippopotamus hunt, mastaba of Ti, Saqqara (relief sculpture), 66, 66, 75

Timgad, Algeria, 206, 206 Tinia (Etruscan deity), 165, 166 Tiryns (Greece), citadel, 94, 94, 95, 95 Titus (Roman emperor), 159, 202, 203, 204-206, 7-40A

- Tivoli (Italy): Hadrian's Villa, 211–212, 212; portrait of a Roman general, Sanctuary of Hercules (sculpture), 184, 184; Temple of Vesta(?), 181, 181
- Tiye, portrait of, Ghurab (sculpture), 76–77, 76
- Tomb 100 wall paintings, Hierakonpolis, 57, 58, 3-1A
- Tomb of Hunting and Fishing, Monterozzi necropolis, Tarquinia, 170, *171*, 192, 6-10A
- tomb of Mausolos (Mausoleum), Halikarnassos, 49, 144, 5-63B, 5-63C
- tomb of Nebamun, Thebes, 74–75, 74 Tomb of the Augurs (Tarquinia), 170, 170, 6-10A
- Tomb of the Diver, Paestum, 141, 142,
- Tomb of the Leopards, Monterozzi necropolis, Tarquinia, *162*, 163, 170, 174, 6-10A
- Tomb of the Reliefs, Banditaccia necropolis, Cerveteri, 169, *169*
- Tomb of the Shields and Chairs, Banditaccia necropolis, Cerveteri, 168, 169, 169, 6-8A
- Tomb of the Triclinium, Monterozzi necropolis, Tarquinia, 174, 6-10A
- tomb of Ti, Saqqara, 66–67, 66, 67, 74, 75 tomb of Tutankhamen, Thebes, 78, 78, 79, 97
- Tower of Babel (Babylon ziggurat), 34, 48, 49
- Trajan (Roman emperor), 206–209, 215, 7-43A, 7-44A, 7-45A, 7-45B, 7-45C, 7-45D
- Trajan Decius (Roman emperor), 220–221, 7-66A
- Trajan's Arch, Benevento, 207, 7-43A,
- Trajan's Column, Rome, 207, 208, 208, 7-43A, 7-45A, 7-45B, 7-45C, 7-45D
- Treasury of Atreus, Mycenae, 95, 96–97, 96, 97, 168, 182

- Trier (Germany), Aula Palatina, 227–228, 227, 228
- Triumph of Shapur I over Valerian, Bishapur (relief sculpture), 52, 2-29 A
- Triumph of Titus, relief panel, Arch of Titus, 205–206, 205, 219
- Tutankhamen (pharaoh of Egypt), 77–78, 79, 97
- Tutankhamen, tomb of, Thebes, 78, 78, 79, 97
- two bison cave reliefs, Le Tuc D'Audoubert, 19, *19*
- two goddesses(?) and a child, Mycenae (sculpture), 99, 99
- Unas (pharaoh of Egypt), 61 unfinished statues (Michelangelo Buonarroti), 11. *11*
- Ur (Tell Muqayyar) (Iraq): banquet scene cylinder seal, tomb of Puabi, 39–40, 39; bull-headed harp, tomb 789 ("King's Grave"), 38–39, 38, 86; bull-headed harp with inlaid sound box, tomb of Pu-abi, 38, 38, 86; Royal Cemetery, 32, 60; The Standard of Ur, 36–38, 37, 40, 2–5A; votive disk of Enheduanna, 41, 41; ziggurat, 42, 42
- uraeus, 63, 70, 78 urban planning, 33, 151, 166, 167, 186, 206, 1-14A
- Urnanshe statuette, Mari, 35, 43, 45,
- Uruk (Iraq): female head (Inanna?) (sculpture), 34–35, 34; Warka Vase (presentation of offerings to Inanna), 30, 31, 35; White Temple and ziggurat, 33–34, 33
- Valerian (Roman emperor), 52, 2-29A Valley of the Golden Mummies, 60 Valley of the Kings, Thebes, 71 Vallon-Pont-d'Arc (France), Chauvet Cave, 23, 23

- Vapheio (Greece), hunter capturing a bull (drinking cup), 98–99, 98
- vase painting: Greek Archaic period, 118–121, 170, 5-19A, 5-20A, 5-23A, 5-24A; Greek Early/High Classical period, 139–141, 5-58A; Greek Geometric period, 106–107, 5-2A, 7-11A; Greek Late Classical period, 5-63A; Greek Orientalizing period, 108–109, 168, 6-10A, 7-53A; Greek techniques, 108–109; Mycenaean, 100
- Venice (Italy), Saint Mark's, 224, 224 Venus de Milo (Aphrodite) (Alexander
- of Antioch-on-the-Meander) (sculpture), 156, 156
- Venus of Willendorf, 17–18, 18, 25 Vergina (Greece), Hades abducting Persephone (fresco), 146–147, 147,
- Vespasian (Roman emperor), 203–204 victory stele of Naram-Sin, Susa, 40, 41, 44, 45, 47, 2-17A
- Villa of Agrippa Postumus, Boscotrecase, 192, 192, 7-34A
- Villa of Livia, Primaporta, 191–192, 191 Villa of Publius Fannius Synistor, Boscoreale, 190, 191
- Villa of the Mysteries, Pompeii, 190, 190, 206
- Vitruvius, 132, 149, 165, 192, 199 votive disk of Enheduanna, Ur, 41, 41 Vulca of Veii, 167; Temple of Jupiter Optimus Maximus, Capitoline Hill,
- Rome, 166, 179

 Vulci (Italy): Achilles and Ajax playing a dice game (Exekias) (vase painting), 118–119, 118; Achilles killing Penthesilea (Exekias) (vase painting), 5-20A; Hermes bringing the infant Dionysos to Papposilenos (Phiale Painter) (vase painting), 141, 141, 143; sarcophagus of Ramtha Visnai and Arnth Tetnies, Ponte Rotto necropolis, 167, 6-17A; three revelers (Euthymides) (vase

painting), 120-121, 120

- Warka Vase (presentation of offerings to Inanna), Uruk, 30, 31, 35
- warrior, sea off Riace (sculpture), 126–127, 126, 157
- warrior seated at his tomb (Reed Painter), Eretria (vase painting), 5-58A
- warrior taking leave of his wife (Achilles Painter), Eretria (vase painting), 140, 140
- Warrior Vase, Mycenae, 100, 100 waterworn pebble resembling a human face, Makapansgat, 1-1A
- Waves at Matsushima (Korin), 8–9, 9 weary Herakles (Farnese Hercules) (Lysippos of Sikyon), 145, 145
- White Temple and ziggurat, Uruk, 33–34, 33
- Willendorf (Austria), nude woman (Venus of Willendorf), 17–18, 18, 25
- woman holding a bison horn, Laussel (relief sculpture), 18–19, *18*, 1-5A
- Woman with stylus and writing tablet ("Sappho"), Pompeii (fresco), 7-24A
- woodcuts, 6
- wounded Romans, Column of Trajan, Rome (relief sculpture), 7-45A
- young god(?), Palaikastro (sculpture), 93, 4-13 A
- youth diving, Tomb of the Diver, Paestum (fresco), 141, 142, 170
- Zeus (Jupiter) (Greek/Roman deity), 49, 105, 116, 123, 128, 165, 166, 173, 187, 7-40A, 7-44A
- Zeus (or Poseidon?), sea off Cape Artemision (sculpture), 128, *128*
- Zeus, Olympia (Phidias), 49 ziggurat, Babylon, 34, 48, 49 ziggurat, Ur, 42, 42
- Zimri-Lim, investiture of, palace, Mari (mural), 43, 45, 46, 2-17A

FIFTH EDITION.

STEPHEN E. SCHNEIDER

THOMAS T. ARNY

Physical and Astronomical Constants

Physical Constants

Gravitational constant (G)

Velocity of light (c)

Planck's constant (h)

Mass of hydrogen atom $(M_{
m H})$ = $9.1094 \times 10^{-31} \text{ kg}$ = $5.6705 \times 10^{-8} \text{ watts} \cdot \text{m}^{-2} \cdot \text{deg}$ $= 6.62608 \times 10^{-34} \text{ joule sec}$ $=6.67259\times10^{-1}$ $= 2.99792458 \times 10^8$ m/sec $1.6735 \times 10^{-27} \text{ kg}$ $^{11}_{24}$ m³·kg⁻¹·s⁻²

Wien's law constant $(T \times \lambda_{\max})$ Stefan-Boltzmann constant (σ)

 $= 2.90 \times 10^6 \text{ K} \cdot \text{nm}$

Mass of electron (M_e)

Astronomical Constants

Mass of Sun (M_{\bigcirc}) Radius of Sun (R_{\bigcirc}) Luminosity of Sun (L_{\bigcirc}) Hubble's constant (H) $\begin{array}{ll} \text{Eigent-year (iy)} &= 9.4605 \times 10^{13} \text{ m} = 63,240 \text{ AU} \\ \text{Parsec (pc)} = 3.26 \text{ ly} &= 3.085678 \times 10^{16} \text{ m} = 206,265 \text{ AU} \\ \text{Year (synodic or "tropical")} = 365.2422 \text{ days} = 3.1557 \times 10^7 \text{ sec} \\ \text{Mass of Sun } (M_{\odot}) &= 1.989 \times 10^{30} \text{ kg} \\ \text{Partition of Sun (M_{\odot})} &= 1.989 \times 10^{30} \text{ kg} \end{array}$ Astronomical unit (AU) = $1.495978706 \times 10^{11}$ m = 9.4605×10^{15} m = 63.7 $\approx 70 \text{ km/sec per Mpc}$ $= 3.83 \times 10^{26}$ watts $=6.96\times10^{8}$ m

giga (G) milli (m) mega (M kilo (k) centi (c) micro (µ) nano (n) **Metric Prefixes** $=10^{-2}$ $=10^{3}$ $=10^{-9}$ II II II П 10-3 : 10-6 10^{9} 10^{6} = 1 hundredth = 1 thousand = 1 thousandth = 1 millionth = 1 billionth 1 billion 1 million

Conversion Between English and Metric Units

10:0:0		0. 1000 AB	
= 28 3495 o	1 07	= 0.4536 kg	_ - - -
= 0.0353 oz	= 0.0022046 lb	= 1 gram	1 g
	= 2.2046 lb	= 1000 grams	1 kg
$= 2.2046 \times 10^3 \text{ lb}$	= 1000 kg	$=10^6$ grams	1 metric ton
			Mass
= 2.5400 cm	1 inch	= 1.6093 km	l mile
$= 3.93 \times 10^{-8}$ inch	$=10^{-9}$ meter	= 1 nanometer	1 nm
$= 3.93 \times 10^{-5}$ inch	$=10^{-6}$ meter	= 1 micrometer	1 μm
= 0.3937 inch	= 0.01 meter	= 1 centimeter	1 cm
= 39.37 inches	= 1.094 yards	= 1 meter	1 m
= 0.6214 mile	= 1000 meters	= 1 kilometer	1 km
			Length

Some Useful Formulas

Geometry

Circumference of circle = $2\pi R$

Surface area of sphere = $4\pi R^2$ **Distance Relationships**

Volume of sphere = $\frac{4}{3}\pi R^3$ Area of circle = πR^2

Distance–Velocity–Time: $d = V \times t$

Linear size–Angular size: $\ell = d \times \alpha/57.3^{\circ}$

Distance from parallax: d(in parsecs) = 1/p(in arcsec)

Hubble's law (for distant galaxies): d = V/H

Kepler's 3rd law pler's 3rd law—orbits around Sun with semimajor axis a (in AU) and period P (in years): $P^2 = a^3$

Gravitational force between masses M and m: $F_G = G \frac{M \times m}{d^2}$

Gravitational potential energy: $E_G = -G \frac{M \times m}{r}$

Newton's modified form of Kepler's 3rd law for the total mass of two

orbiting bodies: $M = \frac{4\pi^2}{G} \times \frac{d^3}{P^2}$

Escape velocity from a mass M at radius R: $V_{\rm esc} = \sqrt{\frac{2GM}{R}}$ Mass of object for orbital speed V at distance d: $M = \frac{d \times V^2}{G}$

Frequency (ν) -Wavelength (λ) relation: $\lambda \times \nu = c$

Energy of a photon: $E = h \times \nu = \frac{h \times c}{r}$

Stefan-Boltzmann law—luminosity L of thermal source at temperature T: $L = \sigma T^4 \times (Surface area)$

Wien's law—temperature of thermal source from wavelength of

maximum emission: $T = \frac{2.9 \times 10^6 \text{ K} \cdot \text{nm}}{2.9 \times 10^6 \text{ K} \cdot \text{nm}}$ ^max

Brightness (B)-Luminosity (L) relation: B =

Doppler effect: Radial velocity = $V_{\mathbf{R}} = c \times \frac{\Delta \lambda}{\lambda}$

Other Physical Relationships

Density = $\frac{\text{Mass}}{\text{Volume}}$: $\rho = \frac{M}{V}$

Newton's 2nd law—acceleration a produced by force F on mass m: a = F/m

Kinetic energy: $E_{\rm K} = \frac{1}{2}m \times V^2$

Conservation of angular momentum:

 $(Mass) \times (Circular \ velocity) \times (Radius) = Constant$

Lorentz factor for special relativistic contraction at speed V:

 $\gamma = \sqrt{1-V^2/c^2}$